City, Temple, Stage

. .

CITY, TEMPLE, STAGE

Eschatological Architecture
and Liturgical Theatrics in New Spain

JAIME LARA

University of Notre Dame Press
Notre Dame, Indiana

The author and publisher are grateful for the assistance of
the Frederick W. Hilles Publication Fund of Yale University
in the publication of this book.

Library of Congress Cataloging-in-Publication Data
Lara, Jaime, 1947–
 City, temple, stage : eschatological architecture and liturgical
theatrics in New Spain / Jaime Lara.
 p. cm.
 Includes bibliographical references and index.
 ISBN 0-268-03364-1 (cloth : alk. paper)
1. Church architecture — New Spain. 2. Architecture, Colonial —
New Spain. 3. Symbolism in architecture — New Spain.
4. Apocalypse in art. 5. Indian architecture — Influence. I. Title.

NA702.2.L37 2004
726.5'0972'09031 — dc22

 2004016391

To the memory of my mother Julia,

and to my father Louis

the first and best of teachers

Map of mendicant foundations c. 1570

MÉXICO

TOPIA
DURANGO
NOMBRE DE DIOS
PEÑOL BLANCO
SOMBRERETE

ZACATECAS

SENTIPAC
JUACHIPILA
JALISCO
AHUACATLAN
ETZATLAN
GUADALAJARA
TONALA
TLASOMULCO
COCULA
CHAPALA PONCITLAN
AXIXIC OCOTLAN
ZACOALCO
AMACUENCA ATOYAC
AUTLAN
JACONA
ZACAPU
ZAPOTLAN
TARECUATO
ZAPOTITLAN
TUXPAN
COLIMA
ERONARICUARO
URUAPAN
PATZCUARO
TZINTZUNTZAN TIRIPITIO
TACAMBARO
CUPANDARO

SAN MIGUEL EL GRANDE
APASEO
QUERETARO
VURIRIA ACAMBARO
HUANGO CUITZEO ACAREO
SANTA FE CUCUPAD
ZINAPECUARO CHARO
JERECUARO
VALLADOLID TAJIMAROA

TAMPICO

XILITLA TATOYUCA
CHAPULHUACAN HUEJUTLA
PAHUATLAN
CULHUACAN
MOLANGO
IXMIQUILPAN METZTITLAN
CHAPANTONGO TUTUPETEPEC
AC TOPAN ATOTONILCO
TULA ACATLAN HUACHINANGO
JILOTEPEC EPAZOYUCA TULANCINGO
TEZONTEPEC ZEMPOALA
ACOLMAN OTUMBA TEPEAPULCO
CUAUTITLAN TEOTIHUACAN APAN
ECATEPEC TEPETLAOZTOC
ATZCAPOTZALCO TETZCUCO
MEXICO HUEXOTLA
CHALCO
TOLUCA CHIMALHUACAN
COYOACAN COATEPEC CHALCO
XOCHIMILCO MIXQUIC
OCUILA TOTOLAPAN TLAMANALCO TLAXCALA
MALINALCO TEPOZTLAN TENANGO AMECAMECA
CUERNAVACA TLAYACAPAN PUEBLA
CUPANDARO OAXTEPEC ATLIXCO TEPEACA
YAUTEPEC ACATZINGO TECALI TECAMACHALCO
TLANQUILTENANGO HUAQUECHULA CUAUTINCHAN QUECHOLAC
IZUCAR TEPEJI TEHUACAN
CHIETLA ZAPOTLAN
CHIAUTLA

TEQUISTEPEC
TEUTILA
TONALA TEQUISTEPEC
TAMAZULPA COIXTLAHUARA
TLAPA TEPOZCOCULA TANETZE
YANHUITLAN YANHUITLAN VILLA ALTA
TECOMAXTLAHUACA ACHIUTLA IXTEPEXI TOTONTEPEC
TLAXIACO ETLA
CUILAPAN OAXACA
OCOTLAN NEJAPA
JALAPA
HUAXOLOTITLAN COATLAN TEHUANTEPEC
HUAMELULA

Dominican ●
Augustinian ▲
Franciscan ■

Adapted from Robert Ricard, *La conquista espiritual de México*, Fondo de Cultura Económica. Used with permission.

Contents

Acknowledgments

This book is the product of many helping hands along the way. Friends and colleagues on four continents—from Mexico City to Jerusalem and from Los Angeles to La Paz—have contributed in their own unique ways to a project that began over a decade ago. Historians, art historians, architects, liturgists, and linguists have each added their suggestions, critiques, or bits of data that I have integrated in the following pages.

I owe a debt of gratitude to those who labored with me on the original conception with their special gifts and who now have gone to their eternal reward: Santiago Sebastián López, Walter Horn, and Harvey Stahl. *Requiescant in pace.*

I am also thankful to those who read, reread, and refined my random ideas as those ideas were coming into focus: John Baldovin, S.J., William Short, O.F.M., Mary Miller, and, later, Juan Antonio Ramírez, Jaime Salcedo, Jeanette Favrot Peterson, William Clark, and Abbas Daneshvari, with their respective critical eyes and precision of speech.

The gold mine of friends and co-researchers in Mexico has been most encouraging to this gringo who wandered into the rich harvest of their fields. Fray Francisco Morales, O.F.M., Elena Estrada de Gerlero, Elisa Vargaslugo, Constantino Reyes-Valerio, Benedict Warren, Leopoldo García Lastra, and Silvia Castellanos Gómez have called my attention to overlooked details, allowed me to use their materials, offered their warm hospitality, or accompanied me on my campaigns of discovery. I am also grateful to Christian Kuttel for executing the scale model of Huejotzingo, and for the assistance of colleagues and staff at the Universidad de Las Américas-Puebla, the Universidad Nacional Autónoma de México, the Instituto Nacional de Arqueología e Historia, and the Lafragua, Palafoxiana, and Franciscana libraries in Puebla. Countless additional humble souls in Cholula, Los Angeles, Bogotá, and New Haven have participated vicariously in this enterprise by their simple but profound gifts of friendship, food, shelter, and encouragement.

The "gift of tongues" was supplied by able-bodied translators: John Leinenweber for assistance with the intrigues of medieval Latin, and Garret Gentry for the pitfalls of medieval Catalan. I am especially honored to have had the help of experts in two native languages: James Lockhart, Stafford Poole, C.M., and Jonathan Amith for Náhuatl; and Moisés Franco for Tarascan/Purepecha.

My many "campaigns" to visit and photograph the sites over the course of the last decade were accompanied by trusty companions who carried cameras, put up with my eschatological babble, and willingly wasted time going to the most out-of-the-way places, especially John Brogan, Michael Brewer, and the hermanos Malo. Then there were the professional photographers who contributed their expertise and who made suggestions for camera angles, exposure settings, and times of day: Javier González, Eréndira de la Lama, and Juan Aruesti.

My graduate students at Yale—architects, theologians, church and art historians—have asked all the right and difficult questions and have more than once made me rethink my statements. Yale University and its Institute of Sacred Music—an interdisciplinary faculty—helped with much-needed moral and financial support.

Lastly, I thank my initial copy editor, Kaudie McLean, for reading the still-evolving text and correcting every tedious footnote; and later the same work done by the editorial staff at the University of Notre Dame Press. It is obvious to me that this has been for them all a labor of love. *¡Felicidades a todos!*

City, Temple, Stage

. .

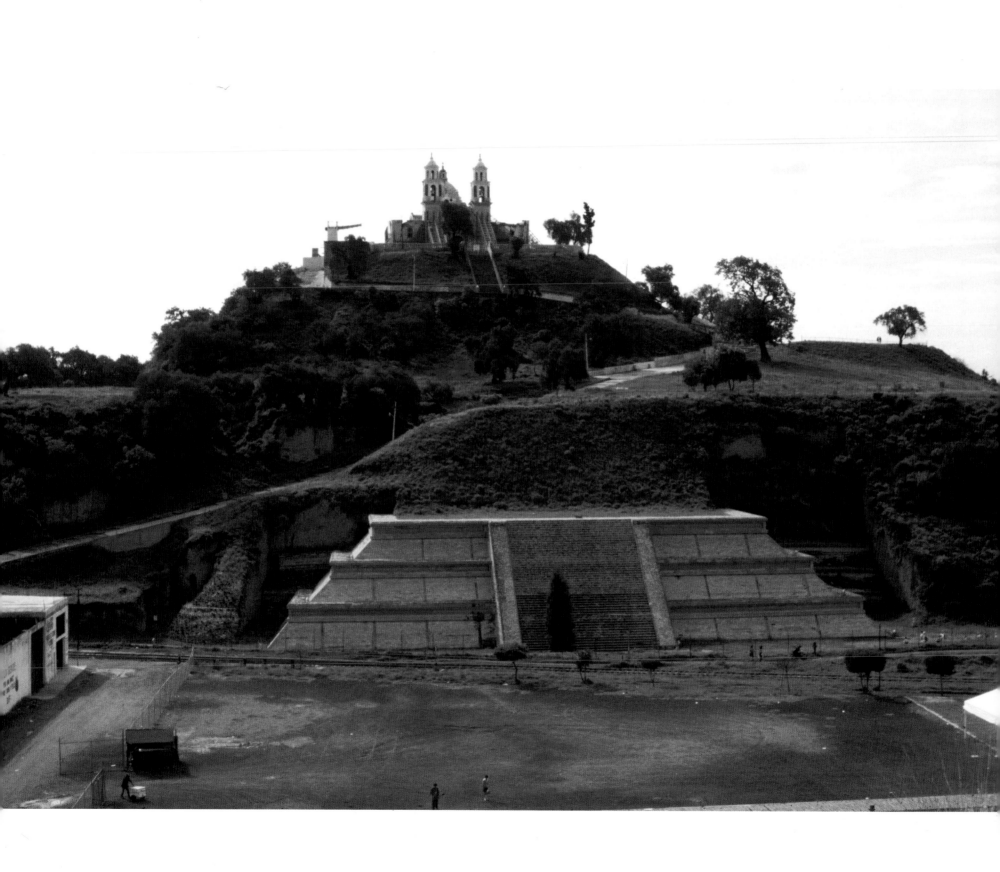

Introduction

Sixteenth-century Mesoamerica is an intriguing and complex area of study. The encounter of Mesoamericans and Europeans that took place at that critical moment has aspects of tragic misunderstanding, cruelty, and brute force; but at the same time, there are moments that reveal a deeply humane, comically fallible, and even entertaining side to the actors and events of the period. It borders at times on a world of fantasy and high theater.[1] Its history has the makings of grand opera, or a Broadway drama, or, more likely, a Hollywood spectacle. In colonial Mexico, religion, ritual, legend, and liturgy created an eschatological fantasyland where utopian dreams were tried and tested, and constructed in stone and mortar.

The area we today call Mexico, known then to the Spaniards as Nueva España (New Spain), is the land of the great civilizations of the Maya and the Mexica. The latter, more commonly known as the Aztecs, were members of a group of Náhuatl speakers of the valley of Mexico and the Puebla-Tlaxcala valley and hence are also known as Nahuas. Following Spanish colonial usage, we might call the generality of indigenous peoples Indians or, better, Amerindians. Their conversion to Christianity at the hands of the mendicant missionary friars—the Franciscans, Dominicans, and Augustinians—is the broad subject of this study.

New Spain was the first theater of operations on the American continent for the event of the Contact—the tragicomical human drama of the encounter and collision of peoples, cultural patterns, world hypotheses, and cosmologies. I avoid saying that there was a meeting of *two* worlds or *two* cultures, because that is an inadequate notion. Neither the indigenous peoples of America nor the colonizing European intruders were so unidimensional or homogenous that we can neatly divide them into Indians and Spaniards, or even pagans and Christians.[2] The encounter was also initially much less global and much more local and limited: a handful of Franciscan friars meeting one of the

1

approximately 287 ethnic groups that made up present-day Mexico, as opposed to the whole Aztec Empire coming to terms with the Spanish Empire or "Europe." This reluctance to speak of two cultures, of course, was not the case in the sixteenth century, when such unidimensionality of "them" and "us" was presumed. But our present hindsight—if it is really all that lucid—recognizes the differences and the subtleties, the nuances and the multidimensionality. This is evident in the literature on the religious expression and the art of New Spain that has appeared and evolved in the last seventy years.[3]

In 1933 Robert Ricard published his seminal work, *La conquête spirituelle du Mexique.* It was groundbreaking and offered a wealth of primary and secondary sources for investigation. But Ricard was writing from a very Eurocentric perspective. His interest lay in Christian missionary technique, as the English subtitle evidences: *An Essay on the Apostolate and the Evangelizing Methods of the Mendicant Orders in New Spain.* On the subject of missiology, Ricard excelled. However, owing to this European focus he almost completely omitted the native voices extant in Náhuatl written documents and glimpsed occasionally even in the mendicant chronicles themselves.[4] Ricard also tended to be somewhat naive in estimating the success of the evangelization process, taking the mendicants' glowing evaluation at face value, while typifying the Amerindians in passive terms and emphasizing what he saw as their quick acquiescence to the new religion.[5] Ricard did not read Náhuatl or any other indigenous language, and by 1933 only a few translations had appeared; hence, although noble in its conception, his work is one-sided and incomplete.

After Ricard, a whole series of studies appeared, again from a European/North American perspective, studies that inquired into the motives and ideologies of the mendicant missionaries who came to the New World. John Leedy Phelan looked into millennial-apocalyptic beliefs among the Franciscans, focusing on the writing of the archetypal Franciscan Fray Geronimo de Mendieta. Georges Baudot observed themes of utopian aspirations as evidenced in the first mendicant chroniclers. Marcel Bataillon examined the influence of the reforming thought of Erasmus and Thomas More in pre-Counter-Reformation Spain and its colonies, while Jacques Lafaye and Alain Milhou took up themes of messianism, crypto-Judaism, and political-

utopian dreams in Christopher Columbus and the creoles in New Spain.[6] Further studies on European culture brought to light important Old World ideological trends that were occurring at the same time as the occupation and evangelization of America: the abiding influence of the eschatology of Joachim of Fiore, the mythical messianism of a Holy Roman Emperor, and the role of eschatological prophecy in Rome as well as in Spain.[7] All these currents were shown to take concrete visual form in art, architecture, dramaturgy, and liturgy, and I shall return to them in detail below.

Initial rejection of Robert Ricard's intellectual hegemony and the Eurocentrism of his followers came from Charles Gibson's work on the survival of Aztec culture under Spanish domination, and from the writings of others like him who developed a "hermeneutic of suspicion" regarding the objectivity of the mendicant chroniclers.[8] By comparing the friars' often-optimistic evaluation with the contrasting voices of native documents and performance, they were able to detect evidence of occasional outright resistance or, more commonly, negotiated accommodation between pre-Contact religious practices and later Christian practices. Historians and anthropologists like Miguel León-Portilla, David Carrasco, James Lockhart, Louise Burkhart, Serge Gruzinski, and Jorge Klor de Alva have given us a wealth of factual and interpretative information about the Mexica and their religious expression at the time of the Contact. They have also attempted to look at the European conquistadors and missionaries through the eyes of Native Americans—to the extent that that is possible. Their findings have demonstrated various levels of acceptance and rejection of Christianity that went largely unnoticed by Ricard.[9]

Art historians like Constantino Reyes-Valerio, Jeanette Peterson, and Gauvin Bailey have followed suit in listening to native voices, and have integrated the intended European meanings of works of religious art with indigenous spirituality, reception, and interpretation. This project has proved quite successful and has given us a more nuanced and complete picture of sixteenth-century New World art.

That art has often been described in terms of its style. Nomenclature has been invented to describe the new style, such as *mestizo* (mixed), *tequitqui* (vassal-like), the somewhat unwieldy *Indo-Christian,* and the simpler *mission art.*[10] Whatever

the term used, we recognize today a convergence of visual expressions, especially in the first century of cultural contact, with a resulting hybrid art combining selected elements of both indigenous and European modes of visualization.[11] Postcolonial theories of hegemony, alterity, and subaltern voices have emphasized the accommodation, acculturation, manipulation, syncretism, hybridity, and selective borrowing at work in these new artistic creations.[12]

As fascinating as this field of study is, style is not my concern here. Rather, I am interested in meaning, and although the use of one style as opposed to another can occasionally reference certain intentions, I am unashamedly more intrigued by iconography, by intended meanings and their reception, and by the way in which they mediated operative ideologies or worldviews.[13] These larger meanings, like the cultures of the New World encounter, were themselves not one-dimensional; they should also be understood as polysemantic or multivalent. But neither were they obtuse or so ethereal as to be incapable of plastic expression. They always seemed to take concrete visual form in art and architecture, as well as in "flower and song," ritual and myth.[14]

Mesoamerican Religion

The Nahuas were an extremely religious people, totally immersed in a sacred cosmos, even though there was an apparent lack of uniformity in their liturgy and standardization in their beliefs. They were pious polytheists whose religion has been dubbed *teoyoism* (from *teotl*, gods).[15] Theological orthodoxy seems to have been a low priority and was probably the province of the priest-scribe elite. As a result, doctrinal lore must have filtered down the social classes in a progressively more diffused form. Local customs and existential exigencies were likely the primary determinants of the form the rituals took, limited by the underlying presuppositions that formed the warp and woof of teoyoism. Foremost among these presuppositions was the belief that the fundamental function of most ceremonies, public and domestic, was to avert catastrophe. In spite of the general belief that the world was a vale of tears, there was a positive sentiment that most ills could be

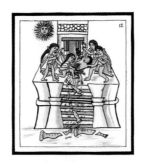
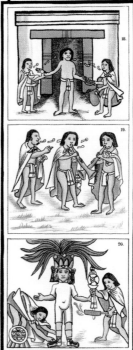
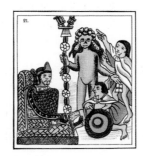

Fig. I.1.
The *Florentine Codex* of Fray Bernardino de Sahagún (c. 1579), book 2. Images of human sacrifice (17) and the impersonator of the god Xipe Totec wearing flayed human skin (21). (From Sahagún, *Historia General de las cosas*, ed. Paso y Troncoso, 1905.)

overcome by acts of communal and individual self-assertion. These centered on forms of sacrifice, or self-inflicted bleeding (autosacrifice), to induce fortunate events to take place and to prevent misfortune from prevailing (fig. I.1).[16]

The Mexica pantheon comprised a bewildering number of male and female deities, some of whom bore superficial affinities to Christ, the saints, and the Christian God.[17] These polymorphous gods personified the earth, wind, water, lightning, and other natural forces, as well as fertility, regeneration, death, and war. The gods were creators and destroyers, bearers of both good and ill. Devotees encountered them in the use of psychotropic drugs, in the intoxication of pulque beer, and in ecstatic dancing.

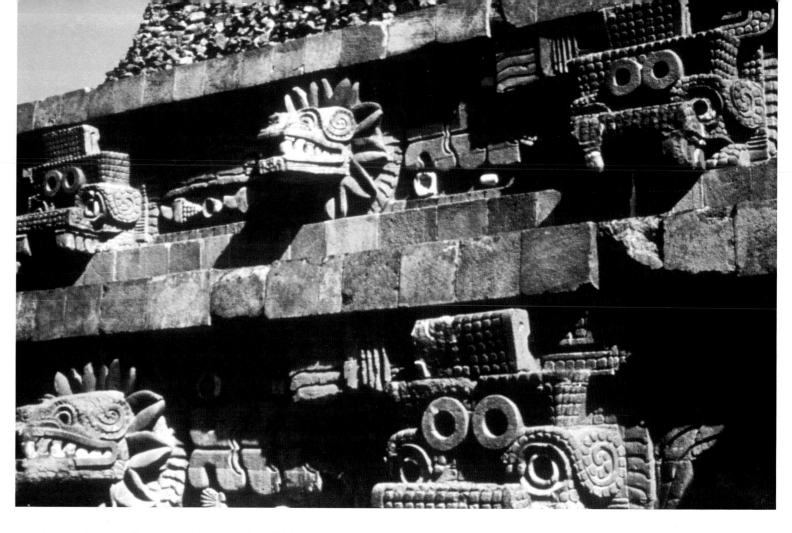

Fig. I.2.
Teotihuacan.
Pyramid of the gods
Quetzalcóatl and
Tlaloc. (Photo by
author.)

Among the more important Mesoamerican deities, Tezcat-lipoca—whose identifying attribute was the dark mirror—was the omnipotent god of rulers, sorcerers, and warriors, while Huitzilopochtli was the supreme deity of the Aztecs and their national god of war. Both Tezcatlipoca and Huitzilopochtli were associated with blood and solar imagery.[18] Tlaloc, with his goggle eyes and jaguar teeth, was the god of rain and lightning bolts. The ever-popular Quetzalcóatl was a miraculous synthesis of serpent and bird, often associated with priests, artists, and merchants (fig. I.2). He had descended from the summit Ometeotl, the heavenly mountain, "resplendent beyond imagining, beyond thought . . . an incarnation of the Inconceivable [on] the axial ladder let down through an opening in the middle of the sky, as though from the golden sun-door of noon to the navel of earth." In a Christlike motif, the god wore a crown of agave thorns and at the moment of his autosacrifice had solemnly declared: "This is my blood."[19]

Quetzalcóatl had been conflated with a historical figure of the ancient Toltec people, supposedly a man-god who had been banished to the east for opposing human sacrifice and who would return someday preceded by ominous signs.[20] This led the early missionaries to believe him to have been the first-century apostle St. Thomas, who had evangelized "beyond the Ganges River."[21] In a similar vein, the god Xipe Totec was assimilated with another martyred apostle, St. Bartholomew, who in Christian legend was flayed alive. Xipe Totec was depicted as a human male inside the flayed skin of another man, suggestive of the spring fertility rites of shedding skin and planting seeds (fig. I.1). Sometimes his impersonator, in the manner of a passion play, was hung on a cross-shaped scaffold (fig. I.3) and shot through with arrows, like St. Sebastian.[22]

Other divinities would later be reread in a Christian manner or associated with benign aspects of the new religion of the invaders. The mother goddess Tonantzin, whose shrine was at

the hill of Tepeyac outside Mexico City, has rightly or wrongly been considered the Aztec ancestress of the Virgin Mary of Guadalupe, whose basilica sits on the same site today.[23]

Location, landscape, and geography were sacred to Mesoamericans (see below, chap. 3). The cosmic world of the Mexica was autocentric, like that of many cultures, focusing on their great metropolis, Tenochtitlán, present-day Mexico City.[24] This hagiopolis or sacred city, located at the center of Lake Texcoco, was for them the "navel of the world." The four corners of the earth radiated out from this umbilical center (forming a quincunx, a fivefold configuration common to medieval and Mesoamerican cultures alike),[25] which functioned as an *axis mundi* and transitional point between the thirteen levels of the celestial realm above and the nine steps downward into the underworld.[26] However, neither the celestial realm of Omeyocan nor the underworld of Mictlán corresponded exactly to the Christian heaven and hell; nor did they correspond to Christian notions of moral choices and the consequences of either reward or punishment. This does not mean, however, that the Mexica did not have a sense of moral significance, of the transgression of established order, or of postdeath bliss or annihilation.[27] But their belief was not the same as the Catholic doctrine of salvation.[28]

Like medieval Catholicism, however, native teoyoism did have both a public, communal, and liturgical manifestation and a private, domestic, and "popular" expression. Public religion among the Mexica took the form of a sort of "great tradition," the official state religion and state theater.[29] Its rituals maintained cosmic balance and manifested themselves in the "work of the people" (*liturgía*, to use a Greek term) at the temples, in the cities, and through the streets in acts of public, communal participation. It betokened the great themes of the myths of origination, cosmic world maintenance, obligations, and reciprocity with nature and the gods, and the ultimate destiny of individuals and the created world. The veil between the sacred and the profane was thin. Consequently, many animate objects were necessarily sacred, particularly those whose propitiatory utility inspired the reverence and respect of the community. In effect, a sacred relation existed between humans and the rest of the empirical world. The inclusion of the material within the metaphysical world transformed the temporal realm into the center stage for all the important religious dramas, whether personal or cosmic.

On the other hand, Mexica popular religiosity, or the "little tradition" of the home rituals, was more concerned with the sacred nature of the immediate material world and the vaguely understood spirits that inhabited it, rather than with the monumental images and the esoteric lore of the mighty. In this, too, Nahua piety had affinities with nondoctrinal aspects of Christianity. Catholic popular religiosity in Europe was heterodox and tended toward being occult and magical, mixing elements like amulets and folk medicine inherited from the Greco-Roman and Nordic past with orthodox Catholic saints, sacramentals, and piety.[30] In its most extreme or antisocial forms, it was considered witchcraft, but there was great latitude and tolerance for practices that did not invoke the demonic and that might be performed by laity and clergy alike.[31] For Nahuas as well as Christians, in the private realm of the home the boundaries between the sacred and the profane were even thinner than in the public realm; and it was the popular, often heterodox

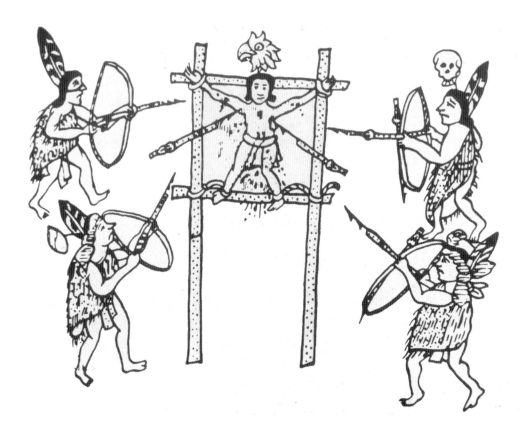

Fig. I.3. *Historia Tolteca-Chicimeca*, mid-sixteenth century, Puebla region. The arrow sacrifice of Xipe Totec. (Redrawn from MS mexicain 51–53, Collection Aubin, Bibliothèque Nationale de France.)

Catholicism of the Spanish layman—in addition to the official doctrine of the friars—that the Mexica subsumed under their version of Christianity. The "little tradition" of the home was what survived the conquest as the cycle of life rites, cures, and practices that accompanied technical activities like agriculture, hunting, or giving birth.[32] A similar dynamic occurred in what we today call "folk Catholicism."[33]

Colonial Mexico is fascinating and complex precisely because mutually alien peoples were attempting to make sense of one another and of their new cohabitation of the same space. Both sides of an admittedly unequal dialogue were bringing their cultural filters, prejudices, and presuppositions through which they scrutinized the new and strange other.[34] Neither side was dispassionately objective; both had something to gain or lose in the transaction. They could not do otherwise. To expect late medieval Franciscan friars to have appreciated Mexica human sacrifice or ritual cannibalism in terms of reciprocity in a cosmic balancing act, and not through their Christian filter of good and evil, is just as ludicrous as to expect the Aztecs to have embraced Aristotelian philosophy with its categories of person, free will, and individual responsibility. The Christian dualism of good and evil, or God versus Satan, was just as abstruse to the Aztecs as the Aztec duality of male-female divinities with their amoral benign-hostile qualities was to the Spaniards. And while the distinction between idolatry and the legitimate veneration of images may have been clear to the European clergy,[35] such subtleties were meaningless to the natives, who quite correctly observed the Spaniards affectionately treating their many images in ways identical to the Aztec treatment of their *teotl ixiptla* (images or impersonators of the gods).[36] Indeed, the imprecision regarding the veneration (*dulia*, in Latin) of images, as opposed to their adoration (*latria*), was a confusion among European Christians themselves and was one of the causes of the Protestant Reformation.[37]

However, in New Spain such ontological and philosophical differences did not annul interaction, creative responses, and adjustments to the changed and changing situation. Probably the human trait of curiosity on both sides of the Contact had much to do with this. Both sides engaged in borrowings and lendings, which were internalized and interpreted in action and reaction.[38] In spite of the obvious brute force and political hegemony of the Spanish, the Nahuas were not rendered passive; they did speak and interact politically and religiously. Colonial circumstances made unequal partners in cultural intercourse, but indigenous peoples were far more than mere victims. The data prove that they were proactive in the inculturation process and that their ethos had actually prepared them well for the cultural exchange.[39] James Lockhart sums up the present state of the question.

> The error of the Ricardian view now became fully apparent. The friars had stepped into a situation already made for them. . . . The extent of their success depended precisely upon the acceptance and retention of indigenous elements and patterns which in many respects were strikingly close to those of [Christian] Europe. Relatively few of the friars' innovations were entirely new to the Mesoamericans. It was because of such things as their own crafts and writing systems, their tradition of sumptuous temples as symbols of state and ethnic group, their well-developed calendar of religious festivities and processions . . . that they could quickly take to similar aspects of the Spanish [Catholic] heritage.[40]

I said above that much has been written recently from the position of indigenous peoples, as far as that is accessible to us. Talented linguists, anthropologists, and historians will continue to bring to light native voices and demonstrate native resiliency in the confluence and convergence that occurred in the sixteenth century. I would, however, like to take a second look at the ideological and metaphorical baggage that the missionaries brought with them—their myths, symbols, and collective dreams. It was my initial instinct in approaching this material, and now my sincere conviction, that the friars' worldview and symbols were much closer to the native imagination and metaphors (and vice versa) than had previously been thought. It is precisely this religious similarity or compatibility that I will explore in the coming chapters and that, I believe, eventually made the synthesis and convergence of the sixteenth century possible. It created what we today call Mexico and Mexican Christianity.

I focus my attention here even more narrowly—on the mendicant friars, on their visual imagination, and on their admittedly limited appreciation of the Native Americans whom they encountered and evangelized. Although Ricard, Bataillon, Lafaye, Phelan, Baudot, and Milhou have offered an immense amount of information about the Iberian intruders, more recent insights need to be integrated with the uncovering of native voices. Moreover, none of the aforementioned historians was primarily interested in the art, architecture, or liturgy that developed in the Contact period.

As a picture thinker, I am suggesting a rather simple analogy taken from the metaphor that Mesoamericanists use for the interaction of the several Aztec calendars, that of the gears of a machine or the cogs of a wheel, although I wish to reject any deterministic connotation. The interacting gears (that is, the Nahua ethos and the European) are of different sizes and have fewer or more teeth in relation one to the other. They have been forced together: occasionally they engage harmoniously, sometimes they grind in conflict, more often than not there is movement, but with both slippage and meshing.[41]

Other images that come to my mind are those of overlaying and recycling. The colonial situation overlaid a new Euro-Christian reading on pre-Hispanic practices.[42] Those practices were now seen through the laminate of a new template that ordered them into a new cosmovision and root metaphor. In this context, I will question whether "destruction" is a totally adequate word for what was done with the native temples, symbols, and religious practices of the past. Should we more accurately speak of the process as one of reuse or recycling? Were the temples, for example, not reduced to their component parts and then reassembled—precisely as "new temples"—in a Christian way? Such reassembling does not preclude an overt or covert indigenous residuum. An examination of colonial architecture and liturgy will demonstrate this to be so.

Mechanical gears, template overlay, and recycling are just metaphors, but perhaps they better model some of the dynamics of the New World encounter than words like destruction and erasure. By using such metaphors, we may better appreciate the cultural differences and discontinuity, but also the religious similarities, meshing, and "grammatical compatibility" that made confluence and convergence possible.[43]

ROOT METAPHORS

> It is in country unfamiliar emotionally or topographically that one needs poems and road maps.
> —Clifford Geertz, *The Interpretation of Cultures*

One aspect of the affinity between the Nahuas and the friars was the structure of Native American and European linguistics and imagery, namely, the use of metaphoric language and visual metaphor.[44] Metaphor and paradigm are basic components of our ordinary conceptual system in terms of which we perceive, think, and act.[45] Through metaphor, the chaos of experience is reduced to meaningful patterns; thus many diverse experiences of everyday life can be related to one another on the basis of a single metaphor that provides a model basic to all such experience. We can, then, speak of "root metaphors" by which world hypotheses and metanarratives are constructed.

Human beings desiring to understand the world look about for a clue to its comprehension. They latch on to some datum of common sense and use it as a template for understanding other areas. Since the basic analogy or root metaphor arises out of common sense, it is observable and demonstrable within the society's common analogies. For example, one may say that the sun "comes up" and "goes down." Both phenomena appear to be self-evident because they arise out of common (even if not scientifically accurate) sense.[46] Mexica cosmic space, for example, could be delimited in terms of the solar metaphor, from "where the sun rises" to "where the sun goes down."[47] But in temporal terms, the Aztec world also existed from "the rising of the sun to its setting," and when the last sun had gone down so would human existence.[48] Like all religious societies, their time and space focused on a mythic center, a cosmic spot, an originating point, a holy metropolis, a symbolic "Jerusalem" of their own—as we shall later see.[49] Similarly, the Nahua practice of human sacrifice as a world-maintaining activity was a self-evident metaphor in the real order of existence. If one looks around at living matter, one sees that plants give themselves up to animals, animals give themselves as food to humans, and, logically, humans give themselves

to the gods as sustenance. Within its presumed horizon, the paradigm makes sense of reality, and it offers a model for moral action in an amoral universe.[50]

Such human observation becomes, then, the basic analogy, ideogram, or root metaphor of a religious society, and such root metaphors occupy a central place in religious teaching and thought. As Thorkild Jacobson explains, "They form a bridge between direct and mediate experience, between the religious founders and leaders and their followers; and they furnish a common bond of understanding between worshippers, and are the means by which religious content and forms are handed down from one generation to the next."[51] These metaphors draw their power from their capacity to grasp, formulate, and communicate social realities that always elude the language of science, and they can mediate more complex meanings than their literal reading suggests. Some root metaphors prove more fertile to a culture than others; these survive in combination with other metaphors and generate an adequate cosmovision.[52] Thus, in its choice of central or root metaphors, a culture or cultural period necessarily reveals more clearly than anywhere else what it considers essential in religious experience.[53]

Therefore, we can state that a world hypothesis, or cosmovision, is largely determined by its foundational metaphors, and that an encounter of two culturally created world hypotheses is, in essence, an encounter of two or more root metaphors.[54] I suggest that we examine the cultural encounter and upheaval of the sixteenth century—the Contact—as such an encounter, clash, and eventual convergence of metaphors.[55]

In the Old World of Europe and the Near East, pagan and Judaic root metaphors tended to come from observable nature and to be expressed in images drawn from animal husbandry and farming, or from dietary restrictions meant to enhance the cohesiveness and distinctiveness of a people among alien neighbors. Participation in such ritual observances put persons in touch with social and religious coherence in the strongest and most accessible way.[56] In many ways Judaic metaphors, like ritual uncleanness and holocaust or burnt offerings, were quite close to those of the Nahuas, a fact that did not go unnoticed among the friars.[57] That is one reason why some friars mistook the Amerindians to be the Lost Tribes of Israel, who never returned from their Babylonian captivity and who were now found "at the end of the world" (see chap. 3).

Among the peoples of the New World, similar dynamics were at work, with the addition of powerful solar, astral, and floral metaphors.[58] Mesoamerican peoples often considered humans to be metaphorically like maize or flowers planted on the surface of the earth; they are born to die and become food or sustenance in sacrifice and ritual cannibalism, but they also contain within themselves the seeds of regeneration.[59] Through metaphor, particular subjects were given a vivid range of associations and meanings, most often expressed through ritual and art. Aztec metaphors reveal that every human action could be described in terms of a natural phenomenon. To speak in lofty words and mellifluous tones, for example, was "to scatter precious jade stones," while to indoctrinate by way of paradigm or exemplar was "to see in a mirror." When the Nahuas were later converted to Christianity, they developed a linguistic formula for indicating that a metaphor was being employed, using the word *teoyotica*, literally, "to speak in a sacred way." Christ is said to have spoken in a sacred way by having scattered precious jade in his preaching and by having used mirrored words, his parables.[60]

Above all, Mesoamericanists agree that the unifying metaphors among the Mexica were ones that derived from the sun and, relatedly, from blood.[61] Solar and sanguinal metaphors were so intertwined that it is hard at times to distinguish the two. While they were not the only metaphors used, they were so central that they can be related to all others as either originating or organizing principles.

Enter the Christians. Whereas nature and the recurring cycles of animal husbandry provided the allegories in which Greco-Romans and Jews spoke, Christians altered this root metaphor to that of the human body.[62] This unprecedented trope both absorbed and transmuted what had gone before it in the Old World. It was lodged not in recurring cycles of nature but in an incarnation of the invisible and inconceivable Deity in time and space in one Jesus of Nazareth. In its most powerful manifestation, the metaphor took the form of the "Body of Christ" (to use St. Paul's words)—a Body that could be dined upon at a table around which sat the same Body, a new corporation of people who conceived of themselves as recon-

ciled to the Deity and at peace both with each other and with a new world. Like the metaphors of pagans, Jews, and Amerindians, this new corporeal metaphor acted as a filter through which the entire world could be viewed and comprehended; and like the root metaphor of the Nahuas, it was implicitly connected with the body's blood.[63] Even Jorge Klor de Alva, who is unsympathetic to missionary efforts, concedes that this Christian body metaphor would totally transform the native notions of the individual and communal body in Mesoamerica.[64]

Nor did this element of metaphor go unnoticed by the missionary friars in the sixteenth century. One Franciscan chronicler strongly recommended attention to metaphor on the part of his confreres, an approach that he had noticed in the rhetorical practices of the Aztecs themselves:

> The preacher should use examples, similarities and comparisons like those that appear in the teaching of our Lord and Savior Jesus Christ, in which there abound parables and comparisons. . . . In relation to this, our Indians are very successful in their commercial transactions, because they are always using similarities and comparisons taken from other entities in order to better express their desires, and it appears that these were perceived very clearly in their actions and speech. They never fail to come up with a metaphor.[65]

Moreover, the classic missionary handbook that the friars had on hand, St. Augustine's *De catechizandis rudibus* (The first catechetical instruction), explained that the most successful way to educate and entertain the illiterate was precisely by similarities and metaphors.[66] And among the first bilingual texts composed in the New World was a list of the metaphors that the "old ones" had used in the pre-Hispanic days.[67]

In the Contact of the sixteenth century, primary and secondary metaphors abounded for Nahua and European alike; some were more useful for intercultural dialogue at certain times and places than others. In the chapters ahead I am going to discuss three categories of related symbols to demonstrate the convergence of metaphors and cultural expression in the New World encounter—namely, those of the city, the temple, and the stage.[68] For Nahuas as well as for Spaniards, all three were spatiotemporal architectural constructions that facilitated the interaction of the body politic, but they were also much more. All three allowed metaphorical expansions and openings through which the divine world could intervene. All three, in their dual sixteenth-century manifestations and confluences, were understood as paradigmatic, cultic, eschatological, and, of course, visual, and I will address each in a separate chapter.

TABULA RASA?

Contrary to Ricard's opinion, the friars did not encounter and could not effect a total tabula rasa in order to begin evangelization with a clean slate.[69] A reading of the primary and secondary sources on the evangelization of America does confirm that the initial activity of the friars was the destruction of temples and idols, together with rudimentary catechesis of the Indians for baptism; but the missionaries also studied and preserved much of the culture and many of the religious symbols they encountered.[70] Moreover, demolition of temples and images was not unprecedented—although the scale of the destruction certainly was. The European invaders could claim biblical justification in the actions of Old Testament prophets like Elijah, who destroyed the *bamot* (literally, "pyramids") of the Canaanites.[71] Indeed, it seemed that the friars and their flock were reliving biblical events in their own times.

However, these practices were not unfamiliar to the natives either. The regular practice of the Mexica themselves was to destroy religious buildings when they conquered neighboring peoples.[72] Their own religious images were also regularly destroyed every fifty-two years at the New Fire ceremony.[73] Even censorship, and the burning of the illustrated codices, had been practiced before the Contact when Aztec rulers erased and then rewrote their hegemonic history. The friars' zealous destruction of elements of the old religion was, therefore, a practice already known and utilized by Mesoamericans. But like peoples and religions worldwide, the Mexica had also engaged in accommodation with earlier or conquered cultures, assimilating from them selected elements, artifacts, and deities.[74] They continued to do so in the post-Contact period.

The missionaries understood from the beginning that conversion would require a comprehension of the local languages

and of ancient religious beliefs and practices. No matter how much was done in the way of building churches and generating the proper sociopolitical climate for imparting Christian doctrine, the success of conversion and indoctrination depended on the missionaries' understanding the Amerindian religion. The friars were quick to observe those similarities—superficial for the most part, but nonetheless real—between Catholicism and native religious expression.[75] (In the colonial period, such coincidences were believed to be part of a remote plan of Divine Providence to prepare the Amerindians for Christianity.)[76] Mesoamericans had crosslike totems. The Aztecs practiced forms of public confession, penance, self-flagellation, and communion. They had divinely inspired scriptures, a liturgical calendar, a ritual priesthood, vestments, relics, and circumcision.[77] Their native priests lived as mendicant beggars and as temporary celibates in monastery-like settings.[78] There were military-monastic orders and consecrated virgins.[79] Their altar sacrifices, accomplished in the body and blood of the deified victim, were a seemingly debased parody of the Catholic sacrifice of the Mass. These practices confused the friars, raising in their minds the possibility of an earlier evangelization and subsequent demonic perversion; but they also opened up points of association to the foreign religion.[80]

Meanwhile, the natives were also noticing similarities between their ancient practices and those of the interlopers.[81] To visual thinkers, one of many examples was sacred scripture. For the Nahua, sacral writing was *in tlilli in tlapalli*, the painted "Red and the Black" of their pictographic codices; that expression could denote hallowed script and sacred speech, as well as being a metaphor for knowledge or wisdom.[82] When the natives looked over the shoulders of the friars to inspect their leather-bound and gilt-trimmed books, as they no doubt did, they spied the very same sacred colors: black type with rubrication on white paper, frequently accompanied by black and red images. This was the standard visual format of printed missals, breviaries, catechisms, and the *Liber Sacerdotalis* ritual book used so pervasively in America, all of which became the new "Red and the Black," the new wisdom of the new religion.[83] Gazing on these sacred colors, the friars chanted, moved in procession, and performed rituals—as had the Aztec priests in the temples (fig. I.4).

The Amerindians would come to equate many elements of Catholicism—like the paradise garden or the tree of the Cross—with particulars in their own religion. This would foster social and individual interpretations of rituals and ceremonials, and later on of the more formal and theological concepts, within the framework of the native religious system.[84] This, the friars hoped, would eventually lead the neophytes to a more thorough and orthodox Catholicism, as their own religious systems would begin to recede and Christianity become more thoroughly internalized. While it is true that the friars were adamant about eradicating those aspects of the native religion that clashed head-on with Catholicism—human sacrifice, cannibalism, suicide, polygamy, and idol worship—they were willing to permit and even actively encourage many identifications where similar rituals, ceremonials, and theological practices were found in both religions. This policy was greatly facilitated by the pseudomorphic similarities between Catholicism and variant forms of teoyoism, especially in their respective root metaphors, liturgical expression, and use of images, both visual and verbal.[85]

Anthropologists characterize this process of conversion to Catholicism as "guided syncretism," or better "synthesization"—a policy identified with the Franciscans but not absent from other orders. It was intended to convert the Amerindians by rapid ritual substitution, and then by a more prolonged search for "grammatical compatibility" and dynamic equivalents between teoyoism and Christianity.[86] There is also evidence among a few enlightened friars of the recognition that Christianity was not identical with Hispanicity, and that becoming an Iberian European in thought, word, and deed was not a prerequisite to becoming a Christian.[87] In this the friars had the biblical precedent of St. Paul's stubborn disagreement with the Jerusalem apostles about the necessity of pagans first becoming Jews before Christian baptism (Acts 15:1–35). Given their knowledge of church history, the friars would also have been aware of situations in which earlier missionaries in Europe had acted creatively in recycling and "baptizing" selected elements of the pagan religions.[88] They were aware that St. Augustine of Canterbury, when sent by Gregory the Great to evangelize the English in 601, was instructed not to destroy their temples but rather to recycle them for Christian purposes, allowing an "exchange" of festivals, even blood sacrifices, with a new meaning.

The heathen temples of these peoples need not be destroyed, only the idols which are to be found in them. Take holy water and sprinkle it in these shrines, build altars and place relics in them. For if the temples are well built, it is a good idea to detach them from the service of the devil, and to readapt them for worship of the true God. . . . And since the people are accustomed, when they assemble for sacrifice, to kill many oxen in sacrifice to the devils, it seems reasonable to appoint a festival for the people by way of *exchange*. . . . If we allow them these outward joys, they are more likely to find their way to the true inner joy. . . . It is doubtless impossible to cut off all abuses at once from rough hearts.[89]

Only a decade after the conversion of the English temples, Pope Boniface IV baptized the Pantheon temple in Rome, cleansing it in the same way with holy water and relics and rededicating it to the Virgin Mary as the Church of Sancta Maria Rotunda.[90] This christianized pagan temple was recreated in sixteenth-century Mexico City—the only circular colonial building in New Spain—as the Church of Santa María la Redonda.[91]

The friars also knew that another Boniface (d. 754), a missionary to the Saxon barbarians of the north, had chopped down the sacred oak tree of Thor at Geismar, a representation of the mythical Yggdrasil or cosmic tree. Then Boniface recycled the same hallowed logs in the construction of his Christian church. The friars would have known that biblical dramas and pantomime were successful methods of indoctrination among such people. They may even have known that the Gospel had been translated into the Saxon tongue and paraphrased in macho Saxon "street talk" with rich imagery and idiomatic expressions taken from the earlier pagan political-religious cultural world.[92] In addition, they were well aware that at the turn of the first millennium, the very same Saxons had inherited the Holy Roman Empire and become the promoters of a missionary and eschatological Christianity. We call them the Ottonians.[93]

More relevant to the mendicant activity in New Spain was the thirteenth-century Franciscan mission to the Mongols of central Asia. If the later friars had known of the correspondence of their confrere Friar William Rubruck (or Ruysbroek,

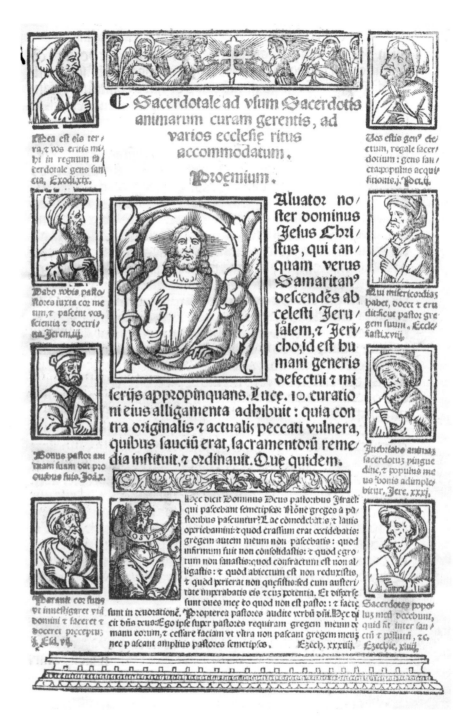

Fig. I.4.
Alberto Castellani, *Sacerdotale ad consuetudinem S. Romanae Ecclesiae: ex apostolicae bibliothecae* (1523/1564), prologue page. (Courtesy of the Beinecke Rare Book and Manuscript Library, Yale University.)

fl. c. 1250), they would have been aware of attempts at inculturating Christianity in an Asian religious ethos. The early missionary Franciscans realized that the sacred edifice of the nomadic Mongolians was the tent, and on successive evangelistic campaigns they brought along with them a portable tent chapel that had Christian paintings decorating its inside walls.[94] Tents also had biblical precedents in both the Old and New Testaments, and they allowed metaphors such as pilgrimage and divine presence that—if the mission had been successful—would have created a symbiotic bridge between the two cultural and religious systems and preserved much in the fusion.

In fact, the sixteenth-century friars chose to level the Meso-american temples, but much in the way of architecture, visual accoutrements, and ritual was reused, recycled, and reinterpreted.[95] Emperor Charles V had given instructions for New Spain: "In regards to temples and adoratories, His Majesty mandates that you demolish the temples [but] without scandal, and with the necessary prudence, and that the stone from them be used to build churches and convents."[96]

In more ways than one, Catholicism was literally and figuratively built on top of the world of the old gods, which acted as a sort of platform or stage or, to use a Náhuatl word, a *momoxtli* for the new faith.[97] Selective "synthesization" or "guided syncretism" are adequate terms for this procedure, as long as we acknowledge that it was not one-sidedly the work of the mendicants. The resultant inculturated Catholicism was evidently accomplished with the suggestions, prodding, and guidance of the Amerindian neophytes, especially the native scholar elite.[98] It also appears that the Nahua converts, because of either culture shock or need for social structures, were desperate for cosmic order and for new rituals, and they had a passion to perform them.[99] Gauvin Bailey rightly calls this process a "partnership" between natives and friars in the intercultural encounter, and he supports his positive assessment of the cultural convergence with examples from several colonial missionary enterprises.[100]

One also needs to remember that soon after the Contact, a new class of people began to emerge in New Spain. We call them *mestizos*, or mixed race, the product of Spanish-Indian intermarriage. This new group, who racially and culturally spanned the two cultures and religious ethoses, no doubt facilitated the confluence and convergence that was beginning.[101] Some of the friars were themselves mestizos. The most famous was the Latin scholar and rhetorician Fray Diego Valadés, whose father was a Spanish merchant and whose mother a Tlaxcalan native. Valadés had been a student at the elite school for Indian nobility at Tlalteloco. His career included being secretary to the artist-friar Pedro de Gante as well as guardian of his hometown mission of Tlaxcala; later he was assistant to the Franciscan provincial in Rome, where he completed his important *Rhetorica Christiana*, the first book ever published by an American-born author.

Diego Valadés was also one of the important "second generation" of friars. The second generation, around mid-sixteenth century, were those friars who began to have the time and leisure to write and reflect on the *meaning* of the Contact. The first generation, like the famous twelve Franciscan apostles who arrived in 1523, had been too concerned with the basic necessities of life and evangelization: building temporary shelters; learning rudimentary conversation, vocabulary, and grammar; and preaching as best they could. They were initially confounded by the variety of languages, dialects, and customs, as well as by the millions of new souls to convert. Travel was difficult and organization for evangelization was chaotic. For the most part, they wrote only sparse but important correspondence to those back in Spain.[102]

The second generation, in contrast, found time to reflect on what the "enterprise of the Indies" meant in the larger scheme of Divine Providence. In this second phase, questions of providentialism, eschatology, and apocalyptic expectations could be raised. Friar scholars, like Bernardino de Sahagún, were not only recording local culture with the help of native literati but also actively interpreting the meaning of the Aztec ethos.[103] At this moment, questions of the racial/genealogical origins of the natives, or their possible prior evangelization by a first-century apostle, could be discussed at length. The second generation also had access to more printed materials imported from Europe, and these informed their reflection on the Indian church and its unique mission in history. This mid-century conforms to what James Lockhart calls Stage Two in the cultural contact, when the Nahuas were being forced into frequent association with greater numbers of Spaniards, and when they

were borrowing much more from the intruders' language and mental concepts.[104]

Mid-century was also the time of the grand architectural constructions, "those great stone texts of the Spanish-Indian encounter"[105]—the evangelization centers and their iconography that are the heart of this study. Erroneously called "fortress monasteries," these huge complexes combined a church, outdoor chapels, a friary, and an atrium with monumental cross. They were a cooperative building effort on the part of Amerindians and European clergy and very often the pride and joy of the Indian pueblo.[106] Like so many other aspects of indigenized Christianity, they sat both literally and metaphorically on top of the old religion (figs. I.5 and I.6).[107]

By mid-century there was a flowering of creativity and imagination in other areas of religious art. The neo-Christian translators who worked under the supervision of friars like Sahagún were creating Christian poetry, songs, and catechisms in their native language, often with great freedom of expression and the use of elements recycled from teoyoism. Louise Burkhart states it well: "The choice of subjects, the sophisticated literary style, the metaphorical language, and the extent to which Christian teachings are reformulated indicate that, within the bounds of what the priests who sponsored and preserved their work would tolerate, Nahua scholars are exercising their own creative genius. The amanuenses have become authors and have appropriated the discourses of Christian devotion to articulate their own view of the Christian order and their place within it."[108] Some call the outcome of this transcultural activity a "Nahua Christianity," suggesting something alien to orthodox Christianity, expressed through a non-Western ethos. I shall disagree with this opinion and affirm that it was an authentic and "traditional" form of Christian identity. I am also disagreeing with those who claim that the friars presumed or desired a cultural-religious tabula rasa in their dealings with the natives. Their knowledge of church history did not encourage it, and their present reality made it impossible. Therefore, simplistic binary models of either jumbled syncretism or occult survival need to be replaced with a more textured, nuanced, and sophisticated understanding of the processes of cultural contact.[109] Burkhart has indicated a new direction in Mexican studies: "Fortunately, scholarship on colonial Meso-

american religion is moving . . . beyond syncretism: beyond the 'mix and match model' of colonial religion as a *bricolage* of traits easily compartmentalized as 'native' or 'Christian,' beyond a search for pagan survivals, beyond a dichotomy between spiritual conquest and native resistance."[110]

We shall see how these themes play out in the drama of the Contact and the evangelization, giving due attention to the scenography of sacred time, geography, topography and urbanization, architecture, dramaturgy, and liturgy. In chapter 1, I briefly survey the monuments of this study, the so-called and misnamed fortress monasteries of central Mexico constructed in the midsixteenth century. Here we shall find that, except for the stonevaulted churches, all the other components of the complex had both indigenous and European precedents that carried symbolic and mythical meanings. These complexes were neither fortresses nor monasteries in the literal sense of the words and can only be understood as such in a multivalent metaphoric sense.

In chapter 2, I turn to aspects of eschatology and compare the Aztec with the Christian sense of time. I focus on Judeo-Christian eschatology and examine its visual qualities, in particular the themes gleaned from the books of Ezekiel and Revelation. Added to these primary documents are the most important apocalyptic texts of the Middle Ages later used in Mexico: the Sibylline Oracles, the *Psychomachia* of Prudentius, and the literary progeny of the Apocalypse commentary and illustrations of Beatus of Liébana. I then turn my attention to the chiliastic years 800 and 1000, and to the Trinitarian theology of history of Abbot Joachim of Fiore, examining the influence of his eschatology on the late medieval political imagination of the Franciscan mendicants, and on the "invention" of America. Throughout this chapter we shall note the importance of the moral battleground made vivid in the visual arts, and of the city of Jerusalem—the real and the ideal Jerusalem—as the theater of holy history. (The reader may want to skip over the first half of this dense chapter, which deals with the Old World, and go directly to apocalyptic thought in the New World at the time of the Contact.) The second half of the chapter brings into the foreground the role of prophecy in shaping the early colonial

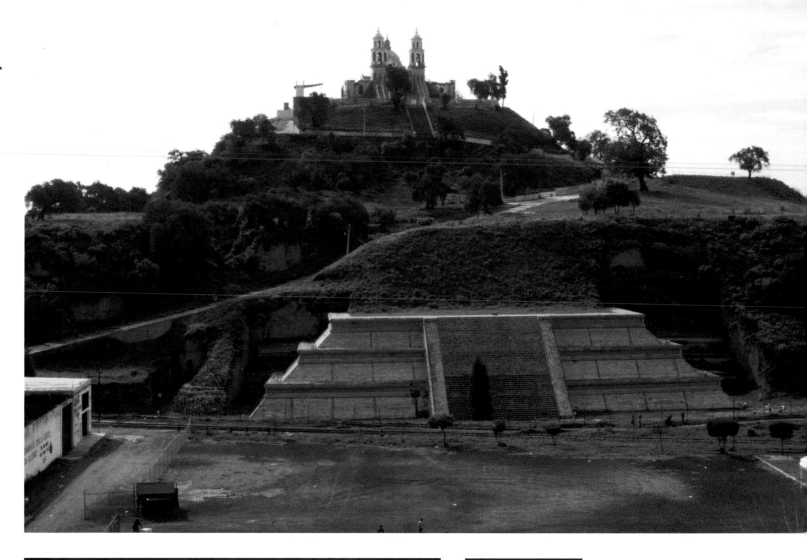

Fig. I.5.
Cholula, Puebla.
The great pyramid
now surmounted by
the Church of Nuestra
Señora de los Remedios.
(Photo by author.)

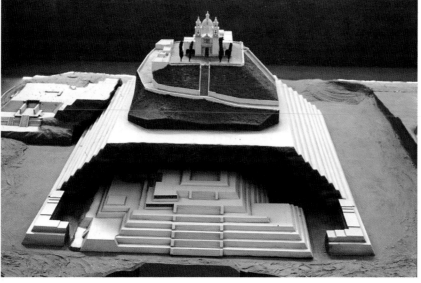

Fig. I.6.
Cholula. Model of the
great pyramid and
Church of Nuestra
Señora de los Remedios.
The cutaway displays
the earlier temples
that had been ritually
"killed" and recon-
structed. Museo de
la Pirámide, Cholula.
(Photo by author.)

imagination, both visual and metaphorical, and its encounter with Aztec eschatology.

Chapter 3 invites us to examine Aztec and European city planning at the moment of the Contact and demonstrates that, for both, the city was a symbolic model of the cosmos and the paradigm of an ideal or utopian world. For late medieval Euro-Christians, that utopian world was summed up in the paradigm "Jerusalem," for it was a new or newer Jerusalem—in one or more senses of the word—that the mendicant friars wished to transport to America.

Chapter 4 focuses on the most important building of the American city—its temple—expanding on the basic architectural studies of George Kubler and John McAndrew.[111] The use of a methodology developed by Richard Krautheimer for an iconography of medieval architecture allows us to examine in greater detail the mendicant evangelization complex—the misnamed fortress monastery—and to recognize its iconographic models as rooted in the Old and New Testaments as well as in medieval apocalyptic literature, conflated with certain aspects of structures that were still extant in the Holy Land of the sixteenth century.

In chapter 5, I attempt to bring into sharper focus one of the most popular metaphors of Nahuas and Christians, the tree of the cross. I examine what cruciforms meant in the cosmovision of each cultural system, what role crosses played in Aztec and Christian eschatology, and how they were adapted or synthesized in Mesoamerica. The evangelization cross is one of the keys that unlocks the rich and polysemantic meaning of the catechumenal complex and its eschatological character.

In chapter 6, I enter the terrain of religious ritual, both Amerindian and Catholic. I examine the theatrical and kinesthetic characteristics of each religious system and show that liturgy and drama had eschatological connotations for both cultures. I call attention to European stage sets for religious plays as important models for selective parts of the mendicant building complex.

The conclusions suggest that much less of the old Aztec religion was destroyed and much more was "recycled" because it was relatively easily Christianized by a change in root metaphors, visual and verbal. I opt to say that the friars' initial missionary efforts were surprisingly creative and, for the most part, successful in what they attempted to do in partnership with the Nahua Christians. This had much to do with the wealth of symbols they gleaned from the Bible and from teoyoism, and with the dynamic qualities of rituals and theatrics in both cultures. It also had much to do with the high hopes of the friars for a religious utopia in a New World that was also understood to be the locus of the beginning of the end of the world. Sixteenth-century Mesoamerica is indeed an intriguing, complex, and even entertaining area of study.

The Architecture of Conversion

THE OPEN-AIR EVANGELIZATION COMPLEX

The mendicant catechumenal complexes of sixteenth-century New Spain are unique constructions. With only a bit of exaggeration, they have been called "the most original American contribution to architecture before the skyscraper."[1] These are the compounds built by the indigenous populations in partnership with the mendicant friars. A generic description of the approximately 250 such constructions demonstrates that they had some remote common model; it will be our task in the following chapters to discover what that model—ideological, ideal, historical, or formal—might be.[2]

With little variation, the evangelization centers are composed of the following elements: a walled patio, an open-air chapel, four corner chapels in the patio, a monumental outdoor cross, a single-nave church, a convent with cloister, and orchard/gardens. I wish to look at each of the component parts and ex-amine its pre-Contact origins in either Amerindian society or the Old World of Europe and the Near East. I also wish to suggest models for the individual parts based on the medieval understanding of metaphor and biblical precedent.

Walled Patios, Corrals, and Atria

> All the monasteries here in New Spain have a large walled patio in front of the church. . . . The old men keep these patios swept and clean, and usually they are adorned with trees set in orderly rows. In the hot country there are alternate rows of cypresses and orange trees, and in the temperate and cold regions there are cypresses and pepper trees from Peru which stay green all year. To walk into these patios is something to make one praise God.
>
> —Fray Gerónimo de Mendieta, c. 1565

17

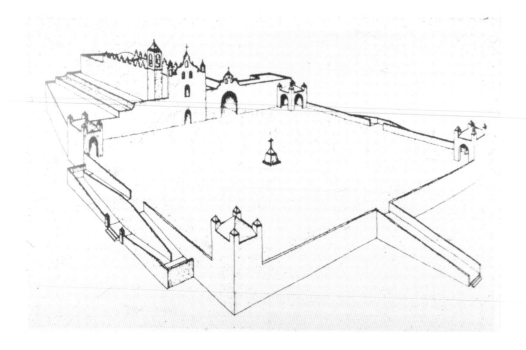

ater, and this sense of the word should not be given short shrift. It will have much to do with catechesis and liturgy. I shall examine this connotation, and the thespian qualities of the mendicant corral, in chapters 4 and 6.

In speaking of the patio, seventeenth-century historians also used the more classical word *atrium* (plural *atria*, in Spanish, *atrio*), and art historians have followed suit.[8] Atria or courtyards were, of course, found in the Old Testament in the temples of Solomon and Herod and therefore had a biblical precedent. Atria were common with early Christian basilicas throughout the Roman Empire, which may lend credence to the colonial association of the mendicant church with the Roman basilicas and hence with the ideals of the early church.[9] Indeed, the friars experimented with the basilica-style church and several are still extant, as at Tecali, Zacatlán de las Manzanas, and Cuilapan (fig. 1.11); but they never gained the popularity of the fortresslike ensembles.[10] Nor were they charged with the high energy of the eschatological connotations that the "fortress temples" carried.

The Mexican patio functioned for the congregants in large measure as an open-air nave, or like the public *galilee* space of the Romanesque monastic churches where pilgrims, catechumens, and penitents gathered.[11] (The *galilee* was, in effect, the reverse of a patio in that it was an indoor, roofed atrium.)

Perfectly square patios are rare in Mexico. That of Huejotzingo measures 120 by 120 meters, or 14,400 square meters in area, but this is exceptionally large. Most atria average between 5,000 and 10,000 square meters and are rectangular.[12] At the patio's center, raised on a plinth or tiered base, is the atrial cross of stone, and occasionally there is a fountain (fig. 1.1).[13]

The patio walls are usually crenellated, giving a defensive appearance, and have porticos for entrance and exit through triumphal archways (or *propylaea*). Like medieval cathedrals, which became the figure of the Heavenly Jerusalem with triple doors on each side (except for the eastern apse), many of the patios originally had three entrances, on the north, west, and south.[14] The gateways are often at the top of wide steps leading either up or down a few feet from the town plaza, which acts as a second patio, or a secular atrium.[15] Such steps add greatly to the monumentality of the simple ensemble. The patio at Izamal in

In sixteenth-century documents, the walled-in area in front of the friars' church and convent is called a *patio* or *corral*, an enclosed space, a quadrilateral, or a sacred precinct (fig. 1.1).[3] In medieval Spain, the word *corral* was used as a common term for a church atrium long before it took on its association with an enclosure for animals.[4] In Catholic America, it could also be used in a metaphorical sense as the corporate Body of Christ, the Church, as one corralled flock.[5] This idea was visibly expressed in the north door of the Franciscan church at Cholula, which opens directly onto the patio corral (fig. 1.30). Around the doorway were carved Christ's words: "I am the gate [of the corral], whoever enters through me will be saved, and will come in and go out [of the corral] and find pasture" (John 10:9). In the exegesis of the Venerable Bede, whose works were known in New Spain, the Old Testament precedent for this sheep gate was the door to Solomon's Temple, which was flanked by two massive columns—as we shall later see realized in carved stone at Huejotzingo.[6]

Corral was also employed in colonial Mexico in the sense of a church narthex or attached building, as in the wing of the early cathedral of Morelia, where the Chapel of the Indians was located.[7] Additionally, in colonial times a corral was also a the-

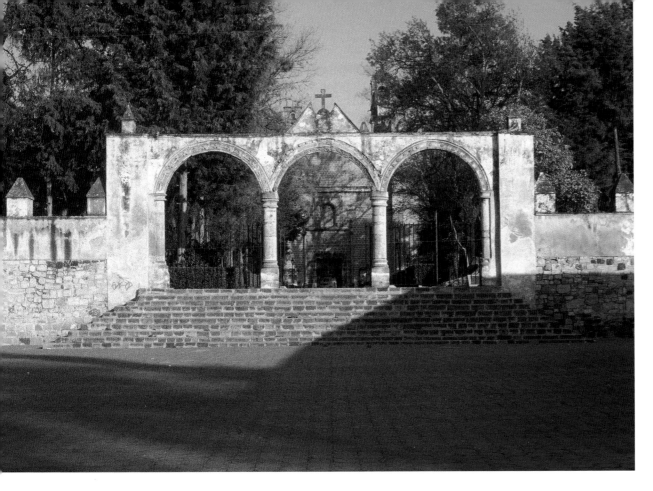

Fig. 1.2.
Huejotzingo, Puebla.
Propylaeum gateway to
the elevated corral of
the Franciscan complex.
(Photo by author.)

Fig. 1.3.
Cholula. Patio or
corral of the Franciscan
evangelization center
of San Gabriel.
(Photo by author.)

the Yucatan, for example, sits at a height of six meters above the street below. The gateway of these complexes is often a monumental frontispiece or dramatic proscenium entrance; it acts as a landmark in a town, large or small (figs. 1.2 and 1.3). At Actopan, for example, the Augustinians erected an ample seven-arch propylaeum. Other patios have gateways of five, three, or two arches.[16] The medieval liturgist William Durandus, whose work was well known in Mexico, offers an anagogical meaning for the atrium, associating it precisely with its gates: "The open court signifies Christ, by whom an entrance is administered into the Heavenly Jerusalem: this is also called porch, from *porta*, a gate; or because it is *aperta*, open."[17]

It is probably true that the friars' use of a patio for outdoor Christian worship initially came about from necessity and was inspired by pre-Contact practice; at Tlalteloco, for example, the first church, a basilica of three naves (1527), was set within the old ceremonial courtyard, a recognized sacred space.[18] Thus an indigenous model for the atrium can be found in the Aztec courtyards that surrounded the open-air *teocalli*, temple pyramids.[19] They were great spaces for the crowds that observed the sacrifices, dances, and sacral dramas of embodied teoyoism. Courtyards were the usual location of communal worship and ritual dancing throughout Mesoamerica, and the idea of spectacular worship indoors would not have occurred to the native population. It is probably also true that the Amerindians felt claustrophobic in the novel enclosed spaces of churches. Vaulted spaces also seemed dangerous in a land of frequent seismic activity, and the natives initially avoided entering them.[20]

There is evidence that the configuration of the patio evolved from a simple quadrangle with an open-air chapel isolated from towns, churches, and convents—before the 1550s—to a later, fully developed form attached to a church and convent and completed with posas and an atrial cross.[21] Fray Diego Valadés, the mestizo Franciscan from Tlaxcala, was a witness to the construction of the sacred compounds. "There are sacred precincts, separated from others and enclosed with high walls of rubble

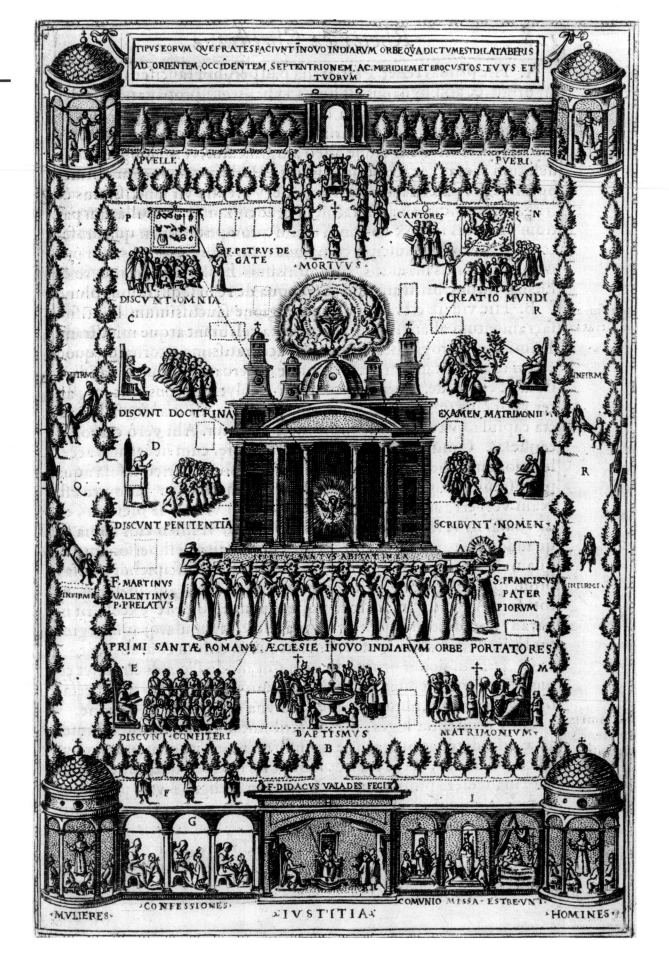

Fig. 1.4.
Diego Valadés,
Rhetorica Christiana
(1579). Engraving
of an idealized Franciscan evangelization
center. (Courtesy of
the Beinecke Rare
Book and Manuscript
Library, Yale
University.)

and mortar painted with lime, without being connected to any buildings. They have the town around them on every side as if they were islands."[22] Although it is debated whether Valadés's engraving is an idealized patio or a literal one at an early stage of evolution (fig. 1.4),[23] the details of the illustration are invaluable for our understanding because they reveal both liturgical and (by implication) theatrical practice. I shall periodically return to this illustration, especially when I discuss liturgical performance.

Whatever its symbolic connotations for natives or friars, there is no denying that the patio was a pragmatic solution to organizing evangelization on a large scale. It was a multipurpose space, acting as a schoolroom, an assembly hall, a dance floor, an unroofed nave, a cemetery, an orchard, and a sort of chapter room for lay friars.[24] Furthermore, the New World patio, together with the rest of the mendicant complex, was in essence a miniature city in itself. Antonio Bonet Correa waxes poetic in the description:

> A sacred place, the atrium is a spatial filter, a distinct area, another city-within-a-city: the *City of God* realized in this world. In the small urbanizations, these Indian *reductions* of the mendicant orders, the atrium—with its spiked wall, its open chapel, posa chapels, atrial cross, portico and other elements—is another universe for the faithful set apart from the earthly city on the margin of civic and everyday life. To enter through its triumphal arch is to cross the threshold of heaven itself.[25]

In chapter 3, I shall return to examine the miniature urban character of the evangelization patios and consider it in a wider context, but here I remind the reader of the biblical precedents for walled atria in the temples of Solomon and Herod at Jerusalem. The biblically minded friars certainly wished to suggest such connotations.

Open-Air Chapels

> The monasteries have a large walled patio in front of the church . . . made to be used mainly on holy days, so that when all the townspeople are gathered together they can hear Mass and be preached to in the patio, for they will not fit inside the body of the church, which they use only when, in their piety, they come to hear Mass on weekdays.
> —Fray Gerónimo de Mendieta, c. 1580

> There usually are artistically made outdoor chapels in which sermons are preached to the Indians on holy days and Sundays, and where Masses are celebrated. Because the assistance at the meetings at which we preside is so numerous, there are no [Christian] temples so spacious that could accommodate such a multitude, not even if they had double capacity.
> —Fray Diego Valadés, *Rhetorica Christiana*

In Latin American architecture, external chapels are called *open chapels* or *Indian chapels*. They are constructions vaulted in stone with tracery or in trabeated wood.[26] They may be located alone, without a church, convent, or cloister, in which case they are considered to be "isolated Indian chapels."[27] Some of these isolated chapels were later given walls and nave and subsequently became the presbyteries of fully actualized churches (fig. 1.36), but those that have survived are most often part of an originally planned complex of patio, single-nave church, and cloistered convent.[28]

The open chapel part of the complex appears in three basic variations.[29] First is a wide-roofed chapel with many parallel naves, demarcated by columns, open to the atrium across the façade. The Royal Chapel of Cholula is the best example still extant, although it has suffered much modification (fig. 1.5). Its similarity to a Muslim mosque has often been noted.[30] (In chap. 4, I shall attempt to show that such a wide-open, columnar building in an atrium had connotations with a historic sacred building in Jerusalem that was its ideological prototype.)

Second, the chapel may be an open-air presbytery attached to the monastic buildings; here the atrium acts as the nave of the unroofed church (figs. 1.6 and 1.7). The axis of the open chapel may be parallel or perpendicular to that of the church. Not without reason do these open chapels have the appearance of a proscenium stage, because liturgy and drama were presented here (as we shall see below), attracting large crowds. Thus

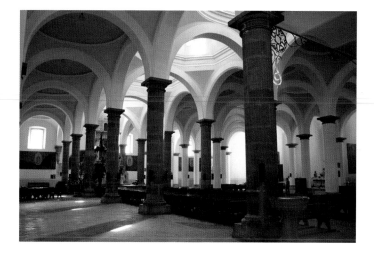

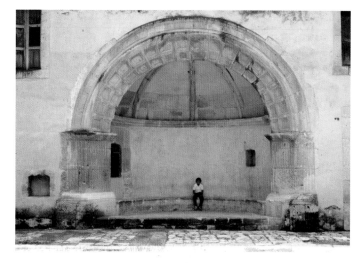

Fig. 1.6.
Tarímbaro, Michoacán. Open chapel with curved *synthronon* bench and wall tabernacle of the Franciscan evangelization complex. (Photo by author.)

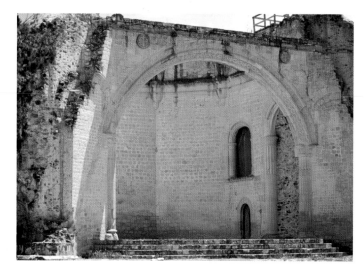

Fig. 1.7.
Coixtlahuaca, Oaxaca. Open chapel of the Dominican evangelization complex with "theatrical" balcony window. (Photo by author.)

again we see architectural aesthetics responding to pragmatic demands of sheer numbers.

A variation of this category is the *portico* or *portería* chapel in which the altar is sheltered under a structure that also acts as the main entranceway of the living quarters and protects people awaiting the friars (fig. 1.8). These chapels were like the medieval porticos that sheltered the pilgrims who often spent the night there, or like the lateral porticos that sheltered catechumens (see below). Fray Valadés informs us that "next to the churches one finds the convent, and on the opposite side the gardens/orchards. The side that has the doors [of the convent] is surrounded by ample porticos, spacious and sunny, where the religious hear confessions and publicly administer all the sacraments."[31]

There is a precedent in European mendicant churches for porchlike devices that act as dividers between the laity in the nave and the clergy near the altar. In Florence, the Franciscan Church of Santa Croce and the Dominican Church of Santa Maria Novella had interior screens, called *tramezzi*, that spanned the full width of the building from north to south, and that sheltered altars and pulpits on two levels. The upper level also functioned as a stage for liturgical dramas.[32] Indeed, one very attractive interpretation of Diego Valadés's idealized conversion center is as an unroofed nave connected to a porchlike *tramezzo* (figs. 1.4 and 6.14). The mendicants in New Spain, many of whom had visited their motherhouses in Italy, surely remembered the practical solution of the *tramezzo* and adapted it in the New World as an outdoor porch for liturgical and dramatic needs. These portico chapels, which also acted as confessional areas (as in Europe), were frequently painted with frescos of the Last Judgment (fig. 2.23) depicting eternal reward or punishment—an appropriate motivational theme for the site of the forgiveness of sins (see chap. 2).

Third, the open chapel can also be elevated above eye level as a second-story balcony on the church façade, on the lateral flank, or even on the façade of the convent, and several open chapels have outdoor pulpits (fig. 1.9).[33] The elevated nature of the chapel was probably reminiscent of the pre-Hispanic altars on top of the *teocalli*, and thus it retained something familiar from the old religion.

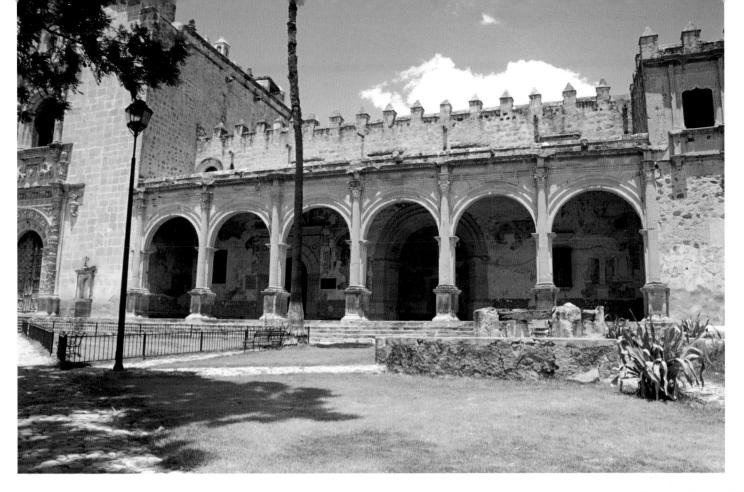

Fig. 1.8.
Cuitzeo, Michoacán.
Portico chapel and
confessional area of
the Augustinian evan-
gelization complex.
(Photo by author.)

Fig. 1.9.
Tochimilco, Puebla.
Façade of the
Franciscan church
with elevated open
chapel above the
portería, and pulpit in
the base of the tower.
(Photo by author.)

Architectural historians have found precedents for the open chapels of New Spain in both Aztec and European architecture. For example, some think that a pre-Hispanic model for the chapel can be discovered in Aztec domestic architecture. The simplest form of the indigenous house, expressed by the hieroglyph *calli*, shows a rectangular—or square—roofed space, but one with its front side open. The smallest houses had a single opening supported by a flat lintel; larger houses had two vertical supports on the façade, making a triple opening and giving the effect of a covered portico fronting an internal patio. The triple opening was also the common distinguishing element of the Aztec temple house erected on top of the pyramid mound. This Aztec representation for the concept "house" might therefore be a possible antecedent of the monastery portico chapel that, by coincidence, was similar to European open stage sets.[34] In his ethnological work, Fray Bernardino de Sahagún described the mendicant open chapels as *totecuio ichan* in his discussion of Aztec houses and *callis* (fig. 1.10), as did the native author of the pictographic *Codex en Cruz* (c. 1555).[35]

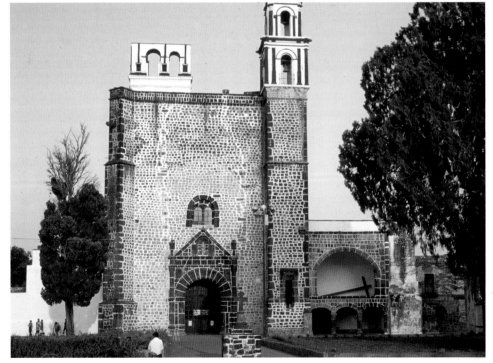

Fig. 1.10.
The *Florentine Codex*, uncolored page, book 11. Various examples of the native *calli* or house, including a Christian *hermita* (900). (From Sahagún, *Historia General de las cosas*, ed. Paso y Troncoso, 1905.)

have facilitated any outdoor worship during the medieval period.[37] When such architecture does appear, it was probably for the purpose of evangelization during times of numerous conversions.[38] It is important to note here that the mendicant friars revived the ancient catechumenate in the sixteenth century for the process leading to baptism.[39] Since the Aztecs became catechumens during their religious instruction, it is logical to look for precedents for New World architecture in earlier buildings designed for evangelization. Catechumenal architecture has existed since the early Christian period. A few examples that bear similarity to the constructions in New Spain will suffice.

At Rome, three fourth-century churches with wide, unobstructed openings in their lateral walls have been discovered. The most important was the Basilica of Santa-Croce-in-Gerusalemme, which was later under Spanish royal patronage and which was open-walled until the sixteenth century.[40] According to Bishop Eusebius of Caesarea, writing in the fourth century, such an architectural arrangement had the purpose of allowing the catechumens to participate in certain parts of the liturgy before their baptism, since they were not allowed into the church proper but were required to stand in a screened-off corral.[41] The basilica of the Dominican friars at Cuilapan (Oaxaca, c. 1555) later replicated this solution for the Mixteca Indians of sixteenth-century Mexico (fig. 1.11).[42] Its eighteen entrances in the nave walls, and three on the façade, would have made it an open-air church even when roofed.[43]

Another such catechumenal church, built in Sicily in the sixth century, was that of Sta. Maria della Pinta de Palermo, which was still extant when Sicily was a colony of the Spanish Empire. It was designed as a roofed Tau cross, surrounded by a freestanding wall within which the catechumens were corralled.[44] Churches with catechumenal porches were common in Mozarabic Spain, one example being the Church of San Miguel de la Escalada with its lateral porches (fig. 1.12). The open porticos, called "sheep pens" (*agnile*, corrals), sheltered the catechumens, who in Spain were converts from Judaism and Islam,[45] just as the Mexican corrals and porticos served the Mesoamerican catechumens.

As in New Spain, pulpits or altars were erected for European medieval throngs gathered in the open air.[46] The Benedictine abbey of Cluny had a pulpit in the galilee-narthex over the

George Kubler found another formal precedent for the open-air chapel in the architecture of the Near East. The *kalube* of Syria (*qubba* in Arabic) is a variant of the primitive dome and became a type of exedra or outdoor apse usually associated with tomb monuments.[36] But Kubler was at a loss to explain how such a Near Eastern design might have made its way to America. He was correct in identifying a precedent from the Near East, but as we shall see in chapter 4, it was found in medieval Jerusalem rather than in Syria (figs. 1.20, 4.12, 4.13) and was imported into Spain and Italy, and thence to New Spain.

Because outdoor eucharistic liturgy was rare in Christianity, we find only a few examples of architecture that would

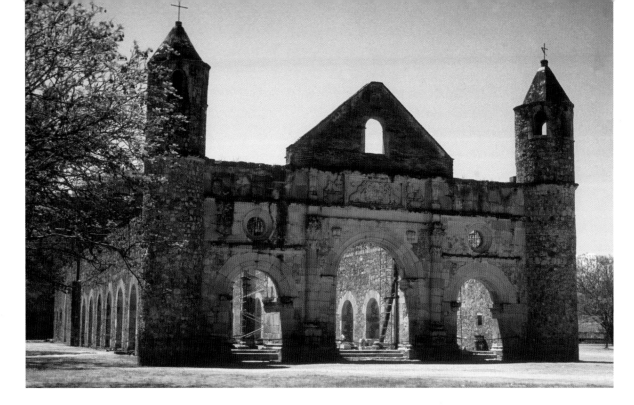

main portal for preaching to the arriving pilgrims,[47] and the imitation Holy Sepulcher complex at Bologna, Italy, had a similar pulpit outdoors (fig. 4.8).[48] Urban religious orders, like the Franciscan and Dominican friars, promoted such installations for street preaching.[49] In the third quarter of the fourteenth century, an open and freestanding chapel with pulpit was constructed in the piazza of Siena, Italy, and mendicant preachers like St. Bernardino used it to catechize the urban throngs (fig. 1.13). In this case, Sunday Mass was also celebrated there for the benefit of the artisans, buyers, and sellers in the marketplace so that they could attend religious service without having to leave their stalls.[50] The erection of liturgical equipment outdoors was especially appropriate after the Black Plague and the resulting intensification of expiatory devotions and the processions of flagellants and confraternities of the Five Wounds or the Precious Blood. As in New Spain, the multitudes could not be accommodated within the church building, so preachers like St. Vincent Ferrer erected pulpits, altars, and crosses on movable stages in public plazas so that their apocalyptic sermons could reach the throngs.[51]

Returning to the third category of open chapel, an Aztec precedent for those chapels and altars located above eye level may certainly have been the *teocalli* with its raised temple house on top. But there were also European precedents for the elevated chapels. For example, in the ninth-century Asturian kingdom of northern Spain, the palace church of Santa María de Naranco had an open balcony with an outdoor altar (fig. 1.14).[52] Indoor raised altars above eye level were also common. In Jerusalem, three elevated chapels dedicated to the Holy Cross—similar to the three chapelettes that surmount the Calvary chapel at Tlax-

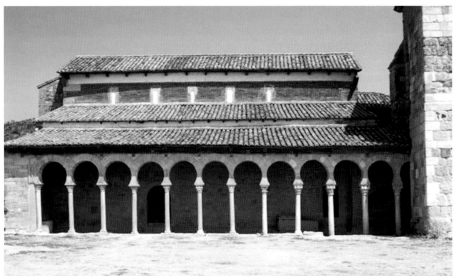

Fig. 1.11.
Cuilapan, Oaxaca. Façade of the Dominican open-walled basilica. (Photo by author.)

Fig. 1.12.
San Miguel de la Escalada, Spain. Lateral portico of the Mozarabic church, tenth century. (Photo by Manuel Martínez. Courtesy of the Aga Khan Visual Archives, MIT.)

cala (figs. 1.15 and 6.3)—were added above Golgotha during the rebuilding of the Holy Sepulcher in the eleventh century.[53] Elevated altars were also common on top of the rood screens of medieval cathedrals or the *tramezzo* wall of mendicant churches, where they were called Holy Cross (rood) altars.[54]

A balcony or loggia, like the one at Santa María de Naranco, could be the site of Mass or the display of relics, but it was also a favored place for the theatricalized liturgy of the

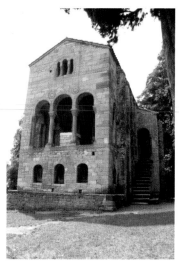

Royal Epiphany, the solemn public appearance of the Pope or the Holy Roman Emperor.[55] Such loggias appear at Charlemagne's royal chapels at Aachen and Trier, and at the Lateran and St. Peter's basilicas in Rome.[56] In the latter instance, the loggia of the papal palace was also known as the "theater" and the "stage," thus confirming a dramatic interpretation of the public ceremonies that took place in what appeared to be an open chapel.[57] On one flank of his monastery retreat of Yuste, Emperor Charles V also had a loggia for public audiences that was similar to some of the Mexican open chapels.[58] Furthermore, medieval and Renaissance mystery plays also used elevated balconies as a cipher for the heavenly paradise. These stage sets, always located on the eastern side of the audience's corral (as in New Spain), had props for the actor impersonating God, such as a throne, a baldachin, or an altar.[59]

There is also contemporary Islamic evidence for other raised worship spaces. The Muslim cities of Andalucia knew a type of oratory that served the needs of overflow crowds on those high holy days when the mosques were inadequate to accommodate the faithful.[60] But it is doubtful that the mendicants would have overtly chosen a practice of Muslim infidels as a model for their New World neophytes; rather, they would more likely have chosen a solution that had been created for converted Muslims. After the Christian reconquest of southern Spain in the late fifteenth century, raised open chapels were constructed in the captured cities for the recently baptized *new*

Fig. 1.13.
Sano di Pietro, *S. Bernardino Preaching in the Piazza del Campo, Siena*, mid-fifteenth century. Note the temporary pulpit and altar, the two shields of the Holy Name, the freestanding baldachin of the outdoor chapel to the left, and the separation of men and women by a curtain. (Scala/Art Resource, NY.)

Christians.[61] Such doctrinal chapels served for the firm implantation of the Catholic faith in areas previously Islamic.[62]

Other examples of raised open chapels can be found in sixteenth- and seventeenth-century Spain.[63] Some were located in the plazas and meat markets for use on market days.[64] Like the freestanding chapel in Siena, these Spanish chapels meant that the buyers and sellers in the plazas would not be deprived of hearing Mass—a liturgical function that migrated to New World cities.[65] In the case of Iberia, civic magistrates used the balcony chapels as legal tribunals to administer justice, and this seems to have carried over into Mexican practice as well.[66] There is even an architectural precedent from the Bible for such adjudication in an open chapel that surely influenced the mendicants' actions: the Hall of the Forest of the Cedars of Lebanon in Solomon's Temple complex in Jerusalem. The fact that the Hall of the Forest was believed to be still extant in the sixteenth century helped to ensure the association.[67]

Stational Chapels in the Patios

> In the four angles of these precincts [atria] there are other chapels; the first of which [also] serves for the instruction of girls, the second for boys, the third for the women, and the fourth for the adult men.
>
> —Fray Diego Valadés, c. 1579

The corner structures in Latin American atria are termed *posas*. Although Valadés indicates that they were occasionally used as small and probably uncomfortable classrooms, their real purpose was as stational chapels for processions (fig. 1.4).[68] Indeed, so important were processions for the neophytes that the first bishop of Mexico felt the need to publish a tract on the topic in 1544.[69] Like some forms of the open-air presbytery, posas have been found in similar complexes in Spanish colonies from the Southwest of the United States to northern Argentina, and in Brazil and the Philippines.[70] In Mexico, posas are either of cut stone with elaborate carvings or of humbler mortar-and-brick or rubble construction (fig. 1.16). Whatever their material, they frequently display pyramidal and crenellated roofs similar to military architecture (fig. 1.17). Most extant posa chapels

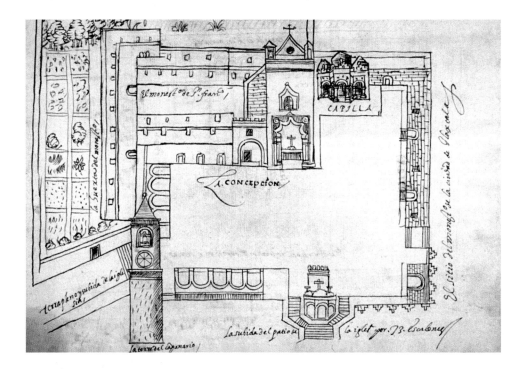

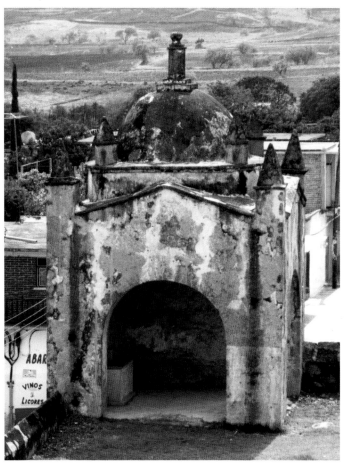

Fig. 1.15.
Diego Muñoz Camargo, *Descripción de la Ciudad y Provincia de Tlaxcala* (c. 1581). Plan of the Franciscan complex of the Asunción at Tlaxcala. Note, at the bottom, the open chapel with the three crosses of Golgotha on the roof. (Courtesy of the Glasgow University Library, Department of Special Collections, MS Hunter 242.)

Fig. 1.16.
Atlatláuhucan, Morelos. Posa chapel of the Augustinian evangelization center. (Photo by author.)

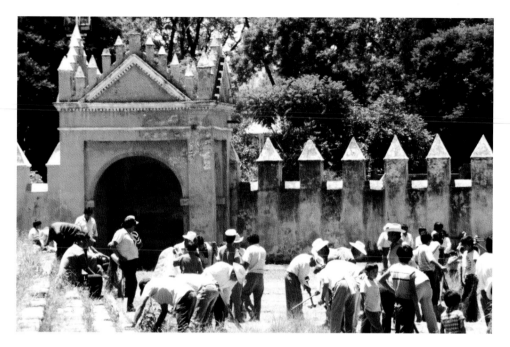

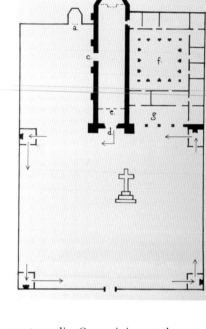

Fig. 1.18.
Generic plan of a
mendicant evangeliza-
tion complex: (*a*) open
chapel, (*b*) church
apse, (*c*) north door or
porciúncula, (*d*) west
door, (*e*) undercroft or
sotocoro, (*f*) cloister,
(*g*) portico. The
counterclockwise
processional movement
through the four posas
is indicated by the
arrows. (Redrawn
from Edgerton,
Theaters of Conversion.)

Fig. 1.17.
Cholula. Posa chapel.
(Photo by author.)

show signs of having had an altar, or else a shelf that acted as a temporary altar for resting objects. Posas were decorated and polychromed on the interior to give the appearance of having an altar retable, but only one is known to exist today with its altar and wooden retable substantially intact.[71] Posas have either one or two doorways; those with two entrances seem to be the earliest.[72] The doorways are positioned in such a way as to indicate that processions traveled in a counter-clockwise direction, starting at the church door on the Gospel side (the left side from the observer's perspective). Where there are two doors, the procession could pass through the posa—in one side and out the other—already correctly oriented to-ward the open door of the next posa.[73] Counterclockwise ritual movement was both a pre-Hispanic and a European custom (fig. 1.18).[74]

I shall explain in more detail below that the four posas have a liturgical theme of the four central mysteries of Christ's In-carnation, Passion, Resurrection, and Glorification. The faith-ful who participated in the liturgical processions thus ritually "passed through" the entire christological mystery from the birth of Christ to his second advent. The erudite professor and cleric of sixteenth-century Mexico City, Francisco Cervantes de Salazar, may have intimated as much during his tour of the metropolis. On arriving at the convent of Santo Domingo, he explained why there was a need to create "chapels or shrines in the corners" of a second cloister, that is, the public patio:

> The [convent] cloister is too narrow to hold so many people, because of the devout multitudes who come here on such solemn festal days as Christ's *Nativity, Death, Resurrec-tion,* and *Ascension;* and on the Conception of the Virgin Mother and her Birth, and the feast days of the Apostle and of Saint Dominic. Space was made so that, as they marched with the cross preceding and the [saints'] images follow-ing, they might stop at each [posa] chapel to make offer-ings and to pray.[75]

Outside Mexico, posas are oftentimes called hermitages or Miserére chapels and, like their Mexican cousins, are uniformly square, cubelike structures; their proportions are also similar to the Mexican examples (fig. 1.19).[76] Even though Diego Val-adés (or his engravers) depicted round, kiosklike posas in his *Rhetorica Christiana,* I have yet to find a rectangular, circular, or polygonal posa in America, which leads me to believe that there was some common prototype or schematic plan that builders as far afield as Argentina, New Mexico, Brazil, and the Philip-

pines were using. The same could be said of the entire atrium-church-convent complex, and I shall later investigate this ubiquitous planimetric similarity for other intended and more significant meanings.

Certainly it seems that New Spain was the working model for missionary methods in other parts of the New World. A letter to King Philip II from the viceroy in Nueva Granada (present-day Colombia), dated April 1575, reports that the natives there are being grouped into Europeanized urban areas for easier indoctrination, "just as they are accustomed to do in the province of Tlaxcala."[77] Obviously either the viceroy had had some previous experience in Mexico or else the fame of Tlaxcala as a model evangelization center had spread as far as South America. My suspicion is that the paradigmatic plan of the whole mendicant evangelization complex also spread from its successful "trial run" in central New Spain to the rest of the American colonies and the Philippines.

As with the open chapels, we can find both native and European exemplars for the posas. Colonial eyewitness reports about the Aztec temple complex in Tenochtitlán indicate that there were small platforms (*momoxtli*) with altars in the four corners of the temple courtyard. Likewise, each of the four *calpulli* neighborhoods (also clans) had its own temple and altar, although these would have been separated by several kilometers. The mendicants' posas did indeed combine some elements of earlier pre-Contact use. Each of the posas kept a relation to a particular *barrio* or quadrant of the Indian town. Each barrio was responsible for the maintenance and upkeep of its posa, and in some locales the particular posa acted as a mortuary chapel for that quadrant.[78]

European exemplars for the formal structure of the posa have been detected in medieval baldachins used outdoors in Iberian cemeteries or indoors as altar canopies in churches of the Knights Templar (fig. 4.15).[79] They have their origin in the Islamic architecture of Palestine brought to Italy and the Iberian peninsula by the Moors, the generic form known as the *kalube* in Syriac (mentioned above in connection with the open-air chapels), *qubba* in Arabic, and transliterated as *cubula* or *cuba* in the Venetian and Sicilian dialects (fig. 1.20). In several instances these *cubula* were constructed for the purpose of rest and repose—like a posa.[80] Cemetery baldachins, wayside crosses

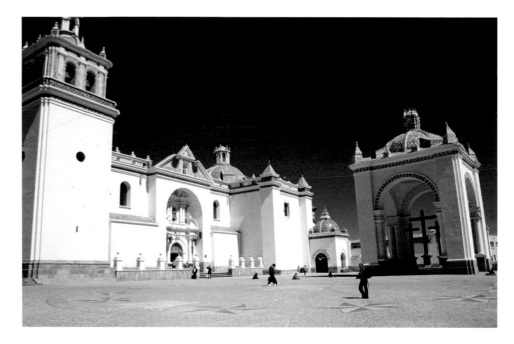

Fig. 1.19. Copacabana, Bolivia. Atrium of the missionary complex with posas and the Miserére chapel sheltering the atrial cross. (Photo by author.)

Fig. 1.20. Haram al-Sharif, Jerusalem. Medieval Islamic *qubba* structure. (Photo by author.)

under a canopy, and church altars were used as stopping places on processional routes, and they effectively functioned as posas, as did church porches and balconies or street-corner shrines.[81] Recent research indicates that there were posa chapels in the Iberian Franciscan convents of Extremadura, where some of the original twelve missionaries to Mexico hailed from. However, they cannot be dated earlier than the second half of the sixteenth century, and they may well demonstrate a reverse influence—from America back to Spain.[82]

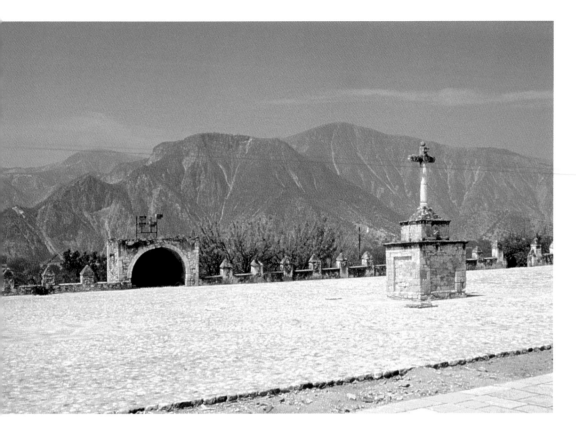

liturgical processions I shall examine below. In turn, the similarity of these stage houses to the Aztec *calli* or house (of humans or of the gods) is intriguing, even if in the first instance it was merely coincidental (fig. 1.10).[84] Additionally, on purely planimetric similarity, the location of four corner buildings in an atrium bears uncanny resemblance to four structures in the great courtyard of the Jerusalem Temple. This may be nothing more than pseudomorphic resemblance, but I shall return to investigate it in chapter 4.

Atrial Crosses

> Everywhere in this land the emblem of the Cross is raised aloft. . . . It is said that in no part of the Christian world is the Cross found so often, esteemed so highly, adorned so richly, and made so large. Those in the patios of the churches are especially stately, and every Sunday and feast day the Indians adorn them with many roses, other flowers, and garlands.
>
> —Toribio de Motolinía, c. 1540

Fig. 1.21.
Metztitlán,
Hidalgo. Atrium
of the Augustinian
complex with atrial
cross and "Holy
Sepulcher" chapel.
(Photo by author.)

Fig. 1.22.
Epozoyucan,
Hidalgo. Atrial cross
and open chapel of the
Augustinian center.
(Photo by author.)

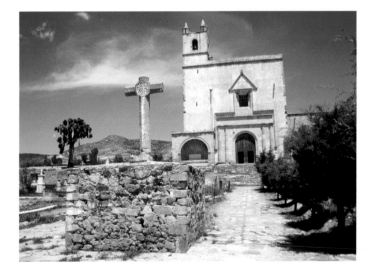

In addition to the open chapels and the four posa chapels, the Mexican mendicant complexes have atrial crosses.[85] Crosses are likewise found in church patios throughout Latin America.[86] The Mexican examples are located either at the geometric center of the patio (fig. 1.21), where they form the fifth cardinal point of a quincunx, or else on an axial line with the altar located in the open chapel, suggesting a relationship to the sacrifice of the Mass (fig. 1.22).[87] In cases where they relate directly to the open chapel, we have good reason to believe that the chapel and cross were constructed before the church, the single-nave church being the last addition to the entire complex. The open chapel, convent, and cross were deemed of more immediate need than the church, and building records confirm that the churches were usually the last element added to the evangelization compound.[88]

The placement of the cross at the center of an open-air nave is comparable to the location of the Holy Cross altar and rood cross "at the heart" of medieval cathedrals and abbey churches in Europe; the altar-*cum*-cross was the heart of the cruciform

Some posas and open chapels are also similar in structural design to the *mansiones* or theatrical stage houses of the medieval liturgical dramas, which were constructed to look like open baldachins.[83] Such structures were common scenery for religious plays, and medieval liturgical theater made "emblematic stations" from stage to stage in a fashion similar to the

body.[89] Like the rood crosses and rood altars of the great cathedrals, the atrial cross belonged to the congregation; it was within the laity's space, and it functioned as a liminal symbol. In Europe, the rood cross and screen acted as a boundary marker between the laity in the cathedral's nave and the clergy within the choir enclosure, or between the lay brothers and the professed monks.[90] The medieval liturgist William Durandus described the rood metaphorically in his well-read *Rationale:*

> In many places a triumphal cross is placed in the midst of the church to teach us, that from the midst of our hearts we must love the Redeemer, who, after Solomon's pattern, "paved the midst of his litter with love for the daughters of Jerusalem" (Canticles 3:10) and that all, seeing the sign of victory, might exclaim, "Hail, thou Salvation of the whole world, Tree of our Redemption!" and that we should never forget the love of God, who, to redeem his servants, gave His only son, that we might imitate him crucified. But the cross is exalted on high, to signify the victory of Christ.[91]

We shall see below in chapter 5 that all the themes that Durandus mentions—tree of redemption, heart, Solomon, sign of victory—are made evident in New Spain and in its sacred atrial tree (the cross), in which an Aztec sensibility and a Christian theology converged in the liminal space of the patio.

The Mexican crosses range in size from six to twelve feet; with the base they sometimes tower to twenty feet. Given that the atrial cross's iconography—the instruments of the Passion—was not always legible to those standing below, I doubt that it was only meant as a catechetical tool. Rather, a process of inculturation by a primary metaphor was occurring, and an operative ideology was being visualized. The location of the cross on an altarlike podium also reminded the biblically literate that an altar of holocausts was similarly located at the "heart" of the Jerusalem Temple complex. This aspect, too, will prove worth investigating.

Single-Nave Churches

Single-nave churches are omnipresent in Mexico, and they can be considered the typical mendicant architecture. They are

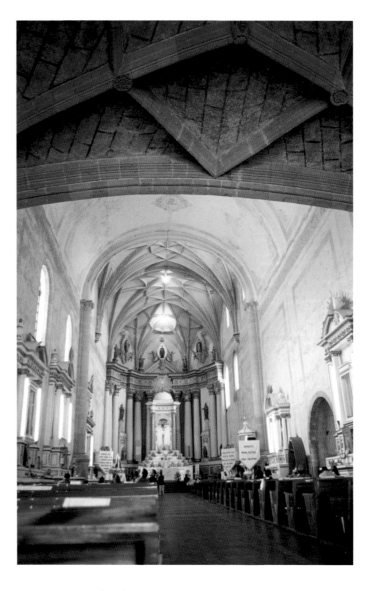

Fig. 1.23.
Actopan, Hidalgo.
Sotocoro and nave of the Augustinian church. (Photo by author.)

constructions that have no indigenous precedent in the New World and are uniquely European imports (fig. 1.23). Mesoamerica had rather primitive vaulting techniques, and no pre-Contact vaulted space could ever have accommodated large numbers of devotees for religious rituals.[92]

In southern Europe, single-nave churches enjoyed a long popularity and may have been adopted for their defensive suitability. The use of a wide and aisle-less interior plan, with traverse arches supporting a barrel vault, also resonated with a classicism related to Roman basilicas and with connotations of the papal protection and power associated with Rome.[93]

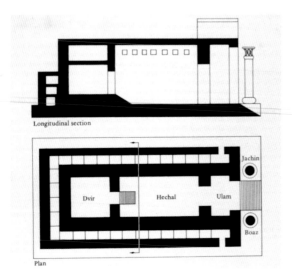

Longitudinal section

Plan

Single-nave churches were especially common in northern Spain of the eleventh century; King Sancho Ramírez and his dynasty favored such constructions during the reconquest of the peninsula from the Moors.[94] But later these churches became rare in Iberia until the fifteenth and sixteenth centuries.[95] Two Spanish Carthusian monastery churches were then constructed with single naves on the eve of the discovery of America.[96] The plan of the oldest Franciscan single-nave church in Spain, San Antonio at Mondéjar, begun in 1509, shows a nave three bays long, an ample presbytery, and a diminutive transept[97]—an architectural cousin of the New World churches.

A possible model for the Mexican single-nave church is the monastery Church of the Order of the Hieronymites at Yuste, Spain. It is of interest to note that Emperor Charles V chose the foundation at Yuste for his final retreat after abdicating the throne in 1558; it thus had regal connotations. The church was finished in 1525, just at the time when the initial groups of mendicants were leaving for the New World.

Another suggestion for a possible European precedent for the single-nave church lies in the Franciscan urban architecture of the duocento and trecento in Italy; Santa Chiara in Assisi (c. 1255) is but one example.[98] A further possibility is the Sistine Chapel of the Vatican in its original fifteenth-century state.[99] The suggestion may not be as far-fetched as it first appears, and in the following chapters I shall relate the pope's chapel both to eschatological imagery and to Franciscan political and liturgical concerns.

Finally, it is significant that single-nave churches also appear in Apocalypse manuscripts of the eighth to eleventh centuries to represent the seven churches of Asia and the eschatological temple of the New Jerusalem as imagined in Revelation.[100] This eschatological imagery might also have been an intended association in the New World.

In Mexico, the single-nave edifice follows a simple plan, usually without transept. A polygonal and blind apse—that is,

one without windows—terminates the east end. At the east end of the church, the presbytery is frequently delimited by a triumphal arch similar to those of the early Christian basilicas in Europe. At the opposite end, a choir balcony is provided for the friars to chant the liturgical Hours. In the majority of cases, the balcony is square, that is, its depth is equal to the width of the nave. A door gives access to the balcony directly from the upper cloister and dormitories. The area below the balcony, the undercroft (*sotocoro*), is vaulted. Even in the simplicity of this plan, there is evident the desire to create a tripartite division within the building: choir/undercroft, nave, and presbytery. The division of the space into three sections was commonly associated with the three divisions in the Temple of Solomon: the Vestibule (*Ulam*), the Holy Place (*Hechal*), and the Holy of Holies (*Dvir*) (fig. 1.24).[101] Once again there is the possibility of a veiled reference to the great Jerusalem construction.

Each of the three sections is distinguished by its ceiling height, or by floor level, or by a different design of the ceiling tracery. There seems to have been some preference among the Franciscans for vaulting the entire structure and differentiating the three areas by creating different rib patterns for each of the three spaces.[102] The Dominicans and Augustinians, on the other hand, were accustomed to using ribbed vaulting only above the presbytery and the sotocoro, and letting the rest of the building be roofed either in barrel vaulting or in trabeated wood construction (fig. 1.25).[103]

In these buildings, windows are sparse and situated high on the lateral walls of the nave. They are splayed, a tradition that supposedly goes back to the visionary temple mentioned by the prophet Ezekiel.[104] On the façade, a Gothic rose window or a large rectangular opening gives light to the choir loft and, in the latter case, acts as an outdoor pulpit on high.[105]

The three means of ingress to the building are the main door in the west façade, a monumental and elaborately decorated north entrance, and a third door on the south that opens onto the cloister for the occasional use of friars and laity alike.[106] The north door is known as the *porciúncula* in Franciscan buildings in imitation of the shrine of Our Lady of Angels in Assisi called the Portiuncula. According to Old Testament tradition, the north was associated with the pagan nations, and it came to be associated with the catechumens waiting for baptism and en-

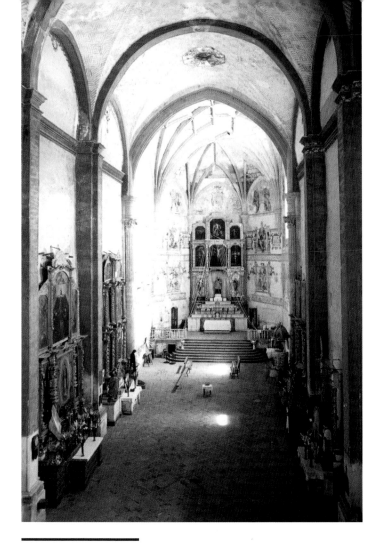

Fig. 1.25.
Acolman, state of Mexico. Nave of the Augustinian church with chancel frescos of the church fathers and the Sibyls. (Photo by author.)

trance into the faith.[107] Both connotations would certainly have had particular resonance for the New World missionaries.

Additionally, the north entrances frequently lacked doors. Either they were always open, day and night, or they were bricked up and only opened on rare occasions (fig. 1.26).[108] Fray Toribio de Motolinía makes a point of informing his readers that the Aztec temples were never closed because the Indians were unaccustomed to having doors; a bit of syncretism might have been at work here.[109]

On the other hand, a sealed door has eschatological implications in the Bible. In Ezekiel's prophetic vision of the future temple, a *porta clausa* stands on the eastern side of the sanc-

tuary facing the Mount of Olives; the closed gate signifies the Lord's entry and permanence within.[110] Typologically, the *porta clausa* is symbolic of the Virgin Mary, ever closed (virginal) but for one miraculous exception. For the Franciscan order, one occasion for a solemn opening of doors was the Jubilee year, when to pass through the original Portiuncula entrance in Assisi brought with it indulgences that would later allow one to pass freely through the portals of paradise.[111] The same practice is reported for coeval Franciscan shrines in the Holy Land.[112]

Conversely, an open door signifies readiness for Christ's proximate return when he descends from heaven to the Mount of Olives on Judgment Day (Rev. 3:7–8), and in the book of Revelation an open door in heaven is shown to the Seer through which he envisions the future (4:1). At the Franciscan establishment of Huaquechula (fig. 5.27), Christ the eschatological judge guards the north door of the church, together with angels trumpeting the Last Days, the apostles Peter and Paul, and two additional figures: King David and the Sibylline prophetess.[113] The scene may refer to Revelation 3:8, "Behold, I have left before you an open door, which no one can close." We shall return to this symbolism.

The exterior roofs of these single-nave churches are flat or slightly concave (fig. 1.27). They are also massively thick in their rubble-and-mortar construction, no doubt in view of the frequent seismic activity in central Mexico. They are invariably equipped with crenellations, merlons, sentry boxes or turrets, and buttresses (fig. 1.28). In many Franciscan buildings, the buttresses number twelve, certainly not by chance.[114] Flying buttresses are occasionally used, both on the ground level to shore up a presbytery or façade and on an upper level to permit passage around the outer walls at window level as a *chemin-de-ronde* parapet (fig. 1.29).[115] The total visual effect is one of military architecture: a lightly castellated and battlemented church with simple and harmonious proportions, rising unnecessarily high above the native settlement, in which it takes on the appearance of a refuge, a citadel, a community center,

Fig. 1.26.
Huejotzingo. North door or *porciúncula* when sealed. (George Kubler Archives, Yale University.)

Fig. 1.27.
Huejotzingo. Roof of
the Church of San
Miguel Archangel.
(Photo by author.)

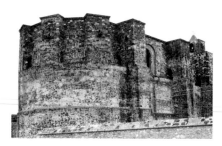

Fig. 1.29.
Cuautinchán, Puebla.
East end of the
Franciscan church
with *chemin-de-ronde*
parapet. (Photo by
author.)

Fig. 1.28.
Cholula. Sentry
boxes (*garritas*) on
the roof of the Church
of San Gabriel.
(Photo by author.)

and preaching and for an unobstructed focus on the liturgical activities at the high altar.[117]

Friaries or Convents

> The first thing they do on the land they are settling is to lay out the monastery complex, with a great expanse of gardens and patios, and this is the right thing to do. And when it is all done, they begin the church and monastery buildings, which they put up very quickly and well.
>
> —Vasco de Puga, c. 1564

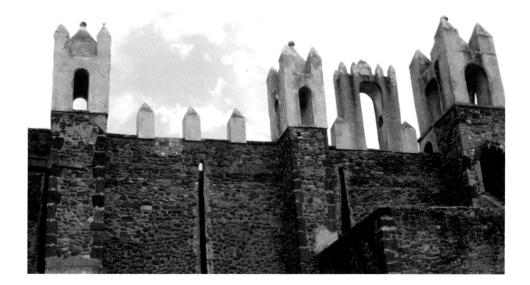

or—to the modern mind—a stage set on a Hollywood back lot. This novel architecture of the interlopers changed the skyline of Mesoamerica forever (fig. 1.30).

As I suggested above, the single-nave church is certainly the common mendicant architectural form in Mexico imported from Europe, and one that carried Old Testament associations with the tripartite Temple space. Its greatest period was between 1540 and 1590, when the mendicants were wielding spiritual and political power and were flourishing.[116] The single-nave church was also ideally suited acoustically for singing

The quality and quantity of the Mexican monastic convents can be explained by the fact that conditions in New Spain, in the intense time of the sixteenth-century evangelization, were in many ways similar to those in sixth- and seventh-century Europe during the evangelization of the Germanic peoples. The distant antecedents of the Mexican convents might be the Carolingian missionary monasteries, but their immediate prototypes were friaries like Santa Maria Novella or Santa Croce in Florence, or the Aracaelis in Rome (figs. 1.18, 1.31, 1.32).[118] One should not forget that the medieval monasteries were centers of the new pacifying and civilizing entities where the monks dispensed justice, directed Latin schools, and taught their lay brothers agriculture and the manual arts. The friars continued these activities in Mexico, where the convent doubled as an educational center.[119] Before 1530 all convents and churches were quite provisional, often consisting of thatched huts. In the decade from 1530 to 1540, friaries of rubble-work masonry began to replace the primitive shelters.[120]

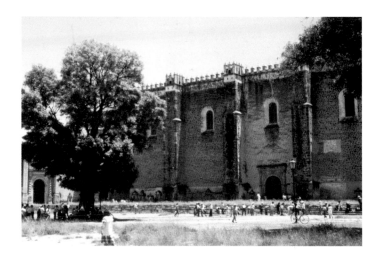

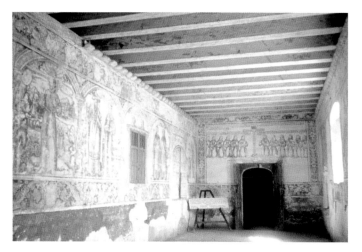

Fig. 1.31.
Huejotzingo. Chapter room with mural of the first twelve Franciscan apostles at rear. (Photo by author.)

Fig. 1.32.
Actopan. Cloister corridor of the convent. (Photo by author.)

Fig. 1.30.
Cholula. Atrium, *porciúncula*, and north flank of the Church of San Gabriel. (Photo by author.)

Cloisters are located on the south side of the church for light and warmth (fig. 1.33), except in the hot country of the Yucatan peninsula, where they are located on the north side.[121] Like their medieval predecessors, the Mexican cloisters were used in ways similar to the outdoor posa chapels: for instruction, for processions, and for individual meditation during perambulation. The devotional niches that terminate each arm of the cloister are oriented such that, while walking in meditation or procession, one approaches each niche from its front and has it in full view for the whole length of that side of the cloister (fig. 1.34).[122]

The richest mural painting of the epoch is found in the monastery cloisters, and it displays an amazing sophistication and diversity. Frequently the program is a Way of the Cross, a synthesis of the Christian life, a visual depiction of verses from the Psalms that are inscribed on the walls, floral and faunal expressions of a paradise garden, or some allusion to the biblical edifices of Jerusalem.[123]

The symbolic connotations of a cloister, as a sacred center or a cosmic microcosm, are well known. At the center, the spatial coordinates of north, south, east, and west cross where the midpoint is fixed by the presence of a well, a column, a fountain, or a tree indicating that a navel or cosmic hub has been

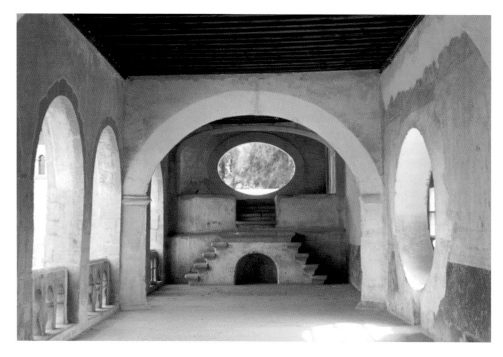

reached (fig. 1.33). In mythical terms, a vertical axis in the tree, column, or fountain acts as a celestial ladder on which one ascends to other realms.[124] In polysemantic medieval typology, the cloister had been imagined as a copy of the utopian holy city of Jerusalem (Rev. 21). It was also imagined to imitate the residence of the Levites in the Old Testament Temple or the Portico of Solomon, where many of Jesus' activities unfolded and where the disciples of the risen Christ organized their new communal life (Acts 2).[125]

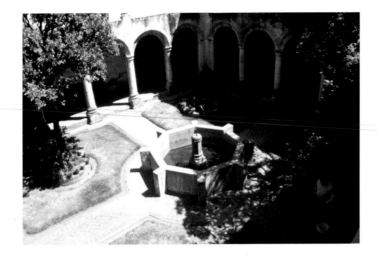

Fig. 1.33.
Huejotzingo.
Cloister and fountain
of the convent of San
Miguel Archangel.
(Photo by author.)

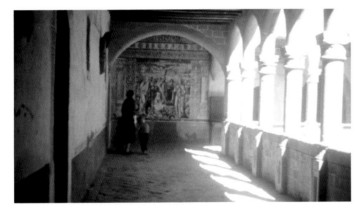

Fig. 1.34.
Acolman. Corner
mural or *testera*
niche in the convent
cloister. (George
Kubler Archives,
Yale University.)

Ramadas and Stages

We know today that the elaborate mendicant missionary complexes were not the first architecture constructed in New Spain. These elaborate compounds were constructed relatively late, most between 1550 and 1590. In contrast, the first constructions of the 1520s and 1530s were thousands of generic thatched huts known as *ramadas*, which can still be seen on the Yucatan peninsula.[126] Archeological work at Huejotzingo (Puebla), for example, has demonstrated that in the first stage a large, basilica-like ramada acted as the open chapel and schoolroom (fig. 1.35). This was most likely the case elsewhere.

Furthermore, there is ample evidence of the existence of "isolated open chapels," that is, walled patios with an open-air apse, atrial cross, and posas, but without any church or convent. This is perhaps what we see represented in Fray Diego Vala-

dés's engraving for his *Rhetorica Christiana* (fig. 1.4). These open chapels stood free or isolated as rural *visitas* (fig. 1.36).[127] Some were later completed with church and convent, while others remain without them today.

As I mentioned above, few scholars have paid attention to the fact that the patio was commonly called a *corral* in the theatrical sense of the word. This leads me to consider a curious detail, namely, that some of the first European constructions in the New World—contemporary with the ramadas and the isolated chapels—were stage sets.[128] Catechetical plays were early means of indoctrination, and we are fortunate to have descriptions of what some of the stage sets, called *mansiones*, looked like both in New Spain and on the Continent. I shall explore this theme further in chapter 6, but for now I would like to suggest that the mendicant complex might be understood in some degree as an elaborate stage set for an eschatological drama. Certainly by the time the Nahua Christians were engaged in the elaborate building campaigns of the mid-century, they had been accustomed to fabricating theatrical cities and temples in ephemeral materials. They also had access to a wealth of illustrated books for architectural plans, elevations, and details. It is not unreasonable to think that they and the friars may have decided to continue such constructions in the impressive and lasting materials of stone, brick, and mortar.

FORTRESS MONASTERIES

The quasi-military features of the architecture I have been examining need clarification before I can speak of the intended meanings or the liturgical use of the complexes. The question of the military and defensive character of the walled monastery has been the subject of controversy for some time (see figs. 1.28, 1.30, 1.38).[129] In 1929 Louis Gillet humorously noted that in these buildings there appeared "crenellated masses of abrupt shape, with a single level of windows placed high enough for fending off scaling, braced by a series of square buttresses crowned by sentry boxes assuring protection for the flanks. The roof is a platform that could serve artillery. The gargoyles imitate cannons. Sometimes a second platform runs around the building half way up to assure two levels of fire."[130]

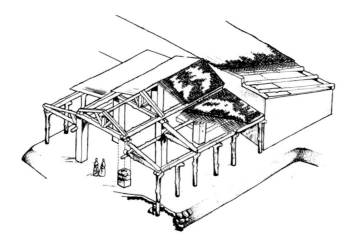

Fig. 1.35.
Huejotzingo. Drawing of the first stage of the ramada. (From Córdova Tello, *El convento de San Miguel de Huejotzingo, Puebla.* Used with permission of the Instituto Nacional de Antropología e Historia, Mexico City.)

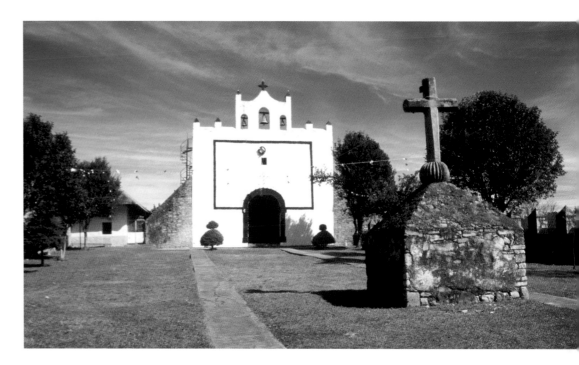

Fig. 1.36.
Nonoalco, Hidalgo.
The Augustinian *visita* chapel, originally open and later enclosed.
(Photo by author.)

Battlemented churches located in unfortified towns were not unknown in Europe of the Middle Ages and were built in places like Transylvania as protection against the Muslim Turks.[131] Earlier, in the second half of the twelfth century, they had frequently been constructed in Languedoc, and fortress churches, cathedrals, and abbeys were known in England, and also in Catalonia and Aragon on the fighting frontier between Christians and Moors.[132] Some of these churches were the work of the mendicants, particularly the Augustinian canons. Along the Mediterranean coast of France, fortified churches were built for defense against the maritime attacks of Saracens, pirates, and brigands, and later against the invasions of rival Christian kingdoms.[133]

It was precisely in the same region of southern France that the Albigensian heresy flourished.[134] After a papal envoy was murdered in 1208, a crusade to eradicate the heresy was begun under the leadership of the mendicants. By the time peace was restored in 1229, the population was decimated, towns were laid waste, and the political situation was in chaos.[135] The French feudal monarchy authorized the founding of new, unfortified towns with a battlemented church to act as a refuge in case of future disturbances, and the Franciscans, Augustinians, and Dominicans began the reconstruction of the devastated zones. These *villes neuves* of the thirteenth century were open,

unfortified towns with truly fortified churches.[136] These fortress churches have real, functioning crenellations and merlons, archery slits in walls and ceilings, and vertical slots for launching projectiles or pouring boiling liquids.

But it was not so in New Spain, where the fortified churches and patios seem more like stage sets (fig. 1.37). In not one of them could the roof or atrium crenellations, or the sentry boxes, ever have been functional. They are of such diminutive size that they could not house, much less protect, a human being. Unlike their earlier European cousins, the evangelization compounds are never provided with wooden fighting platforms (catwalks), archery slits, or machicolation slots. The omnipresent turrets or sentry boxes—often twelve in number—instead acted as collectors and drains for rainwater on the roofs, and the *chemin-de-ronde* parapets served for maintenance, or for the town's orchestra calling the faithful to worship from the elevated spot.[137] The use of artillery on the undulating vaults would have been impossible; cannons could never have been rolled or positioned correctly. Furthermore, such scenographic features as crenellations, merlons, and sentry boxes are found on constructions in areas of New Spain that had long been pacified and were under no threat of an Indian attack; nor were they in proximity to unpacified Indian territory.[138] Merlons and crenellations even appear on walls that were useless for defense, such as those facing

Fig. 1.37.
Yanhuitlán, Oaxaca.
North flank of the
Augustinian church.
(Photo by author.)

Fig. 1.38.
Atlatláuhucan,
Morelos. Merlon
spikes on church
roof and around the
convent cloister.
(Photo by author.)

the friars' dormitories and private living quarters (fig. 1.38). The accoutrements could never be utilitarian, nor were they intended to be so; they were stagecraft and symbolic ornaments.[139] But what did they symbolize and for whom?

Some have suggested that such military features were a display of power to the indigenous population—a warning, so to speak, to submit to European domination.[140] But the question arises how the Amerindians would have been aware of the intimidating character of European military architecture. How would they have "read" the puny medieval sentry boxes, merlons, and crenellations as a military threat to their desire for freedom from Spanish domination? For the Spaniard, the image of a defensive castle might have evoked memories of previous experiences in Iberia, but for the Indian, such was not the case because he lacked the lived experience of castles; he did not know them. Nor can the massiveness of the monastery have impressed him and caused him fear, because the dimensions of the indigenous pyramids and temples were much greater, with height and volume significantly more impressive than that of the mendicant centers (fig. 3.1). The evangelization complex did not intimidate; the literary testimonies show just the opposite: the *teocallis* intimidated the Spaniards.[141]

In the pre-Conquest period, the Mexica had constructed sacred precincts with magical protective devices of merlons or spikes on crenellated walls. Hence there is good reason to think that the Europeans were conflating their buildings with an earlier native practice, but this is not sufficient to explain the total program of the architectural iconography, nor the meaning that the friars wished to communicate.

The patios of New Spain display other aspects that disprove the military character of the architecture. For one thing, the walls average only about three meters in height and could easily have been breached. In some cases, one could jump over an atrium wall without any effort whatsoever. Furthermore, in no extant monument is there any evidence of catwalks on the walls to facilitate firing muskets from between the comically minuscule merlons. Finally, the atria had no gates installed on their monumental portals. If the patio was the supposed citadel where friars and townsfolk were to gather against an attack, it is strange that the defenders would not have been able to close the gates against the enemy—precisely because there were no gates! Whatever ironwork gates exist today can be shown to be nineteenth-century additions.[142]

There must therefore have been a reason other than maintaining law and order for constructing, everywhere and at considerable expense, a merely symbolic feature.[143] But why here at the initiation of the evangelization of the New World? Javier Gómez Martínez has proposed that the fortress motif of the evangelization centers may have been chosen by the friars for the symbolic protection of the Nahua flock against the ravenous Spaniards—a type of religious imperium. The first fortified convents were begun in the 1540s, immediately after violent confrontations between the missionaries and the

civil authorities. Several years earlier, Fray Bartholomé de Las Casas had even conceived of creating a religious military order on the model of the crusaders, the Knights of the Golden Spur, to defend the natives from the abuses committed by the conquistadors.[144]

Certainly one can look to St. Augustine's *City of God* as a primary text in America for themes of spiritual defense and warfare. The corral is a miniature parklike city with gateways, trees, and fountains; and the fortified buildings were the perfect idealization of the Church Militant in which the mendicants were the vanguard—the shock troops, so to speak—of God's approaching kingdom on earth.[145] The *ecclesia militans* had always been a common allegorical trope on the word *Jerusalem*, one that even Christopher Columbus was well aware of.[146] This military metaphor seems closer to the fact, but there may still be additional reasons related either to some common iconographic model for the walled compounds or even to some spiritual and biblical model of fortresses found in the Psalms, which the friars recited daily.[147] For the psalmist, one of the most frequent metaphors of geopolitical, psychological, and religious protection was precisely God's fortress on the heights of Jerusalem, Zion.[148] Spiritual writers elaborated on these military themes for pious purposes. St. Bernard of Clairvaux, quoting the prophet Habakkuk (2:1), says, "I will stand at my sentry box and take up my post on the ramparts, keeping watch." Urging his fellow monks to have an attentive eye and moral readiness, Bernard continues, "I beg you, my brothers, stand at your sentry box, for now is the time of [spiritual] battle."[149] Here the classic themes of moral and cosmic warfare appear in a spiritualized way through Bernard's reflections, and—as we shall see—in a material, architectural way in New Spain.

If the evangelization complexes were not fortresses, neither were they monasteries in the literal sense of the word.[150] In the sixteenth century, friars were not monks who lived isolated from the world in rural monasteries like the Benedictines, Cistercians, or Carthusians. Monasteries were self-sufficient enclaves, and the monks seldom left their compound. They took a vow of "stability" (that is, permanence of locale) and very often died without seeing much of the outside world. Their life was essentially one of *ora et labora:* long hours of sung prayer in chapel and work in the fields or scriptoria. Vis-

itors were stringently regulated, and laymen and -women were strictly forbidden from entering the monastic enclosure under pain of excommunication or imprisonment. The mendicant friars, in contrast, were founded in the thirteenth century to be urban street workers. Their vocation was to live a common life in a convent (friary), but also to go out from the convent daily to accomplish their mission of street preaching and popular catechesis. The friars' cloister, although primarily private space, was occasionally used as a semipublic area when the laymen and -women of the confraternities or the Third Orders were admitted for processions or instruction, or as manual laborers.[151]

While it is true that some early chroniclers use the words *monastery* and *convent* conjointly, they were not suggesting a sort of Franciscan monasticism (an oxymoron) in New Spain. More likely, they were anticipating a utopian age of religious renewal, as we shall see articulated in the next chapter by the famous abbot Joachim of Fiore. In this venture they were aided by the printing press and by the appearance of recent publications that they had in their possession.[152] One was the printed text of Joachim's Apocalypse commentary. Another was the first printed and illustrated commentary on the whole Bible, the work of a fellow mendicant. It provided an easily readable ground plan and elevation of renowned biblical architecture for outdoor worship. Other books offered the first printed maps of the Holy Land and topographically correct panoramas of Jerusalem's skyline and major architectural structures; while still others were liturgical guidebooks for constructing and decorating churches, and for liturgically "playing" in them—all in accord with Old Testament exemplars. These texts proved invaluable for the "imagineers" and architects of the missionary enterprise of the New World.[153]

While many have noted the extraordinary iconography of the Mexican mendicant evangelization complexes, few have attempted to place them in the context of the eschatological spirituality and thinking of the age.[154] Nor has anyone been able to show specifically how the buildings might relate either to utopian urban planning or to any of the sacred structures described in the Bible—the friars' missionary textbook. My next task will be to demonstrate that precisely those entities, the City and the Temple, were being imagined and imaged when saints and scholars turned their minds to the End Times.

The Visual Imagination and the End of History

We begin by looking at a theme that has permeated Western culture and religions for centuries, that of a Judeo-Christian theology of history and a teleological goal toward which history is believed to be moving. It behooves us to define our terms in order to be more precise when speaking of the Contact and the evangelization of the native populations of America as an eschatological event. Mesoamericans and medieval Christians had clear ideas of when and how time would end, and their comparative eschatologies will illustrate that a convergence of these concepts was underway at an early stage of the encounter. The end time was also a favorite theme in Aztec as well as Christian art. Therefore, the notion and visualization of the End Time easily acted as a symbiotic bridge between the two encountering worlds.

THE LAST THINGS

In this study, I have chosen to use the term *eschatological* in relation to both the missionary activity and the religious architecture created in New Spain. The Greek word *eschaton*, "last," gives us *eschatology*, a science of last things. Eschatology in any religion, such as the teoyism of the Aztecs, has to do with ideas about some form of life after death and possible bliss or pain in an afterlife. In Christianity, eschatology has traditionally been divided into two categories: individual eschatology, which treats of death, individual judgment, purgatory, heaven, and hell; and collective eschatology, which considers the end of the physical world, the Second Coming of Christ, the resurrection of the dead, and a general or last judgment.[1] Related to this notion

41

of an End Time is nomenclature usually associated with Judaism and Christianity, such as apocalypticism, chiliasm, and millennialism.[2]

The first term, coming from *apocalypse* (revelation), involves a disclosure or unveiling of the "divine secrets which God made known to certain elect individuals . . . initiated into an understanding of the secrets of heaven."[3] Its sense of unveiling lends itself to intriguing theatrical connotations, such as to draw back a curtain or to reveal a stage set. "Curtain up, light the lights!" as they say on Broadway. *Apocalyptic* suggests a belief that the final act of the drama, when God's ways are revealed, is imminent. Apocalyptic believers live in a world of great intensity. Semiotically sensitized, they see every event as a sign with a specific message for them. The emotions that this belief provokes usually heighten as the anticipated waiting period shortens. In Christianity, the final moment brings the *Parousia*, the return of Christ.

Millennialism (or millenarianism) refers to eschatological expectations associated with the turn of a millennium, a belief set in motion by early church teaching (based on Rev. 20) of a sabbatical millennium, usually referring to the thousand-year reign of the saints with Christ before the final battle with Antichrist and the definitive establishment of the kingdom of God, symbolized by the New Jerusalem. The word millennium is often used in a loose sense as an undetermined period of bliss, not necessarily of precisely one thousand years,[4] and it can be applied both to Euro-Christian behavior and to native resistance in America. It has many affinities with the early modern term *utopia*. *Utopia* (literally, "no-where") was introduced by Sir Thomas More's book of the same title in 1516 and was certainly inspired by the American discoveries.[5]

In the Christian liturgical imagination—which so formed the missionary friars—eschatological themes cluster together in the Advent season, especially during the first two weeks of December. Adventide was the prime eschatological season, with readings in the Mass and Divine Office, taken from the major and minor prophets, concerning the restoration of Zion, the rebuilding of the Temple, and the return of a holy remnant.[6] These past events of the historic people Israel were seen as prophesying the coming of Christ and then projected into the distant future for his return and the final consummation of world history.[7] A second eschatological focus occurred annually at Eastertide, when the glorious victory scenes of the book of Revelation were read at public worship. The friars' imaginations were shaped as much by their liturgical feasts as by any other ideology in the New World. To date, scholars of the colonial period have paid little attention to the liturgical imagination of the missionaries formed by their daily reading, psalm singing, and meditation on the Scriptures.

BIBLICAL ESCHATOLOGY

The Judeo-Christian tradition knows both a linear and a cyclical sense of time. The latter appears in the liturgical calendars of the two faiths with their continuous cycle of feast days and commemorations, while the former takes shape as salvation history from Genesis to Revelation. In eschatological thought, linear time is often periodized either according to a biblical number, as in seven ages, or according to a trinitarian scheme of three eras.[8] Biblical time implies recurring ends—both a termination and a new commencement.[9] It was this linear notion of time and the hope of a new beginning that the religion and art of the friars were to inculcate on the American continent. Amerindians soon learned this biblically based temporality, which, as we shall see below, was not entirely foreign to them.

In the Hebrew Bible, especially in the prophetic books, there are passages that foretell how, out of an immense cosmic catastrophe, a nation will arise that will be nothing less than a new Eden, paradise regained. On that great day the righteous will be assembled once more in the land of Israel, and God will dwell among them as ruler and judge. He will reign from a rebuilt Jerusalem, a Zion that has become the spiritual capital of the world and to which all the Gentile nations of the earth will flow.[10] It will be a just world, where the poor and humble are protected, and a harmonious and peaceful world, where even wild beasts will have become domesticated and harmless.[11] This End Time is never conceived of as a purely or principally spiritual reality, but rather as a spatial, topographical, and, we might say, architectural salvation within human time.[12]

In the later Jewish apocalypses, like the book of Daniel, the tone becomes cruder and more boastful, with references to

contemporary historical and political figures of the second century BCE symbolized by monstrous beasts and an evil empire.[13] Just when injustice has reached its greatest pitch, the Messiah will appear, routing the enemies at the final battle on Mount Zion. A common element in these apocalypses is the city of Jerusalem—the navel of the world—as the theater for the final cosmic encounter. Zion and the Temple are the stagecraft in God's drama of righteous reconquest and the ensuing paradisial bliss. Topography, architecture, and dramaturgy are, therefore, part and parcel of this notion of righteous reconquest, all of which will reappear later in Spanish experience with Muslims and Amerindians.

While the Hebrew Scriptures begin their sacred drama in a bucolic garden called Eden or Paradise, the Christian Scriptures end the cosmic play in a garden city, a metropolis, a hagiopolis—the Heavenly Jerusalem, a "vision of peace."[14] The word *Jerusalem* has, of course, always meant much more than a municipality in Israel or Palestine. In the polyvalent exegesis of the Middle Ages, it could be explained on four levels.[15] Jerusalem was *historically* the city situated in the Holy Land, *allegorically* the Church, especially the Church Militant, *morally* the soul of the believer, and *anagogically* the Heavenly

City mentioned in the biblical book of Revelation, also known as the Apocalypse.[16] But before the anagogical end, Christians have recognized a variety of possible ways of imagining and imaging the millennium with innumerable variations on the master plot.[17]

Like Jews in the times of Daniel and the Maccabees, early Christians suffered oppression and responded to it by affirming ever more vigorously their faith in the imminence of the messianic age. In the book of Revelation, Jewish and Christian liturgical elements are blended with combat mythology (which will later prove very attractive to Mexica warrior culture) in an eschatological prophecy of great poetic power.[18] John the Seer foretells a terrible ten-horned beast that symbolizes the last world power, interpreted as a political entity, or Satan the father of lies, or Antichrist, one of his agents. The Seer's vision details a sabbathlike period (the millennium) and culminates in chapter 21 by proclaiming the establishment of a five-square city (i.e., a perfect cube), the new and heavenly Jerusalem—the final urban destiny of the saved. Topography, urbanization, architecture, and liturgical enthronement rituals are fused to create a metaspatial site of eternal bliss[19]—themes that will all reappear in the apocalyptic New World.

Excursus: The Millennial Old World

NOTE: The reader may want to skip this section, which concerns pre-sixteenth-century Europe, and go directly to "The Apocalyptic New World" on page 59. This section contains background material for what will reappear in New Spain, and the interested reader can return to it later.

Eschatology in the Early Middle Ages

Early commentaries and interpretations of the book of Revelation were plentiful and polemical, and they read like subplots, tropes, and scenarios from this cosmic script. From the very beginning there were disputes about the literal or symbolic value of the text. Its canonicity was doubted or denied,

and its liturgical use was relatively late in coming, and then only in an abridged form.[20] In the early years of the third century, the Egyptian theologian Origen, the most influential thinker of the century, began to present the kingdom of God as an event that would take place not in space and time but only within the souls of the believers. Simultaneously we find literalists like Tertullian, who expected an immediate fulfillment of the apocalyptic prophecies. He writes of a wondrous portent: in Judea a walled city had been seen in the sky early every morning, only to fade away as the day advanced. This was a sure sign that the heavenly Jerusalem was about to descend.[21] This sky city was the same vision that was to hypnotize the mass of Crusaders as they toiled toward Jerusalem, some nine centuries later.[22]

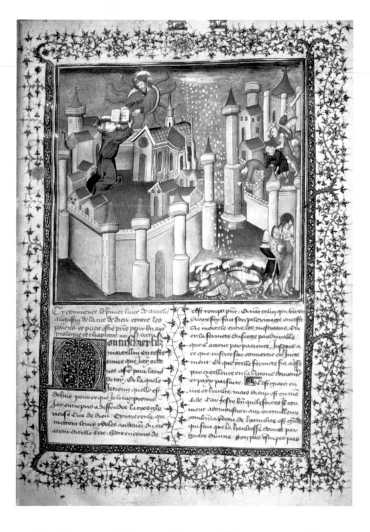

In the pages of Commodianus, a fifth-century Latin poet, the tone changes again and becomes more bellicose. Fantasies of vengeance and triumph crystallize into an urge to take up arms and fight—a foreshadowing of the crusading millenarianism that was to burst over Europe in the later Middle Ages. Now when Christ returns, it will be at the head of the descendants of the ten Lost Tribes of Israel, who have survived in far-off lands, unknown to the rest of the world. This hidden people is shown to be a singularly virtuous community, a *genus angelicus*, which knows nothing of the ways of Antichrist and his band. They hasten to liberate Jerusalem, the captive mother. In Commodianus's view, salvation is once again a spatial experience: the holy people who are victorious over Antichrist live forever in a sacred metropolis that is also a physical paradise.

These myths of the Lost Tribes and the *genus angelicus* will come back on center stage with the sixteenth-century mendicant missionaries to the New World in their attempt to determine the origins and identity of the Amerindians.

Early in the fifth century, Augustine of Hippo (d. 430) propounded a thesis that was to become the predominant doctrine of the Middle Ages. According to his *City of God*—one of the primary texts used in New Spain—the book of Revelation is to be understood as a spiritual allegory. The main theme is salvation, attained by the right worship of the one true God and the rejection of all false gods, idols, and cults.[23] One could call the *City of God* a liturgical-eschatological work in that it represents ortho-praxis, doing it the right way, as opposed to mere ortho-credence, right belief. This theme of ortho-praxis will, of course, reappear in an aggressive way in sixteenth-century New Spain when the Aztec temples, idols, and cult are suppressed and the mendicants' right way of worship imposed. Augustine's theological work seemed like a textbook or stage script for the enterprise of the New World because it fit so well the contemporary situation there, especially vis-à-vis idolatry and human sacrifice.

In [this book] we have brought our discussion to this point, and we have shown sufficiently . . . what is the development in this mortal condition of the two cities, the earthly and the Heavenly, which are mingled together from the beginning to the end of their history. One of them, the earthly city, has created for herself such false gods as she wanted, from any source she chose—even creating them out of men—in order to *worship* them with *sacrifices*. The other city, the Heavenly City on pilgrimage in this world, does not create false gods. She herself is the creation of the true God, and she herself is to be his true sacrifice.[24]

In Augustine's metaphorical thought, salvation is also represented as citizenship in a city (*civitas*) whose visual urban icon (*urbs*) is explicitly taken from the Scriptures, especially from the Heavenly Jerusalem of Revelation.[25] Both the City of God and the City of Man are hopelessly intermingled and entangled in this life; only in the next will God's city prevail. When Augustine describes what he means by "city" he makes

Fig. 2.2.
Puebla, house of the dean of the cathedral. Reception room with murals of the Sibyls. (Photo by author.)

use of other architectural terms like "house" or "temple."[26] The cosmological twining of the metaphors of temple and city applies throughout his figural world; both are images of corporate religious identity. Typical of his mixed metaphors is his commentary on Psalm 96, a hymn composed for the dedication of Solomon's Temple. He writes: "The House for the Lord, the City of God, is the Holy Church that is being built over all the earth." In his theological lexicon, the metaphor of the city, spiritual and physical, is complemented by that of the Church, at once the assembly of the faithful and the physical place of assembly.[27] Humanity is already dwelling in the Last Age, which is the time after the Incarnation and redemptive death of Christ. As for the millennium, Augustine claimed that it had begun with the birth of Christianity and was now fully realized in the Church. This perspective became orthodox doctrine and remained so for centuries. Artistic representation of Augustine's *civitas Dei*, in the guise of certain European cities, would become popular illustrations in the fifteenth century (fig. 2.1) and at the time of the New World Contact.[28]

However, the importance of the more literal apocalyptic tradition should not be underestimated. Even though official Church doctrine downplayed it, it nevertheless persisted in the obscure underworld of popular religion as well as in the spiritual reflections of scholars, mystics, and literati. Particularly at times of general uncertainty or anxiety, people were apt to turn for guidance to the book of Revelation and to the innumerable commentaries on this master plot, alongside which there gradually emerged another and equally influential body of subplot apocalyptic writings known as the Sibylline Oracles. They were adapted for new geopolitical realities and popularized in Renaissance Rome and in colonial Mexico.

THE SIBYLLINE ORACLES

> Day of wrath! Oh doom impending!
> David's words with Sibyl's blending:
> Heaven and earth in ashes ending!
> —*Liturgy of the Dead*,
> thirteenth century

The mythical Sibyls were prophetesses who gave obscure messages with double meanings; they "foretold" *post factum* the history of the world from its origin to the present moment (figs. 2.2 and 2.3).[29] The Tiburtine Sibylline Oracle, for example, reflects the reactions of Catholics to the dominance in the Roman Empire in the fourth century of Arianism, a political theology that denied the divinity of Christ.[30] However, this prophecy found its fullest expression later in medieval Spanish liturgical drama, and as we shall soon see, it would be revived in earnest in Renaissance Rome and in the imperial Spain of Emperor Charles V.[31]

In a surprising similarity to Aztec cosmology, the oracle speaks in terms of multiple solar ages. She tells of nine "suns," which are nine generations or unspecified periods of time.[32] During the fifth sun, which is described as "bloodlike," pagan temples and altars are built, "very large and shapely beyond any other temple in the inhabited world." The last sun will be a time of sorrows when Rome will be captured and tyrants will oppress the poor and innocent while protecting the guilty, but God has a plan and "sends a king from the sun," a sort of solar savior.[33] He is a heroic emperor who unites the western and

·PS·16·

·S·PESICA·ÆTA·30·

·PROPHE·

Fig. 2.3.
Puebla, house of the dean of the cathedral. Detail of
fig. 2.2. The Persican Sibyl and the image of the Woman
of the Apocalypse. (Photo by author.)

Fig. 2.4.
Joachim of Fiore, *De magnis tribulationibus* (Venice, 1516).
A mendicant friar preaches to Muslims; Jews and pagans
are baptized. (Courtesy of the Beinecke Rare Book and
Manuscript Library, Yale University.)

eastern halves of the Roman Empire under his rule in a golden age that sees the final triumph of Christianity.[34] In a foreshadowing of Spain's imperial activity in the New World, the prophesied emperor lays waste the cities of the heathen and destroys their temples, replacing their idols with crosses. "Then will arise a king. . . . He will be the [universal] king of the Romans and the Greeks. . . . [He] will claim the whole Christian Empire for himself and destroy all idolatrous temples; he will call all pagans to baptism, and in every temple the Cross of Christ will be erected" (fig. 2.4).[35]

At the end of the long reign, the Jews too are converted, and when this happens, the edifice of the Holy Sepulcher in Jerusalem shines forth in splendor. The barbaric peoples of Gog and Magog break loose, but the emperor calls his army together and annihilates them. This task accomplished, he journeys to Jerusalem, there to lay down the imperial crown and robes on Golgotha (within the Holy Sepulcher complex) and so hand Christendom over to the care of the Almighty for the millennial reign of the saints (fig. 2.5). When the golden age of peace comes to an end, so does the Roman Empire; but before the end of all things there remains a short time of tribulation. Now Antichrist appears on stage and reigns in a rebuilt Temple of Jerusalem, deceiving many by his miracles.[36] For the sake of the elect, the Lord sends the Archangel Michael to destroy Antichrist (fig. 2.22). Then at last the way lies open for the Second Coming to take place.

The figure of the Last World Emperor, introduced for the first time by the *Tiburtina*, looms still larger in the Sibylline Oracle known as the *Pseudo-Methodius*, composed toward the end of the seventh century CE and later applied to European monarchs.[37] Its original purpose was to bring consolation to Syrian Christians suffering under Muslim rule, but it was disseminated in the West at the court of Charlemagne, where it was used as propaganda to interpret the hidden identity of Charles the Great himself.[38]

As in the *Tiburtina*, the Last World Emperor plays a crucial and melodramatic role.[39] After a period of peace and joy during which the empire flourishes as never before, the hosts of Gog and Magog break out, wreaking universal devastation until God sends St. Michael the Archangel, who destroys them in a flash. Once again, the emperor journeys to Jerusalem, there

to await the appearance of Antichrist. But this time, when the dread event occurs, the emperor places his crown on the cross at Golgotha,[40] which soars up to heaven, while the insignia of the Passion, the *arma Christi* (the passional weapons of Christ), appear to the eyes of the faithful (fig. 2.5). The emperor dies and Antichrist begins his reign. In a parody of Christ's ascension to heaven, Antichrist attempts to ascend from the Mount of Olives. But before long the eschatological cross reappears in the heavens as the "sign of the Son of Man" (cf. Matt. 24:30), and Christ himself comes on the clouds in power and glory to kill Antichrist with the breath of his mouth and to carry out the Last Judgment.[41] The *Pseudo-Methodius* prophecy was reprinted in ten editions from 1470 to 1677, but the most important editions, with woodblock illustrations, were those of 1498, 1516, and 1520, making the prophecy an important addition to Spain's imperial mythology that would cross the Atlantic Ocean to New Spain.[42]

Note that in both versions of the oracle, the End Time events take place in the city of Jerusalem, and they are associated with the *loca santa* of the Holy Sepulcher, the Temple, and the Mount of Olives.[43] It should also be noted that the cross and the instruments of the Passion have a role in the final days, at a moment that will see the conversion of pagans and Jews alike. All of these elements of the cosmic drama, its scenography and props—the Holy City, its sacred buildings, the cross, and the instruments of the Passion with their solar connotations—will reappear in the sixteenth-century New World, yet another moment that would look to signs and prophecies for explanations of contemporary events.[44]

The Sibylline Oracles were treated with great respect by the early church fathers, a respect that was not to decline until the time of the Enlightenment. Augustine himself, generally so opposed to any form of apocalypticism, not only quoted the Sibyl

Fig. 2.5.
Joachim of Fiore, *De magnis tribulationibus.* The Last World Emperor surrenders his crown and kingdom. (Courtesy of the Beinecke Rare Book and Manuscript Library, Yale University.)

but also made her the lead actress of his *City of God*.[45] From the fourteenth century onward, translations of the Sibylline Oracles began to appear in various European languages; and when printing was invented, these texts constituted the very first book to come off the press, even before the Gutenberg Bible.[46] The Sibyls also appeared in Christian art and drama throughout the Middle Ages, and in Renaissance Rome.[47] In 1515 they were depicted in an elaborate stage play for the Holy Roman Emperor, Charles V of Spain. In the scene—which was witnessed by the first Franciscan missionary to Mexico, Friar Pedro de Gante—the Sibylline actress held a scroll addressed to Charles (fig. 6.8), portrayed by an actor and costumed as the earlier Christian emperor and hero Heraclius.[48] The scroll read: "Blessed are the eyes that have longed to see this day!"[49] As we shall see, the day of the Spanish Last World Emperor arrived in the sixteenth century, and the prophetic Sibyls would reappear in fresco, carved stone, and oil paintings in colonial New Spain (figs. 1.25, 2.2, 2.3).[50]

PRUDENTIUS AND THE *PSYCHOMACHIA*

Faith then takes the field to face the doubtful chances
of battle, her rough dress disordered, her shoulders
bare, her hair untrimmed, her arms exposed. . . . Lo,
first Worship-of-the-Old-Gods ventures to match her
strength against Faith's challenge and strike at her.
But she, rising higher, smites her foe's head down,
with its fillet-decked brows, and lays in the dust that
mouth that was sated with the blood of beasts.

—Prudentius, *Psychomachia*

Iberia contributed a further scenario for these eschatological themes in the writings of a Spanish poet who had particular influence on medieval eschatological thinking and its visual imagination—Aurelius Prudentius Clemens (d. 404). Prudentius wrote at a moment when nascent Iberian Christianity was coming into conflict with a revived paganism. Similar to the situation of the Aztec contact, it was a time of many conversions to the Christian faith and of similar resistance.[51]

Prudentius's most famous work, the *Psychomachia*, is an allegorical poem in which the Soul, assisted by personified Virtues, rescues the Body from the attack of the Vices. (Here again, the root metaphor of the body comes into the spotlight.) These themes were later seen as relevant to the moral situation of the Aztecs, and Prudentius was quoted in mendicant literature and art in Mexico. And like the sixteenth-century Spaniards in the pagan New World, the Iberian poet was not averse to allowing for syncretism.

Prudentius uses two extended metaphors to speak of the ethical goal of human life: warfare and (like Augustine) right worship.[52] The poem depicts the combats of seven Virtues with their corresponding Vices, waged on an open field near the Virtues' camp. Their fort is described as a pagan Roman *castrum*, a rectangular construction atop a hill protected by a palisaded rampart, but there are also elements taken from the Heavenly Jerusalem of Revelation 21. The first attacker in Prudentius's military encounter is Cultus Deorum Veterum, the personified cults rendered to the old gods—in other words, idolatrous worship. One can envision how easily the friars could later apply this to the bloody liturgies (*cultus sangrientis et satanicus*) of the Aztecs.

The *Psychomachia*'s other major metaphor is that of temple worship. Prudentius, who had visited Jerusalem around 394, very likely conceived of this allegory through reflection on 1 Kings 5.[53] The materials and building techniques of Solomon's Temple reappear in the Temple of Virtue the victors build. While Prudentius takes his description of the temple from the geometry of Ezekiel 40–42 and the splendor of Revelation 21, the actual building ritual is syncretically conflated with one that Roman augurs of his time might have used to transform a military camp into a city, that is, from profane space to sanctuary.[54] What is architecturally noteworthy is that Prudentius's Temple of Wisdom is described as if it were the city, while the city is described as if it were the temple, a sacred metropolis. The poet also refers to the temple as a type of aedicule or open baldachin, a cipher that will indeed be the way later generations depict the historic Temple of Jerusalem in Western art, and in the architecture and catechetical dramas of the mendicants in New Spain.[55] Spiritual temple and spiritualized municipality are one and the same; both are castel-

lated bulwarks in the spiritual battle.[56] Here again, the text bears visual comparison to the "fortress compounds" of colonial Mexico.

But Prudentius takes this metaphor one step further in a way that would later allow a clear confluence with Aztec mythology: the site of the new temple is also the human heart. The entrance to this metaphorical precinct is through a triple gateway (*propylaea*), not unlike the triple gates of the mendicant evangelization complexes in New Spain. The temple of virtue in the heart (*templum pectoris*) is, in turn, the site of the altar of the heart (*ara cordis*).[57] Such a cardiological coincidence, as a moral allegory representing personal holiness attained through the ascetic way, would prove to be irresistible to the friars in their guided syncretism and ethical teaching with the Aztecs.

The *Psychomachia* was not a static document, but one that continued to evolve over the course of time; and it became institutionalized in Spain and Mexico through art and the choreography of the "Dance of Moors and Christians," stereotypes respectively of evil and good.[58] As the centuries passed, additional characters were added to the deadly drama: King David the giant slayer, the personified cross (as spiritual sword) and the *arma Christi* weapons, saintly Crusader knights, messianic and anointed political leaders, and visionary pilgrims who did battle with their inner demons. The themes of orthodox worship and spiritual combat lent themselves to an infinite variety of cast members: major actors, stand-ins, and cameo roles. Copies of the *Psychomachia* were early provided with illustrations, which in turn inspired a rich group of manuscripts and monumental sculpture in the Middle Ages, particularly in monastic cloisters for the moral formation of monks and friars and those laity admitted to the cloister.[59] As we shall see, the *Psychomachia* was also influential in the figural imagination of sixteenth-century Spain and Mexico.[60] It is not by coincidence that the sixteenth century—an era of many converts and of pagan-Christian conflicts—was perceived as parallel in many ways to that of Prudentius's spiritual conquest and syncretic convergence.[61]

These themes of crusading spiritual warfare and political events linked to the End Time are constant throughout the Middle Ages. They resurfaced with force whenever the time seemed ripe for an eschatological crisis: at the crowning of the *first* Holy Roman Emperor, in the fears surrounding the millennial year(s), at the crowning of the one who was to be the *last* Holy Roman Emperor, and at the discovery of a quasi-mythical New World.

Millennial Years and Crusading Evangelism

Another Spaniard who had an immense influence on eschatological thinking and its visual expression was the monk Beatus of Liébana (d. 798). Beatus had fled from Muslim persecution of the Christian communities in the south to the Cantabrican region of northern Spain.[62] His fame is tied to his *Commentary on the Apocalypse*, a book that would have immense, albeit indirect, impact on the New World. Beatus and his contemporaries, wary of the advancing menace of the Islamic invasion of the Iberian Peninsula after 711, were awaiting a more imminent end of the world, and this spurred him to his work. The original text was probably composed as a handbook, possibly a guide for sermons, to help prepare the Christian community for the anticipated end of the world around the year 800.[63] The traditional calculation of world chronology from the creation, *annus mundi*, assigned the earth an age of more than five thousand years by Beatus's day, and that in turn gave the approaching year 800 its significance as the beginning of the millennial sabbath.[64]

It must be admitted that more important and impressive than the text itself are the illustrations that have accompanied later editions.[65] To these were added the eschatological cross (which I shall discuss in chap. 5), and the allegorical combat of birds and serpents—psychomachian themes that entered into the medieval repertoire of images and that would be repeated later in Mexican sculpture and mural painting.[66] Once again we see the cross linked to warfare: a premonition of the Crusades and the spiritual conquest of Mexico. Another feature distinguishes the later copies of the manuscript: their visual references to Islam as a pagan religion or heretical sect hostile to Christianity and allied with Antichrist.[67]

For our architectural interests, the city of the Heavenly Jerusalem and the Temple are the most significant images (fig. 2.6). The celestial city is depicted both as a square, in

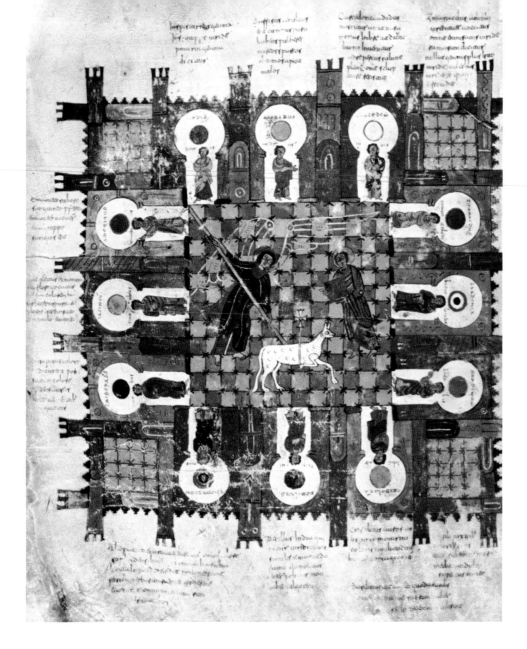

dicta pacis visio."[70] The dedication rite "pretends" that the church building is the Temple of the Old Testament, while the hymn—dated to around the year 700 in Spain—looks forward to a celestial temple. Revelation and the writings of Gregory the Great on Ezekiel form the main patristic source.[71] The hymn text reads:

> The blessed city, Jerusalem, called the vision of peace, which is built in heaven, out of living stones, and adorned by angels as a bride is adorned by her attendants,
>
> Like a bride coming from heaven, is ready for the nuptial bed, so that she may be united with her Lord. Her streets and her walls are made of purest gold.
>
> Her gates shine with pearls, her approaches lie always open; and in accordance with their merits all who in Christ's name are oppressed in this world are made to enter there.
>
> Her stones, shaped by crushing blows, are fitted into their places by the hand of the artificer and are disposed that they may remain forever in the sacred building.
>
> Christ is placed as the corner stone, which is bonded into the framework of both walls. Holy Sion receives him and, placing her faith in him, is fixed in him forever.
>
> The whole of that city, sacred and beloved of God, full of melodies, praises and proclaims God, the one and the triune, with exultation.
>
> Won by our prayers, come, God most high, into *this temple*,[72] receive the prayers of thy suppliants with clemency, and pour ever into it thy bountiful blessing.
>
> Here may all be permitted to obtain their petitions, to possess for ever with thy saints those things which they have obtained, to be translated into their rest and enter Paradise.
>
> Glory and honor be to the most high God forever, to the Father, the Son, and the Holy Spirit, to whom be praise and might throughout all ages.[73]

The hymn became associated with the earthly Jerusalem of Palestine during the Latin Kingdom of the Crusaders (twelfth century).[74] Excerpts from the "Urbs Beata" were inscribed in gilded letters within the Islamic Dome of the Rock on the

Fig. 2.6. Beatus of Liébana, *Expositio super Apocalipsim*, tenth-century copy. The Heavenly City of Jerusalem with grid streets. (The Pierpont Morgan Library, MS 644. Used with permission.)

accord with the strict letter of Revelation, and as a circle—another perfect geometric form, as befits divine architecture (cf. fig. 4.11).[68] Both circle and square were also employed in early medieval buildings that consciously made reference to either the earthly or the heavenly Jerusalem, and these two geometric shapes later carried over into theatrical representations of the city as well.[69]

Certainly one of the most significant developments in the "jerusalemization" of architecture came during the Carolingian period with the invention of the Rite for the Dedication of a Church and its accompanying hymn, "Urbs Beata Jerusalem

Temple esplanade when it was converted into a church.[75] In sixteenth-century Mexico, the hymn, translated into the Aztec language and rhythms, became a popular Eastertide song and was danced to in the evangelization corrals (see below).

Eschatological worries were dense in the Carolingian age, and many apocalyptic and chiliastic texts date from that moment.[76] Charles the Great had been crowned Holy Roman Emperor by the pope in St. Peter's Basilica on Christmas Day 800. Not by coincidence, that December 25 was the first day of the seventh millennium according to Beatus's calculations.[77] In fact, the new emphasis that would soon be placed on the year 1000 as the millennium (rather than the year 800) might well have been a ploy to "postpone" the apocalyptic inbreaking and assuage popular fears during the reign of the new Christian emperor—the mirror image of Constantine the Great and of Christ himself.[78] Architecture helped to reinforce this eschatological imperial image.

Architecturally speaking, Charlemagne's octagonal palace chapel at Aachen "quotes" from venerable prototypes found in early Christian Rome and Jerusalem, among them the Holy Sepulcher complex.[79] Aachen itself was imagined as a great hagiopolis, and Charles kept Augustine's *City of God* at his bedside and as the model for his imperium.[80] We shall see that the friars in New Spain, in their new Rome/new Jerusalem constructions, also quoted architecturally from hallowed buildings of the past for the mendicant imperium.

It is useful to observe other similarities between the Carolingians and New World, because some of their metaphors and myths entered into the enterprise of the Indies, not to mention their stational liturgy, which became a commonplace in Mexico. The Carolingian missionary enterprise to the Saxons paralleled in many ways the later enterprise to the Indies. For example, it followed a protracted war of subjugation. During the spiritual conquest of the Saxons, the Gospels were inculturated and translated into the unwritten Saxon tongue by native scribes. Verbal images from the indigenous culture were applied to biblical places—"Fort Jerusalem," "Rome-burg," "Fort Nazareth"—and they were pictured as equipped with wooden palisades and stockades. Christ was presented as the new Thor or Woden hung on the cosmic tree, as the keeper of the secret runes for God's spell, or as a Germanic chieftain gathering young thanes

to be part of his private retinue. As in New Spain, the task of creating new metaphors was what eventually Christianized the Teutonic people and changed their hearts from resignation to blind fate to a belief in a divine plan that would come to its fulfillment in *muspelli*, the Last Days.[81]

Legends of Charlemagne focus on his two supposed crusades: first to the West where the Moors were entrenched, then to the East to recover the cross and the Holy Sepulcher.[82] Later, in the ninth and tenth centuries, Charlemagne was metamorphosed into the archetypal crusader king conquering the Holy Land and protecting its sites for the faithful. The legend of a second Charlemagne (*Karolus redivivus*), resurrected as the Last World Emperor, would enter the constellation of prophecies surrounding royal pretenders, culminating in Spain in another "Great Charles," the Hapsburg Charles V.[83] Such interest in the coming Heavenly Jerusalem and the Last World Emperor would soon reflect anxieties around the year 1000.[84]

The eleventh century has frequently been seen as an age of strong apocalyptic expectations. This is based on two historical facts: the popularity of the biblical legend of the millennial year (1000), and the political-apocalyptic motivations of the Crusades.[85] Cosmic signs and portents surrounded the dreaded year in the form of plagues, famine, and war, as well as the appearance of Halley's comet, a supernova, and rumors of social chaos and cannibalism. The Feast of the Annunciation (March 25) coincided several times with Good Friday in the century before and after the millennium; such a rare coincidence was understood to presage a cosmic event.[86] During the Feast of Pentecost 1000, there occurred an event that chroniclers characterized as the most spectacular sign of that year: the opening of Charlemagne's tomb at Aachen by Emperor Otto III. The body of Charles the Great was found to be incorrupt, sitting upright on a throne, looking identical to the Byzantine images of Christ in Majesty. Charlemagne was canonized a saint in 1165.[87] As Stephen Nichols has pointed out, the mythic creation of this Christ-sized Charlemagne reminds us that "the establishment of authority in the Middle Ages was a process of symbolic transference from an idealized Christian archetype to an historical place or person."[88] Similar processes will be at work again in the Spain of Charles V and the New Spain of the sixteenth century.

Abbas Joachim magnus propheta.

Hec subiecta in hoc continentur libello.

❡ Expositio magni prophete Ioachim : in librum beati Cirilli de magnis tribulationibus & statu Sancte matris Ecclesie : ab hiis nostris temporibus vsq; ad finem seculi : Vna cum compilatione ex diuersis Prophetis noui ac veteris testamenti Theolosphori de Cusentia: presbyteri & heremite.

❡ Item explanatio figurata & pulchra in Apochalypsim de residuo statu Ecclesie: & de tribus veh venturis debitis semper adiectis textibus sacre scripture ac prophetarum.

❡ Item tractatus de antichristo magistri Ioannis Parisiensis ordinis predicatorum.

❡ Item tractatus de septem statibus Ecclesie deuoti Doctoris fratris Vbertini de Casali ordinis minorum.

❡ Item tabula alphabetica principalium materiarum.

❡ Item vita magni prophete Abbatis Ioachim.

Fig. 2.7.
Abbas Joachim magnus propheta (Venice, 1516). Title page. (Courtesy of the Beinecke Rare Book and Manuscript Library, Yale University.)

In 1009 the Muslim caliph Al-Hakim destroyed the Holy Sepulcher in Jerusalem, provoking an apocalyptic reaction in the West, including violent anti-Jewish outbursts.[89] This was the prime reason for the organization of the First Crusade.[90] With the coming of the Crusades, Jerusalem now became a specific historical place in the mind of western Europe rather than a symbol or paradigm.[91] If the Crusades did nothing else, they advanced the cause of cartography and the mapping of a widening sacred space. The visual imagination now had a more "scientific" focus on the captive city. These changes affecting the political situation of Jerusalem in the eleventh and twelfth centuries were bound to hold apocalyptic implications.[92]

When Pope Urban II called for the First Crusade in 1095, he spoke of the Holy City not simply as a place made forever illustrious by the advent, passion, and ascension of Christ but also as the navel of the world, the land fruitful above all others. Like a second paradise of delights, the royal city at the center was now held captive, demanding help and yearning for liberation. Reestablishment of a Christian kingdom of Jerusalem would be necessary to restore the proper typological relationship between the earthly and the heavenly cities, the real and the ideal Jerusalem. The Old Testament prophecies of Zechariah and the Psalms about the liberation of Jerusalem were literally coming true.[93] Such words would be repeated almost verbatim four centuries later by Christopher Columbus in his call for a last crusade (see below). In Mexico, that liberation would also be enacted and rehearsed in Nahua-Christian drama and in liturgy (see chap. 6).

During the Peoples' Crusade (1096), the monk Ekkehard of Aura witnessed signs that accompanied the pilgrims and presaged the apocalyptic moment, signs that would recur in sixteenth-century Spain and the New World. The victorious eschatological cross was seen hovering in the sky, and rumors circulated that Charlemagne had been resurrected.[94] Indeed, from the eleventh century on, Charlemagne appears at Christ's right hand in visual depictions of the Last Judgment with the prodigious cross.[95]

The liturgical-theatrical possibilities of these legends soon became apparent. The postmillennium period witnessed a continual development of the Last World Emperor legends, often associating them with specific individuals or dynasties. The French, English, and Germans were particularly susceptible to the lure of the myth as covertly referring to one of their own. During the Latin Kingdom of Jerusalem (1099–1187), the rulers used to lay down their crowns at the site of the Temple immediately after their coronation in the hope of being the long-awaited Last World Emperor.[96]

The legend was celebrated theatrically in the liturgical *Play of Antichrist*, composed sometime around 1160 in Germany.[97] It is the earliest of the Antichrist plays that were to proliferate in the following centuries and reappear, in modified

form, in the New World.[98] Drawing on the Sibylline books and psychomachian martial imagery, the play is as much a call to church reform as a political-eschatological prediction. As in the *Pseudo-Methodius* prophecy, a messianic thespian emperor travels to Jerusalem to confront Antichrist in company with a personified Ecclesia (Church). The emperor takes up residence in the rebuilt Jerusalem Temple and awaits the return of the victorious cross and Christ the Judge. As we shall see in subsequent chapters, the Temple of Jerusalem will become an important prop and scenographic convention in future dramatic performances on stage, easily copied in ephemeral materials or in more permanent ones like stone and mortar for the mendicant evangelization compounds.

The connection between the Heavenly City and the appearance of the victorious cross also reinforced the fact that the End Time was no mere abstract ideal, and it stimulated the desire *to see* the divine plan realized in geopolitical, topological, and architectural terms.[99] This was especially the case with the greatest "picture thinker" of the Middle Ages, Abbot Joachim of Fiore, whose images made their way across the Atlantic Ocean.[100] He was the guide adopted later by several mendicant friars in their reflections on the hidden identity and potential of the Amerindian Christians in the New World.

JOACHIM OF FIORE, PROPHET EXTRAORDINARE

Lucemi da lato
il Calabrese abate Gioacchino,
di spirito prophetico dotato.
　　—Dante Alighieri, *Paradiso*

Joachim was born about 1135 in Calabria, the son of a wealthy merchant.[101] After a pilgrimage to the Latin Kingdom of the Crusaders in the Holy Land, where he supposedly foresaw the fall of Jerusalem, he dedicated his life to the pursuit of God. For a time he lived as a hermit on the dangerous slopes of Mount Etna, which had recently erupted;[102] he then became a wandering preacher in his native Calabria before being ordained and entering the Benedictine monastery of Corazzo.

Joachim soon became abbot and during the 1180s was involved in a campaign to have his monastery incorporated into the stricter Cistercian order. It was during this time that he first came to the attention of Pope Lucius III, who encouraged him to write down his apocalyptic theories and to expound a mysterious prophecy attributed to the Sibyls that had recently come to light in Rome.[103]

In 1188 Joachim and his followers separated themselves from the monastery. By 1192 he had founded a new house at San Giovanni in Fiore, in the high Sila plateau, which was to be a new Zion in exile. Despite the remoteness of the new establishment, during the final decade of his life Joachim had numerous contacts with the great and powerful. Richard the Lionhearted, the Emperor Henry VI, the Empress Constance, Pope Innocent III, and the young Frederick II sought his advice and apocalyptic interpretations.[104] By the time of his death in 1202, Joachim was one of the most noted religious figures of his day.[105] He shared much with the Jewish and Christian apocalyptic prophets of the biblical period and identified himself with Ezekiel, the prophet of the Exile. A sense of immediately impending crisis provided the motive for the proclamation of his message from Revelation that "the sixth seal is about to be broken open" (fig. 2.7). A new migration of the sacred was underway.[106]

Joachim was a first-rate and original biblical exegete whose scriptural hermeneutic was based on a new distinction between allegory and typology or, as his *Book of Concordance* has it, between allegory and concordance.[107] These letter-to-letter similitudes and symmetries between Testaments were not used merely to understand the past—as in traditional scriptural allegory—but, far more daringly, to reveal the future. Joachim believed he could anticipate the future from the remembered past.[108] When printing was invented and Joachim's works were published by the mendicant friars (fig. 2.8), his thought and images became available to the New World missionaries and selected members of their native flock.[109]

The abbot's unique contribution is his use of the Trinity as the key to the meaning of world history.[110] Exegesis of Scripture reveals not only the grand plan of the two Testaments but also a scheme of three periods of time, which Joachim says are more properly called states (*status*).[111] These three states are complex, organic, progressive, and interlocking in character

Fig. 2.8.
Joachim of Fiore,
*Expositio magni prophete
Abbatis Ioachim in
Apocalipsim* (Venice,
1527). Title page.
(Courtesy of the
Biblioteca Lafragua,
Puebla.)

(figs. 2.9, 2.10). The first status began with Adam and lasted until Christ or, more specifically, until the announcement of John's birth to Zachary in the Temple. This first status—ascribed to God the Father—was the time of the order of the married folk. The second status overlapped the first. It started with King Josiah and the rededication of the Temple (2 Kings 23), began to bear fruit in Christ, and lasted until Joachim's century. It was credited to the Son and was the time of the order of clerics. The third status, the time of the monastic orders—when all Christendom will be a monastic community— was ascribed to the Holy Spirit. It began with Zerubbabel (the builder of the Second Temple), would make its appearance in the thirteenth century, and will bear fruit in the last age until the end of the world.[112] Thus, the Holy Land, the city founded by David, and its principal religious edifice, the Temple, are all imaginatively woven into the tripartite tapestry of history. In his exegesis of Revelation, Joachim explicitly identifies a Jerusalem with each of the three statuses, and in the third status the Temple will be rebuilt.[113] As this scheme illustrates, Joachim has been correctly described as a picture thinker, one whose mind moved according to the rich combinations of pictorial and symbolic thought rather than the clarity of discursive mentality (fig. 2.11).[114]

To understand the special way in which Joachim spelled out his millenarian hopes, one must remember that the abbot's life was a continuing search for the most perfect form of monastic life. A millennial-like earthly paradise and the cloister were synonymous with happiness.[115] For Joachim, history was the story of the gradual triumph of spirit over flesh, of contemplation over literal mindedness. This triumph was inseparable from the history of monasticism and the Church's constant struggle

to regain the apostolic life of the early church. The twelfth-century renaissance in the Church saw the creation of many experimental forms of the perfect life, both orthodox and heterodox. Successful as these reforms were, they were nostalgic attempts to revive a past golden age. For Joachim, on the other hand, the renewal of monasticism was to be a new eruption of the power of the Holy Spirit within history—a *renovatio* coming from the future age rather than from the past.

According to the abbot, there would be two stages in the more-perfect realizations of monastic life to come. First, during the imminent crisis of history, two new religious orders of spiritual men would arise to confront Antichrist and his forces: an order of preachers in the spirit of Elijah (symbolized by the color white), and an order of hermits in the spirit of Moses (symbolized by the color black).[116] Despite the vagueness of the abbot's descriptions of these orders, it would be hard for future generations not to see in his descriptions a prophecy of the two mendicant orders that were born in the decade after Joachim's death, the Franciscans and Dominicans.[117] They were also the first two orders to arrive in the New World.

For Joachim, however, the two orders would not be the final word in history's drive toward the perfect monastic utopia. That would come in a second moment of realization, when a monastic-like society would be a way of life for every Christian man, woman, and child: married, cleric, or vowed.[118] This is nowhere more evident than in Joachim's most famous drawing, *The New Order of the New People of God Pertaining to the Third Status after the Model of the Heavenly Jerusalem*, which is a rendering of an ideal monastery, thought out topographically and architecturally (fig. 2.12). It is a holistic society analogous to Joachim's idea of the early Christian community—brought about by a quasi-political process that, through history, would have to culminate in the peace and harmony of a new Jerusalem.[119] As we shall see in the next chapter, the physical arrangement of the monastic utopia indicates that Joachim had a material community in mind, not merely some spiritual or internal reality.[120]

Joachim also spoke of this ideal community of the third age as a group of "New Jews" or "New Israelites" who will be liberated from slavery to the material, corrupt world around them and will enter into the monastery-city as into a new Promised Land. The children of Israel who were in Egypt now signify the

Fig. 2.9.
Joachim of Fiore, *Expositio magni prophete Abbatis Ioachim in Apocalipsim*. Explanation of the three states. (Courtesy of the Biblioteca Lafragua, Puebla.)

Fig. 2.10.
Joachim of Fiore, *Expositio magni prophete Abbatis Ioachim in Apocalipsim*. The third state will begin "in the year 1260." (Courtesy of the Biblioteca Lafragua, Puebla.)

children of the Holy Spirit, led by a new Moses through the rugged places of the desert and brought to the serenity of the monasteries.[121] From these metaphors, his followers would identify Joachim as Joseph the patriarch, or Solomon the Temple builder, reinforcing the opinion of the monks that his monastery at Fiore was itself the beginning of the fulfillment of his eschatological prognostications.[122]

In Joachim's discussions of the roles of the religious orders to come, a crowning purpose was always global conversion.[123]

His biographer declared that Joachim and his band settled in Fiore so that the new fruit of the Holy Spirit might be announced in a "new Nazareth . . . until the Lord may work the greatest salvation on all the earth out of this."[124] The anonymous writer here repeats Joachim's prophecy that when the new monastic orders appear, the entire world will be drawn to conversion by twelve "New Israelites." This idea even took an architectural form. The first band of Joachim's men to arrive at Fiore erected twelve huts or booths,[125] suggestive of the Twelve

Fig. 2.11.
Joachim of Fiore,
*Expositio magni prophete
Abbatis Ioachim in
Apocalipsim.* The seven-
headed dragon of the
Apocalypse. (Courtesy
of the Biblioteca
Lafragua, Puebla.)

Fig. 2.12.
Joachim of Fiore,
Liber Figurarum.
"The New Order of
the New People of
God Pertaining to
the Third Status after
the Model of the
Heavenly Jerusalem."
(From Thompson,
"Reinterpretation
of Joachim of Fiore's
Dispositio Novi Ordinis,"
1982. Reproduced with
permission of the
editorial board of
Cîteaux: Comm. cist.)

Until now I have been attempting to paint the backdrop for the discussion of the sixteenth-century missionaries, their eschatological outlook, and the particular topographical and architectural form that the "enterprise of the Indies" took. But before I treat of them, it is still necessary to demonstrate the strong ideological ties between Joachim, the later mendicants, and a Third Order Franciscan layman named Christopher Columbus.

Tribes encamped around the Ark and the Tabernacle (Num. 2). In Joachim's numerology, twelve represented not only the perfect apostolic number but also the number of latter-day preachers who were to convert the world in the coming Age of the Spirit. As there had been twelve patriarchs to propagate the Torah in the First Testament, and twelve apostles in the New Testament, so in the Age of the Spirit there would arise groups of twelve to preach the Gospel and to convert gentile and Jew at the eschatological moment.[126] It would not be coincidental that the mendicant missionaries to the New World would also arrive in groups of "Twelve Apostles." They too would ask whether their new converts were not in fact the descendants of the Lost Tribes of Israel, convinced that after their conversion from false worship, the Indian neophytes would be capable of living a semi-monastic life as a *novus ordo Indianorum.*

THE SPIRITUAL SONS OF JOACHIM

The fulfillment of Joachim's prophecy of a third age of the spirit and of two new orders of spiritual men seemed to appear providentially in the thirteenth century when Francis of Assisi (1182–1226) and Dominic Guzman (1170–1221) began their own spiritual revolutions. By the time of these religious reformers, several pseudo-Joachite texts had appeared, and more would follow in the coming decades. Indeed, for the next several centuries prophetic texts concerning the Sibylline Oracles, the visions of Merlin about the Holy Grail, the return of the lost Jews, the Last World Emperor, the Second Charlemagne, the Angelic Pope, the Islamic menace, the proximity of

Antichrist, and the rediscovery of the terrestrial paradise were often attributed to the Calabrian abbot—and later applied to Charles V of Spain.[127]

Francis of Assisi began his religious career in 1205 as a church builder when he misinterpreted a voice from the cross of the Chapel of San Damiano: "Francis, my house is in ruins, go and repair it."[128] Later, he would understand his mission as one of repairing the institutional Church by a return to the ideals of strictest poverty and the imitation of the apostolic Church. As a spiritual architect, Francis was following in the line of other reformers like St. Bernard of Clairvaux (d. 1153), St. Anselm (d. 1158), and Joachim, who imagined their missions in terms of edification, often using biblical imagery of the Temple or the fortified castle of spiritual warfare.[129]

From about 1240, those in favor of the most rigorous observance of poverty within the Franciscan family began to make use of elements of the Joachite apocalyptic to further their cause. Many of the treatises ascribed to Joachim but written in the thirteenth century originated in Franciscan circles. A distinctive Franciscan Joachite apocalyptic was developing, one whose basic elements continued to influence the later Spirituals, the "Franciscan fundamentalists."[130] Both Franciscans and Dominicans looked forward to the defeat of the dreaded Last Enemy by a second Charlemagne and to the establishment of the contemplative Church of the Perfect in the third state (or seventh age) of history about to dawn.[131] More distinctive of the Franciscan version of this scenario were three subplots: the identification of the Franciscans and the Dominicans with the two groups of spiritual men prophesied by Joachim; the specification of radical poverty as the prophetic sign of the new spiritual men; and the belief that St. Francis was in reality the first of the "New Israelites"[132] and the Angel of the Sixth Seal of Revelation 7:2, whose advent had marked the beginning of the critical period of history, the third status.[133]

These hopes were shared in the highest circles of the order, as well as by the more radical friars who believed that the age of the Holy Spirit would arrive in the year 1260 (fig. 2.10),[134] and who made explicit the identification of Francis as the Angel of the Sixth Seal, who signs the elect on the forehead with the Tau cross.[135] Indeed, it is true that the apocalyptic Tau cross (see Ezek. 9:3–6) had been used by St. Francis as his per-

sonal signature on correspondence and that he had painted it on the wall of his cell.[136]

One radical friar, Gerardo da Borgo San Donnino, wrote *The Introduction to the Eternal Gospel*, which appeared in 1254 and was condemned the following year. His fanatical apocalyptic claims blurred any real distinction between Francis and Christ.[137] This "scandal of the Eternal Gospel" resulted in perpetual imprisonment for Gerardo and the resignation of the Franciscan father-general. His successor, the noted Parisian theologian St. Bonaventure, continued to use apocalyptic ideas in his theology of history, but always in a guarded way.[138]

Bonaventure saw the symbolic equation of Francis and the Angel of the Apocalypse and incorporated this interpretation into the official biography of the saint and into the liturgical hymns for Francis's feast, which made it safe for the orthodox.[139] But for Bonaventure, what marked Francis above all humans as an eschatological figure was his reception of the stigmata, which he had experienced while fasting in honor of his patron, St. Michael the dragon-slaying archangel (figs. 2.13 and 5.22).[140] This all-important event became for Bonaventure something that could be fully understood only in apocalyptic terms. The several references to Francis as the Angel of the Sixth Seal suggest that Bonaventure considered the stigmata—Francis's "seal of the living God"—to be a sign of the end of time.[141] As will be seen below, this same seal will take sculpted and painted form in the ubiquitous Franciscan symbols in Mexico, where they are more than just ideograms for the order.[142]

Far from minimizing Francis's End Time significance, Bonaventure institutionalized it and presented it in a way acceptable to the Church hierarchy. Bonaventure was a disguised Joachite who accepted Joachim's analysis of world history, and who believed in a glorious earthly age when Jerusalem would be restored and its Temple rebuilt, and in which the sons of Francis would play a key role.[143] In 1273 he wrote:

In the seventh age three events will take place: the rebuilding of the Temple, the restoration of the city [of Jerusalem], and the enjoyment of peace. Similarly, in the future seventh age, we will see the restoration of divine worship [in the Temple] and the rebuilding of the City. Now the prophecy of Ezekiel will be fulfilled, when the city will

Fig. 2.13.
A Joachite work, the *Floreto de Sant Francisco* (Seville, 1492).
Frontispiece. (Biblioteca Nacional de Madrid. Used with permission.)

descend from heaven; but not that city which is up there in heaven, *rather that which is down here on earth*, which is the City Militant.[144]

This City Militant, an earthly utopia, was also to take brick-and-mortar shape in colonial America in the fortress compounds of New Spain and in the priestly commonwealth proposed by Ezekiel that would be the model for the mendicants' dreamed-of theocracy (see chap. 3).

Throughout his career as minister-general, Bonaventure made a valiant attempt to preserve balance within the order, but the events following his death proved that the effort was in vain. In the late 1270s, groups of rigorists, whose defense of absolute poverty was buttressed by their apocalyptic understanding of history, soon came into conflict with the majority sentiment in the order.[145] Leading Spiritual Franciscans and their disciples reshaped Joachim's original teachings and combined them with other prophecies to address contemporary sociopolitical events. By the middle of the fourteenth century, a mosaic of prophetic sources had led the Spiritual Franciscans to a broader apocalypticism. This new apocalypticism emphasized events near an anticipated end of time that included the conversion of all the world (a missionary theme that Francis himself had foreshadowed in chap. 12 of his *Rule*), the recapture of Jerusalem, and the rule by a leader who would combine the powers of both church and state to prepare the way for the Second Coming.[146]

The thirteenth-century theorists of the Spiritual Franciscans—like Peter Olivi, Ubertino de Casale, and Angelo Clareno—popularized Joachim's world scheme, applying it specifically to their holy founder, Francis, and their order.[147] Other passionate Joachites—Arnold of Villanova, Johannes de Rupescissa, the Dominican Vincent Ferrer, and the Franciscan "Patriarch of Jerusalem," Francesc Eiximenis—were central to this development in Iberia.[148] They exercised extraordinary influence on Franciscans and on radical fringe groups.[149] The roots of the fifteenth-century Franciscan Observant Reform (the group that evangelized Mexico) are precisely to be found in the writings of these thirteenth- and fourteenth-century Franciscans.[150] Those texts were also being read by Christopher Columbus and the friars who would later travel to Mexico. In every one of them we encounter themes of the restoration

of Jerusalem and its Temple, a new golden age or solar age, and an earthly utopia.

Yet, Christians were not the only ones expecting an imminent inbreaking of God's reign on earth. There were Jewish messianic expectations for the year 1096 based on an interpretation of a verse from the prophet Jeremiah (31:7), and there is little doubt that such Jewish expectations were fueled by the Crusades.[151] Apocalyptic hopes were particularly evident in Spanish Jewish communities between the years 1250 and 1500.[152] A contemporary of Joachim of Fiore, the renowned Jewish scholar and physician Maimonides (Moses-ben-Maimon, 1135–1204), drew up plans for the rebuilding of the city of Jerusalem and its Temple in the hopes of a proximate arrival of the Messiah (fig. 4.16).[153] The Jewish Kabbala came to prominence at this time among Jews and Christians alike, especially in Renaissance Rome, where, in 1463, Pope Pius II (the Kabbalist Enea Silvio Piccolomini) issued the bull *Ezekielis* calling for a final holy war. In 1500 Pope Alexander VI repeated the call.[154]

These events were developing while voyages of exploration were underway and an interest in geography was growing in men like Pierre d'Ailly, bishop of Cambrai and faithful follower of the Joachite prophecies. Like many around him, d'Ailly believed that the Great Schism of the western Church was the preamble to the arrival of Antichrist. His geo-eschatological book, *The Image of the World* (1483), and his *Concordance of Astronomical Truth with Theology* were the two doors through which the eschatology of Joachim of Fiore illumined the enterprise of a maritime explorer with millennial and Franciscan leanings, Christopher Columbus.[155]

THE APOCALYPTIC NEW WORLD

FROM COLUMBUS TO THE TWELVE FRANCISCAN APOSTLES

> According to this calculation, only one hundred and
> fifty years are lacking for . . . the end of the world.
> I believe that the Lord is hastening these things.
> This evidence is the fact that the Gospel must now
> be proclaimed to so many lands in such short time.
> The Abbot Joachim, a Calabrian, said that the restorer
> of the House of Mount Zion would come out of Spain.
> —Christopher Columbus, *The Book of the Prophecies*

In the 1990s Christopher Columbus was deconstructed and dethroned as an heroic figure. Political correctness, as much as revisionist historiography, has made its mark; but this reappraisal has also allowed us the freedom to examine other, more mystical, aspects of the man. Until the twentieth century little attention was given to Columbus's religious nature. If anything, that aspect of his personality was carefully screened by historians to present him as the fearless mariner, the hard-headed seaman, who in classical, heroic fashion sailed the Sea of Darkness, thereby discrediting the religiously locked beliefs of fifteenth-century Europeans.[156] The reality is quite different. The Admiral of the Ocean Sea was saturated by the eschatological prophecies of the late Middle Ages and was well aware of the prophecies of Joachim of Fiore, and of the Spanish progeny of the Calabrian abbot.[157]

In 1501–2, after his third voyage to the New World, Columbus compiled a prophetic treatise addressed to King Ferdinand and Queen Isabella. The monarchs had been prepared for his apocalyptic thesis by Pope Innocent VIII, who had informed the queen in 1489 that the end was imminent.[158] The ambitious title of Columbus's work is *A book, or handbook, of sources, statements, opinions and prophecies on the subject of the recovery of God's Holy City and Mount Zion, and on the discovery and evangelization of the islands of the Indies and of all other peoples and nations.*[159] It is better known to us as *The Book of the Prophecies* and might be thought of as a resource manual because it is a truly masterful compilation of biblical texts, especially Revelation, and selections from every medieval historian and pundit on eschatology.[160] The invention of movable type had put the Scriptures

in the hands of knowledgeable laymen like Columbus, and his biblical comments were complied from the most modern scriptural exposition of the day, Nicholas of Lyra's illustrated *Postillae super totam Bibliam*.[161] (I shall have cause to return to Nicholas's work, which is an iconographic source for the historical and "scientific" depiction of the Jerusalem Temple devised at the end of the Middle Ages and available in New Spain.) It is no surprise, then, that Columbus, like Nicholas of Lyra, should begin his presentation with an explanation of the four senses of Scripture specifically related to the exemplum "Jerusalem": "The fourfold interpretation of Holy Scripture is clearly implicit in the word 'Jerusalem.' In a historical sense, it is the earthly city to which pilgrims travel. Allegorically, it indicates the Church in the world. Tropologically, Jerusalem is the soul of every believer. Anagogically, the word means the Heavenly Jerusalem, the celestial fatherland and kingdom."[162] This fourfold way of representing complex ideas will surface again in Mexico, even in liturgy and architecture.

Like Joachim of Fiore, Columbus calculates world history by studying the years between the completion and destruction of the first and second Temples, giving as the date of the end of the world the year 1656, that is, 155 years after the moment in which he was writing.[163] His eschatology in *The Book of the Prophecies* does not manifest a terrifying chiliastic nearness, but rather he uses the far-off date to urge the enormous task of global evangelization—a theme dear to his patroness Queen Isabella, and one that would certainly have won him papal approval. In light of his encounters with the Amerindians of the Caribbean, he quotes Nicholas of Lyra: "There is another preaching of the Gospel that is yet to take place, with such effectiveness that all the Gentiles will accept the faith of Christ; and this shall take place at the end of the age." Further, prefiguring what would later take place in Mexico, he quotes St. Augustine: "This God . . . is the one who foretold by his oracles, that all these other false gods . . . would be completely abandoned and that their temples, their idols and their altars would be overthrown."[164]

There is also something of a gothic novel in one detail of *The Book of the Prophecies*. In the third section,[165] entitled "Prophecies of the Future: The Last Days," and beginning with the words ABBAS IOACHIM in large letters, ten pages of the text have been expurgated immediately after a quotation from the Calabrian abbot. Why were they removed, and what did they address? The last person to have used the text before this section disappeared was the Dominican Bartolomé de Las Casas, the famous defender of the Amerindians. Whoever the culprit may have been, it seems that the expunged section was the most radical and most Joachite part of Columbus's conclusions.[166]

My interest here concerns the city of Jerusalem, the reconstruction of the Temple, and Columbus's certainty that he had discovered not only the west coast of Asia but, more important, the terrestrial paradise of Adam and Eve; these themes recur later in varied ways in the chronicles of the missionary friars in New Spain. In July of 1498 Columbus had stumbled on the powerful Orinoco River (Venezuela) and knew from its force that he had found a continent. Upon further exploration, he concluded that he had also arrived near the site of the biblical Eden. Medieval geography was quite certain that four rivers flowed from beneath the Tree of Life in paradise, and the Orinoco had to be one of them.[167] Eden could be found because it was perceived as a real location; eschatologically, however, it would not be discovered until near the end of time.[168] The admiral, knowing that he was directly opposite the globe from Jerusalem, reasoned that he had arrived near the highest part of the earth, where the Garden of Eden should be located. A few miles inland the entrance to the terrestrial paradise would be guarded by a dragon.[169]

Columbus had inherited this geo-eschatology from his reading of Pierre d'Ailly's *Image of the World*, and from his own illustrated copy of Bernhard von Breydenbach's *Pilgrimage to the Holy Land* (fig. 4.4),[170] as well as from medieval maps.[171] In a letter of 1502 to Pope Alexander VI, he described his voyages and stated, "I believed and I still believe what so many saints and holy theologians believed and still believe: that there in that region is the Terrestrial Paradise." In the same letter, he assured the pope that "this enterprise was undertaken with the objective of employing the profits from it in restoring the Holy Temple of the Holy Church."[172] Columbus reasoned that the Holy Land could be conquered in three years. In his last will and testament, dated February 22, 1498, he included a clause that would have a portion of the annual income from his estate deposited in the Bank of St. George in Genoa as a revolving

fund destined for financing a crusade of liberation of the Holy Sepulcher.[173] Columbus had his sights set on Jerusalem and was thinking of a new crusade to the Holy Land, as others had before him:[174]

> David, in his will, left three thousand quintals of Indian gold to Solomon, to assist in building the Temple; and, according to Josephus, it came from these lands. Jerusalem and Mount Zion are to be rebuilt by the hands of Christians; as God has declared by the mouth of his prophet in the fourteenth Psalm. The abbot Joachim said that he who should do this was to come from Spain; Saint Jerome showed the holy woman the way to accomplish it; and the Emperor of China has, for sometime since, sent for wise men to instruct him in the faith of Christ. Who will offer himself for this work? Should anyone do so, I pledge myself, in the name of God, to convey him safely thither.[175]

Columbus had the opportunity to accomplish this deed when, on his second voyage of discovery, he brought with him Fray Bernard Boyle and twelve additional priests and lay brothers.[176] The first Christian worship in the New World took place on January 6, 1494, the Feast of the Epiphany, at La Isabela, the ill-fated colony that Columbus founded on the north coast of Hispañola (present-day Haiti/Dominican Republic). The Epiphany had a great importance for the celebrants, not only because it was the feast of revelation to the Gentile and pagan world in which they had just landed, but also because Columbus was convinced that one of the Magi had come from that island.[177]

It appears that even his greed for gold was intertwined with his divine mission to facilitate a last crusade to liberate the Holy Land. For Columbus, gold and silver were sacred metals made holy by their divinely appointed use in the Temple's construction and accoutrements at Jerusalem. He stubbornly held to the belief that Solomon's mines would be discovered on the biblical islands of Tarshish, Ophir, Kittim, and Seba, which he believed he was then exploring.[178] The prophecy of Isaiah 60:7–23 would thus be literally fulfilled, and the Holy House of God in Jerusalem could be rebuilt.[179] More than once Columbus quotes the prophet Haggai (2:7–9): "I will shake all the nations, and the treasures of all the nations will come in, and I will fill this House with glory, says the Lord of hosts. Mine is the silver and mine the gold. Greater will be the future glory of this House [the Temple] than the former; and in this Place I will give peace."

After returning from his second voyage, Columbus began to appear on the streets of Seville dressed in sackcloth and cord as a Third Order Franciscan. He was buried in the Franciscan habit in 1506.[180] In keeping with his name, Christopher ("Christbearer"), he had often spoken of himself as divinely called to transport Christianity to the New World and to be the prophet of the Last Days.[181] "God made me the messenger of the New Heaven and the New Earth of which he spoke in the Apocalypse of St. John after having spoken of it through the mouth of Isaiah; and he showed me the spot where to find it."[182]

THE FINAL COLOSSUS OF HISTORY

Far from diminishing in intensity toward the end of the Middle Ages, apocalyptic expectations were on the rise and steadily increasing in their complexity and political implications. Spain was particularly influenced by prophetic utterances on these themes, and we may attribute this impetus to the continuing reflection on Joachim of Fiore's eschatological heritage.[183] Given the dissemination of the abbot's works after the invention of printing, it is safe to say that more people read him in the sixteenth century than in the three centuries before.[184] But Renaissance Rome was no less inebriated with prophecy soon after the prophetically charged year 1500.[185]

In the Eternal City, the Augustinian prior Giles of Viterbo espoused the Joachite cause. His sermon "On the Growth of the Church," delivered in St. Peter's Basilica in December of 1507, was devoted to the subject of Joachim's third status; he was encouraged by the recent geographic conquests of the Spanish and the Portuguese.[186] Nine years later, the Augustinians began publishing the collected works of Joachim of Fiore at Venice.[187] Giles fostered the publication of another Joachite work in 1527, the *Commentary on the Apocalypse* (fig. 2.8).[188] His personal library contained the manuscript of Joachim's commentary on Isaiah, and his own works were overtly influenced by Kabbalistic studies.[189] Further, he has been suggested as the

Fig. 2.14.
Holy Roman Emperor,
Charles V of Spain.
Miniature from the
scroll *Genealogia
illustrisime domus Austrie*
(1536). (Courtesy of
the Biblioteca Nacional
de Madrid, Res. 265.)

genius who designed the program for the Sistine Chapel ceiling (1507–8) with its muscular Sibylline prophetesses.[190]

Giles was vicar general to Pope Julius II, and it was he whose address opened the Fifth Lateran Council (1512–17), which was itself concerned with the prophetic signs of the times.[191] In his inaugural speech, he reminded the councillor fathers that for the past twenty years he had traversed Italy to explain to the faithful the message of St. John's Revelation, namely, that the current agitation in the Church would soon lead to its correction. In his work *The Shekinah*, Giles provided a list of prophetic proofs of the impending crisis. One was the rediscovery of the ancient language of Christ, Aramaic, into which the Bible had recently been translated in Spain (Cisneros's *Polyglot Bible*) and which would be used to communicate with the Lord upon his Second Coming.[192] A second proof was a marvelous sign newly seen in the night sky by navigators who had traversed the equator: the quincunx stellar constellation that we know as the Southern Cross—in Giles's words, the beginning of the "new heaven and the new earth."[193]

But other preachers, like the popular Fray Serafino da Fermo, were less optimistic and were warning the populace of an approaching peril: "So that we may recognize that the hour [of Antichrist] is approaching, several years ago God permitted the discovery of the New World. . . . Read what Joachim [of Fiore], Ubertino [da Casale] and many others have written in this respect, and the whole of it will become clear, because all that they prophesied for this time we now see to have been fulfilled."[194]

Meanwhile, Erasmus of Rotterdam was calling for church reform, Martin Luther was demanding it, and Sir Thomas More was designing a perfect society in his *Utopia* (1516), locating the mythical isle somewhere in the New World. In a premonition of the convergence that would happen in New Spain, More states that the sun-worshipping residents of his Utopia accepted the Christian faith "because *Christianity is very like the religion already prevailing among them*, they were very well disposed toward it from the start."[195] Later, Bishop Vasco de Quiroga of Michoacán, a devotee of More, proposed that the life of the Indian communities in the New World be organized in ac-

cord with the rules of the island of Utopia as conceived by the English humanist.[196]

Back in Spain, political turmoil and civil war were developing in the form of the *Communes* of an egalitarian millennialism that was surfacing in reaction to an economic crisis caused by hunger, pestilence, and bloodshed.[197] The second decade of the sixteenth century was thus a time of eschatological fever pitch in Spain and in Rome. In the Spanish Netherlands, a new "Charles the Great" had been born at Bruges in the apocalyptic year 1500, the half-century of the millennium—certainly a portentous sign! In 1514 the teenage Prince Charles, grandson of the Holy Roman Emperor Maximillian I of Austria, was bequeathed the Netherlands as his royal domain and took possession in a series of royal visits. The cities of Brussels, Louvain, Antwerp, and Ghent received him with mystery plays, pageants, and civic parades; but it was the town of Bruges—a "new Jerusalem," as we shall see below—that outdid the others in celebrating the future emperor in stage plays and liturgy as a messiah, a new David, and a new Solomon.[198]

In 1519 Charles was elected to succeed his grandfather as the Holy Roman Emperor and the Hapsburg-Burgundian successor to Ferdinand and Isabella. He was also chosen to be the Grand Master of the elite Order of the Golden Fleece, from which, according to popular belief, the leader of the Final Crusade would come.[199] Around the period of the imperial election, and the subsequent coronation as emperor-elect at Aachen in 1520, the prophecies gathered thickly. "Possessed of the title Holy Roman Emperor, of a domain which exceeded that of ancient Rome, surrounded by imperial rhetoric and attired in imperial regalia, Charles V was perceived as the individual towards whom the history of Revelation had been pointing for more than a millennium."[200]

As the new Caesar rode in triumph into Aachen for his coronation, he was greeted at the city gates by clerics bearing a reliquary chest with the head of his spiritual forebearer, Charlemagne.[201] He was further celebrated as the progeny of Constantine, a living icon of Christ, a new sun, a new messiah for a Christendom *in extremis*, a good shepherd, the sanctified Last World Emperor, and the prophesied New Charlemagne (*Karolus redivivus*).[202] Just as Charlemagne had been crowned the first Holy Roman Emperor and was the first to beat back the Muslim

menace, so too this "last Charles" would bring final victory and recover what Christians had lost to Islam in the Holy Land. According to the Sibylline prophecies and their medieval accretions, the emperor would have to travel to Jerusalem as his last deed to cooperate there with the plan of Divine Providence. This messianic identity was made graphically real by the coronation and anointing liturgy at Aachen that proclaimed Charles to be, like Melchisedek and Christ his archetypes, both priest and king (fig. 2.14). On his head he wore three crowns or, more precisely, two regal crowns and a bishop's miter turned sideward. Like David he was to be a visionary king, and like Solomon he was to be a wise king; but the sideward miter identified him as standing in a sacerdotal line—that of the high priest of the Temple of Jerusalem.[203] The imperial crown will later appear in stone in New Spain on the posas at Calpan, Puebla (see chap. 5).

In 1526 Emperor Charles V appointed to his council of state "seven angelic advisers" like the seven angels of Revelation, inspired by his reading of a recently discovered *New Apocalypse*.[204] Religious art commissioned for Charles graphically displayed the portentous themes, and in chapter 6 we shall see that theatrical productions and stage sets also made these themes visible.[205] So dense was the eschatological atmosphere in Spain that even the sack of Rome in 1527 by the imperial armies was seen as a prophetic event. It dramatically fulfilled the prophecies of the King-Chastiser, another role of the Second Charlemagne.[206]

In this same period, signs and portents were seen on the Iberian Peninsula. During the crusade to North Africa (1509) organized by the reforming Franciscan Observant cardinal Francisco Ximénez de Cisneros, a cross appeared several times in the sky, a cross whose Five Wounds were flames of fire. Cisneros hoped to reverse the Muslim conquest of seven centuries earlier, sweep across North Africa, and regain the Holy Land.[207] Once the victory was won, he promised to celebrate Mass in the Holy Sepulcher and there give communion to the monarchs who would assist in the enterprise.[208] As early as 1498, Cisneros had achieved a highly successful reformation of the clergy. As part of his reforms, he suppressed the Conventual Franciscans and elevated the status of the Observants, the group that would soon evangelize New Spain.[209]

In 1517 other signs and portents appeared in Castile, just as Franciscan missionaries were leaving for the New World,[210] and many of the prophetic myths that later appeared in Mexico were first part of the religious lore of the mother country.[211] The second decade of the sixteenth century was indeed afire with eschatological expectations. By chance or by fate, it was also the decade in which the Amerindians of central Mexico discovered Europeans invading their shores, soon to bring an apocalyptic catastrophe upon the native population and usher in the end of the world as they knew it (fig. 2.15).

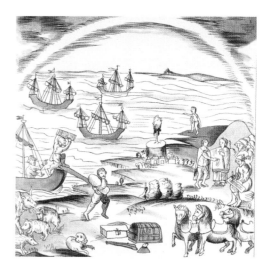

AZTEC TIME AND ESCHATOLOGY

In the year 13 Reed, so they say, it first appeared.
The sun that now exists was born then.
This is the fifth sun, its date-sign is 4 movement.
It is called Movement Sun because on that day it began
 to move.
The old people say that in this age earthquakes will occur
and there will come starvation and we shall perish.
 —*Annals of Cuauhtitlan*

One of several areas of human experience where natives and Christians displayed affinities within their differences was in their calculation of time. Like Christians with their lineal and cyclical-liturgical calendars, Mesoamericans had a dual system of time. Both Christians and Amerindians began their year count from a moment of creation, an *annus mundi*, and both feared chaos and saw it as a sign or cause of the End.[212]

Aztec religion was, in large measure, based on anxiety about the passage of time. One could say that the Aztecs were obsessed with it. The destructive aspect of nature particularly troubled them, and their need for temporal control is evident in their calendar systems. The Aztecs developed sophisticated means for the computation of days, years, and cycles, and for

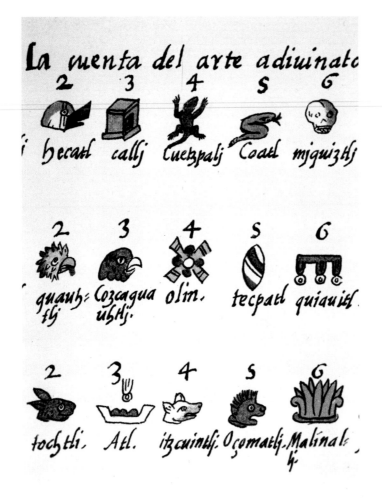

Fig. 2.16.
The *Florentine Codex*,
book 4. The Aztec
calendar. At the center
is the sign for 4 Ollin.
(From Sahagún,
*Historia General de
las cosas*, ed. Paso y
Troncoso, 1905.)

an era (not unlike Joachim of Fiore's status), at the end of which cataclysms might occur if sacrifices were not performed. Ritually this meant that creation needed to be reinvigorated in the New Fire ceremony held in the fifty-second year at the holy city of Teotihuacán (fig. 5.39).[214]

Aztec world history was divided into five eras or "suns," epochs of both world creation and world destruction.[215] Indeed, this solar root metaphor was so fundamental that the Aztecs thought of themselves as "the People of the Sun."[216] Each of the first four "suns" had been governed by one deity, and each had ended with the destruction of the element or phenomenon after which it had been named. For example, the fourth or penultimate sun, called Water, had ended in a gigantic deluge; only one man and one woman survived, sheltered in a huge cypress tree—a story reminiscent to Euro-Christian ears of the biblical tales of Adam and Eve and Noah's flood.[217]

The Aztecs believed themselves to be living in the era of the fifth and last sun, which had been created by Tezcatlipoca and Quetzalcóatl through autosacrifice at the pyramid temple of the sun in the sacred city of Teotihuacán.[218] This hagiopolis, located some forty kilometers northeast of Tenochtitlán (Mexico City), was the place where time began. Like all the other gods, the sun had a date name, 4 Ollin, which corresponded to the day he had been born and therefore represented his destiny. This fifth era was also called Ollin, or "Movement," and was related to the earthquakes by which the Aztec world would be annihilated. In other versions, the fifth age would end in fire, not unlike Christian versions of the apocalyptic end.[219]

Ollin was visually represented as a quincunx glyph in the form of a butterfly or, to European eyes, a sign similar to the Latin letter X or to St. Andrew's cross (fig. 2.16).[220] This glyph sign continued to be used in other contexts in the hybrid art of the Indo-Christian constructions.[221] As in legends related to Jesus Christ, the calendric date on which the Aztec sun god was born was also the date on which he would die.[222] This doomsday scenario of the extinction of the fifth sun would be the final end, when the powers of chaos and nothingness would win out.

Meanwhile, like a living body, the cosmic heart of the fifth age had to be fed if its life were to continue, and its sustenance was human blood (fig. 2.17). Humans were transformed into food for the "cosmic jaws" of the sun. This act, via a continu-

the anticipation of astronomical phenomena. They had two calendars which, when combined, formed a third one.

The first calendar, the *Xihuitl* or natural year calendar, was used to measure the agricultural year; it provided the basis on which the Aztecs performed their seasonal rituals to various gods. A second calendar, the *Tonalpohualli*, was a specifically religious-liturgical calendar with strong apocalyptic overtones. Based on a combination of number and sign systems, it also determined the fate of each individual by date of birth. The profane *Xihuitl* and the liturgical *Tonalpohualli* calendars were combined, or intermeshed like the gears of a machine, to form a third calendar, the *Xiuhmolpilli* or "bundle of years." This calendar round had a cycle of fifty-two solar years, the time needed for the two previous calendars to have coincident beginnings.[213] Each period of fifty-two years was considered

ally creative process of feasting, transformed the otherwise inevitable cosmic death by starvation into cosmic life.[223]

But there would be no sixth era or sun; hence, unlike Christian optimism for an eternity with God, there was an implicit finality within the Aztec cycle of creations and destructions. Even postdeath existence in the celestial Omeyocan or in the underworld Mictlán would eventually end in personal annihilation. In words suspiciously reminiscent of late medieval Christian apocalyptic, Fray Bernardino de Sahagún quotes his Nahua informants to the effect that this will occur "when the earth has become so tired, when already it is all, when already it is so, when the seed of earth has ended."[224] Time grows old and gets tired. For the Mexica, history—both personal and collective—will be no more. Did the encounter with Christian Europeans change that sense of fate?

First Contacts

> The greatest thing since the creation of the world, save the Incarnation and death of Him who created it, is the discovery of the Indies that are thus called the New World.
> —López de Gómara, 1551

The political conquest of Mexico began when Hernán Cortés, the conquistador, set out with his party from the port of Trinidad in Cuba and landed on the Gulf coast of Mexico on Good Friday, April 21, 1519. There he enacted a ritualized taking of possession and, in the name of Spain, founded the Rich City of the True Cross (la Villa Rica de la Vera Cruz) as a Spanish Jerusalem. Cortés's inland march of conquest, his alliances with rival tribes, and his territorial claims for Spain culminated in his arrival at the Aztec capital and hagiopolis of Tenochtitlán in November of the same year. The tragic story of the massacre of the indigenous population by the Spaniards and their Indian allies is one of the saddest and most shameful events of the colonization of the Americas.[225] The fact that the conquistadors and their Tlaxcalan allies carried the flag of the Holy Spirit into battle (fig. 2.18) suggests that they believed they were initiating Joachim's final age of world history.

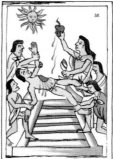

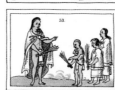
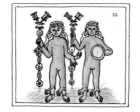
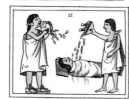

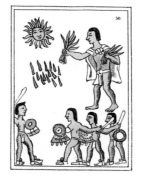

Fig. 2.17. The *Florentine Codex*, book 2. Scenes of heart sacrifice (52), warrior eagle knights (54), and Xipe Totec impersonators (55). (From Sahagún, *Historia General de las cosas*, ed. Paso y Troncoso, 1905.)

Fig. 2.18. *Codex Azcatitlan*, last third of the sixteenth century. Battle scene in Tenochtitlán and the death of Moctezuma. The Tlaxcalan sympathizers carry the banner of the dove of the Holy Spirit. Note the European-style arcade at the rear. (Bibliothèque Nationale de France, Collection Aubin, MS Mexicain 59–64. Used with permission.)

After the fall of Tenochtitlán, it seemed to the natives that the ominous approach of disaster had been insistently foretold by signs that had begun to appear a decade earlier. A comet described as a "bleeding wound in the sky," a fire in the temple of Huitzilopochtli, unusual winds, lightning strikes, lake water that appeared to be boiling, the appearance of two-headed people, a woman wailing in the darkness, a strange bird with a mirror on its head that displayed the images of foreign warriors, and other harbingers foretold some imminent, unparalleled catastrophe.[226] Like medieval Christians who had read *The Fifteen Signs before Doomsday* and been attentive to cosmic portents even in retrospect, the Nahuas recognized that the world around them had been testifying to the fifth sun's demise.[227]

Meanwhile, the new political and religious realities began to unfold. Cortés soon realized the need for a methodical evangelization enterprise, and he initiated negotiations with Emperor Charles V and Pope Adrian VI. In a letter to both, he requested that mendicant friars be sent to accomplish the herculean task. Cortés indicated that the Spanish emperor should ask the pope to give the religious of St. Francis and St. Dominic the widest possible powers so that they might administer the sacraments.[228] The emperor responded favorably by appointing the respected Franciscan provincial Fray Martín de Valencia— a "living link between millennial dreams and evangelization"— to lead the party of twelve to the New World.[229] The group was chosen from the province of Extremadura, Cortés's home and a noted center of Franciscan reform with an unusually strict emphasis on austerity and poverty. There, earlier friars had trained to convert the Moors after the reconquest of the Iberian Peninsula.[230]

Amid extraordinary ceremony, Fray Martín de Valencia and his companions were commissioned by the missionary-minded minister-general, Fray Francisco de los Angeles Quiñones, on January 25, 1524, the Feast of the Conversion of the Apostle Paul.[231] Earlier missionaries to the Americas had traveled there surreptitiously to escape the wrath of the Inquisition, but these friars were now sent by official papal and imperial commission.[232] The wording of the minister-general's missionary charge reflects his eschatological perspicacity and calls attention to the urgency of the apostolate in the final age of world history.

For, indeed, the bounty of the Eternal Father chose the same seraphic standard-bearer of Christ [St. Francis] to exalt the glory of His name and procure the salvation of souls, and to forestall the ruin threatened the Church. . . . But now that *the day is far spent and passing away*, which is the *eleventh hour* of which the Gospel speaks, you are called by the head of the household to go forth into his vineyard; not hired for a price like the others, but rather like true sons of such a father. . . . And therefore, my sons, *with the very end of the world at hand . . .* take up the victorious contest of the heavenly Champion, preach by word and work . . . and hurry now to the active life.[233]

To further emphasize their evangelical mission, the father-general christened the new American jurisdiction the "Custody of the Holy Gospel." There, in a New World untouched by the corruption of the Old, dreams of the *renovatio ecclesiae* could become a reality through an "Indian Church." In a pristine land, among a *genus angelicus*, apocalyptic hopes could flourish just as Joachim of Fiore had prophesied.

Fray Toribio de Motolinía wrote just such a naive account of the native population in his *History of the Indians of New Spain*, where he pictured them as natural practitioners of Franciscan apostolic poverty.[234] Because he believed that the Indian character closely resembled the nature of believers during the apostolic age of the Church, and because the Indians appeared to receive the Gospel message so eagerly, he was sure that their conversion had eschatological significance.[235] "Everywhere on this round earth the name of God must be glorified, praised and extolled, and just as the name of God flourished at the beginning of the Church in the East, which is the beginning of the earth, so now, *at the end of the ages*, it must flourish in the West, which is the end of the earth."[236]

Motolinía exhorted Emperor Charles V to hurry the missionary process so that he might rightfully assume his royal role as the leader of Christ's worldwide kingdom. "What I ask of Your Majesty is [that you initiate] the fifth kingdom of Jesus Christ which must spread over the whole earth, of which Your Majesty is the lord and captain."[237] The fifth kingdom was Joachim of Fiore's third age of the Holy Spirit, as synchronized with the book of Revelation's seven acts or mythic scenes.[238]

Motolonía's disciple, the chronicler Fray Gerónimo de Mendieta (1525–1604), agreed that the Spanish king had been given uncommon powers on earth but also the concurrent dire obligation to carry out missionary work in the New World because "the world is in its eleventh hour."[239] Mendieta can be considered responsible for the most overt, though not the only, mystical interpretation of the discovery and missionary enterprise.[240] His *History of the Indian Church*, written between 1562 and 1596 but unpublished until the nineteenth century, was circulated in manuscript form in mendicant communities in Mexico and Peru.[241] Using the millennial prophecy of Joachim of Fiore and the biblical exegesis of Nicholas of Lyra, Mendieta developed an eschatological interpretation of the discovery, evangelization, and destructive plagues of the Indian church. I shall return to it below.

The Dominican Bartolomé de Las Casas, although embroiled more in matters of human rights in the Americas, also held to a belief in a proximate end (of about one hundred years). He decreed that his *History of the Indies*, although completed in 1559, should not be published before the year 1600 so as not to alarm Christendom or incur the wrath of the Inquisition.[242]

Even more direct than Mendieta or Las Casas is the catechism of the Third Council of Lima (1583), which proposed that the discovery of the Americas was itself an eschatological sign. Its words are reminiscent of those of the ancient Aztecs (as recorded by Bernardino de Sahagún), who thought of the world as growing old and tired.

> This world was born as a child when God created it from nothing. It has passed through many years, more than 6000, and diverse ages. *Now it is old and it gives signs of wanting to end*. But before coming to its end, the Gospel must be preached to all nations throughout the globe . . . and for this reason Holy Wisdom ordained that these remote lands be discovered, . . . and when the Gospel has been preached in all the world, then the End will indeed come.[243]

This belief—that the conversion of the Amerindians was the sign of the approaching End Time—was shared by European theologians as well, and by those about to depart for the New World.[244]

Fig. 2.19. Diego Muñoz Camargo, *Descripción de la Ciudad y Provincia de Tlaxcala*. The arrival of the twelve Franciscan apostles and the planting of the first cross. (Courtesy of the Glasgow University Library, Department of Special Collections, MS Hunter 242.)

The Advent of the Twelve

On January 25, 1524, the Feast of the Conversion of St. Paul, the twelve Observant Franciscans set sail for their missionary destination. They landed on the Mesoamerican coast, significantly enough on the vigil of Pentecost Sunday, in May of that year. The "Twelve Apostles," as they styled themselves (ten priests and two lay brothers), arrived in Mexico City the following month (figs. 1.31 and 2.19). Before leaving Spain, they had received a reminder from Minister-General Quiñones to hurry the evangelization because the world was growing old.[245]

This latter-day apostolic consciousness was also shared by the Dominicans and the Augustinians. The former arrived in Mexico on June 24, 1526, the Feast of John the Baptist, precursor of Christ's first advent and the saint who will sit with him at the Last Judgment.[246] Like the Franciscan apostles, the Dominicans also numbered twelve in their advent.[247] The Augustinians, who were the last of the mendicants to arrive,

landed at Veracruz on May 22, 1533, which was the highly eschatological Feast of Corpus Christi (see chap. 5). Unlike the Franciscans and Dominicans, their chosen number was seven, but we should not doubt that they had a rich symbolic reason for choosing such a biblical figure—relating themselves to the seven angels of the Apocalypse.[248]

These beginnings were quite modest. There were too few workers for such an abundant harvest, but the number of missionaries increased rapidly. Every year the vacancies caused by death or by returns to Europe were filled by a fresh contingent. At mid-century, the "second generation" of friars and their Indian converts were frenetically advancing the work of evangelization and church building. By 1559 the Franciscans could boast of 80 convents and 380 religious (priests and lay brothers). The Dominicans had 40 convents and 210 religious, while the Augustinians also had 40 convents and 212 religious.[249]

Indian Jews of the Last Days

These are the ten tribes which were led away from their own land into captivity in the days of King Hoshea, whom Shalmeneser the king of the Assyrians led captive. He took them across the river, and they were taken into another land. But they formed this plan for themselves: that they would leave the multitude of the nations and go to an even more distant region.

—2 Esdras 13:40–41

In light of the prophecies regarding Jerusalem and the Temple, it should come as no surprise that several of the chroniclers of the New World, especially those with millennial leanings, would hold to a doctrine of a Jewish origin of the Amerindians. They argued that the Indians had to be descended from the lost ten tribes of Israel (c. 772 BCE) who would return at the end of time.[250] As Delno West noticed,

This theory, of course, not only strengthened the legal position of the native population, it fed new fuel to the glowing embers of apocalypticism as it made God's people re-

vealed near the end of time whose salvation would herald the consummation of history. The exploration of Yucatán offered visible proof to back up this seductive thesis. Yucatán sounded too much like the mysterious biblical land of "Jortan" and its natives' religious practices incorporated several Jewish-like rituals such as circumcision. . . .[251]

Early observers in the New World emphasized numerous analogies between Amerindians and Jews based on character, ceremonials, customs, dress, sacrifice, or similar practices that were held to apply to the newly encountered peoples in general.[252] The friars discovered that, like Jews in the time of Christ, an Aztec widow was required to marry her brother-in-law, who raised the children in the name of the deceased.[253] Further, the Aztec laity was called to temple sacrifices by the sound of conch-shell trumpets, as the faithful had been called to sacrifices in the Jerusalem Temple by the ram's horn or silver trumpets.[254] And some of the Aztec holocaust sacrifices involved the immolation of animals, as in the days before the Temple was destroyed by the Romans.[255]

The earliest demonstration of the Hebrew origin of the Amerindians was written by one of the Twelve, Fray Andrés de Olmos, a scholar and professional exorcist,[256] but the most scholarly account is by the Dominican friar Gregorio García. Compiling an impressive list of sources and proof texts, in 1607 García produced the lengthy *Origin of the Indians of the New World and the West Indies*, in which he detailed the Hebraic origins of the Indians and the possibility of an apostolic mission before the arrival of the Franciscans.[257] The discussion of a previous apostolic mission was important owing to the confusion surrounding the Aztec legend of Quetzalcóatl. This legend of the man-god who had been banished to the east for resisting human sacrifice had led some to believe that St. Thomas the Apostle had preached the Gospel to the Indians centuries before but that, over such a long period of time outside the mainstream of Christianity, Thomas's message had been debased.[258] Numerous Aztec and Mayan practices seemed to indicate that a perverted, and therefore heretical, form of Judeo-Christianity was still extant in sixteenth-century Mesoamerica.

But the Jewish identity may not have been seen only as a question of origins. As we saw in the previous section, early

writers like Commodianus held that Christ would someday return at the head, not of angelic hosts, but of a holy remnant of Hebrews, the descendents of the Lost Tribes (fig. 2.20). Indeed, some friars, like Gerónimo de Mendieta and the author of the catechetical play *The Conquest of Jerusalem,* seem to have held messianic expectations for this sanctified Nahua people in hopes of Church renewal and the final liberation of the Holy Land.[259] Motolinía and Mendieta established a number of correspondences between the history and geography of the land of Israel and that of New Spain. They seem to have taken this mythical geography as something more than a metaphor: Mexico too had its Bethlehem, its river Jordan, and its Sea of Galilee.[260] Moreover, just as Moses had liberated the Jews from slavery in Egypt, Cortés had liberated the Aztecs from idolatry. The Spanish conquest had therefore converted the valley of Mexico into the Promised Land, a new Canaan; and the subsequent arrival in Tenochtitlán of the twelve Franciscan missionaries had converted it into another Jerusalem.[261] Toward the end of the century, looking back pessimistically on the work of his confreres in New Spain, Mendieta was forced to mourn the passing of the golden age of the evangelization under Emperor Charles V and the growing tarnish of the silver age under Charles's son Philip II.[262] Like another Jeremiah weeping over Zion, Mendieta laments the destruction of the spiritual enterprise of the Indies—the New World Jerusalem.[263]

One of the most fascinating outcomes of the discovery of these peoples of America was the interest that it raised among European Jews. In 1566 Yoseph ben Yeoshua Hacoen, a descendant of Jews exiled from Spain, translated into Hebrew the chronicle of the conquest of Mexico by Francisco Lopez de Gómara as *Sefer Halindia Hachadasha Ha-Sefaradit VehaPiru* and *Sefer Francisco Corteiz.*[264] In addition to their historical interest, the texts represent a valuable resource reflecting Jewish curiosity about the New World and the possibility of finding kith and kin among the Lost Tribes.

THE ICONOGRAPHY OF PUNISHMENT AND REWARD

But the identifying of Hebraic origins or crypto-Judaism was not the prime concern of the friars. Rather, their biggest anxiety

was the natives' behavior and practices, which alarmed them immensely. A constant preoccupation of the missionaries was the morality—or as they saw it, the immorality—of their new flock. Once human sacrifice and ritual cannibalism were erased, there still remained the vices of polygamy, inebriation, occult idolatry, and sexual sins—some of which they blamed on eating too much chili and other spicy foods![265] One of the fundamental

Fig. 2.20.
Benedictus Arias Montanus,
Biblia Poliglota (Antwerp,
1569–72), vol. 8. World
map depicting the dispersal
of the tribes. (Terra Sancta
Arts, Ltd., Tel Aviv.)

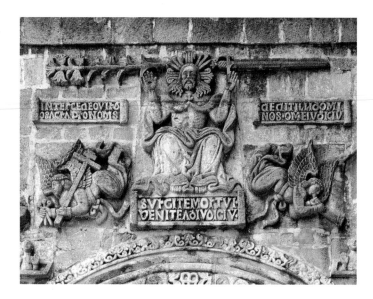

Fig. 2.21.
Calpan, Puebla. Detail of the carving on the southwest posa, east side. Enthroned Christ of the Last Judgment. (Photo by author.)

Fig. 2.22.
Calpan, Puebla. Detail of the carving on the southwest posa, north side. St. Michael the Archangel and the devil. (Photo by author.)

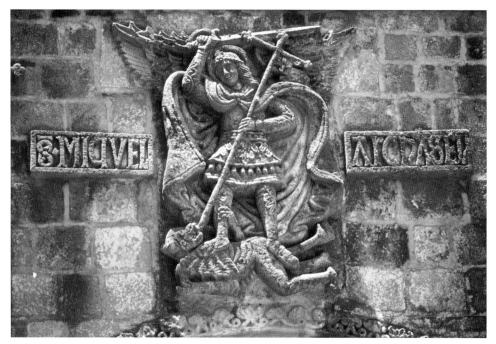

was substituted for the Christian "hell" in Náhuatl liturgical texts. For example, at the Last Judgment St. Michael the Archangel hurls the damned into Mictlán in Fray Bernardino de Sahagún's *Gospel Book*.[267] Although Aztec belief recognized that transgressions of established behavior led to cosmic and societal imbalance, such transgressions were thought to be the result of outside causality, either that of the gods or of chance, and personal responsibility and its eternal consequences were unknown.

Evidence of this eschatological concern not only to educate the Amerindians but also to warn them of the approaching End Time and the agents of Satan is seen in the catechism by the Franciscan Maturino Gilberti in the Tarascan language of Michoacán (1559).[268] Fray Maturino begins his treatise with a preface, directed to Viceroy Luis de Velasco, in which he declares that they are living in the final days of the world.[269] Then he spends a large part of a relatively short catechism in speaking of Antichrist and how to detect his presence when he appears. According to the friar, Antichrist will be preceded by the advent of two witnesses, whom he will murder.[270] After that, he will ascend to heaven from the Mount of Olives aided by Jews and Muslims, but he will be defeated in mid-air at the hands of Michael the Archangel, and as we saw in the medieval Sibylline Oracles, the gleaming cross and the *arma Christi* will return to herald the victorious End.[271] The trumpet will sound and Michael will announce: "Arise you dead and come to judgment! (*Surgite mortui venite ad iudicium!*),[272] whereupon the Final Judgment will commence in the Valley of Jehoshaphat (fig. 2.21).[273] Gilberti follows this central section of the catechism with another chapter dedicated to the powerful St. Michael, and then a section on the three ages of the world, similar to Joachim of Fiore's theories.[274] We have to ask ourselves why the author would devote so much time and attention to the minutia of Antichrist and Michael the Archangel in a prebaptismal catechesis. It seems that there is no reason other than the fact that the End was soon expected.[275] Viceroy Velasco, together with four theologians and linguistic experts, gave written approval to Gilberti's work. Just about the time he was writing, the macho archangel St. Michael was being honored in sculpture, murals, and festivities, and lending his name and protection to some of the most im-

problems surrounding the evangelization of New Spain was to convince the Indian neophytes that the afterlife was conditional upon earthly existence and moral conduct, a concept very different from pre-Hispanic beliefs. The Aztecs did have a conception of Mictlán as a dark, smelly place, which prepared them somewhat for the "sulfur and fire" of the Christian inferno.[266] The word was recycled during the evangelization and

pressive New World monuments, like Huejotzingo and Ixmiquilpan (fig. 2.22).[276]

The concern to teach the four "last things" (death, judgment, heaven, and hell) was common among medieval Christians, but these concepts needed to be presented graphically for the Indians.[277] One means of teaching the new morality was through the visual arts, by means of which the reality of the Christian heaven and hell could be demonstrated to the witness of the eyes. The most common way to "prove" the Christian concept was by depicting biblical images of the original Fall and of Christ's return in judgment, with the resulting rewards or punishments in an eternal heaven or hell (fig. 2.23). Prudentius's *Psychomachia* also served this purpose admirably in light of the never-ending spiritual war of virtue and vice. Indeed, mendicant literature of the sixteenth century is full of examples linking pre-Contact worship with the idolatry and heterodoxy of Muslims and heretics on the Iberian Peninsula. Was the Bible not filled with condemnations of false solar worship and ritual cannibalism (Ezek. 5:10, 8:16) and the cult of plumed and slithering animals (Deut. 4:15–24, Ezek. 8:10), which seemed like eyewitness accounts of Aztec devotions proleptically written ages ago (fig. I.2)? Did the Scriptures not assert that when Jerusalem was reconstructed, the pagans would be converted and forsake their idolatry (Tob. 14:6)? Hence—in the friars' minds—the need for a constant spiritual crusade to extirpate the demonic practices and to safeguard the neophytes for the kingdom of Christ.[278] Iconography reinforced this war of good against evil with the plethora of warrior angels seen on posas, on church façades, and in murals.[279] And talismans of the Holy Name of Jesus, carved in stone or painted with brush, accomplished the same spiritual prophylaxis.[280]

THE BUTCHER SHOP OF HELL

Several monuments offer us a unique entrance to apocalyptic themes in Mexican mural art. We shall examine each of them for their iconographic properties as representing the visual imagination and missionary ideology.

A collection of these images of hellfire and damnation is found in Diego Valadés's 1579 *Rhetorica Christiana*, which was

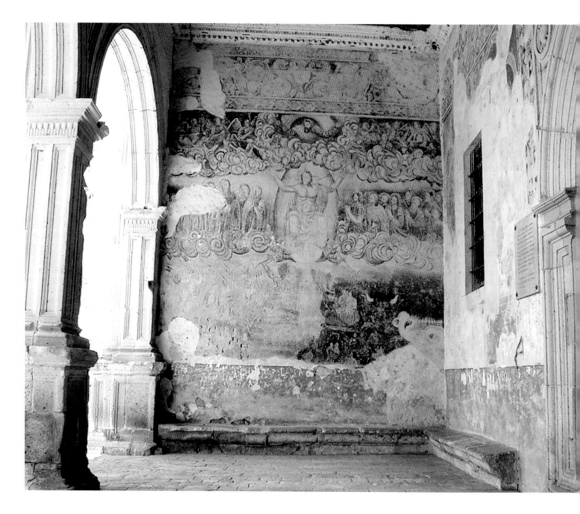

published in Europe for future missionaries to the New World.[281] The scenes, taken from some graphic *Inferno* and originally used on perishable cloth screens, were re-created as billboard-size murals in the Augustinian open chapels at Actopan and Xoxoteco (Hidalgo) and in the undercroft of the Franciscan church of Atlihuitzía (Tlaxcala).[282]

The Augustinians seem to have had a particular penchant for such iconography. San Nicolas de Tolentino at Actopan (fig. 2.24) and Santa María at Xoxoteco are constructions of the mid-sixteenth century.[283] The murals came to light when the whitewash was removed.[284] We can identify the artist of the Actopan murals as the Indian artist Juan Gerson, who also painted an Apocalypse cycle at Tecamachalco.[285] The iconographic programs of the chapels are similar, but the version at Xoxoteco has omitted some scenes for lack of space.

Fig. 2.23. Cuitzeo. *Portería* chapel, confessional area, and mural of the Last Judgment. (Photo by author.)

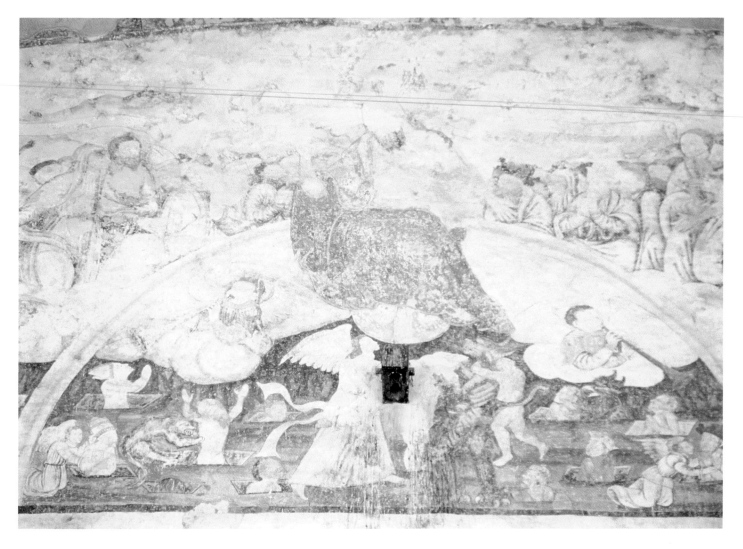

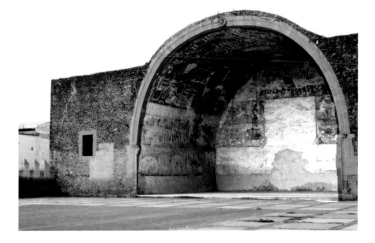

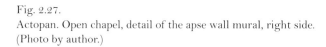

Fig. 2.27.
Actopan. Open chapel, detail of the apse wall mural, right side.
(Photo by author.)

Fig. 2.28.
Actopan. Open chapel, left side wall. Hell mouth. (Photo by author.)

In Actopan, the rear (east) wall is divided into three registers that cover the curving tympanum. The Last Judgment of Revelation, chapters 4 and 20 are combined at the top (fig. 2.25). The position of the Last Judgment as a lunette above the altar continues the European practice of locating this theme there, on the roof of the rood screen separating nave and presbytery, or on the tympana of Romanesque portals.[286]

The intermediate zone of the mural is balanced between the creation of woman and Leviathan with open jaws on the Gospel side (observer's left), and the tree of the knowledge of good and evil and the expulsion from paradise on the Epistle side (observer's right). The lowest register is divided into four scenes. On the Gospel side (fig. 2.26), one sees the labors of man and woman as a result of the loss of grace, together with the jaws of Leviathan, from which emerge two of the four horsemen of the Apocalypse: plague and war (Rev. 6:4–8). Next to this are Noah, the ark, and the deluge. On the Epistle side (fig. 2.27), one finds the opening of the sixth seal (Rev. 6:12), the earthquake and rain of stars (or the fall of Babylon, Rev. 8). Then follow the souls in purgatory, of medieval iconographic origin.[287]

On the side walls at Actopan are depicted other moralizing scenes that Elena Gerlero has identified as the Seven Deadly Sins. On both lateral enclosures nearest the rear wall, a toothy hell mouth—a common theatrical prop in liturgical dramas—threatens to consume the moral offenders (fig. 2.28). The audience for this spectacular spectacle and its warnings must have been Indian and European alike. The torments of the damned are particularly striking and are reminiscent both of the martyrdom of certain saints and of the pre-Hispanic temple rites of ritual cannibalism among the Aztecs (fig. 2.29).[288] Still readable and somewhat entertaining are the scenes of gluttony and inebriation with pulque beer, and the very Augustinian theme of right worship/wrong worship. In this last image, a Spaniard is giving a good example to a native by praying toward the new sun of Christ in the eucharistic wafer (fig. 2.30), while behind the two we spy the lingering worship of the demonized idols in the *teocalli*.[289] However, Spaniards do not have the ethical upper hand in these paintings, because individuals with obvious European features (blond hair or red beards) are also suffering their eternal fate on the rack and in the flames.

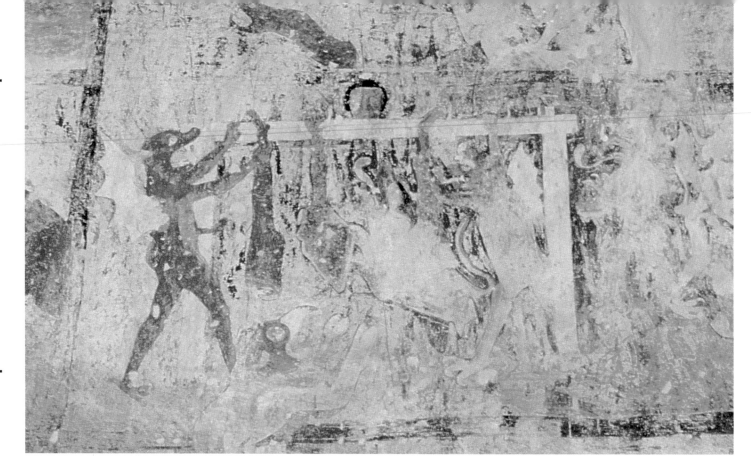

Fig. 2.29.
Actopan. Open
chapel, left side wall.
"Butcher shop" torture.
(Photo by author.)

Fig. 2.30.
Actopan. Open chapel,
left side wall. "True
and false worship."
(Photo by author.)

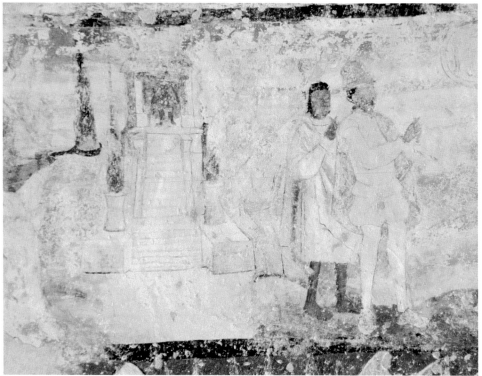

Several kilometers due east, over rugged mountain terrain, is the tiny *visita* chapel of Santa María Xoxoteco, which belonged to the convent at Metztitlán.[290] The chapel was originally open to the elements, but later enclosed. Its mural paintings are among the most fantastic of New Spain. The corresponding scenes at Xoxoteco represent the Final Judgment on the lunette or tympanum of the apse, while in the lateral frescos one sees the jaws of Leviathan, the tree of the knowledge of good and evil, and the expulsion from paradise (fig. 2.31).[291]

The side walls at Xoxoteco present the jaws of Leviathan again, but this time vomiting the condemned into fire and sulfur (Rev. 20:10). Emerging from the gaping mouth is a monstrous figure, clearly the largest individual in the whole program, more than life-size (fig. 2.32). With claws, serpent headdress, and a collar dangling a severed heart and hand, the fiend must be a reference to the ancient gods of blood as well as to Satan or Antichrist. The additional registers display seven scenes of the punishment of the capital sins (fig. 2.33), interspersed with six smaller vignettes of the demons tempting the local Indian populace, and even a Spaniard or two, with con-

Fig. 2.32.
Santa María Xoxoteco.
North lateral wall.
An enigmatic life-
size figure, perhaps
Antichrist or the
prince of devils.
(Photo by author.)

Fig. 2.33.
Santa María Xoxoteco.
Hell as a butcher shop.
The European-looking
man is being flayed on
a scaffold similar to
that of Xipe Totec.
(Photo by author.)

Fig. 2.31.
Santa María Xoxoteco, Hidalgo. Apse wall in the Augustinian *visita* chapel. Adam and Eve and the Fall and the expulsion from paradise. (Photo by author.)

temporary vices: drunkenness, adultery, and idolatry (fig. 2.34). Iconographic models have been found in European book engravings, but also in indigenous butcher shop and torture scenes, and in the *trompantzli* or skull rack of the Templo Mayor in Tenochtitlán.[292] It appears that among the damned is the theatrical character of "Lucia," from the earliest catechetical play *The Last Judgment* (fig. 2.35). With her Spanish name but Indian features, she may represent both European and native sinners who could suffer the same fate.[293] The mu-

rals of Santa María Xoxoteco amply depict such threats as the regression to idolatry or imported vices, and they offer a Christian remedy to overcome them. At the transition from the lateral walls to the ceiling vault, a painted frieze depicts Franciscan saints in medallions in between classical masks, fruit swags, and angels. Further above, the four evangelists sit in a leafy vine grove, an anticipation of the rewards in the garden of heaven for those who practice the new religion (fig. 2.36).

Fig. 2.34.
Santa María Xoxoteco.
Indian man and woman
tempted to drunkenness.
(Photo by author.)

Fig. 2.35.
Santa María Xoxoteco.
A Spanish noblewoman
and the Indian woman
"Lucia," tempted by
devils. (Photo by Juan
Aruesti.)

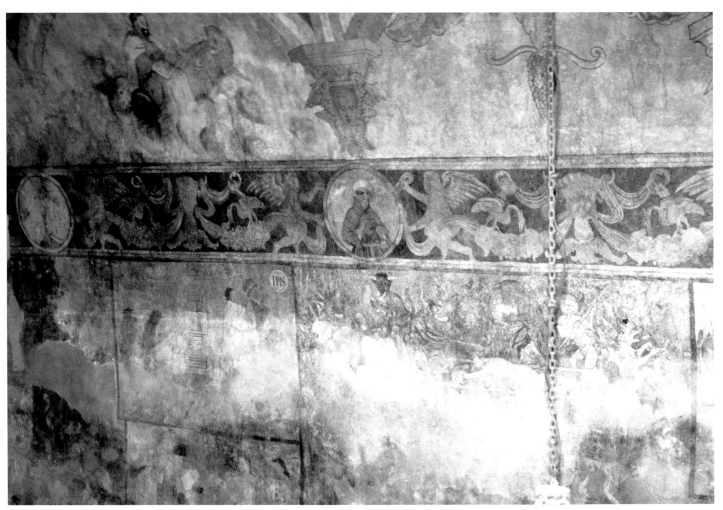

Fig. 2.36.
Santa María Xoxoteco.
South lateral wall,
frieze, and ceiling vault.
(Photo by author.)

Similar programs are barely discernible in two poorly preserved Franciscan buildings, the open chapel at Tizatlán and the now-ruined Church of the Conception of the Virgin at Atlihuitzía (Tlaxcala).[294] In the latter, a monumental image of a paradigmatic sinner, identified as one Valentín de la Roca, stands in a bonfire and is bound by a fiery and horned rattlesnake (fig. 2.37). The fresco of the condemned Spanish nobleman, whose deeds were notorious among the moralizing friars, is surrounded by six scenes of his immoral choices and bad confessions. The location of the image, at the entrance to the nave, indicates that it acted as an exemplum having to do with the sacrament of Penance. Serpents, toads, and insects—with their negative connotations of moral iniquity—are interspersed among the scenes.[295] The barely visible letters on the placard, written in late sixteenth-century Náhuatl, read: "Let it be known to this community how the Human Owl [the devil] carried away this person named Valentín de la Roca, because he did not attend Mass or catechism classes, and because he was obstinate in his lies. He did not declare [all] his sins in confession, and he received Holy Communion in the state of sin. All this took place in Miranda, in the province of Navarra."[296] Similar to moralizing emblems in Renaissance art with their narrative scenes and inscriptions, this fresco acted as a warning to the faithful of Atlihuetzía of what eternal punishments await those backsliders—Indians or even, as here, Spanish nobility—who make a bad confession (fig. 2.38) and receive the Christian sacraments sacrilegiously. In terms of reward and punishment in the hereafter, heaven and hell are depicted as egalitarian places, making no distinction between old Christians or new ones.

All of these fresco cycles are, in one way or another, extended reflections on the Last Judgment, as also at the Augustinian convents of Cuitzeo, Actopan, and Acolman.[297] At Cuitzeo (Michoacán), the Last Judgment mural is set in the very public space of the conventual portal, and it displays angels with the eschatological weapons of Christ's victory (figs. 1.8 and 2.23). As an image for the theme of the forgiveness or punishment of sin, Judgment scenes were quite appropriate here in the place where confessions were heard and legal cases were decided. Additionally, the iconography of the Last Judgment was a reminder to the mendicants themselves of the seriousness of their mission and the real dangers of their own human sins and failings.

Fig. 2.37. Atlihuitzía, Tlaxcala. Mural in the Franciscan church, left wall. The moralizing story of the Spaniard Valentín de la Roca. (Photo by author.)

Fig. 2.38. Atlihuitzía. Detail of fig. 2.37. Valentín makes a bad confession. (Photo by author.)

Fig. 2.39.
Actopan. Mural
painting of the Last
Judgment in the upper
dormitory corridor
of the convent.
(Photo by author.)

Fig. 2.40.
Acolman. Murals in
the upper cloister of
the convent. The Last
Judgment and the
Crucifixion. (George
Kubler Archives,
Yale University.)

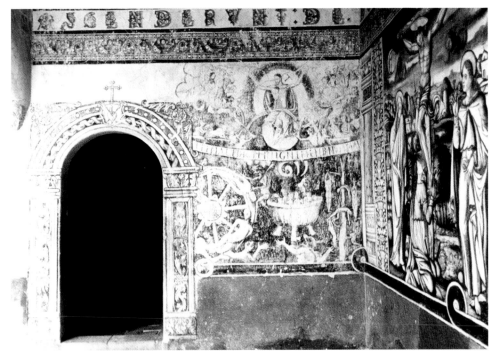

As we see in the fresco at Atlithuitzía, the moral invective was also directed toward the Europeans present in the New World, including the friars. The Last Judgment frescos at Actopan (fig. 2.39), Ixmiquilpan, and Acolman (state of Mexico) (fig. 2.40) are located in the upper-level cloisters and private dormitory corridors where the only audience for the salutary scenes would have been the Augustinians themselves.

THE FLOWER GARDEN OF HEAVEN

With flowers You write, O Giver of Life.
With songs You give color,
with songs You shade those who must live on earth. . . .
We live only in Your book of paintings
here, on the earth.
—Nezahualcoyotl, Nahua poet king, fifteenth century

The representation of heaven as a paradisiacal garden in sixteenth-century Mexican mural art has been dealt with by Jeanette Favrot Peterson, and confirmed in Nahua-Christian doctrinal texts by Louise Burkhart. Peterson sees the black, white, and teal frescos of the Augustinian cloister of Malinalco as a type of cosmic paradigm relating to the Eden of the first Man and Woman, to the earthly utopia that the mendicants wished to establish in New Spain, and to the celestial hereafter of the blest. The murals, painted in the 1570s, cover the four walls and barrel vaults of the lower cloister and are a rich and accurately represented world of native and European flora and fauna (figs. 2.41, 2.42). At the top of the walls, two vegetal friezes are separated by a band of Latin inscriptions.[298]

Flowering gardens as symbols of terrestrial and super-terrestrial bliss have a long history in art and in religious-political thinking and were used by Joachim of Fiore to picture the evolution of history.[299] There is abundant medieval literature concerning imaginary journeys to paradise and descriptions of it, and Hispanic literature is particularly rich in such accounts.[300] Some of these stories were translated into Náhuatl, like the legend of St. Amaro, who looked into paradise through its portal but could not enter. (This indigenized saint discovers that the flowery heaven looks quite similar to the mendicants' patio corral in springtime!)[301] The enclosed garden of Eden is also linked with the city of Jerusalem and its architectural constructions.[302] In the Middle Ages, "paradises" were associated with the atria and porticos next to Solomon's Temple where the apostolic Church taught and met for communal prayer.[303] The three courts of the Jerusalem Temple corresponded to the three paradises of the blest, and for monastics

Fig. 2.41.
Malinalco, Morelos.
"Garden murals" in
the cloister of the
Augustinian convent.
The shield or seal
of the Holy Name.
(Photo by author.)

Fig. 2.42.
Malinalco. Cloister
corridor with paradise
mural. (Photo by
J. Barry Kiracofe)

Jerusalem and paradise were already experienced in the monks' cloister.[304] Both in the Bible and in later thinking, there is a syncretic fusing of hortulan and urban images of paradise (fig. 2.43).[305]

Pre-Columbian Amerindians seem to have made similar associations by arranging luxurious gardens on temple property and distinguishing them visually from the merely utilitarian gardens of the peasants.[306] Indeed, in Mexica mythology "heaven," *Omeyocan*, is a garden, green and fertile.[307]

It appears that the mendicants were aware of these multiple levels of horticultural meaning. The site of Malinalco may have been chosen for a convent because of the medicinal herb and psychotropic plant garden that the indigenous population had established there in the pre-Contact period. At the heart of its cloister the Augustinian convent had a *fons vitae*, that is, a decorative fountain that emptied its waters in four rivulets or tanks, like the four rivers of paradise feeding the four continents of the then known world. Other Augustinian establishments, such as Tiripetío (Michoacán), had similar fountains that watered different quadrants of the town, while the four posa chapels of the Franciscan complex at Huejotzingo had fountains on their external sides.[308] No doubt the inspiration lay in Iberian cloister fountains, or in an Islamic posa chapel in Jerusalem that doubled as a cistern and was associated with the living waters of Ezekiel's New Jerusalem (Ezek. 41:1).[309]

At Malinalco, there are two specific references to the primeval Eden: the presence of the tree of the knowledge of good and evil, and the serpent (fig. 2.44).[310] The lower cloister murals were evidently meant to be seen by the friars and by their trusted Indian servants and catechists, who were admitted into this anticipatory Eden.[311] The Latin inscriptions in the painted banding at the ceiling level confirm that this Eden is also the courtyard of Solomon's Temple by quoting verses from Psalm 84: "How lovely is your Dwelling Place, O Lord of hosts! . . . Even the sparrow finds a home and a nest for her brood: your altars, O Lord of hosts! Happy are they who dwell in your House."[312] In the weighty symbolism of the cloister, one could say that "architecture assumed an ethical as well as eschatological function, not only representing Paradise to men, but preparing them to enter it."[313]

Fig. 2.43.
Malinalco. Mural of
the tree of the cross
in the garden of
paradise. Below, one
of the through-the-
wall confessionals
with painting of a
friar meeting Death.
(Photo by author.)

Fig. 2.44.
Malinalco. Detail of
the murals. A serpent
hypnotizes a bird.
(Photo by author.)

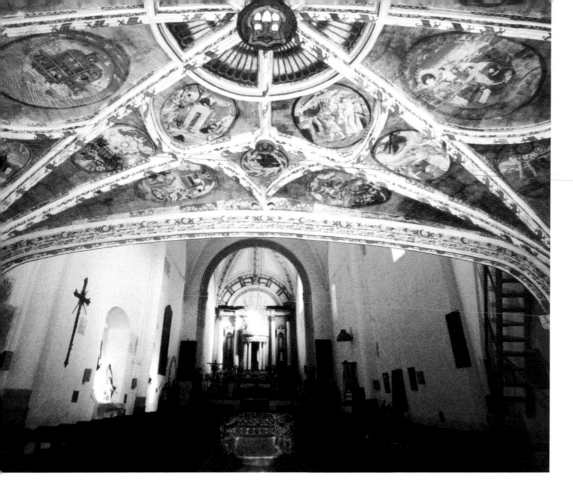

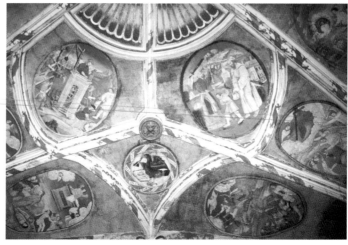

Fig. 2.46.
Tecamachalco. Detail of the Apocalypse paintings. (Photo by author.)

gelists (fig. 2.46), each with the word "Apocalypsis" painted directly on the ceiling outside the medallion. The four occurrences of "Apocalypsis" appear to act as a third and outermost ring and to underscore the meaning of the entire ensemble (figs. 2.47 and 2.48). Since Fray Andrés de Olmos, an exorcist, expert on witchcraft, and dramaturge, was several times a guardian at Tecamachalco, it might well have been he who was responsible for choosing the program.[317]

Several possible iconographic sources have been identified, among them illustrated Scriptures such as the *Biblia Latina* (1543) from Lyon containing a set of woodcuts by Hans Holbein.[318] We note that, like the paintings in the open chapel at Actopan, the scenes chosen are from the first and last books of the Bible, with two scenes from the "middle book" of the prophet of the New Jerusalem, Ezekiel. Indeed, the prophet's images are the most interesting because they display the utopian city, its temple, and altar (figs. 2.49 and 2.50), which we will examine in chapter 3. Additionally, the other scene from Ezekiel illustrates the temple's holocaust altar, which I will propose, in chapter 5, is the iconographic basis for the platform of the atrial crosses. These two Old Testament images, plus that of John the Seer's New Jerusalem from Revelation, will be relevant to our understanding the architectural construction of cities and churches in New Spain.

Fig. 2.45.
Tecamachalco, Puebla. *Sotocoro* of the Franciscan evangelization center with the Apocalypse cycle paintings by Juan Gerson. (Photo by Juan Aruesti.)

The Apocalypse Cycle at Tecamachalco

The most overt iconography of apocalyptic themes is found in the painted medallions on the undercroft of the choir of the Franciscan foundation at Tecamachalco, Puebla.[314] Juan Gerson, the Indian artist who was also responsible for the murals at Actopan, painted the twenty-four biblical scenes on fig paper in 1562. The medallions are grouped in two concentric circles among the ribs of the Gothic vaulting above the area of the baptismal font and the confessionals (fig. 2.45). At the very center is a rib boss with a shield on which are seen the Tau cross and the Five Wounds of Christ and St. Francis. The schema, like the acts or scenes of a cosmic drama, is a complicated series of correspondences between Old and New Testaments. The inner ring of images consists of five scenes from Genesis, plus two from Ezekiel and one from Revelation.[315] The outer ring is composed of episodes taken exclusively from Revelation.[316] Toward the four cardinal directions and at the intersection of the ribs are medallions of the tetramorphic figures identified as the evan-

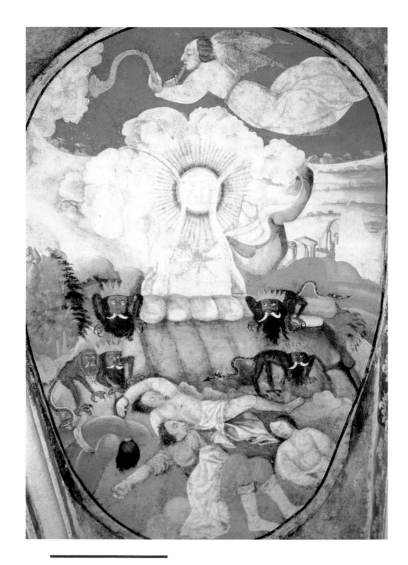

Fig. 2.47.
Tecamachalco. Detail. The plague of locusts and the divine sun.
(Photo by author.)

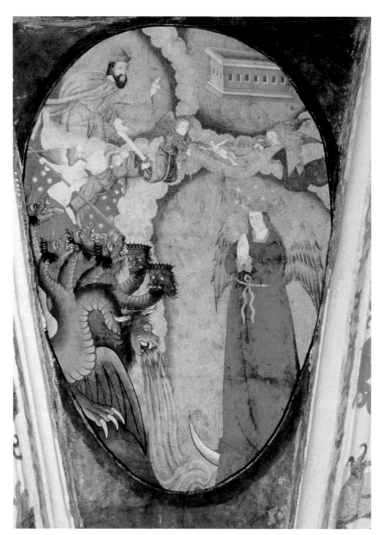

Fig. 2.48.
Tecamachalco. Detail. The Woman of the Apocalypse.
(Photo by author.)

The cycle may also have found its ideological inspiration in the mendicant interpretation of Joachim of Fiore's three ages. Joachim's tripartite division of history was frequently harmonized with the seven temporal divisions in the book of Revelation.[319] The doctrine of the three ages surely came to Mexico with Joachim's *Expositio in Apocalypsim* and Bartholomew of Pisa's *On the Conformities of St. Francis and Christ*, which we know had an impact on Fray Martín de Valencia, Gerónimo de Mendieta, and probably on other friars as well.[320] The only other program that pairs scenes from Genesis with the Apocalypse is in the murals of the Franciscan mother church of Assisi, painted around 1288 when the radical Spirituals were still active. This fact allows the possibility of a Joachite typology based on numerical ratios, symbolic animals, and allegorical correspondence.[321] Moreover, the quadripartite layout of images surrounding the central Tau cross is typical of both Joachite thinking and Aztec quincunx design.

The convent at Tecamachalco was a novitiate for young friars in training. Perhaps the Apocalypse ensemble, in such a public place at the entrance to the conventual church, was a

Fig. 2.49.
Tecamachalco. Detail.
The Heavenly City of
Jerusalem with the
Temple represented as
the Dome of the Rock.
(Photo by author.)

Fig. 2.50.
Tecamachalco. Detail.
The temple's altar
raised on three steps
according to the
prophet Ezekiel.
(Photo by author.)

sort of thematic program to instruct the novices in humanity's creation and fall, and in the new creation that they were laboring to realize on earth. But we should not overlook the location of the images on the ceiling above the physical and sacramental threshold to the sacred space. The paintings act as a corona around the place of baptisms and confessions (fig. 2.51)—two sacraments that bring one into salvation, the

Church, and a state of grace necessary for entrance into the rewards of the Heavenly Jerusalem. In this reading, the events of Revelation—soon to unfold on earth—will similarly be the temporal threshold to eternity (fig. 2.52). With the Apocalypse cycle of Tecamachalco, we have thus come full circle, back to the eschatological hopes of Joachim of Fiore and of the Observant missionaries.

THE *PSYCHOMACHIA* AT TLALMANALCO AND IXMIQUILPAN

The last two monuments I shall introduce in this chapter are presented as examples of the symbolic thinking that held the imagination of the early mendicant missionaries. They will also act as an introduction and bridge to the pictorial iconography that reinforces my belief that the End Time was a visual and religious preoccupation among the evangelizers.

The conventual complex of San Luis Obispo at Tlalmanalco (state of Mexico) was begun in 1525 with the destruction of an important Aztec ceremonial center (fig. 2.53).[322] The catechumenal complex at Tlalmanalco, meaning "place of pounded earth," stood on a famous ritual dance floor that had given the town its name.[323] The chapel, completed by the 1560s, is a masterpiece of sculptural forms, intricate carving, and a complex iconographic program.[324] From the sanctuary, framed by a triumphal arch and a carved alfiz (Moorish frame), the walls of the chapel flare forward in a trapezoidal plan to embrace the broad arcade of a portico. Kubler considered this type of open chapel to be typical of the novel experiments of the "second generation" at mid-century.[325] The portico of five arches of cinnamon-colored stone springs from multishafted Gothic piers (fig. 2.54). The deep layer of carving lavished over its archivolts, capitals, and pilasters is an orgy of many small motifs juxtaposed as densely as in the patterns of a textile. Four protruding corbels are embedded in the façade of the portico, suggesting that they were intended to carry either a second tier of arches or, more likely, the wooden beams supporting a flat, wooden roof, no doubt polychromed on the interior with images of celestial beings.[326] Since the triumphal arch and square frame of the sanc-

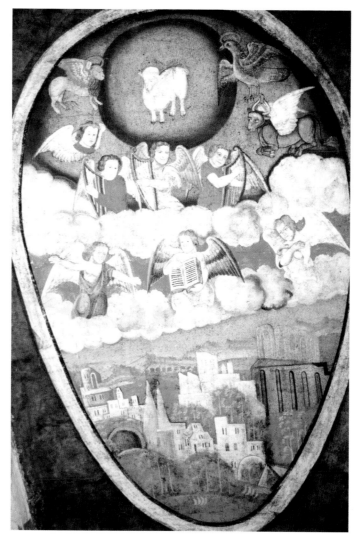

Fig. 2.51.
Tecamachalco.
Baptismal font
below the Apocalypse
paintings. (Photo by
author.)

Fig. 2.52.
Tecamachalco. Detail.
The worship of the
Lamb, the tetramorph,
and musical angels
above the new earth.
(Photo by author.)

tuary extend above the horizontal line of the portico arches, it seems likely that an open, wooden lattice grille would have screened the upper façade to allow light to enter and sound to escape. In this feature, Tlalmanalco resembles its probable prototype, the San José Chapel in Mexico City (see below).[327]

The interior floor of the trapezoidal outdoor chapel is elevated above the level of the atrium, while the chancel was once raised an additional four steps for visibility of the altar and liturgical action. Under an arch in the right diagonal wall is a ruined niche suited in size and shape to hold a big round baptismal font, such as the one preserved in the adjacent church. A diminutive niche in the rear wall, set off center, was intended for the eucharistic tabernacle (fig. 2.55);[328] and a stairway in the thickness of the left diagonal wall reveals that there was once a stone pulpit, raised high above the floor.[329]

But the unique significance of this chapel lies in its iconography. It is nothing less than a "pictorial manifesto of Franciscan beliefs on life, death, and salvation"—a sermon in stone designed to impress and instruct the native converts.[330]

By the 1560s, when the chapel was finished, the optimism of the friars was becoming strained. Charles V, their protector, had abdicated his imperial throne and died; his son Philip II was attempting to bring the mendicants under the control of the bishops and the civil authorities, and the friars' view of their mission in the New World was becoming increasingly dark. The epidemics then decimating the Indian population were interpreted as divine punishment for the alarming survival of pre-Hispanic false worship among their flock. The friars saw overwhelming parallels to the situation in fourth-century Iberia when Christianity was in dire conflict with the resurgence of paganism among the elite. They found an exemplar in the poetic description of that conflict and the victory of right worship in Prudentius's *Psychomachia* and his *Contra Symmachus*, a scorching denunciation of false worship. Prudentius's works have been found in Mexican conventual libraries, and at Tlalmanalco there is indication that his best known poem was present in a volume entitled *Summa de Virtudes y*

Fig. 2.55.
Tlalmanalco. Open chapel, center arch of the façade and triumphal arch of the presbytery behind. (Photo by Javier González.)

Fig. 2.53.
Tlalmanalco, state of Mexico. Open chapel of the Franciscan center seen from the bell tower of the church. (Photo by Javier González.)

Fig. 2.54.
Tlalmanalco. Open chapel. (Photo by Javier González.)

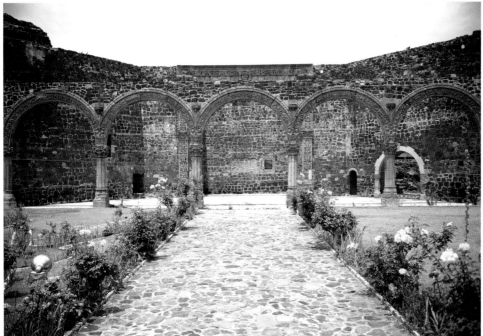

Vicios.[331] The *Psychomachia* and the *Contra Symnachus* provided both an understanding of the psychological dynamics of the Indians' moral peril and the iconographic program for the chapel.[332] They also provided dramatic material for the didactic stage productions, and the open chapel at Tlalmanalco may have doubled as an outdoor theater.[333] The friars saw the events of their decade as portents of the Final Days, when an apocalyptic struggle between the forces of good and evil would culminate in Christ's Second Coming.[334] His triumphal entry would precipitate the Last Judgment and establish the New Jerusalem, the celestial city of the righteous and right worshippers.[335] Although some of the symbols remain obscure, this is most likely the message graphically conveyed by the sculpture of the open chapel.

The five exterior arches of the portico picture unbridled sin and vice, symbolized by wild animals such as horses, lions, and monkeys, entwined in choking vegetation together with European-looking humans (fig. 2.56). Some resist heroically, but others succumb to temptation with agonized expressions. Skulls and crossbones below the center arch symbolize the triumph of death (fig. 2.57), but the serene crowned head at the

apex, flanked by the dragons of the underworld and undaunted, appears to represent at the same time the hope of salvation for humanity's immortal soul.[336] As if to echo the hope for redemption, Christ's monogram is carved at the apex of the first arch on the left, and in several bays imitation "pearls" are set into the face of the voussoirs, suggestive of the celestial pearly gates.[337]

The elaborately carved sanctuary behind the arcade is the focal point of the chapel, containing the richest symbolism. Sinister vegetation climbs the flanking pilasters, which are headed by grim-visaged angels of the Apocalypse on the capitals (fig. 2.58). Friezes of grimacing masks, animals, and skulls continue around the square frame of the alfiz and along the cornice, where a demonic zoo of fantastic animals—griffins, birds of prey, and hybrid creatures, half-animal, half-plant—emerge from the serpentine foliage.[338]

A pyramid of demons ascends the jambs of the archway. Trapped by a welter of spiny tendrils, the contorted faces of sinners and fallen angels alternate with a medieval bestiary of simians, hippogriffs, three-headed eagles, and scaly locusts. All this changes in the curving arch. In Prudentius's bellicose poems, and in Tlalmanalco's sculpted reliefs, the archway itself represents the narrow road to salvation. From the chalices at the base—powerful symbols of redemption and the sacraments— a harmonious foliated design ascends to the radiant face of the New Adam at the apex (figs. 2.55 and 2.59). A knotted mendicant cord frames and protects the arch to emphasize the guiding and saving role of the Franciscan order along the perilous path to salvation.[339]

In the spandrels, shields display the quincunx Jerusalem cross with the Five Wounds of Christ's and Francis's redeeming passion. Diadem-crowned angels, who are carved in profile, are alighting to display the *arma Christi* by which Satan's power is vanquished (fig. 2.60). Above the archway, the symbolic portal to the celestial city, stands Christ as *Salvator Mundi* holding the orb and scepter (fig. 2.59).[340] Similar to the *Salvator Mundi* on the posa chapel at Calpan (fig. 5.26), Christ is the goal of the processional/liturgical space and the assurance that good will triumph over evil on the Last Day.

In order to complete the salvific message, we need to use our imaginations and add to the presbytery the wooden altarpiece that once existed there. The painted panels of this retable

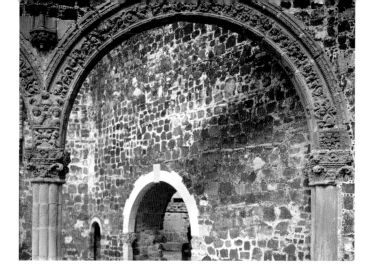

Fig. 2.56.
Tlalmanalco. Open chapel, extreme right arch of the façade. The arch in the rear opens onto the baptismal niche. (Photo by Javier González.)

Fig. 2.57.
Tlalmanalco. Open chapel, detail. The Franciscan cord framing the intrados; skulls and crossbones.
(Photo by author.)

Fig. 2.58.
Tlalmanalco.
Open chapel. Pilasters and capitals of the triumphal arch.
(Photo by Javier González.)

would have depicted Christ as crucified or as incarnate of the Virgin, with the images acting to reassure the congregants that the sacraments and ministry of the friars were their way to escape the perils of this moral jungle and one day pass through the portals of heaven. If such an interpretation of the open chapel is correct, then it would seem that the sculptural program was an accurate barometer of the mendicants' fears and hopes for the new Christians at mid-century.

The theme of the menacing and entrapping vine reappears in the mural paintings at the Augustinian Church of San Miguel Ixmiquilpan (Hidalgo) (fig. 2.61). The program as we see it today is incomplete, and as at the open chapel of Tlalmanalco, we must fill in the missing elements to understand its arcane iconography. All that remains to the eye is a painted banding, two and a half meters high, that girds the church at

Fig. 2.61.
Ixmiquilpan, Hidalgo. Nave of the Augustinian church with mural bands at eye level and ceiling level. (Photo by J. Barry Kiracofe.)

Fig. 2.62.
Ixmiquilpan. Entrance area or *sotocoro*. Right wall with murals of eagle and jaguars, and warriors below. (Photo by author.)

Fig. 2.63.
Ixmiquilpan. Entrance area or *sotocoro*. Left wall with mural of the great eagle with warriors below. (Photo by author.)

eye level, even in the altar area. At the west end of the building it has expanded and completely fills the undercroft walls from floor to ceiling, surrounding the entrance to the nave and the area where the baptismal font was originally located (figs. 2.62 and 2.63). Confessions may also have taken place here. The program consists of scenes of deadly warfare in which mythical beasts, dragons, centaurs, eagle and jaguar knights, and humans dressed in the garb of Mexica priestly nobles battle and decapitate one another (fig. 2.64).[341] Obviously, the native artists who executed the mural had access to European prints of grotesques, but they also knew their own visual heritage of costumed warriors and combined the two in creative and sophisticated ways. Donna Pierce has attempted to identify the combatants holding bows and arrows and to distinguish them from those wielding obsidian axes, but there are no clear-cut victors in this chaotic mayhem, nor are there overt personifications of good or evil (fig. 2.65). All the actors are caught in the sinister acanthus vine that weaves its serpentine way throughout the junglelike scenes.

The murals have been interpreted as representing the Chichimeca War, which took place in the region in the 1560s and pitted the neo-Christian Tlaxcalan and Otomí Indians against the nomadic and pagan tribes of the north. This could only be a partial explanation for such a complicated program, one deliberately created for a totally liturgical space where the sacraments were meant to be celebrated. More likely, the battle

register represents the world of struggle and spiritual combat, the base lower world in which humankind—both Indian and Spaniard—finds itself entrapped.

Additionally, an important fact in interpreting the murals has often been overlooked: namely, that the patron saint of the church, Michael the Archangel, was also the protector against plague and the saint of the dying. The fact that the frieze was painted at the height of the plagues that decimated the Amerindians only lends more weight to this observation. The archangel Michael was also the patron of Christian knights; indeed, in art he is often dressed as a knight in helmet, sword, and shield. In the Middle Ages there briefly existed a religious order known as the "Wing of St. Michael," a group of warrior monks that quickly disappeared. At Ixmiquilpan, eagle knights and jaguar knights have now been proudly brought into the Christian pantheon as comrades-in-arms of the grand knight, Michael.[342]

Moreover, on the Feast of St. Michael, medieval Europeans celebrated "michael's fairs" with displays of horsemanship and mock battles in the context of liturgical processions—exactly what is happening here at Ixmiquilpan, a town renowned for its annual fair and market.[343] Thus the best explanation for this battle banding is that it represents Christian Otomí actors, dressed in costumes and carrying props like severed heads, in a celebratory feast day procession.[344] Only in this way would the Indian artists have been permitted to paint a monumental frieze that converged both native military pride and Christian hagiographical legend. They brought together the best of both worlds in a very sophisticated program.

High above our heads, at the springing of the ceiling vault, another band has been painted, this one of playful angels in a bucolic and flowery heaven filled with tame birds and a benign grapevine laden with ripe fruit.[345] Here Pegasus appears with the same costumed knights, who are not fighting now but calmly parading toward wreaths with the monograms of Christ and the Virgin (fig. 2.66); the victory has been won. Between the two registers is roughly five meters of now blank wall space that must have illustrated the story of redemption. Either the events of Christ's life, or those of his angels and saints (no doubt, several Augustinians) once enhanced the space and proclaimed salvation by a visual bridge between the lower

Fig. 2.64.
Ixmiquilpan. Centaur actor and warrior.
(Photo by J. Barry Kiracofe.)

Fig. 2.65.
Ixmiquilpan. Warrior wearing jaguar knight costume. (Photo by J. Barry Kiracofe.)

bellicose register and the higher angelic one. Therefore, the visual message of the overall ensemble appears to be that of salvation from this plague-ridden and fallen state. The Náhuatl-language hymnal composed in the 1550s, the *Psalmodia Christiana*, may allude to this meaning in its hymn for St. Michael's feast day:

> Let us praise our mighty captain, the great brave warrior,
> the great archangel, God's beloved St. Michael.
> The mighty devil Lucifer started a great battle there in
> heaven . . .
> St. Michael, along with his angels, fought the great con-
> strictor serpent . . .
> And then there was shouting in the Empyrean heaven . . .
> We praise all who dwell in heaven, first of all St. Michael,
> for he leads all heavenly men of war . . .
> We pray you, O Christ . . . may you wish us to ascend to
> the celestial paradise . . .
> May you order all the angels to answer for us, to join with
> us against our foes.[346]

The psychomachian war has been expanded beyond clearly demarcated individuals representing good or evil, or sins particular to the natives. Now the scenes portray the continual spiritual warfare that Indians and Spaniards encounter in this life below, and the tranquility that they will find only in the above world—with Michael and his warrior men—when salvation history has come to its finality. In a liturgical context such as this one, the means to that end are the sacraments of the Church that are celebrated in this space.

Donna Pierce has rightly suggested that a Last Judgment scene may have graced the apse behind the high altar as the culmination of the divine activity; indeed, we recall that St. Michael will be commander-in-chief at that event.[347] This would parallel the location of the same scene in the apses at Actopan and Xoxoteco. Thus the redemptive process is accomplished as the eye moves from actors in the immediate chaotic world of the lower band, through the (hypothetical) history of salvation in the intermediate space together with the altarpiece and Last Judgment in the presbytery, to the Empyrean heaven above where the combatants dwell with angels. The use of such band-

Fig. 2.66. Ixmiquilpan. Ceiling-level banding. Pegasus, angel, and Marian shield/seal. (Photo by Mary Miller.)

ing techniques to represent the human journey to the above and below worlds was not only traditional in European iconographic schemes but also common in pre-Hispanic codices and wall painting.

In this chapter, I have attempted to demonstrate the visual quality of the prognostications of the End Time in which painting, sculpture, architecture, and urban planning were vehicles of eschatological beliefs throughout the Middle Ages and into the era of New World colonialization. We have seen that the fires of these convictions were fed by the friars' belief in a Judeo-Christian ancestry of the Amerindians, by the inexplicably similar practices between the Aztec and Judeo-Christian religions, and by the medieval prophetic obsession with the return to Jerusalem and the reconstruction of its Temple. Is it any wonder then that the early evangelizers of this New World might choose to build a new Temple in an American Zion? Or that it might even be welcomed by the lost (or found) tribes?

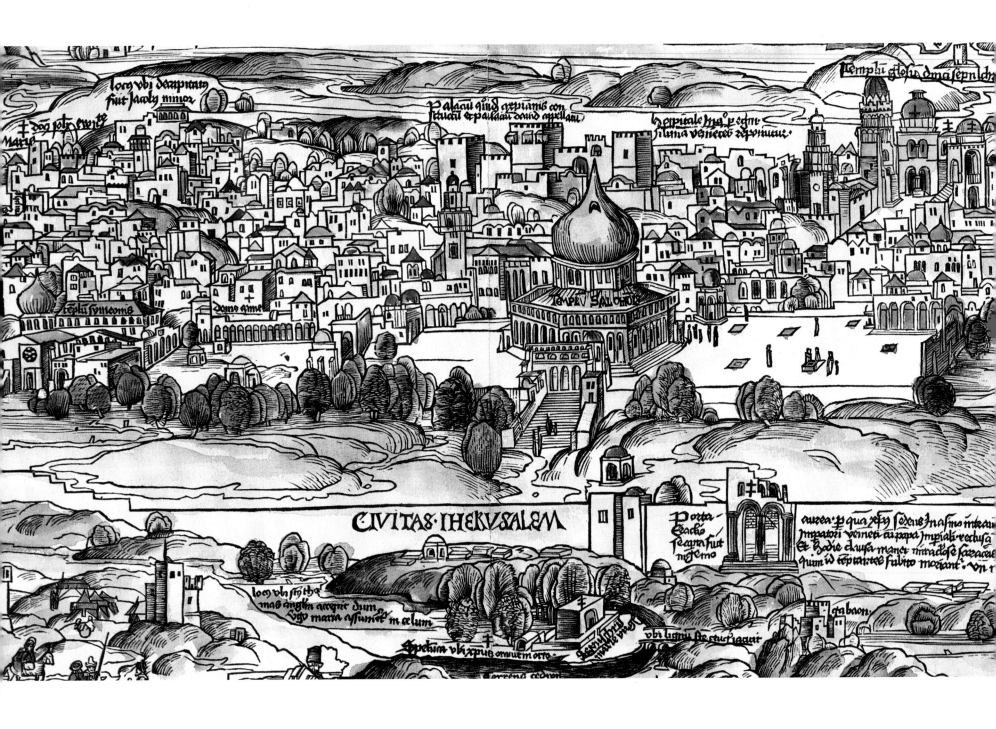

loeq vbi decapitat
fuit Jacoly minoz

Teplu gtofu dmasepnldri

Palacu giund grpvianis con
struetu et paulant domio appellati.

Hespitale mag. p egm
filuna venieces reptinuit.

Templu symeonis

Domo anne

TEMPLU SALOMON

Porta
Ciacho
feapra fuit
nocmo

aurea p qua xfy sedens Inasino inkai
Impatori vernetu as papa Impiali reclusa
Et hodie clusa manet miracloxe saracea
quim id teptantes subito moriant. vn

CIVITAS·IHERVSALEM

loeq vbi sty tha
mas angim accepit dum
Ego maria assumet m celum

ga baon

vbi lignu scescucagit

Spelim vbi xpus omnut orto

Aecensu libri
marie virgin

terrena cedron

3

The Indian Jerusalem

From the beginning, man has seen his city as "the center of the world." Few discussions of urban life, whether of the physical *urbs*, or of the social *civitas*, or of their refraction in the mediums of art, can avoid the city's symbolic dimension, its power to focus our imagination.

—James Dougherty, *The Fivesquare City*

I turn now to the topic of city planning and urban meaning in the colonial New World. This will set the groundwork for examining the symbolic importance of the new utopian cities of the European interlopers by comparing them to the Mesoamerican cities of the Mexica. Here too we will find both similarity and diversity. The new cities and Indian towns were the symbolic matrix in which the mendicants constructed the "fortress compounds." Understanding the city as symbol will also allow us to examine the religious building at its heart and to see it

within the converging culture and layered metaphors of New Spain. As we shall soon observe, eschatology and symbol are encoded here as well.

THE COSMIC MODEL AND THE IDEAL CITY

Historians of religion like Mircea Eliade propose that human beings have always sought to fix their abode at the center of a world. If the world is to be lived in, it must be consciously and ritually founded, for no human world can exist in chaos and profane space. The discovery or projection of a center point—a "navel" with its corresponding delimitation of the periphery—is thus equivalent to the creation of the world as a sacred event in a divine plan. Such ritual orientation and construction of sacred space have cosmogonic value, for space is efficacious in the measure to which it reproduces the work of the gods, especially that human invention in space: the city.[1]

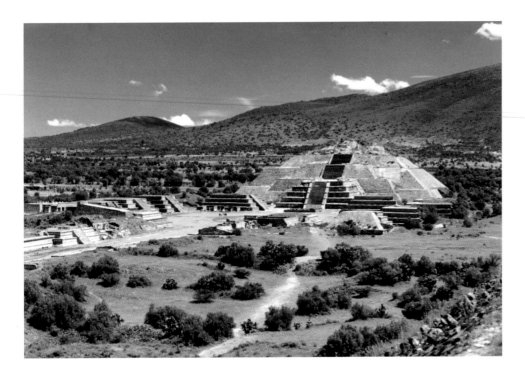

A city plan is more than a conglomeration of functional architecture. Through the purposeful act of founding a city, the urban space and its inhabitants are elevated to a superhuman plane. In prescientific societies, the city was assimilated to a "heavenly" model, and its inhabitants, in turn, became living manifestations of the gods.[2] This was particularly true for the inhabitants of Mesoamerica and for the empire of the Aztecs.

Mesoamericans built their cities and towns to be ceremonial centers, animated by a metaphorical vision of place, and as miniature copies of the natural environment. Plazas and sunken courts represented the primordial sea, the watery underworld; pyramids with their elevated temple houses replicated mountains, with caves and crevices in the mountains acting as portals to a supernatural world.[3] Since the underworld and the celestial world were thought to be where the gods live, access to these realms had to be through either natural or imitative doorways.[4] These symbolic portals were activated by the performance of sacred rituals created by the site-specific formal arrangement of temples, pyramids, atria, plazas, and ball courts.[5] For example, the sacred city of Teotihuacán was the site of the creation of the fifth and last sun. The hagiopolis was planned around a sacred cave and oriented to a crevice in the nearby,

and clearly visible, Cerro Gordo mountain (fig. 3.1).[6] At the time of the Contact, Teotihuacán was sparsely inhabited; it was a ritual site used primarily on state occasions. Yet its straight streets and avenues, oriented toward sun and stars, were hallmarks of Mesoamerican urban planning and the cosmic significance of the city.

Center and periphery—of the Aztec world and empire—were arranged in such a standardized way that it is possible to speak of a quadripartite ordering of the physical universe around an imagined world tree or *axis mundi* that acted as a place of transition or transformation. The axis marked a center within the "four corners" of the universe and was, therefore, a fifth point in sacred geography, the heart of the cosmos (fig. 5.2). This central point was also associated with the hearth of the Aztec home.[7] At this center (and elevated above the plane of the four quarters) resided the fiery sun god, who held the contending elements in balance. The vertical shaft at the center linked the horizontal plane of the terrestrial world with the underworld below and the celestial world above—a formation comparable in many ways to the quincunx cosmology of medieval Christians.[8] The five-point motif became the most familiar Nahua symbol, Ollin, composed of four points—the sign for solar heat—placed about a center (fig. 2.16). The number 5 represents the center, the point where heaven and earth meet. In Nahua mythology, this quincunx is also the precious jewel symbolizing the human heart, the meeting place of opposed principles. This fivefold model of sacred space was not discarded with the arrival of the Spanish—who came with their own "quincunx mania"—but, as we shall see, was recycled and used in a new way for the miniature city of the mendicant evangelization complex, with the cosmic tree-cross at its heart.[9]

While Teotihuacán may have been the occasional ritual city of the Mexica, the real center and capital of their world was Tenochtitlán, founded in 1325 CE (fig. 3.2). At the time of the Conquest, it was the premier urban center of Mesoamerica, the *imago mundi* and heart of the Aztec world's quincunx. The city itself was divided into four large quadrants that radiated out to north, south, east, and west from the ceremonial area of the great temples located on an island in Lake Texcoco. The four *calpullis*, or associated barrios, formed the quadratic domain, while the fifth point was the main temple district "down-

Fig. 3.2.
Tenochtitlán.
Plan attributed
to Hernán Cortés,
*Praeclara Ferdinandi
Cortesii de Nova maris
Hyspania narratio*
(Nuremberg, 1524).
(Courtesy of the
Newberry Library,
Chicago.)

town."[10] Four major highways crossed at the base of the Templo Mayor and extended straight out of the ceremonial precinct, connecting the island city with the mainland. These avenues, carefully aligned to conform to major celestial events, determined the city's primary streets and canals. They were also imagined to extend out to the very reaches of the empire, to the Pacific and Gulf coasts and all the conquered territory. Each of the four quadrants had its own centralized temple that housed deities of the ethnic groups inhabiting that section, as well as a marketplace and an administrative center.

The Aztecs had a sense of choreographed movement through this sacral topography. The appeal of traveling to Tenochtitlán was much like the attraction that going "up to Jerusalem" had for the mindscape of Jews and medieval Chris-

tians.[11] Indeed, the Aztecs imagined their life to be one of pilgrimage through a sacred landscape to the symbolic center. They came to Tenochtitlán and moved through its ceremonial topography to gaze on its *loca sancta* of temples and relics and to participate in its magical power.[12] Aztec cosmology was so similar to medieval Christianity that the friars did not attempt to change it. The natives, in turn, had no difficulty in appreciating Christian urban symbolism. Particularly appealing to the converts was the image of the New Jerusalem of Revelation 21, with its jeweled walls, streets of gold, fruitful and medicinal trees, and living waters. The biblical descriptions of the celestial city easily appealed to the Nahuas' love of order, light, nobility, and beautiful and precious things—baubles, bangles, and beads—as well as evoking their image of a primordial

Fig. 3.3.
Heinrich Bünting,
*Intinerarium sacrae
Scripturae* (Helmstadt,
1582). Jerusalem, the
city at the navel of
the world. (Courtesy
of the Jewish National
and University Library
and the Hebrew Uni-
versity, Jerusalem.)

urban utopia.[13] What is certain is that for Mesoamericans, as for Jews and Christians, earthly cities were modeled after heavenly patterns; they were navels of the earth, pilgrimage centers, and models of ideal living.

In terms of urban planning, Aztec cities had some features of the grid that would later be a hallmark of Spanish colonial cities. But Tenochtitlán may have been atypical in its regularized layout of straight thoroughfares running parallel and perpendicular.[14] As we shall see, the fully orthogonal pattern was imported from Christian Europe and carried with it the weight of other meanings.

GARDEN CITY–TEMPLE CITY

Mesoamericans were, of course, not the only ones to see their land as the navel of time and space. As we have seen, Eden and Jerusalem are for Jews and Christians the two poles of the topos of salvation history, and both locales have entered deeply into the mythic subconscious of Western civilization (fig. 3.3).[15] Both the terrestrial paradise of Adam and Eve and the rebuilt

Jerusalem were embedded in the prophetic literature of the Middle Ages and the Renaissance. "Jerusalem"—in its multiple senses—has always been the metaphor at the center of Judeo-Christian space-time and the teleological goal of human existence; as a reality imagined rather than experienced, the Holy City has always served as a symbol of religious process and not simply of fulfillment or escape from time.[16] Columbus's crusading fantasies, mentioned above in chapter 2, were just one example of this cosmovision.

Similar to the myths of Mesoamericans, Jewish mythology also held that the land of Israel was located at the center of the world, and that the foundation stone of the Temple of Jerusalem represented the very foundation of the world itself. The city and its temple were also a portal, "an awesome place, nothing less than the very gate of heaven" (Gen. 28:17). Like Tenochtitlán, Jerusalem designated the point of intersection and communication between the above world of heaven, the below world of Sheol, and the earth between.[17] In mythic thinking, Jerusalem was "that one place on earth which is closest to heaven, which is horizontally the exact center of the geographical world, and vertically the exact midpoint between the upper world and the lower world, the place where both are closest to the skin of the earth, heaven being only two or eighteen miles above the earth at Jerusalem, the waters [of the abyss] . . . lying only a thousand cubits below the Temple floor."[18] For the Jew, to journey up to Jerusalem was to ascend to the very crucible of creation, the womb of everything, the center and fountain of reality, the place of blessing par excellence.

But in the Hebrew Bible, Jerusalem and its Temple also compose the ideal utopian city of the future. Ezekiel the prophet (sixth century BCE) saw the restored architecture of the city in a mystical vision while in exile in Babylon. An exiled people is one whose spiritual center lies beyond its own physical limits; it has a center only in its shared imagination of a homeland. So the sacred city of Ezekiel was not so much a container as a magnet, a city spatially and temporally far away, experienced not as an enclosure but as a prospect.[19] For other prophets, like Isaiah and the psalmist, not only was Jerusalem the future home of the returning Jews, but it was universalized to become "a light to the gentile nations where all shall call her 'Mother.'"[20] This urban dream would in turn be the inspiration that John the Seer would

use for the Heavenly City of the New Testament book of Revelation and the city that the mendicants would attempt to recreate in New Spain. Jerusalem's geography has always been flexible, and its topography always transportable.

The temple-city imagination that overlay the early Christian and medieval metropolises was the city of the prophets. It was always fed much more by Ezekiel's visionary city than it was by descriptions of the historical urbs, so much so that it is possible to claim that the celestial city iconographically "contaminated" the earthly Jerusalem.[21] This template superimposed on the Palestinian city gained added importance after the first millennium with the coming of the Crusades.[22]

Throughout the Middle Ages, the idealized temple-city on earth might also be visualized as the perfect geometrical form of either a circle or a square—as in the *Beatus* miniatures—or even as cruciform, as Joachim of Fiore had imagined it (figs. 2.6, 2.12, and 4.11).[23] Scholars have further associated the circular temple-cities both with the prestige of the Anastasis rotunda of the Holy Sepulcher and with the later Islamic Dome of the Rock, which had been built on the site of the ancient Jewish Temple.[24] In each case, a selective transference took place from the prototype to the copy, and one could interchange the city for the Temple and vice versa.[25] The Temple, in fact, became a synecdoche for the city. For example, when referring to Constantine's constructions in Palestine as the New Temple, Bishop Eusebius could speak of a new, or newer, Jerusalem that the emperor had set over against Hadrian's pagan city of Aelia Capitolina because of location and similar function.

> So on the monument of salvation [the Holy Sepulcher] was the New Jerusalem built over against the one so famous of old, which, after the pollution caused by the murder of the Lord, experienced the last extremity of desolation, and paid the penalty for the crime of its impious inhabitants. Opposite this, the emperor raised, with rich and lavish expenditure, the trophy of the Savior's victory over death. Perhaps this was that strange and new Jerusalem, proclaimed in the oracles of the prophets [e.g., Ezekiel].[26]

Noteworthy is the fact that the *old* Jerusalem refers not only to the city but also to the temple of Herod, and likewise that the *new* Jerusalem refers not only to Constantine's city but also to the complex of buildings at the Holy Sepulcher—now the prophesied "light to all nations on earth." Already at the early date of the fourth century, a Christian conflation of the historical city, the Temple building, the Christian memorials, and the celestial city is taking place. So interchangeable were the city and its buildings that Jerusalem could be schematically represented by its crenellated walls, by its Temple, by the whole Holy Sepulcher complex, or just by the Anastasis rotunda.[27] The same visual and synecdochical thinking entered into the planning of European cities, which we shall now examine.

In fourth-century Milan, St. Ambrose created an urban blueprint by founding churches outside the city walls in the form of a topographical cross. His purpose was to delimitate the metropolitan territory by means of basilicas distributed in such manner that where their ideal lines were joined, they formed an urban cruciform with his cathedral at the center as a fifth point in a quincunx.[28] We shall soon see that another sacred cruciform of cities was created in New Spain at Puebla.

In the eighth century, Charlemagne had founded a group of royal abbeys each made to resemble a fortified city. They, and the surrounding towns, were icons in brick and mortar that imaged the New Jerusalem as much by their spectacular processional liturgies as by their physical layout.[29] It was precisely during the Carolingian era that the visual-ritual imagination of the monks was stimulated to compose hymns like the "Urbs Beata Jerusalem" and to create the liturgical Rite for the Dedication of a Church, both of which treated the European city or the fortress abbey as a relocated Jerusalem of civic concord and high-quality communal life.[30]

Other churches or towns replicated sacred topography. In the ninth century, the archdeacon Pacifico could call his city of Verona *Minor Hierusalem* because of the several houses of worship that he founded in a "magic circle."[31] The Veronese churches replicated the *loca sancta* of Palestine in their titles: Mount of Olives, Calvary, Holy Sepulcher, Nazareth, and Bethlehem. (The same Holy Land appellations were later applied to edifices in New Spain.)[32] The construction of other medieval shrines continued in the same vein, even though their actual disposition seldom shows conscious geometric form. There was obviously an elastic interpretation of both the structures and

the pattern they formed.[33] More often, it had to do with how they were used in stational worship, which imitated that of Rome or Jerusalem.[34]

Cruciform groupings of religious buildings are even more evident after the turn of the millennium.[35] The location of several churches *in modum crucis* protected a city with an invisible cross and enclosed it within an apotropaic sign. That this practice did not disappear with the Middle Ages is confirmed by the way the Spanish founded their colony of Palermo in sixteenth-century Sicily. The cutting of two perpendicular streets through the existing city, plus the opening of twelve gates in the town walls, visually manifested Palermo's likeness to the celestial prototype of Revelation 21.[36] Something similar would soon transpire in the New World hagiopolises.

JOACHIM'S MONASTIC JERUSALEM

We have already observed the cruciform monastic city that Joachim of Fiore illustrated in *The Book of the Figures*. That urban plan influenced new towns on the Spanish *Duero*, the fighting frontier between Christians and Moors, towns repopulated by monks.[37] Joachim's figure *The New Order of the New People of God Pertaining to the Third Status after the Model of the Heavenly Jerusalem* is a rendering of an ideal monastery, thought out topographically and architecturally (fig. 2.12).[38] Joachim desired that it be located against a mountainous backdrop, as a reference both to Ezekiel's urban vision and, metaphorically, to the contemplative life as an ascent to the celestial heights. It was to be a holistic society analogous to the abbot's idealization of the early Christian communities.[39]

The diagram itself takes the form of a Greek cross mounted on a type of stepped predella base, allowing five upper houses (*mansiones*) and two lower houses.[40] This subtle iconography of cross and base—similar to the atrial crosses—has not escaped the notice of scholars.[41] Each of the seven oratories or *mansiones* within the huge complex has a dedication to a saint, a representative animal, a human body part, and a spiritual attribution.[42] Although separate buildings, the various oratories compose an interdependent and communistic society.[43]

Joachim attempted to design a functional model of environmental planning to support an anticipated existence. A central street connects the different oratories of the married layfolk, the clergy, and the monks in an ascending social order.[44] The entire community was to be isolated from the external world, with access and regress only through the oratory inhabited by the secular clergy. Their oratory would act as a portal to this parklike paradise, and it would be under their care that the laity would live—not unlike the paternal care that the friars would later impose on the natives of New Spain. Based on the two measurements that Joachim offers, it can be assumed that the complex would cover several miles and, in effect, be a hagiopolis, a true cruciform city of God on earth.[45] Joachim drew his dimensions from his interpretation of the measurements of the Heavenly Jerusalem of Revelation.[46] He also took his inspiration from the book of Enoch. Enoch, widely read in the Middle Ages, had also hinted that the New Jerusalem might be rebuilt, not in Palestine, but in some strange and foreign land.[47] And so it was.

JERUSALEM ELSEWHERE

> Jerusalem always existed elsewhere than on its own territory. Because of its highly developed iconography of architecture and representation, and especially because of its highly complex liturgical practices, Christianity has been richer than Islam or Judaism in elaborating other Jerusalems than the Palestinian one.
>
> —Oleg Grabar, *City of the Great King*

In the fifteenth and sixteenth centuries an increasing number of cities, monasteries, and individual buildings claimed Jerusalem status.[48] The eternal city of Rome, for example, had been lauded as a newer Jerusalem ever since the days of the Spanish poet Prudentius, who made the identification in his *Psychomachia*.[49] But the urban theme of a utopian Zion resurfaced with new vigor in quattrocento Rome after the return of the popes from Avignon, especially during the pontificate of Nicho-

las V (1447–55).[50] Nicholas fused Solomonic typologies with the program that his architect Leon Battista Alberti designed for a sacred-secular city to manifest the hierarchical structure of church and state. At the miniature hagiopolis of the Vatican, Nicholas saw himself, through his extensive building program, as surpassing the constructions of Solomon.[51] Later in the same century, under a Franciscan pope, the Sistine Chapel would be built as a replica of Solomon's Temple in its geometry and proportions.[52]

Toward the end of the Middle Ages, it became popular to depict earthly cities like Rome, Florence, or Milan as illustrations for Augustine's *City of God* (fig. 2.1). The actual Italian cities became idealized to act as icons and stage sets of the sacred metropolis.[53] Likewise, in Flemish-influenced paintings of the period, such as those depicting Christ's Crucifixion, the Palestinian city frequently appears in the background, but under the guise of Florence, Siena, or some other European counterpart; these depictions of Jerusalem had much to do with the publication of Bernard von Breydenbach's illustrated travelogue to the Holy Land.[54] These Renaissance municipalities were becoming, for varied reasons, new hagiopolite centers rivaling the ancient centers of Rome, Constantinople, and even Jerusalem itself.[55]

Among the new contenders were the mendicant strongholds of Florence and Milan, while Venice was to be the "New Jerusalem for the restitution of all things," with particular import to the spiritual sons of Joachim of Fiore.[56] A popular legend held that the Calabrian abbot had traveled there in the twelfth century to prophesy the coming of SS. Francis and Dominic, and had even painted their portraits in St. Mark's Basilica.[57] Venice was also a center of mendicant printing: in 1516 the Augustinians started publishing and popularizing Joachim's eschatological writings there.

Venice had also had colonies in Palestine, and the city fathers associated the city with the Holy Land by reading it into Ezekiel's prophecies of conquest. Architectural imitation of Palestinian buildings was another way in which Venice recognized itself in an oriental and biblical light.[58] With the fall of Byzantium to the Muslim Turks in the fifteenth century, Venice took to itself the title of the "mirror of the City of God" be-

cause of its defense of the faith during the Crusades. This civic iconography had much to do with the fact that Venice possessed a relic of the cross, and with the processional liturgy associated with that devotion.[59] The annual procession of the True Cross passed through a cityscape dense with political and prophetic implications, not the least of which was the cruciform basilica of St. Mark.[60] With its great domes imitating the Hagia Sophia of Constantinople, and fronting an immense civic-religious plaza, St. Mark's Basilica became a symbolic center of attention as "another celestial Jerusalem." A biblical trope was accomplished in the piazza by the re-creation of the twin columns from the Temple of Jerusalem and the installation of an open-air loggia, a Solomonic hall of justice.[61]

In the mid-sixteenth century, the French humanist and millennialist Guillaume Postel claimed that Venice was one of the twelve "doors" of an imminent new world order and universal monarchy, metaphorically comparable to one of the twelve gates of the Heavenly Jerusalem. It is worth noting that Postel proposed that Mexico-Tenochtitlán was among the other eleven millennial theocracies.[62] Even from Europe, he was aware of New Spain's larger-than-life status as an experiment in utopian thought, at a refreshing distance from the religious strife of the Old World.

Other cities were also claiming divine status. Bruges, the birthplace of the Last World Emperor Charles V, glorified itself as a new Jerusalem, and the city had particular importance for New World architecture. In the 1480s, the Bruges resident and recent pilgrim from the Holy Land Anselm Adorno built a two-story replica of the Holy Sepulcher. On the lower floor he re-created the niche of Christ's tomb. Elevated above it in a gallery he constructed a fictive hill of Golgotha.[63] The structure was for all purposes identical to the later "Holy Sepulcher chapels" that would be built in New Spain at Tlaxcala, Tzintzuntzan, Meztitilán, and elsewhere (figs. 1.15, 6.13, 1.21); one wonders if some Flemish friar may have remembered it and been instrumental in its relocation to the New World (see chap. 4). I think so.

Bruges could also claim a likeness to the Holy City because it possessed a Jerusalem relic even more important than that of Venice.[64] The relic of the Holy Blood of Christ and the

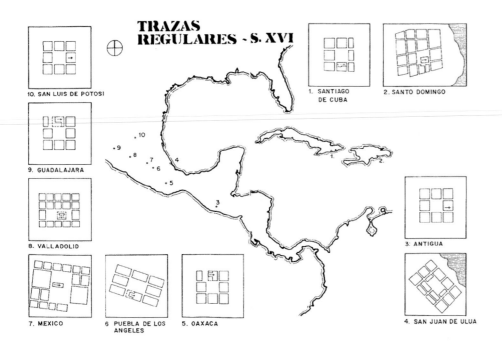

TRAZAS REGULARES · S. XVI

10. SAN LUIS DE POTOSÍ
9. GUADALAJARA
8. VALLADOLID
7. MEXICO
6. PUEBLA DE LOS ANGELES
5. OAXACA
1. SANTIAGO DE CUBA
2. SANTO DOMINGO
3. ANTIGUA
4. SAN JUAN DE ULUA

Fig. 3.4.
First Spanish urbanizations in Mesoamerica. (From Salcedo, *Urbanismo hispano-americano.* Courtesy of the Pontifica Universidad Javeriana, Bogotá.)

procession in its honor were a source of civic pride for the residents of the city,[65] and certainly for the first Franciscan artist to travel to New Spain, Peeter van der Moere of Ghent (later hispanicized as Pedro de Gante, 1480?-1572). Fray Pedro and his royal cousin, Charles V, had witnessed a stage presentation in Bruges about the holy relic in which the future emperor was theatrically represented as reconquering Palestine.[66] Not coincidentally, similar political, spiritual, and prophetic aspirations were already at work in New World city planning and scenography. Later, after his migration to America in 1523, Fray Pedro may well have been the one responsible for the link between the fictive architecture of the Bruges "Jerusalem" and that of New Spain.

The image of these European cities had as much to do with imperial prestige and civic pride as it did with the medieval myth of the westward expansion of the Church, which was resurrected in New Spain by Fray Bernardino de Sahagún.[67] According to this generalized myth, the Christian faith would move relentlessly westward until it encompassed the globe. Christianity began in Jerusalem but quickly spread west to Asia Minor and southern Europe, and from there it continued to travel to the Iberian Peninsula and to the British Isles and Hibernia. With the arrival of Europeans in the Indies in 1492,

the myth of the westward expansion again gained ground; Columbus and other explorers and conquistadors would use it as justification for conquest.[68] We can understand the migration of the city of Jerusalem as part of this myth, that is, that a newer Jerusalem would eventually appear elsewhere in foreign lands, just as the book of Enoch had prophesied. As we saw in the previous chapter, this transportable topography was also part of the prophecies surrounding the Last World Emperor and the Angelic Pope, which had become "best sellers" in fourteenth-century reform-minded Europe.[69] The migration of Christianity and Jerusalem to the American colonies of Emperor Charles V was but a logical conclusion.

Relocating Jerusalem was not, of course, completely original to the mendicant friars or even to Europeans. During the twelfth and thirteenth centuries, the Zagwe dynasty of Ethiopia created a holy city at Lalibela in the Tigre Mountains with its own Calvary, Bethlehem, and Mount of the Transfiguration.[70] The monarchy did so because Ethiopia was the home of the progeny of King Solomon and the Queen of Sheba (also known in Europe as the Sibyl Cassandra), who had supposedly hidden the ark of the covenant there before the destruction of the Temple.[71] The European rediscovery of the African Zion—the home of the mythical Prester John—was understood to be one of the prophetic signs of the times.[72]

THE AMERICAN ZION

> Mount Zion, true pole of the earth,
> the Great King's city!
> God, in the midst of its fortresses,
> has shown himself its stronghold.
> Walk through Zion, walk all round it;
> count the number of its towers.
> Review all its ramparts, examine its turrets.
> —Psalm 48

The ark of the covenant mentioned in the previous section became a metaphor in the New World for the spiritual meaning of the Contact. Writing his memoirs in the 1540s, Fray Toribio

de Motolinía describes the early evangelization of New Spain as nothing less than a new conquest of Canaan, a conquest crowned by the glorious moment when the Franciscans, acting as a collective David, carried the ark into the New World's first temple. By this he meant that the missionaries transported the Christian sacraments into the newly erected convent Church of San Francisco, Tenochtitlán.[73] (Diego Valadés illustrated this metaphorical transport by the twelve Franciscan apostles; see fig. 1.4.) With this single act, Motolinía believed, the Franciscans had converted an ancient pagan city into another holy Jerusalem and the capital of a new Israel. His poetic and spiritual ruminations may have actually had more architectonic truth than appears at first glance.

The founding of Hispanic urban establishments in the New World continued much of the medieval tradition of ritually claiming captured land. However, the actual architectural planning of those urban centers exhibits a significant shift when compared to coeval European cities. Various theories have been proposed to explain the origin of the novel American "checkerboard cities," that is, cities or towns built on the orthogonal grid with streets intersecting at angles of ninety degrees, forming more or less square blocks (figs. 3.4, 3.5).[74]

It has been fashionable to attribute a pre-Hispanic origin to the orthogonal, checkerboard plan of colonial cities, but orthogonal city planning was in fact rare in Mesoamerica.[75] Cholula was a grid city of elongated, not square, blocks (fig. 3.6), and Tenochtitlán had only a few orthogonal elements before the Contact. The four principal avenues radiating from the Templo Mayor of Tenochtitlán did demarcate four barrios, but it is doubtful that, in pre-Hispanic times, the neighborhood streets had been parallel and perpendicular to the avenues.[76] Moreover, even when Mesoamerican city planning was discovered during Cortés's invasion of 1519, the Spanish had already been using orthogonal design for at least fifteen years in their colonial foundations.[77]

It is also highly doubtful that the utopian speculation of the Italian Renaissance could have caused the gridiron pattern, unknown for the most part on the Continent. The Renaissance in Spain, unlike the Greco-Roman and secular-minded version in Italy, was significantly more biblical in its foundational texts and their revelation of God's master plan for humankind.[78]

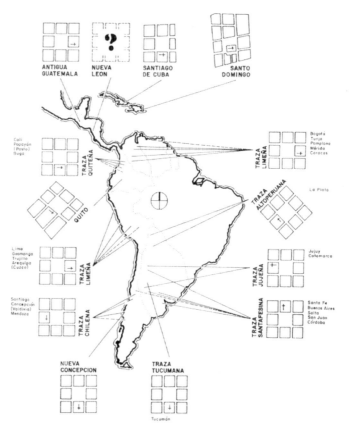

TRAZAS REGULARES ~ S. XVI

Fig. 3.5.
Orthogonal city plans in Latin America. (From Salcedo, *Urbanismo hispano-americano.* Courtesy of the Pontifica Universidad Javeriana, Bogotá.)

That is one reason why, although created in the chronological moment of the Renaissance and using some elements of Renaissance architecture, the urbanizations and churches of New Spain are much more medieval in nature.[79] Besides, the ideal cityscapes of the Italian Renaissance were of circular or polygonal grids, or with their streets laid out in concentric or spiral patterns—schemes that never appear in the New World.[80] Moreover, the influence of urban theoreticians of the grid plan, like that of the ancient Roman architect Vitruvius, is quite late. Vitruvius's writings were surely consulted for the 1573 *Ordinances for the Founding of New Cities,* King Philip II's master plan for founding and laying out new colonial cities, but by then more than two hundred Spanish cities had already appeared in grid form in America.[81] And while it is true that the idealistic concepts of Sir Thomas More's *Utopia* and Plato's

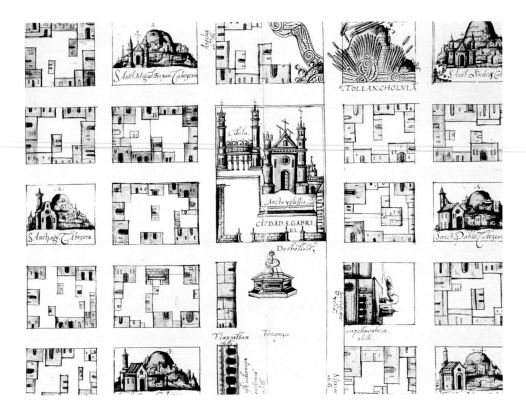

Fig. 3.6.
Cholula. Plan of the
city and Franciscan
evangelization center
according to Gabriel
Rojas, *Relación de
Cholula*, 1580.
(Courtesy of the
University of
Texas, Benson Latin
American Collection.)

Republic were certainly part of the mendicants' urban hopes for the New World, the circular design of their theoretical plans was not.[82]

In the eleventh and twelfth centuries, the reform order of the Cistercians had influenced the design of urban settlements that were springing up around their monasteries, several of which were on the Spanish frontier between Christians and Muslims. The rationale for the Cistercian plan was a desire to create hospice towns—forerunners of the hospice towns of New Spain—for the newly mobile population, and to organize peasant farming near the abbeys. On the spiritual level, there was also a desire to revive the ideals of Roman civilization of antiquity and to anticipate the City of God on earth.[83] These walled cities were designed as a sort of great cloister around which the homes of the townspeople were arranged in a loose orthogonal order. The Cistercians were no doubt influenced in this novel adventure by the eschatological urbanization of a former member of their order, Abbot Joachim of Fiore.[84]

In Spain, there was a long tradition of military architecture, inherited from the Romans, that was preserved in the rectangu-lar layout of new Spanish cities founded during the prolonged period of the reconquest and repopulation of the Iberian Peninsula (from the ninth to fifteenth century).[85] The Spanish cities anticipated by a decade or more the earliest French examples of a regularized city layout, the *bastides* of the thirteenth century.[86] The bastides—elongated rectangles—were commercial cities with one main street catering to the traffic of pilgrims (fig. 3.7). The regular layout of the town provided every citizen a plot of land that fronted the main thoroughfare, affording space for a shop or storefront on the street for commerce. In essence, its function, scale, and design were worlds apart from the idealized utopian cities of the New World.[87] The French bastides must therefore be discounted in any urban paternity.

The regularized layout of late medieval Iberian cities had been founded on the ideals and writings of intellectuals, among them Alfonso the Wise, king of Castille and León from 1252, a poet and musician. In the second of his *Six Partidas*, he codified the plan and organization of a military camp and a new town, with all the psychomachian connotations of a spiritual *castrum*.[88] But a careful reading of his design demonstrates that he found his inspiration in the Scriptures: in the description of the encampment of the Israelite tribes around the desert tabernacle and the ark of the covenant (Num. 2), and in Ezekiel's vision of the Temple and the restored city and tribes of Jerusalem (Ezek. 40). Once again, Holy Writ proved to be the inspiration.

Yet closer to the mendicant enterprise in the New World was the urban design of a medieval Franciscan whom we have already met, the titular patriarch of Jerusalem and devout Joachite Friar Francesc Eiximenis (1340–1409).[89] He was the author of a Last World Emperor prophecy, a book on Joachim of Fiore's three states of world history, and another on the apocryphal archangels and Antichrist.[90] During the days of the reconquest of the Iberian Peninsula, Eiximenis penned a voluminous encyclopedic guide for the faithful entitled *Christendom (Lo Crestià)*, in which he dealt with the ideal political society and with urban planning. It was published in 1499 on the eve of the American evangelization.[91] He proposed a prototypical square Christian city whose parallel and perpendicular streets form a perfect checkerboard design with porticoed plazas, twelve gates, and a dramatic location with mountains acting as backdrop.[92] The urban complex is divided into four

quadrants or barrios (like the four *calpulli* of the Aztecs in Meso-america), each of which has its own church and friary (fig. 3.8). At the heart of the city stands its temple, the cathedral, fronted by a public plaza. But the real novelty of Eiximenis's concept is that this is a mendicant city guarded by friars.[93] With its twelve gates and mountainous scenery, the plan cannot have any model except that of the New Jerusalem of Ezekiel and Revelation.[94] Like St. Augustine and many another medieval theologian, Eiximenis took the celestial urban paradise as the model for every godly city, but he was no idle dreamer. The squared and orthogonal plan was also practical, good for commerce, and for the civic status that the new look would engender.[95]

Eiximenis was active in the city of Valencia in the century after it was captured from the Moors by the Knights Templar. Writing in 1384, he recommended to the city fathers that they re-Christianize the city. Valencia could not be rebuilt *ex novo*, but it could be modified to remove its Islamic appearance. Eiximenis suggested that streets be straightened, that public plazas be added, that dead-end alleys be opened up, and that church towers with crosses be erected to sacralize the skyline.[96] Evidently, he associated twisted thoroughfares, closed alleyways, and a congested cityscape with the Islamic identity of the city.[97] This change in the urban profile was analogous to what his Franciscan confreres would do two centuries later by destroying the elevated *teocallis* in New Spain and replacing the Aztec skyline with recognizably Christian buildings. In Valencia, the city fathers enthusiastically took up Eiximenis's plans for urban alteration, anticipating the New World experience of creating a new sacral metropolis.[98]

One Iberian sacred city created *ex novo* was the orthogonal Santa Fe de Granada built by Ferdinand and Isabella in 1491 as a siege city or *castrum* next to the Muslim city of Granada. From Santa Fe the final crusade of reconquest was launched, and Granada, the last Islamic citadel, was stormed.[99] Its walls fell after the Christian hosts invoked the power of the most treasured "relic" of the Church, the *corpus Christi*, which was carried around Granada in its ark, like Joshua's apotropaic procession at Jericho.[100] (In New Spain, a miniature Santa Fe de Granada was later built as part of a stage set for a Corpus Christi pageant and as the archetypal *spiritual* siege city; see chap. 6.) Nicolás de Ovando, a soldier and New World conquistador, was present

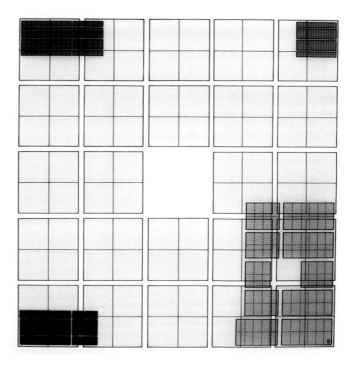

Fig. 3.7. Comparisions of urban designs and size between Spain and America. Darkest blue: thirteenth- and fourteenth-century new cities in Spain and French *bastides*. Medium blue: Mancha Real, Spain, 1537. Lightest blue: Caracas, Venezuela, 1566. (Courtesy of CEHOPU, Ministerio de Obras Públicas y Urbanismo, Madrid.)

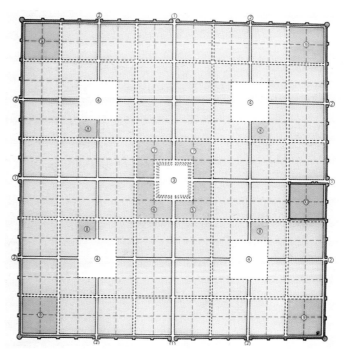

Fig. 3.8. Reconstruction of the ideal city according to Fray Francesc Eiximenis, c. 1383. (1) Principal gates, (2) secondary gates, (3) main plaza, (4) plaza of the quadrants, (5) bishop's palace, (6) cathedral, (7) priests' residences, (8) mendicant parishes, (9) mendicant friaries, (10) palace of the prince. The model is both the prophecy of Ezekiel and the book of Revelation. (Courtesy of CEHOPU, Ministerio de Obras Públicas y Urbanismo, Madrid.)

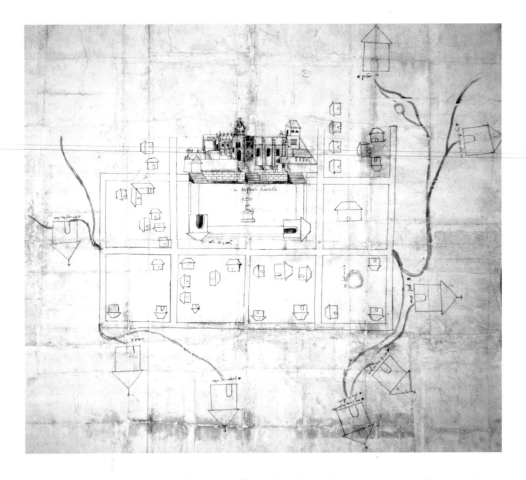

Fig. 3.9.
Huaxutla, Hidalgo.
Plan of the Indian town
and the evangelization
complex with four
posas, ramada, church,
and atrial cross, 1580.
(Archivo General de
Indias, MP-Mexico, 16.
Used with permission.)

at the siege of Muslim Granada in 1492, and a few years later he used Santa Fe as the prototype of his walled city of Santo Domingo on the Caribbean island of Hispañola.[101]

Detailed examination of Latin American cities and Indian towns, designed and constructed by the mendicants, has uncovered the biblical origin of the American urban planning (figs. 3.9 and 3.10).[102] It appears that the New Jerusalem—mediated through the design of Fray Eiximenis—is the model for New World cities, and the biblical sources can be recognized both in the early urban layouts and in the later *Ordinances* of Philip II, which themselves make a veiled reference to the restored city and temple of Ezekiel's vision.[103] In general terms, the division of town lands in the *Ordinances* follows the divine model in Ezekiel (chaps. 40–48), where each of the tribes of Israel is measured out its parcel of land around the Temple. In Hispanic America, the plots around the Christian temple were allotted to the Church, the municipal government,

the Spanish landholders, and the Indian chiefs.[104] The royal decrees of 1573 also quote from Revelation in prescribing that there be a *plaza mayor* from which twelve streets fan out: one street from the middle of each side of the plaza and two streets from each corner. They derive from the twelve gates of Revelation's city and from Beatus's *Apocalypse* manuscripts (fig. 2.6), which illustrate the twelve gates as if they were open porticos surrounding a city plaza—just as in America.[105] In one revealing way, however, the American cities clearly diverge from the royal decrees of King Philip, and they do so on purpose. The *Ordinances* prescribe that the plaza always be an elongated rectangle rather than a square, the Vitruvian proportion of 1:1.5; an elongated rectangle was a very suitable plan for equestrian displays. But American cities consistently prefer square plazas and disregard rectangular ones—a preference that confirms a desire to conform to the biblical archetype rather than to architectural models promoting vain human displays of horsemanship.[106]

An example of this American "jerusalemization" can be seen in the city of Holy Faith, present-day Santafé de Bogotá, Colombia. When the conquistador Jiménez de Queseda founded Bogotá on August 6, 1538—the Feast of the Transfiguration of Christ—he ordered that twelve booths or straw huts be erected around its perimeter "to represent the houses of the twelve tribes of the Hebrews and the springs of water in the land of Elim where they passed, and the twelve stones which they took from the river Jordan and placed in the land of Gilgal as a memorial for their descendants" (Josh. 4:1–5:9).[107] "With the same intent," he says, "did our people erect those booths" in Bogotá, "so that this city might remain . . . until the end of the world."[108]

The Holy City of the future, read in John's vision and in that of his prophetic architect predecessor Ezekiel—and mediated through the writings of Eiximenis—must therefore be a clue for our understanding of the novelty and symbolism of the Latin American city. The analogies are abundant, and they refer both to the city and to its temple with notable continuity from the sixteenth to the eighteenth centuries.[109] Some cities or Indian towns follow this synthesis with more accuracy than others, always making practical adjustments to the local topography and terrain. From present-day aerial photographs these cities may seem imperfect or irregular, but for the colo-

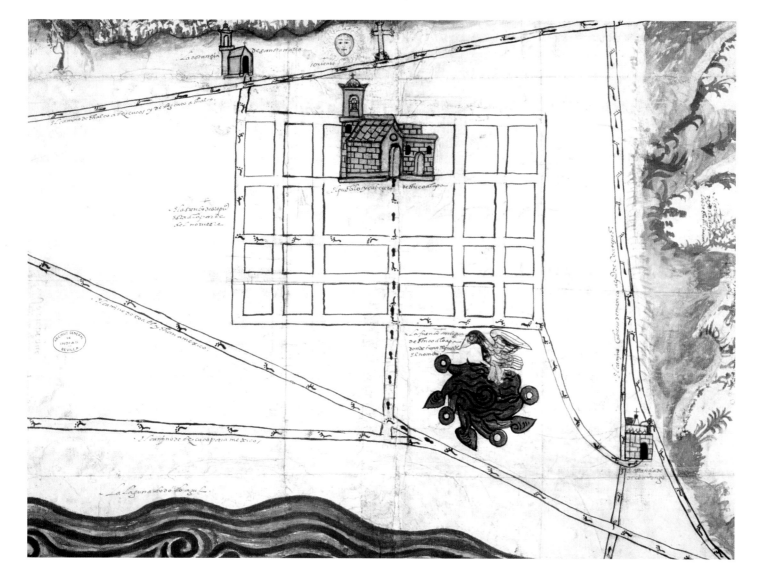

Fig. 3.10.
Chicoloapa, state
of Mexico. Plan of
the Indian town with
humilladero or wayside
cross (with foliate or
feather terminals) on
the entrance road, top.
(Archivo General de
Indias, MP-Mexico, 12.
Used with permission.)

nial impresarios they were imagined as perfectly geometric, the biblical perfection existing more *in essencia* than in measurable, scientific precision. For example, in the New World the cities are rarely walled, probably because walls were deemed unnecessary in pacified territory, but also because—as the prophets had foretold—the restored Jerusalem of the future would need no such material protection, for "God will be a wall of fire around her" (Zech. 2:8).

It is highly likely, then, that the urban-planning treatise employed most frequently in Hispanic America was the book of Ezekiel. It was the only utopian treatise that could be every-

where consulted because it had been brought to the New World by the mendicant friars in illustrated Bibles and Bible commentaries like that of Nicholas of Lyra (fig. 3.11).[110] The invention of printing in the fifteenth century had thus made the construction of surrogate Jerusalems possible even across the Atlantic Ocean.

Transferring Jerusalem to the New World was also accomplished in more subtle fashion. When the great Aztec metropolis of Cholula was Christianized by the Franciscans, it was renamed after the biblical messenger who will announce the destruction and subsequent restoration of the messianic Jerusalem and the rebuilding of its Temple, St. Gabriel the Archangel.[111]

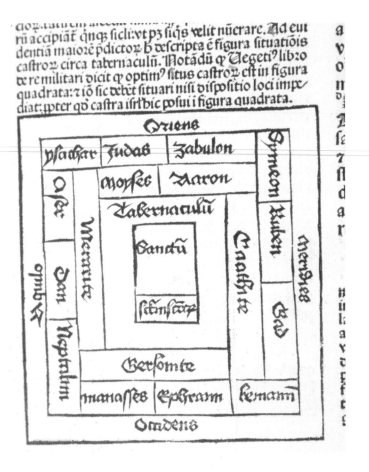

Fig. 3.11.
Nicholas of Lyra,
*Postilla super totam
bibliam* (1503).
Arrangement of the
tribes of Israel around
the desert tabernacle
and ark of the covenant.
(By permission of the
Badè Museum, Pacific
School of Religion,
Berkeley.)

San Gabriel Cholula (Puebla) was divided into seven barrios each with its own church, like the seven churches of the book of Revelation.[112] The oldest street in the city is the Street of the Holy Places of Palestine, along which were built the churches of the Holy Cross of Jerusalem, St. John of Calvary, the Holy Sepulcher, and St. Michael the Archangel.[113] Even just applying a celestial template or naming streets and buildings "in a Jerusalem way" was deemed sufficient to create the sacred replica and transfer its religious power.

ANGELOPOLIS — PERFECTION IN PUEBLA

In the end, New Spain wound up having multiple replicas of Zion both for the Amerindians and for the Spaniards.[114] The natives would have their copies of Jerusalem in the Indian towns

surrounding the mendicant temple complex, while the Spaniards had theirs re-created in Mexico City, with a second in the Puebla valley.[115] Puebla was the only city in the New World that could boast of having been founded for two reasons, one celestial and the other regal. It was to be a city designed *ex novo* for Europeans whose presence in the native utopia was deemed necessary to maintain order and to prevent the return to idolatry. The construction of Puebla of the Angels—*Angelopolis* in Latin—was a much-needed alternative to the increasingly secularized city of Mexico-Tenochtitlán—the New Babylon, as Fray Mendieta would call it. While it was a royal decree that mandated the new urbanization for Spanish colonists, the site of the city was decreed by the angels themselves in 1531 in a dream to Fray Julián Garcés, Dominican bishop of neighboring Tlaxcala.

The episode is worth recounting in full. Note the biblical allusions to the paradise garden and the celestial metropolis.

[One night while the bishop was sleeping], which happened to coincide with the eve of the feast of St. Michael the archangel which the Church celebrates on Sept. 29, he was shown a beautiful, overgrown field, through which ran a crystalline river surrounded by two other rivers that encircled the field. It was populated by a variety of herbs and flowers whose pleasantness stimulated and entertained the eye, and by springs of water that gushed throughout the land. This vision made the venerable gentleman realize that that was indeed the place which the Lord had prepared for the foundation [of the city]. At that moment, he saw some angels descending toward him, who were casting down [measuring] cords to delineate the new town. [Cf. Ezek. 40, Rev. 11.]

He awoke very early and the first thing he did was to celebrate the holy sacrifice of the Mass. . . . Later, he called together the Franciscan friars who were residing in Tlaxcala (among whom was Father Toribio de Motolinía, the guardian) and other distinguished persons, as well as those in his confidence, both Spaniards and Indians. He related his dream and told them that he was determined to go out in person to survey the land, in case he should find the place

that he had been shown in the dream. He went out with his retinue, making his way by heavenly guidance toward the south, and having walked about five leagues and arriving at the spot where the city now stands, he halted where he had a good view all around. There he recognized it as being the same spot as the one revealed in the dream. Turning to his companions, he said: "This is the place that the Lord showed to me and where he wants the new city to be founded."[116]

As the story goes on to relate, Fray Toribio de Motolinía was also instrumental in the founding of Puebla de los Angeles by celebrating the first Mass and directing the laying of the grid. Motolinía, who consistently read the enterprise of the Indies through a biblical lens, understood the founding of Puebla in a spiritual way as well.[117] By naming the metropolis for the angels, he may well have been alluding to the new and growing cult of the seven mystic archangels, whose "ancient" image had been discovered in the Spanish colony of Palermo, Sicily, only a few years earlier.[118]

The City of the Angels! There is no one who believes that there is another than the one in heaven. That city constructed on high is our mother, to whom we all wish to go. Finding ourselves in this valley of tears, we search for it with innumerable sighs because until we find ourselves there our hearts will always be unquiet and uneasy. Such must be that city, it is written, because Saint John the Evangelist saw it and contemplated it in chapters 21 and 22 of the Apocalypse. [Nevertheless,] another city lately founded, and by name called the City of Angels, is in New Spain, in the land of Anahuac.[119]

Because of the region's pleasant climate, Motolinía could also boast of Puebla as a new terrestrial paradise, like the Jerusalem of the prophets but conflated with Eden—a garden-temple-city. The friar further hints that Puebla is to be identified with Jerusalem and the cross. He notes that it was founded in Lent "on the sixteenth of April, the day of blessed Saint Toribio [bishop of Astorga and patron saint of Fray Toribio] who built

the church of Our Savior at Oviedo, in which were placed many relics that he had brought from Jerusalem."[120] Since he had grown up in Oviedo, Motolinía would have known that those renowned relics included two spectacular jeweled crosses frequently displayed to the faithful on holy days: the Cross of the Reconquest and the miraculous, not-made-by-human-hands Cross of the Angels, which had been transported from heaven by supernatural beings.[121] Both crosses are extant and quincunxial in design, with precious stones set at the five points. The pattern of the jewels is identical to that of the City of the Angels, located at an imaginary center, and its four surrounding equidistant sister towns (evangelization centers) identified by Motolinía as Tlaxcala, Huejotzingo, Tepeyaca, and Yzcolán. As he describes it, "The site of the city of Puebla is very good, the area is the best in New Spain, because it has the city of Tlaxcala to the north at *five* leagues; to the west Huejotzingo at *five* leagues; to the east Tepeyaca at *five* leagues; and to the south, in the hot country, Yzcolán [at five leagues?] and Huaquechula at *seven* leagues."[122]

Like the medieval churches and towns that we examined previously and that were set in an imaginary cruciform around a central point, Puebla is the heart of a cross inscribed on the topography of New Spain. As the architects Leopoldo García Lastra and Sylvia Castellanos de García have discovered, here too might be a desire to re-create Joachim of Fiore's monastic utopia, because, in reality, the four evangelization centers form a cruciform only by an imaginative fiction.[123] The distances and the precise cardinal directions that Motolinía indicates existed only in his religious imagination, not in reality. Additionally, if we include the town of Acapetlahuacan, which Motolinía founded in 1551, and the town of Huaquechula at seven leagues distance, we can see a topographical replica of Joachim's cruciform monastery-city in the *The New Order of the New People of God* (fig. 2.12).[124] Like the seven *mansiones* of Joachim's utopian monastery and the seven churches of John's Revelation, the total of seven evangelization towns described by Motolinía replicates the shape of a Latin cross.

Yet another detail may confirm the identification of Puebla with the third age of the spirit, and Fray Toribio may have chosen the city for this reason. The ancient Náhuatl name for the

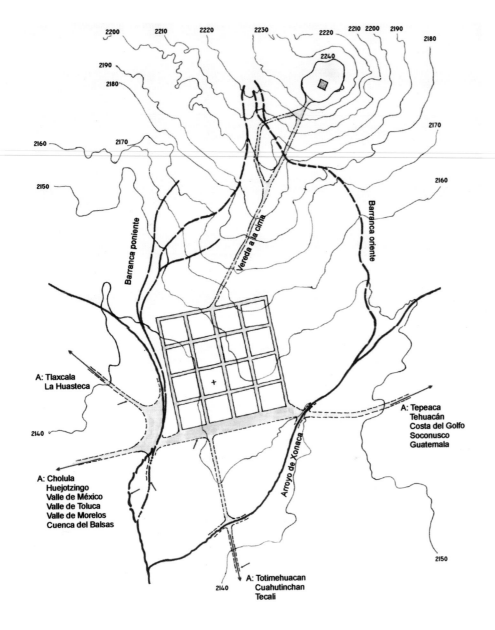

2200 2210 2220 2230 2220 2210 2200 2190

2180

2190

2240

2180

2170

2160 2170

2170

2160

2150

2160

Barranca poniente

Vereda a la cima

Barranca oriente

A: Tlaxcala
La Huasteca

A: Tepeaca
Tehuacán
Costa del Golfo
Soconusco
Guatemala

2140

A: Cholula
Huejotzingo
Valle de México
Valle de Toluca
Valle de Morelos
Cuenca del Balsas

Arroyo de Xonaca

2150

2140

A: Totimehuacan
Cuahutinchan
Tecali

Fig. 3.12.
Puebla. The original
city or *Alto* district and
the Franciscan center
as a "New Jerusalem"
topography; founded
April 16, 1531. (Cour-
tesy of Leopoldo and
Sylvia Garcia Lastra.)

site of Puebla was Huitzilpan, meaning hummingbird or dove.[125] For Joachim of Fiore, the dove of the Holy Spirit was the zoo-morphic personification of the central *mansión* located at the very heart of the sprawling cruciform monastery-city, precisely where Motolinía founded Angelopolis.[126]

Fray Toribio's city of Puebla of the Angels, located at the center of imperial New Spain, with its scenographic backdrop of mountains, ingeniously fulfills the literal requirements of Ezekiel's newer Jerusalem—the ideological prototype of the

perfect city.[127] The original city center of Puebla, called the *Alto* or Heights of St. Francis, suggests that high ground was deliberately chosen for both practical and symbolic reasons (fig. 3.12). The *Alto* later became the mendicant citadel around the convent of St. Francis when the city center shifted in an urban reconfiguration. Moreover, a comparison of the maps of the original city of Puebla and ancient Jerusalem suggests that an even closer replica was created, something like a Hollywood back lot with its literal precision. Someone had known the to-pography of Palestinian Jerusalem firsthand and re-created it in the design of the *Alto* district.[128] At the end of the sixteenth century, the Third Order Franciscans added a monumental Way of the Cross using the streets of the *Alto* as if they were Jeru-salem's Via Dolorosa.[129]

In addition, elements of the Last World Emperor myth were present in Puebla's founding. The coat of arms conceded to the city in 1538 is a shield bordered in red with a golden in-scription from Psalm 91:11—"For God has commanded his an-gels that they guard you in all your ways"—the same psalm quoted at Jesus's temptation on Temple Mount (fig. 3.13). Ap-propriately, two angels or archangels dressed in white albs are ushering a walled and battlemented city down from heaven onto the green, fertile earth—a reference to the descent of the celestial Jerusalem of Revelation 21.[130] Three gates give en-trance to the city, and, by no coincidence, five towers rise above its walls.[131] Above the city, in the azure blue sky, appear the gilt letters *K* and *V*, read as *Karolus V* in Latin but surely a veiled reference to another mythified Holy Roman Emperor—*Karolus Magnus*—who would be resurrected as the Second Charle-magne for the Last Days. Below the green earth, sapphire blue waters flow by, perhaps emanating from under the door of an imagined temple.[132] ("Then I saw water flowing out from be-neath the threshold of the temple to the east"; Ezek. 47:1.) The city of Puebla of the Angels, laid out on the orthogonal grid, was originally planned to be a walled city like the ideal plan of Fray Francesc Eiximenis, but the walls of this hagiopolis, re-vealed in a dream to Bishop Garcés and designed by Friar Mo-tolinía, were never built. It seems that the surrounding moun-tains of fire (the real volcanoes Popocateptl, Ixhuatzihuatl, and La Malinche) and the unseen Lord were deemed to be enough protection, just as Zechariah had prophesied.[133]

Those who trust in the Lord are like Mount Zion,
which is immovable, which stands forever.
Mountains are round about Jerusalem;
so the Lord is round about his people, both now and forever.

—Psalm 125

If American cities could be tangible visualizations of the heavenly or historical Jerusalem, then miniature complexes of buildings, smaller than cities or towns, could also act as surrogate Zions. Small does not equal insignificant, because miniatures always tend toward exaggeration, selecting and magnifying some detail for their own purposes.[134] The Way of the Cross—an imitation of the Via Dolorosa of Jerusalem—was one such invention transported from the Holy Land to Iberia in the fifteenth century and thence to the New World. In Spain, the stational practice was first introduced in cities and towns that, not by chance, possessed Franciscan convents. The individual stations, *calavarios*, evolved from the *humilladero* chapels, which were the ubiquitous large crosses placed on the outskirts of towns, usually on a promontory (fig. 3.10).[135] As we saw above, the *Alto* of Puebla became the stage set for one such Way of the Cross.

Other miniaturizations of the Holy Land were more ambitious, and it is significant that they were being constructed in Europe by mendicant friars just as the evangelization of Mexico was beginning. The *sacro monte*, a type of spiritual theme park with theatrical shrines portraying holy scenes, first appeared in northern Italy in the late fifteenth century and grew in popularity during the sixteenth and seventeenth centuries; it directly influenced Latin American architecture and popular religiosity. *Sacri monti* theme parks were also initially Franciscan inventions with diorama-like stages that featured themes of the Passion of Christ or the life of the father-founder, St. Francis.[136]

Around 1486 Fray Bernardo Caimi, an Observant Franciscan friar who had served as patriarch of the Holy Land, chose Varallo in the Piemonte foothills to become what he called the "New Jerusalem." Crowning a mountaintop rising five hundred feet above the Mastallone River, it was an ideal natural location

Fig. 3.13.
Puebla. Royal shield and coat of arms of the city. (Courtesy of Leopoldo and Sylvia Garcia Lastra.)

for a replica of Mount Zion (fig. 3.14). Caimi's travels in Palestine had given him a thorough knowledge of the topography there and had convinced him that the Ottoman Empire would soon annex the Holy Land, which it did in that crucial year of 1517 (see chap. 2, "The Final Colossus"). Caimi was the first to think of expanding what amounted to the Via Dolorosa stations into a series of separately housed stage sets with life-sized sculptures on a hilltop. With the blessing of Pope Innocent VI, work began in 1493 and was finally completed in 1587. Caimi's purpose was to provide an alternative to the increasingly dangerous pilgrimages to the Holy Land. The project was also intended to have a liturgical and catechetical value: processions

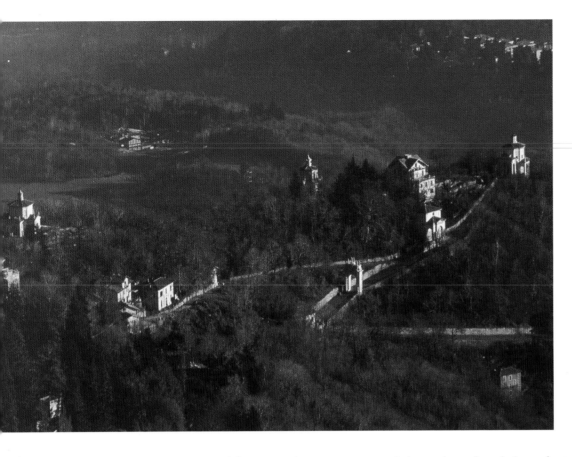

Back to Italy. The first station to be constructed at the Varallo re-creation was a "Church of the Holy Sepulcher," with a hermitage or aedicule of the Holy Sepulcher, and a "Chapel under the Cross"—similar to several Mexican open chapels that we shall investigate and that acted as shrines for an image of the dead Christ (fig. 6.2).[140] This was followed by the chapel of the "Mount of Olives," constructed above a diminutive "Valley of Jehoshaphat."[141] As we saw in chapter 2, both the Mount of Olives and the Valley of Jehoshaphat have eschatological connotations as outdoor theaters for the Last Day events.[142]

By the time of its completion in 1587, the *sacro monte* of Varallo was an accurate re-creation of the Holy Land, owing in part to Caimi's expertise and to the proliferation of guidebooks and maps published by pilgrims upon their return.[143] Some of those travelogues made their way to the New World.[144] In addition, we know that pilgrims brought back souvenirs that could have acted as iconographic models for European imitations.[145] Pilgrims purchased wooden models of the chapel of Golgotha, the church of Bethlehem, the Mount of Olives, and even the Valley of Jehoshaphat.[146] They also had a fancy for pacing out the distances between the Holy Places with great care and recording the measurements. Such detailed mementos could easily be used as plans and elevations in fairly accurate reconstructions of surrogate Jerusalems.

Another Observant Franciscan began an even more scientifically accurate *sacro monte* at San Vivaldo, around 1516, using precise topographical measurements that someone had taken in Jerusalem.[147] Similar to the *Alto* of Motolonía's Angelopolis, Vivaldo attempted to be a map of the Palestinian Holy City superimposed on a site in Italy, with chapels set at precise locales and distances as in Jerusalem, thus transferring the holy powers residing in the prototype. Later *sacri monti* appeared throughout northern Italy, Spain, Poland, Portugal, Brazil, and in Mexico at Amecameca, where the cave of Fray Martín de Valencia is still to be seen.[148] In almost every case, Observant Franciscans either instigated the project or were involved in some way.[149]

Fig. 3.14. Varallo, Italy. View of the Franciscan Holy Land re-creation, the *sacro monte*. (Photo by author.)

with song and prayer connected the various chapels in such an order that the pilgrim would relive the events of Christ, the Virgin, or St. Francis at one and the same time. By visiting the events through meditation (like perambulating through the friary cloister in New Spain), one experienced them in the here and now.[137]

The Franciscans, of course, had a particular interest in the Holy Land. During the Fifth Crusade, Francis of Assisi had visited there with his barefoot friars, and when he returned to Europe in 1221 he left behind a small band of followers. The friars were later driven from the greater part of the territory, but through constant negotiations with the Islamic rulers, they managed to maintain a presence at a few of the sites. This was the start of what was to become the Franciscan custody of the Holy Land that was officially established in 1342. From then on the Franciscans—whose symbol became the Crusader cross of Jerusalem—made it their job to be the special caretakers of its *loca sancta* in the hopes of a final liberation.[138] A similar in-

In Hispanic America, the surrogate hagiopolis likewise took on the aspect of a great open-air stage set similar to the *sacri monti*. The New World Jerusalem was complemented with scenographic additions to create a realistic topography. Even today a *calvario* chapel invariably stands outside the city or town on a hill or mountaintop nearby (fig. 7.5). Indeed, erecting calvaries was one of the first tasks of the friars in Mexico.[150] In that way, the friars replicated the hill of Golgotha in its topographically correct location: *outside* the (imaginary) walls of the American Jerusalem. The processional line from the town plaza to Golgotha still acts as a *via sacra* within the sacred cityscape. *Humilladero* chapels (a version of the posa chapel) along the way mark the locations of Christ's falls on this American Via Dolorosa.[151] The scenography functions particularly well for processions during Holy Week and thereby includes the town liturgically as part of the religious landscape of a *sacro monte*,[152] and so Jerusalem is still overtly re-created and ritually inhabited in Latin America at least once a year.[153]

The material treated in this chapter demonstrates that the Mexican mendicant constructions continued in the line of medieval thinking regarding surrogate Jerusalems. The Latin American city design had its inspiration in the Holy City of the historical and celestial Jerusalems as known from the prophecies of Ezekiel and Revelation, wedded to the practicalities of urban realities, both Mesoamerican and European. Like the European *sacro monte* parks of the friars, the American city and town were part of a sacred landscape with topographical references to the real and ideal Jerusalem, confirmed by mimetic liturgical processions and conflated with pre-Hispanic sacral spaces. Like the cities of the Mexica, it was a hagiopolis and cosmic model, the navel of the world. Specific chapels within the cityscape of New Spain—calvaries, wayside crosses, hermitages of the Holy Sepulcher—localized the identification and hinted at the transcendent meanings given to one locale or the other.

As well as being symbolic, the urban plan was eminently practical and commercially functional, especially in the Indian pueblos gathered around the evangelization compounds. Like the antecedents in reconquest Spain, the new orthogonal layout with open straight streets and centralized markets (plazas) made evident that this was the imprint of European civilization (*política*) and Catholic faith on the American enterprise. Its religious edifices, seen high on the horizon, stamped a new skyline and the new metaphor of the sacred fortress on the Mesoamerican reality. The novel auditory experience of the pealing of bells, marking Christian time and the hours of prayer, called the baptized body politic to sights and sounds both familiar and new. Paraphrasing the words of Psalm 48, which the friars read weekly in their breviaries, "the Great King's city had become the new pole of the earth." By an architectural, theatrical, and liturgical fiction, Jerusalem had been relocated to the New World.

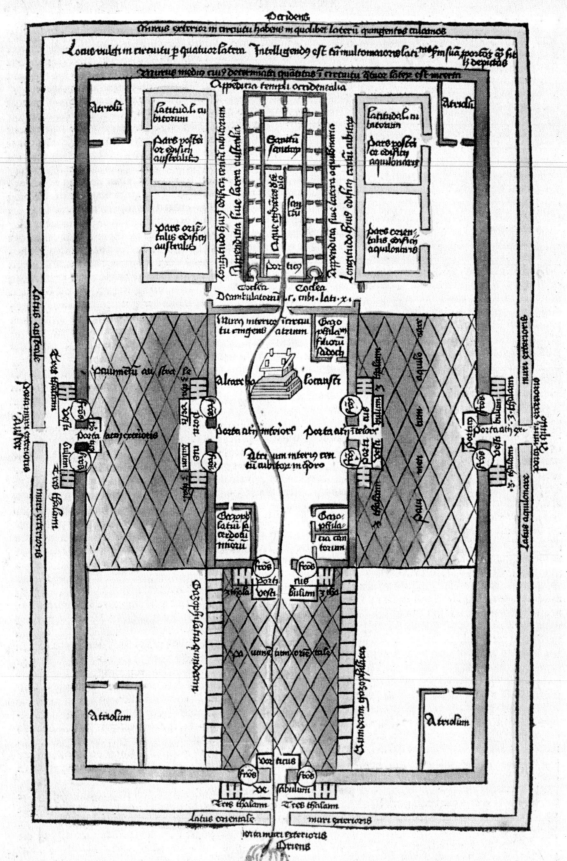

⁴ The New Temple in the New Zion

In the previous chapter, we saw that the American city could replicate the Jerusalem of Scripture and prophecy in a poly-semantic way on the levels of symbol, copy, and substitute. The missionaries accomplished this replication by way of the ground plan, the use of gateways or chapels dedicated to re-vered Jerusalem events or topographical details, and by di-mensional duplication. By these means, the New World ar-chitects made references to the city of David and Solomon, to the Jerusalem that Jesus knew, to the eschatological urban visions of Ezekiel the prophet and John the Seer, to the Jeru-salem of the Crusaders, and to what Columbus had called the "Holy House in captivity." Following this line of thought, I would now like to suggest that if the New World city is a reproduction of ancient/future Zion, then the Christian build-ing at its heart is a reproduction of Jerusalem's Temple. We should remember that it was also a replacement for the temple of the Aztecs and the temple's outdoor cult, and so it was logical for the biblically minded friars to replace a temple with another Temple for the Lost Tribes and New Israelites.

TEMPLES

THE TEMPLO MAYOR

The mendicant missionaries' first deed was to destroy and re-cycle the materials of the Aztec temples. Countless chroniclers report how the neophytes were enlisted in the long job of re-moving the monuments of teoyoism from public view. It was an undertaking that took decades to accomplish.

The Aztec temple had been a microcosm of the universe just as the Mesoamerican city had been. It was a living myth en-fleshed in architecture and the site of the consummate cosmic

Fig. 4.1.
Tenochtitlán. Model
of the Aztec sacred
precinct, the twin
temples of Tlaloc
and Huichilopochtli,
the circular temple
of Quetzalcóatl, and
the ball court. (George
Kubler Archives, Yale
University.)

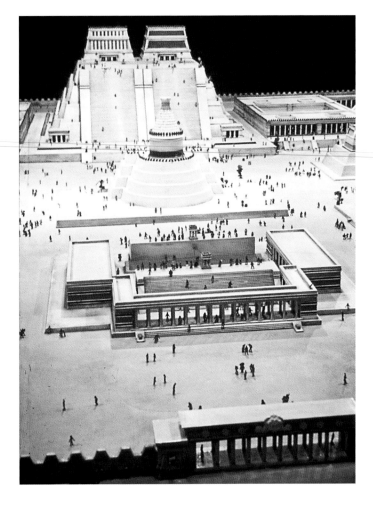

drama; it was not only a visual expression of cosmogony and es-chatology but also the primary center for the ritual activities of the leaders whose charge it was to maintain the Fifth Age.[1] The Templo Mayor at the center of Tenochtitlán was the "sacred pivot" of the four quarters and the whole society.[2] It was also a fivefold model of the cosmos, the state, and the way of the gods. Like Jerusalem at the heart of the biblical cosmic quincunx, the Templo Mayor acted as an orderly arrangement of symbolic and metaphorical components around a central axis: the cos-mic mountain as pyramid, astronomical events and cosmic time, human sacrifice, agricultural renewal, and sacred kingship.[3] The power of this spatial concept extended, of course, into the Aztec images of cosmological time, as in the previously mentioned "five suns." The temple and its offerings—which came from the four corners of the Aztec Empire and as far away as the Ameri-can Southwest—constituted a miniature map of the cosmic order and imperial power.[4] The state validated itself by express-ing its indissoluble connection with the sacred universe, just as the Spanish Empire of Charles V saw itself as the prophesied in-strument of Divine Providence.

At Tenochtitlán, a great patio or atrium enclosed the sacred buildings of sacrifice within crenellated walls and colonnaded porticos—not unlike the Temple of Jerusalem and the later evangelization complexes. The great Templo Mayor (fig. 4.1), a pyramid, had at its summit two temple houses and corre-sponding altars to the gods Tlaloc and Huichilipochtli. Oppo-site them, on an east-west axis, stood the temple of Quetzalcóatl. A sacred dance floor, a ball court, and a skull rack completed the core ensemble and constituted a ritual theater for perform-ers and spectators.[5] All these would be torn down in the 1520s, and the sacred precinct would become the *zócalo* or central plaza of the viceregal capital. Successive cathedrals were built on top of nearby temples and altars, whose platforms can still be seen today in the cathedral's subbasement. Architectural substitu-tion for the Aztec temples was carried out throughout Meso-america even while the friars continued to build *templos*, now christianized temples that were at the same time replicas of a biblical temple.

JERUSALEM APPROPRIATED

Even before they created environments that attempted to cap-ture the mystique of Zion and transport it elsewhere, Christians had appropriated the layered meanings of Jerusalem by way of allegorical interpretation of the Bible, liturgy, and the symbol-ism they read into church buildings. This concern to concep-tualize Jerusalem continued in the New World.

The allegorical typology of Christian buildings goes back to the writings of the early church fathers, and it is a constant theme throughout the Middle Ages.[6] Certainly a prime mover in the "jerusalemization" and dramatization of Christian wor-ship was the Spanish bishop Isidore of Seville (d. 636), who used the extended metaphor of a new Zion and Jerusalem for the Christian building, its furnishings, and its liturgical activi-ties.[7] Liturgists of the Carolingian period continued in the same

typological vein,[8] but it was William Durandus, the thirteenth-century bishop of Mende, who most developed the symbolism and exerted a wide-ranging influence on the medieval desire to make the Christian building conform to Old Testament precedents.[9] His popularity was long lasting, and he was frequently quoted by Columbus and the mendicant chroniclers of New Spain. Durandus's liturgical *Rationale divinorum officiorum* was printed in the early sixteenth century and shipped to the colonial Americas.[10]

One of the most significant allusions to Old Testament elements had been the Rite for the Dedication of a Church and its accompanying hymn, "Urbs Beata Jerusalem," as we noted in chapter 2.[11] In sixteenth-century Mexico, the hymn was translated into Náhuatl by Fray Bernardino de Sahagún and his native scribes in the *Psalmodia Christiana* and converted into a set of popular Eastertide dance songs. We shall return to examine it in chapter 6.

THE SEVERAL TEMPLES

Many factors went into facilitating use of Jerusalem Temple iconography in Spanish America. As previously mentioned, the Franciscans had a vested interest in the holy places of Jerusalem because they were its custodians; also, one of their own had created drawings of the Temple that were well known in Europe and America. But there are additional reasons for the mendicant interest in the edifices of Zion.

First of all, in Mexico the friars called their new buildings "temples." The designation *templo* (from the Latin, *templum*) has a long tradition in southern Europe and especially in Iberia.[12] From the time of Isidore of Seville, the more common designation for a Christian cultic building had been *templo* rather than *iglesia* (Latin, *ecclesia*), and it continues to be so today in Latin American countries, principally Mexico. Therefore, there was a certain predisposition to Temple imagery in the ecclesiastical vocabulary itself.

Second, the New World evangelization complex with its *templo* was frequently erected on the same site, same platforms, or same foundations as the Aztec temple—and functioned as a substitute or "exchange," as Gregory the Great had said

(quoted above, in the introduction). The same stones were commonly reused.[13] The new buildings continued in the same topographical and spatial relationship to the native urban population and continued to be the *axis mundi* at the heart of the Christianized Nahua-Hispanic city.

Third, as we saw in chapter 1, parts of the New World buildings for evangelization copied the old pagan temples. An open chapel, or a balcony chapel, was often raised above eye level, just like the temple houses on top of the pyramids. The friars' replacements maintained selected elements of the past, allowing for a familiar, although altered, spatial continuity. The use of open chapels with aspects of stage houses (*mansiones*) also exploited a form of Aztec domestic architecture, the *calli* or house.

Fourth, the temple-with-corral as a multipurpose place for outdoor worship, processions, and educational activities was an eminently practical solution for dealing with huge numbers of neophytes. Those multitudes could not have been accommodated indoors. What better model could there be for outdoor congregational space than the biblical building designed by God himself, the Jerusalem Temple with its patios, porticos, altars, and auxiliary buildings? Utilitarian architecture was joined to a religious ideal and a venerated prototype.

Fifth, the Aztec cult of blood and sun had been misunderstood by the missionaries as a demonic parody of both Jewish animal sacrifice and the Catholic sacrifice of the Mass. For the evangelizers, a correct notion of the theology of sacrifice was absolutely necessary for understanding Christ's redemptive act. By replicating a Christian version of the Jewish Temple, the friars could thereby rehabilitate the notion of sacrifice in a biblical way, relating it now to the blood of the Lamb of God poured out on the "altar of the cross." They could create a new, "purified" notion of sacrifice, and co-opt the metaphors of blood, heart, and sun for their evangelical purposes.[14]

Sixth, the ancient Jerusalem prototype had also incorporated the seat of civil government in the person of the king and had included in its complex not only cultic objects but also secular auxiliary buildings such as a palace and a court of law. The most famous of those ancillary spaces was Solomon's Hall of the Forest of Lebanon, a sort of multicolumned open chapel or mosque of the tenth century BCE; its description was known

in the New World. In a like way, acting in the name of the emperor and pope the friars fulfilled the functions of judges and civil officials, and thus their copies of the Hall of the Forest possessed regal connotations as "Solomonic" or "royal chapels."[15]

Seventh, at the time of the Contact, "blueprints" for the Temple of Jerusalem and the Hall of the Forest were readily available in the printed books that came in the mendicants' luggage and were at hand in the conventual libraries for use by the native builders and impresarios. The printed plans and elevations allowed a common, easily understood diagram for the evangelization complexes throughout Mesoamerica. But it was a diagram that could be adapted to regional, topographical, and economic circumstances because it was reproduced *in essencia*, not in strict formal detail. A copy—as we shall soon see—need only replicate the prototype in its most schematic form.

Finally, the Bible credits God himself with being the architect of the original Temple and the divine inspiration of the utopian city of the future. This exalted prestige of the Jewish house of worship and its eschatological associations made it a perfect symbolic structure for the utopian dreams that the friars held for the New World "Jews," or for Joachim of Fiore's "new Israelites."

This Temple is precisely the prototype for the mendicant open-air evangelization complex in New Spain. Robert Mullen was the first to suggest that there had existed a common model in Mexico that gave the architectural creations their remarkable unity,[16] and Gauvin Bailey has more recently asserted that the copying of architectural treatises was part and parcel of missionary architecture from the start. But slavish reproduction was not the aim. "It was what one did with the copy that was important, since copying was always considered an interpretation."[17] Therefore, it is perfectly plausible that there was one common prototype for all the evangelization complexes and that the model was one of the several temples of Jerusalem. By using the word "temples" in its plural form, I wish to include buildings that were conflated with the Temple and to suggest an elastic sense of the word that includes all the multiple levels of association and metaphor. Let me outline briefly how those several temples evolved over time.

The *Temple of Solomon* (tenth century BCE), whose dimensions and decoration were dictated by the Divine Architect, was the archetypal building in stone and mortar and the seat of the Jewish sacrificial cult, calendar, and pilgrimage. By coincidence, it was also spoken of with metaphors identical to those used of the Aztec temples: as center with corresponding periphery, as foundation stone of the universe, and as cosmic navel and umbilical center (fig. 1.24).[18] Although not at the center of a lake like the Templo Mayor of Tenochtitlán, the Temple, according to Jewish legend, sat above the primeval waters of chaos over which the spirit of God had hovered at Creation.[19] The building was interpreted in the Middle Ages on the four levels of history, typology, morality, and anagogy; and both Jews and Christians had reconstructed it on paper.[20]

Ezekiel's visionary temple (sixth century BCE): After the destruction of Solomon's Temple by the Babylonians and the deportation of the Jews, the prophets resurrected the hope of the people by announcing the future rebuilding of Jerusalem and its cultic center. Ezekiel, writing in exile, created the spectacular visual images that John the Seer would later develop in the Apocalypse: the measured city, its temple, and the garden aspects of fruit trees and rivers. Some aspects of Ezekiel's architectural design, like the four corner buildings, were incorporated into Herod's temple five centuries later; but for the most part, the prophecy was shrouded in mystery.

Medieval exegetes had great difficulty interpreting Ezekiel's often illogical text. Gregory the Great despaired of its confusing measurements and considered it a mere allegory that could never be built;[21] the Venerable Bede had similar difficulties. The twelfth-century Augustinian canon Richard of St. Victor was the first to render it plausible as architecture (fig. 4.2), but it remained to the Franciscan Nicholas of Lyra in the fourteenth century to make architectural sense of the text and create real plans and elevations (figs. 4.21–24).[22] In later centuries, Ezekiel's utopian city and its temple became a popular iconographic inspiration for both sacred and secular architecture; and in the previous chapter, we saw how the text was used in urban planning.[23] In Spain, it even became the model for the Escorial palace monastery of King Philip II, son of Charles V.[24]

A *second temple* was built after the return from the Babylonian captivity around 515 BCE by King Zerubbabel. Even though it was a meager structure, it generated a great deal of literature in the Bible, and the Church would later use it meta-

phorically in the liturgy of the Advent season.[25] The prophets of the Exile had also spoken of a messianic king who would accomplish the rebuilding, and these prophecies were later applied to European rulers, notably Emperor Charles V and King Philip II of Spain, each of whom was lauded as a new Solomon or Zerubbabel the temple builder.[26]

But Herod's temple (16 BCE to 70 CE) is usually spoken of as the real Second Temple (fig. 4.3). This was the temple known to Jesus and spoken of in the New Testament. Built on a grander scale than Solomon's, and incorporating some of Ezekiel's innovations, it had such features as covered porticos, monumental propylaea entrances, and structures in the four corners of its atria similar to the placement of posas. As with the other temples, medieval exegesis saw in its details multiple levels of meaning and typological foreshadowing.

The temple metaphor of the body: On the level of metaphor, Jesus had used the temple to speak of his body and his resurrection in three days.[27] According to the early church, this reference to the destruction of his corporeal shrine was a foreshadowing of the Roman destruction of 70 CE. As we saw in the introduction, the human body became one of the root metaphors of Christianity, and it could lend itself to multiple understandings. It hints at the tabernacle of the desert pilgrimage and relates to the transportable availability of the incarnate God. The body-temple metaphor also left its mark in the architecture of the medieval cathedrals, which inscribed the human body of Christ by their cruciform ground plans.[28] The cross-shaped cathedrals were representations as much of an anatomical model as of the intersecting beams of the cross. Further, the Church's liturgy has always employed the same metaphor in speaking of the baptized person as a "temple of the Holy Spirit." In words seemingly directed to Nahua-Christian Mexico, St. Paul was the inspiration: "The temple of God has no common ground with idols, and that is what we are—the temple of the living God" (2 Cor. 6:16). This "bodily temple" afforded friars like Motolinía moral lessons and exhortations to the newly baptized natives.[29] The friars could also use Prudentius's phrase "the temple of the heart" to make salutary associations with Aztec heart sacrifice and elevate it to a new spiritual level.[30]

The book of Revelation's temple of heaven, a metaspatial building, is problematic. In chapters 11 to 15 of Revelation, John the

Fig. 4.2. Richard of St. Victor, *Richardi sancti victoris doctoris preclarissimi omnia opera* (1518). Elevation and cross-section of the gatehouse of the Temple of Jerusalem, according to the prophet Ezekiel. (Courtesy of the Biblioteca Lafragua, Puebla.)

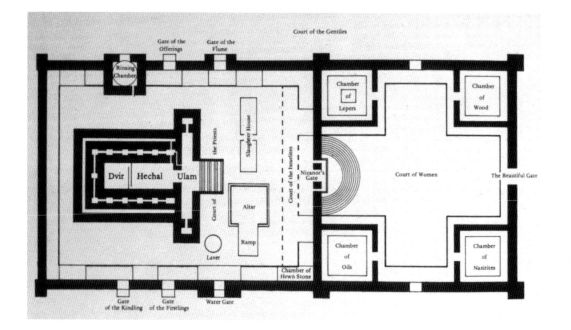

Fig. 4.3. Jerusalem. Plan of the Temple of Herod, first century BCE – 70 CE. (From Comay, *The Temple of Jerusalem.* Used with permission.)

Seer mentions a temple in heaven with outer and inner courts, and an altar that is at one and the same time the altar of holocausts and that of incense.[31] But there is no temple in the New Jerusalem that descends from God in chapter 21. In that transcendent event, it is the Lamb himself who is the city's shrine. By then the whole city has become sacred space and acts as an open-air temple, precisely like the colonial hagiopoli in Mexico.[32]

Constantine's Holy Sepulcher as the new temple: With the destruction of Herod's temple by the troops of Titus (70 CE) and the annihilation of the Bar Kochba uprising (132 CE), the

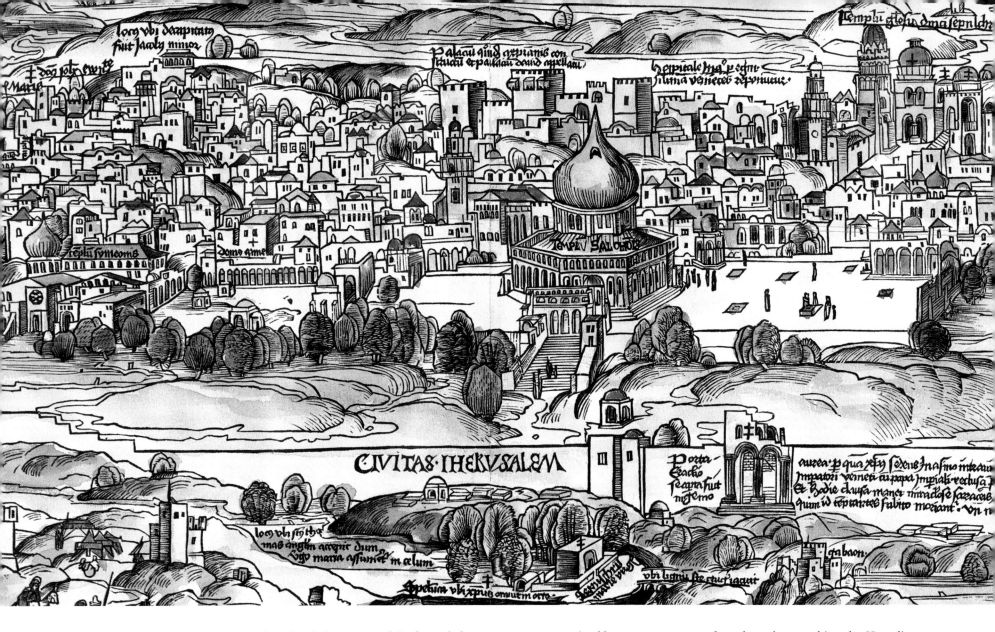

Fig. 4.4.
Bernhard von
Breydenbach,
*Pilgrimage to the Holy
Land* (1486). Bird's-eye
view of Jerusalem
showing the Al-Aqsa
Mosque (*Templum*) at
the left, the Dome of the
Rock (*Templum*) at the
center, and the Holy
Sepulcher at the upper
right. (Terra Sancta
Arts, Ltd., Tel Aviv.)

great esplanade of the House of God was left to serve as an immense base for a statue of the emperor Hadrian and a temple dedicated to Jupiter. In Constantinian times, these pagan accretions on Temple Mount were destroyed under the newfound influence of the Church and its alliance with the empire, and the site lay in ruins as the garbage dump of the city.[33] For Bishop Cyril and the Christians of Jerusalem, the temple had migrated across town to the western side of the city (fig. 4.4). The real temple was now the Holy Sepulcher complex, which included the Martyrium basilica, the rock of Golgotha, the Anastasis rotunda with the tomb aedicule, two patios or atria, and a monumental propylaeum gateway. The Holy Sepulcher, of course, was

itself an attempt to copy loosely and to outshine the Herodian temple, which it mirrored by being occidented (oriented to the west) in the same manner and by being placed in a corresponding position opposite the esplanade.[34] It also took to itself many of the Jewish relics that had been housed in the Temple, as well as its mythic meanings: the umbilical center of the earth, the place of Adam's death and burial, and the foundation stone of the world. Both buildings were dedicated on the Feast of Tabernacles, both possessed a Holy of Holies, and both were known as the "Temple of the Lord."[35]

The Dome of the Rock and the Al-Aqsa Mosque: We shall see that the process of Christian syncretism and conflation contin-

ued with the Crusaders. It is they who began a confusion that European Christians and Jews would follow when they identified not one but two Islamic buildings with the ancient Temple. The mendicant friars later used selected aspects of these structures on Temple Mount as models for Mexico's evangelization complexes.

Joachim of Fiore's rebuilt temple of the third status: Joachim is circumspect regarding this matter, but he hints that the Jerusalem Temple must be rebuilt so that Jews can briefly restore the animal sacrifices of the Old Law before their final conversion by the twelve apostles of the third state.[36] No doubt Christopher Columbus was following a Joachite line of thought in speaking of the rebuilt shrine.

European copies of the temples: In the end, when the Temple or a surrogate Jerusalem was replicated outside Palestine, the patron and architect would have all the above exemplars to choose from. History, metaphor, conflation, and even outright error entered into what the Middle Ages and the Renaissance understood as God's Holy House on Zion, and architects worried little about historical precision in our sense of the word. As the *sacri monti* demonstrate, surrogate Jerusalems and their edifices were favorite architectural expressions of the Franciscans, the official custodians of the Holy Land and beneficiaries of pilgrimage. The pope had entrusted to them the care of the *loca sancta*, and they were the promoters of reproductions worldwide.[37] And initially it would be the Franciscans who would transport the Temple to the American Zion.

Transporting the Topography

In the Middle Ages, architectural copying was not literal reproduction. On the subject of medieval architectural replicas, the most vital contribution comes from Richard Krautheimer in his immensely influential and seminal essay "Introduction to an Iconography of Medieval Architecture."[38] In this essay Krautheimer maps out certain genres of architecture based on the analogy of types or genres of painting. Architectural genres were often determined by functions, such as liturgy, or by their dedication to a particular saint or a theological concept. For example, churches dedicated to the Holy Cross were under-

standably cross-shaped; hilltop churches were often dedicated to St. Michael the Archangel or another angel on high, while centralized structures were consecrated to the Virgin Mary, or used as mausolea or baptisteries—inheriting the ancient Greco-Roman associations of circles, spheres, and the afterlife.[39]

More important, Krautheimer joins the notion of symbolism both to the intentions of the patron and to the response of the medieval onlooker. He notes that certain ancient and venerable structures were frequently copied in medieval architecture, not with verisimilitude to produce an exact reproduction, but approximately and vaguely, with just enough of the essential features to evoke their meaning, to allow the viewer to experience, at second hand, the essential qualities of the originals. The associative power of the architectural forms could thus be used to promote devotion, evoke holy places, or make political statements. The ritual use of these buildings could also erase the distance between the prototype and its copy, thereby making its power present in the here and now.[40] The inexactness of the relations between the holy archetype and the copy exemplifies the loose and vague connections between form and meaning in the medieval visual imagination. Symbolic significance appears to be inherently imprecise, accompanying "the particular form as a more or less uncertain connotation only dimly visible, and whose specific interpretation was not necessarily agreed upon." Far from intending to create a duplicate of the prototype as it looked in reality, the architect intended to reproduce it as a memento of a venerated site and as a symbol of promised salvation.[41] Thus past, present, and future could simultaneously "vibrate" in one building. Imitation stimulated rememoration and liturgical actualization of the past event or its power in the present. Additionally, these meanings of medieval architecture were always multilayered and could be "read" analogously to the four senses of scriptural exegesis: literal history, typology, morality, and anagogy.[42]

Krautheimer entitled his essay an introduction, intending it to be merely a contribution toward a future iconography of architecture; others have continued his line of thought with greater or lesser success.[43] In his postscript he issued a call to "look for specific tertiary comparisons between copies and originals as well as between building types and their meaning."[44] These tertiary comparisons are alternative ways of establishing

affinities and experiencing parallelisms that may escape us if we limit ourselves to any architectural model that remains purely formalistic. This is also a method I am employing here to examine similarities between Mexican buildings and Old World prototypes: to go beyond mere planimetric similarities and see the desire to create a *similitudo* of a venerated model.

The most ubiquitously copied building of Jerusalem was precisely the "new" Christian temple of Jerusalem: the Anastasis rotunda and the tomb aedicule of the Holy Sepulcher complex (fig. 4.5). Copies were built all over Europe from the fifth to as late as the seventeenth century, as circular, octagonal, or cubic structures focusing on a tomb or substitute for the tomb.[45] The original Holy Sepulcher could also be miniaturized in "ritual play houses" with a markedly theatrical quality (fig. 4.6).[46] As Jonathan Smith, writing on miniaturization, has observed:

> The monumental replicas of the Church of the Holy Sepulchre sought to assimilate themselves to the prototype in Jerusalem, thereby erasing distance. The more miniaturized and, ultimately, more stylized replicas of the Sepulchre, along with their attendant ritual, sought to simulate the prototypical experience which lay behind the monument, thereby creating a utopia, a theatre of the mind and imagination, in which there was no distance because the specific locality in Jerusalem was, in the ritual process, erased.[47]

Furthermore, as Robert Ousterhout has remarked, a copy of the Holy Sepulcher could be equated with a specific building, the whole city of Jerusalem, or sometimes the entire Holy Land.[48] Krautheimer's suggestion that the parts could be taken to stand for the whole may be interpreted in a larger, topographical or urban sense, as we saw in chapter 3. And as we shall see below, diminutive copies of the Holy Sepulcher will make their way to New Spain, and ritual use will explain how the replication of the hallowed prototype is to be understood within a new metaphor.

But Jerusalem and its sacred structures—whether Sepulcher or Temple—could also be replicated in other ways. One such "replica" of Solomon's Temple lies in Constantinople, the hagiopolis on the Bosphorus established by the emperor Con-

stantine and enriched in the sixth century by Justinian.[49] Justinian's exclamation upon entering the completed building of the Hagia Sophia is justifiably famous: "Solomon, I have outdone you!" As a palace church and the cathedral of "New Rome," Hagia Sophia appeared to the faithful as an imperial successor and similitude of the Solomonic building in Jerusalem. This architectural connotation was supported by Old Testament relics in its keeping—as would be the case in colonial Mexico.[50] The dimensions of Hagia Sophia also hint at a desire to copy or quote by using proportional affinity. The church measured 300 Byzantine feet long, by 100 wide, by 150 high (60 by 20 by 30 cubits); the same proportions of 3:1:1.5 as the Temple of Solomon. Additionally, the six-winged cherubim, represented in mosaics in the squinches supporting the dome, helped give the space below a sense of being the new Holy of Holies and the place of the Mercy Seat of the Most High.[51]

A second Jerusalem copy, this time of the new Christian temple of the Holy Sepulcher, is the Bolognese pilgrimage complex of Santo Stefano.[52] Rebuilt after 1141, it is the most complete copy of the Holy Sepulcher complex to survive from the Middle Ages (fig. 4.7). The ensemble included an atrium and an Anastasis rotunda, itself octagonal in form with an internal colonnade of twelve supports, and a centrally positioned tomb aedicule. A cruciform chapel was known as Santa Croce, and it contained relics both from the rocky mount of Golgotha and from the True Cross itself.[53] The distance between "Golgotha" and the tomb at Bologna also corresponded to the actual distance at Jerusalem.[54] Later construction added a replica of the Valley of Jehoshaphat (where the Last Judgment will take place) and installed raised chapels above Golgotha, similar to the elevated open chapels of Mexico.[55] An outdoor raised pulpit was also added for preaching to pilgrims under the open sky (fig. 4.8). At Bologna there is a kind of scenographic stage set or a "play house," and the kinesthetic aspect of visiting the site as a pilgrim must have had much to do with the mnemonic experience. The performance of the liturgy and numerous "Palestinian" features of the neighborhood of Santo Stefano further helped to re-create the sacred topography and offered an affective experience of pilgrimage to a surrogate Jerusalem, just as the Franciscan *sacri monti* would do in the sixteenth century.[56]

Fig. 4.7. Bologna, Italy. Pilgrimage complex of Santo Stefano. Holy Sepulcher rotunda and tomb, with Golgotha chapel above. (Photo by author.)

Fig. 4.8. Bologna. Exterior view of the Santo Stefano complex with outdoor pulpit. (Photo by author.)

The buildings of the Anastasis and Holy Sepulcher maintained their fascination for Europe for centuries, but the rise of Islam would alter Christian perception of Jerusalem's holy sites and add additional constructions to that picture. After the Persian conquest of the city (614 CE) and the subsequent Muslim conquest (638), the invading armies of Islam destroyed Christian buildings and built mosques on their foundations. They spared the Holy Sepulcher complex but selectively replaced sites that had had special interest to Christians and Muslims alike, particularly churches dedicated to Miriam, the mother of the prophet Jesus.[57] A process of substitution, identical to what would later occur in Mexico, was carried out by the Islamic invaders and their new religion during their colonization of Palestine.

The temple esplanade on Mount Moriah was cleared of the debris of more than three centuries of neglect and soon became the second holiest *locum sanctum* after Mecca. Muhammad is said to have traveled to Jerusalem by a flying horse and then ascended to heaven from this spot during his Night Journey to encounter Allah. The Muslims named the esplanade the Haram al-Sharif, the Noble Shrine (fig. 4.9). They were apparently conscious of the Old Testament buildings that had once stood there and were aware of their original locations and spatial relation one to another.[58] On the site of the ancient Temple, on an outcropping of rock believed to have been the locus of the altar of holocausts, they built the Qubbat as-Sakhrah shrine, better known as the Dome of the Rock (completed 691). Slightly south of the Dome of the Rock and on an axial line with it, on the supposed site of Solomon's palatine Hall of the Forest of Lebanon, they constructed the Al-Aqsa Mosque (c. 746).[59]

It was just at this time that Christians began to take an interest in the Temple site and that its new buildings began to be seen as relics that the Christian ought to appreciate and appropriate in their dual roles as memorials and pilgrimage sanctuaries.[60] The process was slow, but we can deduce from pre-Crusader pilgrims' texts that the two Islamic structures came to be venerated, mistakenly, as the Templum Domini and the Templum Salomonis: the first, a centrally planned octagonal shrine; the second, a rectangular mosque (figs. 4.4 and 4.10).[61] Over the following centuries, Christian reasoning explained

Fig. 4.9.
Jerusalem. Plan of the Islamic structures on the Haram al-Sharif. (From Comay, *The Temple of Jerusalem*. Used with permission.)

that the two structures were either Constantinian reconstructions or auxiliary buildings from biblical times that had never been destroyed. It was not until the more "scientific" studies of the Old Testament in the late Middle Ages[62] that their authenticity was called into question; and even then, one or the other of the buildings continued as Temple illustrations by Christians and Jews until the nineteenth century.[63]

As the Constantinian buildings of the Holy Sepulcher complex had originally been designed to outshine the Jewish Temple, so too the Dome of the Rock was a Muslim attempt to outdo its prototype: the Anastasis rotunda on the other side of

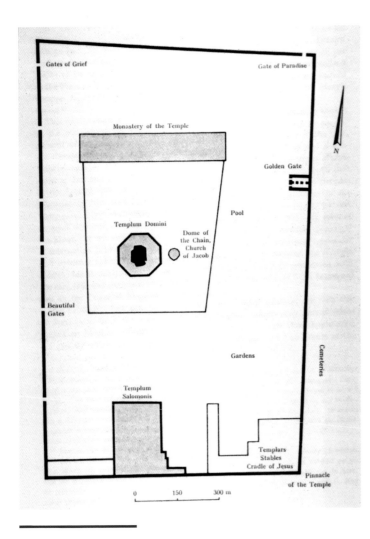

Fig. 4.10.
Jerusalem. Plan of the Crusader structures on the Haram al-Sharif,
twelfth century. (From Wilkinson, *Jerusalem Pilgrimage*. With
permission of the Hakluyt Society.)

town.[64] The Dome gradually became a "venerated ancient site"
worthy of replication after the Christian Crusaders captured
the city in 1099. As strange as it may seem, the Dome of the
Rock then entered into Europe's imagination as a visualization
of the original Temple.[65]

With the Crusaders' successes in the eleventh century
and the establishment of the Latin Kingdom of Jerusalem
(1099–1187), there came about a systematic organization of
pilgrimage sites with more or less fixed lists of sights to be

seen and an accompanying localization of holy legends.[66] When
the Dome and the mosque fell into Crusaders' hands, they also
entered into the mythology of the Knights of the Temple of
Jerusalem (the Knights Templar) and the Hospitaler Knights,
who replicated selected elements of the Islamic buildings in
their European foundations.[67] Thus after the First Crusade there
arose an interest in imitating not only the earlier Christian build-
ings of Jerusalem but also those buildings that tradition had
now "baptized" into the Christian mythos. Iberians were par-
ticularly interested in these replications, as demonstrated by
the Templar Church of the True Cross in Segovia, and several
others.[68]

In addition to the Dome of the Rock and the Al-Aqsa
Mosque, the early Islamic period had added medieval construc-
tions that were also worthy of replication. These constructions
are visible in medieval pilgrims' drawings (fig. 4.4), and some
are still to be seen today on the Haram al-Sharif: posalike chap-
els, monumental propylaeum gateways, a sealed Golden Gate-
way, and a porticoed and crenellated patio wall giving it a for-
tresslike appearance—features that, superficially at least, bear
a strong resemblance to elements of the Mexican evangeliza-
tion complexes.[69] Furthermore, during the Christian reign of
the twelfth century, the Haram literally became a fortress mon-
astery of both the Canons of the Augustinian Order and the
Order of the Knights Templar (fig. 4.10). A closer examina-
tion reveals that both Temple Mount and the Mexican com-
plexes did indeed have many things in common, especially in
the mythical, prophetic, and eschatological milieu of the six-
teenth century.[70]

New World Portals to Zion

We saw in chapter 3 that for Mesoamericans to gain access to
the supernatural realms of the gods, they needed to traverse a
threshold or portal. In the natural world and man-made con-
structions, these portals were activated by the performance of
sacred rituals that allowed passage to the sacred center.[71] Simi-
lar importance has always been accorded by Jews to the gates
of Jerusalem and its Temple, and by Christians to cathedral
portals and monastic entrances.

We should remember that the mendicant catechumenal complex in New Spain was essentially a patio with monumental gateways (propylaea) fronting a church (*templo*) (fig. 1.2). The church itself had two entrances: the west door on the patio and the north *porciúncula* door, which was either always left open or, more likely, bricked-up and opened only on special occasions. Monumental patio entrances were common in Mesoamerican architecture, but the more overtly Christian precedent for the *porciúncula* was its use as a "holy door," as at Rome, Assisi, or Jerusalem—doors that carried the power of indulgences. The Golden Gate, or "Portico of Solomon," was a double door giving access onto Temple Mount. It had special significance for the Franciscans because of its associations with the legend of the retrieval of the Holy Cross by Emperor Heraclius on September 14, the date on which Francis received the stigmata.[72] Jewish eschatology identified it as the "Mercy Gate," where the Lost Tribes would gather to fight for Jerusalem's liberation.[73] It also played a part in the messianic myths surrounding Charles V as the Last World Emperor. Charles was glorified as a new Heraclius about to recapture Jerusalem and restore to it the sacred trophy of the cross. At his reception by the people of Bruges in 1515, mentioned previously, Charles was represented as Heraclius by an actor in an outdoor stage set of the Holy City with a legend that read, "Hail the Conqueror! May you soon deliver Jerusalem!"[74] I believe that this sealing and opening motif was overlaid on the *porciúncula* doors of the Mexican conventual churches. Multiple meanings of indulgences, forgiveness of sin, and papal protection were joined to the expectations of Jerusalem's liberation and Christ's victorious return.

In the west wall of Temple Mount another ingress, called the "Portal of Justice," opened onto the city of Solomon. It was used for the ancient practice of royal judgment at the city gates.[75] Here we find another Mexican parallel. In the engravings that accompany Fray Diego Valadés's *Rhetorica Christiana*, the illustrator went out of his way to show that the entrance to the patios was a place where the friars carried out adjudication proceedings, labeling the stagelike portal IUSTITIA (figs. 1.4 and 6.14).[76] The parallel to the judicial gates of Jerusalem may also be a subtle reference to a prophecy of Ezekiel which says that in the patio of the utopian temple of the future, "it is the priests who shall teach my people . . . and shall stand as judges, judging them according to my decrees" (44:4–24). At the Franciscan convent of Cholula, for example, the lintel of the *porciúncula* door is carved with the words "This is the door of the Lord's justice" (in Latin, "Hic porta domini justicia"). Furthermore, in medieval exegesis on the Heavenly Jerusalem of the Apocalypse, each of the four sides of the city with its central gate corresponds to one of the four cardinal virtues: Prudence, Courage, Temperance, and Justice.[77] Hence, a moral reference to the celestial metropolis is also being made by the oversize letters of IUSTITIA in Valadés's illustration.

Another ideological link to Solomon's porticos on Temple Mount was the medieval cloister.[78] The association of cloister and Temple was furthered during the Crusader occupation of Jerusalem, when the Augustinian canons added a cloister to the Dome of the Rock, and the Knights of the Temple added another to the Al-Aqsa Mosque. The Crusaders' cloisters then came to be known as the "Cloister of the Temple of Solomon."[79] Twelfth- and thirteenth-century maps clearly identify the two temples and their cloisters on the esplanade, now understood as the new porticos of Solomon (figs. 4.10 and 4.11).[80]

The mystical correlation had been made by medieval liturgists, not the least of whom was William Durandus, whose liturgical work the mendicants were reading in New Spain. Particularly appealing was the belief that the monastic cloister originated in the Levites' chambers attached to the Temple (fig. 4.23), and in the Solomonic portico, where the apostles had gathered to be of one mind and heart, and where they had held all things in common, like mendicant friars.[81] The various chambers of the monastic cloister symbolized the different mansions and degrees of glory in paradise—a theme reminiscent of Joachim of Fiore's *mansiones* in his utopian monastic city on earth. Additionally, the cloister was imagined as paradise itself: its fountain was a mystical baptismal font from which flowed the four paradisial rivers, and its claustral cross was the primeval Tree of Life in Eden.[82] As an anticipation of paradise, the cloister looked forward anagogically to the rewards of the just in heaven.[83] All commentators emphasize the claustral quaternary: its four sides, four corners, and four scriptural senses, as well as its fifth point at the center (the tree or fountain) forming a quincunx. These multiple layers of mean-

ing were also intertwined in the Mexican patio corrals, which acted as lay cloisters. The "Solomonic portico" was the imaginary model of the Mexican conventual cloister, where friars and Indian laity mingled and marched in "processions through Paradise."[84]

We can now understand why porticos in general became a synecdoche, a sort of shorthand or schematic for "Temple" in medieval art, and why they might manifest utopian affinities between the Temple cloister and European monastic cloisters, lending credence to the theory that they were useful symbols for political purposes, as we shall see in New Spain.[85]

Posa Chapels in the Corral

Within the corral of the New World temple, the four posa structures stand out as a novel addition. If there was an indigenous model for the colonial posa chapel, it may have been the four *calpulli* barrios, each with its own temple.[86] However, we know little of their formal design, and they were not covered with vaulted structures like the later posas.

In chapter 1, I presented some of the Old World precedents for the posa, but we should note that most of the examples given there postdate the Latin Kingdom of Jerusalem, and it is precisely in the Holy Land that we find the earliest models. In addition, many of the medieval constructions visible in pilgrimage drawings and printed texts are still in existence today on the Haram al-Sharif, and they bear a strong resemblance to particular details of the Mexican monastic complexes.

As I mentioned in chapter 1, George Kubler found what seemed an unlikely iconographic model for the Mexican open chapel/posa in the ancient Syrian *kalube*, a shelter for a pagan god.[87] It appears now that he was not far wrong, but I suggest that the model can more likely be found in Palestine rather than Syria. Two posalike chapels, called *qubba* (derived from the Syriac *kalube* and related to the Italian *cubula* or *cuba*), and similar in several respects to their Mexican cousins, are located in the northwest corner of the Temple Mount within a few meters of one another. One is a diminutive domed octagon (fig. 4.12); the other is a sizable conical structure supported by four open piers (fig. 4.13). Both are associated with Solomon and with Christ.[88]

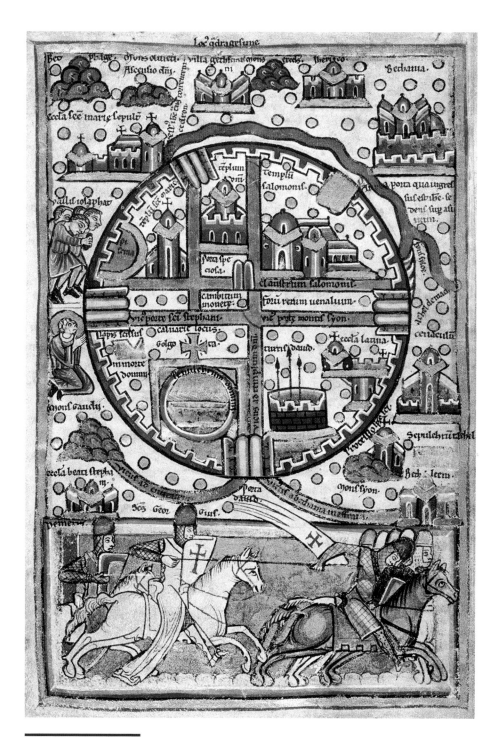

Fig. 4.11.
Jerusalem. Crusader map showing the Templum Salomonis, Templum Domini, and Claustrum Salomonis in the upper right quadrant, twelfth century. (Courtesy of the Koninklijke Bibliotheek, The Hague, MS 76.)

Fig. 4.13.
Jerusalem. Square *qubba* with conical roof, known today as the "Dome of Suliman Pasha," reconstructed. The structures in figs. 4.12 and 4.13 are clearly seen on maps from the sixteenth century on. (Photo by author.)

Fig. 4.12.
Jerusalem. Octagonal and domed *qubba* on the Haram al-Sharif, the "Throne of Jesus" or "Throne of Solomon," originally the first station on the Via Dolorosa. (Photo by author.)

The chapel in the domed octagon is also known today as the *Koursy 'Aisa*, the "Throne of Jesus" (also "Throne of Solomon"),[89] the place where Christ supposedly reposed after his torture in the neighboring Fortress Antonia (figs. 4.9 and 4.14).[90] Originally an Islamic construction over an outcropping of rock, it was altered during the Latin Kingdom and then restored when the kingdom fell in 1187.[91] As noted above in chapter 1, this type of domical-square construction is a common feature of Islamic architecture imported to Spain and Sicily by the Muslims. These domed pavilions likewise acted as shelters for repose.

At an early date, the octagonal chapel was conflated with its nearby neighbor to the east, the conical structure (today the "Throne of Suliman [Solomon] Pasha"), but there was confusion about the identification.[92] During the Christian occupation, one or both of these chapels had been used as the first station of the Via Dolorosa procession[93] and inspired the iconographic representation of the *Herrgottsruh*, Christ's solitary repose (*posa*) under a canopy during his bloody journey to the cross.[94] Both structures continued to be venerated by Muslims after the fall

of the Latin Kingdom. The medieval Islamic pilgrim's manual composed by Ibn al-Muraggà in the first half of the eleventh century instructs visitors to stop, rest, and pray here for a moment on their circuit of visits.[95] As a stational place of repose and prayer for Muslims (and then for Christians), it had the same nominal meaning and function as the later European *cubula* and the Mexican posa chapels.

Another place of "Jesus' repose" stood against the outside north wall of Temple Mount, at the "Sorrowful Gate," as a replacement for the "posa within the precincts" after the Muslims declared the Haram off-limits to Christians, who had to relocate their processions outside its walls.[96] Today the Church of the Repose sits on the site (fig. 4.14). The Franciscans, who held the custody of the Holy Land, would of course have known all these locales, which had been popularized by numerous pilgrimage guides, souvenirs, miniature models, and reports in manuscript and printed form.[97] It is no wonder then that posa-like chapels later appeared in Europe as stations on the pilgrimage circuits of the Franciscan *sacri monti*.

A unique European copy of these two Jerusalem *qubbas* on the Haram stands in the Church of the Knights Templar at Soria, Spain, on what was the fighting frontier between Christians and Moors.[98] Within the sanctuary, flanking the altar, are two dissimilar freestanding baldachin canopies erected at the end of the twelfth century. One is conical, the other domed; they seem asymmetrically out of place (fig. 4.15). Although incongruous in shape, they share a common iconography in the capitals of the columns: knights in armor who fight man-eating birds of prey, flying reptiles and dogs, griffins and ravaging locusts, taken either from Revelation or from Prudentius's *Psychomachia*. The conflict takes place in front of a battlemented city whose walls are punctuated with Moorish windows. There are also other Jerusalem military scenes, confirming a connection with sites in the Holy Land and with the warrior mythos of the Knights Templar.[99] Both George Kubler and John McAndrew suggested the Soria baldachin canopies as possible models for the Mexican posas, but neither realized that their source was in the *qubba* structures found on Temple Mount.

The Open Chapel-Stage-Temple

In chapter 1, I indicated that an important feature of the evangelization compounds was their function as outdoor naves with a raised open apse and altar. These outdoor altars surely recalled the elevated Aztec altars of the *teocalli*. An alternative form of the open chapel was a proscenium arch similar to a theatrical stage house (*mansión*), or a freestanding aedicule. In fact, Fray Diego Valadés uses the same word, "aedicule," in speaking of the isolated open chapels. "In each hamlet that surrounds the town there exists a little aedicule designed for public prayer where the Indians go on major feast days, like Corpus Christi."[100] But the word "aedicule" also had other connotations that a Franciscan would have understood. The most famous aedicule of Christendom was the tomb of Christ in the Holy Sepulcher complex, and some Mexican open chapels also functioned as surrogate tombs of Christ during Holy Week (see below, fig. 6.2 and chap. 6).

The open chapels could also act as miniature representations of the Temple of Jerusalem. Although they might bear

Fig. 4.14. Jerusalem. Plan of the north end of the Haram al-Sharif and the Via Dolorosa, with the "Throne of Jesus" (Koursy 'Aisa) and the Church of the Repose indicated. (From Vincent and Abel, *Jérusalem nouvelle.*)

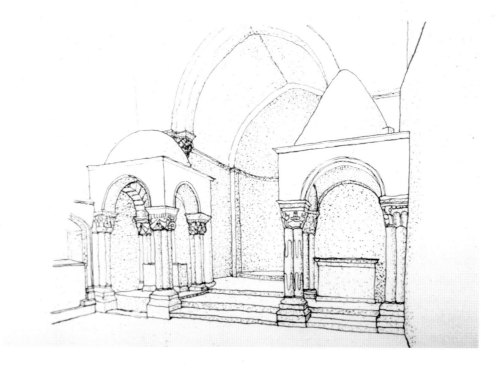

Fig. 4.15. Soria, Spain. Templar Church of San Juan del Duero with asymmetrical baldachins covering the side altars. (Redrawn from McAndrew, *The Open-Air Churches.*)

little resemblance to the Palestinian prototypes, the Mexican open chapels, and to an extent the posa chapels, are schematic and imaginary replicas. Their models can be found in medieval Jewish illuminations and in medieval paintings (figs. 4.50 and 6.5).[101] The tradition originated in Byzantium and strongly influenced trecento and quattrocento painting in Italy, as well as sixteenth-century painting in Spain.[102] The scenes, taken from the Old and New Testaments, all have to do with stories occurring in the Temple of Jerusalem.[103] The Holy House is

depicted either as a ciborium, a simple rounded-arch canopy, a pointed roof over an architrave, a dome on four columns, or a flat-roofed baldachin.[104]

Likewise, Hispano-Flemish paintings of the fifteenth century frequently made use of the same ciborium types for an "iconography of place."[105] For example, in the Spanish cathedral of Teruel, a painting of the Resurrection takes place against the background of Jerusalem and its Temple, which in this case is a replica of the Little Temple (*tempietto*) of San Pietro in Montorio, the Franciscan headquarters in Rome.[106] Diego Valadés used the same Franciscan temple in his *Rhetorica* to illustrate Old Testament worship.[107]

Up to this point, we have seen several pieces of the iconographic puzzle that explain the Mexican replicas of the Temple. But before we can put the pieces together, we must still analyze the artistic representations of the Temple and Temple Mount in the Jewish and late medieval "scientific" versions. Once we have done this, we shall be in a better position to identify more closely the visual sources of the temples constructed in the American Zion.

GRAPHIC SOURCES

GRAPHIC SOURCES OF TEMPLE PLANS

> Son of man, describe this Temple to the house of
> Israel, to shame them out of their filthy practices.
> Let them draw up the plan, and, if they are ashamed
> of their behavior, show them the design and plan of
> the Temple, its exits and entrances, its shape, how all
> of it is arranged, the entire design and all its principles.
> Give them all this in writing so that they can see and
> take note of its design and the way it is all arranged
> and carry it out. This is the charter of the Temple.
> —Ezekiel 43

Christian representations of the Temple complex logically owe their inspiration to Jewish ones. In graphic illustrations found in Hebrew Bibles, the Temple itself is seldom shown; rather, a synecdochic element represents the whole: a schematic façade, a pedimented roof, and perhaps some columns.[108] Occasionally, the ark of the covenant may be seen through a doorway that represents the building. But because the Temple had been destroyed, its depiction is rare, and the doors are more frequently shown closed, awaiting the coming of the Messiah, when it will be rebuilt and the doors opened.[109]

Messianic hopes regained new vigor among European Jews in the later Middle Ages when a new Hebraic iconography of the Temple took hold, influenced by the Last World Emperor legend. The Jewish Sibylline legends undoubtedly lent themselves to this renewed interest in the fate of Temple Mount.[110] Between the years 1250 and 1500 the Temple's ritual objects—always associated with messianic expectations—made their appearance in Hebrew manuscripts.[111] They follow descriptions found in the Middot, part of Maimonides' compilation of rabbinic law, the Mishnah Commentary.[112] Maimonides (1135–1204), a contemporary of Joachim of Fiore, proclaimed a proximate messianic age in which a Jewish kingdom would be reestablished in the land of Israel under a messiah king. In keeping with this hope, he painted the Temple's ceremonial objects into the opening pages of his Bible. Maimonides also created a set of architectural diagrams. They are simple drawings, not always in proportion, meant as visual aids to the text (fig. 4.16). They include plans of the Solomonic/Ezekelian Temple with a cruciform atrium, Solomon's palace, and the Hall of the Forest of Lebanon, as well as the liturgical objects mentioned above. Significant for our New World interest is the fact that his plan shows four posa-like chambers that will be a hallmark of all later attempts at constructing a ground plan of the Temple by Jews and Christians.[113] These Hebrew Temple plans were of particular interest to Spanish Jews like Maimonides and always include the shorthand conventions of porticos, portals, or arcaded ciboria (fig. 4.17).[114]

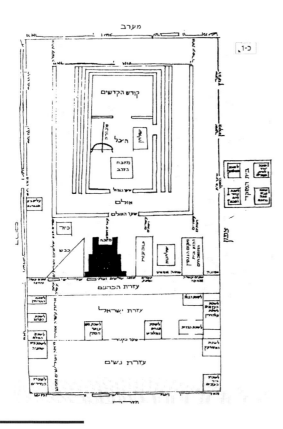

Fig. 4.16.
Maimonides, Mishnah Commentary. Plan of the Temple of
Jerusalem. (Redrawn from MSS Pococke 295, fol. 295r, Bodleian
Library, Oxford University.)

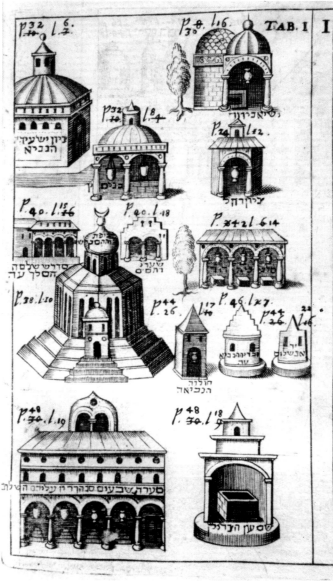

Fig. 4.17.
Johann Hottinger,
*Cippi Hebraici sive
Hebrarorum*, 1662.
Images of the *Yuhus
ha-Avot*, "the genealogy
of the patriarchs," a
type of commemorative
guidebook used for fund-
raising. This printed
example is based on
earlier sixteenth-
century models. Note
the open chapel and
posalike depictions of
holy sites. (Courtesy of
the Beinecke Rare Book
and Manuscript Library,
Yale University.)

In the twelfth century, Christian scholars were attempting
to learn from their Jewish colleagues for a variety of reasons,
some of them polemical. In *Regarding Ezekiel's Vision*, Richard
of St. Victor (d. 1173) based his reconstruction of the Temple
on Ezekiel's text while also making use of Jewish scholarship.[115]
The text with illustrations was first published in Paris in 1518,
just when the mendicants were leaving for the New World, and
several copies are extant in colonial libraries.[116] Richard not
only offered a ground plan, like his Jewish predecessors, but
also, for the first time, supplied some elevations (fig. 4.18).[117] He
reconstructed the Temple's three gates like those of the Mexi-
can atrium, and the gatehouse as a three-story edifice with a flat
crenellated roof, much like the flat roofs of the single-nave
church with crenellations and sentry boxes (fig. 4.2).[118]

Richard's bird's-eye plan of the buildings emphasized
the four posalike chambers in the atrium, which he called
gazophylacia.[119] The plan clearly demonstrates the oblong
shape of the tripartite temple house with its vestibule, holy
place, and holy of holies, much like the tripartite division of
the Mexican single-nave church (fig. 4.19).[120] It is not diffi-
cult to imagine that Richard's diagrams were one available
source that native architects and friars used for inspiration,
but there were others.

Fig. 4.18.
Richard of St. Victor, *Omnia opera* (1518). Plan of the atrium of the new temple of Jerusalem with three gateways, according to the prophet Ezekiel. (Courtesy of the Biblioteca Lafragua, Puebla.)

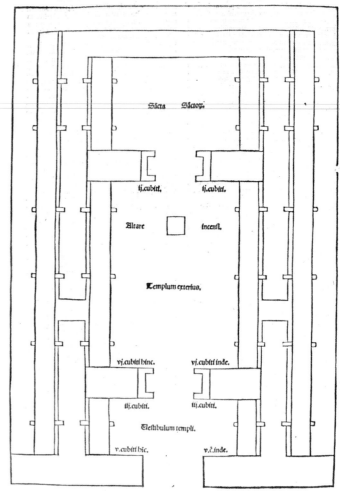

Fig. 4.19.
Richard of St. Victor, *Omnia opera*. Plan of the temple house, with porch, holy place, Holy of Holies, and *latera*, according to the prophet Ezekiel. (Courtesy of the Biblioteca Lafragua, Puebla.)

Franciscan Blueprints of the Temple

Both Jewish drawings and Richard of St. Victor's elevations came together to shape the most influential renderings of the Temple in the late Middle Ages, those of the Franciscan Nicholas of Lyra's *Postillae super totam bibliam*, or *Notes on the Whole Bible*, written between 1322 and 1331.[121] Lyra was considered to be the St. Jerome of the later Middle Ages.[122] He had a profound and lasting influence on biblical studies and was often quoted by Christopher Columbus and Martin Luther, among others.[123]

Several features of Lyra's rendering reveal a similarity to Mexican mendicant complexes, and I speculate that here lies the original model for the architecture of New Spain. This theory

gains strength when we recall that Lyra's *Postillae* was the basic and ubiquitous biblical text and commentary in the New World; it was brought to Mexico in the friars' luggage. In a letter of 1567, Fray Gerónimo de Mendieta even states that it was required for every conventual library in New Spain.[124] Lyra's work is the closest visual source for replicas of the Temple complex, whether the actual copy be a hand-drawn manuscript copy (fig. 4.20), one of the many printed editions (post-1481), or an interpretation by one of the immediate followers of his "school." The courtyards or atria are laid out in ways similar to those of the Mexican patio, while the plan and elevation of the Temple's tripartite sanctuary bear comparison to the tripartite, single-nave church with flat roof and crenellations in New Spain (figs. 4.21 and 4.22).

Further, Lyra's interpretation of the *laterum* as a crenellated, triple-storied monastic cloister connected to the lower portion of the sanctuary is in conformity with the cloisters of the Mexican convent (fig. 4.23).[125] Both Richard of St. Victor and Lyra speculated that the "Temple cloister" might also have had defensive features like *chemin-de-ronde* parapets, identical to those on the exterior of Mexican churches.[126]

Lyra follows Richard's commentary in rendering the complicated gatehouses and patio walls of the biblical building, but his elevation of the gatehouses displays two diminutive buildings with peaked roofs flanking the open outer wall entrance, buildings that bear some resemblance to pyramidal posas within an atrium (fig. 4.24).[127] From the time of Lyra onward, two of the distinguishing features of all Temple ground plans will be the four *atriola* (little patios) in the outer courtyard and the four *gazophylacia* in the inner court surrounding the altar of holocausts.[128] Maimonides and Richard of St. Victor illustrated four such aedicules, and Lyra located them in the corners.[129] In both Maimonides' and Lyra's visualizations of the prophet's text, the corner chambers face one another, just like the Mexican posas, whose double openings create a continuous counterclockwise processional movement.

Lyra and Richard, however, were not the only ones to use the word *gazophylacium* for posalike structures. The ancient Roman architect Vitruvius had defined the *gazophylacium* as a place of repose at midday and a shelter for judicial proceedings. The friars who were reading Vitruvius in Mexico may

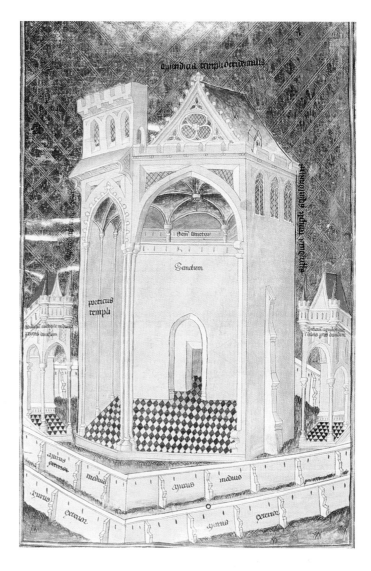

Fig. 4.20. The temple of Ezekiel with "posa chapels." Miniature from a French manuscript of Nicholas of Lyra's *Postillae*, fourteenth century. Bibliothèque Municipale, Cambrai, MS 292. (Giraudon / Art Resource, NY.)

have translated those meanings of rest and adjudication into their buildings as posas or as open-chapel tribunals for the execution of justice (cf. fig. 6.14).[130]

We can distinguish three stages in the evolution of Lyra's illustrations: a primitive stage of manuscript copies of the lost original (the earliest extant one is dated 1331); early incunabula or printed editions with woodblock illustrations (figs. 4.21–24); and mannerist drawings that depart from the earlier simplicity (figs. 4.25 and 4.26). The hand-copied manuscripts are closest to the author's original schematic renderings. Lyra gave little detail on these, and it appears that he, like Maimonides and Rashi, was only interested in giving his readers a visual

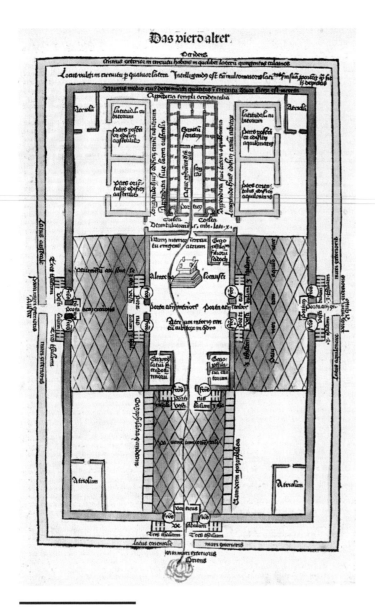

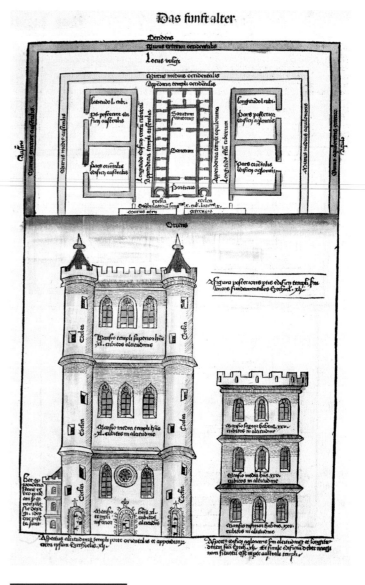

Fig. 4.21.
Nicholas of Lyra's plan of the new temple according to Ezekiel, reused in a hand-colored copy of Hartmann Schedel's *Nuremberg Chronicle* (1493). (Courtesy of Stiftung Weimarer Klassik, Weimar.)

Fig. 4.22.
Nicholas of Lyra's plan and elevation of the temple house according to Ezekiel, reused in Schedel's *Nuremberg Chronicle*. (Courtesy of Stiftung Weimarer Klassik, Weimar.)

aid to the text without attempting to create a real plan or elevation.[131]

 With the invention of printing, the *Postillae* became the first biblical commentary to appear in print (1481), and it was thus the one most readily available for the reading public. Hartmann Schedel popularized Lyra's Temple images by reproducing them wholesale in his *Chronicle of World History* or *Nurem-*

berg Chronicle of 1493. This second stage of rich incunabular editions added details of Gothic architecture and ornament.[132] It was these printed editions that traveled most easily to America and could serve as blueprints. As I suggested in chapter 3, the printed text of the book of Ezekiel could be consulted anywhere and was readily available to friars and native architects alike; it thus became the urban planning manual of the American uto-

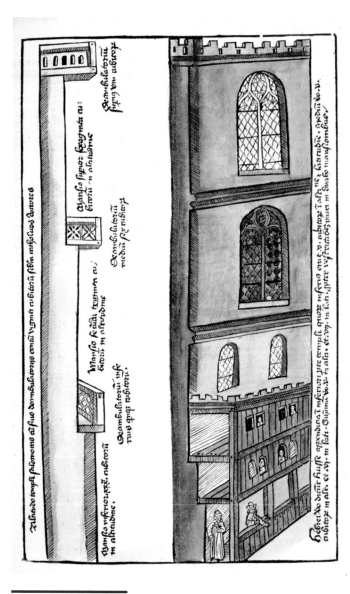

Fig. 4.23.
Nicholas of Lyra's cross-section and lateral elevation of the temple house and *latera* according to Ezekiel, reused in Schedel's *Nuremberg Chronicle*. (Courtesy of Stiftung Weimarer Klassik, Weimar.)

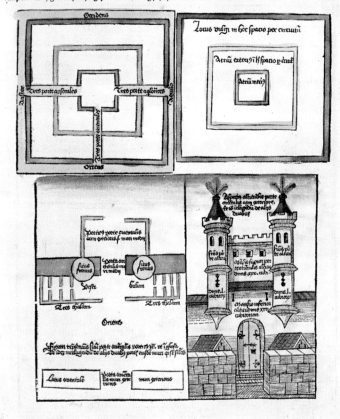

Fig. 4.24.
Nicholas of Lyra's plan and elevations of the atrium and gatehouse of the temple according to Ezekiel, reused in Schedel's *Nuremberg Chronicle*. (Courtesy of Stiftung Weimarer Klassik, Weimar.)

pian city. Lyra's Temple ground plan also provided a basic model for the evangelization centers, even if the formal design of individual parts might have come from other sources such as stage sets, ciboria, baldachins or *qubba*, no doubt because Lyra did not provide elevation drawings for the *atriola* or *gazophylacia*, only for the temple house, "cloister," and altar of holocausts. As I suggested above, the more proximate visual elaboration of

the posas, for example, might very well have been the Islamic *qubba*—the throne of Christ's repose—found even today on the Haram al-Sharif esplanade. In chapter 6, I will suggest a closely related model from the world of the theater.

The third and final evolution of the illustrations in the *Postillae* was a completely new set drawn in mannerist style by François Vatable (d. 1547), professor of Hebrew at the Royal

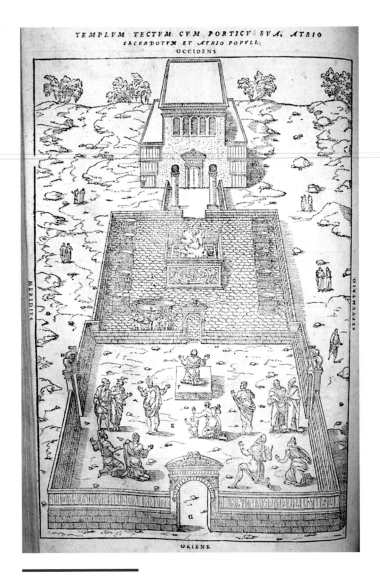

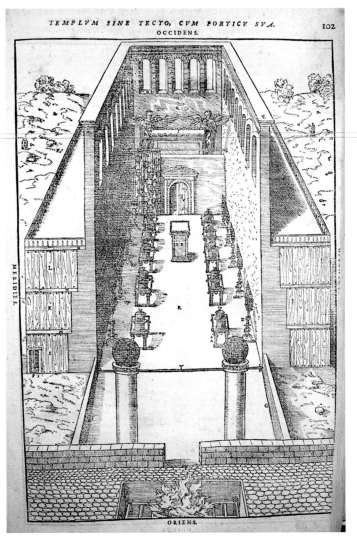

Fig. 4.25.
François Vatable, *Biblia latina* (Paris, 1546). Reconstruction of Solomon's Temple with double atria and altar of holocausts. (Courtesy of the Biblioteca Lafragua, Puebla.)

Fig. 4.26.
François Vatable, *Biblia latina*. Cutaway reconstruction of Solomon's Temple with the columns of Jachin and Boaz. (Courtesy of the Biblioteca Lafragua, Puebla.)

College, Paris (figs. 4.25 and 4.26).[133] Vatable's renderings appeared for the first time in an edition of the *Postillae* in 1540 and were repeated in many subsequent editions and Bibles, one of which was published by the Franciscans themselves.[134] By the time of Vatable, the Gothic style of Temple design was considered outmoded and unhistorical. The classical revival embodied in sixteenth-century mannerism was deemed to be the only true form of architecture that God would have chosen for his Holy House in Zion.[135]

Vatable's edition of Lyra's work was surely known in Mexico. The friary library at Huejotzingo had a copy, and several copies are extant in modern libraries, two of which can be identified with certainty as coming from the Colegio de Santiago Tlalteloco, the college-seminary that the Franciscans es-

tablished for the indigenous elite. Tlalteloco had an excellent library, and it was there that native scholars translated the Bible, as well as liturgical and dogmatic texts, into Náhuatl metaphors and literary images.[136] It was also there that an elite group of Nahua literati worked with Fray Bernardino de Sahagún on his ethnographic collection. Tlateloco was without doubt a dissemination center for Vatable's biblical illustrations and Lyra's text.

In describing the "posas" in the corners of the Temple's atria, Vatable calls them *cubicula*, suggesting a more cubic form for the structures and a greater approximation to the actual shape of the posa chapels in Mexico.[137] His aerial views of the Temple show two patios, one paved and the other not (fig. 4.25). In colonial Mexico, the unpaved town plaza acted as a second patio located immediately in front of the church patio and, as in Vatable's rendering, often provided three gateway entries. No posalike structures are shown in Vatable's drawings because they were omitted for the sake of clarity; but the fiery altar of holocausts is drawn oversize and located where the atrial cross would be in the Mexican version of the Temple patio. As in the single-nave mendicant church, splayed windows are also located high on the walls, and the Levite's "cloister" wraps itself around the bottom half of the temple house (fig. 4.26).[138] With a little reconstructive work — the addition of the posas and the substitution of an atrial cross for the altar of holocausts — the structures could be made to resemble a generic model for any number of mendicant conversion centers in New Spain.

Fray Nicholas of Lyra had laid the foundation for all future Temple reconstruction and its development in artistic, political, and religious utopias. Following the work of the Normandy Franciscan, and almost always derived from literal exegesis, there would spin out an unlimited number of copies of the Temple of Jerusalem, imaginative and fantastic in their form, style, and content.[139] Significantly, in almost every future Temple rendering, the four corner "posas" in the courtyard (*gazophylacia, pastophoria, atriola, cubicula*) become emblematic of the divinely inspired building. It is as if the four diminutive structures, plus a temple house in a patio, fulfilled Krautheimer's requirement that there be some identifiable form or shape transferred from the prototype to the copy.[140]

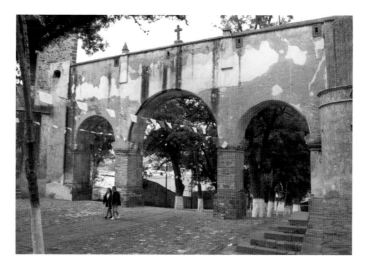

Fig. 4.27. Tlaxcala. Franciscan center. Monumental propylaeum gateway and bell tower at the top of the ramp, from the east. Note the windows of the enclosed passageway above the arches. (Photo by author.)

While the ground plan came from Lyra's printed Bible commentary, other details were selected from additional printed material, including the published work of Bernhard von Breydenbach. Breydenbach, a canon of the cathedral of Münster, organized a pilgrimage to the Near East in 1483.[141] His running commentary with detailed drawings, entitled *The Pilgrimage to the Holy Land*, saw publication in 1486. We know that Christopher Columbus had a copy of Breydenbach's *Pilgrimage* on board during his voyages, and sixteenth-century records of booksellers suggest that other copies were imported to the New World.[142] The friars, with their concern for their Franciscan confreres in the Holy Land, surely had a copy of Breydenbach's *Pilgrimage* in their possession.

It is in Breydenbach's aerial view of Jerusalem and Temple Mount that we can discern the similarity of the Temple's monumental gateways to those in Mexico (fig. 4.4).[143] The eastern propylaeum standing in front of the Dome of the Rock appears to be a structure with a covered second story running lengthwise at the top of a ramp, identical to at least one Mexican gateway, at the complex of Tlaxcala (figs. 1.15, 4.27, and 4.28).[144] At the base of the Temple's ramp of twelve steps, a posalike *qubba* sits to the right, close to the Golden Gate; while on the esplanade several open arcaded buildings are depicted, reminiscent of porticos and of the Temple illustrations seen in Italian frescos.

Breydenbach's *Pilgrimage* was influential for later representations of the historic Temple in European and Mexican art. When Hartmann Schedel's *Chronicle of the World* combined

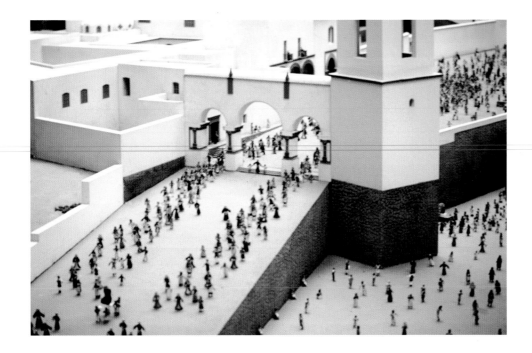

Fig. 4.28.
Tlaxcala. Model of the
ramp and propylaeum
gateway, from the west.
Museo de la Memoria,
Tlaxcala. (Photo by
author.)

the site for the monastery ensemble sometime around 1524 and began the construction of a full evangelization complex after 1529.[147] Recent excavations have discovered three clear stages in the design and construction of the complex.

The first stage, 1524–29, saw construction in the north corner of the present property (fig. 1.35). A straw-and-mud shelter was erected for the friars and, next to it, an open-walled straw hut (*ramada*) for the liturgical services. The second stage, 1530–45, saw the enlarging and enclosing of the ramada walls, the strengthening of the roof by masonry piers, and the addition of a presbytery and altar platform (fig. 4.29). A school building was added to the north side while a second structure, probably a theatrical stage, was located to the south of the ramada. The third phase, 1545–80, included the present buildings—atrium, posas, convent, and church—begun under Juan de Alameda and finished after his death in 1571 (fig. 4.30). A signature and date on the interior cloister murals—"Fray Antonio Roldán, 1558"—seems to indicate the completion of that section by another friar architect.[148]

The patio of Huejotzingo is a perfect square, a rarity in Mexico. At its center, where the axial lines cross, there was once positioned the atrial cross. The present atrial cross is really the finial of one of the corner posas because the original was moved to the town plaza at some date (fig. 4.31). Three entrances give on the patio (like the three entrances drawn by Richard of St. Victor and Lyra), the most interesting of which is the west gate, a monumental propylaeum that Walter Palm compared to the gates that give entrance to Temple Mount in Jerusalem (figs. 1.2 and 4.4).[149]

The four posa chapels of the Huejotzingo patio are all seventeen feet on a side and twice as high as wide, measured to the top of the pyramidal roof (fig. 5.18).[150] Each is richly carved and iconographically unified. The northeast posa is inscribed "1550," whereas the northwest one is marked "1556," probably identifying the start and finish of the atrium and predating the construction or completion of the present church.[151] The posas are a masterpiece of carving and symbolism. Together with those at nearby Calpan, they are considered the most beautiful in all the New World evangelization centers. Their iconography has eschatological significance related to the popular myth of the Angelic Pope and Last World Emperor. This iconogra-

Breydenbach's woodcuts with those from Lyra's *Postillae*, it further encouraged a visual conflation of the Old Testament buildings and those still visible in fifteenth-century Jerusalem.[145] Hans Holbein the Younger did the same in his *Images from the Old Testament* (1539); and his woodcuts were used, in turn, by the Nahua artist Juan Gerson for the Apocalypse cycle at Tecamachalco.[146] The stage had been set for a conflation of several "blueprints" that could be used for architectural replication in the New World. Let us see how the Temple plans of Nicholas of Lyra and the other available iconographic sources manifested themselves in particular Mexican evangelization centers.

THE NEW TEMPLE OF HUEJOTZINGO

The territory where the great Franciscan monastery of St. Michael the Archangel (San Miguel) at Huejotzingo was erected had been the land of an ethnic group closely allied to the Spanish conquistadors. Gerónimo de Mendieta, the apocalyptic author, was guardian of Huejotzingo in 1529; Diego Valadés, the rhetorician and illustrator, was interpreter there in 1567; and Toribio de Motolinía, chronicler of the Indian Jews, resided there for a while. The architect Fray Juan de Alameda chose

Fig. 4.29.
Huejotzingo. Rendering of the open chapel in the second stage of construction, with the addition of an "open theater" to the right. (From Córdova Tello, *El convento de San Miguel de Huejotzingo.* Used with permission of the Instituto Nacional de Antropología e Historia, Mexico City.)

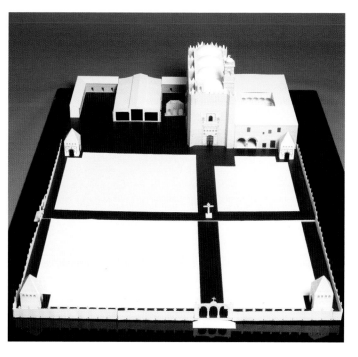

Fig. 4.30.
Huejotzingo. Model of the Franciscan complex before the destruction of the open chapel, "theater," and the friars' temporary dwelling (at the left). (Photo by Robert A. Lisak.)

phy, which I shall analyze in the next chapter, will confirm the association with the rebuilt Temple of Jerusalem and the special status of Charles V as the messianic last ruler.

The superb façade of the Church of San Miguel reveals splayed, corner pier buttresses as seen on St. Gabriel at nearby Cholula, but the decoration of the façade is unique in Mexico (figs. 4.32 and 4.33). Above the doorway arch, under a rectilinear frame of the Franciscan cord, are seven oversized seals with the abbreviations for "Jesus" and "Christ" (fig. 4.34). They can be identified as either imitations of wax seals or, more likely, bread seals (stamps) for eucharistic wafers. Such stamps commonly displayed the divine names or even the *arma Christi*, leading one to wonder whether those emblems connoted the Eucharist in their use in colonial sculpture.[152] In the medieval Church, the most prized stamps were those brought by pilgrims from Jerusalem and the Holy Land, and indeed the concentric circle design of these stamps was common among the Knights Templar and Hospitaler. Proof that there were bread stamps in New Spain is demonstrated by the sculpted hosts clearly identifiable on the atrial crosses at Huichapan, Atzacoalco, and Villa de Guadalupe (Mexico City), which strongly resemble the seals at Huejotzingo (fig. 5.36). In light of the es-

chatological expectations, the number seven must refer to the book of Revelation and the opening of the seven seals of the End Time (Rev. 6); it was also the title of a tract by Joachim of Fiore known to the mendicants in New Spain.[153] In medieval exegesis, the seven apocalyptic seals represented seven Christological mysteries: Christ's Incarnation, baptism, Passion, descent into hell, Resurrection, Ascension, and the sending of the Holy Spirit.[154] They are echoed here by the seven knots in the Franciscan cord of the frame, which, like the seals and the holy names of Jesus or Christ, were used as apotropaic devices.[155] The color of the Huejotzingo façade—imitating striated pinkish stone—is coincidentally the same color used in manuscripts of Richard of St. Victor's illustration for the façade of the Temple of Jerusalem.[156]

Finely worked details, which include the Isabelline pearls, are carved in the horizontal molding under the side of the arch, as well as on the truncated Solomonic bases of the colonnettes and the shields with the Five Wounds of Christ.[157] Not at all common in Europe, the shield of the Five Wounds was the standard Franciscan emblem in sixteenth-century New Spain. It acted as an allusion not only to the five passional wounds of Christ but also to their counterparts in the stigmata of

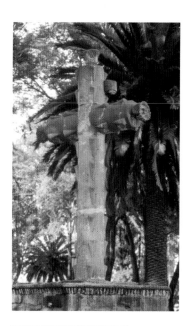

Fig. 4.31.
Huejotzingo. Original atrial cross, a "grafting cross," relocated to the town plaza. (Photo by author.)

Fig. 4.32.
Huejotzingo. Façade of the church with the seven seals, shields of the Holy Wounds, and Franciscan cord. (Photo by Javier González.)

Fig. 4.34.
Huejotzingo. Detail of the seven seals and Franciscan cord above the west portal. (Photo by Javier González.)

St. Francis, the *alter Christus*.[158] Here the wounds are rendered in a surrealistic style that has been copied from Aztec blood glyphs and appear in a typically quincunxial form.[159]

The crenellations on the roof of the church, which are truncated pyramids, are unusual and may have reemployed a pre-Hispanic shape.[160] The external architecture was also designed for a sonic effect. Embedded in the crenellations are vestiges of clay pipes or whistles—similar to the Aztec *chirimía* flutes (figs. 1.27 and 4.35).[161] With the force of the wind, they would produce a "calm, bucolic music, or even a sad sonata, which made the neighbors of the town tremble."[162] This unique musical architecture also fulfilled the biblical text of Tobit (13:17) on the future rebuilding of the City and Temple, when "the gates of Jerusalem shall sing hymns and her very houses will cry out with 'Alleluias,'" as well as Isaiah's prophecy (62:6) "Upon your wall, O Jerusalem, I have stationed watchmen, never, by day or by night, shall they be silent." The biblically minded friars might also have recognized a missiological reference from the prophet Zechariah (10:8): "Thus says the Lord: I will whistle to them and I will gather in the remnant of the house of Israel." This remnant would, of course, include the Lost Tribes, who might have been found here in the New World. According to local tradition, the whistles were broken by order of an official of the Inquisition.

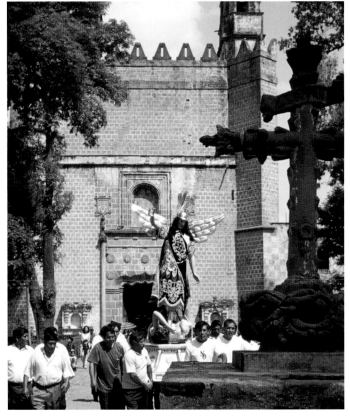

Fig. 4.33.
Huejotzingo. View of the church façade from the atrium on the Feast of St. Michael the Archangel. The present atrial cross was originally the finial of one of the posa chapels. (Photo by author.)

Inside the tall single-nave church, the rib system of vaulting is particularly handsome, with its curved and straight patterns. Three distinctly different patterns are used in the bays of the church proper, while another variation covers the presbytery and undercroft, thereby emphasizing the tripartite division of the Amerindian temple's vestibule, holy place, and holy of holies.

Returning to the outside, the monumental portico or *portería* entrance to the convent is a masterpiece of heavy but skillful carving (fig. 4.36). This portico was the site of sacramental confessions. The central column is really a huge balustrade—often used in stage scenery—probably copied from some two-dimensional source.[163] A nearly identical balustrade appeared as a stage prop in a drama performed for Emperor Charles V in Ghent in 1515, which his cousin Fray Pedro de Gante attended. At Huejotzingo, the archivolts of the portico are carved with both the flattened pattern of the heraldic chain and the cruciform emblems of the Order of the Golden Fleece (fig. 2.14), of which Charles V was Grand Master. Like the balustrade, it too had been pictured in stage representations. The order's heraldic emblem was also an apotropaic shield that provided spiritual protection to its users.[164]

An ancillary patio is located on the north side of the church where the ramada, school, and humble dormitories once stood. The richly carved north doorway, the *porciúncula*, has been the subject of much study and controversy (fig. 4.37). Some have seen in it a recollection of the mihrab of the mosque of Cordoba.[165] The Islamic association may not be farfetched, because its iconographic source is from Jerusalem.[166] Santiago Sebastián López was the first to identify a visual quotation from the Bible in the two columns that flank the doorway (figs. 1.26 and 4.38).[167] They appear as the columns of Jachin and Boaz that Solomon erected in the portico of his Temple. (Similar columns and capitals appear on the façade of the Franciscan church at Altixco.) The biblical columns flanked the door and had elaborated capitals made of metallic lilies and chains, or nets with pomegranates. At Huejotzingo, the biblical decoration crowns the capitals and continues as a curving ornamental frame around the arch of the portal.

The columns reappear in the New Jerusalem Temple of Ezekiel's mysterious vision. In his apparition, it is precisely the

Fig. 4.35. Huejotzingo. Detail of the merlons on the roof with the remains of the whistles. (Photo by author.)

Fig. 4.36. Huejotzingo. Portico entrance to the convent with the chain of the Order of the Golden Fleece carved in the archivolts. (Photo by Javier González.)

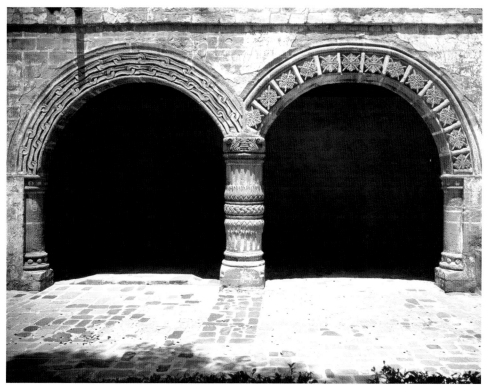

Fig. 4.37.
Huejotzingo. Detail
of the model showing
the north or *porciúncula*
door. (Photo by
Robert A. Lisak.)

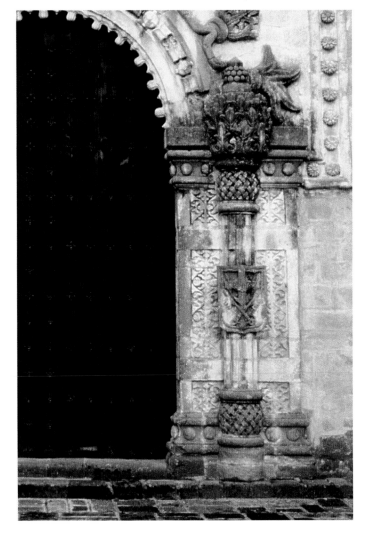

Fig. 4.38.
Huejotzingo. *Porciúncula*
doorway with one of
the two temple columns,
shield of the keys,
basket capital, and
pomegranate finial.
The stylized lilies and
chain of the Order of
the Golden Fleece are
above in the *alfiz*.
(Photo by author.)

north side (as here at Huejotzingo) that gives direct access to the Temple's façade (Ezek. 44:4). "Then [the angel] brought me into the vestibule of the temple . . . and there were two columns by the pilasters, one on each side" (Ezek. 40:48–49).[168]

A spiritual interpretation of the two Temple columns related them to the apostles Peter and Paul, who were the two pillars of the early church, and to their respective missionary activities toward Jew and Gentile.[169] The Augustinian missionary Fray Matías de Escobar related them to the virtues of the mendicant orders: "Nets, pomegranates and lilies were all that adorned the columns; the nets imaged the tight bonds of obedience; the pomegranates, in their bitterness, showed forth poverty; while the lilies which served as crowns [capitals] displayed the hidden laurels of virginity."[170]

At the north portal of Huejotzingo, the Solomonic connotation is confirmed by the two columns, the floriated capitals, the basket mesh or netting at each end of the shaft, the talismanic chain or collar of the Order of the Golden Fleece in the archivolt, and the lily pattern above the arch.[171] The artist obviously worked not only from the biblical text but also from some print or engraving.[172] The source of the two pillars is clearly found in all editions of Nicholas of Lyra's Bible commentary (fig. 4.39). Similar columns had been installed at European cathedrals, as well as on the façade of the Franciscan conventual Church of the Madre de Deus in Lisbon.[173] Like the Temple ground plans and the four atriola, the Solomonic columns of Jachin and Boaz were reproduced in monumental architecture in all sorts of European contexts in later centuries.[174]

The Nahua Christians of New Spain certainly knew of this biblical architecture. Using the symbolic interpretation of the Venerable Bede, Fray Bernardino de Sahagún's *Psalmodia Christiana* instructs them to compare Peter and Paul to the two Solomonic columns in a saints'-day hymn. As they danced in the church atria, they sang:

> At the temple door, on either side, were two copper pillars, profusely beautiful with flowers, well designed.
> The first pillar [*tetlaquetzalli*, lit. *stone* pillar, as at Huejotzingo] was named Jachin, and the second was named Boaz. On each pillar top were flowers and pomegranates and chains.

... And both [of] the copper pillars that are at the temple door are pure, well made, renowned; they are living, they are speaking.

One is named Saint Peter; the second one is named Saint Paul.[175]

Like so many other Mexican north portals, the *porciúncula* of Huejotzingo was sealed (fig. 1.26). Examination of the door frame gives evidence that no hinges or wooden doors were installed until the twentieth century, leading one to believe that the doorway was either always left open or, more likely, that it was sealed and opened only infrequently. A Jerusalem connection is suggested because, like the Golden Gate, a sealed door was part of the Holy Sepulcher complex as it appears in Breydenbach's *Pilgrimage to the Holy Land*, and as it is to be seen today (fig. 4.4).[176] We recall that the sealed door has eschatological connotations, because in Ezekiel's vision of the future temple the door remains closed until the Lord's return; and the north portal, the traditional entrance of the catechumens, visualizes Isaiah's words concerning the pagans in the messianic era: "Open up the gates to let in a nation that is just!" (26:2) — the same words echoed yearly at Huejotzingo and every other church in the liturgy of the Advent season.

Sealed/opened doors also carried indulgences for forgiveness of temporal punishment for sin. The indulgenced quality of the *porciúncula* at Huejotzingo is confirmed by the shields on the column shafts displaying the crossed keys of St. Peter.[177] This emblem of papal power—the power to grant indulgences and remission of the temporal punishment of sin—suggests that the north door may have been unsealed only on certain occasions, for spiritual gain. Diego Valadés underscored the popularity of indulgences among the Nahua-Christians of New Spain, thus lending additional support to a Solomonic connection.[178] But the keys on the column shafts and the open portal might very well have had another eschatological connotation encouraging the vigilance urged in the Apocalypse: "This is the message of the holy one, the true, who holds the key of David: Behold, I put before you an open door which no one is able to close. . . . I am coming quickly. Hold fast to what you have" (Rev. 3:8–11).

Huejotzingo's *porciúncula* is an entrance to a surrogate Jerusalem for a new chosen people taken from among the Gentiles.

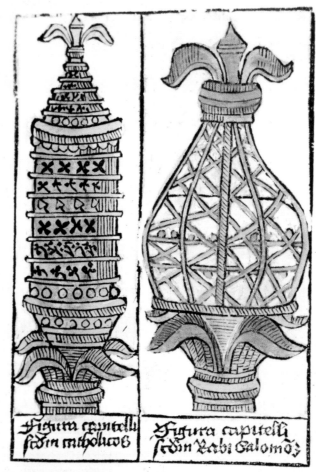

Fig. 4.39. Nicholas of Lyra, *Postilla super totam bibliam* (1503), hand-colored copy. Two versions of the column capitals of Jachin and Boaz. (By permission of the Badè Museum, Pacific School of Religion, Berkeley.)

This is further suggested by the mural painting that surrounds the portal on the interior and that displays the Mount of Golgotha with Christ crucified between the two thieves (fig. 4.40). Three Franciscan friars are taking Christ (or the image of Christ) down from the cross in the liturgical ceremony of Good Friday known as the Deposition or *Descendimiento*. The three crosses of the black-and-white mural appear on top of a rocky hill that spills down on either side of the doorway to totally embrace it.[179] A person entering the *porciúncula* from the north atrium would pass between the temple columns of Fortitude and Strength on the exterior and appear, on the interior, to be

Fig. 4.42.
Huejotzingo. Exterior view of the northwest posa chapel with the remains of a water tank and fountain. (Photo by author.)

emerging through the cave/tomb of Calvary.[180] Conversely, a procession—like that of the flagellants painted opposite the door (fig. 4.41)—would appear to be leaving through Golgotha.[181] This ingenious visual "pilgrimage" to Jerusalem's *loca sancta* cannot be fortuitous.

Another biblical allusion has been uncovered by archeological excavations at Huejotzingo. A sophisticated hydraulic system of reservoirs, aqueducts, and clay plumbing brought water from far away into the monastic complex. Each of the four posa chapels had a water tank and fountain located on its exterior wall, supplied by the underground piping (fig. 4.42).[182] These four fountains gave flowing waters to each of the patio's four cardinal directions and to the town's four *calpulli* neighborhoods.[183] Furthermore, a water channel runs down the length of the atrium from east to west on top of the south patio wall. It runs past the atrial cross on its stepped base and the fruit trees that once lined the patio, terminating at the fountain in the town plaza.[184] Anyone aware of the waterway could surely have made the association with the text of Ezekiel's prophetic vision (47:1–12): "I saw water flowing out from beneath the threshold of the Temple . . . the water flowed down from the *southern* side of the Temple, *south* of the altar. . . .[185] All along the banks of the river, fruit trees of every kind shall grow; their leaves shall not fade, nor their fruit fail. Every month they shall bear fresh fruit, for they shall be watered by

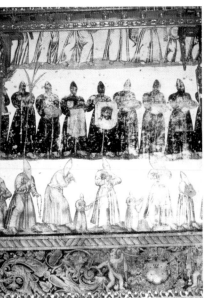

Fig. 4.40.
Huejotzingo. North interior wall of the church with the Golgotha mural surrounding the *porciúncula* door. (Photo by author.)

Fig. 4.41.
Huejotzingo. South interior wall of the church with a procession of flagellants. The figures dressed in black and carrying the *arma Christi* are men, while the figures in white are women and children. (Photo by author.)

the flow from the sanctuary. Their fruit shall serve for food, and their leaves for medicine."[186] This biblical text was also a liturgical one. It was sung at the opening of every Sunday Mass at the moment of the Asperges, the sprinkling with holy water, as the hymn "Vidi aquam qui descendebat in latus templi dextrum." The water allusion is a further identifying mark of the church's Temple association.

Huejotzingo is perhaps the best replica of the Temple of Jerusalem in New Spain and one that made use of Nicholas of Lyra's illustrations to full advantage. With its Solomonic columns, and its seven seals taken from Revelation, it hints at both the past of the Chosen People and the future of the New World Israelites. Now let us look at a further use of Lyra's illustrations, this time his rendering of Solomon's Hall of the Forest of Lebanon.

The Royal Chapel Mosque

One version of the open chapel in Mexico has often been referred to as an imitation of an Islamic mosque. The mendicants built four or five of these chapels in colonial times. The first was the Indian Chapel of San José de Belén de los Naturales; it is no longer extant. It was constructed in the patio of the convent of San Francisco in Mexico City, where once had stood the fantastic aviary of Moctezuma. As the first chapel made specifically for Indians in continental America, it was the venerable ancestor of all subsequent open chapels. It was also the first religious edifice in the world dedicated to St. Joseph, the faithful spouse of the Virgin and the ideal Christian father. Built by the natives at their own expense as a sort of national or ethnic church, it was also maintained by their gifts.

The idea for the San José chapel may well have been conceived by the lay brother Fray Pedro de Gante, a true "Renaissance man" of art and learning. Around Christmas of 1526, he moved into what was to become the monastery of San Francisco in the heart of the sacred precincts of Tenochtitlán. Being an excellent and imaginative teacher, Pedro taught reading, writing, singing, and painting, in addition to the manual arts and trades.[187] Later colonial writers credit him with teaching architecture and being the imagineer of the open chapel. He probably

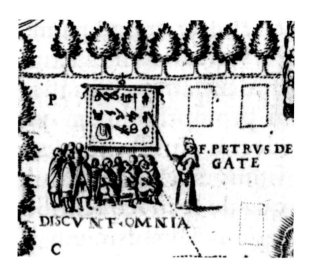

had a hand in the design of other catechumenal complexes as well, and was one of the conduits for a type of Flemish Gothic style that entered early Mexican colonial sculpture and painting.[188] Fray Pedro is also credited with being the first impresario to organize festivals in the corrals, adapting pre-Hispanic insignia for Christian use and designing costumes and eschatological plays (see chap. 6). In an engraving for his *Rhetorica Christiana*, Diego Valadés pays special homage to Pedro by showing him in the idealized patio using a painted screen (fig. 4.43). The accompanying caption states, "Fray Pedro de Ga[n]te explains everything."[189]

In the first of its many incarnations (c. 1527), the San José chapel was no more than a small, thatched shed (*ramada*) facing an atrium in which a two-hundred-foot-tall wooden cross had been erected.[190] In 1532 Fray Pedro wrote to his royal cousin the emperor about the existence of "corrals and a chapel" at the San Francisco complex.[191] He later referred to the open-air chapel as a "poor portico," and this may be significant because, as we saw above, porticos acted as "Temple" short-hand with associations to the Jerusalem shrine.[192] Like the sacramental arcade of Valadés's idealized conversion center, it would have also appeared as an outdoor tramezzo (figs. 1.4 and 4.44).

In its second manifestation, before 1539, the chapel was now "the chief sight of the country, with its aisles and chancel suitably arranged."[193] San José was most likely a portico one bay deep, with an apse set in the middle of its east wall in an arrangement soon to become widespread. An earthquake in 1547 necessitated repairs, and in 1552 Pedro wrote that the chapel "has been done over and well built." In 1558 he claimed that it could hold ten thousand inside and fifty thousand in its patio.[194] In his description of it, the erudite humanist Francisco Cervantes de Salazar called attention to features similar to those found in Scripture and in Lyra's illustrations.

Fig. 4.43. Diego Valadés, *Rhetorica Christiana* (1579). Detail of Fray Pedro de Gante with didactic canvas "discussing all things." (Courtesy of the Beinecke Rare Book and Manuscript Library, Yale University.)

Fig. 4.44.
Mexico City.
Plans and bird's-eye
reconstruction of
Pedro de Gante's open
chapel of San José de
los Naturales. (George
Kubler Archives,
Yale University.)

Most pleasing of all, however, is the little chapel that is behind a *wooden grillwork*, yet wholly open and plainly visible from the front. Its roof, high above the ground, is carried by tall tapering columns of wood, the material ennobled by the fine workmanship. . . . It is arranged in such a way that the crowd of Indians, big as it is, which flocks from all around on feast days, can see without hindrance and hear the priest as he performs the Holy Sacrifice.[195]

It appears that the open chapel was by then a structure of seven naves raised two steps above the corral. Tapered wooden columns supported the high flat roof.[196] Decorative stone arcading, two arches for each of the seven naves, dressed the face of a building that had now grown to roughly 150 feet wide by 75 feet deep, identical to the dimensions recorded in the Bible for a Solomonic building.[197] Like the open chapel we examined at Tlalmanalco, a wooden latticework grille screened the second story of the chapel, as seen in an Indian ideograph of the edifice in a 1570 codex.[198] Since cedar, cypress, and pine were readily available in the vicinity of the city, we can presume that the hall of thirty-six columns could easily have used these materials up to fifty feet in height. The interior had seven altars,

perhaps in imitation of the seven churches of the book of Revelation (chaps. 2 and 3).[199]

By the close of the seventeenth century the chapel had greatly changed. The façade had been closed up and two of the naves had been done away with. Around 1690 Fray Agustín de Vetancurt could write:

In the place of the palace and re-creation of Moctezuma . . . the venerable Friar Pedro de Gante made a church with many naves like a *porch* and without doors so that many might enjoy the sight of the services although outside the main crowd. . . . It [now] has twelve altars, some with wooden retables and others with oil paintings. There are also five chapels although small ones: the *Sagrarium* where the Host is kept that is taken to the sick; the chapel of the *Purification of the Virgin*; the *chapel of the Holy Sepulcher* whose door opens out on the entrance; the baptistery where there is a handsome font of white stone; and a chapel of the *Dormition of the Virgin*. . . . There is [also] a portico of four arches where confessions are heard.[200]

We should note that all of the auxiliary chapels are related to *loca sancta* in Jerusalem: the Temple, the Holy Sepulcher, and the Church of the Dormition in the Valley of Jehoshaphat.[201] This association was strengthened by the fact that the chapel had a relic of the True Cross, as well as stones that someone had brought from Bethlehem, Golgotha, and the Anastasis tomb and embedded in the foundation.[202]

The iconographic prototype suggested for San José has been a Muslim mosque, such as at Cordoba, or a structure based on Sebastiano Serlio's "Hall of the Hundred Columns."[203] I shall propose a different iconographic interpretation, but first it is helpful to see the evolution of San José in one of its architectonic stepchildren, the Royal Chapel of San Gabriel, Cholula (fig. 4.45).

Cholula, in the state of Puebla, was the oldest Mesoamerican city and the site of the ancient cultic center of Quetzalcóatl. The Franciscans arrived in the 1520s and located their conversion center on the demolished site of Quetzalcóatl's temple. A Capilla Real (Royal Chapel) for Indians was already in use before the decimating plague of 1544.[204] It was named after the

Spanish royal chapel in Santa Croce-in-Gerusalemme, Rome, where relics of the *arma Christi* were guarded, where Ferdinand and Isabella had been patrons, and where the Franciscan minister-general Francisco de los Angeles Quiñones was then chaplain and cardinal.[205] Thus, the title and the building carried both Roman and Jerusalemite associations.

San Gabriel was originally a wooden-roofed and columned structure, most likely a forestlike hall of cedar columns, later replaced by stone ones (fig. 4.46). Today the Capilla Real is nine bays wide by seven bays deep (190 by 170 feet) with corner towers at each end (fig. 1.5).[206] Even now one is able to recognize that the sidewalls were originally pierced by 106 (or 110) double-tiered openings. The upper openings give evidence of having once had wooden latticework screening, like San José in Mexico City, or like Solomon's Hall of the Forest of the Lebanon in Jerusalem.[207] The roof of the façade has imitation torches carved in stone, as if for lighting during nighttime services or theatrical performances (fig. 4.47), and such roof torches appear in Flemish books depicting torch-lit stage scenery for Charles V in his Solomonic and messianic roles.[208] Indeed, this Royal Chapel in Cholula may have been conceived as an elaborate stage set for theatrical liturgy both day and night.

Once again, it will be helpful to return briefly to the legends, manuscript illustrations, and book prints of temple buildings on the Haram al-Sharif. This time we are interested in the Al-Aqsa Mosque, another of the supposed Solomonic buildings (fig. 4.48). If Christian artists wished to depict the Temple in the form of one building that stood on Temple Mount during medieval times, they could have shown a multi-aisled rectangular building—a "royal chapel" of King Solomon—whose most conspicuous features were the many columns that formed a nave and seven aisles on each side plus a portico entrance of seven arches, similar to so many porticos in New Spain and, in particular, to Cholula's Royal Chapel.[209] The first mosque constructed in the southwest corner of the esplanade, a wooden one, is mentioned in 670 CE, but the present Al-Aqsa is actually a newer building of the eighth century, then said to be a structure with 280 columns arranged in fourteen rows.[210]

As with the other buildings on the Haram, the mosque became part of Jewish and Christian mythology during the Latin Kingdom. It became a royal chapel and an arsenal for weapons,

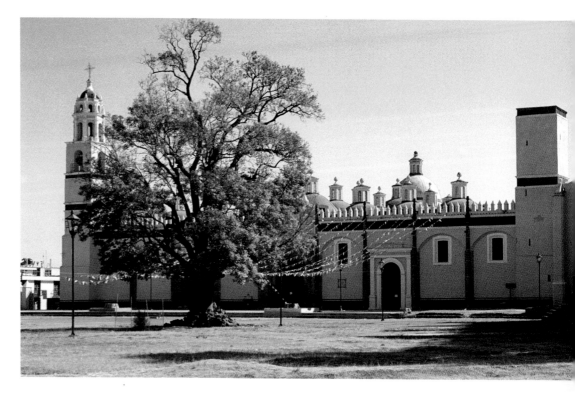

Fig. 4.45.
Cholula, the Royal Chapel as it appears today. (Photo by author.)

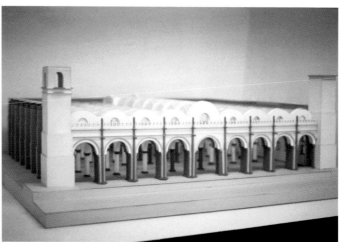

Fig. 4.46.
Cholula. Model of the Royal Chapel at San Gabriel in its early stage of evolution when the façade was still open. (Photo by author.)

just like Solomon's Hall of the Forest.[211] During the early years of the Crusaders' occupation, the Al-Aqsa was known as the "Temple of Solomon" (but just as often the "Palace of Solomon" or the "Portico of Solomon") because it served as the residence of the Latin kings, who wished to associate themselves with the Old Testament monarch.[212] Many medieval visitors believed that the Temple and residence of Solomon still stood.[213]

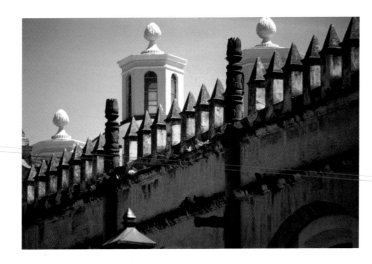

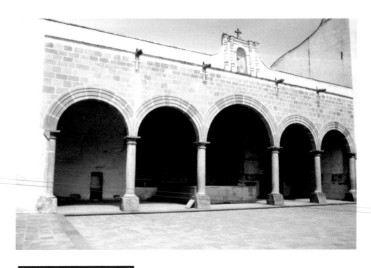

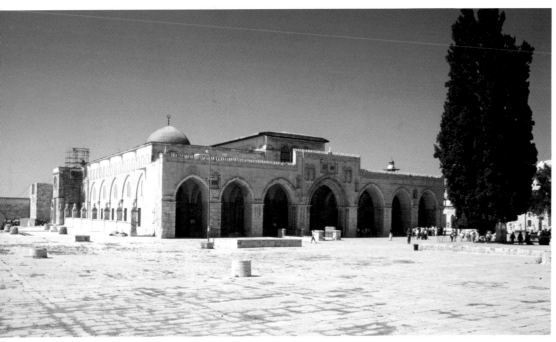

and the Virgin had transpired (fig. 4.4).[216] Chroniclers in New Spain, like Torquemada, repeated the same stories. Similar to the chapels in sixteenth-century Mexico, the Al-Aqsa was an open structure with a seven-arch façade, the center arch being taller than the rest. Christian pilgrims, who were not allowed to enter the Haram, would have spied its lateral flank from the vantage point of the Mount of Olives and would have recognized that the lateral walls were also pierced by wide openings.[217] Seven such openings can be seen in fifteenth-century drawings, and although now blocked up (as at Cholula), five are easily recognized today in photographs.[218] When the Venetian pilgrim Barbon Morosini visited the mosque in 1514, he described it as having seven beautiful wide naves with a porticoed entranceway, a detail also reminiscent of the New World *portería* chapels (fig. 4.49).[219] Indeed, even after modern alterations, the mosque bears an uncanny likeness to some early Mexican open chapels.

We also encounter the Al-Aqsa Mosque as a stage backdrop in European painting, where it was employed as if it were the authentic Temple. A number of Old Testament episodes were painted in fresco for the Franciscan Church of Santa Croce in Florence. There, Giovanni da Milano's *Expulsion of St. Joachim from the Temple* depicts the seven-arched, open wall of a mosque-

By the middle of the thirteenth century, stories surrounding Solomon and his Hall of the Forest had been collected by Jacobus of Voragine in the *Golden Legend*.[214] The Franciscans further associated the hall with the legend of the cross, and by the fifteenth century they were convinced that the whole Temple complex had been erected by St. Helena, the mother of Constantine.[215] Bernard von Breydenbach and Hartmann Schedel identified the mosque as the "Temple of Simeon" or the "Temple of Mary," where events from the childhood of Christ

like building similar to the Al-Aqsa (fig. 4.50). Both the painted Temple and its hypothetical ground plan have an uncanny similitude to the Mexican open chapels of Cholula and San José de los Naturales.[220] It seems likely that the Franciscans who came to the New World might have remembered Temple iconography from their journeys and from the order's principal church in Florence, a church dedicated to the Holy Cross of Jerusalem. Additionally, late medieval and Renaissance drama made use of stage sets imitating the Al-Aqsa Mosque for a theatrical iconography of place, a cipher for Jerusalem (see chap. 6).

The more proximate visual blueprint for San José and Cholula, however, may lie in Nicholas of Lyra's illustrations of Solomon's Hall. It is described in the first book of Kings as a combination of wood and masonry.[221] Lyra's archeological reconstruction displays a four-aisled, or sixteen-aisled (when turned sideways), mosquelike building on the plan (fig. 4.51). A two-storied elevation of the short end shows a flat crenellated roof with arched openings of equal size in both the upper and lower *mansiones*.[222] Each of the openings has a wooden lattice grillwork, as was recorded for the open chapel of San José

Fig. 4.50.
Giovanni da
Milano, *Expulsion
of Joachim from the
Temple* (later fourteenth
century), Santa Croce,
Florence. (Scala/Art
Resource, NY.)

Fig. 4.51.
Nicholas of Lyra, *Postilla super totam bibliam*, hand-colored copy.
Elevation and plan of Solomon's House of the Forest of the Cedars
of Lebanon. (By permission of the Badè Museum, Pacific School of
Religion, Berkeley.)

de los Naturales and as was certainly present in the second-
story openings at the Royal Chapel of Cholula.[223] Lyra offered
a spiritual sense of the building that could later be applied to
the converts from paganism in New Spain: "The [Hall of the]
Forest of Lebanon signifies the Church of the Gentiles which
now builds up the House of God that had formerly been torn
apart by the arrogance of pride."[224]

Most important, in the sixteenth century, as in Lyra's
day, the Hall of the Forest—Solomon's royal chapel and law
court—was believed to be still extant as the Al-Aqsa Mosque.
For a literally minded scholar like Lyra, the Hall of the Forest
was the one biblical building that could correspond to an edi-
fice known to be still standing on the Haram al-Sharif. It was
clearly indicated on medieval maps from the earliest days as a
rectangular basilical structure, and countless pilgrims drew it
with some precision (fig. 4.52).[225] Unlike the octagonal Dome
of the Rock—which did not correspond to the biblical texts in
any regard except location—the Al-Aqsa Mosque could not
disguise its similarity to the biblical prototype. Even a his-
torical mind like Lyra's could detect, if not the original biblical
building, at least a comparable reconstruction. Moreover, both
Christians and Jews had consciously copied the Hall of the
Forest in European architecture in templelike contexts. It was
replicated in Worms, Würzburg, and Venice, and finally in the
mosquelike open chapels of New Spain.[226]

LITERARY TESTIMONY TO THE TEMPLE

It is obvious that the mendicants would have found numerous
references to the Temple in the Bible commentary of Lyra, who
interpreted the building on moral and spiritual levels that they
saw as applicable to themselves and their Nahua flock. More
often, they would have heard the Temple lauded in the psalms
of the Divine Office and the Scripture readings during Mass.
These readings frequently came from the minor prophets like
Haggai, Tobit, and Zechariah, who spoke of the restoration of
Jerusalem and the rebuilding of its Holy House.[227]

The Indians knew the same Scriptures through translation
and liturgy. They knew of the Jewish Temple's design from Sa-
hagún's *Psalmodia Christiana*, in the choreographed hymns that

were composed for Eastertide and the feasts of the apostles and saints. There, the golden cherubim hovering over the ark, the vestments, the brazen sea mounted upon the twelve oxen, the altars of incense and holocaust, the menorah, and columns of Jachin and Boaz were not only described but put into the mouths of Nahua-Christians to be sung and danced.[228]

References to temples and comparisons to the Jerusalem Temple are quite numerous among the sixteenth-century mendicant chroniclers like Duran, Motolinía, and Mendieta. The earliest references almost always refer to the pre-Contact buildings of teoyoism. Fray Diego Duran, who came to New Spain as a child, describes the shrine of Tezcatlipoca in terms of the Jerusalem Temple. It had an inner chamber where the god supposedly dwelled hidden behind a veil, like the Holy of Holies. No one dared enter this place, with the sole exception of the priests appointed to serve the cult of the god—like the Jewish high priest who entered the *sancta sanctorum* only once a year.[229]

Fray Juan de Torquemada, writing at the beginning of the seventeenth century, informs his readers that the "demonic temples" parodied the Solomonic shrine, especially in their having a "Holy of Holies" at the top, preceded by an altar for blood sacrifice: "The spatial division of the [Aztec] temple is worthy of note, because we find an inner room, like that of Solomon's building in Jerusalem, in which no one enters except the priests, and not even all of them, only one. From this the envy of the devil can easily be inferred, because seeing the order of the temple of God [in Jerusalem], he wished to follow suit and imitate it."[230] In the book of Joshua (22:1–20), Torquemada discovered cryptic allusions to immense temples like the pyramids at Tenochtitlán. In Joshua it states that two Hebrew tribes did not cross the Jordan or enter the Promised Land but wandered forlorn. These lost tribes raised a rival altar of *infinitae magnitudinis*, showing by their excessive construction that they were rebels against God, "just as did these demonic temples of the Aztecs."

Torquemada had received this Old Testament information from reading Lyra's *Postillae*. The pagan temples, says Torquemada, also imitated the Jerusalem shrine by having consecrated virgins, just as Solomon's Temple housed the prophetess Anna and the Virgin Mary herself, "just as Nicholas of Lyra informs us."[231] Indeed—says Torquemada—Anna's house be-

Fig. 4.52. Map of Jerusalem, c. 1320, by Petrus Vesconte. Reproduced in Mario Sanuto, *Liber Secretorum Fidelium Crucis* (Hanover, 1611). The Al-Aqsa Mosque is here represented as the Domus Salomonis, the House of the Forest of Lebanon, and is based on Nicholas of Lyra's reconstruction. (Courtesy of the Beinecke Rare Book and Manuscript Library, Yale University.)

came a mosque (the Al-Aqsa). Furthermore, like the House of God in Jerusalem, the pagan temples had patios with rooms and *gazophylacia*, where their priests lived and had their cult objects, firewood, and cleaning apparatus.[232] But, according to Torquemada, if the pagan buildings imitated the Jerusalem Temple, they also resembled the buildings that the mendicants would later erect in the New World. The Aztecs had posas (*hermitas*) and stations (*estaciones*) for their pre-Contact processional cults. Anticipating the mendicants, they even had *humilladero* chapels at the crossroads.[233]

Other friar chroniclers offered testimony to the Jerusalem associations of the mendicant missionary complexes. In his *Chronicle of the Order of Our Father St. Augustine*, written around 1592, Fray Juan de Grijalva noted the Solomonic resemblance of the patio with its open chapel and posas. Moreover, he even recognized that the *calvarios* on the hillsides were conscious imitations of the Holy Sepulcher complex on the Via Dolorosa.[234]

Fifty years later, Fray Diego Basalenque composed his *History of the Province of St. Nicholas of Tolentine*, in which he describes an early Augustinian building campaign at Ucareo (Michoacán) in the decade 1550–60. A friar named Juan de Utrera devised a method of accelerated and economical construction at

Ucareo. His inspiration came from the Old Testament description in 1 Kings 5:26 and 6:7: "Solomon conscripted seventy thousand men to carry stone and eighty thousand to cut the stone in the mountains. . . . The Temple was built of stone dressed at the quarry, so that no hammer, ax, or iron tool was to be heard in the Temple during its construction." In Michoacán, Utrera arranged to have all the stone cut to its final form at the quarries and the lumber finished at the yards by the thousands of conscripted natives. With the inspiration from King Solomon, construction was accomplished within the year.[235]

In the following century, Fray Matías de Escobar wrote his *Americana Thebaida*, a history of the Augustinians in Mexico. He alludes to the building activities in Michoacán, the Augustinian promised land, referring metaphorically to the river Jordan and to the two columns of Jachin and Boaz.[236] Using earlier eyewitness sources, he notes that in the churches of his order it was common practice to erect wooden grillwork in the *toral* archway of the presbyteries during Lent to separate the men (in front of the grille) from the women (behind the grille). Such a separation of the sexes had existed in the Jerusalem patios, where the outer Court of the Women was so distinguished from the inner Court of the Men.[237] Also, the wooden lattices are reminiscent of features of the Hall of the Forest, whereas the spatial divisions are reminiscent of those in Joachim of Fiore's idealized monastery-city for the different *ordines*, all the more so because Escobar names Abbot Joachim as the inspiration and forerunner of the Augustinian missionary enterprise in the Americas.[238]

Escobar calls the posas in the Mexican atria *mansiones* (stage houses). He even refers to an illustration from Nicholas of Lyra's *Postillae* when he describes the church at Tiripitío, Michoacán. The reason for the similarity to the Jerusalem shrine, he says, is that "God wanted to see at Tiripitío what He saw in the Temple of Israel." According to the friar, the inspiration for the church at Tiripitío had been the Old Testament, with its sacrificial altar and ark.[239]

The Augustinian friar mentions that he is aware of the printed designs for the Temple of Jerusalem, such as those of Nicholas of Lyra, which he had no doubt seen in Bibles shipped to the Americas.[240] Thus it appears that while the Temple iconography of the mendicant constructions was never overtly

stated, medieval symbolism had always presupposed it. In New Spain, the association was presumed and reinforced by sermons, catechesis, hymns, and liturgical or theatrical use. Such an association would have been discernible, as Richard Krautheimer would say, to the sensitive or intelligent observer. Lastly, it may have been deemed unwise for the mendicants to declare openly the deliberate copying of a Jewish building at a moment when the Office of the Inquisition was suspicious of clandestine Jews, or judaizing practices, in the New World.[241] Silence about these experiments, like the liturgical experiments we shall witness below, proved to be wiser.

The material documented so far suggests that the Mexican mendicant constructions continued in the line of medieval constructions of surrogate Jerusalems. Specific buildings in the cityscape of the Mexican hagiopolis made the identification localized and provided the multiple meanings given to one locale or the other.

Likewise, the mendicant evangelization complex as a whole was a simplified and clarified reproduction of the Jerusalem Temple, with patio, *gazophylacia*-posas, battlemented façades, paved processional ways, and tripartite temple house. This Temple iconography was mediated by the readily available drawings of Richard of St. Victor and Nicholas of Lyra and by pilgrims' renderings of the actual site, the Haram al-Sharif. The structures also conflated aspects of the Holy Sepulcher temple with the Solomonic temple, giving meanings specifically related to the sacrificial Passion of Christ. As Krautheimer has indicated, architectural imitations need not be accurate and total replications; rather, they need only be suggestive and rememorative of the venerable archetype (figs. 1.1, 1.18, 4.3, and 4.14). It appears to me that one or more patios, monumental gates, corner *gazophylacia*, outdoor altar(s) in the patio, and a tripartite temple house were more than sufficient ciphers for reproducing the Jerusalem Temple. Past, present, and future meanings—allegorical, tropological, and anagogical meanings—also "vibrated" simultaneously in one building.

The open chapels that follow the form of an arcaded ciborium were inspired by medieval paintings and frescos commonly seen on the Continent, especially in Franciscan establishments. In Mexico, they continued in the long tradition of a

shorthand for Temple representation by the use of open porticos and arcaded stage sets. The mosquelike open chapel found its inspiration in representations of the rectangular Hall of the Forest of Lebanon as reconstructed by Nicholas of Lyra and conflated with an actual building on Temple Mount, the Al-Aqsa Mosque. The posa chapels of New Spain, besides replicating the general position of the Temple's *gazophylacia* in the atrium, have taken their specific shape from the "Throne of Christ" and similar *qubba* aedicules on the Jerusalem Via Dolorosa. Elements from at least four easily accessible printed sources—those of Richard of St. Victor, Nicholas of Lyra, Bern-hard von Breydenbach, and Hartmann Schedel—were combined and realized in stone and mortar in Mexico.

After having traced the eschatological mentality of the missionaries and their desire to rebuild the Temple, and their belief in the Jewish origin of the Amerindians, we may logically conclude that the City and Temple of Jerusalem were primary metaphors, first in the minds of the New World apostles, and then in the biblical learning of the native elite. I shall strengthen this proposition by considering eschatological iconography in Mexico—particularly the atrial cross—and then by examining the liturgical/theatrical use of the whole complex.

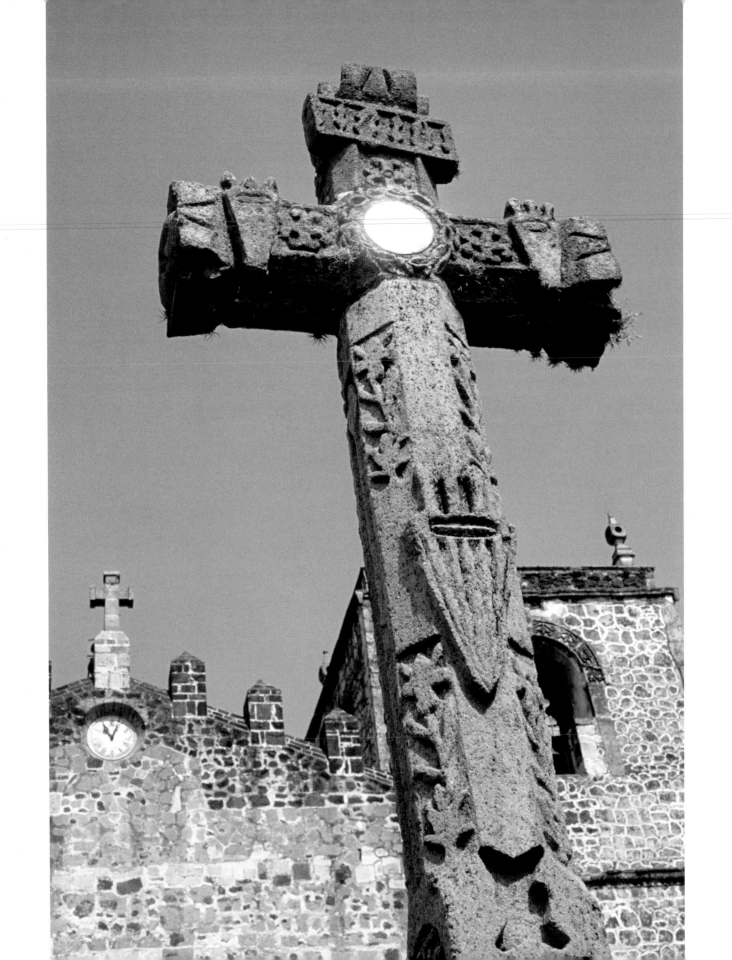

The Cosmic Tree

If there is one element that ties together the multiple meanings of the sixteenth-century mendicant evangelization complex and manifests its transcendent significance, it is the ubiquity of the deceptively simple atrial cross. Cruciforms were a cosmic symbol shared by both parties in the Contact, and the Christian cross would be the most potent symbol and metaphor in the religious revolution of Christianization.

Mesoamericans had cross-shaped images, and Spanish explorers first encountered them on the Yucatan coast in 1517.[1] When asked about the origin of one cruciform, the Indians replied that a "certain, most beautiful man had left the said relic as a souvenir." Others claimed that on it "a man more radiant than the sun had died."[2] Likewise, the Christian cross was the first foreign icon that the native population encountered at the moment of the Contact. In some instances, the friars whitewashed pagan altars, preserving them and using them as a pedestal (*momoxtli*) for the Christian cross.[3]

The iconography of the carved motifs on the cross is based on the instruments of the Passion (fig. 5.1). In Latin, the instruments are called the *arma Christi*, the weapons or trophies of Christ by which he won universal salvation. In chapter 2, I noted that the *arma Christi* also have eschatological connotations associated with the Sibylline prophecies of the Last World Emperor and the final apocalyptic battle before Christ's second advent.[4] Just before Doomsday, the cross will reappear in the sky; and at the Last Judgment itself, the personified Tree of the Cross will act as witness in the adjudication of the saved and the damned.

THE MESOAMERICAN CROSS

In the [pagan] temple courtyards they planted very wide and leafy trees, so much so that under the shade of

151

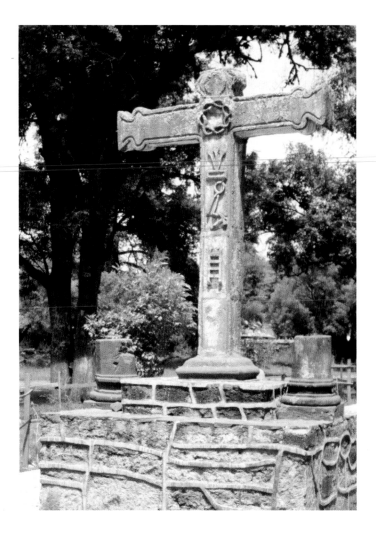

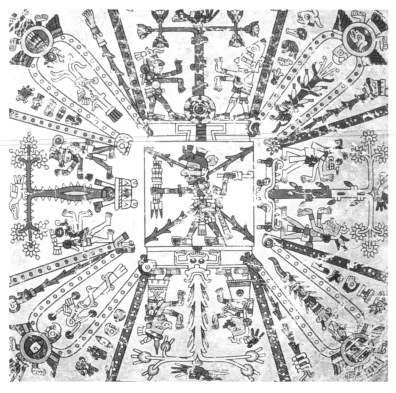

Fig. 5.2.
Codex Fejérváry-Mayer (c. 1400–1521). The quadripartite image of
the Aztec world with the four world tree–crosses and celestial birds.
The center is presided over by the old god of fire, the lord of time.
(Courtesy of the Board of Trustees of the National Museums and
Galleries on Merseyside, Liverpool Museum, MS Mayer 12014.)

one such tree more than a thousand persons could sit. . . .
The Indians call it *ahuehuetl*, and the Spaniards call it the
"tree of Paradise."

—Fray Diego Valadés, *Rhetorica Christiana*

Pre-Columbian beliefs aided in a shared arboreal appreciation,
and a convergence of metaphors took place for both Mesoameri-
cans and missionaries. The Aztec heaven of Tamoanchan—
literally, "the home from which we descend"—had both celes-
tial and terrestrial features of a paradise of origins. Tamoanchan
was often represented by an anthropomorphic tree, sometimes
broken and bleeding, similar to the atrial crosses with the bleed-
ing Five Wounds. Sacred trees were thought to be links between

the celestial and subterranean realms, with certain species of
trees particularly associated with ancestry, rulership, and pros-
perity.[5] Trees, like the stone stele that were erected in the temple
courtyards, acted as cosmic centers, *axes mundi*, and they were
ladders to the upper and lower worlds (fig. 5.2).[6]

Trees were also personified (like the Christian cross, as we
shall see) and were linked to notions of sacrifice and rebirth.[7] In
Aztec mythology, the plumed serpent Quetzalcóatl, in flight
from his solar nemesis, the Judas-like trickster Tezcatlipoca, had
immolated himself so that his burning heart might ascend like a
spark into the heavens to become the Morning Star. When he
was visually represented as the Morning Star (a title also as-
cribed to Christ in Rev. 22), his attribute was a freestanding pil-
lar located at the center of the Aztec universe in Tenochtitlán.[8]

At the rising of the planet, the rites at the base of Quetzalcóatl's pillar were especially sanguinary, with many human holocausts.[9] In Aztec metaphorical thinking on human anatomy, the heart itself is a tree; it sends out shoots—the blood vessels—that are imagined as climbing plants or arboreal limbs.[10]

A further association with sacrifice was embedded in the pre-Hispanic cruciform. In fertility rituals, an individual was tied to an upright scaffold, a cross, or a tree and shot through with arrows (figs. I.3 and 5.32). His blood penetrated the earth and renewed the life force. The executioner was dressed in a loincloth that associated him with the solar deity, implying that the sun and the victim shared in saving and fertilizing the earth.[11] No wonder then that the Aztecs took so easily to the Christian cross with its related meanings of blood, heart, and sun.[12]

For the Christianized Nahuas, a particularly sacred tree was the *ahuehuetl* or cypress.[13] A two-hundred-foot *ahuehuetl* cross was erected in the atrium of the evangelization complex of San Francisco, Mexico City, in front of the Indians' open chapel of San José.[14] The Nahua Christians had made it from the tallest of the trees of Moctezuma's garden, the site on which they had constructed the conventual buildings. The cross towered over everything else in Mexico City; it could be seen for miles around and seemed "to reach to heaven."[15] We should not overlook the importance of this cross's "reaching up to heaven." The description may have signified more than its impressive size.[16] In Sahagún's liturgical work, the *Psalmodia Christiana*, St. Francis is equated with a cypress and a ceiba tree; he is also heaven's florist. Under the arboreal Francis, the new Christians of New Spain are now sheltered.[17]

The Nahua Christians of the Franciscan center at Tlaxcala incensed and venerated their cross as Tonacaquáhuitl, "the tree that sustains our life," which was surely conflated with their earlier totems, as well as with medieval notions of the cross as the tree of life.[18] The natives of Huejotzingo likewise set up a towering wooden cross and would dance around it in cross formation. Dancing round an object (in counterclockwise fashion), such as an Aztec altar or a sacred pole or tree, was an act of magical power. The object's power was increased by the dancers' circumambulating, and that power, in turn, was communicated to the dancers.[19] The friars later encouraged counterclockwise liturgical dancing through the four

posas of the patio corral around the Christian tree of life— the cross.

An early Christianization of the Mexica's sacred tree or pole took place in the Dance of the Flyers, a ceremony related to fire sacrifice (fig. 5.3). In pre-Hispanic times, four *voladores* (flyers) danced on top of the pole accompanied by a fifth person, a musician, forming a human quincunx.[20] To the sound of the drum and flute, they descended by hanging from ropes attached to their ankles. The ropes unwound from the *axis mundi* and the dancers gradually made their descent to earth. The colonial missionaries baptized the spectacle by adding angel wings to the dancers and reinterpreting the ritual as a descent of the angels from the Christian heaven and God.[21] The Nahuas, of course, had had sacred birds and birdmen, who were then syncretized with the Judeo-Christian intermediaries we call angels.[22]

The Maya also had sacred trees and cruciform figures, actually totems of the four winds. Their cosmic tree was a schematic of the underworld, middleworld, and upperworld of the

Fig. 5.3. *Codex Azcatitlan* (later sixteenth century). Friars, baptism, and the dance of the *volador* angels. (Bibliothèque Nationale de France, Collection Aubin, MS mexicain 59–64. Used with permission.)

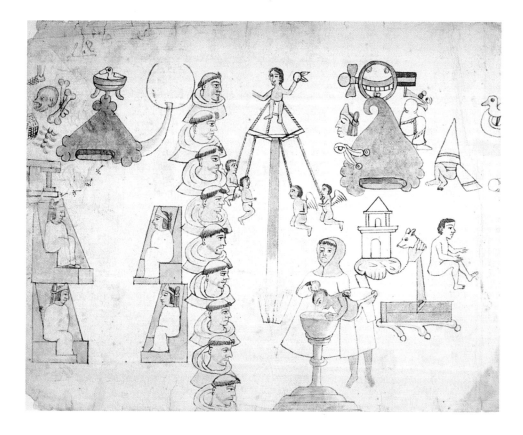

universe. It originally stood in the midst of the primordial chaos but became pregnant as the original Father/Mother, the source and purpose of life.[23] The most famous arboreal representation that has come to light is the one carved on the tomb slab of King Pacal at Palenque, Yucatan (fig. 5.4). In the funereal scene, the king falls backward into the maw of death and the underworld while a sacred tree, a tau-like cross, grows from his navel and is surmounted by a sacred bird of paradise. But even more striking, and similar to the mendicant iconography, are the Maya glyphs on the face of this cruciform for the words "eye," "shining," and "mirror."[24] The cruciform trees were thought to be alive, to see, to reflect images as in a mirror, or to be seen through to glimpse transcendent realities. In colloquial Náhuatl, a mirror could also be, metaphorically, a paradigm—a very useful connotation in the cultural transference. The Christian crosses that replaced the cruciforms at the navel of the New World were similar in many ways and would also use mir-

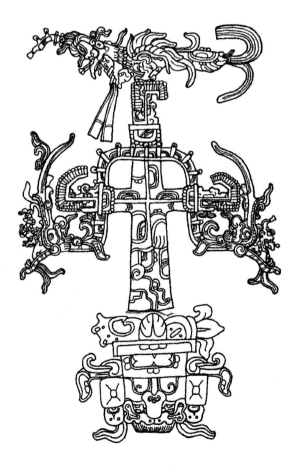

Fig. 5.4.
Palenque, Chiapas.
The world tree carved
on the tomb slab of
King Pacal,
surmounted by the
celestial bird and
decorated with mirror
glyphs. (Drawing by
Linda Schele, © David
Schele, courtesy
Foundation for the
Advancement of
Mesoamerican Studies,
Inc., www.famsi.org.)

rors. The new cruciform, brought by the Europeans and located at the fifth point of the new corral quincunx—a miniature cosmos—now marked the place of Christ's liminal time and transformation. Not without symbolic importance in this regard is the very first question the native penitent was asked in confession: "Have you taken the Cross in vain or refused to give it the veneration that it deserves?"[25]

The Plumed Cross

Christ is the tree
his words are his leaves
these are the evangelios "Gospels"
these are the things that he nurtured
they live in his *santo* "holy" light.
 —a Náhuatl saying

The original crosses erected by the friars on top of mountains and *teocallis*—as talismans against evil—were of wood.[26] But because of the lightning strikes these huge poles attracted, the bishops' synod of 1539 decreed that they should henceforth be of stone and shorter than their timber predecessors.[27] The most common form of the atrial cross has no body of Christ; rather, the instruments of the Passion are carved on its vertical and horizontal beams (figs. 5.5 and 5.36). Often there are indications of huge blood drops that could easily be confused with flames of fire. As we have seen, blood and fire were root metaphors in the Mexica religion and cosmology; similarly, in Iberian stories of the eschatological cross, flames frequently leap from its arms. In the Franciscan crosses of New Spain, the crown of thorns is placed at the crossing or is worn like a collar, sometimes within a sunburst, while the Augustinians preferred placing the head of Christ there, much like the image that appeared on Veronica's veil.[28]

A second form of the atrial cross modifies the first by displaying an abbreviated body of Christ. Only the head, hands, and feet appear in what is known as the *syndesmos* ideogram. It depicts a schematic human body—the root metaphor of Christianity (fig. 5.6). The abbreviated body of Christ is also an

Fig. 5.5.
Acolman. Atrial cross surmounting a diminutive sepulcher.
(Photo by J. Barry Kiracofe.)

Fig. 5.6.
Angahua, Michoacán. Atrial cross with the *syndesmos* abbreviation
of the body of Christ. (Photo by J. Barry Kiracofe.)

apocalyptic image. It represents the ingathering of all humanity by Christ as high priest at the final harvest of time and space.[29] A precedent for the Mexican atrial cross is recognized in late fifteenth-century painted crosses with the *syndesmos* ideogram, accompanied by a banderole with a quotation from Revelation (22:13f): EGO SUM ALPHA ET OMEGA. Speaking of the New Jerusalem, John the Seer quotes the one seated on the throne: "I am the Alpha and the Omega, the first and the last, the beginning and the end. Happy are those who will have . . . the right to feed on the Tree of Life and can come through the gates of the city."[30] The implication of the banderole is that the painted *syndesmos* image is a foreshadowing of this eschatological tree, Christ's cruciform throne. The medieval *syndesmos* ideogram appears not only on crosses but also on world maps and liturgical objects such as reliquaries, eucharistic plates, and portable altars.[31] This suggests that the atrial crosses might reflect subtler levels of meaning relating them to the sacrifice of a holocaust on an altar. We shall see this confirmed below.

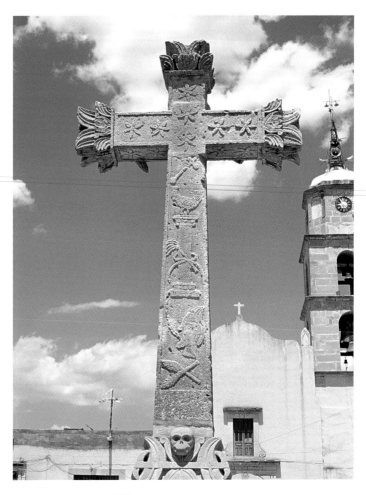

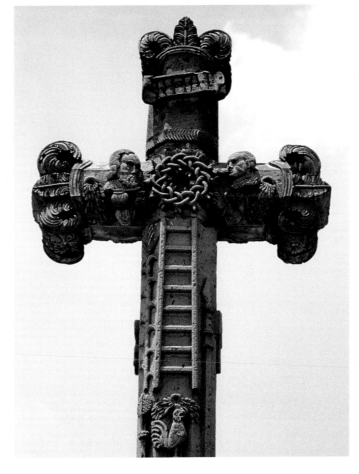

Fig. 5.9.
Huandacareo, Michoacán. Atrial cross with plumed terminations, stars,
and instruments of the Passion. (Photo by author.)

A third form that the atrial cross can take is known as the "grafting cross," which looks as if the cross has been made from two tree trunks whose branches and leaves have been lopped off, like the cross at Huejotzingo (fig. 4.31).[32] The medievals called it a "grafting" cross because they understood it as Christ's body being grafted onto the cosmic tree of paradise.[33] The cross at Huitzilac looks like a petrified limb (fig. 5.7), while that of Acolman has an elaborate vine climbing the shaft and arms, blossoming in stylized *cempohualxochitl* or marigolds—a flower associated with the Nahua-Christian heaven and the pearly gates of the Heavenly Jerusalem (fig. 5.5).[34]

Fig. 5.10.
San Matías el Grande, Michoacán. Atrial cross on tiered base and a second cross surmounting the later "Holy Sepulcher" chapel. (Photo by author.)

Several of the atrial crosses have adapted the foliate design of the fleur-de-lis to terminate the cross arms and headpiece. Foliate-design pendant crosses were common in fifteenth- and sixteenth-century Europe, and several extant ones display the *arma Christi* emblems.[35] Together with other portable items that commonly bore the *arma Christi*, such as embroidered vestments and banners, pendant crosses were an easily transportable means of cross iconography.[36] However, in New Spain, the stone carvers reinterpreted the foliate endings as feathers to display indigenous notions of royalty and divinity, or to indicate a victim crowned with feathers as a god impersonator (*ixiptla*). The horizontal beams and vertical headpieces of the crosses at Cuauhtitlan and Huandacareo, for example, terminate in handsomely sculptured feathers—a novelty that never appears in European art (figs. 3.10, 5.8, and 5.9). Feathers and plumary art were the exclusive property of Aztec nobility and warriors and also attributes of the gods.[37] Additionally, in pre-Contact times, plumed creatures were believed to be the reincarnated souls of dead or unborn human beings nesting in the

Fig. 5.11.
Acolman. Detail of fig. 5.5, the fictive sepulcher of Christ and the image of the Virgin of Sorrows. (Photo by author.)

world tree.[38] The neophyte artists skillfully created artificial trees out of birds' feathers, or even gilded leaves, for the processions and catechetical stage plays. The Nahuas delighted in these arboreal and avian images, and such status symbols were now transferred to Christ and to his regal instrument, the cross, both of which are spoken of as adorned with feathers of the divine Quetzal bird.[39] These plumary symbols harmonize with the wealth of arboreal metaphors that Náhuatl Christian liturgical texts accorded the cross. For example, in a prayer for a Marian feast, Mary is a fruit tree that God grew in his orchard of paradise. Christ is her fruit, which is hung from the Tree of Life (the cross) by the three nails.[40]

In addition to the above types of atrial cross iconography, there are others that make overt reference to buildings in Jerusalem, confirming that the cross is part of a larger reference to the Holy City and its Temple. Several crosses have been mounted on the roofs of small chapels referred to in the chronicles as "Holy Sepulchers" (figs. 1.15 and 5.10),[41] while others present a diminutive doorway, tomb, or sepulcher at their base (fig. 5.11).[42] Still other crosses crown rocky protrusions with Adam's skull, as if still on Golgotha's hill outside Jerusalem.[43] Some of these crosses are mounted on tiered bases with corner spikes or merlons affecting an appearance analogous to the "horns" of the Jewish altar of holocausts (figs. 5.10 and 5.12). A closer look at the iconography will confirm the eschatological hopes and expectations of the New World evangelizers. But first we need to look briefly at the history of the cross and the *arma Christi* symbols.

Fig. 5.12.
Yecapixtla, Morelos. Atrial cross of the Augustinian center. The cross sits on a spiked base with a heart and severed aorta. (Photo by author.)

Both in the Scriptures and in the Christian apocrypha, the cross is a personified actor in the cosmic drama. The second-century *Acts of Peter* related a story of the cross: on Easter Sunday when Christ rose from the tomb, his cross also rose from "the dead"; and when he ascended to heaven, his cross also left the earth with him from the Mount of Olives.[44] The *Acts of Peter* is typical of a vast literature on the victorious cross.[45] Indeed, the legend of the resurrected and ascended cross virtually became doctrine in the Middle Ages and was frequently imaged in mosaic art, sculpture, and liturgical manuscripts.[46] How should we understand this?

The Neoplatonic philosophy in which early Christianity thrived distinguished the soul as reality and the body as shadow. If we personify the cross—which is precisely what the Church of the Middle Ages did in its liturgy[47]—it is easier to understand that the "soul" of the cross, its reality, ascended with Christ to heaven where it awaits his return, while the wooden "body" of the cross remained buried on earth and could thus be discovered by St. Helena, the mother of Constantine. The relic of the True (that is, the heavenly) Cross is just that, a relic like a bone of a saint. And like the saints, the eschatological cross is living gloriously in heaven, reigning on a purple-cushioned throne, called the *hetoimasia* in Greek, "the empty/expectant throne." The cross is reigning until that day when it will appear in the sky as the "sign of the Son of Man," according to the Gospel of Matthew.[48]

> Immediately after the tribulation of those days the sun will be darkened and the moon will not give its light, and the stars will fall from the sky . . . and then the sign of the Son of Man will appear in the heavens, and all the tribes of the earth will mourn, and they will see the Son of Man coming upon the clouds of heaven with power and great glory. And he will send out his angels with a trumpet blast, and they will gather the elect from the four winds. . . .

The biblical "sign of the Son of Man" has usually been understood to mean the cross.[49] Because of his victory over death, Christ is invested with eternal sovereignty. At Judgment Day, the cross will be not only his weapon and symbol of victory but also his scepter as cosmic magistrate, and that in a double sense: its appearance will legitimate the right of the crucified Christ to judge all humankind, and it will be the sign for the resurrected that their sentence is decided. As Christ will return again one day, so will the celestial cross return, preceding him at the Second Coming as his precursor. Even now it is considered the vicar of Christ; it acts in his stead as a sort of stand-in or understudy. This is the origin and meaning of all those early Christian mosaics in which the jeweled cross, proudly standing on the mount of paradise, appears among the stars of a cobalt blue heaven. At sixth-century Ravenna, for example, in the apse mosaic of the basilica of San Apollinare-in-Classe, the head of Christ appears on the cross within a shield at the crossing, similar to Mexican crosses (fig. 5.13).[50]

But the eschatological cross could also intervene in human history. It did so in the year 312 for the Roman emperor Constantine at the Milvian Bridge. It reappeared in 343 for the dedication of its namesake church, the Roman basilica of Santa-Croce-in-Gerusalemme—a church that possessed relics of the *arma Christi*.[51] This church was later placed under the royal patronage of the Spanish monarchy and had particular connection to the Franciscans.[52] Moreover, the cross appeared several times in Jerusalem,[53] and it appeared in Mozarabic Spain to signal the start of the reconquest in the eighth century, where it was known as *la Cruz de la Victoria*—an image known well to Motolinía.[54] It was seen in the night sky in the constellation known as the Southern Cross when Iberian explorers crossed the equator in the 1460s, and finally, the eschatological cross returned more than once in sixteenth-century Spain.[55]

At an early date, the *arma Christi* symbols of the Passion began to appear together with the victorious cross.[56] The martial *arma Christi* became associated with the veneration of medieval relics of the Passion and therefore with those "trophies" that were believed to be preserved in the Holy Sepulcher complex and later in Santa Croce-en-Gerusalemme, Rome.[57] Like the cross, the instruments too were weapons with which Christ conquered death and Satan and were lauded as such by Prudentius in his *Psychomachia*.[58]

By the twelfth century a crown of thorns had been affixed to the cross, while the eschatological mount of paradise of ear-

lier images had been replaced by the hill of Golgotha and Adam's skull. The real flowering of this imagery appears on the tympana of the Romanesque cathedrals and abbeys on the pilgrimage route to Santiago de Compostela, where it takes on psychomachian dimensions as the tree of virtue opposed to Adam's tree of vice. At the abbey church of Conques, the cross is being lowered by angels, who also have the nails and other instruments in their hands (fig. 5.14). Christ displays his wounds against a starry sky, while the sun and moon bear witness in cosmic anguish. The *arma Christi* on these tympana are always part of a New Jerusalem scene where the celestial city is indicated by the stock forms of towers, gates, or crenellated walls. On several of the tympana, Charlemagne or the Last World Emperor is at Christ's right, while at Beaulieu-sur-Dordogne a circular wreath or crown has been carved at the crossing, identical in its placement to the crown of thorns on Mexican crosses (fig. 5.15). A similar image appears at Compostela itself. "Crux micat in coelis," sings many a medieval hymn, "The cross glistens, gleams, shines in the sky."[59]

Later a nuance was added to the devotion to the *arma Christi* and the cross's Five Wounds by the personal spirituality of Francis of Assisi. The consequence of Francis's reception of the stigmata was a heightened devotion to Christ's wounds, and the cross was soon represented by a quincunx of disembodied wounds or blood drops.[60] The Franciscan *Meditations on the Life of Christ* (thirteenth century) encouraged contemplation on the Passion through a series of visualized stations that eventually evolved into the *sacri monti* and the more familiar stations of the cross. With this new affective involvement in the sufferings of Christ from station to station, the instruments of the Passion became important as substitute symbols in devotion and art, but they never lost their significance as instruments of victory either.[61] Moreover, the *Tree of Life, the Crucifix of Jesus,* written by the chiliastic Franciscan Ubertino da Casale (fourteenth century) and immensely popular in Spain and the New World, associated a Joachite interpretation with the cross and the passional instruments.[62]

The theme of the *arma Christi* was taken a step further in 1354 with the introduction of the Feast of the Lance and Spear and the Mass of the Five Wounds.[63] The growing emphasis on Christ's heart (pierced by the lance) and on his blood would aid

Fig. 5.13.
Ravenna, Italy. Church of San Apollinare-in-Classe. Detail of the eschatological cross in the apse mosaic, sixth century. (Photo by author.)

Fig. 5.15.
Beaulieu-sur-Dordogne, France. Pilgrimage Church of St. Pierre.
Last Judgment tympanum from the west portal with the eschatological
cross behind the seated Christ. (Scala/Art Resource, NY.)

Fig. 5.14.
Conques, France.
Pilgrimage Church
of Ste. Foy. Last Judgment
tympanum from the
west portal with the
eschatological cross
above the seated
Christ. (Scala/
Art Resource, NY.)

in the conflation of heart and blood as the new Nahua-Christian metaphor in the sixteenth century.[64] Not by coincidence did the Holy Roman Emperor Charles V affix splinters of the True Cross to his royal lance and spear. He brandished these sacral weapons in his battles against heretics and Turks.[65]

The cross and *arma Christi* reached their zenith in thirteenth-century Rome, where the mendicants were involved in the development of the iconography.[66] At St. Paul's-Outside-the-Walls, the enthroned cross and *arma Christi* were depicted in mosaic in the apse.[67] Although in Greek the scene had been known as the *hetoimasia*, "the throne," a crucial change was made when it was translated into Latin, where it was called the *solisternium*, "the throne of the sun."[68] The *solisternium* at St. Paul's is located on an axial line below the earlier image of Christ as Helios, the Greco-Roman solar god, in the mosaic of the triumphal arch.[69] The heroic solar metaphor was deliberate, and it would resurface later in the sixteenth century, opening the way for a convergence of Mexica and medieval metaphors.[70]

In subsequent centuries the *arma Christi* continued to appear in a mendicant context, such as illuminated manuscripts showing Francis of Assisi as a witness to the spectacle of the Last Judgment.[71] The Passion instruments also appeared in

Hispano-Flemish paintings of the Last Judgment, as in Jan van Eyck's masterpiece, the *Ghent Altarpiece* (fig. 5.16). I wish to call attention to Jan van Eyck, active in Ghent around 1430, because it is impossible that his works were unknown to the first artist who came to New Spain, Fray Pedro de Gante (Ghent). Even in Fray Pedro's days, the *Ghent Altarpiece*, with its eschatological panel of the Adoration of the Mystic Lamb, was a tourist attraction and was frequently copied.[72] The Lamb of Revelation is enthroned on an altar in a paradise garden outside the walled Jerusalem (looking much like Ghent itself) while fourteen angels bear in their hands the *arma Christi* and members of the Order of the Golden Fleece look on.[73] We shall see these medieval iconographic and eschatological traditions converging in the Mexican atrial crosses.

It has been supposed that the source of the Mexican iconography is the Miraculous Mass of St. Gregory. This legend has to do with the appearance of the crucified Christ, rising out of a tomb with the instruments of the Passion, to an incredulous witness during a mass celebrated by Pope Gregory the Great in Santa Croce-in-Gerusalemme, Rome.[74] But this image is quite late, the fifteenth century at the earliest (fig. 5.17). Originally the Gregorian Mass appeared with scenes of the Last Judgment,

but it gradually became detached and was used to defend the sacrificial nature of the Mass and the real presence of Christ in the host. The image, however, retained an eschatological nuance because one could receive an indulgence of twenty thousand years or more of pardon by praying before it, thus bettering one's chances at the Last Judgment.[75] It should be noted that in no Mexican atrial cross does there appear the body of Christ, or Pope Gregory, or the unbelieving witnesses—elements that are never omitted from the Mass iconography. And conversely, in no image of the Mass of St. Gregory do the eschatological symbols of sun, moon, and stars appear as they do on the crosses of Huandacareo (Michoacán, fig. 5.9), Huichapan (Hidalgo), and

La Cañada (Querétero), or on the façade of the Dominican church at Coixtlahuaca, Oaxaca (1576).[76]

The first bishop of Mexico, Zumárraga, who used the *arma Christi* on his *gremial* or coat of arms, offers a further testimony to their eschatological character.[77] In a letter written to the Franciscan general chapter in Toulouse in 1532, he states: "In many places churches and oratories have already been built, and in many parts the resplendent *arma* of the holy Cross have been raised and adored by the Indians."[78] And over the *porciúncula* door of the conventual Church of San Francisco, Puebla, the sixteenth-century sculptor wrote next to the shield of the Passion instruments: "These are the armaments of our warfare."[79]

Fig. 5.16.
Jan van Eyck,
"The Adoration of
the Mystic Lamb"
from the *Ghent
Altarpiece* (1432).
Cathedral of St. Bavo,
Ghent. (Scala/Art
Resource, NY.)

Fig. 5.17.
Cholula. Mural in the
cloister of the friary of
San Gabriel depicting
the Mass of St. Gregory.
(Photo by J. Barry
Kiracofe.)

igniting swords that were brought near it. The cross some-times appeared on a cloud that gave it the form of a predella base with five or six steps.[84] Amid all this commotion there circulated an unauthorized version of the *Vita Christi*, a work written a century earlier by the titular patriarch of Jerusalem, Fray Francesc Eiximenis, concerning the opening of the seven seals of Revelation, the spiritual crisis of the Church, and a proximate encounter between Antichrist and the Emperor (now Charles V) in Jerusalem:

> And it says in *Pseudo-Methodius* [the Sibylline Oracle] that at that time the last emperor who will die in Jeru-salem, knowing that the end is drawing near, will himself travel to Golgotha, that Mount of Calvary on which our Lord received the Cross (✝) to die for us. There he will take off his crown, he will extend his hands unto heaven and renounce the Empire to God the Father and to his son our Lord and Redeemer. Then there shall appear in the sky the sign of the Cross (✝) and the crown of thorns and the other instruments of the holy Passion that are pre-sented to him by angelic intervention. In the name of all Christians he will offer these things to God. . . . Then these [the *arma Christi*] will be taken up to heaven by the hands of angels, and the Holy Roman Emperor and king of all Christians will take off his noble garments and royal robes and take instead the habit of the order of St. Francis, and he shall live a holy life in Jerusalem and commune with our Holy Father [the pope] until the last day. Amen. (✝) Deo gratias.[85]

These same spiritual armaments are seen in the *Lienzo de Tlaxcala*, a document that relates the miraculous appearance of a cross to Hernán Cortés and the local native chiefs at their first contact.[80] According to Fray Mendieta, upon seeing the prodigious sign the native lords remarked, "We have now come to *tlatzompan*, the end of the world, and these men who have come here will remain. There is no need to expect anything further, because what our ancestors foretold has taken place."[81] The supposed apparition is, no doubt, the reason for the special Golgotha shrine at Tlaxcala, where three crosses were erected on the roof of the still extant Holy Sepulcher chapel (figs. 1.15 and 6.2).[82]

The iconographic model is closely related to the legends surrounding the victorious appearances of the cross in Jerusa-lem, Rome, and Spain. Some of the appearances occurred during the eschatological fever pitch of the early sixteenth century and the civil unrest during the *Comunero* movement. Spain had re-cently completed its reconquest and was considering a new crusade to recover the Holy Land.[83] The Second Charlemagne and Last World Emperor, Charles V, had invaded North Africa and conquered Tunis as a first stage in the campaign. In 1517 a cross, from whose arms burst forth fire, appeared several times,

It is here in the long history of the Last World Emperor and in the legend of the eschatological cross that we find the icono-graphic basis of the atrial crosses. Solemnly mounted on a tiered base sometimes equipped with corner spikes, or erected over a diminutive Holy Sepulcher chapel, or poised on a rocky protrusion as if it were still on Golgotha's hill in the Jerusalem complex, the atrial cross acts as an icon of the soon-to-appear Messiah.[86] It is seen in New Spain because Christ himself is soon to reappear in the New World's last days.[87] Two paradig-matic evangelization complexes of the Franciscans confirm this observation: Huejotzingo and Calpan.

At Huejotzingo the program of sculptures on the four posas surrounding the atrial cross reveals a subtle visual reference to the Sibylline legends. The stone cross is a bare stone tree, like the pre-Hispanic world tree but with lopped-off branches. As we saw, the grafting cross symbol was often used in medieval manuscripts for the cross that would return on Judgment Day, or to represent the cross and seraph that gave Francis his stigmata.[88] The cross at Huejotzingo has now been relocated to the town plaza immediately in front of the temple's patio. But when it was still in the patio, it was surrounded by the four posas, on whose façades are sculpted sixteen apocalyptic angels wearing tiaras and bearing the *arma Christi* in their draped hands, as foretold for the moment when the Last World Emperor will initiate the final battle (figs. 4.30, 4.31).[89] The robes of the angels are still in movement, as if they have just alighted from heaven or are still hovering around a central object—the eschatological cross (fig. 5.18). This helps us understand the significance of the atrial quincunx. The cross at Huejotzingo stands forth as the Tree of Life raised up at the center of the paradisial patio, as the *axis mundi* of a new creation, as the altar of holocausts of the new Temple, and as the sign of the soon-to-return Son of Man. The fact that the chain of the Order of the Golden Fleece—symbol of the Last Emperor—is carved over the *portería* entrance, and again over the Solomonic *porciúncula* door, only adds more credence to this interpretation (figs. 4.36, 4.38). The descending *arma Christi* display the weapons of the incipient spiritual battle against the Evil One, and they guarantee that the outcome will be victorious.

The conflation of Temple and paradise images is further emphasized here at Huejotzingo by a detail that was mentioned in the previous chapter. A colonial aqueduct brought water to the complex from a reservoir. The water passed to the south of the church and atrial cross and continued to the four posas, where there are remnants of water tanks with fountains on the exterior (fig. 4.42). The subtle engineering allusion is to Ezekiel 47:1–12 and Revelation 22:2 regarding the temple and the celestial Jerusalem, and shows that the patio was also conceived of as a paradise garden with medicinal fruit trees. This curious fact also hints that the atrial cross/world tree is part of the leg-

Fig. 5.18. Huejotzingo. The northwest posa. Alighting angels and the *arma Christi* carved on the exterior. (Photo by Javier González.)

endary Fountain of Life and the four rivers of paradise (the four posas with their waterspouts) that emanate from it.[90]

THE LAST WORLD EMPEROR MYTH AT CALPAN

A similar iconography was at work at the neighboring Franciscan establishment of San Andrés Calpan, only six kilometers away. Calpan was founded after 1525. The present construction, dedicated to Saint Andrew, dates from about 1548.[91]

By far the most important and interesting feature of Calpan is the richly decorated set of posa chapels, which follow a well-planned and theologically thought-out program.[92] The first chapel, at the northeast, should be considered the posa of

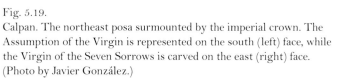

Fig. 5.19.
Calpan. The northeast posa surmounted by the imperial crown. The Assumption of the Virgin is represented on the south (left) face, while the Virgin of the Seven Sorrows is carved on the east (right) face. (Photo by Javier González.)

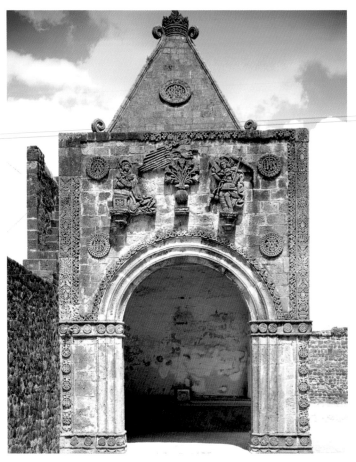

Fig. 5.20.
Calpan. The northeast posa with the Annunciation scene on the west face. (Photo by Javier González.)

the Incarnation.[93] On the east side, the Virgin is seen with seven swordlike rays terminating at her heart (fig. 5.19). At the opposite end of each ray is a roundel that appears to have lost something—probably an obsidian disk mirror much like ones seen on certain atrial crosses.[94] This is the Virgin of Sorrows with seven swords piercing her heart in fulfillment of Simeon's prediction in Luke 2:35.[95] Note that the supposed obsidian discs are the cause of pain and, by implication, the shedding of blood. This indigenous association cannot be fortuitous.

The south face of the chapel displays the Virgin of the Apocalypse (or the Assumption), while the west side has an An-

nunciation scene within a square frame. The Virgin kneels at prayer and turns to give her fiat to Gabriel, whose garments are still in motion as if he has just alighted, bringing a palm branch from paradise. At the summit is an imperial crown, suggestive of metalwork, inset with Aztec precious stones (fig. 5.20).[96] This crown imitates the one worn by the Holy Roman Emperor, who was to travel to Jerusalem, where the eschatological cross and the *arma Christi* would appear—as here at Calpan.

The second posa station (at the northwest) has a kneeling figure of St. Francis set high on the corner (figs. 5.21 and 5.22). This is the posa of the Passion, because Francis, with his

Fig. 5.22.
Calpan. Detail of fig. 5.21,
St. Francis of Assisi.

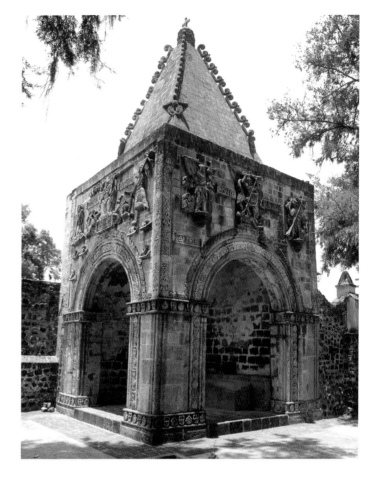

Fig. 5.21.
Calpan. The northwest posa surmounted by an image of St. Francis of Assisi receiving the stigmata. On the east and south faces are carved angels with the instruments of the Passion or the scroll of the Holy Wounds. (Photo by Javier González.)

stigmata, is the homologue of the suffering Christ.[97] This time the border frame is a chain of the Order of the Golden Fleece, from which hangs a medallion of the Five Wounds with blood drops. It is not entirely clear what originally crowned the apex; at present there is a minuscule cross set into a sphere. Upon closer inspection, I have determined that slots cut into the sphere were the footing to secure what must have been a tall and heavy sculpture. The tiny cross is no doubt a replacement for an original crosslike Christ-Seraph figure who transmitted the marks of the stigmata to Saint Francis kneeling in ecstasy below.[98]

The east side of the posa is carved with angels and instruments of the Passion, similar to those of Huejotzingo, while the south side displays an angel holding a parchment scroll with the five huge blood drops of the Holy Wounds in pre-Hispanic style. In Europe, the devout wore the Holy Wounds on a piece of parchment around their necks as amulets and remedies.[99]

The third posa (to the southwest), later dedicated to St. Michael the Archangel, is really the station of the Resurrection. It has a steep pyramidal roof, almost a spire, this time topped by the papal triple crown (fig. 5.23). The tiara is not merely a decoration but an eschatological sign of the Angelic Pope, who will meet the Last World Emperor in Jerusalem for the final days. The north side displays the three military archangels (fig. 2.22). St. Michael, with sword, tramples Lucifer, the Morning Star, associated with the Aztec god Tezcatlipoca.[100] The demon is a marvelous combination of hoofed creature with a

Fig. 5.23.
Calpan. The southwest posa surmounted by the papal tiara. On the north (right) face appear the three archangels, Gabriel, Raphael, and Michael, defeating the devil. On the east face, toward the rising sun, are the resurrection of the dead and the Last Judgment. (Photo by Javier González.)

pig snout and bat wings. St. Raphael stands guard to his right, while St. Gabriel is at attention on his left; each holds a cross standard. Their windblown drapery indicates that they too have just alighted.[101] Surely the scene is a visualization of Revelation 12:7: "Then war broke out in heaven; Michael and his fellow angels battled against the dragon."

On the east side, facing the rising sun, is a large and impressive Last Judgment in relief, ultimately derived from some fifteenth-century woodcut.[102] The powerful Christ-Judge is seated in majesty in the classic posture of displaying the wounds of his Passion (fig. 5.24). In accord with Revelation, the sword of justice and the lily of mercy issue from his mouth. Beneath his feet is an open scroll with the words *Surgite mortui venite ad iudicium*, "Arise, O ye dead, come to judgment," a line from one of the earliest catechetical plays and from Fray Maturino Gilberti's apocalyptic catechism.[103] On either side, figures of the Virgin and John the Baptist kneel in supplication, interceding for the diminutive human beings below who are rising from their graves.[104] Two angels are at Christ's feet; one blows a trumpet to awaken the dead while the other holds the prophesied instruments of the Passion. Carved scrolls implore the intercession of the two saints: that next to Mary reads *intercede virgo sacra ora por nobis*, "O sacred Virgin, intercede and pray for us," while the Baptist's scroll proclaims *dedit illi dominus omne iudicio*, "The Lord gave him all power for judgment."[105]

The final or fourth posa (southeast) is one of contrasts and is somewhat plainer than the rest; nevertheless, its iconography confirms that it is the posa of the Glorification mystery of Christ. On the west side, St. John of Patmos, holding the apocryphal chalice of venom, stands under an archway of diminutive Isabelline pearls (fig. 5.25).[106] Is he greeting us at the pearly gates of the Heavenly Jerusalem? John is surrounded by medallions of the four tetramorphic figures from the visions of Isaiah and Ezekiel and associated with the four evangelists, the four cardinal directions, and the four christological mysteries.[107] On the carved molding just below the frame, trumpeting angels hover among the vegetation, while at the base of the posa's face, another molding displays humanoid masks with horns. There is a hint of the demonology and angelology of Prudentius's *Psychomachia*.[108]

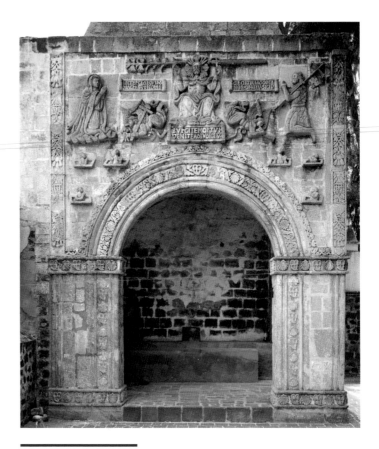

Fig. 5.24.
Calpan. The east face of the southwest posa with the scene of the Last Judgment. (Photo by Javier González.)

On the side facing north is a majestic figure of God the Father, or Christ in his role as *Salvator Mundi*, with papal tiara and jeweled robes, as in Flemish painting (fig. 5.26).[109] In one hand the Almighty One holds the cosmic orb surmounted by a cross while his other hand blesses, and his image here thus finalizes the liturgical and eschatological circuit. He is enthroned within a floral orphrey banding that matches that of the apocalyptic Assumption that faces it (fig. 5.19). The symmetry thus brings us back to the initial Marian image on the first posa, completing the circle.

The four pyramidal posas of Calpan (the christological mysteries of Incarnation, Passion, Resurrection, and Ascension/Glorification) act like oversized *cornua altaris* surrounding the temple's atrium and holocaust altar/cross, where Francis,

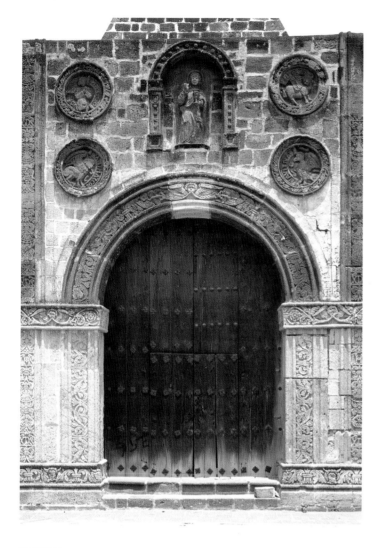

the Angel of the Sixth Seal, will announce the defeat of Antichrist.[110] The imperial crown (fig. 5.19) and papal tiara (fig. 5.23) on the posas' roofs guarantee the spiritual activity and protection of the Last World Emperor and the Angelic Pope in these "the last days" as the mendicants and their neophytes awaited their travel to Jerusalem for the final event.

A Last Judgment scene, similar to that on the third posa, is found not far away at the *porciúncula* door of Huaquechula, another Franciscan establishment. Trumpeting angels, the sword of justice, and the lily of mercy flank Christ the Judge. At his feet are two mysterious figures: a Sibyl and King David (fig. 5.27). David and the Sibyl are, of course, mentioned in the "Dies Irae" hymn that was sung at all funerals until recent times.[111] *Teste David cum Sibylla*— David and the Sibyl testify to the dread Day of Judgment that shall come upon humankind at the End Times "when the world shall dissolve in fire." Both the Old Testament king and the oracle-speaking prophetess would make sense in this apocalyptic context. Here, however, the kingly David may well play two roles: as himself, and as a stand-in for the Last World Emperor in his eschatological responsibilities, as foretold in the Sibylline Oracles.

This Sibylline association of Cross and *regnum* had become an important element of the Hapsburg mythology and the Hapsburgs' spiritual link to the first Christian Roman emperor. The veneration of the archangels and cross increased significantly under Charles V, who attributed his victories against heretics and Turks to an image of Christ's cross that was affixed to his coat of arms. Further, Constantine's vision of the celestial cross was evoked for a mise-en-scène mounted to celebrate Charles's victories at La Goletta and Tunis, and a mock battle was staged in front of a model of Constantinople. When the imperial Hapsburg eagle swept down and the Turks were vanquished, a cross suddenly appeared in the sky.[112] Like a lead actor, the celestial cross too was playing its part in the cosmic drama.

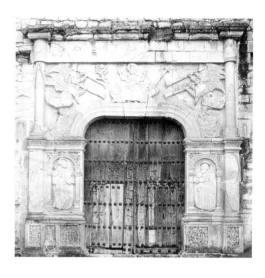

Fig. 5.27. Huaquechula, Puebla. North or *porciúncula* door of the Franciscan church. The entrance is framed by the Last Judgment above with King David and the Sibyl, and by the apostles Peter and Paul in the jambs. (Photo by author.)

Fig. 5.25. Calpan. The southeast posa, west face with St. John the Evangelist surrounded by the tetramorph. (Photo by Javier González.)

Fig. 5.26. Calpan. North face of the southeast posa. God the Father or the *Salvator Mundi* gives his blessing. (Photo by Javier González.)

> The wise man: a light, a torch—a stout torch which
> does not smoke.
> A pierced mirror, a mirror which is pierced on both sides.
> His are the red and black colors . . . he is the wisdom
> which is transmitted.
> He aids; he mediates. He cures all.
>
> —Náhuatl poem, fifteenth century

On several crosses, black obsidian disk mirrors appear at the crossing, replacing the head of Christ (figs. 5.28 and 5.29). Perhaps, with tongue in cheek, the friars wanted to illustrate St. Paul's assertion "We see now as through a glass darkly." Obsidian (*tezcapoctli*, in Náhuatl), a polished volcanic glass, was used in conjunction with the preconquest idols as a representation of the heart or spirit. It was the vital principle of the idol to whose obsidian heart were sacrificed the living human hearts of Aztec ritual offerings.[113] The obsidian mirror, known also as the "smoking mirror," further served as a solar symbol associated with the deity Tezcatlipoca, "Lord of the Mirror," who wore it as a pendant on his chest or carried it like a torch. This dark mirror was also a metaphor for wisdom, as in the epigraph above, and was used for oracular visions to see into the future. By means of it, Tezcatlipoca—whose statue at Tenochtitlán had obsidian eyes—could peer into human hearts, thus uncovering their most intimate secrets.[114] The mirror could also be interchanged with stylized blood drops, the nourishment of the solar god Huitzilopochtli.[115] George Kubler was certain that the use of obsidian on the cross indicated a deliberate attempt on the part of the friars to connect the idea of Christ's sacrifice to those of pre-Contact times.[116] I would go a step further and say that both sun and blood were the metaphors suggested by these mirrored crosses, relating the Christian symbol to the Aztec notion of Ollin, the fifth and last sun of Aztec eschatology (fig. 2.16).[117]

A medieval precedent for solar crosses is found at Jerusalem. There the Emperor Hadrian erected a pillar or column to serve as a measuring device. At a later date it was moved into the "new temple" that Constantine built, the atrium of the

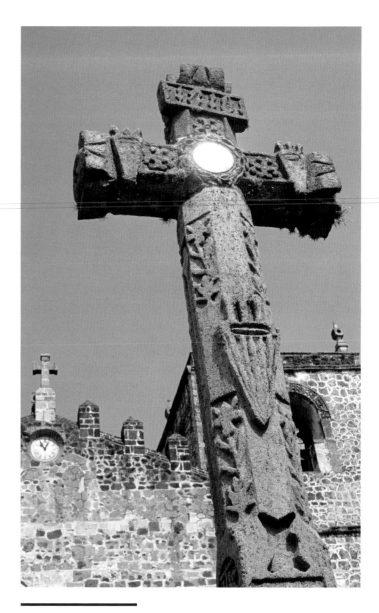

Fig. 5.28.
Ciudad Hidalgo, Michoacán. Atrial cross of the Franciscan center with embedded obsidian mirror and the *arma Christi* symbols. (Photo by author.)

Holy Sepulcher, next to Golgotha. By the fourth century the column had been surmounted by a cross to mark the umbilical center of the earth, because at high noon it never cast a shadow. (Like the sacred pillar of Quetzalcóatl at Tenochtitlán, it marked the *axis mundi*.) The cross, in turn, was crowned by a solar disk of Christ-Helios to indicate this privileged cosmic position (fig. 5.30).[118]

The Mexican atrial cross is itself a reference to the edifice of the Holy Sepulcher. In similar fashion to the original Jerusalem location, the cross is located in an atrium that acts as a New World version of Constantine's "new temple" complex, soon to be liberated by a last crusade. The cross also alludes to the Jerusalem topography by being mounted above a Holy Sepulcher chapel or over a diminutive doorway (also a sepulcher) at the base, as at Acolman (fig. 5.11). Other crosses crown the rocky protrusion of Golgotha's hill, as at Cuauhtitlan.[119]

But there are more proximate connections between spectral devices and the mendicants. St. Augustine, for one, had used the reflection in a mirror as a metaphor for the indirect way in which human beings have an experience of the inscrutable and invisible Trinity, Christ being the reflected image par excellence of the Godhead.[120] St. Clare of Assisi (d. 1253), moreover, had written a spiritual instruction for religious women using the two metaphors of mirrors and crosses. Franciscans read the text yearly in the Divine Office on her feast.

> Look at the parameters of this mirror, that is, the poverty of Him who was placed in the manger and wrapped in swaddling clothes.... Then at the surface of the mirror, dwell on the holy humility, the blessed poverty, labors and burden which he endured.... Then, in the depths of this same mirror, contemplate the charity which led him to suffer on the wood of the Cross and die a shameful death. Therefore, that mirror on the Cross urges those who draw near to consider, "All you who pass this way, look and see if there is any suffering like My suffering?"[121]

Only a few years later, St. Bonaventure would borrow Clare's imagery for his *Hymn to the Cross*, calling the cross the "mirror of all virtue."[122] Such mirror imagery continued throughout the viceregal period in New Spain.[123]

Another possible source for this mirror iconography is an epic poem of the fourteenth century by a Cistercian monk entitled *The Pilgrimage of Human Life*, a work that became popular with the mendicants.[124] It tells the tale of a religious who dreams of a magic mirror in which appears the Heavenly Jerusalem. (Tezcatlipoca's mirror was likewise magical and could foretell the future).[125] This launches him on a lifelong pilgrimage,

Fig. 5.29. San Felipe de los Alzati, Michoacán. Atrial cross with embedded obsidian mirror. (Photo by author.)

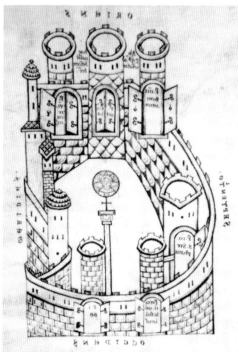

Fig. 5.30. *Glossarium Solomonis* (Regensburg, 1158). Bird's-eye view of Jerusalem. At the center is the column and solar disk of Christ-Helios. (Courtesy of the Bayerische Staatsbibliothek, Munich.)

Fig. 5.31.
Temimilcingo, Morelos.
Atrial cross on spiked
base with niche below.
(Photo by author.)

Fig. 5.32.
Topiltepec, Oaxaca.
Atrial cross with carved
image of the arrow sac-
rifice of Christ as Xipe
Totec, mid-sixteenth
century. (Photo by
Instituto Nacional
de Antropología e
Historia, Mexico City.)

Virtue, the vision draws closer and becomes clearer. Perhaps this too was the moralizing vision that the New World friars wanted their neophytes to see in the mirror, the paradigm on the cross.

THE CROSS AS ALTAR-STAGE

The corner spikes of the tiered base, alluded to several times, are reminiscent of the altar in the Jewish Temple, whose "horns" were painted with the blood of the Paschal lamb. In Mexico, a base with hornlike spikes is a common feature of several atrial crosses (fig. 5.31; also 5.10, 5.12, 5.29).[127] This resemblance is not coincidental. In medieval biblical exegesis, the archetypal foreshadowing of Christ's sacrifice on the cross was the Akedah: the sacrifice of Isaac by Abraham and the last-minute substitution of a ram for the boy's human body (Gen. 22:1–18). The passage had particular resonance for missionaries and their universal message because it ends with God saying that, because of Abraham's faithfulness, "all the nations of the earth shall find blessing in your descendants."[128] When represented visually, the wood and fire of the altar of sacrifice were frequently paralleled to the wood of the cross.

In the book of Revelation, the horned altar appears again. It is at one and the same time the altar of holocausts, under which have been placed the souls of those slaughtered as witnesses for the word of God, and the altar of incense (Rev. 6:9). The horns of the altar even speak (Rev. 9:13–20), giving instruction to the angels to announce the impending plagues and beckon all to repentance at the End Times. The mention of plagues, like those that would occur in sixteenth-century Mexico, and the specific sins listed—idolatry, black magic, and illicit sexual unions— encourage the idea that the friars were reading this chapter of Revelation in the light of current events.

Elements of sacrifice had been associated with the pre-Hispanic cruciforms, and they were occasionally recycled as metaphors for Jesus Christ. The atrial cross at Topiltepec (Oaxaca) has glyphs in the Mixtec pictorial code for the year 1550 and a carving of the deity Xipe Totec, hung on a scaffold and shot through with arrows (figs. 5.32 and I.3). The image of the sacrificed Xipe Totec was associated with prayers for rain and

during which he meets various personified Virtues and Vices in a trope on Prudentius's *Psychomachia*.[126] Lady Faith offers him the aid of a staff shaped like a Tau cross with a mirror on top, which has the power to show him his goal, the future Jerusalem. Faith teaches him to achieve self-control, and he is introduced to Penance and Confession. Afterward he is supplied with weapons that are to protect him against danger; as armor he receives the four cardinal Virtues, but they are too heavy to wear continually. When he succumbs to the temptations of the Vices, especially his own lustful desires, the vision of the Holy City recedes from view. But when he resists heroically with the help of Reason and Memory, and practices

Fig. 5.33.
Cholula. Pre-Hispanic *momoxtli* platform altar in the great pyramid complex. (Photo by author.)

a good grain harvest and, in that guise, may have been reapplied to Christ as the sacrificial "bread of life."[129]

Well into the seventeenth century, the Náhuatl word used by Christian Indians for the base of the cross was *momoxtli*, originally meaning a platform, stage, or altar of human sacrifice (fig. 5.33).[130] Indeed, some of the earliest pedestals for the crosses had been reused pagan altars.[131] A *momoxtli* appears in the pictorial catechisms that were created to teach prayers and doctrine to the natives, as in the visualization of the Lord's Prayer in the Egerton Manuscript at the phrase "give us our daily bread" (fig. 5.34). Here the eucharistic "tortilla" of the Mass has been taken from a stepped platform (atrial cross) composed of three stone blocks that doubles as an altar table.[132]

The native Nahua writer Diego de San Antón Muñón Chimalpáhin Quauhtlehuanitzin uses the word *momoxtli* for a podium that he describes as "an altar on which they erect a stone cross."[133] The same word even survives today among Nahua speakers in central Mexico for the pedestal of a cross (fig. 5.35).[134] I shall examine the theatrical connotations of the *momoxtli* in the next chapter, but here I wish to underline its sacrificial character, associated with the heart extraction practiced by the Aztec priests on the obsidian altar with their obsidian-blade knives.[135] As we have seen above, obsidian—itself a god in the Aztec pantheon—had multiple connotations for the Mexica, and its later association by the friars with blood,

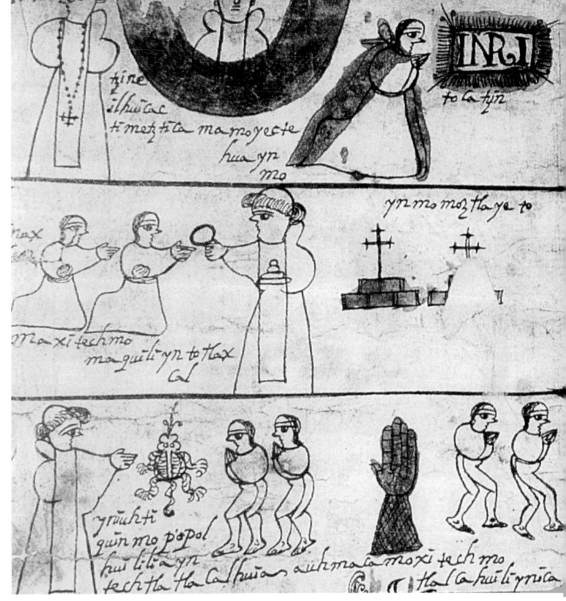

sun, and Christ's sacrifice cannot be fortuitous. The friars used obsidian in making the altar stones (*aras*) containing relics for the sacrifice of the Mass.[136] For men steeped in medieval biblical exegesis, to claim that the Christian cross replaced the ancient Jewish altar of holocausts was a convention of the time, just as Christ was understood as the new Paschal lamb.[137] On the yearly feast of St. Francis (October 4), his spiritual sons read his words in the Divine Office, words that surely would have resonated with the Aztecs on a different level: "Christ reposed his will in that of his Father. The Father willed that the blessed and glorious Son, whom he gave to us and who was born for us, should through his own blood offer himself as a sacrificial victim on *the altar of the cross*. . . . It was intended to

Fig. 5.34.
The Lord's Prayer in pictographs with Náhuatl translation, 1614. The Christian *momoxtli* altar and cross are in the second register. (By permission of the British Library, MS Egerton 2898, fol. 1b.)

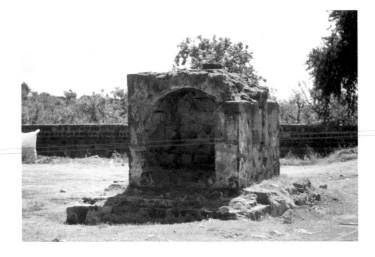

Fig. 5.35.
Calpan. *Humilladero*
cross base or *momoxtli*
with niche below.
(Photo by author.)

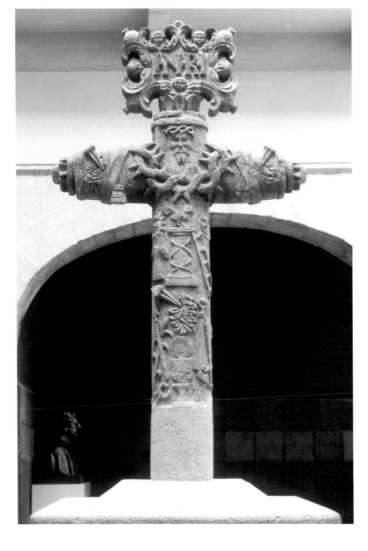

Fig. 5.36.
Villa de Guadalupe,
Mexico City. Atrial
cross now in the
museum of the basilica.
A priest's liturgical stole
is wrapped around the
arms. At the bottom is
a stamped eucharistic
host. (Photo by author.)

leave us an example of how to follow in his footsteps."[138] This passage would certainly have been known to indigenous members of the Third Order of St. Francis and to others in the Franciscan evangelization towns.

The Jewish altar of holocausts is represented in Mexico, most notably in the paintings of Juan Gerson's Apocalypse cycle at Tecamachalco (fig. 2.49), where it was copied from models found in Nicholas of Lyra's biblical commentary and in Hans Holbein's woodcuts, both readily at hand. In addition, the crosses at Atzacoalco and Villa de Guadalupe display a priest's stole wrapped around the horizontal arm instead of the usual shroud (fig. 5.36).[139] Is the atrial cross with its tiered base to be understood as a personification of Christ, both priest and victim, offered on the fiery altar of the Jerusalem Temple—a sacrificial substitute for the Aztec sacrifices of old? There are suggestions to that effect. The atrial cross at Cuernavaca sits in a *cuauhxicalli*, the ancient stone box used to hold the human hearts of Aztec sacrifices, or the voluntary bloodletting of royalty, and believed to be a "cosmic navel" (fig. 5.37);[140] while the cross of Nonoalco (Hidalgo) rises out of a stylized barrel cactus, the species of cactus over which human victims were stretched before having their chests opened.[141] The cross's human heart is framed by the crown of thorns (fig. 5.38). When Sahagún or his elite assistants translated the word "Golgotha" in the Gospels, they used the Náhuatl *quaxicalli*, "skull place," with its connotations of the sacrificial Aztec skull rack.[142] The new Christian sacrifice of the cross—an offering of royal blood—supersedes the former human sacrifices of the Mexicas while it continues their metaphor, in a modified way (fig. 5.12).[143] The use of the heart-box symbol also foreshadowed and influenced the nascent devotion to the Sacred Heart of Jesus that would become so popular in baroque Catholicism.[144]

Holocaust altars play an important role in allegorical biblical exegesis. Christ's cross is the place in the temple where he himself became a metaphorical burnt offering to God.[145] In pre-Contact days, there were also elements of burning associated with the temple sacrifices, because those humans who became divine in the cardiological surrender were temporarily converted into receptacles of divine fire. This was literally so, since at the Aztec ceremony of the fifty-two-year renewal, the new fire was kindled in the chest cavity of the sacrificial victim

(fig. 5.39).[146] Furthermore, we recall that the origin of the Meso-american quincunx is rooted in the image of the hearth at the center of the home; and the fifth cardinal point was the symbolic spot of the fire god, Huehuetéotl (fig. 5.2). Temple victims were also occasionally bound and cast into fire at the great festivals of Xocotluetzi and Quecholli.[147]

Initially, in the early days of the evangelization, the Mexican council of bishops felt it necessary to forbid the natives to burn devotional fires at the base of the atrial crosses, but that policy seems to have changed later.[148] Fray Matías de Escobar, the Augustinian chronicler, furnishes another detail confirming that the cross was linked with the notion of fire and burnt sacrifice.[149] He indicates that at the base of the atrial crosses, bonfires were made wherein wooden idols were consumed.

On the happy day [of adult baptisms] the idols had to be buried below the tenebrith of the most holy Tree of the Cross. Such an exhortation is made [by the friar, and] with the same ease that Rachel and the family of Jacob handed over the idols, the minister, as another zealous Moses, might consume them in fire. The [Indians] joyfully celebrated the burning of those demons. The fires were like *luminarias* celebrating the day of baptism, multiplying the flames for the devil and hell.[150]

Although I have suggested that the iconographic inspiration of the atrial cross is not the Mass of St. Gregory, it appears that a eucharistic connotation need not be denied, because some crosses display eucharistic breads and chalices (fig. 5.36). The atrial cross is often placed on axis with the altar located in the open-air chapel, relating it to the sacrifice of the Mass that was performed there for the Indian congregation. Moreover, the corner spikes give the appearance of the altar (fig. 4.21).[151] Even if the spikes are omitted, there is a semblance to the stepped *Ariel altaris* of Lyra's imitators, Hans Holbein and the indigenous painter Juan Gerson (fig. 2.50).[152] The *Ariel altaris* is described in Ezekiel as a tiered construction used for sacrifices in the Temple's courtyard, and medieval commentators identified it with Christ's cross and his self-sacrifice.[153] The symbolic connection of the altar of holocausts and the cross thus has a long liturgical-spiritual association.[154] It was commemorated as such

Fig. 5.37.
Cuernavaca, Morelos. Detail of the atrial cross base at the Franciscan evangelization center, now the cathedral. The embedded stone box is a *cuauhxicalli* heart receptacle. (Photo by author.)

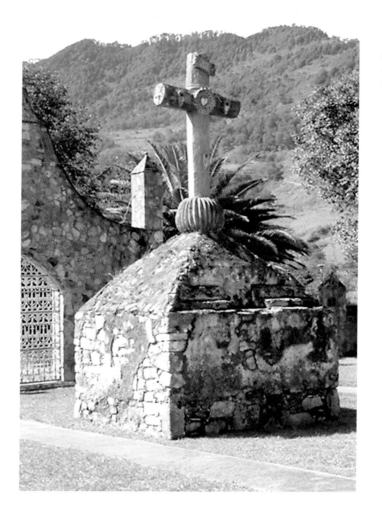

Fig. 5.38.
Nonoalco. Atrial cross (with heart encircled by thorns) rising from a barrel cactus and mounted on an altar base. (Photo by author.)

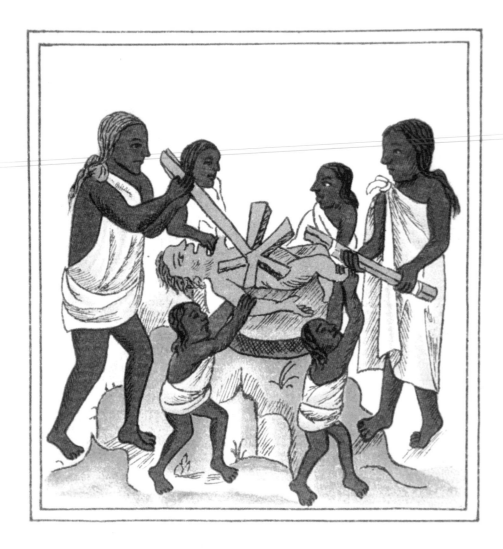

Fig. 5.39.
The *Florentine Codex*,
book 2. Scene of the
Aztec New Fire cere-
mony, during which
the flame was kindled in
the chest of a sacrificed
victim. (From Sahagún,
*Historia General de las
cosas*, ed. Paso y
Troncoso, 1905.)

on every feast of Corpus Christi, which in America was one of the liturgical and social high points of the year. Thus, we see that the atrial cross continued and converged both Mexica and Christian notions of sacrifice in a new light.[155]

THE NEW SUN

The cross—with its obsidian mirror and its *momoxtli* pedestal—also functioned as a replacement for the pre-Contact cult of the sun, which, as noted above, was the strongest cult of Amer-indians and a religious belief common to Aztecs, Maya, and other indigenous peoples of America. Indeed, the Christ-Sun is a common theme in literature, art, and music throughout the colonial period.[156] It also illustrates some ambivalent aspects of the inculturation process, including the sensitive issue of idola-try. It is the sort of identification one might expect the friars to have avoided in the interest of preventing false worship. Never-theless, the fact that they did use it can be seen as an attempt at a synthesization, "the fostering of identifications between in-digenous and Christian figures as an easy way to bring the In-dians into the church."[157]

Christian use of the sun symbol, of course, predates the spiritual conquest of the Americas. Christ had referred to him-self as the light of the world. The book of Revelation addresses him as the Lamb of the eternal city that needs no sun "because he himself is its lamp" (21:23; also Mal. 4:2, John 8:12). Later, theology and liturgy would apply to Christ many Old Testa-ment texts referring to natural daylight. The Advent liturgy, quoting the prophet Malachi (3:20), speaks of Christ as the "Sun of Justice with healing *in his wings*"—using the imagery of the soaring eagle. According to Gregory the Great's exegesis of Ezekiel, the eagle is the only animal that can look directly into the sun without harm; so Christ the solar eagle is the only human who has seen the dazzling glory of divinity.[158] Further-more, the image of eagle's wings implies feathers, a material with regal and divine associations for native peoples of Meso-america. Feather miters were created for the early Mexican bishops, not only because they were valued for their craftsman-ship and aesthetic appeal, but because they carried the transcen-dent connotations of power and divine authority.[159] Thus the feathered sun became a very appealing metaphor—like the mir-ror metaphor—for bridging the Nahua and biblical worlds.

The mendicant friars would have been familiar with solar symbolism through the liturgy and their spiritual reading. Francis of Assisi had composed the "Canticle to Brother Sun": "a likeness and a type, Most High, of Thee [God]."[160] St. Bonaventure, whose *Mystical Theology* was published twice in sixteenth-century Mexico (1549, 1575), had used a solar analogy to describe the mystic's achievement of union with God, comparing the soul to a mirror that reflects the divine rays of sunlight—a common medieval motif. In the fifteenth century, Fray Bernardino of Siena (a convinced Joachite) had reworked

the solar imagery for the novel devotion and worship of the Holy Name of Jesus, which later became so popular in America. He created an apocalyptic symbol: a sun shield of golden rays against a sky-blue field to surround the quasi-magical Name (fig. 1.13). This same solar talisman appears carved on posas and church façades in New Spain.[161] The solar metaphor was also associated with royalty, especially with the Spanish monarchs Charles V and Philip II.[162]

In Mexico, Bernardino de Sahagún used the sun motif in his collection of hymns, the *Psalmodia Christiana*, which was written to be sung to native tunes and danced to in the corrals (see chap. 6). The psalm for the Feast of the Annunciation addresses Christ: "You, you God, you child, you are the sunbeam of your precious father, you are illumination; come to shed light for us, who lie in darkness." When Sahagún comments on the adolescent Christ at age twelve speaking to the priests and sages in the Jerusalem Temple, he says, "Indeed, it became sunny, it dawned, it was time, the New Sun, the new illumination came out, came to spread itself."[163] For the festival of the Transfiguration, the *Psalmodia* imagines that Christ is crowned with the sun: "Christ's celestial crown shimmers greatly, shines greatly, it is like the sun, the way it shines . . . a heavenly glitter issued everywhere from Him."[164] The phrase is reminiscent of the medieval acclamation to the eschatological cross seen in the skies: *Crux micat in coelis*, "The cross gleams in the heavens." Christ, the solar Lord, offered himself on the sacrificial tree: "When Jesus Christ our Lord died on the cross for us, our holy Sun had set, had gone into his house." Additionally, for the Feast of the Nativity the *Psalmodia* addresses Mary with the words "Very truly, from you was born the possessor of proper living, the Divine Sun." Elsewhere, Christ is referred to as the "sunbeam of the Father" and as *toteutonatiuh*, "Our divine Sun."[165] These solar references carry over to liturgical manifestation.

A papal bull of Paul IV, dated 1558, appears to have encouraged such selective syncretism by urging the evangelizers to replace the old pagan feasts with Christian devotion. "The days which the Indians, according to their ancient rites, dedicate to the sun and to their idols should be replaced with feasts in honor of the *true sun*, Jesus Christ, his most holy Mother and the saints whose feast days the Church celebrates."[166]

A stimulus to this solar Christology was surely the Franciscan spirituality of Fray Bernardino de Laredo in *The Ascent of Mount Zion*, published in Seville in 1538. The work gained great popularity as an ascetical text. It continually urges the reader to commune and communicate with Christ, who is received as the "Sacramented Sun" in the Eucharist.[167] Sunlight remained a pervasive metaphor in later Latin American art and religion and found its zenith in the baroque image of the Virgin Mary as the mirror of the Divine Sun.[168]

In this chapter, we have seen how mythical trees, cruciforms, and mirrors could have solar connotations both among Amerindians and in the religious literature and imagination of European Christianity. Because of both the superficial resemblance of the objects and the deeper secondary comparisons of mythology and symbolism, the friars could propose and the natives could accept a Christ who was a sacrificial holocaust victim. The friars hoped to offer the Aztecs a new light of the world, one whose blood sustained the world in existence—or better, made possible access to a new and eternal world.[169] Christ as the new sun or solar eagle of Nahua Christianity was the result of a convergence of root metaphors common to Aztecs and Europeans alike. It was a well-suited cosmic sign of a new age for a *novus ordo laicorum Indianorum*, in the beautiful American city of Jerusalem. If a friar in Mexico had been especially creative with the medieval hymn for the dedication of a church, he might have retitled it "Urbs Beata Jerusalem Americana."

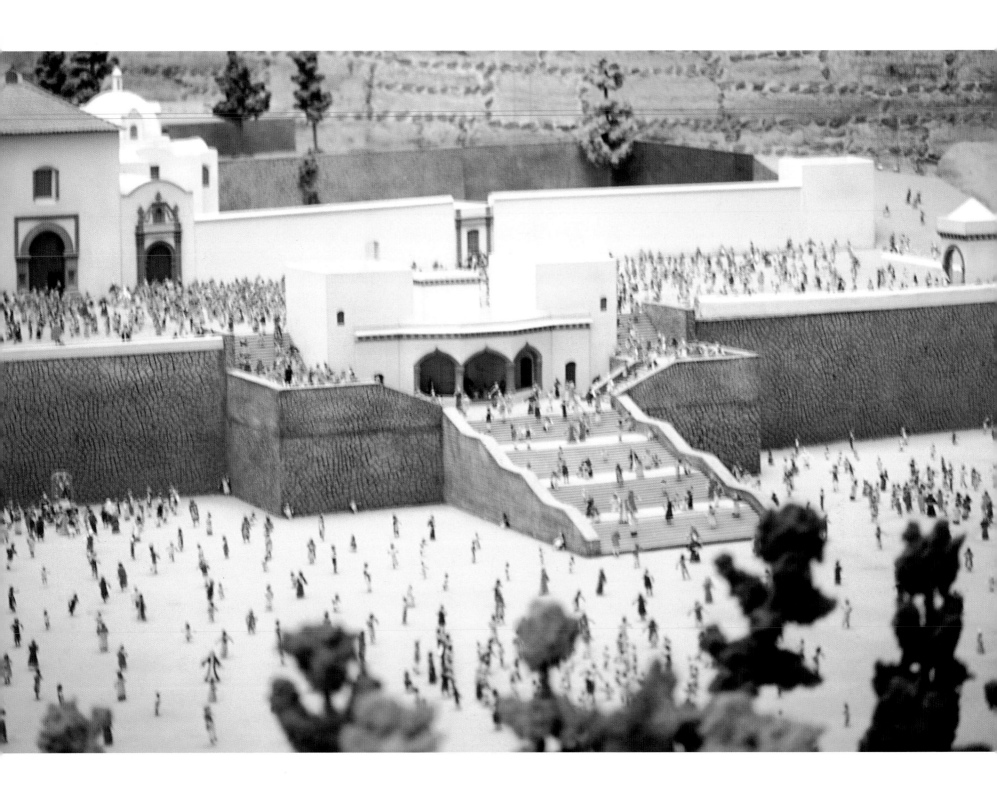

Stages for Rituals of Conversion

CATECHETICAL THEATRICS

All along I have been alluding to the theatrical nature of the mendicant evangelical enterprise and to the scenographic qualities of the missionary complex. The pre-Contact Nahuas had elaborate theatrical productions with costumes, scenery, and makeup.[1] Theater, for them, was sacred speech, the embodied "Red and the Black," and it included dance, music, mime, puppetry, and song—all for the purposes of moral instruction and the actualization of the myths. Even the colorful codices witness to a performative telling of Aztec mythic history.[2]

In the *teocalli* patios, the site of cultic spectacles, costumed and masked actors became the gods they impersonated, there being no distinction between representation and reality. Deity impersonations, pilgrimages, processions, and mock battles— similar in many ways to those of Spanish Catholicism—were performed on stage and around the temples.[3] Fray Diego Durán, writing around 1576, recalls that the stages—also called *mo-*

moxtli, like the altars (and later cross bases)—were commonplace in the temple courtyards and were about thirty feet square.[4] One such native stage is seen in an illustration accompanying Diego Muñoz Camargo's *Description of the City and Province of Tlaxcala* (fig. 6.1), which records the first contact of Spaniards and Tlaxcaltecans. A friar is standing on the *momoxtli* in the *teocalli* courtyard gesticulating dramatically to the potential converts.[5] Whether as stage, platform, or altar, when reused in the new Christian context the *momoxtli* could give the atrial cross at the center of the corral a theatrical, as well as a sacrificial, connotation (see previous chapter).

In my opinion, insufficient attention has been paid to the fact that the walled patio in New Spain was commonly called a *corral*, that is, a theater.[6] More precisely, a corral was the open-air standing area in front of the stage, much like the pit in Shakespeare's Globe. For example, in Europe when the patio gardens of Franciscan convents were temporarily converted into a theater, they became theatrical *corrales*.[7] Hospital patios—which

177

Fig. 6.1.
Diego Muñoz Camargo,
*Descripción de la Ciudad
y Provincia de Tlaxcala.*
A friar, standing on
a *momoxtli* platform,
preaches to the natives
in front of a ball court.
(Courtesy of the
Glasgow University
Library, Department
of Special Collections,
MS Hunter 242.)

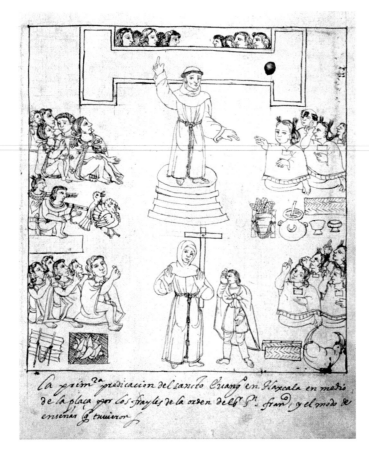

for the conversion of the peoples of Europe, where it allowed them to learn the rudiments of the Christian faith "through the evidence of their own eyes."[9] In New Spain, the friars adapted elements of Aztec religious dramaturgy, employing indigenous traditions of singing, dancing, and puppetry, and even using native playwrights to help compose the scripts.[10] Fray Pedro de Gante and his native artists created the costumes for this edifying theater, along with its props, scenery, and hoisting machinery.

Significantly enough, the first play, in 1531, was an eschatological drama entitled *The Last Judgment,* a *neixcuitilmachiotl* or exemplar performance most likely written by Fray Andrés de Olmos.[11] According to Bartolomé de Las Casas, it had a cast of eight hundred with sixteen speaking roles.[12] It was the first of several plays with end-of-the-world themes, and its mise-en-scène was the city of Jerusalem. The play was performed several times in the wooden open chapel of San José de los Naturales, the Indian national church designed by Fray Pedro de Gante. In the script an angel interrupts the Náhuatl dialogue to announce in Latin, "Surgite mortui, venite ad judicium" (Rise, you dead, come to judgment).[13] We saw above that this same text appears engraved in stone on the third posa at Calpan (figs. 2.21 and 5.24) and was used in Fray Maturino Gilberti's Tarascan catechism. One theme of the play was the condemnation of indigenous polygamy, but the message was intended for native and Spaniard alike, because the protagonist is an Indian woman with a European name, Lucia. Common-law marriage and polygamy were frequent among colonists with loose morals (like the infamous Valentín de la Roca, mentioned in chap. 1). But equally revealing is the concluding scene of the play, which appears to sum up the message that the mendicants wished to communicate to their neophytes and hints at an expected and proximate return of Christ when the curtain will come down at the end of time. The angel reappears at the finale to speak directly to the audience:

O beloved children, O Christians, creatures of God! You have seen these horrible things with your own eyes. Everything is true, written in the Sacred Books. Awaken and see with your own eyes, so that what you have witnessed in this drama may not happen to you. . . . *Tomorrow or the day*

were for all purposes identical to cloisters—were ideal places to stage performances because of the good sight lines from the upper walkways. In these patio corrals, pious confraternities constructed the medieval stage houses known as *mansiones* and mounted mystery plays to raise funds for the indigent sick.[8] In New Spain, hospitals continued to serve as the locale for theatrical productions, and it is no coincidence that Fray Pedro de Gante, the impresario of liturgical drama, was also the first to foster the construction of hospitals.

ESCHATOLOGICAL DRAMATURGY

As early as the 1530s, elaborate plays were being performed with native casts of thousands and in the language of the Mexica, Náhuatl. They were immensely popular and successful in catechizing huge numbers. Missionary theater had been used

after, Judgment Day will come. Pray to Our Lord, and to the Virgin Mary that she petition her beloved Son Jesus Christ, so that after the judgment you may merit and receive the glory of heaven![14]

According to Fray Gerónimo de Mendieta, the play struck a chord of holy fear in both Indian and Spaniard.[15]

In 1538–39 several catechetical plays were staged: *The Annunciation of the Birth of John the Baptist to Zechariah, The Annunciation to the Virgin Mary,*[16] *The Finding of the True Cross by St. Helena,* and *The Temptation of the Lord.* All of the stage sets would have included representations of the walled city of Jerusalem, and at least the last drama would have needed a stage house representing the Jewish Temple, for the devil takes Christ to its roof for the final test: "Throw yourself down!"[17]

In 1539 *The Conquest of Rhodes* and *The Conquest of Jerusalem* were performed as part of a Corpus Christi procession in Tlaxcala to celebrate the Truce of Nice, which was mediated by the papacy in the hope that the unencumbered Holy Roman Emperor, Charles V, would attack the Turks and recapture Jerusalem.[18]

The news was announced in this land a few days before Lent, and the Tlaxcaltecas wished first to see what the Spaniards and Mexica [in Mexico City] would do. When they saw that they staged a representation of the Conquest of Rhodes, the Tlaxcaltecas decided to stage the Conquest of Jerusalem, *an event which had been prophesied that God would bring to pass in our own times.* In order to make it more solemn, they agreed to wait until the Feast of Corpus Christi.[19]

The play dramatized the mendicants' expectations for the return of the Holy Land and holy places to their control, because why else would the Mexica have staged a drama about the island of Rhodes, a place without any biblical or religious significance? It is clear that Rhodes was considered a necessary staging area for fleets from Christian Europe or America to launch the final assault on Muslim Palestine.[20] Both *The Conquest of Rhodes* and *The Conquest of Jerusalem* follow in the line of earlier European theatrical productions to effect what has been called

"wishful" or "anticipatory magic," which would help to achieve in reality the outcome of the narrative.[21]

The Franciscan chronicler Motolinía has left us a description of the scenery, costumes, and props for the *Conquest of Jerusalem* spectacle. There was an ephemeral fortified Jerusalem, with a donjon, towers, and crenellated walls—similar to the evangelization complexes (and identical to the five-towered city on the coat of arms of Angelopolis, fig. 3.13), but made of wood and canvas and painted to imitate carved stone.[22]

In Tlaxcala, the city which they have begun to rebuild, they set aside, down in the center of the plain, a large and pleasant plaza.[23] Here they constructed a Jerusalem on top of some houses which they were erecting for the town council.[24] It was on the site where the buildings were an *estado* in height. They leveled off the buildings, filling the shell with earth, and on this erected five towers. The principal tower[25] stood in the center, larger than the others, while the remaining four occupied the four sides. Along the ramparts there was a parapet with numerous merlons. The towers also had many graceful merlons, together with many windows and fine arches, all covered with roses and flowers. In front of Jerusalem, out on the eastern part of the plaza, the Emperor was seated.[26] To the right of Jerusalem was the royal camp where the army of Spain was to be lodged. Facing this was a place prepared for the provinces of New Spain. In the center of the plaza stood Santa Fe where the Emperor and his army were to have their lodging.[27] All these places were surrounded by walls, on the outside of which were paintings that very realistically simulated mason-work with embrasures, loopholes and many merlons.[28]

The fictive audience for the battle was the leaders of the Church and the personified eucharistic sacrament of the Feast of Corpus Christi, which was presiding over the event as well as being an actor in the drama. We may suppose that the eucharistic bread was displayed in a silver or gold monstrance, probably in the form of a sunburst as the solar sacrament.[29]

The details of the subsequent battles were told in the form of letters sent back and forth between the Holy Roman

Emperor, his captain general, and the pope. The determination to take Jerusalem and regain its holy places was the motive expressed in the fictive correspondence and the accompanying narration. Finally, "when the Spaniards found themselves twice repulsed by the Moors surrounding their camp, they all knelt down, facing the Most Holy Sacrament, and prayed for help." At this point in the drama the action stopped, and the actor playing the Holy Roman Emperor melodramatically stepped to center stage to announce that he would personally take command of the troops. Addressing his armies of Europe and America, the emperor ordered them to kneel and pray to the personified Eucharist, whereupon there miraculously appeared SS. James and Hippolytus on their horses.[30] Both saints encouraged the Indians, the emperor, and his armies, who gained courage for the final onslaught. "Thereupon, they altogether began the bombardment, so that those who were in the city, including those in the two towers, were not able to defend themselves against the balls and missiles that were discharged at them."[31] The balls and missiles were props containing red mud, which looked like blood.[32] The stage set for Zion was also destructible, as in similar contemporary European plays concerning Jerusalem's demise.[33]

> In the rear of Jerusalem, between two towers, there stood a house of reeds, quite large, to which at the time of the attack they set fire. . . .[34] When the attack was in fullest swing, the Archangel Michael appeared on the main tower [and] . . . said to the Moors: "If God considered your evil deeds and sins instead of His great mercy, you would already be buried in the depths of hell; the earth would have opened up and swallowed you alive. But because you showed reverence for the Holy Places, He wished to exercise mercy and wait for you to do penance and turn to Him with all your heart. For this reason, recognize the Lord of majesty, the Creator of all things; believe in his dearest Son Jesus Christ and appease Him with tears and true penance." Having said this, St. Michael disappeared.[35]

Upon this visitation, the sultan, moved to the quick, sent a letter to the emperor, "God's captain on earth," suing for peace and petitioning for baptism. The sultan arrived and humbled himself before the emperor, the pope, and the personified Sacrament.

> But the Emperor, raising him to his feet, took him by the hand and conducted him before the Most Holy Sacrament, where the pope was stationed. Here, all giving thanks to God, the Pope received the Sultan with great affection. The Sultan also brought many Turks, or adult Indians [catechumens], who have been designedly prepared for Baptism. They publicly asked the Pope that they be baptized. The Pope immediately directed a [real] priest to baptize them; whereupon they were actually baptized. With this the Most Holy Sacrament was taken away and the procession again formed and marched in order.[36]

This performance of *The Conquest of Jerusalem* has been interpreted as something more than visual catechesis or pious entertainment. Richard Trexler believes that the purpose of the play was to teach the natives submission to the new religious power of the European Christians. However, the dramaturge Max Harris thinks otherwise, especially in light of the fact that the actor portraying Hernán Cortés in turn portrayed the defeated Muslim sultan, who was brought to his knees before an Indian actor pope.[37] The conquistador Cortés was hence (re)-conquered in being identified with the soon-to-be-conquered sultan. Text and subtext hint that the Franciscan playwright (probably Motolinía himself) and his native actors may in fact have been criticizing the secular rulers and preenacting a subversive, nonviolent reconquest of Mexico *from* the Spanish *by* the new indigenous Christians. These new Christians had now also been inserted into the trajectory of salvation history together with the myth of the Last World Emperor in the person of Charles V.

The drama also appears to have been a rehearsal for an ultimate crusade to the Holy Land—as Columbus and Cardinal Cisneros had earlier hoped—this time by the joint forces of Christian Europeans and the new militant faithful of the Americas (see below). The planning for such a crusade had been in progress for some time.[38] In the envisioned scenario, the Amerindians of New Spain, Peru, and the Caribbean would have a

decisive role in regaining the holy places and in the final conversion of the Muslims.

Several other dramas enacted during this period required Jerusalem stage sets; among them were *The Prophecies of Daniel* and the recently discovered *Holy Wednesday*, both of which referred to the end of the world.[39] The author of the latter, translating Christian concepts into Náhuatl, gave these concepts a certain Mexica nuance, thus transmuting the play into a peculiar native version of Jesus' Passion and sacrificial death.

But the Náhuatl drama that was repeatedly presented throughout the century was *The Destruction of Jerusalem* (not to be confused with the *Conquest*). It is another eschatological drama, translated at the mission of Tlaxcala from a Latin version of *The Vengeance of Jesus Christ*, a play associated with Philip the Good and the Order of the Golden Fleece.[40] The complicated plot has to do with Pontius Pilate, the emperors Vespasian and Titus in 70 CE, and St. Veronica with her miraculous veil, but in this version of history, the Temple is not destroyed.[41] The *Vengeance* is a story of final conversion and baptism, a theme that made it an apt lesson for the neophytes of New Spain. Indeed, Cortés had earlier likened himself and his conquest of Tenochtitlan to Vespasian's siege of Jerusalem, lending credence to an imagined trope on Mexico City as both a new Rome and a New Jerusalem.[42]

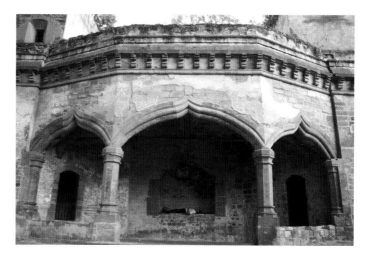

Fig. 6.2. Tlaxcala. The open chapel or "Holy Sepulcher" chapel of the Franciscan evangelization center with volunteer "cadaver" in the niche. (Photo by author.)

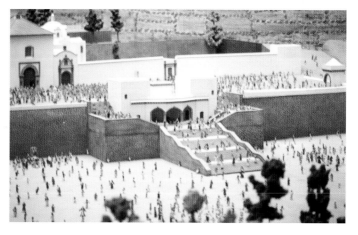

Fig. 6.3. Tlaxcala. Model of the open chapel as in the sixteenth century with ramp and dual staircases on either side. The model maker omitted the three crosses on the roof (cf. fig. 1.15). Museo de la Memoria, Tlaxcala. (Photo by author.)

JERUSALEM STAGE SETS

Fortunately, the sets of several contemporary European plays about Jerusalem have been recorded for posterity, and they confirm that the thespian Holy City and its Temple on stage looked remarkably similar to some of colonial Mexico's earliest architecture, the open chapels and posas.[43]

With this in mind, a more detailed look now at the open chapels built after or contemporary with the New World stage sets can demonstrate their iconographic sources in late medieval theatrical scenery. That is to say, we can trace the design of the open chapels not only to the generic medieval *mansión* (stage house) but more precisely to sets that almost invariably are representations of the Temple of Jerusalem. The chapels are, in effect, domed chambers (the generic *qubba*) from which

the front wall has been removed to permit us to observe actors who portray characters in temple scenes from the life of Christ.

We recall that in New Spain, open chapels can appear either as proscenium openings or as mosquelike sheds or loggia. They can also appear as arcaded pavilions open on the front, often hexagonal in shape. The Franciscan chapels of Tlaxcala and Tizatlán from around 1539—when the use of edifying plays was beginning—are well-preserved examples of the last style.

The chapel of Tlaxcala is located for high visibility at the summit of a ramp that once accommodated people ascending from the town's marketplace.[44] The façade of the chapel, a flattened hexagon in plan, projects like a bay window (figs. 1.15, 6.2, and 6.3). Its three faces are framed by pointed conopial arches. The rear of the chapel is sunk into the floor of the upper patio and forms a recessed apse with a shelf niche similar to the

Fig. 6.4.
Metztitlán. Ceremonial
casket for Good Friday
procession and the
Santo Entierro of the
dead Christ. (Photo
by author.)

European replica of the tomb of Christ, known as the Easter
Sepulcher or *monumentum* (*tepetlacalli*, in Náhuatl).[45] Susan Web-
ster has studied this practice and its props at Huejotzingo,
demonstrating that there pious confraternities of flagellants
were responsible for the procession and elaborate theatrical
drama of the *Santo Entierro* (Holy Burial). Contemporary litur-
gical texts also confirm that a fictive tomb was used during
Holy Week for an image of the dead Christ in the liturgical rites
of Good Friday (figs. 6.4 and 7.9).[46] The image of the dead
Christ was placed in a niche, like the one at Tlaxcala, as if in
a sepulcher. This liturgical-theatrical action originated in the
early Middle Ages and takes place today in Latin countries. An
articulated image of Christ is taken down from the cross in
the ceremony of the Deposition. The image, a puppet with col-
lapsible arms, is then carried in procession (fig. 6.4), with stops
at the four posa chapels, to its resting place in a sepulcher niche.[47]
The Nahua-Christian writer Diego Muñón Chimalpáhin speaks
of these Christ puppets as *imiquilizyxiptlatzin*, literally, "buried
impersonators of God," thus reemploying the ancient Aztec
notion of image-as-impersonation.[48] These puppet sculptures
also have a long liturgical history, from the Middle Ages to the
baroque, and can be found today in Latin countries.[49]

We find confirmation that the Tlaxcala open chapel was a
replica of the Holy Sepulcher in the fact that on the roof of the
structure were once mounted the three crosses of Golgotha, as
recorded by the colonial chronicler Diego Muñoz Camargo
(fig. 1.15).[50] They are also visible in a late nineteenth-century
photo. Furthermore, there is a sixteenth-century painted in-
scription on the inside lip of the conopial arch, which is thir-
teen and a half feet across. The barely discernible text reads:
"They saw nothing but the shroud rolled up in its place." The
quotation refers to the empty tomb on Easter morning and the
arrival of the apostles Peter and John. "When Simon Peter ar-
rived after John, he went into the tomb and saw nothing but
the burial cloths there, and the cloth that covered the head, not
with the burial cloths but rolled up in a separate place" (John
20:6–7). The painted script is also an Easter Sunday liturgical
and theatrical text found in the Divine Office, the Mass texts,
and medieval *Visitatio Sepulchrum* liturgical plays as transcribed
in Alberto Castellani's *Liber Sacerdotalis* of 1523. This *mansión*

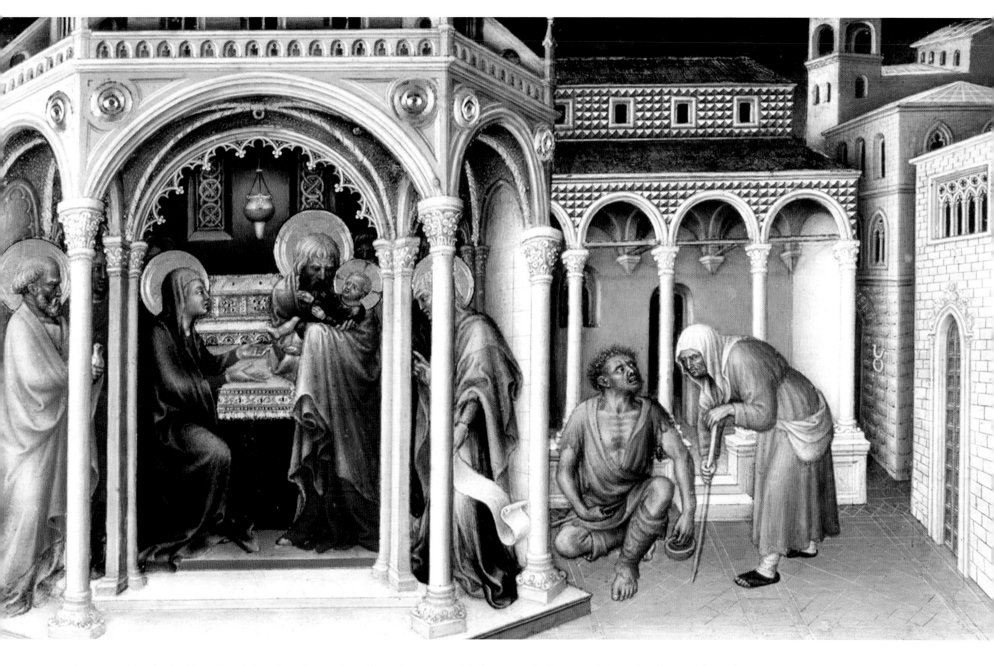

in stone, then, is the Holy Sepulcher chapel mentioned later by the Franciscan chronicler Agustín Vetancurt.[51] European replicas of the Holy Sepulcher often had the crosses of Golgotha mounted above them, as did Spanish multilevel stage sets for plays that presented the sequence of Christ's Passion, burial, and Resurrection.[52] The Tlaxcala chapel would have acted as a liturgical stage set for the Holy Week processions and as a temporary resting place for the theatrical image of the dead Christ.[53] The open chapel at nearby Tizatlán is similar in shape,

and it has a symbolic crypt below the altar, perhaps for some similar enacted burial.[54]

Walter Palm suggested European models for these open chapels. He found them in quattrocento altar paintings, such as the type seen in the mendicant churches and convents of Florence and in several Spanish cathedrals.[55] One of innumerable examples of this genre is Gentile da Fabriano's *Presentation in the Temple* (1423) with its hexagonal open chapel–like temple, which Palm compared to Tlaxcala (fig. 6.5). Another

Fig. 6.5.
Gentile da Fabriano, "Presentation of Christ in the Temple," predella panel from an altarpiece (c. 1400). Louvre, Paris. (Scala/Art Resource, NY.)

Fig. 6.6.
Hans Memling,
The Passion of Christ
(as stage sets), fifteenth
century. Galleria
Sabauda, Turin. (Scala/
Art Resource, NY.)

is Giovanni da Milano's *Expulsion of Joachim from the Temple*, which I am comparing with the open chapel of Zinacantepac, state of Mexico (figs. 4.49–50). Art and theater historians have determined that the painters of such sacred episodes were depicting stage reenactments of the sacred drama that they had seen.[56] Flemish artists, such as Hans Memling (fig. 6.6), were particularly adept at painting such Jerusalem simultaneous-action stage sets (not unlike the simultaneous activity we see in the corral of Diego Valadés's *Rhetorica Christiana*, fig. 1.4).[57] The Franciscan who carried these ideas to the New World

was likely none other than that Flemish Renaissance man himself Fray Pedro de Gante, cousin of Emperor Charles V as well as an artist, craftsman, musician, impresario, costume designer, and all-around man of the arts.[58]

In April of 1515 Fray Pedro de Gante accompanied his royal cousin to the cities of the Spanish Netherlands, where he witnessed the theatrical performances that greeted the entrance of the monarch. At Bruges the "royal epiphany" welcoming ceremonies were conducted at twilight.[59] Triumphal arches, illuminated by torches, had been erected along the route. On top

of the arches were placed stage houses and ephemeral sets (*mansiones*) for actors who represented abstract ideas, such as the city's hoped-for triumph or prosperity. Charles V—who, as we remember, bore the title King of Jerusalem—was himself portrayed by an actor conquering an ephemeral Jerusalem with crenellated walls not unlike the Mexican stage sets described at Tlaxcala for the *Conquest* play (fig. 6.7).[60] The proscenium arch is illuminated by the eschatological sun, moon, and stars, similar to the celestial bodies that we have seen represented on the atrial crosses. Indeed, all the stage sets at Bruges bear great resemblance to either the open chapels or posa chapels of New Spain. The balustrade column of one particular stage set appears to have later been copied in stone in the *portería* of Huejotzingo together with the chain of the Order of the Golden Fleece.[61] Additionally, the torches on the roofs of several stage houses reappear in stone on the roof of the Royal Chapel at Cholula (see chap. 4 and fig. 4.47). The stage master of the Bruges plays, Remi du Puys, had created a full-color remembrance album for the emperor that was later copied and printed in a black-and-white edition for the general public. Pedro de Gante surely had a copy.[62]

On another stage set at Bruges, an angel handed Charles's impersonator the keys to the city with words taken from Christ's charge to St. Peter: "I give you the keys of the kingdom."[63] The scenography of the Holy City included a painted Sibyl who held a scroll addressed to Charles, now represented as the Byzantine emperor Heraclius (the rescuer of the True Cross), assuring him of a prompt victory (fig. 6.8). Not by accident did the words paraphrase Gideon's prophecy in the book of Judges (6:14–16), "Our Lord is with you, O powerful Prince, and with that power you shall deliver Jerusalem." Gideon, the destroyer of idolatry and the deliverer of Israel, had received a sign of his divine election in the dew that fell on the woolen fleece (Judg. 6:36–40). This biblical trope became part of the mythology surrounding the Order of the Golden Fleece, of which Charles V was Grand Master.[64]

The myth of the Golden Fleece would later take on a christological significance as the Mystical Lamb, and it would receive a eucharistic liturgical interpretation.[65] Jan van Eyck would celebrate these associations in the "Adoration of the Mystic Lamb" (fig. 5.16) panels on the *Ghent Altarpiece* (1432), which

Fig. 6.7.
Stage set from Remi de Puys, *La tryumphante entrée de Charles Prince des Espagnes en Bruges (1515)*. Emperor-elect Charles V at the gates of the city of Jerusalem. (Österreichische Nationalbibliothek, Vienna. Used with permission.)

Fig. 6.8.
Stage set from Remi de Puys, *La tryumphante entrée*. On the left, Emperor-elect Charles V represented at Jerusalem as the Byzantine emperor Heraclius rescuing the True Cross. The Sibyl is depicted on the left door. On the right, Charles receives the relic of the Holy Blood. (Österreichische Nationalbibliothek, Vienna. Used with permission.)

Fig. 6.9.
Hubert Cailleau,
stage sets from the
Valenciennes Passion
play, 1547. The Temple
of Jerusalem *mansión*
is anachronistically
surmounted by the
Islamic crescent as the
Dome of the Rock. The
hell mouth and caldron
on the right resemble
painted Last Judgment
scenes in New Spain.
(Bridgeman-Giraudon/
Art Resource, NY.)

he painted only two years after the order had been founded by Philip the Good of Burgundy.[66] The members of the Order of the Golden Fleece regularly celebrated a liturgy in front of this icon and occasionally watched actors in a grand-scale tableau vivant set—called "Jerusalem"—performing the same scene of the mystic adoration.[67] Based on the vision of Revelation 14, the painting shows Christ the Lamb standing on an altar while blood pours from his side into a chalice. Surrounding this liturgical action, his angelic acolytes hold the instruments of the Passion, just like the eschatological *arma Christi* that we noticed on the Mexican atrial crosses raised up on their *momoxtli* altars.[68]

Another iconographic source for the New World stage sets and open chapels is the illustrations that accompany the drama texts themselves, such as the Passion play at Valenciennes, yet another city that Charles V visited on his tour of the Spanish Netherlands (fig. 6.9).[69] In all the depictions, the Temple of Jerusalem has been reduced to a cipher: the short-

hand of a pavilion open on its front side and closed on its rear. The façade projects two freestanding columns, which were identifiable traits of the biblical edifice and which appear as "Solomonic columns" in later architecture.[70] The stage set of the Valenciennes play displays a curtained bedroom in the scene of Christ's healing of the sick (fig. 6.10), and a similar bedroom scene appears in Valadés's *Rhetorica Christiana* for a representation of the sacramental anointing of the sick (fig. 6.14). Similar stage sets/open chapels were even illustrated earlier in pictographic codices.[71]

Yet another synecdochical Temple is represented in Bernard von Breydenbach's popular *Pilgrimage to the Holy Land*. In a woodblock engraving showing Christ healing the blind man next to the Temple precincts, the artist has Christ sitting under an open pavilion that has the same conopial pointed arches as the chapel at Tlaxcala (figs. 6.11 and 6.2).[72] It also has two stylobates between the columns in exactly the same position as those at Tlaxcala. Since Breydenbach's book was known in New

Fig. 6.10.
Stage sets from the Valenciennes Passion play. The cure of the paralytic (*left*), Christ teaching in the Temple (*right*), the cure of the daughter of Jairus (*center*). (Bibliothèque Nationale de France, MS français 12536.)

Fig. 6.11.
Bernhard von
Breydenbach,
*Pilgrimage to the
Holy Land.* Christ
teaching in the
Temple precinct.
(Courtesy of the
Beinecke Rare Book
and Manuscript
Library, Yale
University.)

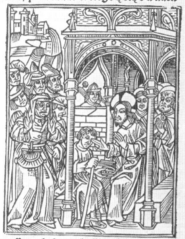

Spain, and since Fray Pedro had worked in Tlaxcala, it is logical to think that he or someone else who knew the *Pilgrimage* book may have been the designer of the chapel.

Still another close relative of the open chapel is the hexagonal set design from an early sixteenth-century edition of the dramas of the Roman author Terence, a book that had connections to a Franciscan pope (fig. 6.12).[73] The collection of Terence's dramas is also known to have been present in New Spain.[74] Fray Diego Valadés, who was born in Tlaxcala, frequently refers to Terence's moralizing dramas in his *Rhetorica Christiana.*[75]

Liturgical confirmation that the friars were thinking theatrically is not lacking either. It is useful to note that the first ritual book or priests' manual brought to the Americas, the *Liber Sacerdotalis* (1523) of Alberto Castellani, indicates the need for diminutive stational chapels called *mansiones.*[76] Four or five *mansiones* are said to be needed for some liturgical processions, and they can be understood to comprise the open chapel plus the four posa chapels of the New World corral.[77] Moreover, in

the early eighteenth century Fray Matías de Escobar was still identifying the posas by the theatrical term *mansiones.*[78]

At least two colonial open theaters have been documented in Mexico. They follow a similar design that links them both to the open chapel and to the medieval temple *mansión.* The first is that of Zumpango de la Laguna, in the state of Mexico, where local residents still remember the *pastorela* plays. The plan and elevation—with cupola and lantern—closely duplicate the European theatrical model.[79] The second is that of Bishop Quiroga's hospital town of Tzintzuntzan, Michoacán (fig. 6.13).[80] As in medieval Europe, a hospital patio has once again served as a theatrical corral. In it, a triple-arched open chapel (*mansión*) has been installed and an atrial cross mounted above a subterranean chamber. The reason for the chamber under the cross is now evident. It is, once again, a Holy Sepulcher replica.[81]

Finally, it will be worthwhile to return to Valadés's engraving (fig. 6.14). The simultaneous activities of liturgical actors in the corral and in the stagelike arcade at the center are similar to the simultaneous depictions in Flemish paintings of the Passion

Fig. 6.12.
Publius Terentius,
Comoediae omnes (Venice,
1561). Stage set for
Terence's moralizing
play *Adelphi.* (Courtesy
of the Biblioteca
Nacional de México.)

Fig. 6.13. Tzintzuntzan. Open chapel of the hospital complex with atrial cross and sunken "Holy Sepulcher" chapel. (Photo by author.)

by Roger van der Weyden and Hans Memling. Features like a curtained center stage where IUSTITIA is being administered, or a curtained bedroom in an open alcove for the administration of the sacrament of EXTREMA UNCTION, hint that Valadés's inspiration for this manner of didactic illustration was theatrical. Moreover, comparing his circular posas with their curtain rods—a design completely unknown in New Spain—to stage sets like those of the Valenciennes play shows that they clearly have a thespian origin.

LITURGICAL THEATRICS

As we have seen, drama was a catechetical tool, and a very successful one, used by the friars in the conversion of the Nahuas, to whose eyes the pomp and circumstance of Christian liturgy must have seemed like just another variation of their own cultic theater. Indeed, neither Aztecs nor medieval Christians made a sharp distinction between formal liturgical practices, liturgical drama, and what we would today call extraliturgical devotional practices. Altar platforms and stage sets, whether in medieval churches or in Mesoamerican *teocalli* patios, were often used in similar ways.[82] The worship of the Aztec gods was high theater, a dramatic event with ritualized choreography, and just as theatrical as the late medieval Mass and the many processions throughout the year with the host, relics, and statues.[83]

The liturgical texts and practices used in the evangelization are a complicated and considerable study in themselves,

and I shall examine them in a separate volume. Nevertheless, given that Christian worship was so visually, acoustically, and kinesthetically appealing to the natives, it is worthwhile mentioning here some aspects of the pre-Tridentine liturgy that was brought to New Spain. This medieval liturgy was either imposed wholesale in the new situation or adapted to the ethos of the Nahua cultural world.

We can gain insight into the developing inculturation of the Nahua-Christian liturgy by examining the collection of liturgical canticles written for Sundays and major feasts of the church year by Bernardino de Sahagún and his students. The *Psalmodia Christiana* was published in Mexico City in 1583 but was already in use in manuscript form as early as the 1550s.[84] It was composed in the Náhuatl language in an effort to replace the pre-Contact hymns that were still dear to the indigenous popu-

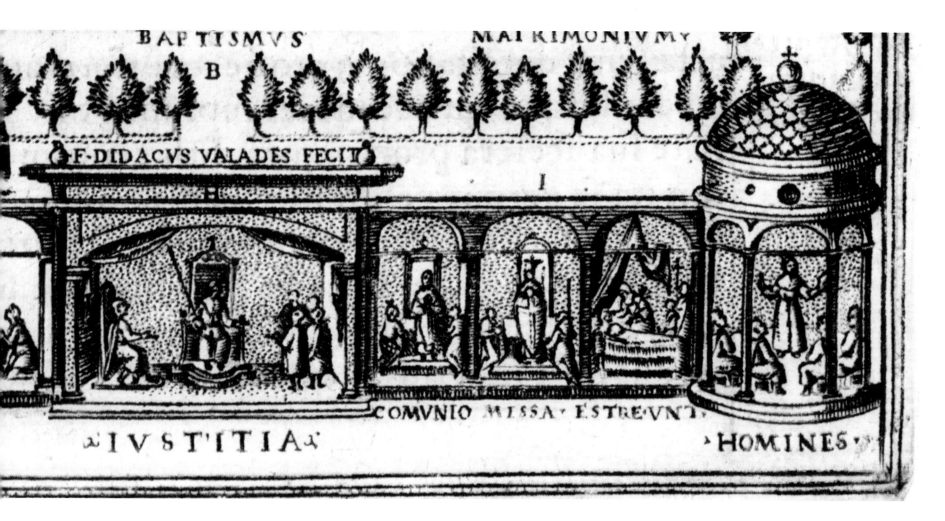

BAPTISMVS MATRIMONIVM

·F·DIDACVS·VALADES·FECIT·

I

COMVNIO·MISSA· ESTREVNT

·IVSTITIA· ·HOMINES·

lation. This book of "psalms" is not the biblical collection of songs attributed to David but rather doctrinal and liturgical paraphrases. Like David's psalms, though, it was meant to be sung while dancing. The book contains a brief catechism, basic prayers, the commandments, and then fifty-four compositions that follow the liturgical year from the Circumcision (January 1) to the Nativity (December 25). The style of the songs attempts to follow as closely as possible the rhythms, characteristics, and metaphors of Náhuatl poetry.[85]

The Lenten set of hymns is entitled *Tlauculcuical*, or "Songs of Lamentation," and started with Septuagesima Sunday (seventy days before Easter). Sahagún incorporates material from the book of Genesis in these lamentations for the sins that bring suffering to humanity, all done with local flavor; for example, the ark of Noah is described in Náhuatl as a canoe. The

trials of this life, the suffering of the Church, and the death of Christ culminate in the hymns that meditate on the mysteries of Passion Week.[86] But of more interest are the *Xochicuicatl*, or "Florid Songs," of Eastertide. They are all based on the book of Revelation, and they describe the City of God, the celestial Jerusalem. The Florid Songs hymn the glories of heaven and the final triumph of good over evil.[87] Here we can observe the development of Nahua-Christian metaphors, which culminates in a paraphrase of Revelation 21, with literal and metaphorical interpretations simulating the activity in the evangelization corrals.

And these city walls are constructed all of precious stones; all the various kinds of stones are placed in the wall. The first kind of precious stones of which it is constructed is

Fig. 6.14.
Diego Valadés,
Rhetorica Christiana.
An idealized Franciscan evangelization center.
Detail of fig. 1.4.
The sacramental arcade or portico "rood screen" of the idealized evangelization center.

called precious flint. It is very precious, much like copal incense. It is called jasper. It befits the eyes, and it signifies the Faith. The second kind of precious stones of which the walls are made is fine turquoise. It is very smoky; it is brightly gleaming. . . . It denotes desire for heavenly things. . . . And the city of our Lord has courtyards in many places, and has courtyards that are totally of gold, translucent, very yellow, most beautifully resplendent . . . they are brilliant there. And in your midst is always joyous song, and there will always be dancing also.[88]

The mention of jewels and sparkle would appeal to the Nahuas' propensity for baubles, bangles, and beads. Objects, deities, and persons who were perceived as precious or mirrorlike had a built-in sacredness for the Mexica. The iridescent blue-green plumes of the quetzal bird, for instance, were believed to have divine qualities. Thus the Nahua emphasis on glitter, sheen, and luminosity coincided, by chance, with the biblical concept of divine glory (*doxa*), which likewise was imagined as brilliant and reflective of light.

After quoting from the text of Revelation, Sahagún's elite translators continued to meditate on the heavenly city theme with a paraphrase of the medieval hymn "Urbs Beata Jerusalem," which they knew in Latin. Originating in Carolingian Europe, this song was used for the dedication or anniversary of a church and appropriated Jerusalem imagery as a trope on the liturgical building and the utopian metropolis.[89]

Ah, you are in Heaven, O Jerusalem, made of precious stones, and the angels form your crown. Your gates shine brightly; they are like precious pearls. They always remain open. There many enter who live here in earth. The stones are living. By suffering, by misery they are polished. And when they are prepared for temple building, they give them their own place apart in the heavenly city. God's blessed city full of song, full of [the sound of] flutes.[90]

Noteworthy also are the hymns for saints' days. For example, the song for the Feast of St. Bernardino of Siena makes special reference to the *ahuehuetl*, the tree and mythic forerunner of the atrial cross or Tree of Life of the mendicant com-

plexes.[91] "Let us praise [St. Bernardino] the precious *ahuehuetl*, Let us praise the plane tree, which God has made resplendent."[92] When lauding the Virgin, Sahagún had his Indian faithful sing: "You are, O Virgin Mary, like precious jade, like the finest turquoise." The imagery of precious jewels, sacred trees, and Nahua objects testifies to the desire to indigenize the Christian message in an appealing way that would guarantee that the message took root in the visual imagination.

This book of dance songs was made to be performed in the corral atrium in a stational liturgical event that utilized the four posa chapels, and the atrial cross at the patio's heart, for kinetic worship. The assembly danced past or through the four posas and around the cross in a counterclockwise fashion (fig. 1.18). The precedents for this Christian liturgical practice have their origin in the papal stational liturgy of Rome and the eschatological-theatrical thinking of Carolingian monks around the year 800.[93] As in the arrangement of the posas in the Mexican patio, the European monasteries created spaces in the four corners of the monastic church or the quadrants of the atrium. These spaces were dedicated to the mysteries of the Incarnation, Passion, Resurrection, and Glorification and surrounded the Holy Cross altar at the center of the medieval quincunx.[94]

The Carolingian liturgical arrangement was known from a work by the abbot Angilbert, the *Libellus Angilberti*.[95] This document was consulted in the Vatican Library by Alberto Castellani for his *Liber Sacerdotalis* of 1523, the ritual book initially used in the New World until the *Roman Ritual* of 1614.

The stations of the Carolingian churches are both their interior altars and their chapels located in the corners of the

atrium/cloister. The cloister arcades act as connecting pathways, while in the church the side aisles or the gallery passages above perform the same service. The four christological mysteries have a place in the four quadrants surrounding the Holy Cross altar. Behind this arrangement is the memory of Jerusalem: the location of the triumphal Golgotha cross that once stood in the atrium between the Martyrium and the Anastasis, and the earlier Temple with its four *gazophylacia* surrounding the holocaust altar.[96] It is also the special placement duplicated by the Mexican atrial crosses. In the Carolingian churches as well as in colonial Mexico, the high cross stands at the center of the Christian temple surrounded by the four stational chapels representing the four christological mysteries.[97]

Angilbert's order of service provides for stational processions, and it permits us to determine with considerable certainty the placement of the altar stations in the churches.[98] In fact, their use in the eighth and ninth centuries would prove identical to that of the posas for the native "lay monks" of the mendicant utopian complexes. Carolingian religious architecture likewise displays an overlay of Temple iconography taken from contemporary exegetical works.[99]

A resemblance to the New World liturgy is also evident in Carolingian liturgical development, where drama and nascent theater entered the worship life of the Church. The Carolingians fostered the theatricalization of the liturgy in a desire to explain Christian worship as the drama of salvation history. This was also an effort at indigenization or inculturation of the liturgy to the dramatic storytelling and hero-worshiping ethos of the Franks and Saxons. The phenomenon first took shape in the theatrical rites of Holy Week,[100] and the same performative techniques would be used centuries later by other missionaries in the New World during Holy Week for the elaborate entombment of the puppet Christ in the Holy Sepulcher chapels. The kinesthetic liturgy that the friars introduced to the Nahuas was essentially medieval and would continue so until the end of the sixteenth century, when the decrees of Trent were finally enforced and new liturgical books created. Even then, much of the pre-Tridentine popular religiosity carried over into the baroque Catholicism of the seventeenth and eighteenth centuries, especially in elaborate processions like that of Corpus Christi.[101]

CORPUS CHRISTI — ESCHATOLOGICAL REHEARSAL

Three Thursdays there are in the year
That shine more brightly than the *sun:*
Holy Thursday, Corpus Christi,
And the day of the Ascension.
 —an old Spanish refrain

The feast of the reverence of Christ's eucharistic body, Corpus Christi, dates from 1264 when Urban IV issued his bull *Transiturus*, but the processions associated with the feast developed later. The theology and popular religiosity of the Middle Ages endowed the consecrated host with apotropaic value, and this quality would carry over to New Spain.[102] According to legend, St. Clare of Assisi repelled the invading Saracen hordes by displaying the sacrament in an ivory pyx. At the sight of the sacrament, the enemy fell back, panic-stricken, and took flight.[103]

Throughout Europe a gradual insertion of local political meanings into the eucharistic procession had been at work during the second half of the fourteenth century, but the militarization of the feast in Spain was unique.[104] From the very start, the Spanish celebration of Corpus Christi took on apocalyptic dimensions, and it was metaphorically linked to notions of triumph—the reconquest of the Iberian peninsula, the defeat of Islam, the conversion of the Jews, and the eschatological paradise.[105] "The eucharistic festival [of Corpus Christi] came to be the supreme symbol of Spanish Catholicism in all the country, first as a crusade against the Moors, and afterwards, following the Council of Trent, as a public manifestation of resistance to spreading protestantism."[106]

In viceregal America, nothing could compare with the procession of Corpus Christi, as we noticed in the feast that was celebrated in the city of Tlaxcala.[107] The Eucharist, which we saw personified in *The Conquest of Jerusalem*, was an actor of heroic proportion. One chronicler boldly remarked that "on this day of Corpus, not even the Ark of Jerusalem could compare with the splendor of the Ark of the Sacrament."[108]

In the Tlaxcala Corpus procession, the sacrament was carried in procession on platforms decorated with gold and

featherwork. There were twelve men dressed as the apostles, and a host of other actor saints. The processional roadway was covered with sedge and mace reeds and flowers, while an assistant kept strewing roses and carnations. Along the route were six stational chapels where a boys' choir sang and danced before the eucharistic ark.[109] Fray Bartolomé de Las Casas was present and remembered:

> There were ten triumphal arches that were very neatly fashioned. More worth seeing and noting, however, was that the entire street was divided into three lanes, like the naves of a church. The middle nave measured about twenty feet in width. Down this lane passed the Most Holy Sacrament, the ministers of the altar and the cross-bearers, with all the display of the procession. Down the two side "naves," which were twenty-five feet in width, passed all the people. The space for the procession was marked off by medium-sized arches, set about nine feet apart. There were by actual count one thousand and sixty-eight arches of this kind. . . . All the arches were covered with roses and flowers in different colors and shapes. It is figured that each arch had about six bushels of roses. . . . There were about a thousand shields consisting of designs in flowers. They were set up within the arches; and in the arches that had no shield there were large rosettes, some of them ring-shaped like the slice of an onion, round, so well constructed and attractive that they appeared to be *pearls*.[110]

The iconography of the pearly gates of the New Jerusalem was complemented by the participants, who wore floral sashes over their chests in the manner of a diaconal stole while acting like the elders in the book of Revelation.

> When the Most Holy Sacrament passes, they throw these before the platform (while kneeling and adoring) as if imitating the twenty-four elders who St. John in the Apocalypse said adored the Living One, throwing down their crowns before his feet, [as he said] *Adorabant viventem in saecula seculorum, et mittebant coronas suas ante thronum Domini Dei sui.*[111]

The processional stations are then described as replicating the Peaceable Kingdom of Isaiah's vision, complete with intoxicated predatory animals on mounds similar to the pre-Hispanic *momoxtli* altars.[112]

> Something very attractive, located at the four corners or turns in the road, was a mound, from which arose a very high rock. From bottom to top, the slope of the mound resembled a meadow with grass and flowers and whatever else is found on a verdant field. The mound and rock were so lifelike that they seemed to be placed there by nature. The mounds presented a wonderful sight because on them were many trees. . . . In the trees there were many birds, small and large, among them falcons, crows and owls; while in the forests there were much game, including deer, hare, rabbits, jackals and a large multitude of snakes. These snakes were piniomed and had their fangs removed. . . . The Indians took them in hand as if they were birds, having for the fierce and poisonous ones an herb called *picethl* [tobacco], which put the reptiles to sleep or benumbed them.[113]

Creating a fictive terrestrial paradise appears to have had particular appeal to the native designers. In another place Motolinía describes the stage set for the mystery play of the primeval parents.

> The abode of Adam and Eve was adorned in such a way as closely to resemble the Terrestrial Paradise. In it there were various fruit trees and flowering trees. Some of the latter were natural, others were artificial with flowers made of feathers and gold. In the trees there was a great variety of birds, from the owl and birds of prey to the little birds. . . . There were also two ocelots. These were tied because they are very fierce. Once, during the play, Eve was careless and went near one of them and, as if well trained, the beast went away. This was before sin; had it occurred after the sin, she would not have been so lucky. There were also artificial animals, all well simulated, with some boys inside them. These acted as if they were domesticated and Adam and Eve teased and laughed at them.[114]

The stage set appears very similar to a mendicant evangelization corral, like the one at Huejotzingo with the four posa fountains surrounding the atrial cross at the center. It visually bridges the first and last books of the Bible with graphic quotes from the garden of Genesis and the city of Revelation.

> Four rivers or springs flowed from Paradise, each bearing its label which read: Phiron, Gheon, Tigris and Euphrates. The Tree of life was in the center of paradise and near it stood the Tree of knowledge of good and evil with many beautiful artificial fruits made in gold and feathers. . . .[115]

Eden and Jerusalem have here converged by liturgics, theatrics, and stage sets in ephemeral materials and, subsequently, in mortar and stone. At the heart of the New World's sacred cities, the temple and its liturgy became a didactic theater of earthly as well as heavenly delights.

The use of stage sets representing Eden, or Jerusalem and its sacred sites, demonstrates the same concern as that of the liturgical dramas enacted in them: to teach, rehearse, and preenact the plan of the Divine Playwright for a final age. Moreover, the particular dramas that we have examined, and their visualization on stage, manifest a transcendent understanding of the missionary enterprise as a utopian hope executed in a replica of that city, both earthly and heavenly, that so fascinated the medieval imagination. This is especially evident in the military and millennial qualities of Corpus Christi and the theatrical events that accompanied the feast as a type of "anticipatory magic."[116] Once the stage had been set, the set itself became an ideological platform, so to speak, from which to stage a desired last crusade. This crusade was supposed to recapture Jerusalem with the help of the new Indian church and would carry the mendicants' work—in both a spatial and a temporal sense— onward to the ends of the earth. Eden and Jerusalem were meant to become one and the same. What we have glanced at in passing in these sacral theatrics is a continuation of the medieval inheritance in a new key by way of the visual and liturgical imagination.

Finale

THE LEGACY OF THE INDIAN JERUSALEM

Of course, neither the reconquest of Jerusalem in Palestine nor the creation of the terrestrial paradise kingdom in New Spain occurred. The Spanish Empire had spread itself too thin and was in dire economic and political straits by the end of the sixteenth century. The Last Crusade to the Holy Land was indefinitely postponed, while in America the crown's financial and moral backing for the construction and maintenance of the evangelization complexes evaporated. Further, the plagues, which seemed to come in apocalyptic waves throughout the 1500s, decimated the native population and robbed the friars of their neophytes, artisans, and laborers. In one sense, Ollin, the last sun and last age, did arrive; a world did indeed end—the world of pre-Hispanic Mesoamerica and the freedom of its indigenous cultures.

In the last quarter of the century, the utopian dreams of the Franciscans, Dominicans, and Augustinians gradually dimmed; all the more so after the Third Provincial Council of Mexico in 1585 curtailed the friars' independence and power. Meanwhile, the secular or diocesan clergy were gaining ecclesial control with the introduction of the parochial system in New Spain, supported by the decrees of the Council of Trent and the wider powers granted to bishops. At the root of these changes was the spirit of the Counter-Reformation, which, with its hostility to innovation and experiment, had been escalating for several decades. The growing concern regarding possible heterodox practices created an air of suspicion about the friars' nativistic leanings, about the legitimacy of an Indian church, and about the literary and artistic creations of the Nahua Christians. Translation of sacred Scripture and the Divine Office into native languages was therefore halted, in part for fear of linguistic errors; but what frightened the authorities most was the lurking menace of Protestantism and private interpretation. The Holy Office of the Inquisition, which had been established in Mexico in 1569, confiscated texts previously translated into

197

Fig. 7.2.
Lima, Peru. Perimeter walls of the Judeo-Christian temple of the Israelites of the New Universal Covenant under construction on the outskirts of the city. (Photo by Arturo de la Torre.)

Fig. 7.1.
Villa de Guadalupe, Mexico City. The façade of the new Basilica of Nuestra Señora de Guadalupe with open chapel, altar, and pulpit. (Photo by author.)

Náhuatl, especially biblical ones. According to Mendieta, the Inquisition was suspicious of the novel metaphors that Náhuatl Christianity had developed.[1] The Inquisition also confiscated a Náhuatl translation of at least one pseudo-Joachite work, the *Floreto de Sant Francisco* (fig. 2.13), a document now deemed dangerous in the hands of the native population.[2]

When the bishops and friars realized that pre-Hispanic idolatry was still very much alive, their naive belief in a *genus angelicus* appears to have faded.[3] Potentially the Indians might have such a nature, but in the current dispensation they had yet to manifest that potential. (The myth of the "noble savage" would have to wait until Rousseau and the Romantics to be resurrected.) Perhaps the greatest error of the friars, as Robert Ricard noted, was their failure to foster native vocations to the priesthood and thus create an indigenous clergy, which would have built up the Church on more solid soil. But in their shortsighted and paternalistic vision, there would never be a need for Indian priests; the friars themselves would always be there to care for their spiritual children and protect them from a world grown increasingly secular and hostile.[4]

However, the picture may have been less gloomy than what some of the disheartened chroniclers, like Mendieta and Juan de Grijalva, present. As the new geopolitical and ecclesial realities sunk in, a younger generation of friars buckled down to the long, hard task of constant catechesis, slower conversion rates, and unremitting moral vigilance over their flocks. The northern frontiers of New Spain were opening up, and a new, less idealistic and more pragmatic wave of friars traveled north to convert the nomadic Chichimecas. Meanwhile, in the central valleys of Mexico, the bilingual mestizo population, growing yearly by leaps and bounds, was balancing the number of natives and successfully bridging the cultures. "Stage Two," as James Lockhart calls the century from 1550 to 1650, was a time when Spanish elements came to pervade every aspect of Nahua life and the process of inculturation became more evident.[5]

While it is true that royal funds were becoming thinner, mendicant construction did not cease. Although somewhat more slowly and more modestly, the friars continued the building campaigns of the evangelization complexes during the following two centuries, and they decorated their churches and cloisters in the latest fashion of baroque filigree and oil paintings.[6] In eighteenth-century California and the Southwest, a more humble fortress monastery model was nostalgically revived for the new missionary efforts taking place in territory

that would become part of the United States.[7] In New Spain, the reproduction of the Temple in an atrium continued to prove useful for future generations, even if there was less need for outdoor worship because of the decreased population. Patio corrals remained in use and continued to be built even when the congregation as a whole moved indoors for all its services. Moreover, many of the new parish churches of the secular clergy adopted the generic plan of the missionary complex with its corral/cemetery and atrial cross. Permanent posa chapels might be deemed unnecessary because they could be re-created in ephemeral materials for the occasion, such as the annual Feast of Corpus Christi.[8] The military architecture of sentry boxes would die out in the seventeenth century, but decorative crenellations and merlons continue to be part of Mexican church design today. Even permanent posa chapels and open chapels have been constructed in recent years (fig. 7.1).[9]

Just as mendicant building did not cease, neither did utopian hopes of paradise and Jerusalem vanish. They have reappeared again and again in the wildest and most unpredictable circumstances throughout the American continent from the beginning of the seventeenth century until the apocalyptic year 2000, often in political, nativistic, and secular contexts.[10] Underground messiahs and the writing of chiliastic prophecy persisted throughout the colonial period, directly inspired by the Judeo-Christian heritage. The book of Revelation has often been used or abused by colonial lords and marginalized natives alike. The latter have ingeniously applied its images of dragons and monsters to the European invaders and the interloping landholders.[11] It is no wonder then that, at the moment I am writing this book, a recently founded fundamentalist and chiliastic Judeo-Christian sect of Peru, known as the Israelites of the New Universal Covenant, is building a full-scale copy of the Jerusalem Temple outside Lima and another in the Amazon jungle, both for animal blood sacrifice (fig. 7.2).[12]

The metaphors of the paradise garden and the hagiopolis have also resurfaced, sometimes with all the vigor of their early forms, as in the case of the Jesuits and their idealist urban experiments in Paraguay.[13] The "solar Christ" lived on throughout the colonial period in Catholic eucharistic liturgy and in indigenous folklore.[14] Even the Trinitarian theory of world history propounded by Joachim of Fiore received a new life in viceregal Latin America; and in colonial painting, Joachim himself eventually appeared accompanying a winged Francis of Assisi, the sixth angel of Revelation (fig. 7.3).[15]

Neither did interest in a newer Jerusalem and its Temple wane. What might have been a literal expectation in the early sixteenth century for some (a Last Crusade, a *renovatio mundi*, a utopian society, a new Jerusalem and new Temple) was transmuted in the seventeenth and eighteenth centuries to a metaphorical overlay on sociopolitical events.[16] The brown-skinned Virgin of Guadalupe would be reread by Creole thinkers as God's "guided syncretism" and the fulfillment of the prophecy of Revelation 12, the Woman of the Apocalypse (fig. 7.4).[17]

Throughout the seventeenth century, hundreds of baroque churches were created in the "Solomonic style," by such architects as Cristóbal de Medina Vargas in Mexico and Francesco Borromini and Gian Bernini in Europe, in which identifiable elements from Solomon's Temple became part of the architectural vocabulary.[18] As Antonio Bonet Correa explains, baroque architecture and urbanization were the conscious manifestations of the triumphal era of the (Counter-Reformation) Heavenly Jerusalem over the (secular) city of man.[19] This new wave of "jerusalemization" had been initiated slightly earlier by the Company of Jesus. Between 1596 and 1605 the Jesuit architects and mathematicians Jerónimo de Prado and Juan Bautista Villalpando sought to correct the medieval inaccuracies that they perceived in Nicholas of Lyra's Temple plans. They published three enormous tomes in Rome, with sophisticated measurements, plans, and elevations of Ezekiel's Temple in the new fashion of the Renaissance and nascent baroque. The project was financially backed by King Philip II of Spain, and it received papal endorsement. Philip had a vested interest in the project because, only a few years earlier, he had commissioned Villalpando's teacher and sometime collaborator, the architect Juan de Herrera, to begin the construction of the Escorial, designed on the same divinely revealed model. Philip, like his father before him, styled himself a successor of the Old Testament kings David and Solomon and the last descendant of the heroic Aeneas.[20]

Dozens of other architects, artists, biblical scholars, and dreamers would create their own versions of Villalpando's "historically and scientifically accurate" Zion and its Temple.

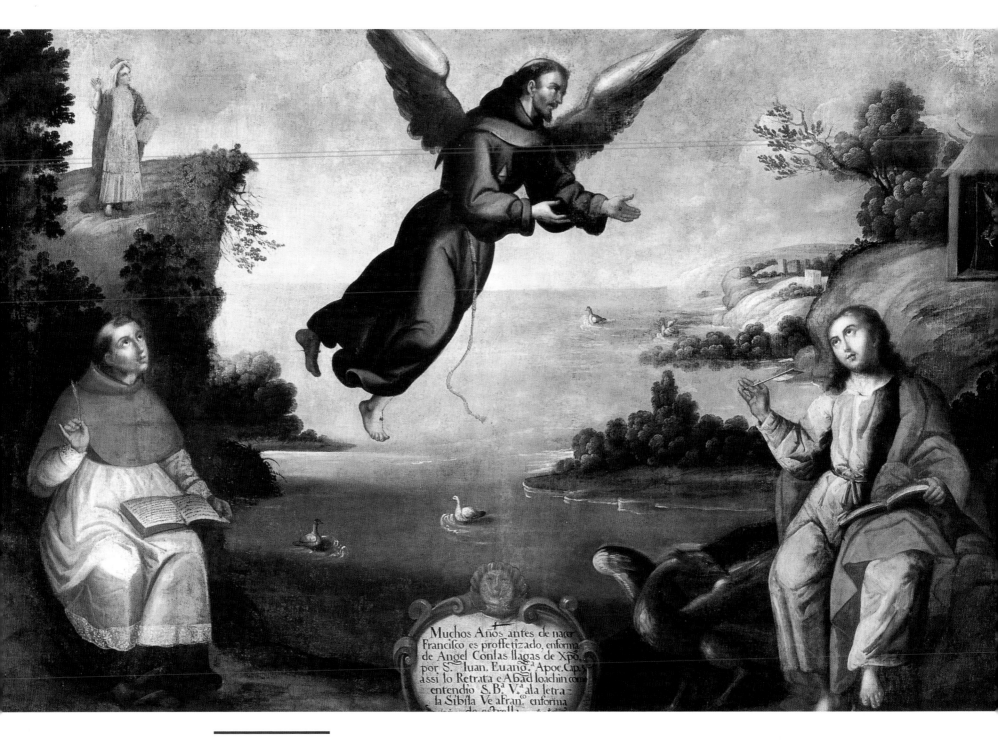

Fig. 7.3.
Juan Zapaca Inka, *The Prophecy of Saint Francis* (c. 1668), Santiago de Chile. St. Francis of Assisi flies as the sixth angel of the Apocalypse while Joachim of Fiore (*upper right*) paints his portrait and the Sibyl, St. Bonaventure, and St. John the Evangelist look on. (With permission of the Franciscan friars of the convent of Santiago.)

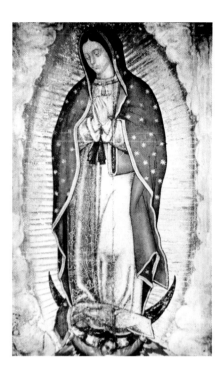

Fig. 7.4.
The Virgin of Guadalupe, the "Virgen Morena," in the basilica, Villa de Guadalupe, Mexico City.

Fig. 7.5.
Santa Cruz Tlacotepec, Puebla. *Sacro monte, calvario* chapel, and way of the cross in the town, originally a Franciscan *visita*. (Photo by author.)

As Manuel González Galván has shown, the gilded opulence of seventeenth-century baroque architecture owes its raison d'être as much to the interest aroused by Villalpando as to the gold and silver acquired from "Solomon's mines" in the New World.[21] Moreover, as late as the nineteenth century, copies of Jerusalem's Holy House were created as far away as the Andean heights of Bolivia, based on Villalpando's quasi-archeological study.[22] But the Indian Jerusalem also survived in the imagination of Latin America in other ways and thus left its imprint on Hispanic society.

Calvario chapels—abridged *sacri monti*—dot the landscape outside hundreds of cities and towns today. No self-respecting town would do without one, and they are a sign of the status and piety of the townsfolk. *Calvarios* crown a nearby hill or mountaintop, often accessible by elaborate staircases with posas or stations of the cross (fig. 7.5). The calvaries function particularly well during Holy Week, when the processions with Christ and the saints of the Passion re-create holy history in the here and now of the cityscape. The *pasos* of the religious floats bring the puppet Christ or puppet Virgin Mary into the commercial streets and noisy traffic of the sacred/secular city, which continues to be a surrogate Jerusalem.

The associated Lenten processions in particular are theatrical events, both medieval and baroque, thus continuing the Nahua and Christian convergence of dramatic liturgy. Sometimes there are isolated extremes and excesses, such as pious peasants who allow themselves to be literally crucified.[23] More often, however, everyone in the town gets into the liturgical act in a more-or-less well-rehearsed role. In recent times, the impact of Hollywood has crept into the open chapel theaters in the decorations and costumes, often with great historical accuracy (fig. 7.6). One can recognize the influence of *Ben Hur, The Robe, King of Kings, The Greatest Story Ever Told,* or any number of cinematic spectacles, but some processions unconsciously maintain older customs. Several Holy Week *pasos,* for example, still involve the participants in the rhythmic dance of the medieval *tripudium:* three steps forward, then two steps back, then three steps forward again. Medieval men and women danced the tripudium in the labyrinths of the great Gothic cathedrals, such as Chartres and Amiens, as a substitute pilgrimage to Jerusalem and a metaphorical pilgrimage through life to the Heavenly Jerusalem.[24] The dancer advances only by a slow route (three steps forward), suffering the backsliding effects of sin (two steps back), but at the same time is

Fig. 7.6.
Cholula. Holy week
pageant in the newly
constructed open
chapel of San Andrés.
(Photo by author.)

fortunate enough to experience the magnetic pull of divine grace (three steps forward).

Choreographic movement toward the flowery paradise survives also in the greatest feast of the late Middle Ages that was translated to America: Corpus Christi. In certain places in Mexico and South America where the older traditions are still preserved, the procession is accompanied by all those menacing figures of the apocalyptic imagination: the *tarasca* dragon taken from Revelation 12, the giants or *cabezudos* from Genesis 6:4, and the dance of Moors and Christians transmutated as combative devils and angels, friend and foe respectively of the archfiend, Antichrist. The winged Woman of the Apocalypse, who is more commonly found in Latin American painting or sculpture than in European art (fig. 7.7), often participates in the procession as a metaphor for the Church, liberated humanity, or the Immaculate Virgin.[25]

In the American Corpus Christi pageant, temporary carpets of flowers or colored sawdust line the streets for the *pasos* of the eucharistic sacrament in its sunburst monstrance (fig. 7.8). The new solar Christ continues to make stops in stational chapels decorated with flowers, tropical fruit, and live birds. Without knowing it, Latin Americans today are re-creating the

Fig. 7.7.
Juan Correa, *The Woman of the Apocalypse with St. Michael Archangel.* Museo Nacional del Virreinato, Tepotzotlán. (Courtesy of Instituto Nacional de Antropología e Historia, Mexico City.)

Peaceable Kingdom for a solar sacrament, not totally different from the sun worship that their ancestors practiced but not a covert residuum either. Moreover, like their spiritual forebearers, on every May 5 they decorate green crosses with flower garlands and mirrors (fig. 7.9). Unaware of the legacy originating in the sixteenth century, they culminate the Easter season with the Feast of the Cruz de Mayo, a direct descendant of the eschatological atrial crosses of the evangelization.[26]

Fig. 7.8.
Huejotzingo. Corpus
Christi procession
through the atrium and
posas of San Miguel
Archangel. (Photo
by author.)

Fig. 7.9.
San Cruz Aquiahuac,
Tlaxcala. The *cruz
de mayo* on the eve of
being decorated with
flowers for its feast day.
(Photo by author.)

Hispanic "folk Catholicism" is not a jumbled collection of pagan relics and orthodox rites, as it has so often been characterized. Latino Catholics are no more "pagan" than German Evangelicals gyrating around a Maypole, British Anglicans singing hymns to the winter solstice to welcome Christmas, or Swedish Lutherans dancing with crowns of lighted candles on their heads. Latin American folk Catholicism is, in large measure, a continuation of the missionary catechesis, theater, and props introduced by the Franciscans, Dominicans, and Augustinians for the new Christians of the last days, wedded to the native's sensibility of the innate sacredness of space and nature. The theatrics and props reflect the survival of the pre-Tridentine spirit and medieval liturgical practices and, as I hope to show in a subsequent volume, can be traced back to the popularity of the ritual books of the evangelization, the new "Red and the Black" of Nahua Christians (fig. I.4).

THE SPIRITUAL CONVERGENCE OF MEXICO

The heart of this study has been "those great stone texts of the Spanish-Indian encounter," the misnamed and misunderstood mendicant evangelization centers that altered the Mesoamerican skyline forever. They are documents of intercultural dia-

logue, and I have looked at them as architectural constructions, as well as copies and metaphors. Urban grids, houses of worship seen on the American horizon, and community playhouses are the three paradigms I have chosen to unpack for meanings common to both religious societies. Each entity was encoded with a wealth of associations in different but potentially complementary ways.

I have suggested that we observe the similarities between the cosmovisions, religious beliefs, and metaphors and symbols of Nahuas and Judeo-Christians while not being oblivious of the real differences and the European hegemony. What occurred in mid-sixteenth-century New Spain was both synthesis

and survival. A society and culture survived, although radically changed, because of a process of fusion. Each side of the admittedly unequal conversation seems to have recognized something of itself in the other. Pragmatics may have had more to do with this than humanist philosophy. Nahua and Spaniard learned to cope and to coexist, and thus to create a hybrid society with hybrid forms of art.[27]

The missionary efforts of the friars were surprisingly collaborative and creative and, for the most part, successful in what they attempted to do in partnership with the Nahua Christians. Some have chosen to call this process syncretic symbiosis, selective synthesis, cultural elision, intentional hybridity, synthesization, or guided syncretism. Whatever the term used, it now seems obvious that the native population was proactive in the process, neither passive nor silent. By selectively responding to the devotional options presented to them by the friars, the Nahuas exerted considerable control over the creation of their church. Perhaps they, more than the friars, were eventually the imagineers responsible for the particular flavors, colors, figures, and metaphors that inculturated Christianity assumed in New Spain.[28] Under their creative genius, eagle and jaguar knights became heroes of St. Michael's militia, feather crowns honored a eucharistic tortilla, and the *momoxtli* or *cuauhxicalli* hinted at the once-and-for-all sacrifice of Calvary.

I suggest that much less of the pre-Hispanic religion was destroyed and much more was recycled because it was relatively easily Christianized (or was it that Christianity was relatively easily indigenized?) by a change in root metaphors. This had much to do with the wealth of complementary symbols gleaned from the Bible and from teoyoism, and with the dynamic qualities of rituals and theatrics in both cultures. It also had much to do with the attractiveness of that perennial symbol "Jerusalem" with all its glitter and sparkle, and with the high hopes for a religious utopia in a New World that was also understood to be the locus of the beginning of the end of the world.

Today, ninety-eight percent of all Latin Americans identify themselves as Christians, approximately 480 million persons. It seems fair to say that Christianity has had success on the continent, a Christianity with its own distinct flavors, as culturally distinct and valid as that of the Christianized Romans, Britains, or Saxons. I would like to suggest that this success had to do with two unspoken, but presumed, principles out of which the evangelization was conducted in the optimistic and experimental early days: dynamic equivalence and ritual substitution. The mendicants and their Nahua elite purposely selected pre-Hispanic rites and religious objects that were not objectively tied to idolatry and that could be given a new, Christian interpretation without too much catechesis. Thus feathers, flowers, mirrors, jewelry, dances, musical instruments, poetic expressions, geography—even tortillas—were reworked to accommodate them to the new religion. In short, a resacralization of Mesoamerican space and time eventually occurred by the end of the century.

While extirpating what they considered idolatry and destroying the temples with their *cultus sangrientis*, the missionaries, in partnership with the catechumens, at the same time erected churches on top of the very same holy hills. They sought to fill the ritual vacuum with the sensorial and kinesthetic splendor of the late medieval liturgy that they had brought with them, wedded to native religious sensibilities. This was nowhere more evident than in the use of the visual arts and in the constant processions, musical spectacles, and liturgical theatrics they created with and for the neophytes. By ritual substitution and symbolic equivalency, the partnership of the friars and neo-Christian natives changed the root metaphor of a civilization from one of sacrificial human blood that kept the sun spinning in its orbit to that of a new sun, the Sun of Justice, whose blood was willingly poured out on the mirror of the cross. By changing the root metaphor, it appears, they Christianized a continent.

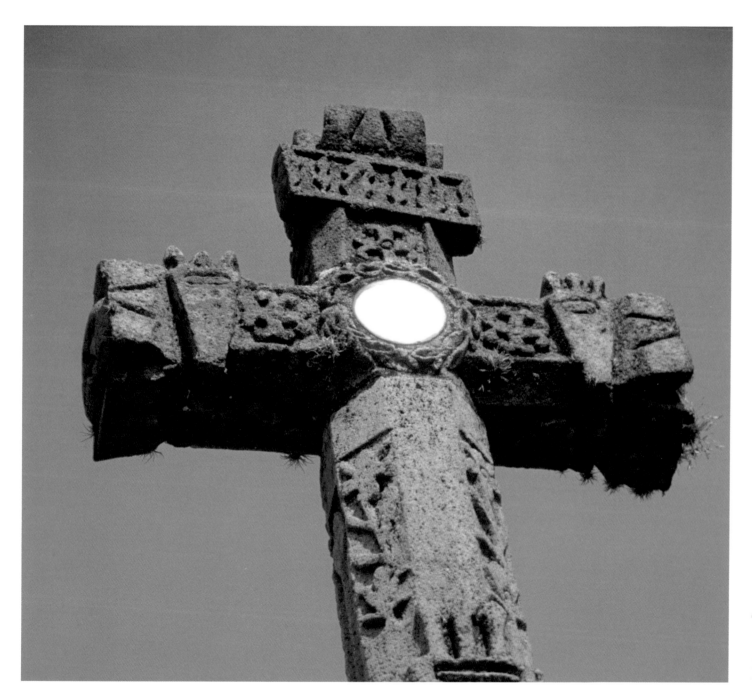

Fig. 7.10.
Ciudad Hildago,
Michoacán. Detail of
fig. 5.28, obsidian mirror.

Notes

Introduction

1. What Octavio Paz has said in general is applicable here to the colonial period: that in Latin America, reality is even more fantastic than fiction.

2. Many of the sixteenth-century missionaries were not Spaniards, but rather Flemings, Dutch, Scots, or eastern Europeans in the employ of the Spanish monarchy.

3. I have taken my inspiration for this paragraph and the next from Bailey, *Art on the Jesuit Missions*, 20.

4. See, e.g., Burkhart, "The Amanuenses."

5. See Klor de Alva, "Spiritual Conflict and Accommodation." To be fair to him, Ricard does document native resistance to Christianity and laments the lack of native vocations (*Spiritual Conquest*, 264–82, 291–95).

6. *Creoles* were Spaniards born in America, while *peninsulares* were those born in Iberia.

7. For example, Bataillon, "Nouveau Monde et fin du monde"; Bataillon, "Evangelisme et millénarisme"; Alba, *Acerca de algunas particularidades*; Weckmann, "Las esperanzas milenaristas"; Sala Catala and Reyes, "Apocalíptica española"; West, "Medieval Ideas"; Ulibarrena, "La esperanza milenaria"; Ulibarrena, "Cristobal Colón"; Reeves, *The Influence of Prophecy*; Reeves, ed., *Prophetic Rome*.

8. Carrasco, *Quetzalcóatl*, 11–12.

9. See Klor de Alva, "Christianity and the Aztecs."

10. The topic is summarized in Peterson, *Paradise Garden Murals*, 5–7; and Bailey, *Art on the Jesuit Missions*, 22–31.

11. Kiracofe, "Architectural Fusion"; and Fane et al., eds., *Converging Cultures.*

12. Bailey, *Art on the Jesuit Missions,* 23–31.

13. This is especially true about religious architecture at the time of the Contact because, as Richard Krautheimer has pointed out for the Middle Ages, the content or significance of architecture seems to have been one of the more important problems of architectural theory, and "perhaps it was its most important problem." See Krautheimer, "Introduction to an Iconography."

14. "Flower and song," *in xochitl in cuicatl,* is a Náhuatl phrase for poetry, metaphor, and symbol that sums up the Nahua religious world, values, and cult.

15. Klor de Alva, "Christianity and the Aztecs." On Aztec piety, see Brundage, *The Fifth Sun,* 220–22.

16. Klor de Alva, "Christianity and the Aztecs"; Klein, "The Ideology of Autosacrifice."

17. Burkhart, "The Solar Christ."

18. Miller and Taube, *Gods and Symbols,* 93–96, 164–65. Like Christian saints, the gods of ancient Mezoamerica were identifiable by the attributes they held in their hands.

19. Fray Bernardino de Sahagún as quoted in Baldwin, *Legends of the Plumed Serpent,* 118.

20. Carrasco, *Quetzalcóatl,* 191–204; and Colston, "No Longer Will There Be a Mexico." In some later stories Quetzalcóatl is a white man who would return from the east as the Morning Star. The Easter *Exultet* hymn also speaks of an eastern advent of Christ, the Morning Star.

21. Baldwin, *Legends of the Plumed Serpent,* 120; Gliozzi, "Apostles in the New World." This far region of St. Thomas's ministry had been visualized centuries earlier in maps accompanying the *Commentary on the Apocalypse* of Beatus of Liébana; see *A Spanish Apocalypse,* fols. 33v and 34r.

22. This god-impersonator on a scaffold was carved into the atrial cross at Topiltec (Oaxaca, my fig. 5.32). See Callaway, "Pre-Columbian and Colonial Mexican Images."

23. The literature on this topic is summarized in Poole, *Our Lady of Guadalupe.*

24. Townsend, *State and Cosmos,* 71.

25. Wagner, "Open Space," 46–57. For the "quincunx mania" of the Christian Middle Ages, see Pajares-Ayuela, *Cosmatesque Ornament,* 217–46.

26. Tibón, *El ombligo,* 200–51.

27. Graulich, "Afterlife in Ancient Mexican Thought," 181, suggests that the Aztecs had a sense of corporate death and forgiveness similar to St. Paul's notion that, in Christ, all have corporately died and been reborn. Also see Read, "The Fleeting Moment"; Burkhart, *The Slippery Earth.*

28. León-Portilla, *Los Franciscanos,* 38.

29. Klor de Alva, "Christianity and the Aztecs." Also see Carrasco, "The Sacrifice of Tezcatlipoca."

30. Menéndez y Pelayo, *Historia de los heterodoxos españoles,* vol. 3.

31. Christian, *Local Religion;* Clendinnen, "Ways to the Sacred."

32. Klor de Alva, "Christianity and the Aztecs," 12–18.

33. For folk Catholicism, see, e.g., Ingham, *Mary, Michael, and Lucifer,* esp. 180–93. For the liturgical origins of folk Catholicism in Latin America, see Lara, "The Liturgical Roots."

34. Todorov, *The Conquest of America;* and O'Gorman, *The Invention of America.*

35. Ricard, *Spiritual Conquest,* 189.

36. Clendennin, "Ways to the Sacred." As we shall see in chap. 6, the Spaniards treated the sculpted image of the dead Christ on Good Friday in ways similar to the Aztec treatment of the impersonator ("living image") of the god Tezcatlipoca who was to be sacrificed. See Carrasco, "The Sacrifice of Tezcatlipoca."

37. Eire, *War against the Idols,* esp. 5.

38. Nutini and Bell, *Ritual Kinship,* 1:291.

39. Restall, "Interculturation." Geertz, *Interpretation of Cultures,* 127, defines a people's ethos as "the tone, character, and quality of life, its moral and aesthetic style and mood; it is the underlying attitude toward themselves and their world that life reflects."

40. Lockhart, "Some Nahua Concepts," 467.

41. Compare the use of intercultural "slippage" in Bhabha, *The Location of Culture.*

42. For example, Lockhart, "Some Nahua Concepts," 476, speaks of the Spanish political overlay on the indigenous *alteptl* community structure.

43. See Vidal, "Towards an Understanding," 73.

44. See esp. the works of Louise Burkhart; and Ingham, *Mary, Michael, and Lucifer,* 185–89.

45. Lakoff and Johnson, *Metaphors We Live By,* 3; and Avis, *God and the Creative Imagination,* 93–102.

46. Connerton, *How Societies Remember,* 68.

47. For Mexica use of solar imagery, see Umberger, "Events Commemorated by Date Plaques."

48. This is also a Christian liturgical expression (from Ps. 113:3); see Justin Martyr's "Dialogue with Trypho," quoted in Jasper and Cuming, *Prayers of the Eucharist,* 27.

49. Lakoff and Johnson, *Metaphors*, 14ff.; Connerton, *How Societies Remember*, 37: "No collective memory can exist without reference to a socially specific spatial reference."

50. Read, "The Fleeting Moment," 113, 131–32.

51. Jacobson, *Treasures of Darkness*, 3.

52. Pepper, *World Hypotheses*, 84–114.

53. Jacobson, *Treasures of Darkness*, 4.

54. Geertz, *Interpretation of Cultures*, 208–20; and D. K. Mumby, *Communication and Power in Organizations*.

55. See, e.g., Dibble, "Náhuatlization of Christianity."

56. Jacobson, *Treasures of Darkness*, 3–21; Kavanagh, "Seeing Liturgically"; and Clendennin, "Ways to the Sacred," 137 n. 137.

57. See Barajau, *El mito mexicano*, 153–61.

58. On the power of metaphor, esp. visual metaphors, in Nahua society, see Heyden, "Metaphors." On the metaphoric power of Aztec myths, see Carrasco, "The Sacrifice of Tezcatlipoca." On Nahua floral metaphors, see Burkhart, "Flowery Heaven," and "The Amanuenses."

59. On sacrifice as energy redirected from destruction, see Duverger, "The Meaning of Sacrifice."

60. Burkhart, "Flowery Heaven," 94; Burkhart, "A Doctrine for Dancing"; and the collection of essays in Gossen, *Symbol and Meaning*.

61. E.g., *The Fifth Sun*, 37, 222. On the metaphoric quality of Nahua language and art, see Alcina Franch, "Lenguaje metafórico."

62. This, of course, was not entirely alien to the Mexica, because the sun's sustenance was the blood of human bodies.

63. Kavanagh, "Seeing Liturgically," 255–58. The fact that this individual and corporate body was associated visually with a cruciform human figure made the cross a primary or root metaphor, and also a synecdoche for the body of Christ. The Nahua concept of the body was significantly different; see Arnold, *Eating Landscape*, 53–64.

64. Klor de Alva, "Religious Rationalization." I disagree with his conclusions. Also see López Austin, *The Human Body and Ideology*, 1:385–406.

65. Valadés, *Rhetorica Christiana*, 208–9.

66. *The First Catechetical Instruction* (De catechizandis rudibus), 32–34. The earliest printed edition is in a collection of Augustine's works from Basel, 1506. The collections were required in mendicant houses and are still well represented in colonial Mexican libraries.

67. The metaphor list, collected between 1533 and 1539, is the nucleus of Fray Andrés de Olmos's *Arte para aprender la lengua mexicana* (1547). See Maxwell and Hanson, *Of the Manners of Speaking*, esp. 1–29.

68. I am using "symbol" in the broad sense of any physical, social, or cultural act or object that serves as the vehicle for a conception. On symbolism in general, see Langer, *Philosophy in a New Key*, 60–66.

69. Ricard, *Spiritual Conquest*, 284–88.

70. Mendieta, *Historia eclesiástica*, 226–30; Morales, "Franciscanos ante las religiones indígenas."

71. 1 Kings 18, later used by Fray Toribio de Motolinía in his *Memoriales*, 188. Also see Zeph. 2:11, which was used by Christopher Columbus.

72. Carrasco, *Daily Life*, 141. On the Aztec conquest of neighboring peoples, see Padden, *The Hummingbird and the Hawk*.

73. This was not a case of Aztec iconoclasm per se. Clendennin, "Ways to the Sacred," 126.

74. Clendinnen, "Ways to the Sacred," 134, and n. 27.

75. Lockhart, "Some Nahua Concepts," 477, calls this process of cross-identification and transference "Double Mistaken Identity"; each side of the cultural exchange presumes that a given form or concept is operating in the way familiar to its own tradition.

76. "What was the religion of the Mexicans but a Christianity confused by time and the equivocal nature of the hieroglyphs." Servando Teresa de Mier, OP, as quoted in Graziano, *The Millennial New World*, 184.

77. See, e.g., the similarities to Catholicism mentioned by Durán, *Book of the Gods*, 100–111.

78. López Austin, *The Human Body*, 1:306.

79. Durán, *The History of the Indies*, 192. Also Weckmann, *La herencia medieval*, 1:234–35.

80. For pre-Hispanic religious practices and the St. Thomas myth, see Lafaye, *Mesías, cruzadas, utopias*, 57–64; Lafaye, *Quetzalcótl and Guadalupe*, 149–206. For modern scientific studies of Aztec rituals, see Clendinnen, *Aztecs*, 236–66; Broda et al., eds., *The Great Temple of Tenochtitlan*; Carrasco, *Religions of Mesoamerica*, esp. 153ff.; Burkhart, *The Slippery Earth*; Lockhart, *The Nahuas after the Conquest*. On anthropophagia as communion, see López Austin, *The Human Body*, 1:382. Fray Diego Durán, *Book of the Gods*, 107, recognized that the extraction and offering of the heart was similar to the elevation of the consecrated host in the Mass.

81. See Lockhart, "Some Nahua Concepts"; Lopez-Portilla, *Los Franciscanos*, 38.

82. Boone, *Stories in Red and Black*, 21. The Nahua-Christian chronicler Domingo de San Antón Muñón Chimalpahin Quauhtlehuanitzin uses the same expression, *in tlilli in tlapalli*, for the Hebrew prophets of the Old Testament. See his *Codex Chimalpahim*, 2:153.

83. E.g., Fray Pedro de Gante's 1553 *Doctrina cristiana en lengua mexicana* was printed in red and black. The *Liber Sacerdotalis* will be discussed in chap. 6. It seems no coincidence that some of the conventual murals were painted in black griselle with red details, among

them those of the "wise" scholars and theologians in the stairwell at Actopan.

84. See Burkhart, "Flowery Heaven"; and Peterson, *Paradise Garden Murals.*

85. Nutini and Bell, *Ritual Kinship,* 1:288–304. One can only speculate how unsuccessful the conversion would have been had Christianity not come with Spanish Catholics but rather with aniconic, antiritualistic Puritans.

86. Nutini and Bell, *Ritual Kinship,* 1:291, define syncretism as equivalent to religious acculturation and the creation of hybridity. "When two religious systems meet . . . the resultant religious system is different from the two original interacting systems because of mutual, albeit often unequal, borrowings and lendings, which are internalized and interpreted in a process of action and reaction." Graziano, *Millennial New World,* 95, prefers the term "selective synthesis." Vidal, "Towards an Understanding," 72–73, defines "synthesization" as a form of religious meshing that does not contaminate the orthodox content of the faith. Also see Lara, "Precious Green Jade Water." For the successful Christian adaptation of native symbols, see León-Portilla, *Los Franciscanos,* 59–61.

87. Phelan, *Millennial Kingdom,* 86–91.

88. See Bailey, *Art on the Jesuit Missions,* 35–39. On destruction and reuse of pagan buildings in the early Middle Ages, see Muldoon, *Varieties of Religious Conversion,* 56–78.

89. Pope Gregory the Great, "Letter to Augustine," in the Venerable Bede, *Ecclesiastical History of the English Nation,* quoted in Norman Thomas, ed., *Readings in World Mission,* 22, emphasis mine. The writings of Gregory and Bede abound in colonial Mexican libraries.

90. Krautheimer, *Rome,* 72.

91. It is no longer extant. See "El Castillo de Chapultepec." The church was used, as at Rome, as a stational church for the procession of the Assumption of the Virgin on August 15. See Mendieta, *Historia eclestiática,* 437. On Mexico City as a second Rome, see Baumgartner, *Mission und Liturgie,* 1:87–91.

92. They would have read of Boniface in printed hagiographical collections. See Murphy, *The Saxon Savior,* and *The Heliand.*

93. See Reeves, *Influence of Prophecy;* and Tanner, *Last Descendant of Aeneas,* 82–86.

94. Dawson, *The Mongol Mission;* and Rubruck, *The Mission of Friar William of Rubruck.*

95. For the archeological data regarding similar reuse in early medieval Europe, see Fletcher, *The Conversion of Europe;* and in reconquest Spain, Remensnyder, "The Colonization of Sacred Architecture."

96. As quoted in Ricard, *Spiritual Conquest,* 107.

97. I shall return to the symbolic significance of the Nahua pedestal or *momoxtli* in chap. 5.

98. Together with Chupungco, *Cultural Adaptation of the Liturgy,* 13–31, I prefer the word *inculturation* to *acculturation* or *transculturation.*

99. Clendinnen, "Ways to the Sacred," esp. n. 26.

100. Bailey, *Art on the Jesuit Missions,* esp. 3–43, 183–98. Pointer, "The Sounds of Worship," goes so far as to call this a "fellowship" between Indians and friars, the latter receiving spiritual sustenance from the natives who acted as their surrogate brothers.

101. Klor de Alva, "Christianity and the Aztecs," believes that Christianization was more successful among the mestizos.

102. Two notable exceptions were Fray Toribio de Motolonía and Fray Andrés de Olmos.

103. See Prosperi, "New Heaven and New Earth"; and Arnold, *Eating Landscape,* 179–231, esp. 226.

104. Lockhart, *The Nahuas after the Conquest.* See also Nutini and Bell, *Ritual Kinship,* 1:299.

105. Clendennin, "Ways to the Sacred," 111.

106. Lockhart, *The Nahuas after the Conquest,* 203–61; Bailey, *Art on the Jesuit Missions,* 21–22.

107. E.g., the Franciscan Church of Nuestra Señora de los Remedios at Cholula sits on top of the largest pyramid in Mexico, while the Augustinian evangelization complex at Yanhuitlán stands on a pre-Hispanic ceremonial platform covering 24,000 square meters.

108. Burkhart, "The Amanuenses," 340; see also Burkhart, "Flowery Heaven," 89.

109. Burkhart, *The Slippery Earth,* 185–88; Burkhart, "Solar Christ," 253; and Bailey, *Art on the Jesuit Missions,* 22–23.

110. Burkhart, *Before Guadalupe,* 4.

111. See Kubler, *Mexican Architecture.* I have used the annotated Spanish edition. (Kubler, who followed the formalist school of art history, was totally unconcerned with liturgy.) See also McAndrew, *Open-Air Churches.*

1. THE ARCHITECTURE OF CONVERSION

1. McAndrew, *Open-Air Churches,* vii.

2. A generic model was first suggested by Mullen, *Dominican Architecture,* 125. Bailey, *Art on the Jesuit Missions,* 30–31, reminds us that copying was an all-pervasive technique in the making of colonial art. "Even buildings usually followed, to greater or lesser degree, models in printed architectural treatise . . . which were known from

the earliest period in missions throughout Asia and the Americas. It was these shared sources which gave them their remarkable unity."

3. The earliest reference to the mendicants' *corral* is, significantly, by Fray Pedro de Gante in a letter to Charles V dated 31 October 1532.

4. Bango Torviso, "Atrio y portico."

5. In medieval Spain the word *agnile*, a sheep pen, was used for the sheltered place of penitents and catechumens. See Férotin, ed., *Le liber ordinum mozarabicus*, 218. It no doubt influenced the use of the word *corral*. Friars Martín de Valencia and Toribio Motolinía use *corral* in the sense of a metaphorical sheep pen in correspondence with Charles V, reminding him that God desires one flock and one shepherd; such language was often associated with the Last World Emperor myth. See García Icazbalceta, "Carta de Fray Martín de Valencia y Fray Toribio Motolinía al Emperador," in *Colección de documentos*, 2:157.

6. Bede the Venerable, *On the Temple*, 75.

7. Mandujano, *La Catedral de Morelia*, 18 and fig. 1.

8. Chanfón Olmos, "Antecedentes." The word *atrium* does not appear in the mendicant chronicles until those of the Dominicans Fernando Ojea (1604) and Antonio de Remesal (1613–19).

9. Krautheimer, *Early Christian and Byzantine Architecture*; and Stapleford, "Constantinian Politics." For the association in the New World, see Román, *Repúblicas del mundo*, 1:4.

10. Sartor, *Arquitectura y urbanismo*, 135–45; Gómez Martínez, *Fortalezas mendicantes*, 100–105.

11. Hubert, "La place faite." The *galilee* was also a medieval theatrical term for a stage set located at the west end of the corral. See Chambers, *The Medieval Stage*, 2:83–84.

12. Secondary atria most often appear to the north of the church and give an L-shape to the walled area around the compound. Kubler, *Arquitectura mexicana*, 362–67.

13. Valadés, *Rhetorica Christiana*, 477: "In the enclosed areas delicious fountains of water are found in which the children wash, because before all else, they are taught the rules of cleanliness." On the medieval monastic cloister as a wash place, see Meyvaert, "The Medieval Monastic Claustrum."

14. Kubler, *Arquitectura mexicana*, 361; and Dougherty, *The Fivesquare City*, 49. In medieval exegesis, such as Gregory the Great's reading of Ezekiel's mystical vision of the New Jerusalem, each of the three entrances corresponds to one of the theological virtues: faith (west), hope (south), charity (north). The three portals were first depicted as architecture in Richard of St. Victor, *Vision of Ezekiel*, written in the twelfth century and printed in 1518. Copies are extant in Mexican colonial libraries.

15. The raised patios were likely reminiscent of the *teocalli* pyramids, while the sunken patios appear to mirror the Aztec ball courts.

16. Palm, "Los pórticos," and "Para enforcar." Palm sees in the Mexican gateways an imitation of those in the temple precincts at Jerusalem as visualized by late medieval illustrators.

17. Durandus, *Rationale divinorum officiorum*, 19.

18. Morales, "Franciscanos ante las religiones indígenas," 93.

19. Chanfón Olmos, "Antecedentes."

20. Canedo, *Evangelización y conquista*, 197 n. 83. The Franciscan Francisco de Mena, who spent three years in Mexico, commented on the claustrophobia and *mal parfume* of the natives, recommending that churches not be built for them. "And in the future churches should not be made for the Indians because their custom and physical condition do not suffer them to be indoors, because they suffocate and sweat, and the stench is so bad that neither they nor the ministers can bear it." Quoted by Montes Bardo, *Arte y espiritualidad*, 156.

21. Artigas, *Capillas abiertas aisladas*; Chanfón Olmos, "Antecedentes"; Chanfón Olmos, "Los conventos mendicantes."

22. Valadés, *Rhetorica Christiana*, 475–76.

23. Chanfón Olmos is, to my knowledge, the only one who upholds a theory of literal representation.

24. The natives performed autoflagellation in the patio, and before the construction of Third Order chapels the patio was where the lay orders and confraternities met. Mendieta, *Historia eclesiástica*, 429.

25. Bonet Correa, "La ciudad hispanoamericana," esp. 42. For the ritual and archetypal meanings of propylaea, portals, and threshold gateways, see Grimes, *Reading, Writing, and Ritualizing*, 67–70.

26. McAndrew, *Open-Air Churches*, 340–52.

27. Valadés, *Rhetorica Christiana*, 477: "In each hamlet that surrounds the town there exists a little chapel [*aedicula*] designated for public prayer where the Indians go on major feast days, like Corpus Christi."

28. As at Santa María Xoxoteco, Hidalgo. See Artigas, *Capillas abiertas aisladas*, 220–47.

29. Buschiazzo, *Estudios de arquitectura*, 23–31.

30. Kubler, *Arquitectura mexicana*, 377–79; McAndrew, *Open-Air Churches*, 237, 368–417. Chanfón Olmos disagrees with the mosque exemplar; see his "Antecedentes," 5.

31. Valadés, *Rhetorica Christiana*, 481.

32. Hall, "The *Tramezzo* in Santa Croce."

33. Kubler, *Arquitectura mexicana*, 370–83; Buschiazzo, *Estudios de arquitectura*, 27. The chapels at Cuernavaca, Tochimilco, and Tlalmanalco had pulpits mounted outdoors. McAndrew, *Open-Air Churches*, 457.

34. Chanfón Olmos, "Los conventos mendicantes."

35. Sahagún, *Florentine Codex*, book 11, fol. 243; and Basich Leija, *Guía para el uso del Códice Florentino*, 241. Here *totecuio ichan* is translated as "hermitage," a place where one prays. Cf. *Codex en Cruz*, 2: fols. 59 and 70, where they are labeled "domus emperrato."

36. Kubler, *Arquitectura mexicana*, 453; also E. Baldwin Smith, *The Dome*, 5, 7, 61, 71. Alternative spelling *kalybe*.

37. In the later medieval period, Mass was allowed outdoors only by exception: on the battlefield, at a public execution, or at a miraculous site before the erection of a permanent building.

38. An unroofed basilica has been excavated in fifth-century Dalmacia; see Dyggve, *History of Salonitan Christianity*. Another was in sixth-century Palestine; see André Grabar, *Martyrium*, 1:69–70.

39. Silvio Broseghini, "Historia y métodos en la evangelización en América Latina"; Focher, *Itinerarium Catholicum*; Escobar, *Americana Thebaida*, 82–84; Baumgartner, *Mission und Liturgie*, 1:144 ff.

40. Krautheimer et al., *Corpus Basilicarum*, 1:134, 162–63. Santa Croce-in-Gerusalemme had as its patrons Ferdinand and Isabella of Spain, and it was under the protection of the Spanish cardinal Bernardino Carvajal, patriarch of Jerusalem, who had intentions of reforming the Church in an eschatological vein. It also had important connections to the reformed Franciscans. See Minnich, "The Role of Prophecy."

41. The bishop was speaking of the basilica of Tyre in Asia Minor. Krautheimer, *Corpus Basilicarum*, 1:134. Catechumens were normally relegated to areas such as the *galilee*, or to the side aisles behind curtains, or outdoors under a covered portico. They shared these areas with those doing public penance and with the *ergumens*, that is, those prone to dementia or seizures.

42. McAndrew, *Open-Air Churches*, 598–617; Mullen, *Architecture and Its Sculpture*, 66–71.

43. I speculate that its ideological prototype was the Spanish "royal chapel" of Santa Croce, Rome.

44. Within the church there was a cemetery or garden, not unlike the Mexican patios. Palm, "Las capillas abiertas."

45. Lampérez y Romea, *Historia de la arquitectura*, 1:240. This is another example of the *agnile*, the metaphorical sheep pen or corral.

46. Palm, "Las capillas abiertas," 54.

47. Conant, *Carolingian and Romanesque Architecture*, 185–208; Conant, *Cluny*, 100, plate 42, figs. 78, 79.

48. Lawerence, *Medieval Monasticism*, 109.

49. Bonet Correa, "La ciudad hispanoamericana," 273; Buschiazzo, *Estudios de arquitectura*, 29.

50. Palm, "Las capillas abiertas," 52.

51. Castelao, *As cruces de pedra na Galiza*, 117. Estrada de Gerlero, "Sentido político," 632, states that outdoor worship exercised a notable influence on the religious architecture of certain parts of Europe where St. Vincent Ferrer left his mark, above all in Galicia and Brittany, where there still remain *humilladeros* (stational crosses bearing the *arma Christi*) and architectural elements clearly designed for worship outdoors. For the influence of the teaching of Ferrer in Mexico, see Baudot, *Utopía e historia*, 238. These outdoor altars or pulpits are seen depicted in paintings, for example, Sano di Pietro's *Appearance of San Bernardino in Piazza del Campo* (Siena). See Mode, "San Bernardino in Glory."

52. The altar was visible to those congregated below through a triple archway decorated with twisted Solomonic columns. As a palatine church or royal chapel, it had Solomonic connotations. Fontaine, *El Prerrománico*, 338.

53. Ousterhout, "Rebuilding the Temple."

54. In Spain, the jubé is called the *trascoro*. Altars on high, whether in a tower as at St. Gall or in a cathedral triforium as at Santiago de Compostela, were dedicated to St. Michael or another archangel, or to the Virgin under some eschatological title like the "Assumption" or the "Immaculate Conception." Braun, *Der christliche Altar*, 1:401–6; Bond and Camm, *Roodscreens*; and s.v. "Coro," *Enciclopedia de la Religión Católica* (Barcelona: Dalmau y Jover, 1950–56). For altars in towers, see Horn and Born, *The Plan of St. Gall*, 1:129–31. For altars in triforia, see Klukas, "Altaria Superiora"; and Moralejo, "Le lieu saint."

55. Palm, "Las capillas abiertas," 53–54; also see Kantorowicz, *Laudes Regia*, 59; Kipling, *Enter the King*.

56. Aachen was built "according to the exemplum of the most wise Solomon" as per the *De Gestis Caroli Magni* (*PL* 98:1387). Like Aachen, Solomon's Temple had been the royal chapel or palatine church of the state religion. See Parrot, *The Temple of Jerusalem*, 55. For Old St. Peter's Basilica, see Alfarano, *De Basilicae Vaticanae*.

57. Westfall, *In This Most Perfect Paradise*, 152–56. The reference is to the fifteenth-century loggia of Nicholas V's palace.

58. Garcia, *El ocaso del Emperador*, 89.

59. Konigson, *L'espace théâtral*, 240–44, 269. I shall return to this in chap. 6.

60. Granada had such an Islamic oratory until 1492. Balbás, "Musalla y saria."

61. *Nuevos cristianos* was a generic term for Jews and Muslims who converted to Christianity rather than face exile or death.

62. Such was the case in Baeza, where in 1530 a freestanding chapel was built to commemorate the first Mass, which had been celebrated decades earlier during the time of the Reconquest. Bonet Correa, "La ciudad hispanoamericana," 270–71.

63. E.g., in the atrium of the Escorial palace monastery of Philip II, which was associated with Jerusalem because of its open-air altar between monumental statues of the Old Testament kings David and Solomon. See Taylor, "Architecture and Magic"; and Tanner, *Last Descendant of Aeneas,* 162–82.

64. In Florence, the Church of Or San Michele was originally a grain market with an outdoor altar. Sunday Mass was celebrated outdoors in these chapels. Bonet Correa, "La ciudad hispanoamericana," 277 n. 15. The topic of outdoor chapels in Spain has been documented by Palomero Páramo, "Antecedentes andaluces."

65. In Peru and Bolivia, the open chapel consists of a balcony that spans the full width of the church façade and overlooks the market. See Bernales Ballesteros, "Capillas abiertas." Other chapels were located directly behind the high altar at the east end and opened eastward onto a courtyard for the exposition of the eucharistic host in its monstrance. See Lara, "The Sacramented Sun."

66. Bonet Correa, "La ciudad hispanoamericana," 277.

67. See Bayle, *El culto del Santísimo,* 614. According to 1 Kings 7:7, Solomon built a "vestibule of the throne where he gave judgment." As we shall see in chap. 4, this was later conflated with two other temple buildings: the Hall of the Forest of Lebanon and Solomon's Portico.

68. Valadés, *Rhetorica Christiana,* 481. The use of the posas as classrooms corresponds to the medieval use of the cloister corners. See Meyvaert, "The Medieval Monastic Claustrum," 54; McAndrew, *Open-Air Churches,* 279–334.

69. Zumárraga, *Compendio breve.* This work was based on the fifteenth-century work of Dionysius the Carthusian.

70. For posas in the religious architecture of the southwest United States, see Kubler, *Religious Architecture,* 74. For Guatemala, see Flores Guerrero, *Las capillas posas,* 27. For Colombia, see Gil Tovar, "Un arte para la propagacion," 728; Goslinga, "Templos doctrineros neogranadinos," 35; and Salcedo, "Los Pueblos de Indios." For Peru, see Gutiérrez, *Arquitectura del altiplano peruano,* 75. For Bolivia, Peru, and Argentina, see Gisbert and Mesa, *Arquitectura Andina,* 148–91. For Chile, see Guarda, "La liturgia." There are also indications that posas once existed in Brazil. For atria with posas in the Philippines, see Coseteng, *Spanish Churches in the Philippines,* esp. 13–18, plates 58, 138, and figs. 5–7.

71. Schroder Cordero, "El retablo plateresco."

72. Flores Guerrero, *Las capillas posas,* 28–29.

73. Flores Guerrero, *Las capillas posas,* 29. See the colonial plan of Huejutla in McAndrew, *Open-Air Churches,* 289.

74. Harris, *Aztecs, Moors, and Christians,* 14; and Edgerton, *Theaters of Conversion,* 62.

75. Cervantes de Salazar, *Life in the Imperial and Loyal City,* 51, emphasis mine.

76. See n. 70 above, esp. the work of Gisbert and Mesa.

77. Friede, ed., *Documentos inéditos,* doc. 2:236.

78. In Colombia, posas are still called *capillas ardientes* where the dead are waked the night before interment.

79. For exterior models, see Gil Atrio, "¿España, cuna?"; and Filgueira Valverde, *Baldaquinos Gallegos,* 17, 35. An unlikely precedent has been suggested in the corner lavatories of medieval Spanish monasteries by Jesús Palomero Páramo, "Un posible antecedente formal." For interior models, see the Templar Church of San Juan del Duero, Soria. Díaz Díaz, *Iglesia y Claustro.*

80. Will, "La tour funeraire"; E. B. Smith, *The Dome,* esp. 45 ff.; Daneshvari, *Medieval Tomb Towers,* 9–10; Hillenbrand, *Islamic Architecture,* 257–60, 443; Caskey, "The Rufolo Palace," 156–62; Campailla, "The *qubba* of the Rabbato"; and Howard, *Venice and the East,* 45, 233 n. 75, 247.

81. A Franciscan convent in Valladolid, Spain, was remodeled around 1560 with one such balcony that faced the street, also used as a processional posa. Bonet Correa, "La ciudad hispanoamericana," 279.

82. Montes Bardo, *Arte y espiritualidad,* 43.

83. Konigson, *L'espace théâtral,* esp. 236–47, 268–73; and Kernodle, *From Art to Theater;* Kernodle, "Déroulement de la procession," 443–48. Such *mansiones* were also the models for the Via Dolorosa stations on the fifteenth- and sixteenth-century *sacri monti* in Europe, the outdoor reproductions of Jerusalem and its sacred topography. See below, chap. 3; and Ventrone, "I Sacri Monti."

84. See Chanfón Olmos, "Los conventos mendicantes"; and Lara, "Conversion through Theatre."

85. McAndrew, *Open-Air Churches,* 247–54. The adorning of the crosses with flowers mentioned in the epigraph was a common practice in medieval Spain during the month of May. See Gil Atrio, "¿España cuna?," esp. 69.

86. Calderón, "Arquitectura y simbolismo."

87. Christian art and architecture had used the quatrefoil and quincunx figures for centuries, long before contact with Mesoameri-

cans. See Esmeijer, *Divina Quaternitas;* and Pajares-Ayuela, *Cosmatesque Ornament*, 217–44.

88. Zavala, *El trabajo indígena*, 61–83.

89. "At the heart," given that the cathedral was metaphorically conceived of as the body of Christ. See Durandus, *Rationale*, 30–33; and Neagley, "Architecture and the Body of Christ."

90. Braun, *Der christliche Altar*, 1:401–6. As we shall see below, the friars treated the Mexica converts like lay friars, according to the thinking of the eschatological prophet Joachim of Fiore. In Mexico, the natives were admitted into the Third Order of the Franciscans, Dominicans, and Augustinians.

91. Durandus, *Rationale*, 25.

92. Kubler, *Arquitectura mexicana*, 241–316; McAndrew, *Open-Air Churches*, 131–67.

93. Bonde, *Fortress-Churches of Languedoc*, esp. 82, 176.

94. Whitehall, *Spanish Romanesque Architecture*, 13–18; and Bonde, *Fortress-Churches of Languedoc*, 133–34.

95. Kubler, *Arquitectura mexicana*, 243.

96. The church of Montealegre (before 1488) and the Cartuja of Milaflores (1454–88). The latter was finished by Simon of Cologne, the most influential architectural designer during the reign of the Catholic kings. See Cómez, *Arquitectura y feudalismo*, 81; and Lampérez y Romeo, *Historia*, 3:450–51.

97. Wadding, *Annales minorum*, vol. 14, sec. 417, art. 31. For the history of the construction, see Gómez Moreno, "Hacia Lorenzo Vázquez."

98. Gillerman, "S. Fortunato in Todi."

99. Battisti, "Roma apocalittica"; Ettlinger, *The Sistine Chapel;* Groffen, "Friar Sixtus IV."

100. Kühnel, *From the Earthly*, 124–27.

101. Estrada de Gerlero, "Sentido político," 626. For a similar Temple-like tripartite division in medieval architecture, see Bond and Camm, *Roodscreens and Roodlofts*, 23; and Frank and Clark, "Abbot Suger and the Temple." Jacobus de Voragine, *The Golden Legend*, 2:385–95, explains the tripartite division of Christian buildings in Old Testament terms.

102. Estrada de Gerlero, "Sentido político," 627.

103. Kubler, *Arquitectura mexicana*, 269–70.

104. Cahn, "Architecture and Exegesis."

105. Estrada de Gerlero, "Sentido político," 626.

106. Kubler, *Arquitectura mexicana*, 260, and n. 44.

107. Salas Cuesta, *La iglesia y el convento*, 80–83. Motolinía informs us that the men stood on the Gospel (left) side of the patio or church, and the women on the Epistle (right) side. According to Tudella, *El legado de España*, 1:178, in some parts of colonial America the women entered the church through the doors from the plaza, while the men entered through the *porciúncula* door. In that case, as in Jewish practice, the men stood in front and the women behind.

108. Salas Cuesta, *La iglesia y convento*, 80–83. There are European precedents for doorways always open. The north portal, the pilgrim's entrance of the cathedral of Santiago de Compostela, had no doors until the sixteenth century, in imitation of the New Jerusalem, whose city gates are never shut (Rev. 21:25). See *Libri Sancti Jacobi: Codex Calixtinus*, book 1, chap. 17; Vazquez de Parga et al., *Las peregrinaciones*, 1:146 n. 77. The Council of Lima (1551) had to mandate that churches have doors (obviously many did not), and that people were not to sleep in them. See Lima, Ecclesiastical Province, *Concilios Limenses*, 1:81.

109. Motolinía, *Memoriales*, 75–76.

110. Ezek. 44:1–2: "Then the angel brought me back to the outer gate of the sanctuary, facing the east; but it was closed. He said to me: 'This gate is to remain closed; it is not to be opened for anyone to enter it; since the Lord, the God of Israel, has entered it, it shall remain closed.'"

111. The papal Jubilee indulgence at the Portiuncula of Assisi embroiled the Franciscans in problems with the Inquisition. See Zimdars-Swartz, "John of Dorston's Response." The Portiuncula at Assisi was also associated with Sukkoth, the Jewish feast of Tabernacles, and with the Transfiguration. In 1221 the Franciscans held a chapter, a type of camp meeting, at the Portiuncula where they dwelt in "tabernacles" (see Lev. 23:42), and in 1480 Giovanni Bellini painted St. Francis living in a Sukkoth hut.

112. See *Bernard von Breydenbach*, comp. Hugh Davies, 37. For the celebration of the Jubilee year in Mexico, see Valadés, *Rhetorica Christiana*, 431.

113. For the significance of these two figures, see below, chap. 5.

114. Estrada de Gerlero, "Sentido político," 626. See also Ps. 48:13–15: "Walk through Zion, walk all round it; count the number of its towers. Review all its ramparts, examine its turrets." During the rite of the consecration of a church, twelve crosses were painted on its walls; the Franciscan church at Tepeaca, Tlaxcala, still displays the crosses of its sixteenth-century consecration.

115. Kubler, *Arquitectura mexicana*, 284–87.

116. Kubler, *Arquitectura mexicana*, 30–31.

117. Estrada de Gerlero, "Sentido político," 632.

118. See Horn, *The Plan of St. Gall*, vol. 1.

119. Zawisza, "Tradición monástica europea."

120. Kubler, *Arquitectura mexicana*, 135–89. The specifics of the humble design were officially approved in Rome in 1541.

121. Kubler, *Arquitectura mexicana*, 302, 396.

122. See Peterson, "The Garden Frescos of Malinalco," 342; and Phillips, "Processions through Paradise," and "La participación de los indígenas."

123. Sebastián López et al., "Arte iberoamericano."

124. Champeaux and Sterckx, *Introduction au monde des symboles*, 153, 297–333, 365–73. In medieval world maps, Christ's navel is the source from which flow the rivers of Eden. See the *axis mundi* tree-ladder in the Nahua-Christian *Codex Azcatitlan*.

125. Braunfels, *Monasteries of Western Europe*, 65; Dynes, "The Medieval Cloister"; and Ramírez, *Construcciones ilusorias*, 113–214.

126. Folan, *The Open Chapel of Dzibilchaltun*.

127. A *visita* was the chapel of a hamlet that did not have resident clergy.

128. Native Americans, of course, had events that we might term theatrical, and pre-Columbian centers such as Tlaxcala, Cholula, and Tlalteloco seem to have been the most popular sites for dramaturgy. Rojos Garcidueñas, *Autos y coloquios*, x–xii.

129. McAndrew, *Open-Air Churches*, 255–78.

130. Louis Gillet, "L'art dans l'Amérique Latine," as quoted in McAndrew, *Open-Air Churches*, 255.

131. Davies, *The Secular Use of Church Buildings*, 92–95.

132. For possible Near Eastern influences, see Bonde, *Fortress-Churches of Languedoc*, 145–50.

133. Rey, *Les vielles églises*, 89–120; Bonde, *Fortress-Churches of Languedoc*, 1–65.

134. The heresy asserted that matter and corporeality were evil, and denied the divinity of Christ and the validity of the sacraments.

135. Rey, *L'art gothique*, 35–84.

136. Lavedan, *Histoire de l'architecture urbaine*, 290–91. The Knights Templar were also energetic in building fortified churches. Bonde, *Fortress-Churches of Languedoc*, 59.

137. Motolinía, *Memoriales*, 1, 13.

138. McAndrew, *Open-Air Churches*, 262–65.

139. Records show that at the beginning of the evangelization each compound had an average of two or three unarmed friars, certainly not a number capable of defending such a large complex. Kubler, *Arquitectura mexicana*, 33–38, 313–15. The arguments are summarized in Gómez Martínez, *Fortalezas mendicates*, 15–24.

140. Kubler and McAndrew are proponents of this theory.

141. Chanfón Olmos, "Los conventos mendicantes," esp. 16.

142. McAndrew, *Open-Air Churches*, 267–71.

143. Kubler, *Arquitectura mexicana*, 312–16. On crenellations and merlons as symbolic decorations, see Porada, "Battlements in Military Architecture"; on the use in medieval friaries and cathedrals, see Coulson, "Hierarchism in Conventual Crenellation"; and Zawisza, "Tradición monástica europea," 120–22.

144. Gómez Martínez, *Fortalezas mendicates*, 24, 63.

145. Estrada de Gerlero, "Sentido político," 637–38. In 1513 the Dominican friar Isidore Isolani composed a treatise on the discovery and evangelization of the Indies in a military-eschatological vein, *In hoc volumine hic continentur* (published 1516 in Milan), with innumerable references to an approaching messianic era that will see a re-built and walled Jerusalem with ramparts and fortresses. The pagan nations will stream to its open gates (cf. Isa. 25:12 ff).

146. Bredero, "Jérusalem dans l'Occident medieval." I will address Columbus and Jerusalem in the next chapter.

147. See below, chap. 4. On fortress imagery, see Pss. 31 and 46 among others, and Isa. 25.

148. Dougherty, *The Fivesquare City*, 6.

149. Bernard of Clairvaux, "Sermo de diversis," in Catholic Church, *Liturgy of the Hours*, 4:230–31.

150. Montes Bardo, *Arte y espiritualidad*, 33–57; the mendicants never call themselves monks, only friars or religious.

151. Phillips, "La participación de los indígenas." Lopez-Portilla, *Los Franciscanos*, 55. Indians who belonged to the Third Order would wear the Franciscan habit at certain times and have the privilege of being buried in it. Many requested this in their last will and testament.

152. Incunabula like Augustine's *City of God* and Dionysius the Carthusian's *De vita militari*, both of which are found in Mexican colonial libraries today, are typical of publications on the theme of spiritual warfare.

153. I am here referring to Joachim of Fiore's *Commentary on the Apocalypse*, Nicholas of Lyra's *Notes on the Whole Bible*, Bernard of Breydenbach's *Pilgrimage to the Holy Land*, Hartmann Schedel's *Chronicle of the World*, Alberto Castellani's *Liber Sacerdotalis*, and William Durandus's *Rationale*, all of which are likewise found in Mexican libraries with colonial holdings.

154. While the writing of this book was in progress, there appeared Miguel Angel Fernández, *La Jerusalén indiana*, a popular photo album of Mexican colonial architecture using eschatological themes.

For some strange reason, it copies almost identically a rough draft of my work, which I circulated in 1990 among a few Latin America scholars.

2. THE VISUAL IMAGINATION AND
THE END OF HISTORY

1. "Eschatology," *NCE* 5:524–38. In the collective sense of the word, *eschatological* refers to any belief in a climactic, God-wrought conclusion to history in which the good are rewarded and the evil suffer.

2. I am here following the definitions of Landes, "Fear of an Apocalyptic Year."

3. Russell, *Between the Testaments*, 95–96.

4. E.g., by Tertullian, Augustine, etc., as quoted below in chap. 3.

5. Zavala, *Ideario de Vasco de Quiroga*, 43. Thomas More read the description of the New World by Amerigo Vespucci, but the concept of a golden age that informs his work was recorded early in antiquity. Graziano, *Millennial New World*, 10.

6. The major prophets are Isaiah, Jeremiah, Ezekiel, and Hosea. Baruch, Daniel, Joel, Amos, Obadiah, Jonah, Micah, Nahum, Habakkuk, Zephaniah, Haggai, Zechariah, and Malachi are considered minor prophets.

7. The nonbiblical readings in the Divine Office, those taken from the church fathers, emphasized the future fulfillment of the prophecies.

8. The seven ages of the world find their origin in the seven days of creation of Genesis 1. The tripartite division first appears in the first book of Enoch (second century BCE), while a specifically Trinitarian scheme of world history is attributed to the twelfth-century abbot Joachim of Fiore. The two divisions, of either seven or three ages, could be used simultaneously. See below.

9. Eliade, "Paradise and Utopia."

10. On the recovery of Mount Zion by the faithful, see, e.g., Pss. 2:6–8, 48:1–2, 50:1–2, 79:1, 102:13, 122:1–2. For the place of Jerusalem in Hebrew eschatology, see Kühnel, *From the Earthly*, 17–48; and Sacchi, *Storia dell' apocalittica giudaica*. For the rebuilding of the Temple, see the minor prophets like Zechariah 6.

11. The so-called peaceable kingdom; see Isa. 11:6–9.

12. For the Old Testament notion of salvation as open space, see Brinkman, *The Perception of Space*; and R. Cohn, *The Shape of Sacred Space*.

13. On the final conquest and conversion of pagans (as in Mexico), see Pss. 18:43–44, 22:27–28, 46:10, 57:9–11, 67:3–4, 72:10–11, 86:8–10, 96:1, 106:47, 115:1–6.

14. For the "vision of peace," see the medieval hymn "Urbs Beata Jerusalem" below.

15. They were *history*, the literal meaning of the reality, together with three senses that gave it deeper spiritual meaning. The second sense, the *allegorical*, signified the fulfillment in the New Testament antitype; it was an explanation in terms of Christ, the Church, or the sacraments. The third or *moral* sense, provided an ethical meaning, applied to humans and the salvation of the soul; while the fourth sense, the *anagogical*, provided an eschatological explanation that elevated the thoughts of the exegete or his reader from visible to invisible things and to a higher truth. Esmeijer, *Divina Quaternitas*, 9, quoting Henri de Lubac. For a discussion of the role of this formula in medieval exegesis, see Smalley, *Study of the Bible*, 28.

16. Adolf, *Visio Pacis*, 68–72. This fourfold interpretation of "Jerusalem" is made by Christopher Columbus in his *Libro de las Profecías* (West and King ed.), 101. Also see article "Eschatology," cited n. 1.

17. N. Cohn, *Pursuit of the Millennium*, 15.

18. L. Thompson, "Cult and Eschatology"; Cothenet, *Exégèse et liturgie*, 287–304.

19. For the many New Testament meanings of "Jerusalem," see Kühnel, *From the Earthly*, 49–59.

20. Revelation was first used for Paschaltide readings in Spain in the seventh century when the Fourth Council of Toledo prescribed its liturgical predication under pain of excommunication; see canon 17 in *Concilios visigóticos*, 198. The pericopes avoided the frightening scenes of judgment and punishment and instead celebrated the parts concerning the elect and their doxological worship; see Werckmeister, "The First Romanesque Beatus Manuscripts"; and Meer, *Maiestas Domini*, 82–145, 467–79.

21. Tertullian, *Adversus Marcionem*, 3:24. Another miraculous portent is recorded by Cyril, bishop of Jerusalem: On the morning of May 7, 351, a parhelion (sun spot) in the shape of a cross appeared over Jerusalem, shining for several hours over an area extending from the hill of Golgotha to the Mount of Olives (recounted in Kühnel, *From the Earthly*, 68). We shall see below that a miraculous cross, Golgotha, and the Mount of Olives have apocalyptic connotations linked to the messianic figure of the Last World Emperor.

22. For the People's Crusade, see N. Cohn, *Pursuit of the Millennium*, 63–65.

23. Augustine, *The City of God*, 18:54.

24. *The City of God*, xxxi. Augustine considered the Erythraean sibyl to belong to the heavenly city precisely because she attacked the worship of false gods (see 18:23). For the meaning of "ortho-doxy" as right worship, and its connection to the city of God, see Kavanagh, *On Liturgical Theology*, 3–38.

25. Salvation is also represented in spatial terms as arriving at a harbor (*ad portus*) in a ship or at the fatherland (*ad patria*), or as being on the highway (*in via*). The image of the harbor was used in Augustine's *De Beata Vita*, where the major metaphor is the "land of desire" located on the far side of an allegorical sea. Such images will later lend themselves to the theological reflection on the discovery of the Americas across the Atlantic Ocean. Augustine's "salvation ship" appears in a mural at the convent of Actopan, Hidalgo.

26. *City of God*, 18:48.

27. Quoted in Dougherty, *The Fivesquare City*, 32.

28. For illustrated manuscripts of Augustine's *City of God*, see Laborde, *Les manuscrits à peintures*; and Chastel, "Un épisode de la symbolisme."

29. McGinn, *Visions of the End*, 19. The original pagan sibyls go back to the eighth century BCE. During the Hellenistic period, their fame spread throughout the Mediterranean world, but nowhere were they more popular than in imperial Rome.

30. In its Christian form, the *Tiburtina* dates from the middle of the fourth century. See Prawer, "Jerusalem," 779–80.

31. Donovan, *Liturgical Drama in Medieval Spain*, 160–67, 181–87. "To date no examples of such a custom [of the impersonation of the prophetesses] have been found anywhere outside the Hispanic peninsula" (167).

32. McGinn, *Visions of the End*, 45–50. For example, during the fifth "sun" three kings will arise to carry out many persecutions against the Christians "because of the one who was crucified on the cross." They will build pagan temples and altars, and these blasphemous shrines will be the largest in the inhabited earth.

33. Collins, *The Scepter and the Star*, 39.

34. Tanner, *Last Descendant of Aeneas*.

35. "The Tiburtine Sibyl," translated in McGinn, *Visions of the End*, 49–50. The erection of exorcistic crosses in pagan temples is repeated by Bede the Venerable, *Sibyllinorum Verborum Interpretatio*, esp. 1185. The collected works of Bede were published in Basel in 1563 and are extant in Mexican colonial libraries.

36. The rebuilding of the Temple by Antichrist is mentioned as early as the beginning of the third century by Hippolytus in *The Antichrist*. On this theme, see Bousset, *Antichrist Legend*, 160–63.

37. McGinn, *Visions of the End*, 70–76. It was published in 1498.

38. Alexander, "Byzantium and the Migration of Literary Motifs"; Alexander, "The Diffusion of Byzantine Apocalypses."

39. Reinink, "Pseudo-Methodius."

40. Sackur, *Sibyllinsiche Texte*, 167: "Deposition von Kronen und anderen Insignien am hl. Grabe sint auf einem Boden, aus einem Gedanken erwachsen." In a German play, the Emperor places his crown on the altar of the rebuilt Temple. See Young, *Drama of the Medieval Church*, 2:369–95; and English translation by John Wright, *The Play of Antichrist*. Also see Emmerson, *Antichrist in the Middle Ages*, 168. Craig, *English Religious Drama*, 74, argues that Antichrist dramas grew out of the liturgy for the Advent season.

41. Sackur, *Sibyllinsiche Texte*, 93: "et adsumentur crux in caelum simul cum coronam regis."

42. McGinn, *Visions of the End*, 302 n. 21. The *Pseudo-Methodius* was included in the prophecies of Joachim of Fiore published by the mendicants in Venice. See below.

43. For the legends surrounding the Temple in the Jewish Sibylline literature, see Chester, "The Sibyl and the Temple." A liturgical/allegorical interpretation of Antichrist's coming is offered by Honorius of Augustodunensis, *Gemma anima sive Divinae Officiis*, PL 172:679.

44. For a reevaluation of the temporal extension of the Middle Ages, see Le Goff, *The Medieval Imagination*, 1–23. For the medieval quality of the sixteenth century in the Americas, see Weckmann, *La herencia medieval*; Kearney and Medrano, *Medieval Culture*, esp. 103–36.

45. Augustine quoted her in an acrostic poem in the *City of God*, 18:23.

46. The printing of the Sibylline Oracles preceded that of the Gutenburg Bible; only a single page survives. See *New York Times*, 12 May 1987, p. C1.

47. The sibyls appear in marble inlay on the floor of the cathedral of Siena, and in fresco on the ceiling of the Sistine Chapel. For their presence in Iberian drama, see Donovan, *Liturgical Drama in Medieval Spain*, 162–67, 181–87.

48. In March of 629 CE, Emperor Heraclius restored the cross that had been stolen from Jerusalem by the Persians in 614.

49. Remi du Puys, *La tryumphante entrée*, 24.

50. For example, around 1580–90 in the house of the dean of the cathedral, Puebla, on the presbytery walls of the church at Acolman, in the Portiuncula sculpture at Huaquechula, and in oil paintings that once hung in the Church of Remedios on top of the Cholula *teocalli*. See Sebastián López, *Iconografía e iconología*, 118–28; Gruzinski, *El Agila y la Sibila*; and Arellano Hernández, "Un aspecto del renacimiento."

51. His poems in lyric meters form hymns that were later used in both the Roman and Mozarabic rites. "Prudentius," *NCE* 11:928–29. See also Flanagan, "Apocalypse and Medieval Liturgy."

52. Macklin Smith, *Prudentius' Psychomachia*, 109–67.

53. Flanagan, "Apocalypse and Medieval Liturgy."

54. In the pagan Roman ritual, the *templum* was first the cosmic square inscribed on the ground to bring down upon the featureless earth the harmony of heaven. Dougherty, *The Fivesquare City*, 20–21; Champeaux and Sterckx, *Introduction*, 108–10; Virgilio Vercelloni, *Altante storico*, 11.

55. Dougherty, *The Fivesquare City*, 21.

56. See Baldovin, *Urban Character*, esp. 253–68.

57. Gnilka, *Studien zur Psychomachie des Prudentius*, 83–128.

58. Warman, *La danza de moros y cristianos*, esp. 27, 81.

59. See Woodruff, "Illustrated Manuscripts"; E. Baldwin Smith, *Architectural Symbolism*, 58 and fig. 52; Pressouyre, "St. Bernard to St. Francis"; Norman, *Metamorphoses of an Allegory*, esp. 143–262; O'Reilly, *Studies in the Iconography*, esp. 265–434; Katzenellenbogen, *Allegories of the Virtues and Vices in Medieval Art* (Toronto: University of Toronto Press, 1989); Kinney, "The Apocalypse"; Sebastián López, *Mensaje del arte medieval*, 112–17; and Herz, "Borromini, S. Ivo, and Prudentius."

60. The *Psychomachia* was first printed in Spain in 1495 in a collection dedicated to Queen Isabella. See Bataillon, *Erasmus y España*, 26–27; and Gaston, "Prudentius." Printed editions of 1533 and 1574, and several without date, are found in the Biblioteca Nacional de México.

61. Torquemada recognized this fact and quoted Prudentius in his *Monarquía indiana*, 4:125; also see Cervantes, *The Devil in the New World*.

62. Stierlin, *Le livre de feu*.

63. Fontaine, "Fuentes y tradiciones paleocristianas," 1:77–105. In 1502 Christopher Columbus would compile a similar handbook to interpret the end of the world in his own day; see below.

64. Gil, "Los terrores del año 800"; Landes, "Lest the Millenium be Fulfilled." In book 4 of the Beatus commentary (the exegesis of the sealing of the 144,000 of Rev. 7) Beatus inserted a computation of chronology in which the sixth world age would end in the Spanish era 838 (800 CE), thus potentially within Beatus's own lifetime. *Beati in Apocalypsim*, 367–71:

All the time from Adam to Christ comes to 5227, and from the coming of our Lord Jesus Christ to the present, era 814, is 776 years. Count then from the first man, Adam, to the present era of 814 and you will have 5976 years. Therefore, twenty-five years remain in the sixth millennium. The sixth age will end in the era 838 (800 C.E.). . . . Thus, for all that has been said above, every Catholic ought to ponder, wait and fear, and to consider these twenty-five years [that remain before the end] as if they were no more than an hour, and should weep day and night in sackcloth and ashes for their destruction and the world's, but not strive to calculate time.

65. Neuss, *Apokalypse des hl. Johannes*.

66. J. Williams, "Purpose and Imagery," 226.

67. Stierlin, *Le livre de feu*, 220, suggests that a stimulus for producing the multiple eleventh-century Beatus copies may have been the Islamic destruction of the Holy Sepulcher in 1009. Also see J. Williams, "Purpose and Imagery."

68. And reflective of the circular buildings from Constantine's Jerusalem, or in Carolingian versions. Heitz, *L'architecture religieuse*, 209–22.

69. Heitz, *L'architecture religieuse*, 209–22; and Konigson, *L'espace théâtral*, 79–89.

70. Stookey, "The Gothic Cathedral"; and Bowen, "The Tropology."

71. Ashworth, "Urbs Beata Ierusalem"; see also *NCE* 7:290.

72. This line implies an actualization of the hymn in the here and now, that is, the "jerusalemization" of the particular church edifice; see Kantorowicz, *The King's Two Bodies*, 83.

73. Brittain, *Penguin Book of Latin Verse*, 127–28.

74. The hymn appears in the Office created for the yearly memorial of the conquest of Jerusalem that took place on July 15, 1099. It takes over the notion of *templum*, but always replacing it with the words *sancta civitas Hierusalem*, therefore conflating the two architectural entities, "temple" and "city." See Linder, "The Liturgy of the Liberation of Jerusalem."

75. Wilkinson, *Jerusalem Pilgrims*, 44, notes that John of Würzburg (c. 1170) and Bishop Theoderic of Würzburg (1169–74) both give a list of inscriptions in the Dome, all taken from the Rite for the Dedication of a Church and the hymn "Urbs Beata Jerusalem." See *NCE* 14:488.

76. See, e.g., Adso of Montier-en-Der, *Letter on Antichrist*; and the "Play of Antichrist" in McGinn, *Visions of the End*, 82–87.

77. The Carolingian year began at Christmas. See Landes, "Fear of an Apocalyptic Year," 144.

78. Landes, "Fear of an Apocalyptic Year," 116; Nichols, "Signs of Royal Beauty Bright."

79. Krautheimer, "The Carolingian Revival."

80. Dougherty, *The Fivesquare City*, 44–47.

81. McGinn, *Visions of the End*, 80–81.

82. Tanner, *Last Descendant of Aeneas*, 42–44.

83. Reeves, *Influence of Prophecy*, 359–74.

84. Tanner, *Last Descendant of Aeneas*, 122–30.

85. Landes, "Fear of an Apocalyptic Year."

86. This belief is first articulated by Adso of Fleury around the year 1000. See McGinn, *Visions of the End*, 89–90.

87. Einhard, *Vita Karoli Magni*, 130; Nichols, "Signs of Royal Beauty Bright," 21–23.

88. Nichols, "Signs of Royal Beauty Bright," 43.

89. Landes, "Fear of an Apocalyptic Year," 133.

90. McGinn, *Visions of the End*, 90–93; Landes, "Fear of an Apocalyptic Year."

91. Wilkinson, *Jerusalem Pilgrims*, 78–84.

92. McGinn, *Visions of the End*, 88–89.

93. Adolf, *Visio Pacis*, 60.

94. Ekkehard of Aura, *Jerusalem Journey*, as quoted in McGinn, *Visions of the End*, 92–93:

> After the sign in the sun that had been foretold was seen, many portents appeared in the sky as well as on the earth and excited not a few who were previously indifferent to the Crusade. . . . Not many years before, a priest of venerable life by the name of Siger one day at about three in the afternoon saw two knights charging against each other in the sky and fighting for a long time. The one, who was carrying a good-sized cross with which he struck the other, turned out the victor. . . . Others reported that they saw the likeness of a city in the air and that they beheld various crowds hurrying to it from different places both on horseback and on foot. Some showed the sign of the cross stamped by divine influence on their foreheads or clothes or on some part of their body, and by the mark they believed themselves to be ordained for the army of God.

95. As in the tympanum of the Church of Conques on the pilgrimage route to Compostela.

96. Adolf, *Visio Pacis*, 111.

97. McGinn, *Visions of the End*, 117–21, and notes. Young, *Drama of the Medieval Church*, 2:376.

98. For later versions of the play, see Aichele, *Das Antichristdrama*.

99. When Hugh of St. Victor (d. 1141) explains in *The Mystical Ark of Noah* that the end of the world is approaching because the sequence of events has reached the geographical end of the world, he makes use of maritime architecture to expound the mystery. See Zinn, "Hugh of St. Victor"; also Reeves, *Influence of Prophecy*, 301–2, 320–31.

100. On Joachim as a picture thinker, see Reeves, "The *Liber Figurae*." The literature on Joachim is enormous. The most important bibliographies are found in Grundmann, *Studien über Joachim von Floris*; Grundmann, *Neue Forschungen über Joachim von Floris*; M. Bloomfield, "Joachim of Flora"; Bloomfield, "Recent Scholarship on Joachim"; Reeves, *The Influence of Prophecy*; Reeves, *Joachim of Fiore and the Prophetic Future*; Reeves and Hirsch-Reich, *The Figurae of Joachim of Fiore*; West, ed., *Joachim of Fiore in Christian Thought*; Mottu, *La manifestation de l'esprit*; Lubac, *La posteridad*; West and Zimdars-Schwartz, *Joachim of Fiore*; Saranyana and Zaballa, *Joaquín de Fiore y América*. Some consider Joachim of Fiore to be the inspiration for the "Dies Irae" hymn alluded to in the epigraph above; see "Dies Irae," *NCE* 4:864.

101. Robert Lerner speculated on a Jewish origin for Joachim, based on new evidence, in an address at Columbia University in New York City, 26 October 1996, entitled "Joachim of Fiore's Vision of Irenic Conversion."

102. Mount Etna had erupted in 1163, accompanied by an earthquake and tidal wave. This event was incorporated into the apocalyptic prophecy known as the *Vaticinium Sibillae Erithraeae*. See McGinn, *Visions of the End*, 122–25. In colonial Latin America, Joachim would come to be associated with volcanoes and catastrophic natural phenomena.

103. McGinn, *Visions of the End*, 126. For the text and interpretation of the Sibylline Oracles, see McGinn, "Joachim and the Sybil." According to McGinn, the 1180s were a time of great upheaval in Europe, and many people turned to signs, stars, and sibyls.

104. Richard the Lionhearted had just come from concluding the peace treaty of 1192 with Saladin after the defeat of the Latin Kingdom of Jerusalem by the Muslims. For the political significance of these encounters, see Reeves, *Influence of Prophecy*, 3–15.

105. The order that he founded experienced such an expansion in the following decade that it was hailed by the Fourth Lateran Council in 1215 as one of the four pillars of the Church. Innocent III had opened the council with a homily, based on Ezek. 9:4, in which signing with the Tau became a symbol for spiritual renewal in the Church. Francis of Assisi, thought to have been present at this event (and whose personal signature was the Tau), became the figure of renewal who carried out Innocent's program both literally and spiritually. See below.

106. Wessley, "The Role of the Holy Land."

107. *Liber Concordie Novi ac Veteris Testamenti* (Venice, 1519). Reeves and Hirsch-Reich, *The Figurae of Joachim of Fiore*, 6: "Concord

is not allegory; it is a similitude of proportion between actual historical events which exist in their own right, each in its own dispensation. The concords are inbuilt in their very historical existence by the hand of God."

108. Mottu, *La manifestation de l'esprit*, 101–13.

109. The schema of world history, first explained in the *Book of Concordance*, was later summarized and included in the printed version of his commentary on the Apocalypse (1527). I used the copy in the Biblioteca Nacional de México. It is a compilation of his thought—with tracts on the Sibylline Oracles, Antichrist, and the temporal *status* of the Church—published as *Abbas Joachim magnus propheta . . .* (Venice, 1516).

110. McGinn, "Influence and Importance," 18:

If there is one thing that modern research on Joachim's view of history has shown us, it is that his views on historical periodization are highly complex, a combination of binary, ternary and multiple patterns involving elements of finality, progression and recurrence. . . . The notion of *concordia* involves not just a synoptic attempt to harmonize texts, or to compare a parallel series of events from the Old and New Testaments, but also the working out of the structural conformity or correlation of the two Testaments necessary to understand a coming third stage of history.

111. Joachim divides the three periods differently in different contexts according to the image he is developing at the moment. In general, they conform to (1) Old Testament, (2) New Testament, and (3) The Age of the Holy Spirit, an approaching moment in the thirteenth century, c. 1260, according to his calculations. See Reeves and Hirsch-Reich, *The Figurae of Joachim of Fiore*, 248–55.

112. McGinn, *Apocalyptic Spirituality*, 102–3; A. Thompson, "A Reinterpretation"; West and Zimdars-Swartz, *Joachim of Fiore*, 93.

113. *Expositio in Apocalypsim*, fol. 18v: "Prima Hierusalem edificata est in primo status, secunda in secundo, tertia in tertio." Quoted in Wessley, *Joachim of Fiore*, 74 n. 21. See also fol. 15r: "In tertio quoque sabbato *reedificandum est templum dei*, reedificanda est civitas de lapidibus novis, et hoc a filiis transmigrationis moderne sicut quondam templum illud et civitas a filiis transmigrationis iude" (emphasis mine). Also see McGinn, "Influence and Importance," 19. On the transmigration of the Vatican to a New Jerusalem, and the pope as Temple builder, see Reeves, *Influence of Prophecy*, 396. A mid-fourteenth-century synthesis of Joachite thought, the *Summula seu Breviloquium super Concordia Novi et Veteris Testamenti*, speaks of a Spanish *novus Zorobabel* who would recapture Jerusalem and usher in a "period of silence" during which the Temple would be rebuilt. See West, "Medieval Ideas," 301.

114. See McGinn, "Symbolism." Joachim's many drawings and analyses using flora can be seen as vitalistic renewal in the general sense. See Ladner, "Vegetation Symbolism."

115. West, "A Millenarian Earthly Paradise," discusses the monastic ideal of the twelfth century in which the cloister was a microcosm of paradise.

116. Joachim associates these two orders with Enoch and Elijah, as well as with the two witnesses of Rev. 11:1–14. *Expositio in Apocalypsim*, fols. 175v–176r, on Rev. 14:15–16. See Grundmann, *Neue Forschungen*, 106–7.

117. The Augustinian Observants also saw themselves as the spiritual sons of Joachim. See Reeves, "Joachimist Expectations."

118. Joachim's predecessor and leader of the eleventh-century Gregorian reforms, Peter Damian (d. 1072), also wanted to convert the whole world into a monastery. See his "Totum mundum," 78. Viceroy Mendoza's constant complaint against the mendicants in Mexico was that they wanted to make the whole country into a monastery.

119. West, "A Millenarian Earthly Paradise," 262.

120. McGinn, *Visions of the End*, 111; Seibt, "Liber Figurarum XII."

121. *Psalterium decem chordarum*, fol. 270v.

122. Wessley, "Additional Clues," 299.

123. *Liber Concordiae*, fol. 85v, and esp. Daniel, "Apocalyptic Conversion."

124. Wessley, "Additional Clues," 299.

125. The later Franciscans did likewise. In 1221 they held a chapter, a type of camp meeting, at the Portiuncula, where they dwelt in "tabernacles" (cf. Lev. 23:42). In the 1480s Giovanni Bellini depicted Francis with a Sukkoth hut in the desert. Mount Alverna becomes a Franciscan antitype of Mount Tabor in his painting *San Francesco nel deserto*. See John V. Fleming, *From Bonaventure to Bellini*, 75–98.

126. *Liber concordiae*, fols. 21v, 57v, and 58r. Also see Wessley, "Additional Clues," 294–95.

127. For the Sibylline Oracles, see McGinn, "Joachim and the Sibyl." For Joachim and Merlin, see Lubac, *La posteridad*, 1:15, 78. For the reappearance in the late fifteenth century of prophecies related to Merlin, the Grail legend, and the Grail castle, see *El baladro del sabio Merlín con sus profecías*. The Grail was supposedly a possession of Charlemagne, and the Grail legend later passed into the mythology surrounding the Hapsburg dynasty, especially Charles V of Spain. See Tanner, *Last Descendant of Aeneas*, 207–14. For a possible Joachite origin of the Grail legend, see Reeves, *Influence of Prophecy*, esp. 71–95; and Milhou, *Colón y su mentalidad*.

128. Saint Bonaventure, *Legenda maior*, chap. 9, no. 8.

129. For each of them, the cloister would always be the locale of "choirs of praise" as well as "camps of spiritual combat." Like that of their earlier medieval confreres, their conventual cloister would be an anticipation of the garden of paradise. See Lubac, *La posteridad*, 1:30; and Meyvaert, "The Medieval Monastic Claustrum," 57.

130. McGinn, *Visions of the End*, 203–21.

131. Reeves, *Influence of Prophecy*, 320–22. In the commentary of Friar Alexander of Bremen on Revelation (1242), the Franciscans and Dominicans are the key players of the apocalyptic drama. They are also metaphorically the walls, castles, towers, and gates of the New Jerusalem. See Kleinhaus, "De Commentario."

132. It is evident that some of the friars in New Spain were aware of these attributions; one was Motolinía, *El libro perdido*, 41.

133. Bihel, "S. Franciscus"; da Campagnola, *L'Angelo del sesto sigillo*, 7–48; Fleming, *From Bonaventure to Bellini*, 129–57. On Francis as the initiator of the third state, see Manselli, *La "Lectura Super Apocalypsim,"* 211 n. 1; and da Campagnola, "Dai viri spiritualis."

134. The number 1260 was arrived at by multiplying the biblical number 42 by 30, which is the number of years in a generation. The arithmatic was confirmed for the Joachites in Holy Writ, because the two witnesses "shall prophesy a thousand two hundred sixty days, clothed in sackcloth" (Rev. 11:3), and the woman clothed with the sun will be fed for "a thousand two hundred sixty days" (Rev. 12:6). See Manselli, "L'anno 1260."

135. Bihel, "S. Franciscus," 62–63. Gerardo da Borgo San Donnino applied to Francis's stigmata the term "sign of the living God," which the angel of the sixth seal carries. He also recognized in Francis the other angel who flies to the zenith proclaiming the eternal gospel, as Joachim (so he claimed) had predicted. Cf. Rev. 7:2 and 14:14–17. Nicholas of Lyra, in his *Glossa Ordinaria*, vol. 4, fol. 266v, credits Gerardo, "frater girardus de pruuino ordinis fratrum minorum," with being an important interpreter of the mystical temple of Ezek. 40.

136. Vorreux, "Un symbole franciscan," 74–78; Emmerson and Herzman, *The Apocalyptic Imagination*, 47:

The scriptural resonances of the Tau clarify its special meaning for Francis and its precise apocalyptic association in Bonaventure's prologue. It links two of the most important apocalyptic books of the Bible, Ezekiel and the Apocalypse, by identifying the remnant during both a past and a future time of tribulation. Just as the remnant in the last days are to be marked on the forehead, so the Tau was the saving seal that identified the remnant during the Old Testament time of tribulation connected with the Babylonian captivity.

For a detailed discussion of the Tau sign in Franciscan lore and painting, see Fleming, *From Bonaventure to Bellini*, 99–128.

137. Emmerson and Herzman, *The Apocalyptic Imagination*, 40.

138. Lubac, *La posteridad*, 1:125–37; Emmerson and Herzman, *The Apocalyptic Imagination*, 36–75.

139. Bonaventure, *Legenda maior*, col. 13, Prologue: "And so not without reason is he considered to be symbolized by the angel who ascends from the sunrise bearing the seal of the living God, in the true prophecy of that other friend of the Bridegroom, John the apostle and evangelist. For 'when the sixth seal was opened,' John says in the Apocalypse, 'I saw another Angel, ascending from the rising of the sun, having the seal of the living God.'" The orthodox equation was also made in the papal bull of Leo X, *Ite vos in vineam meam* (1517), for the official recognition of the Observant Reform and the effective suppression of the Conventuals. See Di Fonzo, "La famosa bolla"; and Lubac, *La posteridad*, 1:164. Also see Fleming, *From Bonaventure to Bellini*, 18.

140. *Legenda maior*, 5: "But even more is this confirmed with the irrefutable testimony of truth by the seal of the likeness of the living God, namely of Christ crucified, which was imprinted on his body not by natural forces or human skill but by the wondrous power of the Spirit of the living God." Francis received the stigmata on September 14, 1224, the Feast of the Triumph of the Holy Cross, which commemorates Emperor Heraclitus's retrival of the relic of the Passion in the seventh century.

141. Emmerson and Herzman, *The Apocalyptic Imagination*, 38.

142. Bartholome of Pisa refers to the stigmata emblem itself as the "conformities."

143. See Bonaventure, *Collationes in Hexaëmeron*, in *Opera Omnia*, 5:327–449, where these events are mentioned.

144. *Collationes in Hexaëmeron*. My translation is from the Italian translation, *La sapienza cristiana*, 231, emphasis mine.

145. For mendicant exegesis of Revelation in the Middle Ages, see Kleinhaus, "De Commentario"; Smalley, *Study of the Bible*, chap. 6; Burr, "Mendicant Readings"; Manselli, "L'Apocalisse"; Cazenave, "La vision eschatologique"; and Roest, "Franciscan Commentaries on the Apocalypse."

146. Daniel, *The Franciscan Concept of Mission*; also Reeves, *Influence of Prophecy*, 191–228, 320–31.

147. West, "Medieval Ideas." Peter Olivi's Joachimist ideas circulated in Spain in spite of the Inquisition. Olivi's exaltation of Francis anticipates the later *De Conformitate* of Bartholomew of Pisa in considering Francis to be a perfect *alter Christus*. See Manselli, "La resurrezione di san Francesco." On Ubertino de Casale, see West, "Apocalyptic Missions," 297; and Callaey, "L'influence."

148. F. Vemdrell, "La actividad proselita"; Bonilla, *Mitos y creencias*, 153–60. On Arnold of Villanova: Lee, "Scrutamini Scripturas." On Johannes de Rupescissa: McGinn, *Visions of the End*, 232; Ulibarrena, "La esperanza milenaria"; Lubac, *La posteridad*, 1:117–18; and Milhou, "El concepto de 'destrucción,'" 301. On Francesc Eiximenis: West, "Medieval Ideas," 299; Milhou, "El concepto de destrucción," 302–3; and Bohigas, *Prediccions i prophecies*, 23–38. Eiximenis's major works are the *Apparatus de triplici statu mundi*, the *Exposició de la visió damunt vita*, a *Vita Christi* in rhyme, the *Libro de los Angeles* (which was used in Mexico by Fray Jerónimo de Mendieta and Maturino Gilberti), and *Lo Crestià*, a work that includes a treatise on urban planning, to be discussed below. On Eiximenis and his writings, see Pou y Martí, *Visionarios*, 397–415; and Cervera Vera, *Francisco de Eiximenis*.

149. On the Beguines, the Fraticelli, the Brothers of Penitence, and the *alumbrados*, see Pou y Martí, *Visionarios*, 397–415; West, "Medieval Ideas."

150. Reeves, *Influence of Prophecy*, 229: "In some respects [the Observants were] nothing but continuators of the Spirituals of the thirteenth and fourteenth centuries, and were nourished on their writings which they sought diligently and read in secret." Nieto, "The Franciscan Alumbrados."

151. Prawer, "Jerusalem," esp. 790.

152. Gutmann, "When the Kingdom Comes"; Gladstein, "Eschatological Trends." Abraham of Avila, and one Abulafia, had plans to inaugurate the messianic era in 1290. See Desroche, *Dieux d'hommes*, 45–46, 176–77.

153. Zeitlin, *Maimonides*, 29–30, 151–55; Wischnitzer, "Maimonides' Drawings"; Dienstag, *Eschatology in Maimonidean Thought*; Gladstein, "Eschatological Trends." In 1393 a Jewish apocalyptic figure, Moises de Cisneros, appeared on the Iberian scene preaching the Messiah's advent. For the Jewish influence on the ideology of the New World, see Lafaye, *Mesías*. In anticipation of the miraculous events, medieval Jewish illuminations show a concern to depict the Messiah's return to Jerusalem, the restoration of the Temple, and the messianic banquet of the future. See Gutmann, "When the Kingdom Comes"; Wischnitzer, "Die messianishe Hütte," "The Messianic Fox," and "Maimonides' Drawings"; Revel-Neher, "L'alliance et la promesse."

154. Reeves, *Prophetic Rome*; and West, "Christopher Columbus," esp. 537–38.

155. Ulibarrena, "La esperanza milenaria," 57–58. Fray Bartolomé de Las Casas notes that d'Ailly, "great theologian, philosopher, mathematician, astrologer, cosmographer . . . greatly influenced Columbus and *confirmed all the past*. . . . I believe that among those of the past, this doctor moved Christopher Columbus the most toward his enterprise." Quoted in Kadir, *Columbus and the Ends of the Earth*, 48.

156. West, "The Abbot and the Admiral."

157. Milhou, *Colón y su mentalidad*.

158. Graziano, *Millennial New World*, 22.

159. Two translations and commentaries are *The "Libro de las Profecias" of Christopher Columbus*, ed. and trans. Delno West and August King; and *The Book of Prophecies*, trans. and intro. Roberto Rusconi.

160. On Columbus as an exegete, see J. Fleming, "Christopher Columbus as a Scriptural Exegete"; Avalos, "Columbus as Biblical Exegete"; and Rusconi's introduction to his edition of *The Book of Prophecies*, 22–23.

161. Also known as the *Postilla litteralis et moralis* or the *Glossa Ordinaria*. See Avalos, "Columbus as Biblical Exegete."

162. Columbus, *The Libro de las Profecias*, 101. He is quoting from Durandus's liturgical *Rationale divinorum officiorum*.

163. Columbus, *The Libro de las Profecias*, 90; and Milhou, *Colón y su mentalidad*, 469. New England Puritans came to the same conclusions and the same date for the end of the world. See Kadir, *Columbus and the Ends of the Earth*, 37.

164. Columbus, *The Libro de las Profecias*, 153–55.

165. Columbus, *The Libro de las Profecias*, 29 and 239. The book is divided in a trinitarian fashion suggestive of the trinitarianism of Joachim. See Ulibarrena, "La esperanza milenaria," 70.

166. Delno West proposes as a possible explanation that Las Casas may have removed the pages—fols. 67v to 77r—if they were deemed derogatory of the Indian peoples. Columbus, *The Libro de las Profecias*, 82–83. One early reader had written in the margin: "An evil deed was done by whoever ripped from here these sheets because it was the best of the prophecies of the book." In my examination of incunabula in Mexican libraries, I have discovered that the Inquisition frequently expurgated pages that might be interpreted in a crypto-Jewish way.

167. For the rivers of paradise legend, see Champeaux and Sterckx, *Introduction*, 208–28; and Sebastián López, *Iconografía medieval*, 19.

168. On the connection between the New World and the spatial location of paradise, see Ulibarrena, "La esperanza milenaria," 65–66.

169. For the origin of the dragon and its role, see Vigneras, *La búsqueda*.

170. Columbus had on board the Spanish translation by Martín Martínez de Ampiés (1493), who was also the author of the *Book of Antichrist* and other apocalyptic collections. For Ampiés's translation,

see Breydenbach, *Viaje de la Tierra Santa*. I shall return below to the importance of the illustrations for mendicant architecture in New Spain.

171. The medieval maps Columbus used showed the continents to form the shape of a Tau cross with Jerusalem at the umbilical center and the terrestrial paradise at the head. Columbus, *The Libro de las Profecias*, 7–18; and Rusconi in *Book of Prophecies*, 23–33. For the world map as a representation of the mystical body of Christ in Columbus's thought, see Milhou, *Colón y su mentalidad*, 406; also Esmeijer, *Divina Quaternitas*.

172. Varela, "Aproximación."

173. Reproduced in Lollis, *Raccolta*, 1:310. In the fourteenth century there were rumors of a fantastic treasure hidden in Aragon, which, if found, was likewise to be used to finance the reconquest of the Holy Sepulcher. See Adolf, *Visio Pacis*, 140.

174. Milhou, *Colón y su mentalidad*, 372–401; and West, "Christopher Columbus," 536–41.

175. From a letter of Columbus to Ferdinand and Isabella describing the fourth voyage, as quoted in Watts, "Prophecy and Discovery."

176. There is some confusion about the identity of Boyle and about the exact number of his clerical companions; they may have been Benedictines. See Ulibarrena, "Cristobal Colón"; and Flores Santana, *La isla Española*, 25–28.

177. Dobal, *La Isabela*, 24–37. In *Cartas particulares a Colón*, ed. Gil and Varela, 260, Columbus is quoted as saying: "Dear sirs, I want to take you to the place whence parted the Magi to adore Christ, a place called Saba." Having arrived at that place, he asked the locals what it was named, and they responded "Sobo." Then the admiral said that this was the same place, but that the natives did not pronounce the name accurately.

178. West, "Christopher Columbus," 533–36. For these biblical islands, see 1 Kings 9:28, 10:21–22, 22:49, and Jon. 1:3.

179. Gil, "Colón y la Casa Santa." Milhou, *Colón y su mentalidad*, 113–44, has brought to light the religious/eschatological motives of Columbus, including his search for gold. Such a mystical interpretation of the precious metal was also held by other noteworthy Spaniards, particularly those, like Francesc Eiximenis and Raymond Llull, who dabbled in alchemy. The prophecy in Isaiah reads: "Then you shall be radiant at what you see, your heart shall throb and overflow, for the riches of the sea shall be emptied out before you, the wealth of nations shall be brought before you. . . . All from Seba shall come bearing gold and frankincense, and proclaiming the praises of the Lord. . . . All the vessels of the sea are assembled, with the ships of Tarshish in the lead to bring your children from afar with their sil-

ver and gold. . . . Foreigners shall rebuild your walls, O Jerusalem. . . . Your gates shall stand open constantly; day and night they shall not be closed. But I shall admit to you the wealth of nations to bring beauty to my [rebuilt] sanctuary and glory to the place where I set my feet."

180. Ulibarrena, "Cristobal Colón," has suggested an additional meaning for Columbus's habit. The pseudo-Joachite *Floreto de Sant Francisco* (1492) provides prognostications attributed to Francis regarding the Antichrist and three orders of *viri sancti* who would arrive in the last age. The third order, *ordo saccis vestitus*, would dress in sackcloth as their distinctive habit, and this may be the identity that Columbus wished to adopt.

181. Manuscripts of the *Floreto* display an illustration of a building with crenellations and merlons that represent each of the three Joachite status. Ulibarrena, "Cristobal Colón," 481.

182. This passage occurs in a letter from Columbus to a member of the royal court in 1500. Quoted in Watts, "Prophecy and Discovery." Columbus was not the only one to have such a high opinion of himself. A polyglot psalter, entitled *Psalterium Hebreum, Grecum, Arabicum et Chaldaeum* (Genoa, 1516), contains a complete vita of Columbus immediately after verse 5 of Psalm 19: "Through all the earth their voice resounds and to the ends of the earth their message." See Prosperi, "New Heaven and New Earth," 281 n. 4.

183. Bonilla, *Mitos y creencias*, 153–60.

184. McGinn, "Reading Revelation."

185. Reeves, *Prophetic Rome*; and McGinn, "Reading Revelation."

186. His sermon was published in 1507. See Reeves, "Cardinal Egidio of Viterbo."

187. Published in Venice were *The Book of the Great Tribulations* (1516), *On Jeremiah the Prophet* (1516), *On Isaiah the Prophet* (1517), *The Book of the Concords* (1519), and *The Ten-Stringed Psaltry* (1527). On Venetian Joachite circles, see Reeves, *Influence of Prophecy*; and McGinn, "Circoli gioachimiti veneziani."

188. It was printed together with Joachim's *Ten-Stringed Psaltry*; a copy is extant in the Biblioteca Nacional de México. McGinn, "Reading Revelation," 18: "[T]he years between 1501 and 1601 saw the production of perhaps two hundred and fifty commentaries and treatises devoted to the Apocalypse—four or five times what the previous thirteen centuries produced!"

189. His most eschatological works are the *Historia viginti saeculorum*, which he wrote during the Fifth Lateran Council, and the *Scechina e libellus de litteris hebraicis*. Reeves, *Influence of Prophecy*, 99; Bull, "The Iconography."

190. Wind, "Typology in the Sistine Ceiling"; Dotson, "An Augustinian Interpretation"; and Bull, "The Iconography."

191. For the wealth of prophetic and eschatological themes related to the New Jerusalem at the Fifth Lateran Council, see Minnich, "Prophecy and the Fifth Lateran Council."

192. Popkin, "Jewish Christians."

193. Reeves, *Influence of Prophecy*, 365. Dante Alighieri (*Purgatorio* 1:23–24) had described four stars in a cross pattern; they had hovered over Eden and "had never yet been seen save by the first people." In *Purgatorio* 29:130 he interpreted them allegorically as the four cardinal virtues; see Tanner, *Last Descendant of Aeneas*, 206, 300 n. 61.

194. Serafino da Fermo, *Breve dichiaratione sopra l'apocalisse de Giovanni*, as quoted in Prosperi, "New Heaven and New Earth," 297–98.

195. More, *Utopia*, 79, emphasis mine.

196. Graziano, *Millennial New World*, 169.

197. Sala Catala and Reyes, "Apocalíptica española"; and Duran, "Profecia i revolta." The political tension was expressed theatrically in a work that anticipated the drama of *The Conquest of Jerusalem*, which was performed in New Spain a few years later. See Surtz, "A Spanish Play (1519)."

198. Checa Cremades, *Carlos V y la imagén del héroe*, 165, 201–14; and Remi du Puys, *La tryumphante entrée*, 17, and unpaginated woodcut. Charles's identification with Solomon the Temple builder was recognized in his royal sponsorship of a new cathedral-temple at Granada, thought to be designed with the Solomonic building in mind. Granada, of course, was the last stronghold of the Moors on the peninsula and the site of the jerusalemized siege city of Santa Fe de Granada.

199. Checa Cremades, *Carlos V y la imagén del héroe*, 190–95. Tanner, *Last Descendant of Aeneas*, 56–118, 146–61. The recapture of the golden fleece by Jason and the Argonauts was seen as a pagan foreshadowing of the recapture of Jerusalem by a member of the Order.

200. Tanner, *Last Descendant of Aeneas*, 120–30.

201. Checa Cremades, *Carlos V y la imagén del héroe*, 242.

202. Checa Cremades, *Carlos V y la imagén del héroe*, 127, 149–84; Reeves, *Influence of Prophecy*, 359–74; Milhou, *Colón y su mentalidad*, 331; Checa Cremades, *Carlos V: La imagén del poder*, 94–101.

203. See Tanner, *Last Descendant of Aeneas*, 83–118. The *Rituum ecclesiasticorum sive sacrarum cerimoniarum*, 30, used in Mexico, makes explicit the sacerdotal character of the emperor and his headgear. In a 1532 cycle of stained glass windows on the theme of the seven sacraments at the Church of St. Catherine at Hoogstraten, Charles V is the visual representative of the priestly sacrament of Holy Orders. See Checha Cremades, *Carlos V y la imagén del héroe*, 149–84.

204. Mujica Pinilla, *Ángeles apócrifos*, 64. Graziano, *Millennial New World*, 12; messianic figures frequently have a coterie of disciples referred to in religious terms.

205. Reeves, *Prophetic Rome*. The art works depict the "flagellation of the Church," the new cult of the secret names of the seven archangels, and the recently discovered *New Apocalypse* of Amadeus of Portugal; all the themes that we have been examining here were present. See also Checa Cremades, *Carlos V y la imagén del héroe*, esp. 171, regarding works by Titian and Dürer; Checa Cremades, *Carlos V: La imagén del poder*; and Soly, *Charles Quint 1500–1558*.

206. Reeves, *Influence of Prophecy*, 367. The theme of chastisement is linked with the prophecy of Ezek. 17:3.

207. Bataillon, *Erasmo y España*, 51–61, 226–27.

208. Alba, *Acerca de algunas particularidades*, 81–91.

209. Bataillon, *Erasmo y España*, 1–12; Weckmann, "Las esperanzas milenaristas"; Sylvest, *Motifs of Franciscan Missionary Theory*, 24–36.

210. The year 1517 was the year of the publication of Joachite and Sibylline works in Venice.

211. Andrés Martín, "Antropología," and "Nuevo planteamiento."

212. *Annus mundi*, the date since the creation of the world, was the way of reckoning time before the *annus Domini* or *annus Passionis* of the late Middle Ages. See Landes, "Fear of an Apocalyptic Year," 110–18. For the Mexica, see Colston, "No Longer," and Brundage, *The Fifth Sun*; for medieval Christians, see Landes, "Fear of an Apocalyptic Year," 106.

213. Brundage, *The Fifth Sun*, 28.

214. The ceremony took place on top of the Temple of the Sun. The new fire was ignited in the chest cavity of a human victim whose heart had been extracted.

215. Each solar age was 2028 years long. For a detailed study, see Barajau, *El mito mexicano*.

216. Carrasco, *Daily Life*.

217. The four previous ages were made visible in the great calendar stones. Brundage, *The Fifth Sun*.

218. In a pseudo-Christlike way, Quetzalcóatl had revived the dried bones of the dead by sprinkling them with his salvific blood. Cf. Ezekiel's vision of the dry bones (37:1–14).

219. Bonilla, *Mitos y creencias*, 161–70.

220. In Mesoamerican thinking regarding the quincunx, the center or fifth direction was considered a place of transition or transformation in the physical or spiritual realm. See Elzey, "Some Remarks."

221. Reyes Valerio, *Arte indocristiano*; and Landa Abrego, *Ollin y cruz*, 1–21.

222. Brundage, *The Fifth Sun*, 40. According to the well-known legend, Christ was both conceived (at the Annunciation) and died (Good Friday) on the calendar date of March 25. He would also return to earth for the events of the Last Days on a future March 25 when an Annunciation Day coincided with Good Friday. March 25 was also believed to be the date of the creation and death of Adam. See Landes, "Fear of an Apocalyptic Year," 125 n. 120.

223. Bonilla, *Mitos y creencias*, 165; Carrasco, "Cosmic Jaws"; Read, "The Fleeting Moment," 123.

224. Sahagún, *Florentine Codex*, book 6, chap. 37.

225. See Diaz del Castillo, *Historia verdadera*.

226. Graziano, *Millennial New World*, 49.

227. Colston, "No Longer," 240. For medieval speculation on the specific end-time catastrophies, see Heist, *The Fifteen Signs*. The fifteen signs are repeated by Jacobus de Voragine, *Golden Legend*, 1:8.

228. Ricard, *Spiritual Conquest*, 21.

229. Weckmann, "Las esperanzas milenarias," 97; Baudot, *Utopía e historia*, 96 and n. 25.

230. Their austerity frequently led to ecstasy, visions, and heights of contemplative bliss possible only through extreme meditation and denial of the body. These were values that friars like Martín de Valencia took with them to the New World. Later, in the New World, he would declare: "Now I see fulfilled what the Lord had showed me in spirit."

231. A major missionary thrust into the New World had been Quiñones's dream, and before being called to church administration he had planned to lead a mission there himself; Motolinía, *History of the Indians*, 175. Quiñones later became a cardinal of the Church of Santa-Croce-in-Gerusalemme, Rome, a church of particular importance for the Franciscans, and for the eschatological themes of the appearance of the eschatological cross and the vision of St. Gregory (see below, chap. 5). In 1524, the same year as the commisioning of the Twelve, Quiñones dedicated his *Commentary on the Apocalypse* to the new emperor, Charles V.

232. While the arrival of the twelve Franciscan apostles in Mexico in 1524 is generally considered by historians to be the first arrival of Christians on continental America, in reality it was preceded by an unsuccessful and tragic mission of twelve Franciscans to the north coast of Venezuela, at Cumaná, in 1516. The friars had come from southern France and had some connection with the heretical Beguines. Several of them had been persecuted by the Inquisition because of their eschatological/political beliefs, and their missionary venture was a means of escape. The expedition carried four pseudo-Joachite books: two copies of Bartholomew de Pisa's *On the Conformity of Saint Francis to Christ* (1390), and two copies of the Spanish apocalyptic *Floreto de Sant Francisco* (1492)—(my fig. 2.13)—which fact appears to confirm the eschatological interests of the first evangelizers. See Bartholomew of Pisa, *Liber conformitatum*, first printed in 1513. *Floreto de Sant Francisco*; also see Ulibarrena, "Cristobal Colón," 485–87, 494 n. 32. Additional copies of the *Liber conformitatum* were held in the convents of Huejotzingo and Texcoco in New Spain. See Tovar de Teresa, "Noticias sobre," esp. 163. Tragically, the friars were murdered by their own neophytes at Cumaná when Spanish slave traders interfered in the project. See Borges, *El envío de misioneros*, 428; Weckmann, "Las esperanzas milenaristas."

233. Quoted in West, "Medieval Ideas," 307, emphasis mine. In the same vein, the minister-general commanded them: "And therefore at present I do not send more than one superior and twelve companions, because this was the number which Christ took in His company to carry out the conversion of the world. And St. Francis, our father, did the same in announcing the Gospel."

234. Motolinía, *History of the Indians*, 148: "There is hardly anything to hinder the Indians from reaching heaven, nothing like the obstacles which hinder us Spaniards and which submerge us. The Indians live in contentment, though what they possess is so little that they have hardly enough to clothe and nourish themselves. Their meal is extremely poor and the same is true for their clothing."

235. Borges, "El sentido transcendente"; Baudot, *Utopía e historia*, 98.

236. Motolinía, *History of the Indians*, 194, emphasis mine. The predestined movement of Christianity from east to west is an ancient belief; see Borges, "El sentido transcendente," 149–52. In 1590 the Jesuit Pedro Acosta wrote of this migration of the Church in his *Historia natural y moral de las Indias* (Seville) quoting the prophecy of Haggai:

> And the transmigration of this army of the Cannanite sons of Israel to Sarapht [France], and the transmigration of Jerusalem which is in Sepharard [Spain] will possess as an inheritance the cities of the South, and those who procure salvation [the Indians] will go up to Mt. Zion, there to judge the mountain of Esau and to be the kingdom of the Lord. . . . Whoever would interpret that prophecy of Haggai in this way should not be criticized, for it seems a reasonable thing that so great an event as the discovery and conversion of the New World would have been mentioned in the Holy Scriptures.

237. García Icazbalceta, "Carta de Fray Martín," 212.

238. Montes Bardo, *Arte y espiritualidad*, 182. Also see Frost, "El milenarismo franciscano."

239. Mendieta, *Vidas franciscanas*, 182.

240. Phelan, *Millennial Kingdom*, 3–11. The key to Mendieta's thinking is the Gospel parable of the wedding banquet (Luke 14) via the interpretation of Nicholas of Lyra. In Mendieta's view, each of the three invitations to the guests is a prototype of the different methods to be used in calling Jews, Muslims, and Gentiles to believe in Christ. The actual conversion of these three groups will signify that the millennial reign of Christ and the Last Judgment are soon to follow. For Mendieta's biblical exegesis, see Frost, "America: Ruptura del providencialismo."

241. For Mendieta's influence on the Christian Inca Felipe Guamán Poma de Ayala, see Milhou, "El concepto de destrucción," 314–15.

242. Cionarescu, "La *Historia de Indias*"; Milhou, "El concepto de destrucción," esp. 306. For similar beliefs of the Franciscan ethnographer Bernardino de Sahagún, see Burkhart, *The Slippery Earth*, 50.

243. *Tercero catecismo*, fol. 205r–v, emphasis mine. Also see Broseghini, *Historia y metodos*; and Borges, "El sentido transcendente," 171–77.

244. Lumnius, *De Extremo Dei Judicio*, fols. 44–45.

245. Borges, "El sentido transcendente," 143:

You are going to plant the Gospel in the hearts of those infidels . . . who do not know Jesus Christ and who find themselves in captivity to Satan. Now, when the world is declining, *at the eleventh hour*, you are called by the Father of the vineyard to go into his vineyard . . . so that, fools to the world with the foolishness of your preaching . . . and fighting for the faith of Christ and for the conversion of the infidels, you can win for Jesus Christ the souls of your neighbors. Remember that you are at the end of the age, [of a world] which is swiftly growing old.

246. Estrada de Gerlero, "Sentido político."

247. Ricard, *Spiritual Conquest*, 21–22; Prosperi, "New Heaven and New Earth," 290. The Jesuits would later do the same.

248. Basalenque, *Historia de la provincia*, 27–28; also Peterson, *Paradise Garden Murals*, 158–59. A seventeenth-century painting of the seven original Augustinians with wings is found in the sacristy of the Church of San Agustín, Guadalajara, and reproduced in Basalenque, *Historia*.

249. Ricard, *Spiritual Conquest*, 61–82.

250. Sala Catala and Reyes, "Apocalíptica española," 311–12. The search to explain the origin of the native populations of the New World has continued to present times, with scholars at one time or another advocating every ancient people—real or imagined—known to history. See Huddleston, *Origins of the American Indian*, esp. 33–47, 83–128; Jacobs, "Tribes, Lost Ten," *Jewish Encyclopedia* (New York, 1901–6), 12:249–53; Glaser, *Indians or Jews?*, 3–32; and Sanders, *Lost Tribes*, 43–46. Early Puritans in New England also shared this belief; see Kadir, *Columbus and the Ends of the Earth*, 178–92.

251. West, "Medieval Ideas," 311. See also Góngora, *Studies in the Colonial History*, 20; the early discovery that the natives of the Yucatan practiced circumcision seems to have launched the speculation.

252. Graziano, *Millennial New World*, 35.

253. López Austin, *The Human Body*, 1:304.

254. Hassig, *Time, History and Belief*, 142.

255. Sahagún, *Florentine Codex*, book 2, chap. 33.

256. See Baudot, *Utopía e historia*, 180–91.

257. Gregorio García, *Origen de los indios*, esp. 256–59. García attributed the origin of the Indian population to the migration of the Ten Tribes of Israel (4 Ezra), who were carried off as captives to Assyria and never returned to their homeland. In the 1570s the theory was expounded by the Mexican chroniclers Juan Tovar, Juan Suárez de Peralta, and Diego Durán, and in Europe by the erudite Benedictine monk Benedictus Arias Montano, librarian to Philip II at the Escorial.

258. St. Thomas's footprints had been found in Brazil. See Graziano, *Millennial New World*, 186.

259. Mendieta, *Historia eclesiástica*, 536–40, 555–63; and see below.

260. Tizatlán (Tlaxcala), for example, literally means "House of Bread," like Bethlehem.

261. Wilson, "The New World's Jerusalems," 145–46.

262. Phelan, *Millennial Kingdom*, 81–85.

263. Mendieta, *Historia eclesiástica*, esp. 555–60. Mendieta uses Psalm 79, "On the destruction of Jerusalem," as the basis for his critique.

264. Lopez de Gómara had published his *Historia de las Indias y Conquista de Mexico* in 1552. See Senkman, "The Concept of the Holy Land."

265. Gerson, *Tripartito*, chap. 11.

266. Fray Andrés de Olmos seems to have capitalized on the pre-Columbian belief. See Baudot, *Utopía e historia*, 187.

267. Sahagún, *Evangeliarum*, 421.

268. Gilberti, *Dialogo de la doctrina cristiana*. I am grateful to Moises Franco of the Colegio de Michoacán for translating selected passages for me. For contemporary Antichrist prophecies and the probable source of Gilberti's information, see Martínez de Ampiés, *Libro del Anticristo*, which collected and expanded on the theme by the Dominican Vincent Ferrer.

269. On fol. 1v. The letter of approval of the *Doctrina* by the four experts (below) is on fol. 3r.

270. Fol. 196r. These witnesses are Elias and Enoch, sometimes interpreted as the Last Holy Roman Emperor and an angelic pope.

271. Fols. 196v–197r.

272. This Latin phrase was carved in stone on the third posa (SW) at Calpan; cf. Matt. 25:6 and Eph. 5:14. See below, chap. 5.

273. Fol. 198v.

274. The section on St. Michael is folio 314v–317r, but the pagination is wrong. An analysis of Fray Gilberti's text shows that he is paraphrasing an Iberian source, the *Book of the Angels* (1392), by the eschatological medieval Franciscan Francesc Eiximenis, whom we shall meet below. See Eiximenis, *De Sant Miguel Arcàngel*, 7–34; Gilberti seems to have paraphrased chap. 41. Gilberti's section on the three ages of history is fols. 236r–239v.

275. Gilberti's inclusion of this controversial material in a native language may have been part of the reason why he got in trouble with the Inquisition. See Ricard, *Spiritual Conquest*, 59. Gilberti refers again to the Antichrist in his sermons for the first Sunday of Advent and the twenty-fourth Sunday after Pentecost (last Sunday of the liturgical year). There are warnings to his flock to "stay awake and be vigilant" (fols. 240–44).

276. Ingham, *Mary, Michael, and Lucifer*, 6–7, speculates that the popularity of Michael demonstrates that the indigenous population was introduced early to the symbols of the book of Revelation.

277. Motolinía, *Memoriales*, 161–62, says that the Indians were taught to daily "give themselves over to mental prayer. One day they think on their sins . . . another day they meditate on death; another on the Judgment, both particular and general, another day the pains of Purgatory and Hell; another on the Passion of the Lord, and another day on the Resurrection and the glory of Paradise." This conforms to the exhortations that St. Augustine had made in his *First Catechical Instruction*, 27–28, to the candidates for baptism.

278. Ricard, *Spiritual Conquest*, 75–108. Fray Andrés de Olmos, author of the *Tratado de Hechicerías y Sortilegios*, was an expert on sorcery and demonology both before he came to Mexico and after. He was probably responsible for much of the theological information about demons that appear in the catechetical murals. Mendieta called him the "font from which all the streams of the knowledge [of pre-Columbian religion] flow"; quoted in Baudot, *Utopía e historia*, 129. According to Lafaye, *Mesías*, 122, Fray Andrés composed the early Nahua drama "The Last Judgment."

279. There are more images of angels, archangels, cherubim, and seraphim in Hispanic art than in all of coeval European art. See Center for Inter-American Relations, *Gloria in Excelsis*, 58, 62. Sahagún, *Coloquios*, chap. 10, calls the angels by the martial term "princely knights" (*principes caballeros*).

280. Lenhart, "Devotion to the Holy Name"; Estrada de Gerlero, "El nombre y su morada."

281. Estrada de Gerlero, "La demonología."

282. Artigas, *La piel de la arquitectura*, 99. For the source in Andrea Orcagna's painting and engravings of Dante's *Inferno*, see Paxson, "The Nether-Faced Devil," fig. 6.

283. Peterson, "Synthesis and Survival," is of the opinion that the Augustinians, more so than the other two orders, fostered visual syncretism in mural art.

284. Estrada de Gerlero, "Los temas escatológicos"; Artigas, *La piel de la arquitectura*.

285. Ballesteros García, *La pintura mural*, 72–73.

286. Last Judgments on rood screens were particularly common in Britain and Scandinavia and were inspired by religious dramas. See Stolt, *Medeltida teater*, 137 and fig. 80.

287. Estrada de Gerlero, "Los temas escatológicos."

288. The European images included the evisceration of St. Erasmus, the roasting at the grill of St. Lawrence, the disemboweling of St. Bartholomew, the boiling of St. John Evangelist.

289. The friars saw the need to attack sun worship in order to recycle it for Christ as the "Sun of Justice." See below, chap. 5. In the early Nahua-Christian catechetical play *The Sacrifice of Isaac*, the villain Ishmael is portrayed as a sun worshipper. Ravicz, *Early Colonial Religious Drama*, 89 and n. 6.

290. A *visita* chapel was one that did not have a convent or resident clergy.

291. Here the serpent is given a feminine face, a conventional representation of fifteenth- and sixteenth-century engravings.

292. Estrada de Gerlero, "La pintura mural." Proposed models include the *Ars Moriendi* (1465), the *Vision Lamentabilis* (1487), and the *Final Judgment* by Lucas Cranach the Elder (1513).

293. The play *The Final Judgment*, by Fray Andrés de Olmos, was performed as early as 1531. The character Lucia has been studied by Schuessler, "Géneros renacientes," 149–85.

294. Artigas, *La piel de la arquitectura*, 51–99.

295. Alcántara Rojas, "Fragmentos," and "Breve aclaración." The "moral iniquity" of these symbolic animals may have been interpreted differently by the natives.

296. Alcántara Rojas, "Breve aclaración," 267. The story of the infamous Valentín had been publicized in Fray Joan Baptista's *Confessionario*, chap. 9.

297. Estada de Gerlero, "Los temas escatológicos."

298. Burkhart, "Flowery Heaven," 83–123; and Peterson, "La flora y la fauna," 29–34.

299. Champeaux, *Introduction*, 76–78, 214–29; McClung, *The Architecture of Paradise*. For Joachim's use of flowers and vines, see n. 114 above.

300. See Patch, *El otro mundo*.

301. Burkhart, "The Voyage of Saint Amaro." The Náhuatl manuscript relates Amaro's visions, which are clearly adapted from the architecture of Ezek. 40 and Rev. 21.

302. McClung, *Architecture of Paradise*, 9–46.

303. George Williams, *Wilderness and Paradise*, 48.

304. Daniélou, "Terre et paradis"; Raedts, "St. Bernard of Clairvaux."

305. McClung, *Architecture of Paradise*, 9–46, 92, 150 n. 2.

306. Valadés, *Rhetorica Christiana*, 389: "They used to embellish these temples with gardens, fountains, thermal baths, pools and delicious green gardens with flowers and trees, because they had flowers of exquisite and varied fragrances. With great care they used to plant wide and leafy trees in these gardens; so wide that under the shade of a single one a thousand people could be seated."

307. Peterson, *Paradise Garden Murals*, 132. Tlalocan, the rainy paradise of the deity Tlaloc, was also envisioned as expectionally fertile and green.

308. Escobar, *Americana Thebaida*, 145, states that water for Tiripitío's fountain flowed from a *calvario* chapel because it was thought that in Jerusalem, in like manner, an underground stream connected the Pool of Siloam and the Holy Sepulcher.

> [At Tiripitío] the water came down from the high mountain of Calvary, and was hidden in subterranean conduits, arriving at the plaza . . . to water that Paradise and a fountain which divided into four rivulets and ran to distinct parts [of the town]. The first went to the convent; the second, to the hospital; the third, to the house of the encomendero; the fourth to the rest of the town. . . . With this division of waters, Tiripitío seemed to be a transplant of the Terrestrial Paradise . . . in the middle of which was the tree of knowledge, that is, the university.

A similar hydralic system was employed at the Franciscan convent of Huejotzingo. See below.

309. Kubler, "The Claustral 'Fons Vitae'"; Sebastián López, "La versión iconográfica"; Wilkinson, *Jerusalem Pilgrims*, 43.

310. Peterson, "La flor y la fauna," 36. The tree is a native type of apple tree known as the *zapote*. A similar tree of good and evil ap-

pears in the murals of Santa María Xoxoteco, see Artigas, *La piel de la arquitectura*, 47–50.

311. Phillips, "Processions through Paradise."

312. "COR MEUM ET CARO MEO EXSULTAVERUNT IN DEUM VIVUM. ET ENIM PASSER INVENIT SIBI DOMUM, ET TURTUR NIDUM SIBI, UBI PONAT PULLOS. ALTARIA TUA, DOMINE VIRTUTUM, REX MEUS ET DEUS MEUS. BEATI QUI HABITANT IN DOMO TUA, DOMINE: IN SAECULA SAECULORUM LAUDABUNT TE." Also see Peterson, *Paradise Garden Murals*, 142.

313. McClung, *Architecture of Paradise*, 70.

314. Tecamachalco was established in 1541; the church was dedicated in 1551. See Kubler, *Arquitectura mexicana*, 446–49; Arredondo et al., *Juan Gerson, Tlacuilo de Tecamachalco*; Fondo Editorial de la Plastica Mexicana, *Juan Gerson, pintor indígena*; Kügelgen, "Problemas de aculturación." The symbolic number 24 should not be overlooked, because it is the number of the adoring elders in the book of Revelation (4:4), and in medieval thought it represented the sum of the twelve tribes of the Old Testament plus the twelve apostles of the New Testament. Montes Bardo, *Arte y espiritualidad*, 182–89.

315. The sacrifice of Abel (Gen. 4), Noah's ark and the Flood (Gen. 6), the Tower of Babel (Gen. 11), the sacrifice of Isaac (Gen. 22), Jacob's ladder (Gen. 28), the Holy City of the New Jerusalem (Ezek. 40), the altar of holocausts, Ariel Altaris (Ezek. 43), the vision of God and the 24 elders (Rev. 4).

316. The vision of Christ among the seven candelabra (Rev. 1), the Four Horsemen (Rev. 6), the cry of the martyrs and the giving of the garments (Rev. 6), the fall of the stars (Rev. 6), the selection of the Elect (Rev. 7), the fourth trumpet (Rev. 8), the plague of locusts (Rev. 9), angels chaining the Euphrates (Rev. 9), St. John eating the book (Rev. 10), the two witnesses (Rev. 11), the woman of the sun and the dragon (Rev. 12), the beasts of earth and sea (Rev. 13), the lamb of God on Mount Zion (Rev. 14), the fall of Babylon (Rev. 18), the defeat of the dragon (Rev. 20), the vision of the celestial Jerusalem (Rev. 21, 22).

317. For the work and writings of Fray Andrés de Olmos, see Baudot, *Utopía e historia*, 102–245.

318. There are several illustrated Bibles from Lyon in the Biblioteca Nacional, Mexico City, and in the La Fragua and Palafoxiana libraries of Puebla. Hans Holbein the Younger published his *Historiarum Veteris Testamenti Icones* in Lyon in 1539, continuing the tradition of Nicholas of Lyra. See *La Bibbia Perduta*; and Holbein, *Images from the Old Testament*. The centerpiece of his illustrations is a view of Jerusalem derived from Lyra's 1481 *Postillae*. The temple accoutrements of Lyra appear again in Holbein's commentary on Numbers and Ezekiel. See Rosenau, *Vision of the Temple*, 68.

319. Montes Bardo, *Arte y espiritualidad*, 182.

320. I consulted the 1510 Milan edition of the *Conformities* in the Biblioteca Nacional de México.

321. Kügelgen, "Problemas de aculturación."

322. McAndrew, *Open-Air Churches*, 535–43; Kubler, *Arquitectura mexicana*, 379–81; Curiel, "Escatología y psychomachia," and *Tlamanalco*.

323. The surface was paved with burnished red stucco, traces of which can still be detected on the inner floor of the open chapel.

324. Probably completed before the plague of 1564, which killed half the population. Curiel, *Tlalmanalco*, 88–89.

325. Kubler, *Arquitectura mexicana*, 379.

326. McAndrew, *Open-Air Churches*, 535, 542. An original painted wooden ceiling, adorned with flowers, angels, and cherubs, exists in the open chapel at Tizatlán.

327. Curiel, *Tlalmanalco*, 89.

328. Such placement was common in coeval Spain. See Braun, "Puertas mudejas eucarísticas."

329. McAndrew, *Open-Air Churches*, 539.

330. Curiel, *Tlalmanalco*, 95.

331. Curiel, *Tlalmanalco*, 104, 199. Also see Gaston, "Prudentius," 161–76.

332. Curiel, *Tlalmanalco*, 97–110, 163–77. The *Psychomachia* had been reedited in Spain with a commentary by the humanist Antonio Nebrija (whose works are legion in Mexican libraries) in 1512, 1536, 1540, and 1546. In 1522 a Spanish translation appeared as *La batalla o pelea del alma* (The Battle or Struggle of the Soul). See Prudentius Clemens, *Obras completas*, 72; and Bataillon, *Erasmus y España*, 15, 27, 272.

333. Fothergill-Payne, "La *Psychomachia* de Prudencio"; and Kimminich, "The Way of Vice."

334. E.g., Gilberti, *Dialogo de la doctrina cristiana*.

335. Curiel, *Tlalmanalco*, 151–61.

336. Curiel, *Tlalmanalco*, 111–27.

337. The "pearls" are white stones that were set into carved grooves, *dentils*, on the fascia of the intrados. In the restoration of the last century many were filled with mortar; the subtle reference to the heavenly gates may have gone unnoticed by the restorers.

338. Curiel, *Tlalmanalco*, 127–35.

339. Curiel, *Tlalmanalco*, 135–50.

340. Curiel, *Tlalmanalco*, 140–50.

341. Pierce, "Identification of the Warriors," and "Sixteenth-Century Nave Frescoes"; Estrada de Gerlero, "Los temas escatológicos," and "El friso monumental"; Wright Carr, "Sangre para el sol." The metaphor of spiritual warfare was perfectly understandable to the Nahua Christians because of the heroic status of warriors in pre-Hispanic society. The Christian apostles and saints became their new warrior-knight heroes. See Burkhart, "The Amanuenses," 346–47.

342. See "St. Michael the Archangel," *Catholic Encyclopedia* (New York: Robert Appelton, 1907–12), 10:275–77. St. Michael was the personal protector of Francis of Assisi. Michael's feast, September 29, was by coincidence the same day as the principal Aztec feast of Tezcatlipoca, the archangel's nemesis; see Sahagún, *Florentine Codex*, book 2, chap. 12.

343. The battle scenes in Prudentius's *Psychomachia* are also arranged as if in a Roman procession. See Macklin Smith, *Prudentius' Psychomachia*, 117–18.

344. Several of the warriors are clearly wearing costumes, and one of the "dragons" wears sandals to protect his or her feet; a centaur actor carries the Augustinian emblem of the three arrows. The militarization of St. Michael's feast is similar to the way in which Corpus Christi was celebrated in Spain and its colonies. Theatrical props, like artificial blood, were used in liturgical plays; see below, chap. 6. Estrada de Gerlero, "El teatro de evangelización," hints at a similar theatrical interpretation of the murals. See Rev. 12:7 for Michael's war with the dragon. "Liturgical dragons," effigies of evil on a pole, are mentioned in Castellani's *Liber Sacerdotalis*, used in New Spain. Furthermore, St. Michael continues to be a superhero in mock combats today; see Ingham, *Mary, Michael, and Lucifer*, esp. 31–36, 139–60.

345. An almost identical angelic banding is found not far away, at Metztitlán. See Artigas, *Metztitlán, Hidalgo*, esp. 177. Joachim of Fiore used the vine as a symbol of the progession of history; see n. 108 above.

346. Sahagún, *Psalmodia Christiana*, 287–89.

347. Pierce, "Sixteenth-Century Nave Frescoes," 106–13. A small Last Judgment mural graces the upper cloister next door.

3. THE INDIAN JERUSALEM

1. Eliade, "The World, the City, the House."

2. Werblowski, "Mindscape and Landscape."

3. Carrasco, "The Sacrifice of Tezcatlipoca."

4. Wagner, "Open Space," 9–16.

5. Schele and Freidel, *A Forest of Kings*, 71–72.

6. Millon, *The Urbanization of Teotihuacán*, 137–42.

7. Miller and Taube, *Gods and Symbols*, 92. The fifth cardinal point was an attribute of the fire god, Huehuetéotl.

8. Carrasco, *Quetzalcóatl*, 70–113; Pajares-Ayuela, *Cosmatesque Ornament*, 238–46.

9. Dougherty, *The Fivesquare City*, 4; Pajares-Ayuela, *Cosmatesque Ornament*, 246.

10. Townsend, *State and Cosmos*, 7–9; Carrasco, *Quetzalcóatl*, 160–67.

11. See Ps. 122; French, "Journeys to the Center of the Earth."

12. Carrasco, *Quetzalcóatl*, esp. 153 ff.; Broda et al., *The Great Temple of Tenochtitlan*, esp. 61–123. The Aztec *loca sancta* were, of course, the temples, shrines, and *adoratorios* at crossroads. Their relics included the sacrificed deity impersonators, the skulls on the *tzompantli* racks, and the flayed human skins on the ritual actors.

13. Burkhart, *The Slippery Earth*, 47–50.

14. Toussaint, *Planos de la ciudad de México*, 71.

15. McClung, *The Architecture of Paradise*, 9–46; Zampa, "Il Giardino."

16. See the discussion on the symbolic meanings of Jerusalem for Jews and Christians in Dougherty, *The Fivesquare City*, 5–22; and French, "Journeys to the Center of the Earth."

17. Eliade, "The World, the City, the House."

18. J. Z. Smith, "Earth and Gods." See also Vilnay, *Legends of Jerusalem*.

19. Dougherty, *The Fivesquare City*, 14.

20. See Isa. 2:2–3, 62:1–9; Ps. 87.

21. Corboz, "La ciudad," 55.

22. At the final assault on Jerusalem in 1099, Baldric, bishop of Dol, could say: "The city that you see is the cause of all our labors. This Jerusalem is the likeness of Heavenly Jerusalem; this city has the form of that to which we aspire. . . . Clearly, if you diligently consider, this Jerusalem which you see before you, to which you came and at which you are now present, prefigures and reflects the heavenly city." Quoted in Prawer, "Jerusalem," 749.

23. On the holy city of Jerusalem as a divine/cosmic quaternity, see Esmeijer, *Divina Quaternitas*, 73–96.

24. Corboz, "La ciudad," 55–56; also see Ramírez, *Construcciones ilusorias*, 113–214; and *Edificios y sueños*, 35–100.

25. Corboz, "La ciudad," 56. This choice, never arbitrary although at times difficult to decipher, was made because of the hidden properties of the imitated object, which came to be indicated by the details common to both objects.

26. Eusebius, *Vita Constantini*, trans. John Wilkinson in *Egeria's Travels to the Holy Land*, rev. ed. (Jerusalem and Warminster: Ariel, 1981), 167; J. Z. Smith, *To Take Place*, 83. On Constantine's identification with Moses, and his palatine architecture as linked to the Tabernacle, see A. Grabar, *Martyrium*, 1:560, 565–70.

27. On this conflation, see Kühnel, *From the Earthly*, 79–89, 112–67.

28. Ambrose's words are quoted in Heitz, *Recherches*, 166 n. 2.

29. The septiform procession may have been an imitation of the Roman procession relating to the seven deaconal regions of the city, but such processions also imaged the sacred number in Revelation (chaps. 1–3). See below, chap. 6.

30. For laudatory hymns to medieval cities as surrogate Jerusalems, see Raedts, "The Medieval City."

31. Baldovin, *Urban Character*, 235; processions that encircled a city could also form a magical ring of protection as an apotropaic act.

32. Maza, *La ciudad de Cholula*. The first Indian church in New Spain was San José de los Naturales de Belén, i.e., St. Joseph of the Indians of Bethlehem.

33. Hubert et al., *L'empire carolingien*; and Corboz, "La ciudad," 56.

34. For stational liturgy in Rome and Jerusalem, see Häussling, *Mönchskonvent und Eucharistiefeier*; and Baldovin, *Urban Character*.

35. As at Paderborn, Utrecht, and Hildesheim.

36. A mural of the apocryphal warrior archangels was discovered in Palermo, and it was the Spanish crown that fostered the cult and built the Church of Santa María degli Angeli, an apotropaic shrine. See Mujica Pinilla, *Ángeles apócrifos*, 30.

37. Guidoni, "Cistercensi e Città Nove"; and Raspi Serra, "Il rapporto."

38. Between the purely contemplative *mansiones* and the oratory of the secular priests "there ought to be a distance of about three miles." The precise indications of distance between the oratories, as well as the fairly minute regulations, affirm that Joachim had a real and not a mystical community in mind. McGinn, *Visions of the End*, 111.

39. West, "A Millenarian Earthly Paradise," 262.

40. See John 14:2: "In my Father's house there are many mansions." Durandus, in his *Rationale*, speaks of the various chambers in the monastic cloister as representing the different mansions and the degrees of glory in the heavenly kingdom. See Dynes, "The Medieval Cloister," 62. In Mexico, Fray Matías de Escobar, *Americana Thebaida*, 153, calls the atrium posas *mansions*. As we shall see in chap. 6, the word also meant a stage house or set. On the importance of the numbers 2, 5, 7, and 12, see Reeves and Hirsch-Reich, *The Figurae of Joachim of Fiore*.

41. See Grundmann, *Neue Forschungen*, 94: "Sie erscheinen in der Figur wie Sockel und Predella eines Kreuzes, das von vier mönchischen Oratorien mit dem Mutterhaus in der Mitte gebildet wird." Also Pásztor, "Architettura monastica."

42. E.g., the seventh or last mansion is given over exclusively to the laity. Its title and attributes are Oratory of St. Abraham the Patriarch and of all the Holy Patriarchs, The Sheep, The Human Body, The Spirit of Fear. In this oratory the married folk with their children will live a common life. They will have food and clothing in common and will obey their resident *magister* according to the direction of the spiritual father. Like monks, they will fast occasionally. Each one will work at his or her craft or trade. They will give tithes to the clerics for training the boys in doctrine (as in New Spain). Joachim was not the only one to think of lay monks—Benedictine and Cistercian monasteries often had *conversi*, lay brothers who did manual work, and in a similar way the later mendicant friars in Mexico established their Third Orders for laymen and women.

43. Thompson, "A Reinterpretation," 203; West and Zimdars-Swartz, *Joachim of Fiore*, 68. The sixth age of the second status, which Joachim considered to be his own time, was characterized by the emergence of new orders of laity such as Knights Templar and the *conversi* of the Cistercian order. The abbot of Fiore attributed great significance to the calling forth of these laity by God. These lay movements were a sign that a new order was emerging which would gather together the diverse orders distinguished in the different times of the past. Organized under monastic rule, this new order would be dedicated to the task of carrying the Gospel to the ends of the earth. Also see Seibt, "Liber Figurarum XII."

44. See Pásztor, "Architettura monastica," 151.

45. Between the oratories of St. Stephen and St. John the Baptist, Joachim suggests three Roman mile stones (one Roman mile = 1,000 paces or c. 1,620 yards), and between the oratories of St. John the Baptist and St. Abraham the Patriarch, he recommends two *stadi* (i.e., ⅖ or ¼ of a Roman mile). Figure XII is most likely an expansion and refinement of Joachim's earlier drawing, which was included in his text of the *Expositio in Apocalypsim*, fol. 218. See West, "A Millenarian Earthly Paradise," 270 n. 26. *Expositio in Apocalypsim*, fol. 18: "Hec autem civitas una est et nomen eius proprium Hierusalem." On the diagram as a *civitas Dei*, see Pásztor, "Ideale del monachesimo."

46. Reeves and Hirsch-Reich, *The Figurae of Joachim of Fiore*, 68–69.

47. The book of Revelation provided much to flesh out his utopian Third Age of world history and those who would inhabit it, like the two witnesses Elijah and Enoch—later interpreted as SS. Francis and Dominic. Joachim was clearly familiar with the apocryphal Scriptures that prophesy the return of Elijah and Enoch. See Enoch 45:4–5.

48. See O. Grabar, "Jerusalem Elsewhere."

49. Tanner, *Last Descendant of Aeneas*, 25–35, 171. On the theme of surrogate Jerusalems, see also Wilson, "The New World's Jerusalems."

50. Fedeli Bernardini, "Roma."

51. Westfall, *In This Most Perfect Paradise*, 120–25, 150–51, 173, 180–83.

52. Battisti, "Roma apocalittica."

53. Chastel, "Un episode," 75–79; Rovetta, "L'immagine della Gerusalemme."

54. O. Grabar, "Jerusalem Elsewhere," 334.

55. Gatti Perer, ed., *La dimora di Dio*, 104–13.

56. Florence: The Dominican friar Savonarola had often proclaimed his city to be a new Jerusalem of grace. McGinn, *Apocalyptic Spirituality*, 183–275; Weinstein, *Savonarola and Florence*, esp. chaps. 4 and 5. In a strange turn of events, Savonarola himself came to be depicted as the Antichrist incarnate. In the frescos of the cathedral of Orvieto, in the apocalyptic year 1500, Luca Signorelli painted him in the demonic role standing in front of the Jerusalem Temple. See Riess, *Luca Signorelli*, 7–27.

Milan: Milan had such celestial self-consciousness since the eighth century. Le Goff, "L'immaginario urbano." In the thirteenth and fourteenth centuries, historical and cosmological myths elevated the importance of the city and its topographical design to being a reproduction of the Greco-Byzantine world and a new geographic center. Gatti Perer, "Umanismo a Milano."

Venice: The eschatological myth of Venice, and its exalted place in salvation history, were the special themes of Guillaume Postel (1510–81), an ex-Jesuit priest. According to him, Venice had to assume the function of "another Jerusalem of stable institutions and pure religion." See Kuntz, "The Myth of Venice." Ironically, Postel was condemned by the Venetian Inquisition in 1555.

57. Niccoli, "La donna e il dragone."

58. Howard, *Venice and the East*, esp. 29–42.

59. Corboz, "La ciudad," 66.

60. Rodini, "Describing Narrative." In 1462 the English Dominican William Wey, a Holy Land pilgrim, passed through Venice and commented that the city was "edificata ad modum templi christianorum in Jerusalem." Wey describes the Venetian Zion in terms of its sumptuous liturgical processions. Puppi, "Verso Gerusalemme."

61. The description is by the Holy Land tour director Friar Felix Faber, as related in Puppi, "Verso Gerusalemme," 76. Also see Howard, *Venice and the East*, 180–216; and Paul von Naredi-Rainer, *Salomos Tempel*, 235–59.

62. Kuntz, "Guillaume Postel," esp. 454, 463 n. 177.

63. In 1518 a local chronicler reported that there were life-size sculptures of "an Entombment of Our Lord situated in the crypt of the church, in a dark and secluded place called 'Jerusalem.'" See Martens, "New Information," 9–11, n. 43; and Gatti Perer, "Gli studi sulle origini."

64. Checa Cremades, *Carlos V y la imagén del heroe*, 211–14.

65. The relic had been sent to Bruges by Baldwin the Crusader following the sack of Constantinople in 1204.

66. This event took place during their state visit to Bruges in April of 1515. Remi du Puys, *La tryumphante entrée*, 23–24. Charles V was later immortalized in the stained glass windows of the Chapel of the Holy Blood at Bruges as the legitimate heir of Charlemagne, who, by legend, had possessed the Holy Grail. See Tanner, *Last Descendant of Aeneas*, 210.

67. Borges, "El sentido transendente," 211.

68. The year 1492 had been proclaimed as the moment of the "fullness of time" and the beginning of the "renewal of the world" by the Florentine Platonists, such as Marsilio Ficino. See Reeves, *Influence of Prophecy*, 429.

69. M. Fleming, *Late Medieval Pope Prophecies*, 2, 70.

70. The "Solomonic emperor" Lalibela constructed a mystical topography, a re-creation of the city of Jerusalem named after himself. Eleven churches were carved from the living rock, with a river flowing between them named Yordanos, after the river in Palestine. The names given to the churches and various other sites indicate the intention to create a new Jerusalem and a new Israel. There is, for example, a hill known as "Calvary" under which the tomb of Adam is believed to be located. Below it, in a crypt called "Golgotha," is a "tomb of Christ." Another hill is known as the "Mount of Transfiguration"; a nearby church of "Bethlehem" stands at almost the same distance from it as the original. See *Verdadera Informaçam das terras do Preste Joam das Indias* (Lisbon, 1540).

71. Grierson, ed., *African Zion*, 10–11; Heldman, "Architectural Symbolism."

72. Aregay, "Millenarian Traditions."

73. Motolinía, *Memoriales*, 89–90. See Wilson, "The New World's Jerusalems," 105–6.

74. The theories are summarized in Guarda, *Santo Tomás de Aquino*, 63–84, 213–21; and Salcedo, *Urbanismo*. Also see Rodríguez de Ceballos, "El urbanismo"; *La ciudad hispanoamericana*, 63–84, 213–21.

75. *La ciudad hispanoamericana*, 98.

76. Camacho Cardona, *Historia urbana novohispánica*, 99–107.

77. As at the first American city, Santo Domingo, Hispañola (1502), and at Santa María de Darien, Panama (1509). Guarda, *Santo Tomás de Aquino*, 13 n. 11; Tejeira Davis, "Pedraris Dávila."

78. The greatest publication of Renaissance Spain was not a text of the ancient Greeks and Romans but rather the *Polyglot Bible* of Cardinal Cisneros.

79. On the peculiar quality of the Spanish Renaissance and Iberian humanism, see Bataillon, *Erasmus y España*; Bono, *Cultural Diffusion of Spanish Humanism*; Weckmann, *La herencia medieval*; and Edgerton, *Theaters of Conversion*, 31. Early medieval architecture was experiencing a revival in parts of Europe; see Campbell, "A Romanesque Revival."

80. *La ciudad hispanoamericana*, 96–97; Vercelloni, *Atlante storico*, 41. Architectural treatises of Francesco di Giogio Martini and Filarete remained unpublished until the nineteenth century. The other European urban planners, Dürer, Vasari, and Serlio, published their works when the American gridiron was already a reality.

81. Mathes, *The America's First Academic Library*, 13–20, 27–32. A copy of Vitruvius's work was owned by the Franciscan library at Tlatelolco.

82. Viceroy Mendoza, Fray Juan de Zumárraga (the first bishop of Mexico), and Vasco de Quiroga (the first bishop of Michoacán) were particularly devoted to More's *Utopia* and possessed copies of the work. See Tovar de Teresa, León-Portilla, and Zavala, *La utopia mexicana*. On Zumárraga as the first "bishop of Utopia," see Montes Bardo, *Arte y espiritualidad*, 135.

83. Guidoni, "Cistercensi e Città Nuove"; and Raspi Serra, "Il rapporto."

84. Pásztor, "Architettura monastica," 149–56.

85. Iberian military camps later became cities: Sangüesa and Puente la Reina (both founded by Alfonso I in the twelfth century), Villareal (before 1272), Almenara (1258), Briviesca (1208), and Guernica (1366).

86. Guarda, *Santo Tomás de Aquino*, 20–21.

87. *La ciudad hispanoamericana*, 90, 99, 100.

88. Guarda, *Santo Tomás de Aquino*, 21; and Camacho Cardona, *Historia urbana*, 70.

89. Cervera Vera, *Francisco de Eiximenis*, 91–113; Bohigas, *Prediccions i profecies*, 24 ff. For Eiximenis's influence on the sixteenth century, see Marías, *El largo siglo XVI*, 64–68.

90. *Vita Christi* (1396), *De triplici statu mundi* (c. 1398), and *Llibre del Angels* (1382) with a Castillian translation in 1516. See Guadalajara Medina, *Las profecías del anticristo*, 211–13.

91. Cervera Vera, *Francisco de Eiximenis*, 133–71.

92. Mountainous scenery as an urban backdrop is mentioned by the prophet Ezekiel and in Psalm 125.

93. Eiximenis, *Lo Crestiá*, 188–90; Guarda, *Santo Tomás de Aquino*; Beltrán de Heredia, "El plan regular de Eximenis"; Rodríguez de Ceballos, "El urbanismo"; *La ciudad hispanoamericana*, 91; Camacho Cardona, *Historia urbana*, 71.

94. This fact is emphasized by the title of his third chapter, "Com la ciutat de Paradis és pintada dins l'hom" [How the city of Paradise has been pictured by man]. Eiximenis, *Lo Crestiá*, 181–83.

95. Eiximenis, *Lo Crestiá*, 198: "And this is guaranteed by Saint Augustine when he says [*City of God*, 2.19] that in the era of the end of the world the mercy of God will grant this grace to the earth: that the polity of the present world will reflect the image of that glorious community of Paradise, as St. John lets us see when he says Vidi civitatem."

96. Eiximenis, *Lo Crestiá*, 293: "These cities have been built by the Moors after their fashion, narrow and mean, with many narrow alleys, crooked and with other deformities. But starting a few years ago, every day something gets improved or beautified. Thanks be to God."

97. Falomir Faus, "El proceso de 'cristianización urbana'"; also see Lleó Cañal, "De mezquitas a templos."

98. For the influence of Eiximenis's theories on the re-Christianization of Granada, see Orozco Pardo, *Christianopolis*, esp. 24–25.

99. Guarda, *Santo Tomás de Aquino*, 22–23.

100. On the role of the eucharistic sacrament in the final reconquest of the peninsula, see Bellver Cano, *El Corpus en Granada*, 44–45.

101. Vercelloni, *Altante storico*, 47.

102. Salcedo, "El model urbano."

103. This could have been influenced by the illustrated work of the Hieronymite friar Hector Pinto, who in 1567 had received royal permission from Philip II to publish an early version of his *In Ezekielem Prophetam Commentaria*. See Salcedo, "La estructura urbana." I have found this early version of the work in Mexican colonial libraries. There were, of course, earlier commentaries on Ezekiel, complete with drawings, such as that of Richard of St. Victor, Maimonides, and Nicholas of Lyra (see next chap.). They also could have been combined with King Alfonso's *Partidas* and Eiximenis's idealized conception.

104. Camacho Cardona, *Historia urbana*, 111; in New World cities all distances were measured from the tower of the principal church as the center point, just as the Aztecs had measured distances from the Templo Mayor in Tenochtitlan.

105. Salcedo, "El model urbano," 72.

106. Salcedo, "El model urbano," 72; and *La ciudad hispanoamericana*, 84.

107. The liturgical Feast of the Transfiguration was a favorite date for the founding of cities.

108. As quoted in Sebastián López, "Concepción mística." Jiménez de Quesada was a convert from Judaism, according to the contemporary poet-priest Juan de Castellanos.

109. And even into the twentieth century. See Vercelloni, *Atlante storico*, 114, 127–35.

110. Salcedo, "El modelo urbano," 71.

111. See Dan. 9:1–27, where Gabriel interprets the vision of the seventy weeks, the cleansing of the Holy of Holies, and the rebuilding of plazas and ramparts—now spiritualized in Cholula.

112. Rev. 1–3. The churches and barrios are San Gabriel at the center, surrounded by San Miguel, Santiago, San Juan, San Pablo, San Andrés, and Santa María. The barrios may correspond to pre-Hispanic divisions.

113. Maza, *La ciudad de Cholula*, 94. St. Michael is, of course, a Jerusalem actor because there, in the Valley of Jehosaphat, he will defeat Antichrist and oversee the Last Judgment.

114. Wilson, "The New World's Jerusalems," 107–10.

115. For Mexico City as another Jerusalem, see Kagan, *Urban Images*, 151–69; and Torres, "De la ciudad cristiana."

116. As quoted in Fernández Echeverría y Veyta, *Historia de la fundación*, 65–67.

117. See, e.g., Motolinía, *El libro perdido*, 442–47. Cf. Ezek. 40–42, Zech. 2, and Rev. 21.

118. For the apocalyptic cult of the seven archangels and its association with the Franciscans, see Mujica Pinilla, *Ángeles apócrifos*. Images of the seven archangels abound in the Mexican states of Puebla and Tlaxcala.

119. Motolinía, *Memoriales*, 108.

120. Motolinía, *Memoriales*, 239, 106 (quotation).

121. Both are ninth-century craftsmanship. See Nieto Alcaide, *Arte prerrománico asturiano*, 171–79.

122. Motolinía, *Memoriales*, 106, 107 (quotation, emphasis mine). The city of Yzocalán has not been identified. It might be Izucar de Matamoros, or another town that has disappeared, or the city founded in 1551 by Fray Toribio, Acapetlahuacan.

123. Castellanos de García, "Concretización de la ciudad"; and García Lastra, "Joaquinismo." Later chroniclers of Puebla, such as Fray Agustín de la Madre de Dios in 1648, make explicit the association of the city with Joachim of Fiore.

124. See above, section entitled "Joachin's Monastic Jerusalem."

125. Since the dove was unknown in New Spain, the hummingbird replaced it in Christian iconography. See the *Codex Azcatitlan*, where the hummingbird-dove is depicted on an Indian banner.

126. García Lastra, "Joaquinismo," 131.

127. García Lastra, "Joaquinismo," 107 n. 10. Throughout the colonial era there were reports that Puebla had been founded in fulfillment of the prophecies in Ezekiel, Zechariah, or Revelation. See, e.g., Torres Pezellín, *Jerusalén triunfante y militante;* and Rubial García, "Palabra e imagen."

128. Cf. the *sacro monte* of San Vivaldo, below, which also replicated Jerusalem with topographical precision.

129. Ruíz Martínez, *Las capillas del via crucis;* and Castellanos de García, "Concretización," 86–96. In the seventeenth and eighteenth centuries the jerusalemization of Puebla became even more elaborate. The chapels of the stations of the cross survive today and contain stones (relics) from all the important *loca sancta* of the Holy Land.

130. Joachim had also claimed that angels would descend to earth to dwell with human beings in the Last Days.

131. Five towers, forming a quincunx when seen from above, are also a hallmark of the mythical Grail Castle; see Adolf, *Visio Pacis,* 93, 129. A five-towered city was re-created in ephemeral materials for a stage set of the captive Jerusalem in the Tlaxcalan catechetical play that I shall examine in chap. 6.

132. Castellanos de García, "Concretización," 78–85, and figs. 3 and 3A.

133. Zech. 2:5–9 is quoted by several chroniclers: "Again I raised my eyes and looked: there was a man with a measuring line in his hand. 'Where are you going?' I asked. 'To measure Jerusalem.' Then the angel who spoke with me advanced, and another angel came out to meet him [thus two angels, like the two on Puebla's coat of arms] and said to him, 'Run, tell this to that young man: people will live in Jerusalem as though in open country [without walls].' But I will be for her an encircling wall of fire, says the Lord."

134. J. Z. Smith, "Constructing a Small Place."

135. Wilson, "The New World's Jerusalems," 43.

136. Ferri Piccaluga, "Il 'Monte Sacro' dei filosofi"; Kubler, "Sacred Mountains."

137. Kubler, "Sacred Mountains," 414–15. Wolin, "Mnemotopias," calls these parks *mnemotopia,* mental landscapes existing in real space but standing for an absent or imaginary realm reconstructed by the memory.

138. De Sandoli, *The Peaceful Liberation;* Kloetzli, "The Franciscans in the Holy Land."

139. Rusconi, "Gerusalemme"; Innocenti, "Il francescanesimo e I Sacri Monti"; Cardini, "La devozione a Gerusalemme"; Langé, "Problematiche emergenti." Wadding, *Annales minorum,* 15:375–76: "Constructus . . . in similitudinem locorum sacrorum, quae exstructa sunt in sacro Monte Sion et Monte Oliveti; et enim colles et valles hujus loci valde similes sunt illis Hierosolimitanis."

140. Debiaggi, "La capella *subtus crucum.*" This chapel under the cross housed a portable image of the dead Christ. The building corresponded spatially to the Stone of Unction between Golgotha and the Holy Sepulcher tomb in the original Jerusalem complex.

141. For the importance of the Valley of Jehosaphat at the *sacri monti* of Vivaldo, see Neri, *Il Santo Sepolcro,* 102.

142. Lippe, *Missale Romanum Mediolani 1474,* 1:330, lists a medieval votive Mass of the Five Wounds, "Missa quinque plagarum santissimi corporis iesu christi."

143. Between 1470 and 1530 there appeared in print at least sixty travelogues by Europeans who had journeyed to the Holy Land. See Schur, *Jerusalem in Pilgrims' and Travellers' Accounts.* Among the more scientifically accurate were Bernard von Breydenbach, *Peregrinatio in Terram Sanctam,* 1486, translated into Spanish by Martín Martínez de Ampiés and published 1498; Cristiano Adricomio Delpho (d. 1585) (listed in bibliography under Adrichem), *Breve Descripcion de la Ciudad de Jerusalem;* Bernardino Amico, *Trattato delle piante e immagini dei Sacri Edifici* (Florence, 1609).

144. The Biblioteca Nacional de México possesses several examples.

145. Friar William Wey, tour guide to Breydenbach's party and chronicler of Venice, returned home with a great assortment of mementos: a cloth painted with the Temple of Jerusalem, leaves of parchment with pictures of the Temple and the Mount of Olives, and a whole quire of paper with paintings of the Lord's Passion. See William Wey, *Itineraries,* 221–23; also see Prescott, *Friar Felix at Large.*

146. On wooden models, see Goren, "An Imaginary European Concept"; and Goren and Rubin, "Conrad Schick's Models."

147. Vannini, "S. Vivaldo e la sua documentazione"; and Ousterhout, ed., *The Blessings of Pilgrimage,* 113, on measurements.

148. See Kubler, "Sacred Mountains"; and Smosarski, "Kalwaria Zebrydowska come spacio teatrale." For Amecameca, see Vera, *El santuario del Sacromonte.*

149. Langé, "Problematiche emergenti," 5; and Gatti Perer, ed., *La dimora di Dio,* 104–13.

150. Escobar, *Americana Thebaida,* 79; and Nebel, "El rostro mexicano de Cristo," 63.

151. For *humilladero* chapels and their use as posas, s.v. "Adoratorio," in *Enciclopedia de la Iglesia Católica* (Mexico: Enciclopedia de Mexico, 1982), 1:71. These chapels appear to have originated in Spain on the fighting frontier between Christians and Moors where they probably acted as apotropaic devices for protection and to indicate whether a town was Christian or Muslim. See Gil Atrio, "¿España?" 68–69.

152. Palm, "¿Urbanismo barroco en América Latina?"; Guarda, "La liturgia," 51–61; Bonet Correa, "Sacromontes y calvarios"; and Maza, *La ciudad de Cholula*, 94, for the Street of the Holy Places of Palestine.

153. Salcedo, *Urbanismo*, 209–12.

4. THE NEW TEMPLE IN THE NEW ZION

1. Matos Moctezuma, "Symbolism of the Templo Mayor"; Broda, "Templo Mayor as Ritual Space"; and Read, "The Fleeting Moment," 188.

2. The quarternity-quincunxity is comparable to other ancient urban areas. See Wheatly, *Pivot of the Four Quarters*.

3. Carrasco, "Myth, Cosmic Terror." The Temple of Jerusalem functioned in a similar way. See Smith, *To Take Place*, 47–73.

4. Broda, "The Provenience of the Offerings."

5. Molina Montes, "Templo Mayor Architecture"; Averni, "Mapping the Ritual Landscape."

6. Sauer, *Symbolik des Kirchengebäudes*, 102–3.

7. Isidore of Seville, *De Ecclesiasticis Officiis* (*PL* 83:739) speaks, for example, of the Levites (deacons) who, at one point in the Mozarabic Mass, have the task of opening the "Ark of the Covenant." Du Cange, *Glossarium Mediae et Infimae Latinitatis*, 1:1, identifies the *arca* in this case with the apse area. The separate and hidden space of the Iberian apse is thus the Christian equivalent of the Temple's *Sancta sanctorum*. See Fernandez Arenas, *La arquitectura mozárabe*, 214.

8. Walafried Strabo, *De Rebus Ecclesiasticis*, 1; Honorius Augustodunensis, *Gemma anima sive de Divinae Officiis* 1.123. Honorius asserts (col. 582) that the church sanctuary corresponds to the Holy of Holies and the nave to the Holy Place, as in the Mexican single-nave churches.

9. Durandus, *Rationale*, 18. Durandus spent most of his mature years at the papal court and was a principal adviser to Gregory X at the second Council of Lyon in 1271. He summarized the liturgical knowledge of the Middle Ages, basing his work largely on the temple symbolism of the *Homilies on the Vision of Ezekiel* by Gregory the Great. His writings, in turn, exercised a decisive influence on the liturgical books of Piccolomini (1496), Bruchardus (1506), and Castellani (1507 and 1523), which were also influential in the New World.

10. Copies abound in Mexican libraries with colonial holdings. Also see Elsa Cecilia Frost, "Fuentes bíblicas, clásicas y contemporáneas," in Torquemada, *Monarquía indiana*, 7:267–341.

11. Stookey, "The Gothic Cathedral."

12. Joüon, "Les mots employés."

13. Edgerton, *Theaters of Conversion*, 47, 82, says that by this means "the new shrine founded on the earlier holy site osmotically assum[ed] the latter's holiness even when the old cult had been supplanted."

14. A letter from the Franciscans in Huejotzingo to Charles V in 1533 asserts that the friars were not surprised when they encountered human sacrifice in Mexico, because even though it was evil, it arose out of a pious desire for divine assistance. The letter is quoted in Morales, "Franciscanos ante las religiones indígenas," 91.

15. For "Solomonic chapels" in Europe, see Holmes, "The Arthurian Tradition."

16. Mullen, *Dominican Architecture*, 125.

17. Bailey, *Art on the Jesuit Missions*, 30–31.

18. Tibón, *El ombligo*, 60–65.

19. Vilnay, *Legends of Jerusalem*, 78–79.

20. Bede, *On the Temple*; Rosenau, *Vision*, 19–64.

21. *The Homilies of Gregory the Great*, 158–59.

22. Both Richard of St. Victor's text and Nicholas of Lyra's are extant in great numbers in Mexican colonial libraries.

23. Rosenau, *Vision*, 91–183.

24. For the growing literature on this subject, see Taylor, "Architecture and Magic"; Ramírez, *Dios arquitecto;* and the Web site of Juan Rafael de la Cuadra Blanco, "El Escorial y el Templo de Salomón," at http://sapiens.ya.com/jrcuadra/jr-0.htm.

25. Comay, *The Temple of Jerusalem*. Zerubbabel's temple is mentioned in the prophets of the exile, especially Zechariah, Haggai, and Malachi. Typical of the liturgical use is a passage like the following describing the openness of the city that now needs no walls for defense: "Zion is our mighty citadel; our saving Lord its wall and defense. Throw open the gates, for our God is here among us." Also see Ezra 4:24–25.

26. Columbus's *Book of the Prophecies* is filled with quotations from the minor prophets regarding Jerusalem, the Spanish monarchy, and the rebuilding of the Temple.

27. John 2:13–22: "Destroy this temple and in three days I will raise it up. . . . They did not understand that he was speaking of the temple of his body."

28. Neagley, "Architecture and the Body of Christ," 27–36.

29. Motolinía quotes St. Paul in *El libro perdido*, 73. Also see the early baptismal ritual in Focher, *Enchiridion*.

30. See Gnilka, *Studien zur Psychomachie*, 83–92.

31. The temple and altar of Revelation symbolize the New Israel of the Church. See explanatory notes in *New American Bible* (Wichita: Catholic Bible Publishers, 1987), 1383.

32. One further note about this heavenly temple might be apropos. In chap. 11:2 of Revelation the angel tells the Seer to measure the building, but to exclude the outer courtyard, which has been handed over to the nonbelievers. In the mendicants' complexes in New Spain only the inner court of the true Israelites has been reconstructed; the outer courtyard is the town's civic plaza.

33. The one Constantinian construction on Temple Mount was the Golden Gate. Landay, *Dome of the Rock*, 46–59.

34. Eusebius, *Vita Constantini*; and Egeria, *Travels*, 19–22. Eusebius of Caesarea, who quoted Ezekiel's passages on the eschatological temple in his dedicatory speech, spoke of the Anastasis rotunda as the new "Holy of Holies." A comparison of the ground plans of the Jewish Temple and the Holy Sepulcher reveals that the placement of Christ's tomb in relation to the rock of Calvary is the same as that of the ark of the covenant to the altar of holocausts. See Egeria, *Travels*, 40–41. There was thus established a symbolic connection between the altar on Mount Moria (in an atrium) and the cross of Christ on Golgotha (in an atrium). Bede made a similar connection in *On the Tabernacle* and *On the Temple of Solomon*.

35. Egeria had seen the relics during her pilgrimage: the ring of King Solomon, the anointment horn of the kings of Judea, and others. See Kühnel, *From the Earthly*, 84–89. For the mutual feast of dedication and the transference of the relics, see Schwartz, "The Encaenia."

36. Lerner, "Joachim of Fiore's Irenic Vision."

37. The latest was the Franciscan complex "Holy Land in America," built in 1899 in Washington, DC.

38. Also see Krautheimer's "The Carolingian Revival."

39. See, e.g., David-Roy, "Chapelles hautes." In New Spain, the first church dedicated to the Virgin was Santa María la Redonda (St. Mary the Round) on the hill of Chapultepec in Mexico City.

40. Smith, "Constructing a Small Place," 24.

41. Krautheimer, "Introduction to an Iconography" (*Studies*, 122, 128).

42. On the four senses of Scripture used in architecture, see Sedlmayer, *Epocas y obras artísticas*, 2:230–42.

43. E.g., Bandmann, *Mittelalterliche Architektur*; Sedlmayer, *Die Entstehung der Kathedrale*; Kitschelt, *Die frühchristliche Basilika*; and Panofsky, *Gothic Architecture and Scholasticism*. For architectural copies of venerated Jerusalem buildings, see Ousterhout, ed., *The Blessings of Pilgrimage*; Ousterhout, "The Temple, the Sepulchre"; Posner, "Cloister, Court and City Square"; Fergusson, "The Refectory at Easby Abbey"; Ramírez, *Construcciones ilusorias*; Ramírez, *Edificios y sueños*; Battisti, "Roma apocalittica"; Taylor, "Architecture and Magic"; Rodríguez de Ceballos, "El simbolismo"; A. Grabar, *Martyrium*; Krautheimer, "Introduction to an Iconography," and "The Carolingian Revival"; Neri, *Il Santo Sepolcro*. Also see the collection of essays in Kühnel, ed., *The Real and Ideal Jerusalem*; Frank and Clark, "Abbot Suger"; and the essays in Paszkiewicza and Zadroznego, eds., *Jerozolima w Kulturze Europejskiej*.

44. Krautheimer, "Introduction to an Iconography" (*Studies*, 149–50).

45. See, e.g., Krautheimer, "Introduction to an Iconography" (*Studies*, 17); Baum, *Romanesque Architecture*, vii–viii; Conant, *A Brief Commentary*, 25; Lasteyrie, *L'architecture religieuse*, 279; Vallery-Radot, *Eglises romanes*, 36–38; Hubert, "Les églises"; Rosenthal, "A Renaissance 'Copy'"; and Smith, "Constructing a Small Place," 20–24.

46. As at Aquilea in northern Italy.

47. Smith, "Constructing a Small Place," 23.

48. Ousterhout, *The Blessings of Pilgrimage*, 114.

49. For the Byzantine Empire's "Jerusalem consciousness" in later centuries, see Patlagean, "Byzantium's Dual Holy Land."

50. Ramírez, *Edificios y sueños*, 70–74.

51. Scheja, "Hagia Sophia"; McClung, *Architecture of Paradise*, 78–82. An even more overt statement of resemblance to the Jerusalem Temple and Holy Sepulcher is suggested for Hagia Sophia's sister church, the cathedral of the same name in Edessa. See McVey, "The Domed Church."

52. A document of the year 887 already calls the site Sancta Hierusalem. Corboz, "La ciudad," 59.

53. As in Mexico. Rocks or stone from these sites made their way to the first open chapel in Mexico City and to the stations of the cross in Puebla.

54. This "Jerusalem" at Bologna illustrates the practice followed in laying out a copy. Obviously the builder of a reproduction of a holy site would try to get the needed data either by traveling himself, by sending correspondents to the site, or by relying on plans and de-

scriptions of the prototype. Plans—such as the one by Arculf (9th c.), which was copied throughout the Middle Ages—were evidently of considerable importance, and it is most likely that it was this or a similar plan that formed the basis for the general arrangement of the edifices at Bologna. The extensive use made of such plans throughout the Middle Ages becomes evident time and again. Krautheimer, "Introduction to an Iconography" (*Studies*, 129).

55. Apparently the Bologna copy was meant to reproduce the eleventh-century form of the Holy Sepulcher after the Byzantine reconstruction by Constantine Monomachus (c. 1042–48). Ousterhout, "Rebuilding the Temple," 66–78.

56. Ousterhout, "Church of S. Stefano," 315–16; Ramírez, "Evocar," esp. 10. The liturgical use of the complex, especially during the Holy Week rites, further confirmed the mimetic character.

57. Muslims hold Isa [Jesus] and his mother Miriam in great respect, and legends of the Virgin entered the Koran. Soucek, "The Temple after Solomon."

58. Kaplony, *Haram of Jerusalem*, esp. 194–97. In the Koran, Solomon is the exemplum of wise rulership, and thus the site of his law court, the Hall of the Forest of Lebanon, was venerated by the early Muslims of Jerusalem. Mohammad mentions the "room where Solomon wrote the book of Wisdom." Also see Howard, *Venice and the East*, 180.

59. Kaplony, *Haram of Jerusalem*, 23–88; the Dome and the mosque are still considered to be "the new Muslim Temple on Temple Mount," a rebuilt Temple; correspondingly, the Koran is the new Torah.

60. Wilkinson et al., *Jerusalem Pilgrimage.*

61. Ramírez, "Evocar." Even Hebrew manuscripts and incunabula label the Dome of the Rock "the Temple." See Sabar, "Messianic Aspirations."

62. Such as that of Fray Nicholas of Lyra, fourteenth century.

63. Rosenau, *Vision*. In utopian city planning well into the nineteenth century, the ideal city, sacred or secular, was often laid out around a now secularized octagonal structure that had the Dome of the Rock, or the Anastasis rotunda, or both as its original model(s). Here too the intent to copy is evident. See Limpricht, *Platzanlage und Landschaftsgarten*, 3–12; and Tod and Wheeler, *Utopia*, 65, 85, and 135.

64. Creswell, *A Short Account*, 204–13.

65. It has been proposed that the cathedral complex at Pisa is a replica of the several buildings on the Haram al-Sharif. The Pisan complex consists of a centrally planned baptistery, a rectangular basilica, and a tower, all located in the Campo dei Miracoli, the equiva-

lent of the Temple esplanade. The form and proportions of the basilica's arcades are identical to those of the lower register of the Dome of the Rock. The basilica's columns and cupola also repeat those aspects of the Qubbat al-Sakra. Also, the position of the baptistery relative to the basilica repeats the position of the Dome of the Rock relative to the major Islamic mosque, the Al-Aqsa, on the Temple esplanade. Cahn, "Solomonic Elements"; Corboz, "La ciudad," 60–61. A second "leaning" tower had been planned to flank the basilica symmetrically; this would have created a gigantic reproduction of the two temple columns of Jachin and Boaz.

66. Pilgrims called the Templum Domini (i.e., the Dome of the Rock) the "Church of the Holy of Holies" because a *sancta sanctorum* under the rock beneath the dome was said to contain such relics as Aaron's rod, the tablets of the Law, the altar Jacob erected after his dream of the ladder, and manna from the desert. The Templum Domini was entrusted to the Augustinian canons, who constructed altars, chantries, and stalls within and added an external cloister to the north side. See Krinsky, "Representations," n. 19.

67. The description of these buildings is also given in a Crusader ballad, "The Conquest of Jerusalem"; see Adolf, *Visio Pacis*, 109. Ramírez, *Edificios y sueños*, 79–99, proposes, for example, that the portico arcading of the Templar Church of Nuestra Señora at Eunate, Spain, replicates what the Knights of St. John of Jerusalem had seen on the Haram al-Sharif.

68. For Templar architecture in general, see Lambert, "L'architecture des Templiers." For twelfth-century "Solomonic chapels" in France mentioned in Crusader literature, see Holmes, "The Arthurian Tradition."

69. The twelfth-century pilgrim would have seen several Christianized aedicules in the vicinity of the Templum Salomonis: the little school of the Virgin at the southwest, an anonymous aedicule at the southeast; and a large "posa" of Islamic origin called the Cupola of the Chain, which later became a chapel dedicated to St. James. The Dome of the Rock itself acted as a fourth posa. See Vincent and Abel, *Jérusalem nouvelle*, 971.

70. For example, the Haram, like the New World corrals, acted as a Christian cemetery. Burying the dead on Temple Mount would have been unthinkable to Jews or to Muslims. See Boas, *Jerusalem*, 182.

71. Wagner, "Open Space," 11–16.

72. Dynes, "The Medieval Cloister," 64; and Vincent and Abel, *Jérusalem nouvelle*, 832–41. In the first century CE, while Herod's Temple still stood, it was common to speak of the eastern arcade of the complex as the "Portico of Solomon," and it would later be

conflated with the Golden Gate in the eastern precinct wall. For European copies of the Golden Gate, see Cahn, "Solomonic Elements," 48 and n. 3. It was frequently visualized as an open arcade, similar to Mexican porticos. See Ramírez, *Construcciones ilusorias*, 113–214. The legend of Heraclius (629 CE) is found in Jacobus de Voragine, *The Golden Legend*, 2:169. The episode of the retrieval is portrayed in fourteenth- and fifteenth-century frescos in the Franciscan Church of Santa Croce, Florence. See Hatfield, "The Tree of Life."

73. Prawer, "Jerusalem," 790. Cf. Zech. 14:4–5, Joel 3. The Golden Gate was also conflated with the "closed temple gate" of Ezekiel's vision (44:1–3). In Christian exegesis, that gate would be opened only upon Christ's second advent, and therefore it had connotations of messianic victory. See Vincent and Abel, *Jérusalem nouvelle*, 837–41. The Golden Gate was frequently depicted in medieval paintings dealing with New Testament themes.

74. Tanner, *Last Descendant of Aeneas*, 183–206; Remi du Puys, *La tryumphante entrée*, 16.

75. Gen. 19:1, 23:10; Vincent and Abel, *Jérusalem nouvelle*, 850.

76. See Zawisza, "Tradición monástica europea," 114–16.

77. Kobielus, "Bramy Nirbianskiej Jerozolimy," quoting Gregory the Great and St. Bonaventure.

78. Dynes, "The Medieval Cloister"; Pressouye, "St. Bernard to St. Francis"; Cahn, "Solomonic Elements."

79. Only a shell of this work remains, and excavation is lacking in this part of the esplanade.

80. Ramírez, *Edificios y sueños*.

81. Acts 5:12, 2:44, 4:32. Also see Pressouyre, "St. Bernard to St. Francis," 74–92.

82. Kubler, "The Claustral 'Fons Vitae'"; Sebastian López, "La versión iconográfica."

83. Its many vertical columns reminded the monks and friars that they stood like the morally upright martyr Abel and the eschatological prophet Enoch, pillars of faith. See Sicardus of Cremona (1160–1215) in his *Mitrale* (*PL* 213:13–436).

84. Phillips, "Processions through Paradise," and "La participación de los indígenas."

85. Krinsky, "Representations"; Dynes, "The Medieval Cloister," 66–68; Cahn, "Solomonic Elements"; and Naredi-Raimer, *Salomos Tempel*, 103–15. For utopian concepts associated with the cloister-atrium-plaza at Loretto, see Posner, "Cloister, Court and City Square."

86. See above, chap. 2. In certain annual ceremonies, the deity impersonator visited four ceremonial locations associated with the four cardinal directions, similar to the liturgical stations. Tezcatli-poca, for example, made four stational stops during the annual ceremony of Toxcatl. See Carrasco, "The Sacrifice of Tezcatlipoca."

87. Kubler, *Architectura mexicana*, 538; E. B. Smith, *The Dome*, 67–71. The *kalybe* or *kalube* comes into Arabic as *qubba*, a dome, shrine, or memorial for the dead.

88. Kaplony, *Haram*, 90, 659–62. The conical domed structure was substantially rebuilt in the nineteenth century, although along former lines.

89. Known today in Arabic as the Koursy 'Aisa, and sometimes referred to as the Dome of Solomon, Qubbat Sulaiman. See Wilkinson, *Jerusalem Pilgrims*, fig. 19. It is a smaller replica of the Qubbat al Miraj, which acted as the baptistery of the Augustinians' Templum Salomonis during the Crusader period.

90. In 1418 De Caumont wrote in his *Voyage d'Outremer*, "Under an arch there are two white stones on which it is said Jesus Christ reposed while carrying his cross." Quoted in Vincent and Abel, *Jérusalem nouvelle*, 616 n. 2. Breydenbach, *Viaje de la Tierra Santa* (1486), fol. 65v, relates: "About ten paces in front of the temple [Dome of the Rock] there is a rock where Christ, carrying his cross, fell. There is another rock next to the wall which shows signs of Christ's precious blood." According to Wilkinson, *Jerusalem Pilgrims*, 74, there was general confusion about where the praetorium of the Fortress Antonia had been located.

91. Wilkinson, *Jerusalem Pilgrims*, 76. Crusader capitals originally from this chapel are to be found today in the Islamic Museum on the Haram. See Folda, *Art of the Crusaders*, 259.

92. Just like the confusion about the Dome of the Rock or the Al-Aqsa Mosque and the Temple. The conical structure is also known as the "Dome of Those Who Love the Prophet," *Qubbat Ushshaq An Nebi*.

93. Vincent and Abel, *Jérusalem nouvelle*, 587, 604–6, 612, 614; Wilkinson, *Jerusalem Pilgrims*, 75. According to Wilkinson, 43, a cistern, located under a baldachin or *qubba* in the same part of the Haram, was associated with the prophecy of Ezekiel (47:1) regarding the water that would flow from the right side of the Temple.

94. Schiller, *Iconography of Christian Art*, 2:73 and illus. 259 (c. 1460, Ferrarese school) and 260 (c. 1521, Hans Holbein the Younger). Schiller, 2:73 n. 56, presumes that the European *Herrgottshuh* chapels go back to the Crusader Church of the Repose in Jerusalem, mentioned as early as 1187. The passional iconography may have to do with another Islamic-Christian *qubba* nearby, that of the Jewish priest Zechariah, who was martyred in the Temple while offering sacrifice.

95. Kaplony, *Haram*, 660–61.

96. Vincent and Abel, *Jérusalem nouvelle*, 606–16. The latter aedicule, which seems to duplicate the former, measures 4.90 meters each side, identical to the posas at Huejotzingo. Also see Wilkinson, *Jerusalem Pilgrims*, 75–76.

97. See the souvenirs mentioned by Friar William Wey, chap. 3, n. 145 above; and Bonnery, "L'edicule du Saint-Sepulcre."

98. It too was a pilgrimage church and the architecture of its cloister has striking Islamic features. Hillenbrand, *Islamic Architecture*, 443, claims that Moorish Spain depended on Syria for its architectural styles. See also Melkian, "Un cloitre inspiré d'une mosquee." Architects from Morocco worked in Spain before Philip II's systematic destruction of Spanish mosques.

99. Díaz Díaz, *Iglesia y claustro*, 37–46. The scenes represented are the Annunciation, Nativity, visit of the Magi, flight into Egypt, Resurrection of Christ, beheading of John the Baptist, and slaughter of the Holy Innocents by soldiers of King Herod who are dressed in medieval armor.

100. Valadés, *Rhetorica Christiana*, 477. Note that the aedicules are located in hamlets that surround a larger metropolis, just as the four *calpulli* barrios and their religious buildings and altars surrounded the Aztec urban center, repeating the familiar quincunx pattern.

101. Krinsky, "Representations"; Ramírez, *Construcciones ilusorias*, 113–214; Ávila, *Imágenes y símbolos*. For the theme of the Temple in visual arts, s.v. "Temple," *Encyclopaedia Judaica* (Jerusalem: Keter, 1971), 15:984–88; Palm, "La aportación de las ordenes mendicantes." Cf. White, "Giotto's Use of Architecture."

102. Ávila, *Imágenes y símbolos*, 30–32, 47–76; and Edgerton, *Theaters of Conversion*, 173–80.

103. The ciborium-temple appears in the works of artists like Jacobo Bellini, Taddeo Gaddi, Ambrogio Lorenzetti, Duccio di Buoninsegna, Andrea Orcagna, Gentile da Fabriano, and Fra Angelico. See Krinski, "Representations"; Ramírez, *Construcciones ilusorias*, 113–216; and Naredi-Rainer, *Salomos Tempel*, 90–102.

104. Bramante's "little temple" in the atrium of San Pietro in Montorio, the Franciscan missionary center, appears to follow from the same line of thinking. See Ramírez, "Evocar," 15–16.

105. Ávila, *Imágenes y símbolos*, 30–32, 47–76; Krinsky, "Representations," 13; Ramírez, *Construcciones ilusorias*, 155–57.

106. Ávila, *Imágenes y símbolos*, 55.

107. Valadés, *Rhetorica Christiana*, 96.

108. Revel-Neher, *L'arche d'alliance*, 201–5.

109. Rosenau, *Vision*, 38–39, 43.

110. Prawer, "Jerusalem," 779–81.

111. Gutmann, "When the Kingdom Comes."

112. *Mishnah*, 873–82. The Middot dates from c. 150 CE. Van Pelt, "Los rabinos."

113. *Middot* 1:6. Rosenau, *Vision*, 35–39. Maimonides used some measurements from Ezekiel, but the temple he wished to reconstruct in a liberated Israel was that described by God to Solomon.

114. See Sarfati, *Offerings from Jerusalem*, for abundant examples. Rosenau, *Vision*, 35–36, states that another Spaniard, Joshuah-ben-Abraham-Gaon, who worked in Soria, Castile, was the creator of a manuscript of which two fragments exist in the Bodleian Library, Oxford. They display a complicated series of arcades to represent the Temple, or perhaps its porticos. Rosenau, *Vision*, 35–36. For the symbolic importance of arcades and porticos, see Baltrustaitis, "Villes sur arcatures."

115. Smalley, *Study of the Bible*, 149–56, et passim.

116. As with so many other important works, such as those of Joachim of Fiore, the second decade of the sixteenth century saw a great interest in having these works published.

117. Cahn, "Architectural Draftsmanship"; Cahn, "Architecture and Exegesis"; Rosenau, *Vision*, 36; Schöller, "Le dessin d'architecture"; Gardelles, "Recherches."

118. French churches with crenellated façades (Moissac and Saint-Denis) were constructed contemporaneously with Richard's work and probably made use of it as a model. See Crosby, *L'abbaye royal*, 35. The central passageway of the eastern gatehouse is entered by means of a round-arched doorway flanked by columns thought to represent the restored columns of Jachin and Boaz. The doorway is in turn surmounted by a second relieving arch identical to the double-arched *porciúncula* in Mexico. See Cahn, "Architecture and Exegesis," 60, where the second arch is labeled *tectum portae*.

119. A *gazophylacium* can be interpreted as a closet, kitchen, sacristy, storeroom, and, according to the Roman architect Vitruvius, a place of repose—a posa.

120. The temple house is shown with *latera* (my fig. 4.19), which Richard interprets as stalls running lengthwise through the three halls, even into the Holy of Holies. Richard, who was an Augustinian canon in Paris, is imagining the canons' stalls of a medieval cathedral or collegiate church. He had used Bede's influential *De Templo Salomonis Liber* as a basis for his work. For the influence of Bede, see the introduction to Bede the Venerable, *On the Tabernacle*, trans. Holder. It seems likely that Richard knew of the buildings on the Haram al-Sharif by firsthand reports. See Cahn, "Architecture and Exegesis," 61–63.

121. For the history of Lyra's work, see Nicholas of Lyra, *Biblia Latina cum Glossa Ordinaria*, vii–xxv. It was also known as the *Postillae perpetuae* or the *Postillae litteralis in vetus et novum testamentum*, or

sometimes simply as the *Glossa Ordinaria* because it included and annotated an earlier work by that name of Anselm of Laon. I have found copies of all titles in Latin American colonial libraries.

122. Nicholas of Lyra's portrait hangs in the Franciscan convent of Cholula, Mexico. He was born in the Norman town of Lyre c. 1270, entered the Franciscans in 1301, and became minister provincial of Paris, northern France, and Flanders in 1319. The basic works on Lyra and his *Postillae* are Wadding, *Annales minorum*, 5:297–300, 7:281–82; Labrosse, "Sources de la bibliographie"; Reinhardt, "Das Werk des Nicholas von Lyra"; s.v. "Lyra, Nikolaus de Lyranus," *Encyclopaedia Judaica* (Berlin: Eschkol, 1928–34), 10:1263; s.v. "Lyra, Nicolas de," *Universal Jewish Encyclopedia* (New York, 1942), 7:257; Gosselin, "A Listing of the Printed Editions"; Herrmann, "Unknown Designs"; Kaczynski, "Illustrations of Tabernacle and Temple"; Rosenau, "Architecture"; Laguna Paúl, *Postillae in vetus*; Laguna Paúl, "Nicolás de Lyra"; Martínez Ripoll, "Exégesis escrita"; and Krey and Smith, eds., *Nicholas of Lyra*.

123. Which led to the Counter-Reformation dictum, "Si Lyra non lirasset, ecclesiam Dei non saltesset, Lutherus non saltasset." Lyra received his information regarding the Talmud through the writings of Maimonides and the earlier Rabbi Solomon-ben-Isaac (1040–1105), better known as Rashi. Rashi, a contemporary of Richard of St. Victor, had also drawn plans to illustrate his commentaries. He was particularly interested in the *peshat*, the literal understanding of Scripture, and this suited Lyra's interests precisely. See Levy, *Rashi's Commentary*; Hailperin, *Rashi and the Christian Scholars*, 290–91; and Signer, "Vision and History." Lyra's sources for the Middot rabbinical commentary were Jewish informants, whom he regarded as more reliable in their interpretations than the Latin authors. He often supplies two renderings of the same Temple section or object, one labeled "according to the Catholics" (i.e., Latin authors) and the other "according to Rabbi Solomon" (i.e., Rashi), always favoring the latter.

124. *Códice Mendieta*, in García Icazbalceta, *Nueva colección*, 1:81. In a letter of 1567, Mendieta states that among the books that must be in every conventual library are the *Glossa Ordinaria* and the *Flos Sanctorum*. Since the normal *Glossa* was that contained in Lyra's commentaries, we can be sure that he is referring to the *Postilla*. Archbishop Zumárraga of Mexico City had Lyra's *Glossa-Postilla* in six volumes in his personal library, as well as his *Contra Judios*. See Gil, *Primeras doctrinas*, 661.

125. See Cahn, "Architecture and Exegesis," 65.

126. Laguna Paúl, "Nicolás de Lyra," 44–46, 54. In light of the medieval understanding of the Solomonic origin of the cloister and

the biblical identification of the *latera* as a place for the temple clergy, it is reasonable to see here a visual precedent for the mendicant arrangement.

127. Andean posas display two pitched roofs rather than a pyramidal roof. The two gatehouses reappear in two Spanish temple illustrations based on Lyra's model: a Spanish Haggadah (mid-fourteenth century), now in Sarajevo and thus known as the Sarajevo Haggadah (National Museum, fol. 32r), and the Bible of the Duke of Alba. See Rosenau, *Vision*, 37; Nordstrom, *The Duke of Alba's Castillian Bible*, 22. The Hebrew caption accompanying the Sarajevo illumination says: "The temple which will be built soon in our days."

128. On Nicholas's plan, the northeast *gazophylacium* combines two rooms or structures together, making a total of four.

129. However, Ezekiel's references to these structures are quite unclear, so it was apparently for reasons of symmetry that Lyra chose to present the chambers in the corners and without regard to scale or to the letter of Ezekiel's text:

Then [the angel] led me to the inner court where there were two *chambers*, one beside the north gate, facing south, and the other beside the south gate, facing north. He said to me, "This *chamber* which faces south is for the priests who have charge of the temple, and the *chamber* which faces north is for the priests who have charge of the altar." . . . Then he measured the court, a perfect square. The altar stood in front of the temple. [40:44–47, emphasis mine]

Then he brought me by the entrance which is on the side of the gate to the *chambers* which face the north. There, at their west end, I saw a place, concerning which he said to me, "Here the priests cook the guilt offerings and the sin offerings, and bake the cereal offerings, so that they do not have to take them into the outer court at the risk of transmitting holiness to the people." Then he led me into the outer court and had me pass around the four corners of the court, and I saw that in each corner there was another *court*: in the *four corners* of the court, *minor courts*, forty cubits long and thirty wide, all four of them the same size. A wall of stones surrounded each of the four. [46:19–23, emphasis mine]

130. See Valadés's illustration of the ideal evangelization patio, where the word IUSTITIA indicates a tribunal scene.

131. Laguna Paúl, "Nicolás de Lyra," 40.

132. Laguna Paúl, "Nicolás de Lyra," 56–58. For the *Nuremberg Chronicle*, see Schedel, *Chronicle of the World*, esp. 640, 644.

133. Rosenau, *Vision*, 91; Herrmann, "Unknown Designs," 151–52, 155; Martínez Ripoll, "F. Vatable y R. Éstienne"; Naredi-Rainer, "Between Vatable and Villalpando."

134. The Franciscans published Lyra's *Postillae* with Vatable's illustrations in 1589. See Fernández de Castillo, *Libros y libreros*, 254–56, 514–17, 580; Rosenau, *Vision*, 91–92. The illustrations also found their way into the Protestant Bible of Geneva (1560) and the Biblia Sacra of Antwerp (1576); see Laguna Paúl, *Postillae*, 58–59. The fact that the illustrations had been used in a Protestant Bible led to suspicions of unorthodox doctrine, and the Inquisition later confiscated Vatable's Bibles in the Americas.

135. This case is strongly made by the Jesuits Hector Prado and Juan Baptista Villalpando, in their monumental work, *In Ezekielem Explanationes et Apparatus Urbis ac Templi Hiersolymitani* (Rome, 1596–1602).

136. For Huejotzingo, see Tovar de Teresa, "Noticias sobre," 162. The copies from Tlalteloco are to be found in the Sutro Library, San Francisco, CA, and the Biblioteca Nacional de México. For the history of the Colegio de Tlalteloco, see Mathes, *America's First Academic Library*.

137. Vatable also uses *pastophoria*, *exedrae* and *gazophylacia*, terms that recall early Christian and Byzantine rooms that functioned as sacristies or chapels. They are often found either flanking the apse or located in the church's atrium—as Ezekiel suggests.

138. For the use of splayed windows in the Bible, see 1 Kings 6:4, and Ezek. 40:16, 41:16.

139. Martínez Ripoll, "Exégesis escrita," 89.

140. Villalpando uses two words for the Temple's "posas" in his 1596–1602 commentary: *pastophoria* and *gazophilacia*. Villalpando explains that *pastophoria* comes from the Hebrew word meaning to enclose in an arch or a dispensary. In speaking of *gazophilacia* he relies on Vitruvius, "who described the use of these rooms in the Greek academies. . . . Cicero, for his part, affirms that they were the place where one *reposes* at midday. . . . As regards the seats in them, they were used to administer justice." See *In Ezechielam*, 85, 153–54, emphasis mine. Villalpando, while harshly criticizing Lyra, actually demonstrates how influential the Franciscan had been: "Lyra tried with all his means and schemes to clarify the prophecy of Ezekiel with the help of the commentaries of Hebrew and Christian authors. His efforts and his interest were valued at that time, a time in which, ignorant of what concerns the art of architecture, the creations and fictions of the Longobards [Gothic architecture] could be seen all over Europe. They erected the most monstrous buildings while wasting a lot of money" (ibid., 37).

141. The Dominican Felix Faber, whom we met earlier in speaking of Venice, acted as his tour guide. One of the forty or more pilgrims in the group was the painter Erhard Reuwich, who did the drawings.

142. Bataillon, *Erasmo y España*, 809. Nor was Breydenbach's book the only one on the topic of travel to Palestine. Other sixteenth-century works included those of Fray Antonio de Lisboa (1507), Fray Diego de Mérida (1512), Alonso Gómez de Fugueroa (1513), Fadrique Enríquez de Rivera (1520), Pedro Manuel de Urrea (1523), Fray Antonio de Aranda (1533), which for the first time gave measured distances, Jacob Ziegler (1536), Sebastian Münster (1550), and Cristiaan van Adrichen (1584).

143. Palm, "Los Pórticos," and "Para enforcar." For the influence of Breydenbach's book and illustrations on the architecture of the *sacri monti* in Italy, see Pacciani, "L'architettura."

144. See below. Both ramp and shrine reappear in another of Breydenbach's woodcuts illustrating Jesus' temptation on the roof of the Temple (an open chapel) by Satan. Breydenbach, *Viaje de la Tierra Santa*, fol. 74r. They were also copied by Schedel for his world chronicle.

145. See Schedel, *Chronicle of the World*, fols. 63v, 65v.

146. Holbein, *Images from the Old Testament*. Holbein also used Lyra's 1481 edition of the *Postilla*. Rosenau, *Vision*, 68. For Juan Gerson, see above, chap. 2, "Tecamachalco."

147. Córdova Tello, *El convento*.

148. For the three phases, see Córdova Tello, *El convento*, 45–62, 62–101, and 101–10, respectively.

149. Palm, "Para enfocar."

150. By coincidence, this is the same size of the conical *qubba* on the Haram al-Sharif.

151. McAndrew, *Open-Air Churches*, 316; Córdova Tello, *El convento*, 102.

152. See Trens, *La Eucaristía*, 88–89. The seals at Huejotzingo are more like those of the military orders such as the Knights Templar or Hospitaler of Jerusalem. See Bascapé, *Sigillografia*, 2:205–26, 251–93. Also see Galavaris, *Bread and the Liturgy*, 78–108. The names "Jesus" and "Christ" commonly appear on medieval bread seals. For the *arma Christi* stamps, see Toussaint-Samat, *The History of Food*, 230. There is a large collection of similar bread seals at the Deutsches Brotmuseum in Ulm, Germany.

153. *De Septem Sigillis*; see Reeves, "Cardinal Egidio of Viterbo," 107.

154. See Esmeijer, *Divina Quaternitas*, 70.

155. Motolinía, *History of the Indians*, 181; and Montes Bardo, *Arte y espiritualidad*, 87, 270.

156. See Cahn, "Architectural Draftsmanship." Pinkish striated stone façades appear again at the Franciscan churches of Tepeyaca and Tepeyanco.

157. Kubler, *Arquitectura Mexicana*, 498–99.

158. See the *Liber Conformitatum* of Bartholomew of Pisa, c. 1390, which parallels every event of Christ's life with an event in the life of Francis.

159. McAndrew, *Open-Air Churches*, 320; Reyes Valerio, *Arte indocristiano*, 276. Vetancurt, *Teatro mexicano*, book 2, chap. 4, speaks of Francis's wounds as rubies, and indeed in later colonial art the wounds are given semiprecious jewels.

160. They are meant to appear Near Eastern or "exotic." See Porada, "Battlements in Military Architecture."

161. In June 1994 I inspected the remains of the whistles. I estimate them to have been about four or five centimeters in diameter, with the mouth at the bottom. Some appear to have stood straight out from the merlon wall, while a second type appears to have been spiral in shape. There were two whistles to each side of the merlons, set sixteen inches apart, and one in between the merlons.

162. Salazar Monroy, *Huejotzingo*, 23.

163. McAndrew, *Open-Air Churches*, 323.

164. Tanner, *Last Descendant of Aeneas*, 152. Also see Udina, "Recuerdos del Capítulo": "Worn across the chest, the renowned insignia of the chain was a remote image of the Eucharist, adopted by Philip the Good in memory of that lamb's wool fleece which Gideon wore and on which Jehovah, in his mercy, rained down dew as a proof that Gideon would be victorious."

165. Garcia Granados and MacGregor, *Huejotzingo*.

166. The mihrab of the Al-Aqsa Mosque has two Solomonic columns.

167. 1 Kings 7:15–21:

Two hollow bronze columns were cast, each eighteen cubits high and twelve cubits in circumference; their metal was four fingers' thickness. There were also two capitals cast in bronze, to place on top of the columns, each of them five cubits high. Two pieces of network with a chainlike mesh were made to cover the nodes of the capitals on top of the columns, one for each capital. Four hundred pomegranates were also cast; two hundred of them in a double row encircled the piece of network on each of the two capitals. The capitals on top of the columns were finished wholly in lotus pattern above the level of the nodes and their enveloping network. The columns were then erected adjacent to the porch of the temple, one to the right, called Jachin, and the other to the left, called Boaz.

2 Chron. 3:15–17:

In front of the building he set two columns thirty-five cubits high; the capital topping each was of five cubits. He worked out chains in the form of a *collar* with which he encircled the capitals of the columns, and he made a hundred pomegranates, which he set on the chains. He set up the columns to correspond to the nave, one for the right side and one for the left, and he called the one to the right *Jachin* and the one to the left *Boaz*.

Notice the reference to a collar, like that of the Order of the Golden Fleece and re-created at Huejotzingo in stone carving. The columns were not destroyed during the Babylonian captivity of the sixth century BCE but rather were transported to Babylon. Cf. Jer. 27:19 and 52:17–23. See Sebastián López, "La significación salomónica." Similar columns flanked the portal of the Augustinian Church of Tiripitío in Michoacán. See Escobar, *Americana Thebaida*, 185–86.

168. Nicholas of Lyra, *Glossa Ordinaria*, vol. 4, fol. 274, asserts that St. Jerome had interpreted the two columns of Jachin and Boaz as representing SS. Peter and John, who had performed the first apostolic miracle of healing a crippled beggar at the Beautiful Gate or Portico of Solomon's Temple (Acts 3:1–11). The Venerable Bede follows the same interpretation but also relates the symbolism to Gal. 2:9, interpreting the two columns as referring to the apostolic mission to Jews and Gentiles, respectively; see *On the Temple*, 74. Durandus, *Rationale*, 21, describes the piers and columns in a Christian church in the same way. They also make an appearance in the book of Revelation (3:12), where Christ indicates that they are inscribed columns: "Those who prove victorious I will make into columns in the sanctuary of my God, and they will stay there forever; I will inscribe on them the name of my God and the name of the city of my God, the new Jerusalem which comes down from my God in heaven, and my own new name as well."

169. Bede the Venerable, *On the Temple*, 74: "The pillars placed there stand around this door on either side when the ministers of the word show both groups of people the way into the heavenly kingdom so that each of them—whether they come to the faith of the Gospel from the light of the knowledge of the Law or from the ignorance of heathendom—may have people at hand to show them the way of salvation both by word and example."

170. Escobar, *Americana Thebaida*, 186.

171. Basket capitals, spolia from the Byzantine and Crusader periods, can be seen strewn on the Haram al-Sharif today. The lilies and pomegranates of Solomon's "patio and cloister" are also described in Román, *Repúblicas del mundo*, 12r–v.

172. Sebastián López, "La significación salomónica," 85–86.

173. For medieval columns, see Cahn, "Solomonic Elements," 51. The Portuguese church was begun in 1509; see the illustration of the façade in *La fiesta en la Europa de Carlos V*, fig. 66, p. 192. In 1534 Solomonic columns were added to the façade of Senlis cathedral in France; and Martin Luther popularized the columns of Jachin and Boaz in his illustrated German Bible in the same year.

174. Naredi-Rainer, *Salomos Tempel*, 148–59. They became the iconographic models for Emperor Charles V's heroic paired columns with the legend "Plus Ultra." They later were used as an important part of the visual mythology embodied in Philip II's Escorial palace monastery. Sedlmayer, *Epocas y obras artísticas*, 2:240; also Ramírez et al., *Dios arquitecto;* Rosenthal, "The Invention"; and Tanner, *Last Descendant of Aeneas*, 155, 167.

175. Sahagún, *Psalmodia Christiana*, 189, and n. 3.

176. Breydenbach, *Viaje de la Tierra Santa*, unnumbered foldout plate "Jerusalem." For the celebration of the Jubilee year in Mexico, see Valadés, *Rhetorica Christiana*, 431.

177. Montes Bardo, *Arte y espiritualidad*, 87.

178. *Rhetorica Christiana*, 431.

179. A diminutive doorway or niche appears below many sculpted and painted crosses in New Spain. See next chapter.

180. A complementary interpretation has been offered by Estrada de Gerlero, "El programa pasionario."

181. See Webster, "Art, Ritual," and "Descent from the Cross."

182. The fountain outside the northwest posa, the best preserved, measures 48 inches wide by 53 inches high, with a basin 25 inches deep.

183. Córdova Tello, *El convento*, 90–101.

184. In the next chapter we shall see that this stepped base is called a *momoxtli* in Náhuatl, that is, an altar. The water passes to the south of the Mexican "altar of holocausts" (the atrial cross), just as Ezekiel had prophesied. See the epigraph from Mendieta in chap. 1 about imported fruit trees in the patios.

185. Here at Huejotzingo the water flows south of the atrial cross and *momoxtli* altar. Cf. fig. 4.21.

186. See Peterson, *Paradise Garden Murals*, for the use of medicinal herbs by Aztecs and friars.

187. Mendieta, *Historia eclesiástica*, 607–11. Pedro succeeded in mastering the Náhuatl language well enough to complete a catechism by writing in the Spanish phonetic near equivalents of the Aztec idiom. It was published in Antwerp in 1528. Maza, "Friar Pedro de Gante"; McAndrew, *Open-Air Churches*, 369. Pedro was much beloved by the locals, who composed Náhuatl hymns in his honor. See Ravicz, *Early Colonial Religious Drama*, 46.

188. Torquemada, *Monarquía indiana*, 5:187–88, claims that Pedro built over a hundred churches in Mexico City, Tlaxcala, and elsewhere, and was another Solomon-the-Temple-builder. Pedro may not have been so much the architect of the evangelization centers as their ideologue. Regarding the Flemish impact on early colonial architecture, see Chanfón Olmos, "Flemish Influences"; and Obregón, "Flemish Contribution."

189. The many errors in Latin spelling and grammar in this engraving convince me that Fray Diego, the Latin rhetorician, could not have executed the image, in spite of the legend at the bottom, "F. Didacus Valades fecit." More likely, he was the ideologue.

190. McAndrew, *Open-Air Churches*, 375, 247. The size of this cross "reaching up to heaven" should not be overlooked; it may have had more meaning than just its impressive stature. The Indians of Tlaxcala called the cross Tonacaquáhuitl, "the tree that sustains our life," which is not unrelated to the medieval appellation of the cross as the "Tree of Life"; cf. Champeaux and Sterckx, *Introduction*, 365–73. The Indians of Huejotzingo also set up a towering wooden cross and used to dance round it in cross formations. In the next chapter I will show that these atrial crosses are key elements in an apocalyptic interpretation of the mendicant complex.

191. Chauvet, "The Church of San Francisco."

192. McAndrew, *Open-Air Churches*, 375.

193. Palm, "La aportación," 136, suggests that the open chapel looked like the east end of the Franciscan Church of Santa Croce in Florence, with its central chapel flanked by ten smaller chapels; but it probably looked more like the *tramezzo* screen at Santa Croce.

194. *Códice franciscano*, in García Icazbalceta, *Nueva colección*, 4:207, 215. In 1564 the main altar was given an altarstone of black obsidian. On the symbolism of obsidian, see below.

195. Cervantes de Salazar, *Life in the Imperial and Loyal City*, 54, emphasis mine; see below. Fray Diego Valadés also mentions that the Aztec temples were encircled with chancels and wooden latticework tied together with ropes. See Palomera, *Fray Diego Valadés*, 215, n. 6. Wooden latticework is also known to have fronted the aedicule of the Holy Sepulcher and the Al-Aqsa Mosque in Jerusalem.

196. The wooden columns were not replaced by stone ones until 1698.

197. The dimensions (100 by 50 cubits or 150 by 75 feet) are also those of Solomon's House of the Forest of Lebanon in 1 Kings 7:2.

198. *Codex Mexicanus caractere hieroglyphi*, 23–24. The placement of the latticework is disputed, but I believe that the iconographic meaning of the chapel will clarify its location and purpose.

199. McAndrew, *Open-Air Churches*, 382–86. The main altarpiece was painted before 1564 by a native artist, Marcos Cipac de Aquino. It was composed of two triptychs, one above the other, with a predella below—a medieval format less like works currently being made in Spain than like the van Eyck brothers' famous *Ghent Altarpiece*. Fray Pedro de Gante may have been more familiar with Flemish than with Spanish altarpieces, and must have known the already famous one in his hometown of Ghent firsthand. On the presence and work of Jan van Eyck and other Flemish artists in Spain, see Garcia Granados and MacGregor, *Huejotzingo*, 186–87.

200. As quoted in Maza, "Friar Pedro de Gante," 106–7, emphasis mine.

201. The purification of the Virgin was thought to have occurred in the Al-Aqsa Mosque, alias the Temple.

202. Mendieta, "Descripción de la relación." There was precedent for this because the Crusaders brought back stones from the *loca sancta* of Jerusalem. A wooden box, once kept in the Sancta Sanctorum of the Lateran Basilica in Rome, contains similar stones from Palestine. In this way the "holy of holies" of the Lateran became a vicarious second Jerusalem. According to legend, the Lateran also housed the menorah and ark of the covenant from the Temple of Jerusalem. See Adolf, *Visio Pacis*, 30, 111, and 183 n. 54; and Morello, "Il tesoro del Sancta Sanctorum." For the liturgical implications of these relics at Rome, see de Blaauw, "The Solitary Celebration." Similar Holy Land stones were housed in the Spanish Royal Chapel in Santa-Croce-Gerusalemme, Rome. For an anthropologist's take on this, see Smith, "Constructing a Small Place," 21.

203. Serlio's treatise, however, did not appear until 1540, and the Spanish text was not published until 1552. Serlio, *Libro tercero*, book 3. For the late medieval conversion of mosques into churches in Spain, see Remensnyder, "The Colonization of Sacred Architecture," 212–19. However, "the converted mosques were not intended for newly converted peoples, but for the Christian conquerors" (209).

204. Maza, *La ciudad de Cholula*, 75. The chapel stands on the site of a temple of the mythical Aztec priest, prophet, and king Quetzalcóatl, whose second advent was supposed to end the Aztec world.

Thus the Christian royal chapel replaced an Aztec "royal chapel." Montes Bardo, *Arte y espiritualidad*, 69, reminds us that the first catechism in New Spain promises the Indian convert that "after your days on earth, [God] will take you to his palace and royal house in heaven." The author sees this as a reference to the palacelike evangelization compounds of the mendicants.

205. It was also the basilica where Christ's eschatological cross had supposedly appeared on the day of dedication in 334. See next chapter.

206. In one of its rebuilding campaigns, the chapel was vaulted in brick. The vaulting collapsed in 1581, but remains of it can still be seen today on the roof.

207. Maza, *La ciudad de Cholula*, 75. The expression "cedars of Lebanon" was used as a metaphor in prophetic and apocalyptic literature; see Lerner, *The Powers of Prophecy*, esp. 16–19. Peterson, *Paradise Garden Murals*, 136, links the cedar to the notion of the paradise garden and the four rivers of Eden: "Its life span of up to several thousand years, its proclivity to grow and flourish by water, and its enormous dimensions, with branches that cast expansive shade, made it a natural metaphor for a beneficent ruler standing in majesty and extending protection to his subjects."

208. E.g., Remi de Puys's theatrical representation of Charles's triumphal entrance into Bruges in 1515, which was published shortly thereafter. See Remi du Puys, *La tryumphante entrée*, 11. The torches are seen on the roofs of several sets of the unpaginated incunabulum. According to Westfall, *In This Most Perfect Paradise*, 155–56, similar rooftop torches were employed on the papal loggia at the Vatican.

209. Vincent and Abel, *Jérusalen nouvelle*, 935. In 1027 the porch was removed and the façade reduced to five arched doorways. There were ten doorways on the east side.

210. Hamilton, *Structural History*, 70–74; and Vincent and Abel, *Jérusalem nouvelle*, 934. In the eighth century, a Christian pilgrim mentions the mosque: "[On the esplanade] to the south is the Temple of Solomon, where the Saracens have built their synagogue." See the Itinerarium Bernardi Monachi Franci (c. 865–70) as recorded in Tobler, *Bibliographia Geographica Palestinae*.

211. 1 Kings 10:17 and 2 Chron. 9: 16; and Boas, *Jerusalem*, 91.

212. Krinsky, "Representations," n. 19.

213. For example, in the twelfth century Peter the Deacon could claim: "Not far away to the south [of the Dome of the Rock] has been built the Temple of Solomon [the Al-Aqsa], in which he lived, which has twenty-five doors. There are 362 columns inside it." An-

other visitor, the Abbot Daniel, wrote about the Al-Aqsa Mosque: "Here too was the House of Solomon and it was a mighty house and very great and exceedingly beautiful. It was all paved with marble slabs and supported on arches and the whole House was supplied with water. . . . And here is the gate of the House, very beautifully and cunningly overlaid with tin, ornamented with mosaic and gilded copper, and this gate is called the Beautiful Gate, where Peter and John healed the lame man." Trans. in Wilkinson, *Jerusalem Pilgrims*, 132–33; see also 173.

214. In addition to the cedars of Lebanon used in the construction, Solomon had employed wood from a tree that had grown in paradise; a beam that was to become, centuries later, Christ's cross. See Voragine, *Golden Legend*, 1:277–78; and John 5:2.

215. Howard, *Venice and the East*, 204, quoting Fray Francisco Suriano, who was the guardian of the convent at Mount Zion.

216. Schedel, in his *Chronicle of the World* of 1493, identified the Al-Aqsa as the Templum Mariae. See Ramírez, *Edificios y sueños*, 55.

217. Hamilton, *Structural History*, 72; Creswell, *A Short Account*, 204–13.

218. This is confirmed by images on Templar seals and by the appellation that the pilgrim visitors gave to the mosque as the "Portico of Solomon," implying its wide-open character. Vincent and Abel, *Jérusalem nouvelle*, 932.

219. Howard, *Venice and the East*, 45. Morosini also misidentified the *qibla* wall of the mosque facing Mecca as the choir or presbytery of the building. The *qibla* is identical in its location to the apse in the Royal Chapel of Cholula.

220. For the ground plan and other paintings in which a mosque is used for a biblical backdrop, see Ramírez, *Construcciones ilusorias*, 186–94.

221. 1 Kings 7:1–12:

His own palace Solomon completed after thirteen years of construction. He built the hall called the Forest of Lebanon one hundred cubits long, fifty wide and thirty high; it was supported by four rows of cedar columns, with cedar capitals upon the columns. Moreover, it had a ceiling of cedar above the beams resting on the columns; these beams numbered forty-five, fifteen to a row. . . . The porch of the columned hall he made fifty cubits long and thirty wide. The porch extended the width of the columned hall, and there was a canopy in front. He also built the vestibule of the throne where he gave judgment—that is, the tribunal; it was paneled with cedar from floor to ceiling beams. . . . All these

buildings were of fine stones, hewn to size and trimmed front and back with a saw, from the foundation to the bonding course. The foundation was made of fine large blocks. . . . Above were fine stones and cedar wood. . . . So was the temple porch.

222. Had Lyra also been inspired by the theatrical sets, the multilevel stages we call *mansiones*? See Shoemaker, *The Multiple Stage in Spain*, 11–59.

223. Lattice screening appears in representations of the Holy Sepulcher aedicule, the *sacellum*, on early medieval oil flasks. See Kühnel, *From the Earthly*, 94–100. In an effort to make the building relevant to his fourteenth-century students, Lyra claimed that the hall was similar to what they could observe in the palace of the French king in Paris. One version of his drawings shows High Gothic tracery comparable to the type used in New Spain. A later incunabulum edition of Lyra's *Postillae* makes a radical change in the elevation. The lower portion is of cut and trimmed masonry blocks punctured by small windows of latticework, while the upper story is of paneled wood with iron clasped shutters. Two Gothic gargoyle downspouts are located at either end. See Rosenau, *Vision*, fig. 51.

224. Nicholas of Lyra, *Glossa Ordinaria*, vol. 2, fol. 138v. He is quoting the Carolingian exegete, Walafrid Strabo.

225. For example, Breydenbach's travelogue. An Italian contemporary of Lyra, Marino Santuro Torselli, drew a map of Jerusalem in the year 1310 in which the Al-Aqsa is labeled "Domus Salomonis" and is represented as a two-story building whose lower level consists of open arcades on at least two sides (my fig. 4.52). Like the Royal Chapel of Cholula, the edifice rendered in the plan has four diminutive corner towers. See de Sandoli, ed., *Itinera Hierosolymitana Crucesignatorum*, 4:446. It was also imitated in Venice in the Ducal Palace of Justice; see Howard, *Venice and the East*, 181.

226. For Germany, see Cahn, "Solomonic Elements," 50–56, and "The Bîmah." Also see Ramírez, *Construcciones ilusorias*, 186–94. For Venice, see Sinding-Larsen, *Christ in the Council Hall*; Corboz, "La ciudad," 66; Puppi, "Rex cum justicia; and Howard, *Venice and the East*, 180–88.

227. Christopher Columbus was particularly fond of quoting these minor prophets.

228. *Psalmodia Christiana*, 79–81, 187–91, 221–23.

229. Durán, *Book of the Gods*, 100. By coincidence, Tezcatlipoca's principal feast fell on September 29, the Christian Feast of St. Michael the Archangel. Sahagún, *Florentine Codex*, book 1, identifies Tezcatlipoca with Lucifer, the fallen angel and nemesis of St. Michael.

230. Torquemada, *Monarquía indiana*, 3:237.

231. Mendieta, *Historia eclesiástica*, 84; and Torquemada, *Monarquía indiana*, 3:381 ff. The house of Anna was an indulgenced tourist stop on Jerusalem pilgrimages within the Haram al-Sharif. Breydenbach, *Viaje de la Tierra Santa*, 37, says, "The house of Anna was once a very beautiful church in honor of its foundress, but it has now been made into a mosque. No Christian may enter except secretly."

232. Torquemada, *Monarquía indiana*, 3:213: "For the temple service, there were rooms and chambers where the priests and ministers lived and for their worship and hygiene, as well as kindling wood and similar things."

233. Torquemada, *Monarquía indiana*, 3:213: "Not only were there altars in the principal temples and smaller ones within the compound, but in each neighborhood or 'parish,' and outside the towns at a quarter of a mile, there were small patios where there were three, four, even six small temples. . . . And also there were altars at the roadways, as we Christians now have crosses and *humilladeros*. They served to remember their gods as they passed by. They erect the same altars in their fields and sowing areas just like *ermitas* and [processional] stations." At these Aztec *humilladeros* the gods were also thought to repose. See Durán, *The History of the Indies*, 93 n. 8.

234. See Ricard, *Spiritual Conquest*, 319–20.

235. Basalenque, *Historia de la provincia*, 1:120, 137–38. Like the Temple of Solomon, the conventual complex at Ucareo had a subterranean water storage tank, likewise inspired by the Old Testament. See also Kubler, "Ucareo and the Escorial." Utrera's method was later copied by the Spanish architect Juan de Herrera for the Escorial palace monastery of King Philip II.

236. Escobar, *Americana Thebaida*, 77.

237. Escobar, *Americana Thebaida*, 100. The Franciscans in Florence also practiced this gender separation at Santa Croce, where the men were allowed around the altar within the *tramezzo* or choirscreen, while the women were kept outside the screen. See Hall, "The *Tramezzo* in Santa Croce."

238. Escobar, *Americana Thebaida*, xvii.

239. Escobar, *Americana Thebaida*, 154–55, 156. Before a disastrous fire leveled the establishment, the ceiling had been constructed of geometric paneling with golden pine cones and stars hanging from it, as in the Jerusalem Temple.

240. Escobar, *Americana Thebaida*, 185.

241. For example, the copy of Gerónimo Román's *Repúblicas del mundo* (1575) that I used in the Biblioteca Franciscana in Cholula had been mutilated by the Inquisition and expurgated of any positive reference to things Jewish.

5. THE COSMIC TREE

1. Raynaud, "Les nombres sacrés."

2. Both statements are suspiciously similar to early Christian legends surrounding the cross; see below. The "most beautiful man" was interpreted by Peter Martyr to be St. Thomas the Apostle. See Graziano, *Millennial New World*, 185.

3. Ybot León, *La iglesia*, 1:435.

4. See Schiller, *Iconography*, 2:184–97; Christe, *La vision de Matthieu*, esp. 80–88; Sebastián López, "Los 'Arma Christi'"; and Berliner, "Arma Christi."

5. Read, "The Fleeting Moment," 117–22. Trees acted as a sort of indigenous Limbo; children who died in infancy returned to inhabit them. Brundage, *The Fifth Sun*, 46, suggests that this myth was early contaminated by the friars' story of the garden of Eden.

6. Similar to the concept of Jacob's ladder in Gen. 28:10–22.

7. Trees were humans who had lived in former times, and thus they deserved respect even when used for practical needs. Heyden, "El arbol."

8. On Quetzalcóatl as a type of Christ, and Tezcatlipoca as a type of Judas, see Baldwin, *Legends of the Plumed Serpent*, 117–18. In the Vulgate version of the Bible, the morning star is called Lucifer, the fallen angel; see Isa. 14:12. In Sahagún's *Psalmodia Christiana*, p. 183, St. John the Baptist is called Venus, the Morning Star.

9. Brundage, *The Fifth Sun*, 112. Sahagún, *Florentine Codex*, book 1, considered the "demon" Tezcatlipoca to be, in reality, Lucifer.

10. López Austin, *The Human Body*, 2:69.

11. Callaway, "Pre-Columbian."

12. See Mendieta, *Historia eclesiástica*, 307–10.

13. Palomera, *Fray Diego Valadés*, 216 n. 10. Etymologically the word *ahuehuetl* means "that which does not grow old." Sometimes the word was also used for a cedar tree.

14. Callaway, "Pre-Columbian," 210. For trees as cosmic symbols and ladders to heaven, see Sebastian López, *Iconografía Medieval*, 281; and Champeaux and Sterckx, *Introduction*, 365–73. The ahuehuetle tree is a metaphor for St. Bernadino of Siena in Sahagún's *Psalmodia Christiana*, 155–61.

15. McAndrew, *Open-Air Churches*, 375, 247; Cervantes de Salazar as quoted in Maza, "Friar Pedro de Gante," 105. When it was torn down in 1671, its splinters were given away as relics. See Montes Bardo, *Arte y espiritualidad*, 110.

16. This recalls a Franciscan legend of the cross: A huge dragon encircles and threatens to destroy all of Assisi. The city is saved when a golden cross, whose top touched heaven and whose arms stretched

far and wide and seemed to extend to the ends of the world, emerges from Francis's mouth (*Legenda maior*, 23); for the apocalyptic significance, see Rev. 1:16, 19:15.

17. Sahagún's *Psalmodia Christiana*, fols. 89–90; Burkhart, "Flowery Heaven," 99.

18. Callaway, "Pre-Columbian," 206; Anderson, "La enciclopedia," 174. Sahagún's *Psalmodia Christiana* uses the word for the Christian concept of Limbo as a tree, a place were unbaptized children go in death.

19. Harris, *Aztecs, Moors and Christians*, 5–14.

20. Brown, "All Around the Xocotl Pole."

21. Harris, *Aztecs, Moors and Christians*, 113. When the Mexican council of bishops forbade the *voladores* ceremony in church patios in 1539, it just moved elsewhere. See "Copia de un original muy precioso de la junta que se hicieron en la ciudad de Thenuxtitlan México," in the appendix to *Concilios provinciales*.

22. Burkhart, "Flowery Heaven," 94.

23. Carrasco, *Religions of Mesoamerica*, 98–103.

24. Schele and Miller, *Blood of Kings*, 43, 282–85. In Sahagún's *Florentine Codex* similar eye glyphs indicate the sheen and sparkle of pre-Hispanic featherwork. Trees with mirrors also appear in the Aztec *Borgia Codex*. Medieval Christians used similar words (e.g., *mica*, in Latin) to speak of Christ's victorious cross: "Crux micat in coelis."

25. Alonso de Molina, *Confesionario mayor*, 25.

26. Planting a cross was also part of the elaborate ritual for taking possession of land. Guarda, "Tres reflexiones." On replacing idols with crosses, see Pérez de Ríbas, *My Life*, 181.

27. Nebel, "El rostro mexicano"; also Trexler, "Aztec Priests." Fray Maturino Gilberti had to begin his *Dialogo de la doctrina cristiana* with an explanation to the natives of why God permits lightning to strike the crosses (fol. 5r).

28. Monteverde, "Sixteenth-Century Mexican Atrium Crosses."

29. Sebastián López et al., *Iconografía*, 51. For the meaning of the *syndesmos* ideogram, see Esmeijer, *Divina Quaternitas*, esp. 97–127.

30. García Barragan, "Precedentes de las cruces atriales"; Lara, "El espejo en la cruz." In Revelation, the Seer indicates that the "spring of life-giving water" bubbles up from the celestial city's Tree of Life.

31. Esmeijer, *Divina Quaternitas*, 99, 106.

32. Sebastián López et al., *Iconografía del arte*, 53–54.

33. Esmeijer, *Divina Quaternitas*, 104–16.

34. Burkhart, "Flowery Heaven," 91 and n. 4. In Latin, the word *margarita* can mean both marigold and pearl, and it is used as such in the medieval hymn "Urbs Beata Jerusalem" which was translated into Náhuatl by Sahagún in his *Psalmodia Christiana*, 139.

35. Boutell, *Heraldry*, 50–51; and Muller, *Jewels in Spain*, figs. 67, 70, and 71.

36. Benedict, "Iconographic Sources," 38–52.

37. Heyden, "Metaphors," 41. Artificial feathers were even made out of gold and used in stage productions, such as the 1538 play of Adam and Eve at Tlaxcala.

38. Sahagún, *Florentine Codex*, book 3, chaps. 47–48.

39. Sahagún, *Psalmodia Christiana*; and Motolinía, *History of the Indians*, 143. According to Motolinía, 147, artists made Christian crosses out of feathers.

40. In the *Sanctoral en mexicano* (no date), quoted in Burkhart, "Flowery Heaven," 103–4.

41. See, e.g., the sixteenth-century chronicle of Vetancurt, *Teatro mexicano*, 2:110, where he speaks about the open chapel of Tlaxcala.

42. At Acolman the miniature sepulcher at the base of the atrial cross measures $3\frac{3}{4}$ inches wide by 9 inches high. Sacred trees set on hills above caves were part of the sacral geography of the Aztecs. See León-Portilla, *Aztec Thought and Culture*, 25–62. For imitations of Christ's sepulcher in Mexican caves, see Wilson, "The New World's Jerusalems," 133–43.

43. Sebastián López et al., *Iconografía del arte*, 41. Also s.v. "Adoratorio," *Enciclopedia de la Iglesia Catolica* (México: Enciclopedia de Mexico, 1982), 1:71.

44. Bagatti, *Il Golgota e la croce*, 73–75.

45. Bagatti, *Il Golgota e la croce*, 73–75; Kühnel, *From the Earthly*, 68–69:

> Now in the night whereon the Lord's day dawned, as the soldiers were keeping guard two by two in every watch, there came a great sound in heaven, and they saw the heavens opened and two men descended thence, shining with a great light, and drawing near unto the sepulchre. And that stone which had been set on the door rolled away on itself and went back to the side, and the sepulchre was opened and both of the young men entered it. When therefore those soldiers saw that, they waked up the centurion and the elders; and while they were yet telling them the things which they had seen, they saw again three men come out of the sepulchre, and two of them sustaining the other, and a cross following after them.

46. Christe, *La vision de Matthieu*, 80–88.

47. See the hymn for Good Friday "Pange lingua, gloriosi proelium certaminis"; and the Middle English poem "The Dream of the Rood," where the cross speaks and tells its own story. On the influence of the hymn and the poem in visual art, see Werner, "The Cross-Carpet Page."

48. Matt. 24:29–31. Berliner, "Arma Christi."

49. In the seventeenth century, the Jesuit theologian Cornelius a Lapide ridiculed this belief. Duriez, *La théologie*, 620.

50. Rordorf, "Liturgie et eschatologie"; Vogel, "La croix eschatologique."

51. Gieben, *Christian Sacraments*, 19. They had originally been housed in the Holy Sepulcher complex.

52. Minister-General Francisco de los Angeles Quiñones, whom we met in chap. 2, became a cardinal of that church and its Spanish Royal Chapel.

53. As recorded by bishops Eusebius of Caesarea and Cyril of Jerusalem. See Bagatti, *Il Golgota*, 87–89.

54. King, "The Triumph of the Cross"; Schlunk, *La pintura*, 64–65, 102–3. The most famous reproduction of the cross was housed in Motolinía's hometown. See above, chap. 3, "Angelopolis."

55. For example, during the Reconquest the cross had been seen hovering above the Alhambra of Granada. See Montes Bardo, *Arte y espiritualidad*, 108–9.

56. At Ravenna in the sixth century, and in Carolingian manuscripts of the ninth century.

57. See Vincent and Abel, *Jérusalem nouvelle*, 191.

58. Van der Meer, *Maiestas Domini*, 142–43, 238–44, and figs. 32, 52, and 53. On the Tree of the Cross and its connection to Prudentius's *Psychomachia*, see O'Reilly, *Studies in the Iconography*, 348. At the end of the twelfth century the *arma Christi* began to draw closer to the Passion and Crucifixion scenes, but they did not cease to refer to victory. Colli, "La tradizione figurativa"; Mâle, *Religious Art in France: Twelfth Century*.

59. See, e.g., the medieval hymn written by Hrabanus Maurus, as quoted in Heitz, *Recherches sur les rapports*, 140: "Behold the trumpet sounds and the dead resign themselves to judgment / The cross glistens in the heavens, clouds and fire surrounding." A similar eschatological refrain appears inscribed on the atrial cross and *Misérere* posa at Copacabana, Bolivia: "Crux aparuit in caelis" (The cross appears in the heavens). The Venerable Bede, *Sibyllinorum Verborum Interpretatio, PL* 90:1186, explains the event in Sibylline terms. The *Golden Legend* of the thirteenth century and the *Speculum humanae salvationis* of the fourteenth century take up the same theme in prose. Schiller, *Iconography*, 2:184–97; Voragine, *Golden Legend*, 1:10: "The insignia of the Passion will also appear at the Last Judgment, the Cross, the Nails, and the marks of the Wounds; and [St. John] Chrysostom says that 'the Cross and the Wounds will shine seven times more brightly than the rays of the sun.'" Cf. Isa. 30:26.

60. Rubin, *Corpus Christi*, 302.

61. Mâle, *Religious Art in France*, 99–116.

62. Sebastián López, "Los 'Arma Christi'"; and West, "Apocalyptic Missions."

63. The collect of the Mass of the Five Wounds: "Lord Jesus Christ, you who descended to earth from the breast of the Father, who suffered five wounds on the wood of the cross, and who poured out your blood for the remission of our sins; we humbly beg you that we, at your right side on Judgment Day, may hear the words: 'Come, blessed ones.'" Lippe, *Missale Romanum Mediolani*, 330.

64. Schiller, *Iconography*, 2:184–97; van Os et al., *The Art of Devotion*, 112–20.

65. C. Wright, *The Maze and the Warrior*, 196–202. Charles V was depicted with the Holy Lance in hand in Titian's painting *Charles V at the Battle of Mühlberg* (1548).

66. Cook, *Images of St. Francis*, 184–87.

67. Miziolek, "When Our Sun Is Risen." In contemporary apse mosaics at Sta. Maria Maggiore and the Lateran basilicas, SS. Francis and Dominic now appear in eschatological scenes. Francis and Dominic are, of course, the two *viri spirituales* of the Final Age of Joachim of Fiore. Cook, *Images of St. Francis*, 185–86; Recio Veganzones, "Francisco en la iconografía."

68. Bartoli, *La Chiave*, 265. The name derives from Ps. 89:37: "His throne is like the sun."

69. On the frequent use of Helios to represent Christ, see Mathews, *The Clash of Gods*, 142–79; and Miziolek, "When Our Sun Is Risen."

70. In medieval exegesis of Psalm 19, which the friars recited weekly from their breviaries, the sun was interpreted as Christ the Bridegroom: "In the heavens God has placed a tent for the sun; it comes forth like a bridegroom coming from his tent, rejoices like a champion to run its course. . . . Nothing is concealed from its burning heat." For the Mexica, the sun was also a warrior and champion. See Brundage, *The Fifth Sun*, 37–44.

71. In fourteenth-century miniatures the instruments of the Passion appear within a shield with an important addition: the Mount of Olives. The reference is the long-standing eschatological legend that the appearance of cross and weapons would take place above the Mount of Olives in Jerusalem on Doomsday. Honorius Agustodunensis, *Elucidarium*, book 3 (*PL* 172:1165C).

72. Philip, *The Ghent Altarpiece*, esp. 32–34. The possibility that Pedro de Gante had made sketches of the altarpiece should not be discounted.

73. Some of the onlookers in the wing panels were ancestors of Charles V of Spain.

74. Schiller, *Iconography*, 2:240–42. Note that the miracle took place in the Roman Basilica of Santa Croce-in-Gerusalemme, a building later under the patronage of the Spanish crown and with connections to the Franciscans.

75. Schiller, *Iconography*, 2:198–210; Sebastián López, "Los 'Arma Christi.'"

76. In Gilberti's *Dialogo de la doctrina cristiana* for the Tarascan Indians, the sun and moon speak as actors at the Last Judgment in accusation of the impious (fol. 198v). The Mass of St. Gregory does appear in conventual murals in Mexico, where, I believe, it is a devotional image of the eucharistic mystery rather than an apocalyptic image of Doomsday. It acted as an indulgenced meditation icon for the niches (*testerae*) in the convent cloister. Estrada de Gerlero, "La pintura mural," informs us that the image of the Mass of St. Gregory was prohibited by the Sacred Congregation of the Faith in the second decade of the seventeenth century.

77. Above the cross one reads the legend "The Sign of Our Redemption," and around the border, "The Armaments of the Redeemer of the World, the King of Kings, Creator of the Universe, Jesus Christ, our Savior." Note the reference to Rev. 19:16. See Montes Bardo, *Arte y espiritualidad*, 133.

78. Mendieta, *Historia eclesiástica*, 637.

79. A biblical reference to 2 Cor. 10:4: "For the weapons of our battle are not of flesh but are enormously powerful, capable of destroying fortresses."

80. Artigas, *Capillas abiertas aisladas*, 117–29. Mendieta, *Historia eclesiástica*, 308, locates this event in Tizatlán on the outskirts of the city of Tlaxcala. The event was commemorated as a drama. See Casteñeda, *The First American Play*.

81. Mendieta, *Historia eclesiástica*, 309.

82. See the map reproduced in Muñoz Camargo, *Descripción*. The eschatologically minded Fray Toribio de Motolinía lived at the convent of Tlaxcala from 1537 to 1539 and may have had something to do with this identification.

83. Bataillon, *Erasmus y España*, 51–61; and Alba, *Acerca de algunas particularidades*, 81–91.

84. Alba, *Acerca de algunas particularidades*, 94–97.

85. *Vita Christi* (1404), quoted in Alba, *Acerca de algunas particularidades*, 203–4. The Castillian translation of the *Vita* was done in honor of Ferdinand's victory over the Moors at Granada in 1492. The insertion of crosses (†) into the text indicated to the reader that he should make the sign of the cross on himself when reading the sentence. Hence, the text was also a type of invocation or prayer for protection.

86. On the iconographic connection between the cross and the tomb, see Kühnel, *From the Earthly*, 70.

87. See Fray Maturini's catechism on the prior appearance of Antichrist, above, chap. 3.

88. Noguera, *El pantocràtor romànic*, 86–88. Esmeijer, *Divina Quaternitas*, 105, indicates that the purpose of lopping off the branches is to "graft" Christ's body onto the Cosmic Tree. The grafting cross was also an emblem of the penitential and flagellant confraternities of the Passion.

89. Schiller, *Iconography*, 2:184–97; such a "Byzantine" gesture of carrying sacred instruments in drapery is iconographically associated with the Last Judgment. The tiaras of the angels are in the Flemish style. The friary of Huejotzingo owned a copy of Bartolomeo de Pisa's apocalyptic *Conformity of Saint Francis to Christ*, in which the stigmatization is offered as the greatest proof of Francis's eschatological role in human history. See Tovar de Teresa, "Noticias sobre," 163.

90. Códova Tello, *El convento*, 90–101. For a similar fountain at Malinalco, see Peterson, *Paradise Garden Murals*, 128. For the religious symbolism of garden fountains, see Underwood, "The Fountain of Life"; Kubler, "The Claustral 'Fons Vitae'"; Sebastián López, "La versión iconográfica"; Sebastián López, *Iconografía medieval*, 165–70, 281; Estrada de Gerlero, "Sentido politico," 640; Champeaux and Sterckx, *Introduction*, 225–29, 297–373. For the "fountain of Paradise" at Tiripitio, Michoacán, see Escobar, *Americana Thebaida*, 145. According to Zahm, *The Quest for El Dorado*, 199, the four streams are the basis of the New World legend of El Dorado.

91. On the spirituality of the Franciscans as manifest at Calpan, see Montes Bardo, *Arte y espiritualidad*, 81–84. St. Andrew was also the patron saint of Charles V's elite Order of the Golden Fleece. Tanner, *Last Descendant of Aeneas*, 151.

92. Flores Guerrero, *Las capillas posas*, 38. At Calpan, the dedications of the posas are attested to at a late date by Fray Agustín de Vetancurt. They refer to the altars inside the posa chapels, not to the iconography on the exterior.

93. The interior altar was dedicated to the Assumption of the Virgin.

94. Obsidian was sometimes placed in eye sockets, as in those of the apocalyptic angels with crosses on the façade of the church at Molango, Hidalgo. See Perry, *Mexico's Fortress Monasteries*, 75–76. In Spain, *azabache* or jet stone was commonly used for the eyes of statues where it acted as a talisman against the evil eye. See González Cirimele, *Artesanía en azabache*, 10–37.

95. The iconography is typical of late medieval Flemish artists. See Schuler, "The Seven Sorrows."

96. Vázquez Benítez, *Las capillas posas de Calpan*, 15.

97. The altar of this posa was dedicated to St. Francis. According to Bartholomeo de Pisa's *De Conformitate* and similar literature, Francis is Christ's perfect mirror image.

98. See McAndrew, *Open-Air Churches*, 329. I suggested what the original Christ image may have looked like, in "El espejo en la cruz."

99. Rubin, *Corpus Christi*, 305.

100. See Isa. 14:12, where Lucifer, the Morning Star, is cut down. According to Sahagún, Tezcatlipoca is the archenemy of Michael the Archangel.

101. McAndrew, *Open-Air Churches*, 330; Montes Bardo, *Arte y espiritualidad*, 142–43. The iconographic model may be an illustration from the Schedel's *Nuremberg Chronicle*, which was reused for Gilberti's apocalyptic catechism the *Dialogo de la doctrina cristiana*, fol. 308r.

102. Kubler suggested the *Flos Sanctorum*, which was a required text for all convent libraries.

103. This paraphrase of Matthew 25:6 seems to have been catechetical, if not in origin, at least in use. See above, chap. 2. Also see Yhmoff Cabrera, *Los impresos mexicanos*, 41. The phrase was also used earlier in the very popular play *The Final Judgment*, written in Náhuatl by Fray Andrés de Olmos around 1531; the text is found in Horcasitas, *El teatro Náhuatl*, 561–93.

104. The fact that the Last Judgment scene on this posa faces eastward and to the rising sun should not be overlooked. Jacobus of Voragine, *Golden Legend*, 1:8, says that "at the rising of the sun the tombs will be opened, so that the dead may come out of them"—as here at Calpan.

105. Kubler, *Arquitectura mexicana*, 490; McAndrew, *Open-Air Churches*, 330. The same imagery was reused in Juan de Padilla's book *Retablo de la vida de Cristo* (Seville, 1518), which circulated in Mexico; and in the chapter "Antichrist and Where He Will Be Born" of the fourteenth-century travelogue of John Mandeville, *Libro de las Maravillas del mundo y viaje a la Tierra Santa* (c. 1356), translated and printed in Spanish in 1521, 1531, and 1546.

106. Schroder Cordero, "El retablo platersco."

107. Each of the medallions bears the name of the respective evangelist, expect for that of the eagle, John, which is inscribed "Navitas." Either the native sculptor was using two different iconographic models, or else there was some other intention implied.

108. The fourth posa of Calpan, dated to the end of the sixteenth century, was the only one that retained its altar and carved wooden retable intact (at least before pieces were robbed in 1969). Crowning the altarpiece is another Pantocrator between panels of St. Matthew and St. Luke. The Pantocrator (or possibly it is God the Father) seems by his gesture not so much to be in the act of blessing, as he is on the exterior relief, but rather in the act of creating, separating light from darkness. Maza, "Los retablos dorados."

109. In Jan van Eyk's *Ghent Altarpiece*, the central figure with tiara is Christ as the new high priest and the icon of God the Father.

110. Durandus, *Rationale*, 31: The altar with its four horns "signifieth the Spiritual Church: and its four horns teach how she hath been extended into the four corners of the world."

111. See chap. 2, the epigraph to the section entitled "The Sibylline Oracles."

112. Strong, *Splendor at Court*, 94.

113. Heyden, "Black Magic." For a detailed description of the Aztec ritual of human sacrifice, see Duverger, "The Meaning of Sacrifice." Cf. García Granados, "Reminiscencias idolátricas"; Sebastián López et al., *Iconografía del arte*, 49–50.

114. Heyden, "Black Magic"; and Carrasco, "The Sacrifice of Tezcatlipoca." The epigraph is translated and quoted in Ravicz, *Early Colonial Religious Drama*, 2–3.

115. Brundage, *The Fifth Sun*, 81–82; Hunt, *Transformation of the Hummingbird*, 142–48, 182, 220–21.

116. Kubler, "On the Colonial Extinction."

117. Hunt, *Transformation of the Hummingbird*, 182.

118. Kühnel, *From the Earthly*, 92–93, and fig. 14; French, "Journeys to the Center of the Earth," 52–72. The column can be seen in late antique mosaics of Jerusalem. Bertelli, "Visual Images," esp. 133. The inspiration for the Christianization of this pagan Roman pillar may be found in Christ's words in Rev. 3:11: "I am coming quickly. Hold fast! The victor I will make into a pillar in the temple of my God, and he will never leave it again. On him I will inscribe the name of my God and the name of the city of God, the new Jerusalem, which comes down out of heaven from my God, as well as my new name." Cf. Ezek. 48:5.

119. Sebastián López et al., *Iconografía del arte*, 41.

120. See the chapter "The *De Trinitate* of St. Augustine and the Lyric Mirror" in Goldin, "The Mirror and the Image," 417–500.

121. Clare of Assisi, *Early Documents*, 204–5.

122. Bonaventure, *Hymn to the Cross*, trans. de Vinck, verse 17:

Oh Cross, mirror of all virtue
glorious guide to life eternal
hope of those whose faith is clear
brilliant standard of the chosen
expectation, consolation, trophy of those who persevere.

Also see the use of mirrors in Bonaventure, *Itinerarium Mentis in Deum*.

123. In seventeenth-century New Spain, Sor Juana Inés de la Cruz would take up the same mirror imagery for Christ's self-immolation in *El Divino Narciso*. See Gallo, *Reflexiones sobre espejos*, 26–46.

124. There are illustrated editions of the work. See Hagen, *Allegorical Remembrance*; and Norman, *Metamorphoses of an Allegory*, 181–224.

125. Brundage, *The Fifth Sun*, 81.

126. Kimminich, "The Way of Vice and Virtue," 82.

127. Gil Atrio, "¿España, cuna del Viacrucis?" 68. In Spain, outdoor crosses were mounted on circular or polygonal platforms without spikes.

128. In Durandus's *Rationale*, 31, the four horns of the altar represent the Church Militant in its missionary extension "into the four quarters of the world." It is also the psychomachian "interior altar of the heart." See Bowen, "The Tropology," 476: "The altar is to the temple what the heart is to man."

129. Callaway, "Pre-Columbian," 211–20. Several atrial crosses have eucharistic wafers carved on the vertical shaft, suggesting a similar theme.

130. Fray Alonso de Molina uses the word in this sense in his *Vocabulario*, part 2, fol. 61v. He says that it can also be used in the sense of a *humilladero*, that is, a wayside chapel of the cross. See Dedenbach-Salazar Sáenz and Crickmay, eds., *La lengua de la cristianización*, 29.

131. Ybot León, *La iglesia*, 1:435.

132. Whited Normann, "Testerian Codices," 129–65. Edgerton, *Theaters of Conversion*, 29; the word *momoxtli* is here being used in more than one sense. On the use of the word *tortilla* for sacred bread, see Chimalpáhin, *Codex Chimalpahin*, 2:179; and Bartolomé de Alva, *A Guide to Confession*, 162. Sahagún uses tortilla for the eucharistic wafer throughout the *Psalmodia Christiana*.

133. Chimalpáhin, *Diario*, 332–39.

134. I have discovered the word used by Náhuatl speakers in the states of Tlaxcala and Puebla. It is also employed for a boundary marker that bears a cross and is placed on a property line. In the state of Guerrero, Náhuatl speakers call the base of the atrial cross *tlaixpan*, literally, "altar." My thanks to Náhuatl scholar Jonathan Amith for this information.

135. Brundage, *The Fifth Sun*, 210–12.

136. McAndrew, *Open-Air Churches*, 357. These altar stones were so prized that some were exported to Europe.

137. Significantly, the two strongest voices regarding the cross as a holocaust altar were the mendicant friars Thomas Aquinas and Bonaventure. Thomas Aquinas, *Summa Theologiae*, 1:2 Q. 102, art. 4:

"The figurative reason for all these things may be derived from the relation of the tabernacle to Christ whom it prefigured. . . . A number of different figures were set up in the Temple to signify Christ. . . . Christ himself is signified by the two altars of holocaust and incense since through him, we should offer to God all the works of virtue . . . offered as it were on the altar of holocausts. . . . Christ is our altar."

For the iconography of the medieval interpretation of sacrificial burning, see O'Meara, "In the Hearth of the Virginal Womb." On the mendicants as the principal propagators of this type of iconographic interpretation, see Rigaux, *A la table du Seigneur*, 125–281, esp. 226 ff. The Council of Trent (1545–63) stated that the host at Mass is "the same Christ contained and immolated in an unbloody manner, who, on the altar of the Cross, offered himself in a bloody manner."

138. Francis of Assisi, "Letter to All the Faithful," in *Opuscula*, 87–94, emphasis mine.

139. Monterrosa, "Cruces de la Colonia."

140. Weismann, *Mexico in Sculpture*, 24; the box is decorated with a skull. See also *Arqueología Mexicana* 9, no. 63 (2003): 56 for a similar example. Mary Miller, of Yale University, considers that it might more accurately be called a Chac Mool of the square Tula variety. The Chac Mool was a type of mythic umbilical bowl for the sacrifices. It was related to the eagle and the sun at its zenith, two symbols that have also been used by Christians for Christ. See Tibón, *El ombligo*, 239–51. Another *cuauhxicalli* supports a cross at Nativitas Zacapa (Mexico State). Fray Diego Durán, *The History of the Indies*, 187, wanted to use the gigantic *cuauhxicalli* of the Templo Mayor in Mexico City as a baptismal font!

141. Human sacrifice over a barrel cactus (*Echinocactus grusonii*) is attested to in the *Florentine Codex*, book 3. In Hidalgo the barrel cactus grows only at high altitudes on hilltops, a choice place for religious rituals and precisely where missionaries later planted crosses.

142. Sahagún, *Evangeliarum*, 200: "Golgotha, onan quaxicalli tepeuh toc . . ."

143. The use of the *cuauhxicalli* as a receptacle for the voluntary shedding of blood by Aztec kings is attested to by Durán, *The History of the Indies*, 297, 300.

144. There is good reason to believe that the heightened devotion to Christ's heart in the following century is an example of reverse cultural influence—that it traveled from Nahua Christians in America back to Europe. See Kehoe, "The Sacred Heart."

145. E.g., St. John Fisher, *On Psalm 129*, as quoted in Catholic Church, *Liturgy of the Hours*, 2:350–52: "Our high priest is Christ Jesus, our sacrifice is his precious body which he *immolated on the altar of the cross* for the salvation of all. . . . The temple in which our high

priest offered sacrifice was not one made by human hands but built by the power of God. For he shed his blood in the sight of the world, a temple fashioned by the hand of God alone." Emphasis mine.

146. López Austin, *The Human Body*, 1:377.

147. Clendinnen, "Ways to the Sacred," 137, and n. 51.

148. This was decreed by the 1539 ecclesiastical junta. See *Concilios provisionales*.

149. Joachim of Fiore had seen both fire and charity symbolized in the fifth pole of his quincunx figure and as the fifth *mysterium Christi*.

150. Escobar, *Americana Thebaida*, 85.

151. The medieval Iberian liturgy found in the *Missale Mixtum* speaks of the "horns of the altar" during the adoration of the cross on Good Friday. Also see Amalarius of Metz, *De ecclestiaticis officiis*, 1.4. For the four christological meanings of the horns of the altar, see Walafrid Strabo's *Apocalypsis B. Johannes*, 9.13 (*PL* 114:728), often quoted by later commentators like Nicholas of Lyra:

Understand that the four horns of the altar are four things that are proclaimed of Christ: his nativity, passion, resurrection and ascension. Other things surround these: the altar is Christ, the horns of the altar are the preachers who hold Christ up [to view], who are ready to die for him just as blood used to be smeared on the horns of the altar. Or the altar is the Church, which has horns, that is, those who defend others, who all strive for the same thing. Or we can understand by the four horns the evangelical doctrines that teach how the deceits of Antichrist are to be purged.

152. Holbein, *Images from the Old Testament*; and Kubler, *Arquitectura mexicana*, 446.

153. Ezek. 43:13–17:

These were the measurements of the altar in cubits of one cubit plus a handbreadth. Its base was one cubit high and one cubit deep, with a rim around its edge of one span. The height of the altar itself was as follows: from its base at the bottom up to the lower edge it was two cubits high, and this ledge was one cubit deep; from the lower to the upper ledge it was four cubits high, and this ledge was also one cubit deep; the hearth of the altar [*ariel altaris*] was four cubits high, and extending from the top of the hearth [*ariel*] were the four horns of the altar. The hearth was square . . . as was the upper ledge . . . as was the lower ledge. And there was a base of one cubit all around. The steps of the altar face the east.

See Bede the Venerable, *De Tabernaculo* (*PL* 91:451), and *De Templo Salomonis* (*PL* 91:801).

154. See the commentary on Ezek. 43 in Nicholas of Lyra, *Glossa Ordinaria*, vol. 4, fols. 280r–v; and Durandus, *Rationale*, 31: "An interior altar is the altar of the cross. This is the altar on which they offered the evening sacrifice."

155. Thomas Aquinas, "In festo Corporis Christi," in Catholic Church, *Liturgy of the Hours*, 3:610–11: "Since it was the will of God's only-begotten Son that men should share his divinity, he assumed our nature in order that by becoming man he might make men gods. Moreover, when he took our flesh he dedicated the whole of its substance to our salvation. He offered his body to God the Father on *the altar of the cross* as a sacrifice for our reconciliation" (emphasis mine). Blood sacrifices of animals continue today at the foot of the atrial crosses in the state of Guerrero. Callaway, "Pre-Columbian," 208.

156. See Lara, "The Sacramented Sun." For the metaphor of Christ-sunlight in late medieval art, see Meiss, "Light as Form."

157. Burkhart, "The Solar Christ," 235. Present-day Mesoamerican Indians view Christ as a solar deity. See Volt, *Zincantan*; Gossen, *Chamulas in the World of the Sun*; Hunt, *Transformation of the Hummingbird*; Taggart, *Nahuat Myth and Social Structure*.

158. Gregory the Great, *Homilies*, 40–41. Incunabular editions of Gregory's homilies abound in Mexican colonial libraries. Christ the solar eagle is an iconographic theme in the murals of Ixmiquilpan, according to Wright Carr, "Sangre para el sol," 89–103.

159. On feather art, see Castelló Yturbide, *Art of Featherwork*. Fray Diego Durán, *Book of the Gods*, 110, uses the word "miter" for the headdress of the Aztec hierarchy.

160. As quoted in Burkhart, "The Solar Christ," 236.

161. Mode, "San Bernardino in Glory," 58–76; Arasse, "Iconographie et évolucion"; and Estrada de Gerlero, "El nombre y su morada." For Bernardino as a follower of Joachim of Fiore, see Zimdars-Swartz, "Joachite Themes."

162. Tanner, *Last Descendant of Aeneas*, 231–48, says that the solar metaphor was applied to the Hapsburg monarchs Charles V and Philip II, who were addressed as "new Apollo" and "defenders of the Real Presence" of Christ in the Eucharist.

163. Sahagún, *Psalmodia Christiana*, 249. Sahagún was not alone in speaking of the solar Christ. Louise Burkhart has demonstrated that the Franciscan fray Juan Bautista and the Augustinian fray Juan de la Anunciación both composed sermons and catechisms in Náhuatl in which they describe Christ in a solar manner. In commenting on Rev. 19:12, concerning the crowns that the Lamb/Christ receives,

Juan de la Anunciación declares that "on his head came spreading, shone in abundance, many royal sunbeams, a royal crown."

164. Sahagún, *Psalmodia Christiana*, 217; and Burkhart, "The Solar Christ," 245. The New Testament passage on the Transfiguration itself uses the sunlight motif, announcing that "his face and garments shone like the sun."

165. *Psalmodia Christiana*, 359 (reminiscent of Ps. 19), 246–48.

166. As quoted in Guarda, "La liturgia," 59, emphasis mine.

167. Bernardino de Laredo, *The Ascent of Mount Sion*, esp. 212.

168. Vargas Lugo, "Erudición escritural." On the iconographic relationship of the "sun of justice" to the Virgin Mary of the Immaculate Conception, see González Galván, "Sol de Justicia." On the Virgin Mary as a substitution for the sun goddess, see Lafaye, *Mesías*, 122–23. A eucharistic monstrance from Lima, Peru, took the form of a silver image of the Virgin Mary holding the sun, the receptacle for the sacred host. It was called "La Sola," that is, the feminine form of the word *sun*. Toribio de Mongrovejo, archbishop of Lima (d. 1606), added additional acclamations to the Marian *Litany of Loretto*, one of which became, "Chosen One of the Sun, pray for us." See Vargas Ugarte, *Historia del culto*, 135.

169. Lara, "The Sacramented Sun."

6. STAGES FOR RITUALS OF CONVERSION

1. Pre-Columbian centers such as Tlaxcala, Cholula, and Tlatelolco were the most popular theatrical sites. Rojos Garcidueñas, *Autos y coloquios*, x–xii; and Johansson, "Espacios rituales prehispánicos."

2. Clendinnen, "Ways to the Sacred," 126, and n. 73; Boone, "Migration Histories"; Ravicz, *Early Colonial Religious Drama*, 2–25.

3. Carrasco, "The Sacrifice of Tezcatlipoca."

4. Durán, *Book of the Gods*, 134–35.

5. Muñoz Camargo, *Descripción*, fol. 238r. Here the *momoxtli* is circular, which is how Torquemada, *Monarquía indiana*, 2:10, describes them. An almost identical circular *momoxtli* was discovered in Mexico City when the Pino Suárez metro station was excavated.

6. McKendrick, *Theater in Spain*, 47. The word *corral* appears in the sense of a patio in the thirteenth-century *Fueros de Huesca*. It can also mean the oratory of a saint, the yard of a castle, a place where knights hold council, or the entrance to a monastery or palace. By the time of Antonio Nebrija's *Diccionario Latino Español* (1492), it already meant a theater; also see Corominas and Pascual, *Diccionario crítico*, 2:202–6.

7. Nagler, *The Medieval Religious Stage*, 13, 19–22; Konigson, *L'espace théâtral*, 135. Also see Shergold, *History of the Spanish Stage*, xviii, 104–7, 156, 177–81; and Clendinnen, "Ways to the Sacred," 136, and n. 46.

8. Rennent, *The Spanish Stage*, 26–30; Ekdhal Ravicz, *Early Colonial Religious Drama*, 47. Fray Pedro de Gante, the costume maker and visual artist, was a major promoter of the building of hospitals and added one to his chapel of San José de los Naturales. See Moreno Proaño, "The Influence of Pedro de Gante."

9. Albert of Buxhoven, thirteenth-century bishop of Riga, as quoted in Bolton, "Message, Celebration, Offering," 97.

10. Burkhart, "Pious Performances"; Watts, "Languages of Gesture."

11. Arroniz, *Teatro de evangelización*, 91–99; and Schuessler, *Géneros renacientes*, 149–85. Similar performances often accompanied the Sunday sermon as a pantomime of the lesson being taught.

12. Cited in Horcasitas, *El teatro Náhuatl*, 562.

13. Ekdahl Ravicz, *Early Colonial Religious Drama*, 150.

14. Horcasitas, *Teatro Náhuatl*, 593, emphasis mine.

15. Mendieta, *Historia eclesiástica*, 648.

16. This play was first presented in 1527 in Valladolid, Spain, for the birth of Philip II. Horcasitas, *Teatro Náhuatl*, xv.

17. In a contemporary European version of this Gospel episode, the actor playing Christ was hoisted onto the roof of the temple house by a winch. For drawings and diagrams of the staged temple (an early open chapel), see Konigson, *La représentation*, 42–50, and plates.

18. The truce was signed on 18 June 1538. Motolinía, *History of the Indians*, 152–67.

19. Motolinía, *Memoriales*, 106, emphasis mine.

20. By the early sixteenth century, the conquest of Rhodes had been in the planning for some time. See Leopold, *How to Recover the Holy Land*, esp. 172–207.

21. The play appears to have been based in part on the twelfth-century Crusader ballad *Le Conquête de Jérusalem*; see Adolf, *Visio Pacis*, 29; and West, "Medieval Ideas," 293. As we shall see, the five-towered Grail castle is the inspiration for the Jerusalem set. On religious theater as anticipatory magic, see Surtz, *The Birth of a Theater*, 81–84, 104–11, and nn. 75–76. For a more cynical interpretation of missionary theater, see below, at n. 37.

22. A similar stage set was erected in Bruges for the reception of Charles V in 1515, which Fray Pedro de Gante attended. See Remi du Puys, *La tryumphante entrée*, 14 and fol. Eii.

23. The following placement of stages and actors conforms to the medieval practice of strictly orienting the sacred geography for theatrical productions of mystery plays. See Konigson, *L'espace théâtral*, 37, 113–204, 212–26.

24. According to Rennert, *The Spanish Stage*, xiii, town halls and their porticos were favorite places for European stage dramas.

25. *Torre de homenaje* in the Spanish text, i.e., the highest and principal tower of a fortress. The Grail castle is described in the same way. See Adolf, *Vision Pacis*, 93–94, 128–29; and Ringbom, *Graltempel und Paradies*, 21–25.

26. The arrangement and seating of the actors in the plaza correspond to medieval liturgical drama: the Temple of Jerusalem is always at the east, while the emperor and his entourage are at the west. See Konigson, *L'espace théâtral*, 37.

27. Although an anachronism, Santa Fe de Granada is mentioned here as the archetypal siege city miraculously transported to Palestine, thus recalling the Christian victory at Muslim Granada in 1492. See above, chap. 3.

28. Motolinía, *History of the Indians*, 160.

29. Motolinía, *History of the Indians*, 160: "After the Most Holy Sacrament had reached the plaza in procession, accompanied by the Pope, cardinals, bishops—all impersonated [by Amerindians]— these took their seat on their platform which was very nicely adorned. It was located near Jerusalem, in order that all the festivities might be enacted before [the gaze of] the Most Holy Sacrament. Thereupon the army of Spain began to enter the plaza and besiege Jerusalem."

30. It was on the Feast of St. Hippolytus, 22 August 1521, that the Spaniards under Cortés defeated Moteczuma and the Aztecs. Burkhart, "The Amanuenses," suggests that the saint was later adopted as a Nahua hero.

31. Motolinía, *History of the Indians*, 165.

32. Surtz, *The Birth of a Theater*, 83; the same missile props were used in Spain in 1414 for a coronation play.

33. Shergold, *History of the Spanish Stage*, 93.

34. A similar stage set was set on fire during the tableaux vivants performed for the entrance of Charles V in Bruges in 1515, witnessed by Fray Pedro. See Remi du Puys, *La tryumphante entrée*, unpaginated woodcut.

35. Motolinía, *History of the Indians*, 165.

36. Motolinía, *History of the Indians*, 166.

37. E.g., Trexler, "We Think, They Act." For the counterargument, see Harris, *Dialogical Theater*, 82–94; and Clendinnen, "Ways to the Sacred," 119.

38. Leopold, *How to Recover the Holy Land*, 189–207.

39. Rojas Garcidueñas, *Autos y coloquios*, xvii; and Burkhardt, *Holy Wednesday*.

40. Philip commissioned a lavish copy of the play text, now in the library of the Duke of Devonshire, MS 48. B.

41. Stephen K. Wright, *The Vengeance of Our Lord*, esp. 186–90.

42. Hernán Cortés, *Cartas de Relación*, quoted in Wilson, "The New World's Jerusalems," 113. Mexico City had a copy of the Pantheon in the Church of Santa María la Redonda on Chapultepec hill; see introduction, above.

43. See, e.g., Konigson, *L'espace théâtral*; and reproductions of a mid-fifteenth-century hospital play in Paris, *Toiles peintes*, 1:xxxv, lxi–lxii, 3: plates 13–19. The first person to notice this similarity was the drama historian José Rojos Garcidueñas in 1939.

44. Hernán Cortés, in a letter sent to Charles V, mentioned similar raised stages that could be seen well above the market stalls. See Ekdahl Ravicz, *Early Colonial Religious Drama*, 21. The patio of the Augustinian establishment at Acolman, in contrast, still has a sloping, terraced amphitheater for the seating of the audience.

45. Sahagún, *Evangeliarum*, 200, literally, "dead house." Also see Mendieta, *Historia eclesiástica*, 433–34.

46. Webster, "Art, Ritual." The burial ceremony is found in Alberto Castellani's 1523 *Liber Sacerdotalis*, discussed below.

47. On these temporary sepulchers and their theatrical uses in Europe, see Gil Atrio, "¿España?" 73–77; Sheingorn, "The Sepulchrum Domini"; and Smith, "Constructing a Small Place." For their use in Mexico, see Webster, "Descent from the Cross."

48. Chimalpáhin, *Diario*, 327. In many ways these sculptural Saviors were treated in the same way as the living icon (*ixiptla*) of the Aztec god Tezcatlipoca. This human victim, or divine impersonator, voluntarily surrendered his life in sacrifice in order to re-create his mythic prototype in the annual feast of Toxcatl in May. See Carrasco, "The Sacrifice of Tezcatlipoca."

49. Taubert and Taubert, "Mittelalterliche Kruzifixe."

50. Cf. Debiaggi, "La capella *subtus crucum.*"

51. Vetancurt, *Teatro mexicano*, 2:10. Several European copies of the Holy Sepulcher complex, notably the Santo Sepolcro of Bologna, placed the site of Christ's cross on top of his tomb. See Bocchi, ed., *7 colonne e 7 chiese*, 125–39. Other similarities between architecture in colonial Latin America and in the Near East have been detected by Palm, "Los pórticos"; Kubler, *Arquitectura mexicana*, 538 (on the *kalybe*); and Estrada de Gerlero, "Sentido político." For recessed tomb niches in Europe, see Colvin, *Architecture and the After-Life*, 143 and figs.

52. Shoemaker, *The Multiple Stage in Spain*, esp. 40–59.

53. The burial niche at Tlaxcala measures 95 inches wide by 36 inches deep, a perfect setting for a life-size statue of the dead Christ.

54. European precedents for all of these variations of symbolic sepulchers are found in Justin Kroesen, *The Sepulchrum Domini*.

55. Palm "La aportación," 138. Also see Krinsky, "Representations"; Ramírez, *Construcciones ilusorias*, 104–216; and the Web site of architect Juan Rafael Cuadra: http://www.sapiens.ya.com/jrcuadra/index.htm (last consulted June 2004).

56. Kernodle, *From Art to Theatre*; Pochat, *Theater und bildende Kunst*; and Ventrone, "On the Use of Figurative Art."

57. Compare Memling's *Passion* painting of 1490 (in the Pinacoteca, Turin, and another in the church of la Madre de Deus, Lisbon), in which all the episodes of Christ's Passion are happening simultaneously in chapel-like *mansiones* throughout a staged Jerusalem. Budde and Nachama, eds., *Die Reise nach Jerusalem*, esp. 12, 152.

58. Maza, "Friar Pedro de Gante."

59. See Kipling, *Enter the King*, esp. chaps. 1, 3, and 5. A copy of the *Rituum, Ecclesiasticorum sive sacrarum cerimoniarum*, with the ceremony for receiving and crowning Charles V as the Holy Roman Emperor, was owned by the Dominican friary in Mexico City and is now in the Biblioteca Nacional.

60. See Remi du Puys, *La tryumphante entrée*, 16.

61. Remi du Puys, *La tryumphante entrée*; also see above, chap. 4. The balustrade is more evident and legible in the color edition (see next note).

62. Remi du Puys, *La tryumphante entrée*, 8. A black-and-white woodcut edition was printed in Paris later in the same year, when a deluxe color manuscript was presented to the emperor. It is currently in the Öesterreichische Nationalbibliothek in Vienna (Cod. 2591). See Blockmans, "Fondans en melencolie," 26–27.

63. Checa Cremades, *Carlos V: La imágen del poder*, 41–58.

64. Checa Cremades, *Carlos V y la imágen del heroe*, 211–12. For the eschatological identity of the Order of the Golden Fleece, see Tanner, *Last Descendant of Aeneas*, 146–61. The Tiburtine Sibyl and the Roman emperor were characters in the 1418 *Ordo Prophetarum* play. See Shergold, *History of the Spanish Stage*, 19. The multiple associations of the fleece to biblical and mythological personages were made by the chancellor of the order Guillaume Fillastre, in his history *Le premier volume de la Toison d'or*, 4 vols., published in Paris in 1517.

65. Tanner, *Last Descendant of Aeneas*, 146–61, and see below.

66. Philip the Good is immortalized among the holy Crusaders and just judges on the viewer's left. Philip had sent Jan van Eyck on a reconnaissance mission to Palestine in 1426 to create a detailed map for a future crusade; the map later made its way to Spain. See Sterling, "La mappemonde."

67. Tanner, *Last Descendant of Aeneas*, 153; and Martens, "New Information on Petrus Christus' Biography," 9–11.

68. At Antwerp another theatrical production was offered to the emperor-elect in 1520. It was a modernized version of Prudentius's *Psychomachia*, in which Charles was encouraged to embrace the practice of the Virtues as spiritual protection against the Vices and enemies from without in his herculean task of latter-day messiah. See Checa Cremades, *Carlos V y la imagén del heroe*, 169, 178, 203, 268–73. Fray Pedro also witnessed this performance before sailing to New Spain, and it is reasonable to think that it influenced his theatrical creativity in America.

69. Konigson, *La représentation*, 77–121.

70. Ramírez et al., *Dios arquitecto*, 17–36.

71. *Codex en Cruz*, fols. 59, 70.

72. The woodcut appears in all editions. See the Castillian edition translated in 1498 by Martín Martínez de Ampiés, fol. 60r. The biblical reference is to John 9:1 ff.

73. Pochat, *Theater und bildende Kunst*, 214–21; Lawrenson and Purkis, "Les éditions illustrées de Térence." Eschatological expectations had infiltrated Rome with mythic references to a New Eden and New Jerusalem; see Reeves, *Prophetic Rome*. An almost identical stage pavilion, in which Charles V is enthroned as Solomon the Wise, appeared in a contemporary book of poems. See Antonio Francesco Oliverio's *L'alamanna* (Venice, 1567), reproduced, in Checa Cremades, *Carlos V y la imagen del héroe*, following p. 272.

74. They were published in Lyon in 1493; Irving Leonard, *Books of the Brave*, 164, 204. Fray Juan de Torquemada, writing his *Monarquía indiana* at the beginning of the seventeenth century, quotes extensively from Terence's plays.

75. Valadés, *Rhetorica Christiana*, 44, 47.

76. Alberto Castellani, *Liber Sacerdotalis* or *Sacerdotale ad consuitendum* (Venice, 1523). There were eight additional editions of the work in the sixteenth century; see Cattaneo, "Il rituale romano di Alberto Castellani."

77. The fifth *mansión* or chapel is the sheltered cross in the center of the patio. In Andean versions of the missionary corral, the fifth chapel, located at the cross, is called the *Miserére*. See Lara, "Precious Green Jade Water."

78. Escobar, *Americana Thebaida*, xvii.

79. This theater is an eighteenth-century addition with the date 1772 carved on it. Compare the design of this set with that in Konigson, *La représentation*, 40–50, and figs. 2, 3, and 4.

80. Mendoza, "Un teatro religioso colonial." In light of the history of theatrical performances in the patio of European hospitals, it is significant that the latter is in a hospital town.

81. The *mansión* dates from 1619. I am afraid that the suggestion that the sunken chamber was once a baptismal tank for immersion just doesn't hold water. See González Galván and Hancock, *Arte virreinal en Michoacán*, 94.

82. See, e.g., the studies on medieval mansions: Konigson, *L'espace théâtral*; and Shoemaker, *The Multiple Stage*.

83. On the theatrical quality of Aztec worship, see Carrasco, "The Sacrifice of Tezcatlipoca," esp. 47–53; and Clendinnen, "Ways to the Sacred."

84. Sahagún, *Psalmodia Christiana*, xv–xxv. For studies on the *Psalmodia* and Sahagún's other works, see the collection of essays edited by Hernández de León-Portilla, *Bernardino de Sahagún*.

85. Burkhart, "A Doctrine for Dancing"; and Burkhart, "El *Tlauculcuicatl* de Sahagún." In praising God for creation, special thanks are offered for "the gold, the jade, the feathers of the Quetzal bird." Also see Anderson, "La enciclopedia."

86. *Psalmodia Christiana*, 63–77. Burkhart, "El Tlauculcuicatl," 221.

87. *Psalmodia Christiana*, 109–39. Burkhart, "El Tlauculcuicatl," 222; Burkhart, *The Slippery Earth*, 50.

88. Sahagún, *Psalmodia Christiana*, 132–35.

89. Cf. the text of the hymn in chap. 2, above.

90. Sahagún, *Psalmodia Christiana*, 138–39.

91. In New Spain, Saint Bernardino was conflated with the pre-Hispanic deity Camaxtli because both hold solar discs in their respective iconographies. See Nutini and Bell, *Ritual Kinship*, 1:447.

92. Sahagún, *Psalmodia Christiana*, 168. For the biblical inspiration, see Ezek. 31:3–9, known as the "Allegory of the Cedar Tree."

93. For the origin and evolution of stational liturgy in the Old World, see Häussling, *Mönchskonvent und Eucharistiefeier*, esp. 303–22; and Baldovin, *Urban Character*.

94. Heitz, "Architecture et liturgie," n. 34: "In the middle of the church is represented the holy Passion. In the south transept, the Ascension. In the north transept, the Resurrection. In the portico next to the [west] doors, the Nativity. All the images are magnificent plaster and mosaic gold, and other beautiful things are represented in precious colors." Also see Pajares-Ayuela, *Cosmatesque Ornament*, 217–38.

95. The *Libellus Angilberti* was known at the end of the eleventh century from the *Chronicon Centulense*, written by Hariulf, a monk of St. Riquier, as well as from a document conserved at the Vatican, the *Instituto Sancti Angilberti abbatis de diversitate officiorum*, dating from c. 800. See Heitz, "Architecture et liturgie processionnelle," 31.

96. The conflation of Temple and Holy Sepulcher is, as we have seen, typical of Carolingian allegorical thinking. Heitz, "Retentissement de l'Apocalypse," 225, says of the monastery of St. Riquier: "The rôle of the nave, in which is found the Altar of the Holy Cross, appears to be, on a functional level, identical to that of the inner atrium in the Holy Sepulcher of Jerusalem with its 'holy garden' surmounted by the hillock located between two architectural poles: the Basilica of the Martyrium to the east, and the Anastasis Rotunda to the west."

97. Heitz, *Recherches sur les rapports*, 110: "For the sake of symmetry, Angilbert had placed the cross on a central axis."

98. Heitz, "Architecture et liturgie processionelle," 35. For the question of the monastic visitation of altar stations, see Couneson, "La visite des autels."

99. Volpi, "L'esegesi biblica di Beda."

100. Heitz, *Recherches sur les rapports*, 178–88. Cattin, "Testi melici."

101. Lara, "Liturgical Roots."

102. Mitchell, *Cult and Controversy*. The ubiquitous examples in the Mexican chronicles are too numerous to mention.

103. Van Dijk and Walker, *Origins of the Modern Roman Liturgy*, 368.

104. Rubin, *Corpus Christi*, 258–61; Matern, *Zur Vorgeschichte*, 280–81.

105. Very, *The Spanish Corpus Christi Procession*, 6; Matern, *Zur Vorgeschichte*, 272–301; Bataillon, "Ensayo de explicación," 192: "The Holy Eucharist is the [military] hero of this feast."

106. Foster, *Culture and Conquest*, 193. On the Iberian peninsula, the institution of the procession spread from north to south and followed the advance of the Christian armies during the Reconquest. See Matern, *Zur Vorgeschichte*, 109–45, 262, and esp. 273–301.

107. The story is related by Motolinía, *History of the Indians*, 152–67; by Torquemada, *Monarquía indiana*, 17, chap. 9; and by another eyewitness, Fray Bartolomé de Las Casas, in his *Apologética historia sumaria*, 328–37. My translation draws on all three texts. Sala Catala and Vilchis Reyes, "Apocalíptica Española," 310, consider the Tlaxcalan plays to "fit perfectly the eschatological hopes of the mendicants." See Bayle, *El culto del Santísimo*, 256–61, for a similar story of the sacralizing of Australia and New Zealand as the "New Jerusalem of the Holy Spirit" by a Corpus Christi procession in 1606.

108. Escobar, *Americana Thebaida*, 92.

109. Like the *seises* of the cathedral of Seville, six boys who dance today in the choir on Corpus Christi.

110. Recall the "pearly gates" of Rev. 21:21, and the "Urbs Beata Jerusalem," "Portae nitet margaritis," verse 3.

111. Las Casas, *Apologética historia sumaria*, 1:329.

112. According to Doris Heyden in Durán, *The History of the Indies*, 93 n. 8, another meaning of the word *momoxtli* was a place where the gods sat and reposed—thus a type of pre-Hispanic posa or station.

113. Motolinía, *History of the Indians*, 153. Professor Teresa Gisbert de Mesa of La Paz has kindly informed me that she has witnessed Corpus Christi processions in Bolivia in which colorful live birds are tied to the ephemeral posas.

114. Motolinía, *History of the Indians*, 157.

115. Motolinía, *History of the Indians*, 158.

116. See n. 22 above.

FINALE

1. Mendieta, *Historia eclesiástica*, 549–53; and Baudot, *Utopía e historia*, 110–13, and esp. n. 78. Catechisms and prayer books continued to be produced in Náhuatl and other languages. See Klor de Alva, "La historicidad," 209, 224–25. The Inquisition attempted to prohibit the publication of Sahagún's *Psalmodia* because of the quantity of biblical citations in the (proscribed) native languages. Moreover, it appears that Sahagún may have used a Protestant Latin Bible as his source. Anderson, "La enciclopedia," 174, notes that Sahagún never mentions either original sin or Limbo, and therefore may have been suspected of heresy. Children who die before baptism are just said to go to *Tonacaquahuitl*, the "Tree which sustains our life," the Aztec word also used for the atrial cross.

2. *Floreto de Sant Francisco*, 149–58.

3. Mendieta, *Historia eclesiástica*, 555–60, compares the decline of the Indian church and commonwealth with the fall of Jerusalem at the hands of the Persians, and mourns the transformation of the missionary vineyard into a wasteland, an image taken directly from Isaiah. Ricard, *Spiritual Conquest*, 264–82; Phelan, *Millennial Kingdom*, 103–11; Peterson, *Paradise Garden Murals*, 171–78.

4. Ricard, *Spiritual Conquest*, 291–94.

5. Lockhart, *The Nahuas after the Conquest*, 429–51.

6. Escobar, *Americana Thebaida*, 358–59.

7. Kubler, *Religious Architecture*, 29–37.

8. Gómez Martínez, *Fortalezas mendicantes*, 117–18.

9. See, e.g., the open chapel on the façade of the Basilica of Our Lady of Guadalupe, Mexico City. Several more are currently being built in Cholula.

10. Eliade, "Paradise and Utopia"; Milhou, "Apocalypticism in Central and South American Colonialism"; Levine, "Apocalyptic Movements in Latin America"; Graziano, *Millennial New World*.

11. Exogenous millenarianism, such as native rebellions resisting colonial rule, emerges in response to external factors that threaten sociocultural survival. These protests usually involve violent action to eradicate the threat and realize an idealized version of their preconquest society. See Graziano, *Millennial New World*, esp. 8–9. The most famous prophetic collection, showing evidence of the Last World Emperor myth on the latter-day Maya, is the *Book of Chilam Balam*; see Roys, *The Book of Chilam Balam*, 147–64.

12. D. Thompson and Balaban, "The Israelites of the New Covenant."

13. Fagiolo, "La fondazione delle città"; McNaspy, *Lost Cities of Paraguay*; Cazzato, "Sentido y simbolismo"; Gutiérrez, *The Jesuit Missions*; Rodríguez de Ceballos, "El urbanismo."

14. Lara, "The Sacramented Sun."

15. Lara, "Il vulcano e le ali."

16. On metaphor as reality, see Avis, *God and the Creative Imagination*, 93–102, 152–57.

17. Poole, *Our Lady of Guadalupe*, 100–126.

18. Fernández, *Cristóbal de Medina Vargas*, esp. 360–92; Ramírez et al., *Dios arquitecto*.

19. Bonet Correa, *Urbanismo en España*, 177; and Salcedo, "El modelo urbano," 64–65.

20. Tanner, *Last Descendant of Aeneas*; Taylor, "Architecture and Magic"; Ramírez et al., *Dios arquitecto*, 177–82.

21. González Galván, "El oro en el Barroco."

22. See the bibliography in Lara, "God's Good Taste."

23. Escobar, *Americana Thebaida*, 79, 100–102, records such extremes already in the eighteenth century.

24. Stephen K. Wright, *The Vengance of Our Lord*, 207–32.

25. Very, *The Spanish Corpus Christi Procession*, 6–49; Warman, *La danza de moros y cristianos*, 55–102; Keleman, *Baroque and Rococo*, 138–50.

26. Hunt, *Transformation of the Hummingbird*, 90; Damen and Zanon, eds., *Cristo Crucificado*, esp. 207–8; and Lara, "The Sacramented Sun."

27. See Clendinnen's brilliant insights in "Ways to the Sacred."

28. Burkhart, "Pious Performances."

\mathcal{B}ibliography

Primary Works

Acosta, José de. *Historia natural y moral de las Indias.* Seville, 1590. Reprinted in *Cronicas de América*, 34. Madrid: Historia, 1987.

Adrichem, Christiaan van. *Breve descripción de la ciudad de Jerusalén y lugares circunvecinos, compuesta en latín por Cristiano Adricomio Delpho y traducida al castellano por el P. F. Vicente Gómez, del Orden de Predicadores y doctor en teología.* Barcelona, n.d.; Madrid: Imprenta Imperial, 1679.

Alonso de Molina. *Confesionario mayor en lengua mexicana y castellana.* 1569. Introduction by Roberto Moreno. Mexico City: UNAM, 1984.

———. *Vocabulario en lengua castellana y mexicana.* Mexico: Casa de Antonio de Spinosa, 1571.

Amalarius of Metz. *De ecclestiaticis officiis. PL* 105:985–1242.

Amico, Bernardino. *Trattato delle piante e immagini dei Sacri Edifici di terra Santa disehnate in Jerusalem secondo le rogole della prospettiva e vera misura della loro grandezza.* Florence, 1609. Translated by Theophilus Bellorini and Eugene Hoade as *Plans of the Sacred Edifices of the Holy Land.* Jerusalem: Franciscan Press, 1953.

Augustine, Saint. *The City of God.* Translated by John O'Meara. London: Penguin, 1984.

Baptista, Joan. *Confessionario en lengua mexicana y castellana: Con muchas advertencies muy necesarias para los confesores.* Mexico: Casa de Mechior Ocharte, 1599.

Bartholomew of Pisa. *Liber conformitatum vitae beati ac seraphici patris Francisci ad vitam Iesu Christi, domini nostri.* In *Analecta Franciscanum sive chronica aliaque varia documenta ad historiam Fratrum Minirorm spectantia*, 4. Quaracchi-Florence: Collegii S. Bonaventurae, 1906.

Bartolomé de Alva. *A Guide to Confession Large and Small in the Mexican Language.* Edited by Barry Sell and John Frederick Schwaller. Norman: University of Oklahoma Press, 1999.

Basalenque, Diego. *Historia de la provincia de San Nicolas de Tolentino de Michoacán, del Orden de N.P.S. Agustin.* Mexico, 1673. Mexico City: Editorial Jus, 1963.

Beatus of Liébana. *Adversus Eldirpandum. PL* 96:890–94.

———. *Beati in Apocalipsim libri duodecim.* Edited by Henry A. Sanders. Rome: American Academy, 1930.

———. *A Spanish Apocalypse: The Morgan Beatus Manuscript.* Introduction and commentary by John Williams. New York: George Braziller, 1991.

Bede the Venerable. *On the Tabernacle.* Translated by Arthur G. Holder. Liverpool: Liverpool University Press, 1994.

———. *On the Temple.* Translated by Sean Connolly. Liverpool: Liverpool University Press, 1995.

———. *Opera Bedae Venerabilis.* Basel, 1563.

———. *Sibyllinorum Verborum Interpretatio.* PL 90:1181–86.

Bibbia Perduta. Facsimile of *Biblia, bibliorum opus sacrosanctum vulgates.* Lyons, 1541. Florence: Officine del Novecento, 1998.

Bonaventure, Saint. *Hymn to the Cross.* Translated by José de Vinck. Paterson, NJ: Paulist, 1960.

———. *La sapienza cristiana: Collationes in Hexaëmeron.* Translated by Vicenzo Cherubino Bigi. Milan: Jaca, 1984.

———. *Legenda maior S. Francisi Assisiensis et eiusdem legenda minor.* 1263. Quaracchi: Collegii S. Bonaventurae, 1941.

———. *Opera Omnia.* 11 vols. Quaracchi: Colegio San Bonaventura, 1882–1902.

Breydenbach, Bernhard von. *Bernardo de Briedenbach, Viaje de la Tierra Santa.* Translated by Martín Martínez de Ampiés. 1493. Edited by Jaime Moll. Madrid: Ministerio de Educacion y Ciencia, Instituto Bibliografico Hispanico, 1974.

———. *Bernhard von Breydenbach and His Journey to the Holy Land 1483–4, a bibliography.* Compiled by Hugh William Davies. London: J. & J. Leighton, 1911.

Castellani, Alberto (or da Castello, or Castellano). *Liber sacerdotalis nuperrime ex libris sanctae Romanae esslesiae et quarundam ecclesiarum: et ex antiquis codicibus apostolicae bibliothecae: et ex iurium sanctionibus et ex doctorum ecclesiasticorum.* Venice, 1523. In later editions, the title was changed to *Sacerdotale ad consuetuden[m] S. Roman[a]e Ecclesi[a]e.*

———. *Missale Romanum.* Venice, 1506.

———. *Processionarium ordinis fratrum predicatorum.* Venice: Lucantonium de Giunta, 1517.

Cervantes de Salazar, Francisco. *Life in the Imperial and Loyal City of Mexico in New Spain and the Royal and Pontifical University of Mexico as Described in the Dialogues for the Study of the Latin Language.* Translated by Minnie Lee Barrett Shepard. Westport, CT: Greenwood Press, 1970.

Chimalpáhin Quauhtlehuantzin, Domingo de San Antón Muñón. *Codex Chimalpahim.* 2 vols. Edited and translated by Arthur Anderson and Susan Schroeder. Norman: University of Oklahoma Press, 1997.

———. *Diario.* Translated by Rafael Tena. Mexico City: Conacultura, 2000.

Ciudad Real, Antonio de. *Relación breve y verdadera de algunas cosas de las muchas que sucedieron al Padre Fray Alonso Ponce.* Madrid: Imprenta de la viuda de Calero, 1873.

Clare of Assisi. *Early Documents.* Translated by Regis J. Armstrong. New York: Paulist Press, 1988.

Codex Azcatitlan. Paris: Bibliotheque National de France and Societé des Americanistes, 1995.

Codex en Cruz. Edited by Charles Dibble. 2 vols. Salt Lake City: University of Utah Press, 1981.

Codex Mexicanus caractere hieroglyphi, 1570–71. Facsimile of Bodleian Library MSS., Laud Misc. 678. Graz: Akademische Druck, 1966.

Columbus, Christopher. *The Book of Prophecies.* Translation and introduction by Roberto Rusconi. Berkeley: University of California Press, 1997.

———. *The "Libro de las Profecias" of Christopher Columbus.* Edited and translated by Delno West and August King. Gainesville: University of Florida Press, 1991.

Concilios provinciales primero y segundo. Mexico: Imprenta de el Superior Gobierno, 1769.

Concilios visigóticos e hispano-romanos. Edited by Jose Vives. Barcelona: Consejo Superior de Investigaciones Científicas, Instituto Enrique Flórez, 1963.

Cuevas, Mariano. *Documentos inéditos del siglo XVI para la historia de México.* Mexico City: Museo Nacional de Aqueologia, Historia y Etnologia, 1914.

De Gestis Caroli Magni. PL 98:1369–1409.

De Sandoli, Sabino, ed. *Itinera Hierosolymitana Crucesignatorum.* 4 vols. Studium Biblicum Franciscanum, Collectio Maior 24. Jerusalem: Franciscan Printing Press, 1984.

De Sandoli, Sabino. *The Peaceful Liberation of the Holy Places in the XIV Century: The Third Return of the Frankish or Latin Clergy to the Custody and Service of the Holy Places through Official Negotiations in 1333.* Cairo: Franciscan Center of Christian Oriental Studies, 1990.

Díaz del Castillo, Bernal. *Historia verdadera de la conquista de la Nueva España.* 2 vols. Edited by Carlos Pereyra. Madrid: Espasa-Calpe, 1968.

Durán, Diego. *Book of the Gods and Rites and The Ancient Calendar.* Translated and edited by Fernando Horcasitas and Doris Heyden. Norman: University of Oklahoma Press, 1977.

———. *The History of the Indies of New Spain.* Translated and annotated by Doris Heyden. Norman: University of Oklahoma Press, 1994.

Durandus, William. *Rationale divinorum officiorum.* Translated by J. M. Neale and Benjamin Webb as *The Symbolism of Churches and Church Ornaments.* Leeds: T. W. Green, 1843.

Egeria. *Egeria's Travels to the Holy Land.* Translated by John Wilkinson. Rev. ed. Jerusalem and Warminster: Ariel, 1981.

Einhard. *Vita Karoli Magni: The Life of Charlemagne.* Translated by Evelyn Scherabon Firchow and Edwin H. Zeydel. Coral Gables: University of Miami Press, 1972.

Eiximenis, Francesc. *De Sant Miguel Arcàngel: El quint tractat del "Libre dels angels."* Edited by Curt Wittlin. Barcelona: Curial, 1983.

———. *Lo Crestià: Selecciò.* Edited by Albert Hauf. Barcelona: Edicions 62, 1983.

———. *Vita Christi.* Granada, 1396.

El baladro del sabio Merlín con sus profecías. Burgos, 1498, 1535. 2 vols. Madrid: Joyas Bibliográficas, 1956.

Escobar, Matías de. *Americana Thebaida: Vitae patrum de los religiosos hermitaños de N.P. San Augustín de la provincia de S. Nicholás Tolentino de Michoacán.* 1729. Edited by Manual de los Angeles Castro. Morelia, Mexico: Basal, 1924.

Faber, Felix. *Noblissimae Urbis Venetianae fidelis descriptio.* In L. Puppi, "Verso Gerusalemme," *Arte Venata* 32 (1978): 73–78.

Férotin, Marius, ed. *Le liber ordinum en usage dans l'église wisigothique et mozarabe d'Espagne du cinquième au onzième siècle.* Paris: Firmin Didot, 1904.

———, ed. *Le liber ordinum mozarabicus.* Paris: Firmin Didot, 1904.

Floreto de Sant Francisco. Seville, 1492. Edited by Juana Mary Acelus Ulibarrena. Madrid: Fundación Universitaria Española, 1998.

Focher, Juan. *Enchiridion baptismi adultorum et matrimonii baptizandorum / Manual del bautismo de adultos y del matrimonio de los bautizados.* Tzintzuntzan, 1544. Introduction by Fredo Arias de la Canal. Mexico City: Frente de Afirmación Hispanista, 1997.

———. *Itinerarium Catholicum Proficiscentium ad infideles convertendo.* 1574. Madrid: Libreria General V. Suarez, 1960.

Francis of Assisi. *Opuscula sancti patris Francisci Assisiensis.* Quaracchi: Colegio San Bonaventura, 1949.

Friede, Juan, ed. *Documentos inéditos para la historia de Colombia.* 10 vols. Bogotá: Academia de Historia, 1960.

García Icazbalceta, Joaquín. *Colección de documentos para la historia de México.* 2 vols. Mexico City: J. M. Andrade, 1858.

———. *Nueva colección de documentos para la historia de México.* 4 vols. Mexico City: Chávez Hayhoe, 1941.

Gerson, Jean. *Tripartito del christianissimo y consolatorio doctor Juan Gerson de doctrina christiana.* Mexico: Cromberger, 1544.

Gilberti, Maturino. *Dialogo de la doctrina cristiana en lengua de Michoacán.* Mexico: Juan Pablos, 1559.

Gregory the Great, Pope. *Homilarium in Ezechielem prophetam libri duo. PL* 76:785–1072.

———. *The Homilies of Gregory the Great: On the Book of Ezekiel.* Translated by Theodosia Gray. Etna, CA: Center for Traditionalist Orthodox Studies, 1990.

———. *Moralium libri, sive Expositio in Librum B. Job. PL* 75:509–76.

Grijalva, Juan de. *Cronica de la Orden de N.P.S. Agustin en las provincias de Nueva España, en quatro edades desde el año de 1533 hasta el de 1592.* Mexico: Joan Ruyz, 1624.

Holbein, Hans. *Images from the Old Testament: Historiarum Veteris Testamenti Icones.* Introduction by Michael Marqusee. New York: Paddington, 1976.

Honorius Agustodunensis. *Elucidarium. PL* 172:1109–76.

———. *Gemma anima sive Divinae Officiis. PL* 172:541–738.

Hugh of St. Victor. *De archa Noe. PL* 176:667–78.

Isidore of Seville. *De Ecclesiasticis Officiis. PL* 83:737–826.

Isolani, Isidoro. *In hoc volumine hic continentur: De imperio militantis Ecclesiae.* Milan: Gotardum Ponticum, 1516.

Jacobus de Voragine. *The Golden Legend.* Translated by Granger Ryan. 2 vols. Princeton: Princeton University Press, 1993.

Joachim of Fiore. *Abbas Joachim magnus propheta. Hec subiecta in hoc continentur libello. Espositio magni prophete Ioachim: in librum beati Cirilli de magnis tribulationibus & statu Santae matris ecclesie: ab hiis nostris temporibus vsque ad finem seculi vna cum copilatio ex diversis prophetis Noui ac Veteris Testamenti . . . Item explanatio figurate & pulchra in Apochalypsim de residuo statu Ecclesie . . . Item Tractus de Antichristo . . . Item Tractus septem statibus Ecclesie.* Venice: Laca de Soardis, 1516; reprinted by Bernardinum Benalium, 1520.

———. *Expositio in Apocalypsim.* Venice, 1527.

———. *Liber Concordie Novi ac Veteris Testamenti.* Venice, 1519.

———. *Psalterium decem chordarum.* Venice, 1527.

———. *Vaticinia, sive Prophetiae, Vaticinii, overo Profetie.* Venice: H. Porro, 1589.

Laredo, Bernardino de. *The Ascent of Mount Sion.* London: Faber & Faber, 1953.

Las Casas, Bartolomé de. *Apologética historia sumaria.* Edited by Edmundo O'Gorman. Mexico City: UNAM, 1967.

Levy, A. Y. *Rashi's Commentary on Ezekiel 40–48.* Philadelphia: Dropsie College, 1931.

Libri Sancti Jacobi: Codex Calixtinus. Transcribed by W. M. Whitehill. Santiago de Compostela, 1944.

Lima, Ecclesiastical Province. *Concilios Limenses, 1551–1772.* 3 vols. Lima, 1951–54.

Lippe, Robert. *Missale Romanum Mediolani 1474.* 2 vols. Henry Bradshaw Society. London: Harrison & Son, 1899–1907.

Lollis, César de. *Raccolta di documenti e studi pubblicati della R. Commissione Colombina per quarto centenario della scoperta dell' America.* Part 1, vol. 2, "Scritti di Colombo." Rome: Ministero della Publica Istruzione, 1894.

López de Gómara, Francisco. *Cortés: The Life of the Conqueror by His Secretary.* Translated and edited by Lesley Byrd Simpson, from the *Historia de la conquista de Mexico*, printed in Zaragoza, 1552. Berkeley and Los Angeles: University of California Press, 1964.

Lorenzana, Francisco A., ed. *Concilios provinciales primero y segundo, celebrados en la muy noble y muy leal ciudad de México, presidiendo el Illmo. Y Rmo. Señor D. Fr. Alonso de Montúfar, en los años de 1555 y 1565.* Mexico: Imprenta de el Superior Gobierno de Joseph Antonio de Hogal, 1769.

Lumnius, Johannes Fridericus. *De Extremo Dei Judicio et Indorum Vocatione.* Antwerp, 1567.

Mandeville, Juan. *Libro de las Maravillas del mundo y viaje a la Tierra Santa.* Seville, 1356. Facsimile with prologue by J. Ernesto Martínez Ferrando. Madrid: Joyas Bibliograficas, 1958.

Martínez de Ampiés, Martín. *Libro del Anticristo, Declaración del Sermón de San Vicente.* 1496. Edited by Françoise Gilbert. Pamplona: Ediciones Universidad de Navarra, 1999.

Mendieta, Gerónimo de. *Codice Mendieta.* Vol. 1 of García Icazbalceta, *Nueva colección de documentos para la historia de México.* Mexico: Francisco Diaz de Leon, 1886.

———. "Descripción de la relación de la provincia del Santo Evangelio." In *Historia eclesiástica indiana*, edited by Francisco Solano y Perez-Lila, 2:272. Madrid: Biblioteca de Autores Españoles, 1973.

———. *Historia eclesiástica indiana.* Mexico City: Editorial Porrua, 1980.

———. *Vidas franciscanas.* Mexico City: UNAM, 1945.

Mishnah: A New Translation, The. Edited by Jacob Neusner. New Haven: Yale University Press, 1988.

More, Sir Thomas. *Utopia.* Edited and translated by Robert M. Adams. New York: W. W. Norton, 1975.

Motolinía, Toribio de Benevente. *El libro perdido: Ensayo de reconstrucción de la obra histórica extraviada de fray Toribio.* Edited by Edmundo O'Gorman. Mexico City: Consejo Nacional de la Cultura, 1954.

———. *Memoriales: Libro de oro (MS JGI 31).* Edited by Nancy Joe Dyer. Mexico City: El Colegio de México, 1996.

———. *Motolinia's History of the Indians of New Spain.* Translated by Francis Borgia Steck. Washington, DC: Academy of American Franciscan History, 1951.

Muñoz Camargo, Diego. *Descripción de la Ciudad y Provincia de Tlaxcala de las Indias y del Mar Océano para el buen gobierno y ennoblecimiento dellas.* Facsimile of the manuscript in Glasgow University Library. Mexico City: UNAM, Instituto de Investigaciones Filológicas, 1981.

Nebrija, Antonio. *Diccionario Latino Español.* Salamanca, 1492.

Nicholas of Lyra. *Biblia Latina cum Glossa Ordinaria, facsimile reprint of the Editio Princeps 1480.* Introduction by Karlfried Froehlich and Margaret Gibson. Brepols: Turnhout, 1992.

———. *Glossa ordinariam cum expositione literali et morali.* 5 vols. Basel, 1507.

———. *Postillae seu expositio literal et moralis nicholai de Lira ordinis minor sur epistolas et evangelia quadragesima.* Venice, 1494.

———. *Postilla super totam bibliam.* 1492. Facsimile edition. 4 vols. Frankfort: Minerva, 1971.

Pérez de Ríbas, Andrés. *My Life among the Savage Indians of New Spain.* Translated by Tomás Antonio Robertson. Los Angeles: Ward Ritchie, 1968.

Peter Damian, Saint. "Totum mundum in eremum convertere." In *Fonti per la storia d'Italia*, vol. 94. Rome: Istituto Storico Italiano, 1957.

Prado, Hector, and Juan Baptista Villalpando. *In Ezekielem explanationes et apparatus urbis ac templi Hiersolymitani, commentariis et imaginibus illustratus.* Rome, 1596–1602. Translated into Spanish as *El Templo de Salomón*, with introductory volume *Dios arquitecto*, edited by Juan Antonio Ramírez et al. Madrid: Siruela, 1991.

Prudentius Clemens, Aurelius. *Obras completas en latín y castellano.* Madrid: Biblioteca de Autores Cristianos, 1950.

———. *Psychomachia.* In *The Poems of Prudentius.* Translated by M. Clement Eagan. Washington, DC: Catholic University of America Press, 1962.

Psalterium Hebreum, Grecum, Arabicum et Chaldaeum. Genoa, 1516.

Remi du Puys. *La tryumphante entrée de Charles Prince des Espagnes en Bruges 1515.* Facsimile with introduction by Sydney Anglo. Amsterdam: Theatrum Orbis Terrarum, 1973.

Rituum ecclesiasticorum sive sacrarum cerimoniarum. Venice, 1516.

Román, Gerónimo. *Repúblicas del mundo.* 2 vols. Medina del Campo: Francisco del Canto, 1575.

Sackur, Ernst. *Sibyllinsiche Texte und Forschungen.* Halle: Max Niemeyer, 1898.

Sahagún, Bernardino de. *Coloquios y doctrina cristiana.* Mexico: UNAM, 1986.

————. *Evangeliarum, epistolarum et lectionarum Aztecum sive mexicanum.* Edited by Bernardinus Biondelli. Milan: Typis Jos. Bernardoni Q. Johannis, 1858.

————. *Historia General de las cosas de la Nueva España [Florentine Codex].* Edited by Francisco de Paso y Troncoso. Madrid: Hauser & Menet, 1905–.

————. *Florentine Codex: General History of the Things of New Spain.* Translated by Arthur Anderson. Utah: School of American Research and the University of Utah, 1951.

————. *Psalmodia christiana, y sermoniario de los sanctos del año en lengua mexicana.* Mexico: Pedro Ocharte, 1583. Translated by Arthur J. O. Anderson. Salt Lake City: University of Utah Press, 1993.

Schedel, Hartmann. *Chronicle of the World: The Complete and Annotated Nuremberg Chronicle of 1493.* Introduction and appendix by Stephen Füssel. Cologne: Taschen, 2001.

Serlio, Sebastiano. *Libro tercero y quarto de arquitectura.* Toledo: Juan de Ayala, 1552.

Sicardus of Cremona. *Mitrale. PL* 213: 13–436.

Tercero catecismo y exposición de la doctrina cristiana para sermones para que los curas y otros ministros prediquen y enseñen a los indios y a otras personas. Lima: En la Oficina de la Calle de San Jacinto, 1585.

Tobler, Titus. *Bibliographia geographica Palestinae.* Leipzig: S. Hirzil, 1867.

Torquemada, Juan de. *Monarquía indiana.* 7 vols. Mexico City: UNAM, 1983.

Torres Pezellín, José. *Jerusalén triuphante y militante traslada en la portería de Nuestro Padre San Francisco de la ciudad de los Ángeles.* Puebla, 1682.

Valadés, Diego. *Rhetorica Christiana ad concionandi, et orandi vsum accommodata vtrivsque facultatis exemplis svo loco insertis: quae quidem ex Indorum maxime de prompta sunt historiis. Unde, praeter doctrinam summa quoque delectatio comparabitur.* Perusiae: Petrumiacubum Petrutium, 1579. Reprinted in facsimile with notes and translation by Esteban Palomera, *Fray Diego Valadés: Retórica Cristiana.* Mexico City: UNAM and FCE, 1989.

Verdadera informaçam das terras do Preste Joam das Indias. Lisbon, 1540.

Vetancurt, Agustín de. *Teatro mexicano: Crónica de la provincia del Santo Evangelio.* Mexico, 1698. 4 vols. Mexico City: E. Porrúa, 1971.

Vives, J. *Concilios visigóticos e hispano-romanos.* Barcelona and Madrid, 1963.

Wadding, Luke. *Annales minorum seu trium ordinum a S. Francisco institutorum.* 3rd ed. Florence-Quaracchi: Tipografia Barbera, 1931–33.

Walafrid Strabo. *Apocalypsis B. Johannes. PL* 114:709–52.

————. *De Rebus Ecclesiasticis. PL* 114:919–66.

Zumárraga, Juan de. *Compendio breve que tracta de la manera de cómo se han de de hazer las processions.* Mexico: Juan Cromberger, 1544.

Secondary Works

Adolf, Helen. *Visio Pacis: Holy City and Grail.* State College: Pennsylvania State University Press, 1960.

Aichele, Klaus. *Das Antichristdrama des Mittelalters der Reformation und Gegenreformation.* The Hague: Martinus Nijhoff, 1974.

Alba, Ramón. *Acerca de algunas particularidades de las comunidades de Castilla tal vez relacionadas con el supuesto acarcer terreno del Milenio Igualitario.* Biblioteca de visionarios, heteredoxos y marginados, 3. Madrid: Editora Nacional, 1975.

Alcántara Rojas, Berenice. "Breve aclaración sobre el *exemplum* de Valentín de la Roca." *Anales* 76 (2000): 265–68.

————. "Fragmentos de una evangelización negada." *Anales* 73 (1998): 69–85.

Alcina Franch, José. "Lenguaje metafórico e iconografía en el arte mexica." *Anales* 66 (1995): 7–44.

Alexander, P. J. "Byzantium and the Migration of Literary Motifs: The Legend of the Last Roman Emperor." *Medievalia et Humanistica*, n.s. 2 (1971): 47–68.

————. "The Diffusion of Byzantine Apocalypses in the Medieval West and the Beginnings of Joachimism." In Ann Williams, *Prophecy and Millenarianism*, 65–67.

Alfarano, Tiberio. *De Basilicae Vaticanae.* Edited by M. Cerrati. Studi e Testi, 26. Rome: Tipografia Poliglotta Vaticana, 1914.

Alonso, Martin. *Diccionario Medieval Español.* 2 vols. Salamanca: University of Salamanca, 1986.

Amades, J. "Los animales simbólicos en la procesión de Corpus." In *Paz Cristiana: XXXV Congreso Eucaristico Internacional.* Barcelona: Seminario Conciliar, 1952.

Anderson, Arthur. "La enciclopedia doctrinal de Sahagún." In Hernández de León-Portilla, *Bernardino de Sahagún*, 164–79.

Andrés Martín, Melquiades. "Antropología de los doce Apóstoles de México y su vinculación con Extremadura." In *Hernán Cortés y su tiempo: Actas del Congreso Hernán Cortés y su Tiempo: V Centenario (1485–1985)*, edited by Miguel Rodríguez Cancho, 448–60. Mérida: Editora Regional de Extremadura, 1987.

———. "Nuevo planteamiento de la útopia franciscana en México." In *Extremadura en la evangelización del Nuevo Mundo, actas y estudios del congreso celebrado en Guadalupe 24–29 Oct. 1988*, edited by Sebastián García, 269–90. Madrid: Turner, 1990.

Arasse, Daniel. "Iconographie et évolucion spiritualle: La tablette de saint Bernardin de Sienne." *Revue de l'Histoire de la Spiritualité* 50 (1974): 433–56.

Aregay, Merid Wolde. "Millenarian Traditions and Peasant Movements in Ethiopia, 1500–1855." In *Proceedings of the Seventh International Conference of Ethiopian Studies*, edited by Sven Ruberson. Addis Ababa: Institute of Ethiopian Studies; Lansing: Michigan State University Press, 1984.

Arellano Garcia, Mario. *La capilla mozarabe o del Corpus Christi.* Toledo: Instituto de Estudios Visigoticos-Mozarabe de San Eugenio, 1982.

Arellano Hernández, Alfonso. "Un aspecto del renacimiento en la ciudad de los Ángeles." In *Primer coloquio sobre Puebla*, 135–46. Puebla: Colección V Centenario, 1990.

Arnold, Philip. *Eating Landscape: Aztec and European Occupation of Tlalocan.* Niwot: University Press of Colorado, 1999.

Arredondo, Rosa Camelo, et al. *Juan Gerson: Tacuilo de Tecamachalco.* Mexico City: INAH, 1964.

Arroniz, Othón. *Teatro de evangelización en la Nueva España.* Mexico City: UNAM, 1979.

Artigas, Juan. *Capillas abiertas aisladas de México.* Mexico City: UNAM, 1982.

———. *La piel de la arquitectura: Murales de Santa María Xoxoteco.* Mexico City: UNAM, 1979.

———. *Metztitlán, Hidalgo: Arquitectura del siglo XVI.* Mexico City: UNAM, 1996.

Ashworth, Henry. "Urbs Beata Ierusalem, Scriptural and Patristic Sources." *Ephemerides Liturgicae* 70 (1956): 238–41.

Avalos, Hector. "Columbus as Biblical Exegete: A Study of the *Libro de las profecías*." In *Religion in the Age of Exploration: The Case of Spain and New Spain*, edited by Bryan Le Beau et al., 59–80. Omaha: Creighton University Press, 1996.

Averni, Anthony F. "Mapping the Ritual Landscape." In Carrasco, *To Change Place*, 58–73.

Ávila, Ana. *Imágenes y símbolos en la arquitectura pintada española, 1470–1560.* Barcelona: Anthropos, 1993.

Avis, Paul. *God and the Creative Imagination: Metaphor, Symbol and Myth in Religion and Theology.* London: Routledge, 1999.

Bagatti, Bellarmino. *Il Golgota e la croce: Ricerche storico-archeologiche.* Studium Biblicum Franciscanum, Collectio Minor, 21. Jerusalem: Franciscan Press, 1978.

Bailey, Gauvin Alexander. *Art on the Jesuit Missions in Asia and Latin America, 1542–1773.* Toronto: University of Toronto Press, 1999.

Balbás, Leopoldo Torres. "Musalla y saria en las ciudades hispano-musulmanes." *Al-Andalus* 12 (1948): 167–80.

Baldovin, John. *The Urban Character of Christian Worship: The Origins, Development, and Meaning of Stational Liturgy.* Rome: Pontificium Institutum Studiorum Orientalium, 1987.

Baldwin, Neil. *Legends of the Plumed Serpent.* New York: Public Affairs, 1998.

Ballesteros García, Victor Manuel. *La pintura mural del convento de Actopan.* Hidalgo: Universidad Autónoma del Estado de Hidalgo, 1999.

Baltrustaitis, J. "Villes sur arcatures." In *Urbanisme et architecture: Etudes éscrites et publiées en l'honneur de Pierre Lavedan*, 31–40. Paris: H. Laurens, 1956.

Bandmann, Günter. *Mittelalterliche Architektur als Bedeuntugsträger.* Berlin: Geb. Mann, 1951.

Bango Torviso, Isidoro Gonzalo. "Atrio y portico en el románico español: Concepto y finalidad civico-litúrgica." *Boletín del Seminario de Estudios de Arte y Arqueología* 40, no. 41 (1975): 175–88.

Barajau, Luis. *El mito mexicano de las edades.* Mexico City: Porrua, 1998.

Bartoli, Luciano. *La Chiave: Per la comprensione del simbolismo e dei segni nel sacro.* Trieste: LINT, 1982.

Bascapé, Giacomo. *Sigillografia: Il sigillo nella diplomatica, nel diritto, nella storia, nell'arte.* 3 vols. Milan: Editore Antonio Giuffre, 1978.

Basich Leija, Zita. *Guía para el uso del Códice Florentino.* Mexico City: INAH, 1987.

Bataillon, Marcel. "Ensayo de explicación del auto sacramental." In Bataillon, *Varia lección de clásicos españoles.* Madrid: Gredos, 1964.

———. *Erasmus y España: Estudios sobre la historia espiritual del siglo XVI.* Mexico City: FCE, 1950.

———. "Evangelisme et millénarisme au Nouveau Monde." In *Courants religieux et humanisme a la fin du XV siècle*, 25–36. Colleque Strasbourg, 30. Paris: Presses Universitaires de France, 1959.

———. "Nouveau Monde et Fin du Monde." *L'Education Nationale* 32 (1952): 3–6.

Battisti, Eugenio. "Roma apocalittica e re Salomone." In Battisti, *Rinascimento e Barocco*, 72–95. Turin: Einaudi, 1960.

Baudot, Georges. *Utopía e historia en México: Los primeros cronistas de la civilización mexicana (1520–1569).* Madrid: Espasa-Calpe, 1983.

Baum, Julius. *Romanesque Architecture in France.* New York: Westermann, 1928.

Baumgartner, Jakob. *Mission und Liturgie in Mexiko*. 2 vols. Supplementa 18–19. Schöneck/Beckenried: Neue Zeitschrift für Missionswissenschaft, 1971–72.

Baxter, Sylvester. *Spanish-Colonial Architecture in Mexico*. Boston: Millet, 1901.

Bayle, Constantino. *El culto del Santísimo en Indias*. Madrid: Consejo Superior de Investigaciones Científicas, Instituto Santo Toribio de Mongrovejo, 1951.

Bellver Cano, J. *El Corpus en Granada*. Granada, 1913.

Beltrán de Heredia, Soledad Vila. "El plan regular de Eximenis y las Ordenanzas Reales de 1573." In *La ciudad iberoamericana, actas del Seminario Buenos Aires*, 375–82. Madrid: Centro de Estudios y Experimentación de Obras Públicas, 1987.

Benedict, Nancy. "Iconographic Sources of the Mexican Atrio Crosses." M.A. thesis, Tulane University, 1976.

Berliner, R. "Arma Christi." *Münchner Jahrbuch der bildende Kunst* 3, no. 6 (1955): 35–118.

Bernales Ballesteros, Jorge. "Capillas abiertas en las parroquias andinas del Peru en los siglos XVI-XVII." In *Arte y arquitectura*, 113–30. La Paz, 1969.

Bertelli, Carlo. "Visual Images of the Town in Late Antiquity and the Early Middle Ages." In *The Idea and Ideal of the Town between Late Antiquity and the Early Middle Ages*, edited by G. P. Brogiolo and Bryan Ward-Perkins, 127–46. Leiden: Brill, 1999.

Bhabha, Homi. *The Location of Culture*. New York: Routledge, 1994.

Bihel, Stephanus. "S. Franciscus fuitne angelus sexti sigilli?" *Antonianum* 2 (1927): 59–90.

Bloch, P. "Seven-Branched Candelabra in Christian Churches." *Journal of Jewish Art* 1 (1974): 44–49.

Blockmans, Wim. "Fondans en melencolie de povreté: Living and Working in Bruges 1482–1584." In *Bruges and the Renaissance*, edited by Maximilian Martens. Belgium: Ludion, 1998.

Bloomfield, M. "Joachim of Flora." *Traditio* 13 (1957): 249–311.

———. "Recent Scholarship on Joachim of Fiore and His Influence." In Ann Williams, *Prophecy and Millenarianism*, 222–52.

Boas, Adrian. *Jerusalem in the Time of the Crusades*. London: Routledge, 2001.

Bocchi, Francesca, ed. *7 colonne e 7 chiese: La vicenda ultramillenaria del complesso di Santo Stefano in Bologna*. Bologna: Grafis, 1987.

Bohigas, Pere. *Prediccions i profecies en les obres de fra Francesc Eiximenis*. Barcelona: Editorial Franciscana, 1928.

Bolton, Brenda. "Message, Celebration, Offering: The Place of Twelfth- and Early Thirteenth-Century Liturgical Drama as Missionary Theatre." *Studies in Church History* 35 (1999): 89–103.

Bond, Frederick, and Bede Camm. *Roodscreens and Roodlofts*. London: I. Pitman, 1909.

Bonde, Sheila. *Fortress-Churches of Languedoc: Architecture, Religion and Conflict in the High Middle Ages*. Cambridge: Cambridge University Press, 1994.

Bonet Correa, Antonio. "La ciudad hispanoamericana." In *Gran enciclopedia de España y America*, 9:9–50. Madrid: Espasa-Calpe, 1986.

———. "Sacromontes y calvarios en España, Portugal y América Latina." In Gensini, *La Gerusalemme di San Vivaldo*, 173–214.

———. *Urbanismo en España e Hispanoamérica*. Madrid: Cathedra, 1991.

Bonilla, Luis. *Mitos y creencias sobre el fin del mundo*. Madrid: Escelicer, 1967.

Bonnery, André. "L'edicule du Saint-Sepulcre de Narbonne." *Cahiers de Saint-Michel-de-Cuxa* 22 (1991): 7–42.

Bono, Dianne. *Cultural Diffusion of Spanish Humanism in New Spain: Francisco Cevantes de Salazar's "Diálogo de la dignidad del hombre."* New York: Peter Lang, 1991.

Boone, Elizabeth Hill, ed. *The Aztec Templo Mayor: A Symposium at Dumbarton Oaks, 8th and 9th October 1983*. Washington, DC: Dumbarton Oaks, 1987.

———. "Migration Histories as Ritual Performance." In Carrasco, *To Change Place*, 121–51.

———. *Stories in Red and Black: Pictorial Histories of the Aztecs and Mixtecs*. Austin: University of Texas Press, 2000.

Borges, Pedro. *El envío de misioneros a América durante la época española*. Salamanca: Universidad Pontificia, 1977.

———. "El sentido transcendente del descubrimiento y conversión de Indias." *Missionalia Hispanica* 13 (1956): 141–77.

Bousset, Wilhelm. *The Antichrist Legend, a Chapter in Christian and Jewish Folklore*. London: Hutchinson, 1896.

Boutell, Charles. *Heraldry*. Revised by C. W. Scott-Giles. London: F. Warne, 1950.

Bowen, Lee. "The Tropology of Medieval Dedication Rites." *Speculum* 16, no. 4 (1941): 469–79.

Braun, Joseph. *Der christliche Altar in seiner geschichtlichen Entwicklung*. 2 vols. Munich: Guenther Kor, 1924.

———. "Puertas mudejas eucarísticas." *Archivo Español de Arte y Arqueología* 3 (1927): 197–220.

Braunfels, Wolfgang. *Monasteries of Western Europe: The Architecture of the Orders*. Princeton: Princeton University Press, 1972.

Bredero, Adriaan. "Jérusalem dans l'Occident medieval." In *Mélanges offerts à René Crozet*, edited by P. Gallais and Y. J. Riou, 1:259–82. Poitiers: Société d'Etudes Médiévales, 1966.

Bresc-Bautier, Geneviève. "Les imitations du Saint-Sépulcre de Jérusalem (IX–XV siècles): Archéologie d'une dévotion." *Revue de Histoire de la Spiritualité* 50 (1974): 319–42.

Briggs, Robert. *Jewish Temple Imagery in the Book of Revelation*. New York: Peter Lang, 1999.

Brinkman, Johan. *The Perception of Space in the Old Testament*. Kampen: Pharos, 1992.

Brittain, Francis. *The Penguin Book of Latin Verse*. Baltimore: Penguin, 1962.

Broda, Johanna. "The Provenience of the Offerings: Tribute and Cosmovision." In Boone, *The Aztec Templo Mayor*, 211–56.

———. "Templo Mayor as Ritual Space." In Broda et al., *Great Temple of Tenochtitlan*, 61–110.

Broda, Johanna, David Carrasco, Eduardo Matos Moctezuma, eds. *The Great Temple of Tenochtitlan: Center and Periphery in the Aztec World*. Berkeley and Los Angeles: University of California Press, 1987.

Broseghini, Silvio. "Historia y metodos en la evangelización en America Latina." In *V Centenario*, 229. Bogotá: Consejo Episcopal para Latino America, 1989.

Brown, Betty Ann. "All Around the Xocotl Pole: Reexamination of an Aztec Sacrificial Ceremony." In *Smoke and Mist: Mesoamerican Studies in Memory of Thelma D. Sullivan*, edited by J. Kathryn Josserand and Karen Dakin, 173–89. BAR International Series 402. Oxford: BAR, 1988.

Brundage, Burr Cartwright. *The Fifth Sun: Aztec Gods, Aztec World*. Austin: University of Texas, 1979.

Budde, Hendrik, and Andreas Nachama, eds. *Die Reise nach Jerusalem: Eine kulturhistorische Exkursion in die Stadt der Stadte 3000 Jahre Davidsstadt*. Berlin: Argon, 1996.

Bull, Malcolm. "The Iconography of the Sistine Chapel Ceiling." *Burlington Magazine* 130 (1988): 597–605.

Burkhart, Louise. "The Amanuenses Have Appropriated the Text: Interpreting a Nahuatl Song of Santiago." In *On the Translation of Native American Literatures*, edited by Brian Swann, 339–55. Washington, DC: Smithsonian Institution Press, 1992.

———. *Before Guadalupe: The Virgin Mary in Early Colonial Nahuatl Literature*. Albany: University of Albany; Austin: University of Texas Press, 2001.

———. "A Doctrine for Dancing: The Prologue to the Psalmodia Christiana." *Latin American Indian Literatures Journal* 11 (1995): 21–33.

———. "El *Tlauculcuicatl* de Sahagún: Un lamento Náhuatl." In Hernández de León-Portilla, *Berdardino de Sahagún*, 219–64.

———. "Flowery Heaven: The Aesthetic of Paradise in Nahuatl Devotional Literature." *Res* 21 (1992): 89–109.

———. *Holy Wednesday: A Nahua Drama from Early Colonial Mexico*. Philadelphia: University of Pennsylvania Press, 1996.

———. "Pious Performances: Christian Pageantry and Native Identity in Early Colonial Mexico." In *Native Traditions in the Postconquest World*, edited by Elizabeth Hill Boone and Tom Cummins, 361–81. Washington, DC: Dumbarton Oaks, 1998.

———. *The Slippery Earth: Nahua-Christian Moral Dialogue in Sixteenth Century Mexico*. Tucson: University of Arizona Press, 1989.

———. "The Solar Christ in Nahuatl Doctrinal Texts of Early Colonial Mexico." *Ethnohistory* 35 (1988): 234–56.

———. "The Voyage of Saint Amaro: A Spanish Legend in Nahuatl Literature." *Colonial Latin American Review* 4, no. 1 (1995): 29–57.

Burr, David. "Mendicant Readings of the Apocalypse." In *The Apocalypse in the Middle Ages*, edited by Richard Emmerson and Bernard McGinn, 89–102. Ithaca: Cornell University Press, 1992.

Buschiazzo, Mario. *Estudios de arquitectura colonial hispano americana*. Buenos Aires: G. Kraft, 1944.

Cahn, Walter. "Architectural Draftsmanship in Twelfth-Century Paris: The Illustrations of Richard of Saint-Victor's Commentary on Ezekiel's Temple Vision." *Gesta* 15 (1976): 247–54.

———. "Architecture and Exegesis: Richard of St.-Victor's Ezekiel Commentary and Its Illustrations." *AB* 76 (1994): 53–68.

———. "The *Bîmah* of the Worms Synagogue Reconsidered." *Journal of Jewish Art* 12/13 (1986/87): 266–68.

———. "Solomonic Elements in Romanesque Art." In *The Temple of Solomon*, edited by Joseph Gutmann, 45–72. Missoula, MT: Scholars Press, 1976.

Calderón, J. Rafael. "Arquitectura y simbolismo de la Cruz en el Cuzco." *Revista del Instituto Americano de Arte* 4, no. 1 (1945): 19–26.

Callaey, Frédègand. "L'influence et la diffusion de l'Arbor Vitae d'Ubertino de Casale." *Revue d'Histoire Ecclesiastique* 17 (1921): 533–46.

Callaway, Carol. "Pre-Columbian and Colonial Mexican Images of the Cross: Christ's Sacrifice and the Fertile Earth." *Journal of Latin American Lore* 16, no. 2 (1990): 199–231.

Camacho Cardona, Mario. *Historia urbana novohispánica del siglo XVI*. Mexico City: UNAM, 2000.

Camelo Arredondo, Rosa, et al. *Juan Gerson: Tlacuilo de Tecamachalco*. Mexico City: INAH, 1964.

Campailla, Roberto. "The *qubba* of the Rabbato at Mineo in Sicily." *Al-Masaq* 7 (1995): 1–20.

Campbell, Ian. "A Romanesque Revival and the Early Renaissance in Scotland, c. 1380–1513." *Journal of the Society of Architectural Historians* 54 (1955): 302–25.

Canedo, Lino Gómez. *Evangelización y conquista*. Mexico City: Porrua, 1977.

Capmany, Aurelio. "Los gigantes de la procesión del Corpus Christi." In *Paz Cristiana: XXXV Congreso Eucarístico Internacional*. Barcelona: Seminario Conciliar, 1952.

Cardini, Franco. "La devozione a Gerusalemme in occidente e il caso sanvivaldino." In Gensini, *La Gerusalemme di San Vivaldo*, 55–102.

Carrasco, David. *Daily Life of the Aztecs*. Westport, CT: Greenwood Press, 1988.

———. "Myth, Cosmic Terror, and the Templo Mayor." In Broda et al., *The Great Temple of Tenochtitlan*, 124–62.

———. *Quetzalcóatl and the Irony of Empire: Myths and Prophecies in the Aztec Tradition*. Chicago: University of Chicago Press, 1982.

———. *Religions of Mesoamerica*. San Francisco: Harper & Row, 1990.

———. "The Sacrifice of Tezcatlipoca." In Carrasco, *To Change Place*, 31–57.

———, ed. *To Change Place: Aztec Ceremonial Landscapes*. Niwot: University of Colorado Press, 1991.

Caskey, Jill. "The Rufolo Palace in Ravello and Merchant Patronage in Medieval Campania." Ph.D. diss., Yale University, 1994.

Castelao, Alfonso R. *As cruces de pedra na Galiza*. Vigo: Editorial Galaxia, 1984.

Castellanos de García, Silvia. "Concretización de la ciudad de los Angeles: Su traza y paralelismo con la Jerusalén Celeste, su escudo. Reflejo del Joaquinismo-Franciscano y del apocalipticismo romano renacentista." *Florensia: Bollettino del Centro Internazionale di Studi Gioachimiti* 13/14 (1999–2000): 45–96.

Castelló Yturbide, Teresa. *The Art of Featherwork in Mexico*. Mexico City: Banamex, 1993.

Casteñeda, Carlos. *The First American Play*. Austin, TX: St. Edward's University Press, 1936.

Catholic Church. *The Liturgy of the Hours*. New York: Catholic Book Publishing Co., 1975.

Cattaneo, E. "Il rituale romano di Alberto Castellani." In *Miscellanea liturgica in onore di sua Eminenza il Cardinale G. Lercaro*, 619–47. 2 vols. Rome: Herder, 1967.

Cattin, Giulio. "Testi melici e organizzazione rituale nella processione fiorentina di 'Depositio' scondo il manoscritto 21 dell'opera di S. Maria del Fiore." In *Dimensioni drammatiche della liturgia medioevale*, 243–67. Atti del I Convengo di Studio, Centro di Studi sul Teatro Medioevale e Rinascimentale, Viterbo, 31 May–2 June 1976. Rome: Bulzoni, 1977.

Cazenave, Anne. "La vision eschatologique des spirituels franciscains autour de leur condamnation." In *The Use and Abuse of Eschatology in the Middle Ages*, edited by Werner Verbeke et al., 393–403. Louvain: Louvain University Press, 1988.

Cazzato, Vicenzo. "Sentido y simbolismo de las reducciones jesuiticas americanas." *Cuadernos Internacionales de Historia Psicosocial del Arte* 2 (1983): 55–64.

Center for Inter-American Relations. *Gloria in Excelsis*. New York: Center for Inter-American Relations, 1988.

Cervantes, Fernando. *The Devil in the New World*. New Haven: Yale University Press, 1994.

Cervera Vera, Luis. *Francisco de Eiximenis y su sociedad urbana ideal*. Madrid: Grupo Editorial Swan, 1989.

Chambers, E. K. *The Medieval Stage*. 2 vols. Oxford: Oxford University Press, 1954.

Champeaux, Gérard de, and Sébastien Sterckx. *Introduction au monde des symboles*. 3rd ed. Saint-Leger-Vauban: Zodiaque, 1980.

Chanfón Olmos, Carlos. "Antecedentes del atrio mexicano del siglo XVI." *Cuadernos de Arquitectura Virreinal* 1 (1989): 4–16.

———. "Flemish Influences in Mexican Architecture of the 16th Century." *Artes de México* 19, no. 150 (1972): 107–10.

———. *Historia: Temas escogidos*. Mexico City: UNAM, Facultad de Arquitectura, 1990.

———. "Los conventos mendicantes novohispanos." Paper presented at the Coloquio extraordinario de historia de arte Manuel Toussaint, su proyección en la historia del arte mexicano, Tlaxcala, July–August 1990.

Chastel, André. "L'Apocalypse en 1500: La fresque de l'Antéchrist à la chapelle Saint-Brice d'Orvieto." *Bibliothèque d'Humanisme et Renaissance* 14 (1952): 124–40.

———. "Un épisode de la symbolisme urbaine au XV siècle: Florence et Rome, cités de Dieu." In *Urbanisme et architecture, études éscrites et publiées en l'honneur de Pierre Lavedan*, 75–79. Paris: H. Laurens, 1954.

Chauvet, Jesús. "The Church of San Francisco in Mexico City." *The Americas* 7 (1950/51): 22–23.

Checa Cremades, Fernando. *Carlos V: La imagén del poder en el Renacimiento*. Madrid: Ediciones del Viso, 1999.

———. *Carlos V y la imagén del héroe en el Renacimiento*. Madrid: Taurus, 1987.

Chester, Andrew. "The Sibyl and the Temple." In *Templum Amicitiae: Essays on the Second Temple presented to Ernst Bammel*, edited by William Horbury, 37–69. Sheffield: JSOT Press, 1991.

Christe, Yves. *Grands portails romans: Etudes sur l'iconologie des théophanies romanes*. Geneva: Droz, 1969.

———. *La vision de Matthieu: Origines et développement d'une image de la Seconde Parousie*. Paris: Klincksieck, 1973.

Christian, William. *Local Religion in Sixteenth-Century Spain*. Princeton: Princeton University Press, 1981.

Chupungco, Anscar. *Cultural Adaptation of the Liturgy*. New York: Paulist Press, 1982.

Cionarescu, A. "La *Historia de Indias* y la prohibición de editarla." *Anuario de Estudios Americanos* 22 (1966): 363–76.

Clendinnen, Inga. *Aztecs: An Interpretation*. Cambridge: Cambridge University Press, 1991.

———. "Ways to the Sacred: Reconstructing 'Religion' in Sixteenth Century Mexico." *History and Anthropology* 5 (1990): 105–41.

Cohn, Norman. *The Pursuit of the Millennium*. Rev. ed. New York: Oxford University Press, 1970.

Cohn, Robert. *The Shape of Sacred Space: Four Biblical Studies*. Atlanta: Scholars Press, 1990.

Colli, Agostino. "La tradizione figurativa della Gerusalemme celeste: Linee di sviluppo dal sec. III al sec. XIV." In *La dimora di Dio con gli uomini: Immagini della Gerusalemme celeste dal III al XIV secolo*, edited by Maria Gatti Perer, 119–44, 231–37. Milan: Vita e Pensiero, 1983.

Collins, John J. *The Scepter and the Star: The Messiahs of the Dead Sea Scrolls and Other Ancient Literature*. New York: Doubleday, 1995.

Colston, Stephen. "No Longer Will There Be a Mexico." *American Indian Quarterly* 9 (1985): 239–58.

Colvin, Howard. *Architecture and the After-Life*. New Haven: Yale University Press, 1991.

Comay, Joan. *The Temple of Jerusalem*. New York: Holt, Rinehart and Winston, 1975.

Cómez, Rafael. *Arquitectura y feudalismo en México: Los comienzos del arte novohispano en el siglo XV*. Mexico City: IIE, 1989.

———. *El documento más antiguo del Archivo General de la Nacion (fragmento de un Beato del siglo XIII)*. Mexico City: UNAM, 1985.

Conant, Kenneth John. *A Brief Commentary on Early Medieval Church Architecture*. Baltimore: Johns Hopkins University Press, 1942.

———. *Carolingian and Romanesque Architecture, 800–1200*. New York: Penguin, 1959; rev. ed., 1990.

———. *Cluny: Les églises et la maison du chef d'ordre*. Macôn: Impr. Protat Fréres, 1968.

Connerton, Paul. *How Societies Remember*. Cambridge: Cambridge University Press, 1989.

Constable, Giles. "Renewal and Reform in Religious Life: Concepts and Realities." In *Renaissance and Renewal in the Twelfth Century*, edited by R. Benson and G. Constable. Toronto: University of Toronto Press, 1982.

Cook, William R. *Images of St. Francis of Assisi in Painting, Stone and Glass from the Earliest Images to ca. 1320 in Italy: A Catalogue*. Florence: Leo Olschki Editore, 1999.

Corboz, André. "La ciudad como templo." In Ramírez et al., *Dios arquitecto*, 51–77.

Córdova Tello, Mario. *El convento de San Miguel de Huejotzingo, Puebla: Arqueologia historica*. Mexico City: INAH, 1992.

Corominas, J., and J. A. Pascual, *Diccionario crítico etimológico castellano e hispánico*. 2 vols. Madrid: Gredos, 1980.

Coseteng, Alicia. *Spanish Churches in the Philippines*. Manila: UNESCO National Commission of the Philippines, 1972.

Cothenet, Edouard. *Exégèse et liturgie*. Paris: Cerf, 1988.

Coulson, Charles. "Hierarchism in Conventual Crenellation: An Essay in the Sociology and Metaphysics of Medieval Fortification." *Medieval Archaeology* 26 (1982): 69–100.

Couneson, S. "La visite des autels dans la tradition monastique." *Revue Liturgique et Monastique* 21 (1936): 142–54, 378–87.

Craig, Hardin. *English Religious Drama of the Middle Ages*. Oxford: Clarendon, 1955.

Creswell, K. A. C. *A Short Account of Early Muslim Architecture*. Harmondsworth: Penguin, 1958.

Crosby, Sumner McKnight. *L'abbaye royal de Saint-Denis*. Paris: P. Hartmann, 1953.

Curiel, Gustavo. "Escatología y psychomachia en el programa ornamental de la capilla abierta de Tlalmanalco, Mexico." In *Iconología y sociedad: Arte colonial hispanoamericano, XLIV Congreso Internacional de Americanistas*. Mexico City: IIE, 1987.

———. *Tlalmanalco, historia e iconología del conjunto conventual*. Mexico City: UNAM, 1988.

Da Campagnola, Stanislao. "Dai viri spiritualis di Gioacchino da Fiore ai fratres spiritualis di S. Francesco d'Assisi." *Picenum Seraphicum* 11 (1974): 24–52.

———. *L'Angelo del sesto sigillo e l'alter Christus: Genesi e sviluppo dei due temi francescani nei ss. XIII–XIV*. Rome: Laurentianum, 1971.

Damen, Frans, and Esteban Judd Zanon, eds. *Cristo Crucificado en los pueblos de América Latina*. Quito: Ediciones Abya-Yala, 1992.

Daneshvari, Abbas. *Medieval Tomb Towers of Iran: An Iconographical Study*. Lexington, KY: Mazdâ Publishers, 1986.

Daniel, E. Randolph. "Abbot Joachim of Fiore: The *De Ultimis Tribulationibus*." In Ann Williams, *Prophecy and Millenarianism*, 165–89.

———. "Apocalyptic Conversion: The Joachite Alternative to the Crusades." *Traditio* 25 (1969): 127–39.

———. *The Franciscan Concept of Mission in the High Middle Ages*. Lexington: University Press of Kentucky, 1975.

Daniélou, Jean. "Terre et paradis chez les pères de l'église." *Ernos Jahrbuch* 22 (1954): 433–72.

David-Roy, Marguerite. "Chapelles hautes dédiées à saint Michel à l'époque romane." *Archeologia* (1977): 49–57.

Davies, John Gordon. *The Secular Use of Church Buildings*. New York: Seabury, 1968.

Davis-Weyer, Caecilia. *Early Medieval Art, 300–1150*. Toronto: University of Toronto Press, 1986.

Dawson, Christopher. *The Mongol Mission: Narratives and Letters of the Franciscan Missionaries in Mongolia and China in the Thirteenth and Fourteenth Centuries*. Translated by a nun of Stanbrook Abbey. New York: Sheed and Ward, 1955.

Debiaggi, Casimiro. "La capella *subtus crucum* al Sacro Monte di Varallo." *Bollettino Storico per la Provincia di Novara* 66, no. 1 (1975): 72–80.

de Blaauw, Sible. "The Solitary Celebration of the Supreme Pontiff: The Lateran Basilica as the New Temple in the Medieval Liturgy of Maundy Thursday." In *Omnes Circumadstantes: Contributions towards a History of the Role of the People in Liturgy Presented to Herman Wegman*, edited by Charles Caspers and Marc Schneiders, 120–43. Kampen: Kok, 1990.

Dedenbach-Salazar Sáenz, Sabine, and Lindsey Crickmay, eds. *La lengua de la cristianización en Latinoamérica: Catequización e instrucción en lenguas amerindias*. Bonner Amerikanistische Studien, 32. Markt Schwaben, Germany: A. Saurwein, 1999.

Desroche, Henri. *Dieux d'hommes: Dictionnaire des messianismes et millénarismes de l'ère chrétienne*. Paris: Mouton, 1969.

Díaz Díaz, Adelia. *Iglesia y claustro de San Juan de Duero*. Soria: Junta de Castilla y León, 1997.

Dibble, Charles, "The Náhuatlization of Christianity." In *Sixteenth-Century Mexico: The Work of Sahún*, edited by Munro Edmonson. Albuquerque: University of New Mexico Press, 1974.

Dienstag, Jacob. *Eschatology in Maimonidean Thought: Messianism, Resurrection, and the World to Come*. New York: Ktav, 1983.

Di Fonzo, P. "La famosa bolla di Leone X *Ite vos* non *Ite et vos*." *Miscellanea Franciscana* 44 (1944): 164–71.

Dix, Gregory. *The Shape of the Liturgy*. London: Dacre, 1978.

Dobal, Carlos. *La Isabela: Jerusalén Americana*. Santiago de los Caballeros, Dominican Republic: Universidad Catolica Madre y Maestra, 1987.

Donovan, Richard. *The Liturgical Drama in Medieval Spain*. Toronto: Pontifical Institute of Medieval Studies, 1958.

Dörner, R. "Die Auferstehungsfeier am Charsamtag nach dem Sacerdotale Romanum." *Caecilien-Kalender* 10 (1885): 27–36.

Dotson, E. "An Augustinian Interpretation of Michelangelo's Sistine Ceiling." *AB* 61 (1979): 223–56, 405–29.

Dougherty, James. *The Fivesquare City: The City in the Religious Imagination*. Notre Dame: University of Notre Dame Press, 1980.

Du Cange, Charles. *Glossarium Mediae et Infimae Latinitatis*. 8 vols. Paris: Librairie des Sciences et des Arts, 1937–38.

Durán, Eulàlia. "Profecia i revolta social al regne de València a l'inici del segle XVI." In Rusconi, *Storia e figure*, 175–94.

Duriez, Georges. *La théologie dans le drame religieux en Allemagne au Moyen Age*. Facultés Catoliques de Lille, Mémoires et traveaux. Lille: R. Giard, 1914.

Durrieu, Paul. "Le temple Jérusalem dans l'art français et flamand du XV siècle." In *Mélanges offerts à M. Gustave Schlumberger*. 2 vols. Paris: P. Geuthner, 1924.

Duverger, Christian. "The Meaning of Sacrifice." In *Fragments for a History of the Human Body*, edited by Michel Feher et al., 3:367–85. New York: Zone, 1989.

Dyggve, Ejnar. *History of Salonitan Christianity*. Oslo: Aschenhoug; Cambridge, MA: Harvard University Press, 1951.

Dynes, Wayne. "The Medieval Cloister as Portico of Solomon." *Gesta* 12 (1973): 61–69.

Edgerton, Sam. *Theaters of Conversion*. Albuquerque: University of New Mexico Press, 2001.

Eire, Carlos. *War against the Idols: The Reformation of Worship from Erasmus to Calvin*. New York: Cambridge University Press, 1986.

"El Castillo de Chapultepec." *Arqueología Mexicana* 8, no. 46 (2000): 24–33.

Eliade, Mircea. "Paradise and Utopia: Mythical Geography and Eschatology." In Eliade, *The Quest: History and Meaning in Religion*, 88–111. Chicago: University of Chicago Press, 1969.

———. "The World, the City, the House." In Eliade, *Occultism, Witchcraft and Cultural Fashions: Essays in Comparative Religion*, 18–31. Chicago: University of Chicago Press, 1976.

Elzey, Wayne. "Some Remarks on the Space and Time of the Center." *Estudios de Cultura Náhuatl* 12 (1976): 315–34.

Emmerson, Richard. *Antichrist in the Middle Ages: A Study of Medieval Apocalypticism, Art and Literature*. Seattle: University of Washington Press, 1981.

Emmerson, Richard, and Ronald Herzman. *The Apocalyptic Imagination in Medieval Literature*. Philadelphia: University of Pennsylvania Press, 1992.

Enciclopedia de la Iglesia Católica. Mexico City: Enciclopedia de Mexico, 1982.

Enciclopedia de la Religión Católica. Barcelona: Dalmau y Jover, 1950–56.

Esmeijer, Anna. *Divina Quaternitas: A Preliminary Study in the Method and Application of Visual Exegesis*. Assen: Gorcum, 1978.

Estrada de Gerlero, Elena. "El friso monumental de Itzmiquilpan." In *Actes du XLII Congrès International des Américanistes, 1976*, 9–19. Paris: Société des Américanistes, 1977–79.

———. "El nombre y su morada: Los monogramas de los nombres sagrados en el arte de la nueva y primitiva iglesia de Indias." In *Parábola novohispana: Cristo en el arte virreinal*, edited by Elisa Vargas Lugo, 177–202. Mexico City: Banamex, 2000.

———. "El programa pasionario en el convento franciscano de Huejotzingo." *Jahrbuch für Geschichte von Staat, Wirschaft und Gesellschaft lateinamerikas* 20 (1983): 643–706.

———. "El teatro de evangelización." In *Teatros de México*, edited by Armando Díaz de León de Alba, 23–33. Mexico City: Banamex, 1992.

———. "La demonología en la obra gráfica de fray Diego Valadés." In *Iconología y sociedad: Arte colonial hispanoamericano, XLIV Congreso Internacional de Americanistas*, 77–90. Mexico City: IIE, 1987.

———. "La pintura mural durante el Virreinato." In *Historia general del arte mexicano*, edited by Pedro Rojas, 7:1011–27. Mexico City: Editorial Hermes, 1988.

———. "Los temas escatológicos en la pintura mural Novohispana del siglo XVI." *Traza y Baza* 7 (1978): 71–88.

———. "Sentido político, social y religioso en la arquitectura conventual novohispana." In *Historia general del arte mexicano*, edited by Pedro Rojas, 5:624–43. Mexico City: Editorial Hermes, 1986.

Ettlinger, L. D. *The Sistine Chapel before Michelangelo: Religious Imagery and Papal Primacy*. Oxford: Clarendon Press, 1965.

Fagiolo, Marcello. "La fondazione delle città latino-americane gli archetipi della guitizia e della fede." *Psicon* 5 (1975): 35–58.

Falomir Faus, Miguel. "El proceso de 'cristianización urbana' de la ciudad de Valencia durante el siglo XV." *Archivo Español de Arte* 254 (1991): 127–39.

Fane, Diana, et al. *Converging Cultures: Art and Identity in Spanish America*. New York: Harry N. Abrams, 1996.

Fedeli Bernardini, Franca. "Roma nei secoli XII–XVII tra rappresentazione e realità." In *Città e linguaggi: Utopie, rappresentazioni e realità*, edited by Franca Fedeli Bernardini, 31–43. Rome: Fratelli Palombi, 1991.

Fergusson, Peter. "The Refectory at Easby Abbey: Form and Iconography." *AB* 71 (1989): 334–50.

Fernández, Martha. *Cristóbal de Medina Vargas y la arquitectura salomónica en la Nueva España durante el siglo XVII*. Mexico City: IIE, 2002.

Fernández, Miguel Angel. *La Jerusalén indiana: Los conventos-fortaleza mexicanos del siglo XVI*. Mexico City: Smurfit Carton, 1992.

Fernández Arenas, José. *La arquitectura mozárabe*. Barcelona: Ediciones Polígrafa, 1972.

Fernández de Castillo, Francisco. *Libros y libreros en el siglo XVI*. Mexico: Fondo de Cultura Económica, Archivo General de la Nación, 1982.

Fernández Echeverría y Veyta, Mario. *Historia de la fundación de la ciudad de la Puebla de los Angeles en la Nueva España*. Mexico City: Consejo Nacional para la Cultura y las Artes, 1990.

Ferri Piccaluga, Gabriella. "Il 'Monte Sacro' dei filosofi e la pratica del 'pellegrinaggio della conoscenza.'" In Gensini, *La Gerusalemme di San Vivaldo*, 109–32.

Filgueira Valverde, José. *Baldaquinos Gallegos*. La Coruña: Fundación Pedro Barrié de la Maza, 1987.

Flanagan, C. Clifford. "The Apocalypse and the Medieval Liturgy." In *The Apocalypse in the Middle Ages*, edited by Richard Emmerson and Bernard McGinn, 333–51. Ithaca: Cornell University Press, 1992.

Fleming, James. "The Undiscovered Gate beneath Jerusalem's Golden Gate." *Biblical Archeological Review* 9, no. 1 (1983): 24–37.

Fleming, John V. "Christopher Columbus as a Scriptural Exegete." *Lutheran Quarterly* 5 (1991): 187–98.

———. *From Bonaventure to Bellini: An Essay in Franciscan Exegesis*. Princeton: Princeton University Press, 1982.

Fleming, Martha, ed. *The Late Medieval Pope Prophecies*. Tempe: Arizona Center for Medieval and Renaissance Studies, 1999.

Fletcher, Richard. *The Conversion of Europe: From Paganism to Christianity, 371–1386*. New York: Harper Collins, 1997.

Flores Guerrero, Raul. *Las capillas posas de México*. Mexico City: Ediciones Mexicanas, 1951.

Flores Santana, Juan Antonio. *La isla Española: Cuna de la evangelización de América*. La Vega, Dominican Republic: Obispado de la Vega, 1986.

Folan, George. *The Open Chapel of Dzibilchaltun, Yucatan*. New Orleans: Tulane University Press, 1961.

Folda, Jaroslov. *The Art of the Crusaders in the Holy Land, 1098–1187.* Cambridge: Cambridge University Press, 1995.

Fondo Editorial de la Plastica Mexicana. *Juan Gerson, pintor indígena del siglo XVI—símbolo del mestizage—Tecamachalco Puebla.* Mexico City: Fonde Editorial de la Plastica Mexicana, 1972.

Fontaine, Jacques. *El Prerrománico.* Madrid: Ediciones Encuentro, 1978. Originally published as *L'art préroman hispanique.* Paris, 1973.

———. "Fuentes y tradiciones paleocristianas en el método espiritual de Beato." In *Actas del Simposio para el Estudio de los Códices del "Comentario al Apocalipsis" de Beato de Liébana,* 1:77–105. Madrid: Joyas Bibliograficas, 1978–80.

Foster, George McClelland. *Culture and Conquest: America's Spanish Heritage.* Chicago: Quadrangle, 1960.

Fothergill-Payne, Louis. "La *Psychomachia* de Prudencio y el teatro alegórico pre-calderoniano." *Neophilologus* 59 (1975): 48–62.

Frank, Jacqueline, and William Clark. "Abbot Suger and the Temple in Jerusalem: A New Interpretation of the Sacred Environment in the Royal Abbey of Saint-Denis." In *The Built Surface: Architecture and the Pictorial Arts,* edited by Christy Anderson, 109–29. Burlington, VT: Ashgate, 2002.

French, Dorothea. "Journeys to the Center of the Earth: Medieval and Renaissance Pilgrimages to Mount Calvary." In *Journeys toward God: Pilgrimage and Crusade,* edited by Barbara Sargent-Baur, 45–82. Kalamazoo: Medieval Institute Publications, 1992.

Frost, Elsa Cecilia. "America: Ruptura del providencialismo." In *El descrubimiento de América y su sentido actual,* edited by Leopoldo Zea, 169–81. Mexico City: FCE, 1989.

———. "El milenarismo franciscano en México y el profeta Daniel." *Historia Mexicana* 26 (1976): 3–28.

Galavaris, George. *Bread and the Liturgy: The Symbolism of Early Christian and Byzantine Bread Stamps.* Madison: University of Wisconsin Press, 1970.

Gallo, Marta. *Reflexiones sobre espejos. La imagen especular: Cuatro siglos en su trayectoria literaria hispanoamericano.* Guadalajara: Universidad de Guadalajara, 1993.

García, Gregorio. *Origen de los Indios del Nuevo Mundo e Indias Occidentales.* Madrid, 1729. Facsimile, Mexico City: FCE, 1981.

Garcia, Simón Agustín. *El ocaso del Emperador: Carlos V en Yuste.* Madrid: Nerea, 1995.

García Barragan, Elisa. "Precedentes de las cruces atriales de la Nueva España." *Traza y Baza* (1979): 130–32.

García Granados, Rafael. "Reminiscencias idolátricas en monumentos colonials." *Anales* 5 (1940): 54–55.

———. "Simulacros de Misa." *Excelsior,* Mexico City, 8 Dec. 1931.

García Granados, Rafael, and L. Fernandez MacGregor. *Huejotzingo, la ciudad y el convento franciscano.* Mexico City: Talleres Graficos de la Nacion, 1943.

García Icazbalceta, Joaquín. "Carta de Fray Martín de Valencia y Fray Toribio Motolinía al Emperador." In García Icazbalceta, *Colección de documentos para la historia de México,* 2:155–57. Mexico City: J. M. Andrade, 1858–66.

———. "Fray Pedro de Gante." Reprinted in *Artes de México* 19, no. 150 (1972): 99–101.

García Lastra, Leopoldo A. "Joaquinismo, profecía y apocalipticismo: La Utopía Angelopolitana, Jerusalén Celeste de la Nueva España." *Florensia: Bollettino del Centro Internazionale di Studi Gioachimiti* 13/14 (1999–2000): 105–37.

Gardelles, Jacques. "Recherches sur les origines des façades a étages d'arcatures des églises médiévales." *Bulletin Monumental* 136 (1978): 113–33.

Gaston, Robert. "Prudentius and Sixteenth-Century Antiquarian Scholarship." *Medievalia et Humanistica,* n.s. 2, no. 4 (1973): 161–76.

Gatti Perer, Maria Luisa. "Gli studi sulle origini del Sacro Monte di Varallo e sulla personalità di Bernardino Caimi." In *Arte, Religione, Comunità nell'Italia rinascimentale e barocca: Atti del convengo di studi in occasione del V centenario di fondazione del Santuario della Beata Vergine dei Miracoli di Saronno (1498–1998),* edited by Lucia Saccardo and Danilo Zardin, 95–119. Milan: Vita e Pensiero, 2000.

———, ed. *La dimora di Dio con gli uomini: Immagini della Gerusalemme celeste dal III al XIV secolo.* Milan: Vita e Pensiero, 1983.

———. "Umanismo a Milano: L'Osservanza Agostiniana in Lombardia e l'Incoronata." *Arte Lombarda* 53/54 (1980).

Geertz, Clifford. *The Interpretation of Cultures: Selected Essays.* New York: Basic Books, 1973.

Gensini, Sergio, ed. *La Gerusalemme di San Vivaldo e i sacri monti in Europa.* Montaione: Pacini, 1989.

Gibson, Charles. *The Aztecs under Spanish Rule: A History of the Indians of the Valley of Mexico, 1519–1810.* Stanford: Stanford University Press, 1964.

Gieben, Servus. *Christian Sacraments and Devotion.* Leiden: E. J. Brill, 1980.

Gil, Fernando. *Primeras doctrinas del Nuevo Mundo: Estudio histórico-teológico de las obras de fray Juan de Zumárraga.* Buenos Aires: Universidad Católica de Argentina, 1993.

Gil, Juan. "Colón y la Casa Santa." *Historiografía y Bibliografía Americanistas* 21 (1977): 125–35.

———. "Los terrores del año 800." In *Actas del Simposio para el Estudio de los Códices del Comentario al Apocalipsis de Beato de Liébana,* 1:228–35. Madrid: Joyas Bibliográficas, 1978–1980.

Gil, Juan, and Consuelo Varela, eds. *Cartas particulares a Colón y relaciones coetáneas.* Madrid: Alianza, 1984.

Gil Atrio, Cesário. "¿España, cuna del Viacrucis?" *Archivo Ibero-Americano* 11 (1951): 63–92.

Gillerman, David. "S. Fortunato in Todi: Why the Hall Church?" *Journal of the Society of Architectural Historians* 48 (1989): 158–71.

Gil Tovar, Francisco. "Un arte para la propagación de la fe." In *Historia del arte colombiana,* 6:721–44. Bogotá: Salvat, 1983.

Gisbert, Teresa, and José de Mesa. *Arquitectura andina.* 2nd ed. La Paz: Embajada de España en Bolivia, 1997.

Gladstein, Ruth. "Eschatological Trends in Bohemian Jewry during the Hussite Period." In Ann Williams, *Prophecy and Millenarianism,* 239–56.

Glaser, Lynn. *Indians or Jews? An Introduction to a Reprint of Manasseh Ben Israel's "The Hope of Israel."* Gilroy, CA: R. V. Boswell, 1973.

Gliozzi, Guiliano. "The Apostles in the New World: Monotheism and Idolatry between Revelation and Fetishism." *History and Anthropology* 3 (1987): 123–48.

Gnilka, Christian. *Studien zur Psychomachie des Prudentius.* Wiesbaden: Otto Harrassowitz, 1963.

Goldin, Frederick R. "The Mirror and the Image in Medieval Courtly Love." Ph.D. diss., Columbia University, 1964.

Gómez Martínez, Javier. *Fortalezas mendicantes: Claves y procesos en los conventos novohipanos del siglo XVI.* Mexico City: Universidad Iberoamericana, 1997.

Gómez Moreno, Manuel. "Hacia Lorenzo Vázquez." *Archivo Español de Arte y Arqueología* 1 (1925): 23–28.

Góngora, Mario. *Studies in the Colonial History of Spanish America.* Cambridge: Cambridge University Press, 1975.

González Cirimele, Lilly. *Artesanía en Azabache.* Caracas: Consejo Nacional de la Cultura, 1989.

González Galván, Manuel. "El oro en el Barroco." *Anales* 45 (1976): 73–96.

———. "Sol de Justicia: Expresión alegorica plástica de un teólogo pintor." In *Iconología y sociedad: Arte colonial hispanoamericano,* 179–89. Mexico City: UNAM, 1987.

González Galván, Manuel, and Judith Hancock. *Arte virreinal en Michoacán.* Mexico City: Frente de Afirmación Hispanista, 1978.

Goren, Haim. "An Imaginary European Concept of Jerusalem in a Late Sixteenth-Century Model." *Palestine Exploration Quarterly* 127 (1995): 106–21.

Goren, Haim, and Rehav Rubin. "Conrad Schick's Models of Jerusalem and Its Monuments." *Palestine Exploration Quarterly* 128 (1996): 103–24.

Goslinga, Cornelis. "Templos doctrineros neogranadinos." *Cuadernos de la Valle,* 5:6–51. Colombia: Universidad de la Valle, 1970.

Gosselin, Edward. "A Listing of the Printed Editions of Nicolaus de Lyra." *Traditio* 26 (1970): 399–426.

Gossen, Gary. *Chamulas in the World of the Sun.* Cambridge, MA: Harvard University Press, 1974.

———, ed. *Symbol and Meaning beyond the Closed Community: Essays in Mesoamerican Ideas.* Albany: Institute for Mesoamerican Studies, State University of New York, 1986.

Grabar, André. *Martyrium: Recherches sur le culte des reliques et l'art chrétien antique.* 2 vols. Paris: Collège de France, 1943–46.

Grabar, Oleg. "Jerusalem Elsewhere." In *City of the Great King: Jerusalem from David to the Present,* edited by Nitza Rosovsky, 333–43. Cambridge, MA: Harvard University Press, 1996.

Graulich, Michel. "Afterlife in Ancient Mexican Thought." In *Circumpacifica,* edited by Bruno Illius. New York: P. Lang, 1990.

Graziano, Frank. *The Millennial New World.* Oxford: Oxford University Press, 1999.

Grierson, Roderick, ed. *African Zion: The Sacred Art of Ethopia.* New Haven: Yale University Press, 1993.

Grimes, Ronald. *Reading, Writing, and Ritualizing: Ritual in Fictive, Liturgical, and Public Places.* Washington, DC: Pastoral Press, 1993.

Grodecki, Louis, et al. *El siglo del año mil.* Madrid: Aguilar, 1973.

Groffen, Rona. "Friar Sixtus IV and the Sistine Chapel." *Renaissance Quarterly* 39 (1986): 218–62.

Grundmann, Herbert. *Neue Forschungen über Joachim von Floris.* Marburg: Simons Verlag, 1950.

———. *Studien über Joachim von Floris.* Leipzig: B. G. Teubner, 1927.

———. "Zur Biographie Joachims von Fiore und Rainers von Ponza." *Deutsches Archiv für Erforschung des Mittelalters* 16 (1960): 528–34.

Gruzinski, Serge. *El Agila y la Sibila.* Barcelona: Moleiro, 1994.

Gry, Leon. *Le millénarisme dans ses origines et son dévelopment.* Paris: Alphonse Picard, 1904.

Gschwend, K. *Die Depositio und Elevatio Crucis im Raum der alten Diözese Brixen.* Sarnem: L. Ehrli, 1965.

Guadalajara Medina, José. *Las profecías del anticristo en la Edad Media.* Madrid: Gredos, 1996.

Guarda, Gabriel. "La liturgia, una de las claves del barroco americano." In *El Barroco en Hispanoamerica.* Santiago de Chile: Universidad Católica, 1981.

———. *Los laicos en la cristianización de América.* Santiago de Chile: Universidad Católica, 1987.

———. *Santo Tomás de Aquino y las fuentes del urbanismo indiano.* Santiago de Chile: Academia Chilena de la Historia, 1965.

———. "Tres reflexiones en torno a la fundación de la ciudad indiana." *Revista de Indias* 127/130 (1972): 89–106.

Guidoni, Enrico. "Cistercensi e Città Nuove." In *I Cistercensi e il Lazio: Atti delle gionate di studio dell'Istituto di Storia dell'Arte dell'Università di Roma,* 259–73. Rome: Multigrafica, 1978.

Gutiérrez, Ramón. *The Jesuit Missions: City Planning, Architecture and Art.* Asunción: Mediterráneo, 1988.

Gutíerrez, Ramón, et al. *Arquitectura del altiplano peruano.* Buenos Aires: Libros de Hispanoamerica, 1986.

Gutmann, Joseph. "When the Kingdom Comes: Messianic Themes in Medieval Jewish Art." *Art Journal* 27, no. 2 (1967/68): 168–75.

Hagen, Susan. *Allegorical Remembrance: A Study of "The Pilgrimage of the Life of Man" as a Medieval Treatise on Seeing and Remembering.* Athens: University of Georgia Press, 1990.

Hailperin, Herman. *Rashi and the Christian Scholars.* Pittsburgh: University of Pittsburgh Press, 1963.

Hall, Marcia B. "The *Tramezzo* in Santa Croce, Florence, Reconsidered." *AB* 56 (1974): 325–41.

Hamilton, R. W. *The Structural History of the Aqsa Mosque.* Oxford: Oxford University Press, 1949.

Harris, Max. *Aztecs, Moors, and Christians: Festivals of Reconquest in Mexico and Spain.* Austin: University of Texas Press, 2000.

———. *Dialogical Theater: Dramatizations of the Conquest of Mexico and the Question of the Other.* New York: Macmillan, 1993.

Hassig, Ross. *Time, History and Belief in Aztec and Colonial Mexico.* Austin: University of Texas Press, 2001.

Hatfield, Rab. "The Tree of Life and the Holy Cross: Franciscan Spirituality in the Trecento and Quattrocento." In *Christianity and the Renaissance,* edited by Timothy Verdon and John Henderson, 132–60. Syracuse: Syracuse University Press, 1990.

Häussling, A. *Mönchskonvent und Eucharistiefeier.* Münster: Liturgiewissenschaftliche Quellen und Forschungen, 1973.

Heist, William Watts. *The Fifteen Signs before Doomsday.* East Lansing: Michigan State College Press, 1952.

Heitz, Carol. "Architecture et liturgie processionnelle à l'époque préromane." *Revue de l'Art* 24 (1974): 30–47.

———. *L'architecture religieuse carolingienne.* Paris: Picard, 1980.

———. *Recherches sur les rapports entre architecture et liturgie à l'époque carolingienne.* Paris: S. E. V. P. E. N., 1963.

———. "Retentissement de l'Apocalypse dans l'art de l'époque carolingienne." In *L'Apocalypse de Jean: Traditions exegetiques et iconografiques III–XIII siecles.* Geneva: Droz, 1979.

Heldman, Marilyn. "Architectural Symbolism, Sacred Geography and the Ethiopian Church." *Journal of Religion in Africa* 22 (1992): 222–41.

Hernández de León-Portilla, Ascensión, ed. *Bernardino de Sahagún: Diez estudios acerca de su obra.* Mexico City: UNAM, 1990.

Herrmann, Wolfgang. "Unknown Designs for the 'Temple of Jerusalem' by Claude Perrault." In *Essays in the History of Architecture Presented to Rudolf Wittkower,* edited by Douglas Fraser, Howard Hibbard, and Milton J. Lewine, 143–58. London: Phaidon, 1967.

Herz, Alexandra. "Borromini, S. Ivo, and Prudentius." *Journal of the Society of Architectural Historians* 48 (1989): 150–57.

Heyden, Doris. "Black Magic: Obsidian in Symbolism and Metaphor." In *Smoke and Mist: Mesoamerican Studies in Memory of Thelma D. Sullivan,* edited by J. Kathryn Josserand and Karen Dakin, 1:217–36. Oxford: B. A. R., 1988.

———. "El arbol en el mito y el simbolismo." *Estudios de Cultura Náhuatl* 23 (1993): 201–19.

———. "Metaphors, Nahualtocaitl, and Other 'Disguised' Terms among the Aztecs." In *Symbol and Meaning beyond the Closed Community: Essays in Mesoamerican Ideas,* edited by Gary Gossen, 35–43. Albany: Institute for Mesoamerican Studies, State University of New York, 1986.

Hillenbrand, Robert. *Islamic Architecture: Form, Function and Meaning.* Edinburgh: Edinburgh University Press, 1994.

Holmes, Urban T. "The Arthurian Tradition in Lambert d'Ardres." *Speculum* 25 (1950): 100–103.

Horcasitas, Fernando. *El teatro Náhuatl: Épocas novohispanoa y moderna.* Mexico City: UNAM, 1974.

Horn, Walter, and Ernest Born. *The Plan of St. Gall.* 3 vols. Berkeley and Los Angeles: University of California Press, 1979.

Howard, Deborah. *Venice and the East: The Impact of the Islamic World on Venetian Architecture, 1100–1500.* New Haven: Yale University Press, 2000.

Hubert, Jean. "La place faite aux faïcs dans les églises monastiques et dans les cathédrals aux XI et XII siècles." In *I laici nella societas*

christiana del secoli XI e XII, Settimane di Studi, Mendola, 470–87. Milan: Vita e Pensiero, 1968.

———. "La vie commune des clercs et l'archeologie." In *La vita comune del clero nei secoli XI e XII*. Miscellanea del Centro di Studi Medioevali, Mendola. Milan: Vita e pensiero, 1962.

———. "Les églises à rotonde orientale." In *Fruhmittelalterliche Kunst in den Alpenlanden*, Akten Zum III Internationalen Kongress für Fruhmittelalterforschung, 309–17. Olten: Urs Graf, 1954.

Hubert, Jean, et al. *L'empire carolingien*. Paris: Gallimard, 1968.

Huddleston, L. *Origins of the American Indian: European Concepts, 1492–1929*. Austin: University of Texas Press, 1965.

Hunt, Eva. *The Transformation of the Hummingbird: Cultural Roots of a Zinanantan Mythical Poem*. Ithaca: Cornell University Press, 1977.

Ingham, John. *Mary, Michael and Lucifer: Folk Catholicism in Central Mexico*. Austin: University of Texas Press, 1989.

Innocenti, Alessandro. "Il francescanesimo e i sacri monti." In Gensini, *La Gerusalemme di San Vivaldo*, 233–40.

Jacobson, Thorkild. *The Treasures of Darkness: A History of Mesopotamian Religion*. New Haven: Yale University Press, 1976.

Jasper, R. C. D., and G. J. Cuming. *Prayers of the Eucharist*. New York: Pueblo, 1987.

Johansson, Patrick. "Espacios rituales prehispánicos." In *Teatros de México*, 13–22. Mexico City: Banamex, 1992.

Joüon, Paul. "Les mots employés pour designer le temple." *Recherches de Science Religieuse* 25 (1935): 329–43.

Jungic, Josephine. "Joachimist Prophecies in Sebastíano del Piombo's Borgherini Chapel and Raphael's Transfiguration." In Reeves, *Prophetic Rome*, 321–43.

Kaczynski, B. M. "Illustrations of Tabernacle and Temple, Implements in the Postilla in Testamentum Vetus of Nikolaus de Lyra." *Yale University Library Gazette* 48 (1973): 1–11.

Kadir, Djelal. *Columbus and the Ends of the Earth*. Berkeley and Los Angeles: University of California Press, 1992.

Kagan, Richard. *Urban Images of the Hispanic World, 1493–1793*. New Haven: Yale University Press, 2000.

Kantorowicz, Ernst. *Laudes Regia: A Study in Liturgical Acclamations and Medieval Emperor Worship*. Berkeley: University of California Press, 1946.

———. *The King's Two Bodies: A Study in Mediaeval Political Theology*. Princeton: Princeton University Press, 1957.

Kaplony, Andreas. *The Haram of Jerusalem, 324–1099*. Freiburger Islamstudien 22. Stuttgart: Franz Steiner, 2002.

Katzenellenbogen, Adolf. *Allegories of the Virtues and Vices in Medieval Art from Early Christian Times to the Thirteenth Century*. Toronto: University of Toronto Press, 1989.

Kavanagh, Aidan. *On Liturgical Theology*. New York: Pueblo, 1984.

———. "Seeing Liturgically." In *Time and Community*, edited by J. Neil Alexander, 255–79. Washington, DC: Pastoral Press, 1990.

Kearney, Milo, and Manuel Medrano. *Medieval Culture and the Mexican American Borderlands*. College Station: Texas A&M University Press, 2001.

Kedar, Benjamin Z. *Crusade and Mission: European Approaches toward the Muslims*. Princeton: Princeton University Press, 1984.

Kedar, Benjamin Z., and R. J. Zwi Werblowsky, eds. *Sacred Space: Shrine, City, Land*. New York: New York University Press, 1998.

Kehoe, Alice. "The Sacred Heart: A Case for Stimulus Diffusion." *American Ethnologist* 6 (1979): 763–71.

Keleman, Pal. *Baroque and Rococo in Latin America*. New York: Macmillian, 1951.

Kernodle, George. "Déroulment de la procession dans les temps ou espace théâtral dans les fêtes de la Renaissance." In *Lés fêtes de la Renaissance*, edited by Jean Jacquot. Paris: Centre National de la Recherche Scientific, 1956.

———. *From Art to Theatre: Form and Convention in the Renaissance*. Chicago: University of Chicago Press, 1944.

Kimminich, Eva. "The Way of Vice and Virtue: A Medieval Psychology." In *Iconographic and Comparative Studies in Medieval Drama*, edited by Clifford Davidson and John Stroupe, 77–86. Kalamazoo: Medieval Institute Publications, 1991.

King, Georgiana Goddard. "The Triumph of the Cross: A Note on a Mozarabic Theme." *AB* 11, no. 4 (1929): 317–26.

Kinney, Dale. "The Apocalypse in Early Christian Monumental Decoration." In *The Apocalypse in the Middle Ages*, edited by Richard Emerson and Bernard McGinn, 200–16. Ithaca: Cornell University Press, 1992.

Kipling, Gordon. *Enter the King: Theatre, Liturgy, and Ritual in the Medieval Civic Triumph*. Oxford: Clarendon Press, 1998.

Kiracofe, James B. "Architectural Fusion and Indigenous Ideology in Early Colonial Teposcolula." *Anales* 66 (1995): 45–85.

Kitschelt, Lothar. *Die frühchristliche Basilika als Darstellung des himmlischen Jerusalem*. Munich: Neuer Filser-Verlag, 1938.

Klein, Cecelia. "The Ideology of Autosacrifice at the Templo Mayor." In Boone, *The Aztec Templo Mayor*, 293–370.

Kleinhaus, A. "De Commentario in Apocalypsim Fr. Alexandri Bremensis, O. F. M." *Antonianum* 2 (1927): 289–334.

Kloetzli, Godfrey. "The Franciscans in the Holy Land." *Holy Land Review* 1 (1975): 16–21.

Klor de Alva, J. Jorge. "Christianity and the Aztecs." *San Jose Studies* 5 (1979): 6–21.

———. "La historicidad de los coloquios de Sahagún." In Hernández de León-Portilla, *Bernardino de Sahagún*, 180–219.

———. "Religious Rationalization and the Conversions of the Nahuas: Social Organization and Colonial Epistemology." In Carrasco, *To Change Place*, 233–45.

———. "Spiritual Conflict and Accommodation in New Spain: Toward a Typology of Aztec Responses to Christianity." In *The Inca and Aztec States, 1400–1800*, edited by George Collier et al., 345–66. New York: Academic Press, 1982.

Klukas, Arnold. "Altaria Superioria: The Function and Significance of the Tribune-Chapel in Anglo-Norman Romanesque." Ph.D. diss., University of Pittsburgh, 1978.

Kobielus, Stanislaw. "Bramy Nirbianskiej Jerozolimy w Sredniowiecznej Egzegezie i Malarstwie." In *Jerozolima w Kulturze Europejskiej*, edited by Piotra Paszkiewicza and Tadeusza Zadroznego, 99–111. Warsaw: Instytut Sztuki Polskiej Akamemii Nauk, 1997.

Konigson, Elie. *La représentation d'un mystère de la Passion à Valenciennes en 1547*. Paris: Editions du Centre National de la Recherche Scientifique, 1969.

———. *L'espace théâtral médiéval*. Paris: Centre National de la Recherche Scientifique, 1975.

Krautheimer, Richard. "The Carolingian Revival of Early Christian Architecture." In Krautheimer, *Studies in Early Christian, Medieval and Renaissance Art*, 203–56. New York: New York University Press, 1965.

———. *Early Christian and Byzantine Architecture*. 4th ed. Hammondsworth: Penguin, 1986.

———. "Introduction to an Iconography of Medieval Architecture." *Journal of the Warburg and Courtland Institutes* 5 (1942): 1–33. Reprinted with a postscript in Krautheimer, *Studies in Early Christian, Medieval and Renaissance Art*, 115–50. New York: New York University Press, 1969.

———. *Rome, Profile of a City, 312–1308*. Princeton: Princeton University Press, 1980.

Krautheimer, Richard, et al. *Corpus Basilicarum Christianarum Romae*. 5 vols. Rome: Pontificio Istituto di Archeologia Cristiana, 1939–.

Krey, Philip, and Lesley Smith, ed. *Nicholas of Lyra: The Senses of Scripture*. Leiden: Brill, 2000.

Krinsky, Carol. "Representations of the Temple before 1500." *Journal of the Warburg and Courtlaud Institutes* 33 (1970): 1–19.

Kroesen, Justin. *The Sepulchrum Domini throughout the Ages: Its Form and Function*. Louvain: Peeters, 2000.

Kropfinger-von Kügelgen, Helga. "Problemas de aculturación en la iconología franciscana de Tecamachalco." *Comunicaciones: Proyecto Puebla-Tlaxcala* 7 (1973): 113–16.

Kubler, George. *Building the Escorial*. Princeton: Princeton University Press, 1982.

———. "The Claustral 'Fons Vitae' in Spain and Portugal." *Traza y Baza* 2 (1972): 7–14.

———. *Mexican Architecture of the Sixteenth Century*. New Haven: Yale University Press, 1948. Translated and annotated as *Arquitectura mexicana del siglo XVI*. Mexico City: FCE, 1982.

———. "On the Colonial Extinction of the Motifs of Pre-Columbian Art." In *Essays in Pre-Columbian Art and Archeology*, edited by Samuel Lothrop. Cambridge, MA: Harvard University Press, 1961.

———. *The Religious Architecture of New Mexico*. Albuquerque: University of New Mexico Press, 1990.

———. "Sacred Mountains in Europe and America." In *Christianity and the Renaissance: Image and Religious Imagination in the Quattrocento*, edited by Timothy Verdon and John Henderson, 413–41. Syracuse: Syracuse University Press, 1990.

———. "Ucareo and the Escorial." *Anales* 8 (1942): 5–15.

Kühnel, Bianca. *From the Earthly to the Heavenly Jerusalem: Representations of the Holy City in Christian Art of the First Milllennium*. Römische Quartalschrift für Altertumskunde und Firchengeschichte, 42 Supplementheft. Rome: Herder, 1987.

———, ed. *The Real and Ideal Jerusalem in Jewish, Christian and Islamic Art*. Special edition of *Jewish Art*, 23/24 (1997–98).

Kuntz, Marion Leathers. "Guillaume Postel and the World State: Restitution and the Universal Monarchy." In *Venice, Myth and Utopian Thought in the Sixteenth Century*, 299–465. Variorum Collected Studies Series. Aldershot: Ashgate, 1999.

———. "The Myth of Venice in the Thought of Guillaume Postel." In *Venice, Myth and Utopian Thought in the Sixteenth Century*, 505–23. Aldershot: Variorum Collected Studies Series, 1999.

Laborde, A., comte de. *Les manuscrits à peintures de la Cité de Dieu de Saint Augustin*. 3 vols. Paris: Société des Bibliophiles François, 1909.

Labrosse, H. "Sources de la bibliographie de Nicolas de Lyre." *Etudes Franciscaines* 16 (1906): 383–404; 17 (1907): 489–505, 593–608; 19 (1908): 41–52, 153–75, 368–79, 35 (1924): 171–87, 400–32.

La ciudad hispanoamericana: El sueño de un orden. Madrid: Centro de Estudios Históricos de Obras Públicas y Urbanismo, 1989.

Ladner, G. "Vegetation Symbolism and the Concept of the Renaissance." In *De Artibus opuscula XL: Essays in honor of Edwin Panofsky*, edited by M. Meiss, 303–22. Zurich: Buehler Buchdruck, 1961.

Lafaye, Jacques. *Mesías, cruzadas, utopias: El Judeo-cristianismo en las sociedades ibéricas*. Mexico City: FCE, 1988.

———. *Quetzalcótl and Guadalupe: The Formation of Mexican National Consciousness, 1531–1813*. Translated by Benjamin Keen. Chicago: University of Chicago Press, 1976.

La fiesta en la Europa de Carlos V. Madrid: Sociedad Estatal para la Conmemoración de los Centenarios de Felipe II y Carlos V, 2000.

Laguna Paúl, Teresa. "Nicolás de Lyra y la iconografía bíblica." *Apotheca* 5 (Cordoba, 1985): 39–78.

———. *Postillae in vetus et novum testamentum de Nicolás de Lyra*. Seville: Universidad de Sevilla, 1979.

Lakoff, George, and Mark Johnson. *Metaphors We Live By*. Chicago: University of Chicago Press, 1980.

Lambert, Elie. "L'architecture des Templiers." *Bulletin Monumental* 112 (1954): 7–60, 129–65.

Lampérez y Romea, Vincente. *Historia de la arquitectura cristiana española. . . .* 3 vols. Madrid: Espasa-Calpe, 1930.

Landa Abrego, Maria Elena. *Ollin y cruz en la simbología náhuatl*. Mexico City: INAH, 1985.

Landay, Jerry. *The Dome of the Rock*. New York: Newsweek, 1972.

Landes, Richard. "The Fear of an Apocalyptic Year 1000: Augustinian Historiography, Medieval and Modern." *Speculum* 75, no. 1 (2000): 97–145.

———. "Lest the Millennium be Fulfilled: Apocalyptic Expectations and the Pattern of Western Chronology, 100–800." In *The Use and Abuse of Eschatology*, edited by Werner Verbeke, 137–211. Louvain: Louvain University Press, 1988.

Langé, Santino. "Problematiche emergenti nella storiografia sui Sacri Monti." In *Sacri Monti: Devotione, arte e cultura della Controriforma*, edited by Luciano Vaccaro and Francesca Riccardi, 1–26. Milan: Jaca, 1992.

Langer, S. *Philosophy in a New Key*. Cambridge, MA: Harvard University Press, 1957.

Lara, Jaime. "Conversion through Theatre: The Drama of the Church in Colonial Latin America." *Yale Latin American Review* 1, no. 1 (1999): 48–52.

———. "El espejo en la cruz: Una reflexión medieval sobre las cruces atriales mexicanas." *Anales* 69 (1996): 5–40.

———. "God's Good Taste: The Jesuit Aesthetics of Juan Bautista Villalpando in the Sixth and Tenth Centuries BCE." In *The Jesuits: Cultures, Sciences and the Arts, 1540–1773*, edited by John O'Malley et al., 505–21. Toronto: University of Toronto Press, 1999.

———. "Il vulcano e le ali: The Iconography of Joachim of Fiore in Latin America." *Florensia: Bottetino del Centro Internazionale di Studi Gioachimiti* 13/14 (1999–2000): 159–89.

———. "The Liturgical Roots of Hispanic Popular Religion." In *Misa, Mesa, Musa*, edited by Kenneth Davis, 25–33. Chicago: Paulch Press, 1999.

———. "Precious Green Jade Water: A Sixteenth-Century Adult Catechumenate in the New World." *Worship* 71, no. 5 (1997): 415–28.

———. "The Sacramented Sun: Solar Eucharistic Worship in Colonial Latin America." In *El Cuerpo de Cristo: The Hispanic Presence in the United States Catholic Church*, edited by Peter Casarella and Raúl Gómez, 261–91. New York: Crossroad, 1998.

Lasteyrie, R. de. *L'architecture religieuse en France à l'époque Romane*. Paris: Picard, 1929.

Lavedan, Pierre. *Histoire de l'architecture urbaine, Antiquité, Moyen-Age*. Paris: Henri Laurens, 1926.

La vita comune del clero nei secoli XI e XII. Miscellanea del Centro de Studi Medievali, Mendola 3:1. Milan: Vita e Pensiero, 1962.

Lawrence, C. H. *Medieval Monasticism: Forms of Religious Life in Western Europe in the Middle Ages*. London: Longman, 1984.

Lawrenson, T. E., and Helen Purkis. "Les éditions illustrées de Térence dans l'historie du théâtre." In *Le lieu théâtral à la Renaissance*, edited by Jean Jacquot, 1–24. Paris: Centre Nacional de la Recherche Scientifique, 1964.

Le Goff, Jacques. "L'immaginario urbano nell'Italia medievale (secoli V–XV)." In *Storia d'Italia: Annali 5: Il Paesaggio*, edited by Cesare De Seta, 3–43. Turin: G. Einaudi, 1982.

———. *The Medieval Imagination*. Chicago: University of Chicago Press, 1988.

Lee, H. "Scrutamini Scripturas: Joachimist Themes and Figurae in the Early Religious Work of Arnold of Villanova." *Journal of the Warburg and Courtauld Institutes* 37 (1974): 33–56.

Lenhart, John. "The Devotion to the Holy Name of Jesus and Superstition." *Franciscan Studies* 29 (1948): 79–81.

Leonard, Irving. *Books of the Brave*. Rev. ed. Berkeley and Los Angeles: University of California Press, 1992.

León-Portilla, Miguel. *Aztec Thought and Culture: A Study of the Ancient Náhuatl Mind*. Translated by Jack Emory David. Norman: University of Oklahoma Press, 1963.

———. *Los Franciscanos vistos por el hombre náhuatl: Testimonios indígenas del siglo XVI.* Mexico City: UNAM, 1985.

Leopold, Antony. *How to Recover the Holy Land: The Crusade Proposals of the Late Thirteenth and Early Fourteenth Centuries.* Aldershot: Ashgate, 2000.

Lerner, Robert. *The Powers of Prophecy: The Cedar of Lebanon Vision from the Mongol Onslaught to the Dawn of the Enlightenment.* Berkeley and Los Angeles: University of California Press, 1983.

Levine, Robert. "Apocalyptic Movements in Latin America in the Nineteenth and Twentieth Centuries." In *The Encyclopedia of Apocalypticism,* edited by John Collins et al., 3:179–203. New York: Continuum, 2000.

Licht, J. "Time and Eschatology in Apocalyptic Literature and in Qumran." *Journal of Jewish Studies* 16 (1965): 177–82.

Lida de Malkiel, María Rosa. "La visión de trasmundo en la literatura hispánica." Appendix to Howard Rollin Patch, *El otro mundo en la literatura medieval.* Mexico City: FCE, 1956.

Limpricht, Cornelia. *Platzanlage und Landschaftsgarten als begehbare Utopien: Ein Beitrag zur Deutung der Templum-Salomonis-Rezeption im 16 und 18 Jahrhundret.* Frankfurt: Peter Lang, 1993.

Linder, Amnon. "The Liturgy of the Liberation of Jerusalem." *Mediaeval Studies* 52 (1990): 110–31.

Lleó Cañal, Vicente. "De mezquitas a templos: Las catedrales anadaluzas en el siglo XVI." In *L'église dans l'architecture de la Renaissance,* 213–22. Tours: Picard, 1995.

Lockhart, James. *The Nahuas after the Conquest: A Social and Cultural History of the Indians of Central Mexico, Sixteenth through Eighteenth Centuries.* Stanford: Stanford University Press, 1992.

———. "Some Nahua Concepts in Postconquest Guise." *History of European Ideas* 6, no. 4 (1985): 465–82.

López Austin, Alfredo. *The Human Body and Ideology: Concepts of the Ancient Nahuas.* 2 vols. Salt Lake City: University of Utah Press, 1988.

Lotz, Wolfgang. "Bramante and the Quattrocento Cloister." *Gesta* 12 (1973): 111–22.

Lubac, Henri de. *Exégèse médiéval: Les quatre sens de l'escriture.* 4 vols. Paris: Aubier, 1959–64.

———. *La posteridad espiritual de Joaquín de Fiore.* 2 vols. Madrid: Encuentro Edicions, 1989. Originally published as *La postérité spiritualle de Joachim de Flore.* Paris, 1981.

Mâle, Emile. *Religious Art in France: The Late Middle Ages.* Princeton: Princeton University Press, 1986.

———. *Religious Art in France: The Twelfth Century.* Princeton: Princeton University Press, 1978.

Mandujano, Gabriel Silva. *La Catedral de Morelia: Arte y sociedad en la Nueva España.* Mexico City: Instituto Michoacano de Cultura, 1984.

Manselli, Raoul. "L'anno 1260 fu anno giochimitico?" In *Il Movimento dei Disciplinati nel Settimo Centenario di suo inizio,* 99–108. Spoleto: Panetto & Petrelli, 1962.

———. "L'Apocalisse e l'interpretazione francescana della storia." In *The Bible and Medieval Culture,* edited by W. Lourdaux and D. Verhelst, 157–70. Louvain: Louvain University Press, 1979.

———. *La "Lectura Super Apocalypsim" di Pietro di Giovanni Olivi: Richerche sull' escatologismo medievale.* Rome: Palazzo Borromini, 1955.

———. "La resurrezione di san Francesco dalla teologia di Pietro de Giovanni Olivi ad una testimonianza di pietà popolare." *Collectanea Franciscana* 46 (1976): 309–20.

Marías, Fernando. *El largo siglo XVI: Los usos artísticos del renacimiento español.* Madrid: Taurus, 1989.

Martens, M. J. P. "New Information on Petrus Christus' Biography." *Simiolus* 20 (1990–91): 5–23.

Martínez Ripoll, Antonio. "Exégesis escrita y explanación dibujada de la arquitectura biblica de N. De Lyra." In Ramírez et al., *Dios arquitecto,* 87–89.

———. "F. Vatable y R. Éstienne, o la metamórfosis de la arqueografía bíblica." In Ramírez et al., *Dios arquitecto,* 90–93.

Matern, Gerhard. *Zur Vorgeschichte und Geschichte der Fronleichnamsfeier besonds in Spanien: Studien zur Volksfrömmigkeit des Mittelalters und der beginnenden Neuzeit.* Münster: Aschendorffesch, 1962.

Mathes, W. Michael. *The America's First Academic Library: Santa Cruz de Tlatelolco.* Sacramento: California State Library Foundation, 1985.

Mathews, Thomas. *The Clash of Gods: A Reinterpretation of Early Christian Art.* Princeton: Princeton University Press, 1993.

Matos Moctezuma, Eduardo. "Symbolism of the Templo Mayor." In Boone, *The Aztec Templo Mayor,* 185–209.

Maxwell, Judith M., and Craig A. Hanson. *Of the Manners of Speaking That the Old Ones Had: The Metaphors of Andrés de Olmos.* Salt Lake City: University of Utah Press, 1992.

Maza, Francisco de la. "Friar Pedro de Gante and the Open-Air Chapel of San Jose de los Naturales." *Artes de México* 19, no. 150 (1972): 104–7.

———. *La ciudad de Cholula y sus iglesias.* Mexico City: Imprenta Universitaria, 1959.

———. "Los retablos dorados de Nueva España." In *Enciclopedia Mexicana de Arte,* 9:9–43. Mexico City: Ediciones Mexicanas, 1950.

McAndrew, John. *The Open-Air Churches of Sixteenth-Century Mexico: Atrios, Posas, Open Chapels, and Other Studies*. Cambridge, MA: Harvard University Press, 1965.

McClung, William A. *The Architecture of Paradise: Survivals of Eden and Jerusalem*. Berkeley and Los Angeles: University of California Press, 1983.

McGinn, Bernard. "Angel Pope and Papal Antichrist." *Church History* 47 (1978): 155–73.

———. *Apocalyptic Spirituality*. New York: Paulist Press, 1979.

———. "Circoli gioachimiti veneziani (1450–1530)." *Cristianesimo nella Storia* 7 (1986): 19–39.

———. "Influence and Importance in Evaluating Joachim of Fiore." In Potestà, *Il profetismo gioachimita*.

———. "Joachim and the Sibyl." *Cîteaux* 24 (1973): 97–138.

———. "Reading Revelation: Joachim of Fiore and the Varieties of Apocalypse Exegesis in the Sixteenth Century." In Rusconi, *Storia e figure*, 11–36.

———. "Symbolism in the Thought of Joachim of Fiore." In Ann Williams, *Prophecy and Millenarianism*, 143–64.

———. *Visions of the End: Apocalyptic Traditions in the Middle Ages*. New York: Columbia University Press, 1979.

McKendrick, Melveena. *Theater in Spain: 1490–1700*. Cambridge: Cambridge University Press, 1989.

McNaspy, C. J. *Lost Cities of Paraguay*. Chicago: Loyola University Press, 1982.

McVey, Kathleen E. "The Domed Church as Microcosm: Literary Roots of an Architectural Symbol." *Dumbarton Oaks Papers* 37 (1984): 91–121.

Meer, Frederik van der. *Maiestas Domini: Théophanies de l'apocalypse dans l'art chrétien*. Rome: Pontificio Istituto di Archeologia Cristiana, 1938.

Meiss, Millard. "Light as Form and Symbol in Some Fifteenth-Century Paintings." *AB* 27 (1945): 175–81.

Melkian, Souren. "Un cloitre inspiré d'une mosquee." *Connaissance des Arts* 260 (1973): 98–101.

Mendoza, Vicente. "Un teatro religioso colonial en Zumpango de la Laguna." *Anales* 16 (1967): 49–61.

Menéndez y Pelayo, Marcelino. *Historia de los heterodoxos españoles*. 3 vols. Madrid: Consejo Superior de Investigaciones Científicas, 1947.

Meyers, Carol L. "Jachin and Boaz in Religious and Political Perspective." In *The Temple in Antiquity: Ancient Records and Modern Perspectives*. Provo, UT: Brigham Young University, 1984.

Meyvaert, Paul. "The Medieval Monastic Claustrum." *Gesta* 12 (1973): 53–59.

Milhou, Alain. "Apocalypticism in Central and South American Colonialism." In *The Encyclopedia of Apocalypticism*, edited by John Collins et al., 3:3–35. New York: Continuum, 2000.

———. *Colón y su mentalidad mesiánica en el ambiente franciscanista español*. Valladolid: Casa-Museo Colon, 1983.

———. "El concepto de 'destrucción' en el evangelismo milenario franciscano." *Archivo Ibero-Americano* 48 (1988): 297–315.

Miller, Mary, and Karl Taube. *The Gods and Symbols of Ancient Mexico and the Maya: An Illustrated Dictionary of Mesoamerican Religion*. London: Thames & Hudson, 1993.

Millon, Rene. *The Urbanization of Teotihuacán*. Austin: University of Texas Press, 1973.

Minnich, Nelson. "Prophecy and the Fifth Lateran Council (1512–1517)." In Reeves, *Prophetic Rome*, 63–90.

———. "The Role of Prophecy in the Career of the Enigmatic Bernadino López de Carvajal." In Reeves, *Prophetic Rome*, 111–20.

Mitchell, Nathan. *Cult and Controversy*. New York: Pueblo, 1982.

Miziolek, Jerzi. "When Our Sun Is Risen: Observations on Eschatological Visions in the Art of the First Millennium." *Arte Cristiana* 82 (1994): 245–60; 83 (1994): 3–22.

Mode, Robert. "San Bernardino in Glory." *AB* 55, no. 1 (1973): 58–76.

Molina Montes, Augusto. "Templo Mayor Architecture: So What's New?" In Boone, *The Aztec Templo Mayor*, 97–107.

Monterrosa, Mariano. "Cruces de la Colonia." *Boletín del INAH* 40 (1969): 42–45.

Montes Bardo, Joaquín. *Arte y espiritualidad franciscana en la Nueva España, siglo XVI*. Jaen: Universidad de Jaen, 1998.

Monteverde, Mildred. "Sixteenth-Century Mexican Atrium Crosses." Ph.D. diss., University of California, Los Angeles, 1972.

Moralejo, Serafín. "Le lieu saint: Le tombeau et les basiliques medievales." In *Santiago de Compostela: 1000 ans de pelerinage européen*. Gand, Belgium: Credit Communal, 1985.

Morales, Francisco. "Franciscanos ante las religiones indígenas." In *Franciscanos en América*, edited by Morales, 87–102. Mexico City: Conferencia Franciscana de Santa Maria de Guadalupe, 1993.

———, ed. *Franciscan Presence in the Americas*. Potomac, MD: Academy of American Franciscan History, 1983.

Morello, G. "Il tesoro del Sancta Sanctorum." In *Il Palazzo Apostolico Laterense*, edited by C. Pietrangeli, 94–95. Florence: Nardini, 1991.

Moreno Proaño, Agustín. "The Influence of Pedro de Gante on South American Culture." *Artes de México* 19 (1972): 112–14.

Mottu, Henri. *La manifestation de l'esprit selon Joachim de Fiore.* Neuchatel: Delachaux & Niestle, 1977.

Mujica Pinilla, Ramón. *Ángeles apócrifos en la América virreinal.* Lima: FCE, 1992.

Muldoon, James. *Varieties of Religious Conversion in the Middle Ages.* Gainesville: University Press of Florida, 1997.

Mullen, Robert. *Architecture and Its Sculpture in Viceregal Mexico.* Austin: University of Texas Press, 1997.

———. *Dominican Architecture in Sixteenth-Century Oaxaca.* Tempe: University of Arizona Press, 1975.

Muller, Priscilla. *Jewels in Spain, 1500–1800.* New York: Hispanic Society of America, 1972.

Mumby, D. K. *Communication and Power in Organizations: Discourse, Ideology, and Domination.* Norwood, NJ: Ablex, 1988.

Murphy, G. Roland. *The Heliand, the Saxon Gospel: A Translation and Commentary.* New York: Oxford University Press, 1992.

———. *The Saxon Savior: The Germanic Transformation of the Gospel in the Ninth-Century Heliand.* Oxford: Oxford University Press, 1989.

Nagler, A. M. *The Medieval Religious Stage.* New Haven: Yale University Press, 1976.

Naredi-Rainer, Paul von. "Between Vatable and Villalpando: Aspects of Postmedieval Reception of the Temple in Christian Art." In Kühnel, *The Real and Ideal Jerusalem,* 218–25.

———. *Salomos Tempel und das Abendland.* Cologne: Dumont, 1994.

Neagley, Linda Elaine. "Architecture and the Body of Christ." In *The Body of Christ in the Art of Europe and New Spain, 1150–1800,* edited by Clifton Jones, 27–36. Munich: Prestel, 1997.

Nebel, Richard. "El rostro mexicano de Cristo." In *Cristo crucificado en los pueblos de America Latina,* edited by Damien and Esteban Judd Zanon, 59–82. Quito: Ediciones Abya-Yala, 1992.

Neri, D. *Il Santo Sepolcro riprodotto in Occidente.* Jerusalem: Franciscan Printing Press, 1971.

Neuss, William. *Apokalypse des hl. Johannes in der altspanischen und altchristlichen Bibel-Illustrarion.* 2 vols. Munster: Aschendorff, 1988.

Niccoli, Ottavia. "La donna e il dragone nella basilica de San Marco: Iconografie apocalittiche del tardo Cinquecento." In Rusconi, *Storia e figure,* 37–51.

Nichols, Stephen G. "Signs of Royal Beauty Bright: Word and Image in the Legend of Charlemagne." *Olifant* 4 (1976): 21–47.

Nieto, José. "The Franciscan Alumbrados and the Prophetic-Apocalyptic Tradition." *Sixteenth Century Journal* 8 (1977): 3–16.

Nieto Alcaide, Victor. *Arte prerrománico asturiano.* Salinas, Asturias: Ayalga Ediciones, 1989.

Noguera, Antoni. *El pantocràtor romànic de les terres gironines.* Barcelona: Terra Nostra, 1986.

Nordstrom, C. A. *The Duke of Alba's Castillian Bible: A Study of Rabbinical Features of the Miniatures.* Upsala: Almqvist & Wiksells, 1967.

Norman, Joanne. *Metamorphoses of an Allegory: The Iconography of the Psychomachia in Medieval Art.* New York: Peter Lang, 1988.

Nutini, Hugo, and Betty Bell. *Ritual Kinship: The Structure and Historical Development of the Compadrazgo System in Rural Tlaxcala.* 2 vols. Princeton: Princeton University Press, 1980.

Obregón, Gonzalo. "The Flemish Contribution to Mexico." *Artes de México* 19, no. 150 (1972): 111–12.

O'Gorman, Edmundo. *The Invention of America: An Inquiry into the Historical Nature of the New World and the Meaning of Its History.* Bloomington: Indiana University Press, 1961.

Olmos, Andrés de. *Tratado de hechicerías y sortilegios.* Edited by Georges Baudot. Mexico City: Misión Arqueológica y Etnográfica Francesa en México, 1990.

Olsen, Glen. "The Idea of the Ecclesia Primitiva in the Writing of the Twelfth-Century Canonists." *Traditio* 25 (1969): 61–86.

O'Meara, Carra Ferguson. "In the Hearth of the Virginal Womb: The Iconography of the Holocaust in Late Medieval Art." *AB* 63, no. 1 (1981): 75–87.

O'Reilly, Jennifer. *Studies in the Iconography of the Virtues and Vices in the Middle Ages.* New York: Garland, 1988.

Orozco Pardo, J. L. *Christianopolis: Urbanismo y contrarreforma en la Granada del seiscientos.* Granada: Diputacion, 1985.

Ousterhout, Robert, ed. *The Blessings of Pilgrimage.* Urbana: University of Illinois Press, 1990.

———. "The Church of S. Stefano: A Jerusalem in Bologna." *Gesta* 20 (1981): 311–21.

———. "Rebuilding the Temple: Constantine Monomachus and the Holy Sepulchre." *Journal of the Society of Architectural Historians* 48 (1989): 66–78.

———. "The Temple, the Sepulchre, and the Martyrion of the Savior." *Gesta* 29 (1990): 44–53.

Pacciani, Riccardo. "L'architettura delle capelle di S. Vivaldo: Rapporti stilistici e iconografici." In Gensini, *La Gerusalemme di San Vivaldo,* 299–332.

Padden, R. C. *The Hummingbird and the Hawk: Conquest and Sovereignty in the Valley of Mexico, 1503–1541.* New York: Harper & Row, 1967.

Pajares-Ayuela, Paloma. *Cosmatesque Ornament: Flat Polychrome Geometric Patterns in Architecture.* London: Thames & Hudson, 2002.

Palm, E. Walter. "La aportación de las ordenes mendicantes al urbanismo en el virreinato de la Nueva España." *Verhandlungen des XXXVIII Internationalen Amerikanistenkongresses, Stuttgart-Munchen, 12–18 Aug., 1968.* 4 vols. Munich: International Congress of Americanists, 1969–72.

———. "Las capillas abiertas americanas y sus antecedentes en el occidente cristiano." *Anales del Instituto de Arte Americano e Investigaciones Estéticas* 6 (1953): 47–75.

———. "Los pórticos del atrio en la arquitectura franciscana de Nueva España." In *Les cultures ibériques en devenir: Essais publiés en hommage à la mémoire de Marcel Bataillon,* 497–501. Paris: Fondation Singer-Polignac, 1979.

———. "Para enforcar la estructuración de la realidad en el arte de la Nueva España." *Comunicaciones Proyecto Puebla-Tlaxcala* 16 (1979): 225–34.

———. "¿Urbanismo barroco en América Latina?" In *Simposio Internazionale sul Barocco Latino Americano,* 1:217–20. Rome: Istituto Italo-Latino Americano, 1962.

Palomera, Esteban. *Fray Diego Valadés, OFM, evangelizador humanista de la Nueva España.* Mexico City: Universidad Iberoamericana, 1962–63.

Palomero Páramo, Jesús M. "Antecedentes andaluces en las 'Capillas de Indios.'" In *Actas del I Congreso Internacional sobre Los Dominicos y el Nuevo Mundo, Sevilla, 21–25 April 1987,* 917–36. Madrid: Editorial Deimos, 1988.

———. "Un posible antecedente formal de las 'posas' mexicanas: La 'glorieta del lavatorium' medieval." In *Congreso Franciscanos Extremeños en el Nuevo Mundo: Actas y estudios,* 247–61. Guadalupe, Spain: Monasterio de Santa Maria de Guadalupe, 1986.

Panofsky, Erwin. *Gothic Architecture and Scholasticism.* New York: Meridian Books, 1951.

Paris, Louis. *Toiles peintes et tapisseries de la ville de Reims, ou, la mise en scène du théâtre des Confrères de la Passion.* Paris: Bruslart, 1843.

Parrot, André. *The Temple of Jerusalem.* New York: Philosophical Library, 1955.

Paszkiewicza, Piotra, and Tadeusza Zadroznego, eds. *Jerozolima w Kulturze Europejskiej.* With English summaries. Warsaw: Instytut Sztuki Polskiej Akademii Nauk, 1997.

Pásztor, Edith. "Architettura monastica, Sistemazione urbanistica e Lavoro del *Novus Ordo* auspicato da Gioacchino da Fiore." In *I Cistercensi e il Lazio: Atti delle giornate di studio dell'Istituto di Storia dell'Arte dell'Università di Roma,* 149–56. Rome: Multigrafica, 1978.

———. "Ideale del monachesimo ed 'età dello Spirito' come realità d'utopia." In *L'Età dello Spirito e la fine dei tempi in Gioacchino di Fiore e nel gioachimismo medievale,* 118–21. San Giovanni in Fiore, Italy: Centro Internazionale di Studi Gioachimiti, 1986.

Patch, Howard Rollin. *El otro mundo en la literatura medieval.* With an appendix, "La visión de trasmundo en la literatura hispánica," by María Rosa Lida de Malkiel. Mexico City: FCE, 1956. Originally published in English as *The Other World, according to Descriptions in Medieval Literature.* Cambridge, MA: Harvard University Press, 1950.

Patlagean, Evelyne. "Byzantium's Dual Holy Land." In *Sacred Space: Shrine, City, Land,* edited by Benjamin Z. Kedar and R. J. Zui Werblowsky, 112–26. New York: New York University Press, 1998.

Paxson, James. "The Nether-Faced Devil and the Allegory of Parturition." *Studies in Iconography* 19 (1998): 139–76.

Pepper, Stephen. *World Hypotheses.* Berkeley and Los Angeles: University of California Press, 1961.

Perry, Richard. *Mexico's Fortress Monasteries.* Santa Barbara, CA: Espadaña Press, 1992.

Peterson, Jeanette Favrot. "The Garden Frescos of Malinalco." Ph.D. diss., University of California, Los Angeles, 1985.

———. "La flora y la fauna en los fresco de Malinalco: Paraíso convergente." In *Iconología y sociedad: Arte colonial hispanoamericano, XLIV Congreso Internacional de Americanistas,* 23–40. Mexico City: IIE, 1987.

———. *The Paradise Garden Murals of Malinalco: Utopia and Empire in Sixteenth-Century Mexico.* Austin: University of Texas Press, 1993.

———. "Synthesis and Survival: The Native Presence in Sixteenth-century Murals of New Spain." In *Native Artists and Patrons in Colonial Latin America,* edited by Emily Umberger and Tom Cummins, 14–35. Tempe: Arizona State University, 1995.

Phelan, John Leddy. *The Millennial Kingdom of the Franciscans in the New World.* 2nd ed. rev. Berkeley and Los Angeles: University of California Press, 1970.

Philip, Lotte Brand. *The Ghent Altarpiece and the Art of Jan van Eyck.* Princeton: Princeton University Press, 1980.

Phillips, Richard. "La participación de los indígenas en las processions por los claustros del siglo XVI en México." *Relaciones: Estudios de Historia y Sociedad* 78 (1999): 225–50.

———. "Processions through Paradise: A Liturgical and Social Interpretation of the Ritual Function and Symbolic Signification of the Cloister in the Sixteenth-Century Monasteries of Central Mexico." Ph.D. diss., University of Texas, Austin, 1993.

Pierce, Donna. "Identification of the Warriors in the Frescos of Ixmilquilpan." *Research Center for the Arts Review* 4 (1981): 1–8.

———. "The Sixteenth-Century Nave Frescoes in the Augustinian Mission Church of Ixmilquilpan, Hidalgo, Mexico." Ph.D. diss., University of New Mexico, 1987.

Pochat, Götz. *Theater und bildende Kunst in Mittelalter und in der Renaissance in Italien.* Granz: Akademische, 1990.

Poggiaspalla, Ferminio. *La vita comune del clero dalle origini all reforma gregoriana.* Rome: Edizioni di Storia e Letteratura, 1968.

Pointer, Richard. "The Sounds of Worship: Nahua Music Making and Colonial Catholicism in Sixteenth-Century Mexico." *Fides et Historia* 34 (2002): 25–44.

Poole, Stafford. *Our Lady of Guadalupe: The Origins and Sources of a Mexican National Symbol, 1531–1797.* Tucson: University of Arizona Press, 1995.

Popkin, Richard. "Jewish Christians and Christian Jews in Spain, 1492 and After." *Judiasm* 41, no. 3 (1992): 248–68.

Porada, Edith. "Battlements in the Military Architecture and in the Symbolism of the Ancient Near East." In *Essays in the History of Architecture Presented to Rudolf Wittkower,* edited by Douglas Fraser et al., 1–16. London: Phaidon, 1967.

Posner, Kathleen Weil Garris. "Cloister, Court and City Square." *Gesta* 12 (1973): 123–32.

Potestà, Gian Luca, ed. *Il profetismo gioachimita tra Quattrocento e Cinquento: Atti de III Congresso Internazionale di Studi Gioachimiti, San Giovani in Fiore (17–21 Sept. 1989).* Genoa: Marietti, 1991.

Pou y Martí, José Mª. *Visionarios, beguinos y fraticelos catalánes (siglos XIII–XV).* Vich: Serafica, 1930.

Prawer, Joshua. "Jerusalem in the Christian and Jewish Perspectives of the Early Middle Ages." In *Gli Ebrei nell'Alto Medioevo, Settimane de studio del Centro Italiano di Studi sull'Alto Medioevo XXVI (30 March–5 April 1978),* 738–812. Spoleto: Presso de la Sede del Centro, 1980.

Prescott, Hilda. *Friar Felix at Large.* New Haven: Yale University Press, 1950.

———. *Jerusalem Journey: Pilgrimage to the Holy Land in the Fifteenth Century.* London: Eyre & Spottiswoode, 1954.

Pressouye, Léon. "St. Bernard to St. Francis: Monastic Ideals and Iconographic Programs in the Cloister." *Gesta* 12 (1973): 71–85.

Prosperi, Adriano. "New Heaven and New Earth: Prophecy and Propaganda at the Time of the Discovery and Conquest of the Americas." In Reeves, *Prophetic Rome,* 279–303.

Puppi, Lionello. "Rex cum justicia: Note per una storia metaforica del Palazzo dei Dogi." In *I Dogi,* edited by Gino Benzoni. Milan: Electa, 1983.

———. "Verso Gerusalemme." *Arte Venata* 32 (1978): 73–78.

Raedts, Peter. "The Medieval City as a Holy Place." In *Omnes Circumadstantes,* edited by Charles Caspers and Marc Schneiders, 114–54. Kampen: J. H. Kok, 1990.

———. "St. Bernard of Clairvaux and Jerusalem." In *Prophecy and Eschatology,* edited by Michael Wilks, 169–82. Oxford: Blackwell, 1994.

Ramírez, Juan Antonio. *Construcciones ilusorias: Arquitecturas descritas, arquitecturas pintadas.* Madrid: Alianza, 1983, 1988.

———. *Edificios y sueños: Estudios sobre arquitectura y utopía.* Madrid: Nerea, 1991.

———. "Evocar, reconstruir, tal vez sonar." In Ramírez et al., *Dios arquitecto,* 3–50.

Ramírez, Juan Antonio, et al., eds. and trans. *Dios arquitecto: J. B. Villalpando y el Templo de Salomon.* Commentary accompanying Prado and Villalpando, *El Templo de Salomón.* Madrid: Siruela, 1991.

Raspi Serra, Joselita. "Il rapporto tra la *civitas* cistercense e la *civitas* romana." In *I Cistercensi e il Lazio: Atti delle gionate di studio dell'Istituto di Storia dell'Arte dell'Università di Roma,* 275–79. Rome: Multigrafica, 1978.

Ravicz, Marilyn Ekdahl. *Early Colonial Religious Drama in Mexico: From Tzompantli to Golgotha.* Washington, DC: Catholic University of America Press, 1970.

Raynaud, G. "Les nombres sacrés et les signes cruciformes dans la Moyenne Amérique Precolombienne." *Revue de l'Historie des Religions* 44 (1901): 235–61.

Read, Kay. "The Fleeting Moment: Cosmogony, Eschatology, and Ethics in Aztec Religion and Society." *Journal of Religious Ethics* 14 (1986): 113–38.

Réau, Louis. *Iconographie de l'art chrétién.* 3 vols. Paris: Presses Universitaires de France, 1955–59.

Recht, Roland, ed. *Les batisseurs des cathedrales gothiques.* Strasbourg: Editions les Musées de la Ville de Strasbourg, 1989.

Recio Veganzones, Alejandro. "Francisco en la iconografía musiva medieval de Roma." In *Studia Hierosolymitana,* edited by Giovanni Bottini, 255–72. Studium Biblicum Franciscanum 30. Jerusalem: Franciscan Printing Press, 1982.

Reeves, Marjorie. "Cardinal Egidio of Viterbo: A Prophetic Interpretation of History." In Reeves, *Prophetic Rome,* 91–109.

———. *The Influence of Prophecy in the Later Middle Ages: A Study in Joachimism.* Oxford: Clarendon Press, 1969.

———. "Joachimist Expectations in the Order of Augustinian Hermits." *Recherches de Theologíe Ancienne et Medievale* 25 (1958): 111–41.

———. *Joachim of Fiore and the Prophetic Future.* London: SPCK, 1976.

————. "The *Liber Figurae* of Joachim of Fiore." *Mediaeval and Renaissance Studies* 2 (1950): 57–81.

————, ed. *Prophetic Rome in the High Renaissance Period: Essays.* Oxford: Clarendon Press, 1992.

Reeves, Marjorie, and B. Hirsch-Reich. *The Figurae of Joachim of Fiore.* Oxford: Clarendon Press, 1972.

Reeves, Marjorie, and Warwick Gould. *Joachim of Fiore and the Myth of the Eternal Evangel in the Nineteenth Century.* Oxford: Clarendon Press, 1987.

Reinhardt, Klaus. "Das Werk des Nicholas von Lyra im mittelalterlichen Spanien." *Traditio* 43 (1987): 321–58.

Reinink, G. J. "Pseudo-Methodius und die Legende von römishen Endkaiser." In *The Use and Abuse of Eschatology in the Middle Ages*, edited by Werner Verbeke et al., 82–111. Louvain: Louvain University Press, 1988.

Remensnyder, Amy. "The Colonization of Sacred Architecture: The Virgin Mary, Mosques, and Temples in Medieval Spain and Early Sixteenth-Century Mexico." In *Monks and Nuns, Saints and Outcasts: Religion in Medieval Society*, edited by Sharon Farmer and Barbara Rosenwein, 212–19. Ithaca: Cornell University Press, 2000.

Rennert, Hugo. *The Spanish Stage in the Time of Lope de Vega.* New York: Hispanic Society of America, 1909.

Restall, Matthew. "Interculturation and the Indigenous Testament in Colonial Yucatan." In *Dead Giveaways: Indigenous Testaments of Colonial Mesoamerica and the Andes*, edited by Susan Kellogg and Matthew Restall, 141–62. Salt Lake City: University of Utah Press, 1998.

Revel-Neher, Elisheva. "L'alliance et la promesse: Le symbolisme d'Eretz-Israël dans l'iconographie juive du Moyen Age." *Journal of Jewish Art* 12/13 (1986/87): 135–46.

————. *L'arche d'alliance dans l'art juif et chrétien du second au dixième siècles.* Paris: Association des Amis des Etudes Archeologiques Byzantino-slaves et du Christianisme Oriental, 1984.

Rey, Raymon. *L'art gothique du midi de la France.* Paris: H. Laurens, 1934.

————. *Les vielles églises fortifiées du midi de la France.* Paris: H. Laurens, 1925.

Reyes-Valerio, Constantino. *Arte indocristiano.* 2nd ed. Mexico City: INAH, 2000.

Ricard, Robert. *The Spiritual Conquest of Mexico: An Essay on the Apostolate and the Evangelizing Methods of the Mendicant Orders in New Spain, 1523–1572.* Translated by Lesley Byrd Simpson. Berkeley: University of California Press, 1966. Originally published as *Conquête spiritualle de Mexique.* Paris: University of Paris, 1933.

Riess, Jonathan. *Luca Signorelli: The San Brizio Chapel, Orvieto.* New York: George Braziller, 1995.

Rigaux, Dominique. *A la table du Seigneur: L'Eucharistie chez les primitifs italiens.* Paris: Editions du Cerf, 1989.

Ringbom, Lars Ivar. *Graltempel und Paradies.* Stockholm: Walstrom & Widstrand, 1951.

Rodini, Elizabeth. "Describing Narrative in Gentile Bellini's *Procession in Piazza San Marco.*" *Art History* 21, no. 1 (1998): 26–44.

Rodríguez de Ceballos, Alfonso. "El simbolismo de 'Jerusalen celeste' constante ambiental del templo cristiano." In *Arte sacro y Concilio Vaticano II.* Leon: Junta Nacional Asesora de Arte Sacra, 1965.

————. "El urbanismo de las misiones jesuíticas de América meridional: Génesis, tipología y significado." In *Relaciones artísticas entre España y América*, 151–71. Madrid: Consejo Superior de Investigaciones Cientificas, 1992.

Roest, Bert. "Franciscan Commentaries on the Apocalypse." In *Prophecy and Eschatology*, edited by Michael Wilks, 29–37. Oxford: Blackwell, 1994.

Rojos Garcidueñas, José. *Autos y coloquios del siglo XVI.* Mexico City: UNAM, 1939.

Rordorf, W. "Liturgie et eschatologie." *Augustinianum* 18 (1978): 153–62.

Rosenau, Helen. "The Architecture of Nicolaus de Lyra's Temple Illustrations and the Jewish Tradition." *Journal of Jewish Studies* 25 (1974): 294–304.

————. *Vision of the Temple: The Image of the Temple of Jerusalem in Judaism and Christianity.* London: Oresko, 1979.

Rosenthal, Earl. "The Invention of the Columnal Device of Emperor Charles V at the Court of Burgundy in 1516." *Journal of the Warburg and Courtauld Institutes* 36 (1973): 198–230.

————. "A Renaissance 'Copy' of the Holy Sepulchre." *Journal of the Society of Architectural Historians* 17 (1958): 2–11.

Rosovsky, Nitza, ed. *City of the Great King: Jerusalem from David to the Present.* Cambridge, MA: Harvard University Press, 1996.

Rovetta, A. "L'immagine della Gerusalemme celeste nei secoli XV–XVI." *Città di Vita* 40 (1985): 83–106.

Roys, Ralph. *The Book of Chilam Balam of Chumayel.* Norman: University of Oklahoma Press, 1967.

Rubial García, Antonio. "Palabra e imagen: Un mural franciscano desaparecido en la Puebla del siglo XVII." *Anales* 73 (1998): 209–13.

Rubin, Miri. *Corpus Christi: The Eucharist in Late Medieval Culture.* Cambridge: Cambridge University Press, 1991.

Rubruck, William. *The Mission of Friar William of Rubruck: His Journey to the Court of the Great Khan Mongol, 1253–1255.* Translated by Peter Jackson. London: Hakluyt Society, 1990.

Ruíz Martínez, Rafael. *Las capillas del via crucis en Puebla, su historia.* Puebla: Gobierno del Estado, 1992.

Rusconi, Roberto. "Gerusalemme nella predicazione populare quattrocentesca tra millennio, ricordo di viaggio e luongo sacro." In *Toscana e Terrasanta nel Medioevo,* edited by Frabco Cardini, 284–98. Florence: Alinea, 1982.

———, ed. *Storia e figure dell'Apocalisse fra '500 e '600: Atti del IV Congresso internazionale di studi gioachimiti, San Giovanni in Fiore, 14–17 settembre 1994.* Rome: Viella, 1996.

Russell, David. *Between the Testaments.* 2nd ed. Philadelphia: Fortress, 1965.

Sabar, Shalom. "Messianic Aspirations and Renaissance Urban Ideals: The Image of Jerusalem in the Venice Haggadah." In Kühnel, *The Real and Ideal Jerusalem,* 294–312.

Sacchi, Paolo. *Storia dell'apocalittica giudaica.* Brescia: Paideira Editrice, 1990.

Sala Catala, José, and Jaime Vilchis Reyes. "Apocalíptica española y empresa misional en los primeros Franciscanos de Mexico." *Revista de Indias* 45, no. 176 (1985): 421–47.

Salas Cuesta, Marcela. *La iglesia y el convento de Huejotzingo.* Mexico City: IIE, 1982.

Salcedo, Jaime. "Doctrina de Indios, conventos y templos doctrineros en el nuevo reino de Granada durante el siglo XVI." *Hito: Revista de la Asociación Colombiana de Facultades de Arquitectura* 1 (1983): 7–13.

———. "El model urbano aplicado a la America Española: Su genesis y desarrollo teorico-práctico." In *Estudios sobre urbanismo iberoamericano: Siglos XVI al XVIII,* 1–72. Seville: Junta de Andalucia, 1992.

———. "La estructura urbana de la ciudad colonial." *Dana* 23 (Bogotá, n.d.): 58–70.

———. "Los Pueblos de Indios en el nuevo reino de Granada y Popoyán." In *Pueblos de Indios: Otro urbanismo en la región andina,* edited by Ramón Gutierrez, 179–203. Quito: Alya-Yala, 1993.

———. *Urbanismo hispano-americano, siglos XVI, XVII y XVIII.* Bogotá: Universidad Javeriana, 1994.

Sanders, Ronald. *Lost Tribes and Promised Lands: The Origins of American Racism.* Boston: Little, Brown, 1978, 1992.

Santi, Bruno. *The Marble Pavement of the Cathedral of Siena.* Florence: Scala, 1982.

Saranyana, Josép, and Ana de Zaballa. *Joaquín de Fiore y América.* 2nd ed. Pamplona: Eunate, 1995.

Sarfati, Rachel, ed. *Offerings from Jerusalem: Portrayals of Holy Place by Jewish Artists.* Jerusalem: The Israel Museum, 2002.

Sartor, Mario. *Arquitectura y urbanismo en Nueva España: Siglo XVI.* Mexico City: Grupo Azabache, 1992.

Sauer, Joseph. *Symbolik des Kirchengebäudes und seiner Ausstattung in der Auffassung des Mittelalters.* Freiburg: Herder, 1924.

Scheja, G. "Hagia Sophia und Templum Salomonis." *Istanbuler Mitteilingen* 12 (1962): 44–58.

Schele, Linda, and David Freidel. *A Forest of Kings: The Untold Story of the Ancient Maya.* New York: Morrow, 1990.

Schele, Linda, and Mary Miller. *The Blood of Kings: Dynasty and Ritual in Maya Art.* New York: George Braziller, 1986.

Schiller, Gertrud. *Iconography of Christian Art.* 2 vols. Greenwich, CT: New York Graphic Society, 1972.

Schlunk, Helmut. *La pintura mural austriana de los siglos IX y X.* Madrid: Leon Sanchez Cuesta, 1957.

Schöller, Wolfgang. "Le dessin d'architecture à l'époque gothique." In *Les batisseurs des cathedrales gothiques,* edited by R. Recht, 227–35. Strasbourg: Editions les Musées de la Ville de Strasbourg, 1989.

Schroder Cordero, Francisco Arturo. "El retablo plateresco, siglo XVI in fine, de la Cuarta Capilla Posa de San Andrés, Calpan, Puebla." *Cuadernos de Arquitectura Mesoamericana* 3 (1984): 93–116.

Schuessler, Michael Karl. "Géneros renacientes en la Nueva España: Teatro misionero y pintura mural." Ph.D. diss., University of California, Los Angeles, 1996.

Schuler, Carol. "The Seven Sorrows of the Virgin: Popular Culture and Cultic Imagery in Pre-Reformation Europe." *Simiolus* 21 (1992): 5–28.

Schur, Nathan. *Jerusalem in Pilgrims' and Travellers' Accounts: A Thematic Bibliography.* Jerusalem: Ariel, 1980.

Schwartz, Joshua. "The Encaenia of the Church of the Holy Sepulcher, the Temple of Solomon and the Jews." *Theologische Zeitschrift* 43 (1987): 265–81.

Sebastián López, Santiago. "Concepción mística del trazado de Bogotá." *El Tiempo de Bogotá,* Suplemento Literario, 17 October 1965, 6.

———. *Iconografía e iconología del arte novohispano.* Mexico: Azabache, 1992.

———. *Iconografía medieval.* Donostia, Spain: Editorial ETOR, 1988.

———. "La significación salomónica del templo de Huejotzingo (Méjico)." *Traza y Baza* 2 (1973): 77–88.

———. "La versión iconográfica del Paraíso en el patio de los Evangelistas." *Fragmentos* 4/5 (1985): 65–73.

———. "Los 'Arma Christi' y su transendéncia iconográfica en los siglos XV y XVI." In *Relaciones artísticas entre la Península Ibérica*

y América: Actas del V Simposio Hispano-Portugués de Historia del Arte (11–13 May 1989), 265–72. Madrid: Consejo Superior de Investigaciones Científicas, 1990.

———. *Mensaje del arte medieval.* Cordoba and Valencia: Departamentos de Historia del Arte, Universidades de Córdoba y Valencia, 1978.

Sebastián López, Santiago, et al. "Arte iberoamericano desde la colonización a la independencia." In *Summa Artis: Historia general del arte*, vol. 28. Madrid: Espasa-Calpe, 1985.

Sebastían López, Santiago, Mariano Monterrosa, and A. Teran. *Iconografía del arte mexicano del siglo XVI.* Zacatecas: Universidad Autónoma de Zacatecas, 1995.

Sedlmayer, Hans. *Die Entstehung der Kathedrale.* Zurich: Atlantis Verlag, 1950.

———. *Epocas y obras artísticas.* 2 vols. Madrid: Ediciones Rialp, 1965. Originally published as *Epochen und Werke.* Vienna: Herold, 1959.

Seibt, Fernand. "Liber Figurarum XII and the Classical Ideal of Utopia." In Ann Williams, *Prophecy and Millenarianism*, 257–66.

Senkman, Leonardo. "The Concept of the Holy Land in Iberoamerica." In *With Eyes toward Zion*, edited by Moshe Davis and Yehoshua Ben-Arieh, 99–114. New York: Praeger, 1991.

Sheingorn, Pamela. "The Sepulchrum Domini: A Study in Art and Liturgy." *Studies in Iconography* 4 (1978): 37–60.

Shergold, N. D. *A History of the Spanish Stage from Medieval Times until the End of the Seventeenth Century.* Oxford: Clarendon Press, 1967.

Shoemaker, William. *The Multiple Stage in Spain during the Fifteenth and Sixteenth Centuries.* Princeton: Princeton University Press, 1935.

Signer, Michael. "Vision and History: Nicholas of Lyra on the Prophet Ezechiel." In *Nicholas of Lyra: The Senses of Scripture*, edited by Philip D. W. Krey and Lesley Smith, 147–51. Leiden: Brill, 2000.

Sinding-Larsen, Staale. *Christ in the Council Hall.* Acta ad Archaeologiam et Artium Historiam Pertinentia 5. Rome: Erma di Bretschneider, 1974.

Smalley, Beryl. *The Study of the Bible in the Middle Ages.* 2nd ed. Notre Dame: University of Notre Dame Press, 1964.

Smith, E. Baldwin. *Architectural Symbolism of Imperial Rome and the Middle Ages.* Princeton: Princeton University Press, 1956.

———. *The Dome: A Study in the History of Ideas.* Princeton: Princeton University Press, 1950.

Smith, Jonathan Z. "Constructing a Small Place." In *Sacred Space: Shrine, City, Land*, edited by Benjamin Kedar and R. J. Zwi Werblowsky, 18–31. New York: New York University Press, 1988.

———. "Earth and Gods." *Journal of Religion* 49 (1969): 112.

———. *To Take Place: Toward Theory in Ritual.* Chicago: University of Chicago Press, 1987.

Smith, Macklin. *Prudentius' Psychomachia: A Reexamination.* Princeton: Princeton University Press, 1976.

Smosarski, Józef. "Kalwaria Zebrzydowska come spazio teatrale." In Gensini, *La Gerusalemme di San Vivaldo*, 163–72.

Soly, Hugo, ed. *Charles Quint 1500–1558: L'empereur et son temps.* Arles: Acts Sud, 2000.

Soucek, Priscilla. "The Temple after Solomon: The Role of Maryam Bint 'Imrān and her Mihrāb." In Kühnel, ed., *The Real and Ideal Jerusalem.*

Stapleford, Richard. "Constantinian Politics and the Atrium Church." In *Art and Architecture in the Service of Politics*, edited by Henry A. Millon and Linda Nochlin, 1–19. Cambridge, MA: MIT Press, 1978.

Steck, Francis Borgia, ed. *Motolinia's History of the Indians in New Spain.* Washington, DC: Academy of American Franciscan History, 1951.

Sterling, Charles. "La mappemonde de Jan van Eyck." *Revue de l'Art* 33 (1976): 69–102.

Stierlin, Henri. *Le livre de feu.* Geneva: Sigma, 1983.

Stolt, Bengt. *Medeltida teater och gotlöandsk kyrkokonst* [Medieval Drama in the Churches of Gotland: Parallels and Influences]. With English summary. Visby, Sweden: Ödins Förlag, 1993.

Stookey, Laurence Hull. "The Gothic Cathedral as the Heavenly Jerusalem: Liturgical and Theological Sources." *Gesta* 8 (1969): 35–41.

Strong, Roy. *Splendor at Court: Renaissance Spectacle and the Theatre of Power.* Boston: Houghton Mifflin, 1973.

Surtz, Ronald. *The Birth of a Theater: Dramatic Convention in the Spanish Theater.* Madrid: Castalia, 1979.

———. "A Spanish Play (1519) on the Imperial Election of Charles V." In *Formes teatrals de la tradició medieval*, Actes del VII Colloqui de la Société Internationale pour l'Étude du Théâtre Médiéval, Girona 1992, 225–30. Barcelona: Institut del Teatre, 1996.

Sylvest, Edwin Edward. *Motifs of Franciscan Mission Theory in Sixteenth Century New Spain Province of the Holy Gospel.* Washington, DC: Academy of American Franciscan History, 1975.

Taggart, James. *Nahuatl Myth and Social Structure.* Austin: University of Texas, 1983.

Tanner, Marie. *The Last Descendant of Aeneas: The Hapsburgs and the Mythic Image of the Emperor.* New Haven: Yale University Press, 1993.

Taubert, Gesine, and Johannes Taubert. "Mittelalterliche Kruzifixe mit schwenkbaren Armen." *Zeitschrift des deutschen Vereins für Kunstwissenschaft* 23 (1969): 79–121.

Taylor, René. "Architecture and Magic: Considerations on the Idea of the Escorial." In *Essays in the History of Architecture Presented to*

Rudolf Wittkower, edited by Douglas Fraser, 81–109. London: Phaidon, 1967.

———. "El arte de la memoria en el Nuevo Mundo." In *Iconología y sociedad: Arte colonial hispanoamericano, XLIV Congreso International de Americanistas*. Mexico City: IIE, 1987.

Tejeira Davis, Eduardo. "Pedraris Dávila y sus fundaciones en Tierra Firme, 1513–1522." *Anales* 69 (1996): 41–77.

Thomas, Norman, ed. *Readings in World Mission*. London: SPCK, 1995.

Thompson, Augustine. "A Reinterpretation of Joachim of Fiore's *Dispositio Novi Ordinis* from the Liber Figurarum." *Cîteaux* 33 (1982): 195–205.

Thompson, Damian, and Victor Balaban. "The Israelites of the New Covenant: A Peruvian Millennial Movement." *Millennial Stew* 2/3 (1999): 1–5.

Thompson, Leonard. "Cult and Eschatology in the Apocalypse of John." *Journal of Religion* 49 (1969): 330–50.

Tibón, Gutierre. *El ombligo como centro cósmico*. Mexico City: FCE, 1981.

Tod, Ian, and Michael Wheeler. *Utopia*. London: Orbis, 1978.

Todorov, Tzvetan. *The Conquest of America: The Question of the Other*. Translated by Richard Howard. New York: Harper Torchbooks, 1984.

Torres Balbás, Leopoldo. "Musallà y saria en las ciudades hispanomusulmanes." *Al-Andalus* 12 (1948): 167–80.

Toussaint, Manuel. *Planos de la ciudad de México: Siglos XVI al XVII*. Mexico City: Editorial Cultura, 1938.

Toussaint-Samat, Maguelone. *The History of Food*. Oxford: Blackwell, 1994.

Tovar, Antonio. *Lo medieval en la conquista y otros ensayos americanos*. 2nd ed. Mexico City: FCE, 1981.

Tovar de Teresa, Guillermo. "Noticias sobre el convento de Huexotzinco en los siglos XVII y XVIII." In *Simposium international de investigación de Huejotzingo*, edited by Erendira de la Lama, 153–74. Mexico City: INAH, 1997.

Tovar de Teresa, Guillermo, Miguel León-Portilla, and Silvio Zavala. *La utopia mexicana del siglo XVI: Lo bello, lo verdadero y lo bueno*. Mexico City: Grupo Azabache, 1992.

Townsend, Richard Fraser. *State and Cosmos in the Art of Tenochtitlan*. Washington, DC: Dumbarton Oaks, 1979.

Trens, Manuel. *La Eucaristía en el arte español*. Barcelona: Aymá, 1952.

Trexler, Richard. "Aztec Priests for Christian Altars: The Theory and Practice of Reverence in New Spain." In Trexler, *Church and Community*, 469–92.

———. *Church and Community, 12000–1600: Studies in the History of Florence and New Spain*. Rome: Edizioni di Storia e Letteratura, 1987.

———. "We Think, They Act: Clerical Readings of Missionary Theatre in 16th Century Mexico." In Trexler, *Church and Community*, 575–613.

Tudella, José. *El legado de España a América*. 2 vols. Madrid: Ediciones Pegaso, 1954.

Udina, Federico. "Recuerdos del Capítulo del Toisón de Oro." In *Paz Christiana: XXXV Congreso Eucaristico Internacional*, 239–41. Barcelona: Seminario Conciliar, 1952.

Ulibarrena, Juana Mary Arcelus. "Cristobal Colón y los primeros evangelizadores del Nuevo Mundo: Lección de profetismo joaquinista." In Potestà, *Il profetismo gioachimita*, 475–504.

———. "La esperanza milenaria de Joaquín de Fiore y el Nuevo Mundo: Trayectoria de una utopia." *Florensia: Bollettino del Centro Internazionale di Studi Gioachimiti* 1 (1987): 47–75.

Umberger, Emily. "Events Commemorated by Date Plaques at the Templo Mayor: Further Thoughts on the Solar Metaphor." In Boone, *The Aztec Templo Mayor*, 411–50.

Underwood, Paul A. "The Fountain of Life in Manuscripts of the Gospels." *Dumbarton Oaks Papers* 5 (1959): 41–138.

Vallery-Radot, Jean. *Eglises Romanes: Filiations et échanges d'influences*. Paris: La Renaissance du Livre, 1931.

van Dijk, S. J. P., and J. Hazelden Walker. *The Origins of the Modern Roman Liturgy: The Liturgy of the Papal Court and the Franciscan Order in the Thirteenth Century*. Westminster, MD: Newman Press, 1960.

Vannini, Guido. "S. Vivaldo e la sua documentazione materiale: Lineamenti di una ricerca archeologica." In Gensini, *La Gerusalemme di San Vivaldo*, 241–70.

van Os, Henk. "St. Francis of Assisi as a Second Christ in Early Italian Painting." *Simiolus* 8 (1974): 115–32.

van Os, Henk, et al. *The Art of Devotion in the Late Middle Ages in Europe, 1300–1500*. Princeton: Princeton University Press, 1994.

van Pelt, Robert Jan. "Los rabinos, Maimónides y el Templo." In Ramírez et al., *Dios arquitecto*, 83–86.

van Regteren Altena, I. Q. "Hidden Records of the Holy Sepulchre." In *Essays in the History of Architecture Presented to Rudolf Wittkower*, edited by Douglas Fraser. London: Phaidon, 1967.

Varela, Consuelo. "Aproximación a los escritos de Cristóbal Colón." *Jornadas de Estudios Canarias-America* 3–4 (1984): 311–12.

Vargas Lugo, Elisa. "Erudición escritural y espresión pictorica franciscana." In *Franciscan Presence in the Americas*, edited by Francisco Morales, 376–92. Potomac, MD: Academy of American Franciscan Studies, 1983.

Vargas Ugarte, Ruben. *Historia del culto de María en Iberoamérica y sus imagenes y santuarios más celebrados*. Buenos Aires: Huarpes, 1947.

Vázquez Benítez, José Alberto. *Las capillas posas de Calpan*. Puebla: Gobierno de Estado de Puebla, 1991.

Vázquez de Parga, Luis, et al. *Las peregrinaciones a Santiago de Compostela*. 3 vols. Madrid: Consejo Superior de Investigaciones Cientificas, 1948.

Vemdrell, F. "La actividad proselita de San Vicente Ferrer durante el reinado de Fernando I de Aragon." *Sefarad* 13 (1953): 87–104.

Ventrone, Paola. "I Sacri Monti: Un esempio di teatro 'pietrificato'?" In Gensini, *La Gerusalemme di San Vivaldo*, 145–62.

———. "On the Use of Figurative Art as a Source for the Study of Medieval Spectacles." In *Iconographic and Comparative Studies in Medieval Drama*, edited by Clifford Davidson and John Stroupe, 4–16. Kalamazoo: Medieval Institute Publications, 1991.

Vera, Fortino Hipólito. *El Santuario del Sacromonte*. Amecameca, Mexico: Tipografía del Colegio Católico, 1881.

Vercelloni, Virgilio. *Altante storico dell'idea europea della città ideale*. Milan: Jaca, 1994.

Verdon, Timothy, and John Henderson, eds. *Christianity and the Renaissance*. Syracuse: Syracuse University Press, 1990.

Very, Francis. *The Spanish Corpus Christi Procession: A Literary and Folkloric Study*. Valencia: Moderna, 1962.

Vidal, Jaime. "Towards an Understanding of Synthesis in Iberian and Hispanic American Popular Religiosity." In *An Enduring Flame: Studies on Latino Popular Religiosity*, edited by Anthony Stevens-Arroyo and Ana María Síaz-Stevens. New York: Bild Center for Western Hemisphere Studies, 1994.

Vigneras, Louis-André. *La búsqueda del Paraíso y las legendarias islas del Atlántico*. Cuadernos Colombinos, 6. Valladolid: Casa-Museo de Colon, 1976.

Vila Beltrán de Heredia, Soledad. "El plan regular de Eiximenis y las Ordenanzas Reales de 1573." *La ciudad iberoamericana: Actas del Seminario Buenos Aires*. Madrid, 1987.

Vilnay, Zev. *Legends of Jerusalem*. Philadelphia: Jewish Publication Society, 1973.

Vincent, Hugues, and F. M. Abel. *Jérusalem nouvelle*. Vol. 2 of *Jérusalem, Recherches de topographie, d'archéologie et d'histoire*. Paris: J. Gabalda, 1914–26.

Vogel, Cyril. "La croix eschatologique." In *Nöel, Epiphanie, retour du Christ*, edited by André Marie Dubarle, 85–108. Paris: Cerf, 1967.

———. *Medieval Liturgy: An Introduction to the Sources*. Washington, DC: Pastoral Press, 1981.

Volpi, Lorenzo. "L'esegesi biblica di Beda e l'architettura altomedioevale: Ipotesi sul westwerk della Chiesa di Saint-Riquier a Centula." *Arte Cristiana* 773, no. 84 (1996): 85–96.

Volt, Evon. *Zincantan: A Maya Community of the Highlands of Chiapas*. Cambridge, MA: Harvard University Press, 1969.

von Simson, Otto. *The Gothic Cathedral: Origins of Gothic Architecture and the Medieval Concept of Order*. New York: Harper Icon, 1956.

Wagner, Eugene Logan. "Open Space as a Tool of Conversion: The Syncretism of Sacred Courts and Plazas in Post Conquest Mexico." Ph.D. diss., University of Texas, Austin, 1997.

Warman, Arturo. *La danza de moros y cristianos*. Mexico City: UNAM, 1972.

Watts, Pauline Moffitt. "Languages of Gesture in Sixteenth-Century Mexico: Some Antecedents and Transmutations." In *Reframing the Renaissance: Visual Culture in Europe and Latin America, 1450–1650*, edited by Clare Farango, 140–51. New Haven: Yale University Press, 1995.

———. "Prophecy and Discovery: On the Spiritual Origins of Christopher Columbus's Enterprise of the Indies." *American Historical Review* 90 (1985): 73–102.

Webster, Susan Verdi. "Art, Ritual and Confraternities in Sixteenth-Century New Spain." *Anales* 70 (1997): 5–43.

———. "The Descent from the Cross in Sixteenth-Century New Spain." *The Early Drama, Art, and Music Review* 19, no. 2 (1997): 69–85.

Weckmann, Luis. *La herencia medieval de México*. 2 vols. Mexico City: Colegio de Mexico, 1984. Translated by Frances M. López-Morillas as *The Medieval Heritage of Mexico*. New York: Fordham University Press, 1992.

———. "Las esperanzas milenaristas de los franciscanos de la Nueva España." *Historia Mexicana* 32 (1982): 89–105.

Weinstein, Donald. *Savonarola and Florence*. Princeton: Princeton University Press, 1970.

Weismann, Elizabeth Wilder. *Mexico in Sculpture, 1521–1821*. Cambridge, MA: Harvard University Press, 1950.

Werblowsky, R. J. Zwi. "Mindscape and Landscape." In *Sacred Space: Shrine, City, Land*, edited by Benjamin Z. Kedar and R. J. Zwi Werblowsky, 9–17. New York: New York University Press, 1998.

Werckmeister, O. "The First Romanesque Beatus Manuscripts and the Liturgy of Death." In *Actas del simposio para el estudio de los códices del comentario al Apocalipsis de Beato de Liébana*, 2:165–92. Madrid: Joyas Bibliográficas, 1978–80.

Werner, Martin. "The Cross-Carpet Page in the Book of Durrow: The Cult of the True Cross, Adomnan, and Iona." *AB* 72, no. 2 (1990): 174–223.

Wessley, Stephen. "Additional Clues to a Role for Joachim's Order." In *L'Età dello Spirito e la fine dei tempi in Gioacchino di Fiore e nel gioachimismo medievale*. San Giovanni in Fiore, Italy: Centro Internazionale di Studi Gioachimiti, 1986.

———. *Joachim of Fiore and Monastic Reform*. New York: Peter Lang, 1990.

———. "The Role of the Holy Land for the Early Followers of Joachim of Fiore." In *The Holy Land, Holy Lands, and Christian History*, edited by R. N. Swanson, 142–53. Suffolk: Boydell Press, 2000.

West, Delno. "The Abbot and the Admiral: Joachite Influences in the Life and Writings of Christopher Columbus." In Potestà, *Il profetismo gioachimita*, 461–73.

———. "Christopher Columbus, Lost Biblical Sites, and the Last Crusade." *Catholic Historical Review* 78, no. 4 (1992): 519–41.

———, ed. *Joachim of Fiore in Christian Thought*. New York: B. Franklin, 1975.

———. "Medieval Ideas of Apocalyptic Mission and the Early Franciscans in Mexico." *The Americas* 45 (1989): 293–313.

———. "A Millenarian Earthly Paradise: Renewal and the Age of the Holy Spirit." In *L'Età dello Spirito e la fine dei tempi in Gioacchino di Fiore e nel gioachimismo medievale*, 259–76. San Giovanni in Fiore, Italy: Centro Internazionale di Studi Gioachimiti, 1986.

West, Delno, and Sandra Zimdars-Swartz. *Joachim of Fiore: A Study in Spiritual Perception and History*. Bloomington: Indiana University Press, 1983.

Westfall, Carroll William. *In This Most Perfect Paradise: Alberti, Nicholas V, and the Invention of Conscious Urban Planning, 1447–1455*. University Park: Pennsylvania State University Press, 1974.

Wey, William. *Itineraries of William Wey*. London: Nichols & Sons, 1857.

Wheatly, Paul. *The Pivot of the Four Quarters: A Preliminary Enquiry into the Origins and Character of the Ancient Chinese City*. Chicago: Aldine, 1971.

White, John. "Giotto's Use of Architecture in 'The Expulsion of Joachim' and 'The Entry into Jerusalem' at Padua." *Burlington Magazine* 115 (1973): 439–47.

Whited Normann, Anne. "Testerian Codices: Hieroglyphic Catechisms for Native Conversion in New Spain." Ph.D. diss., Tulane University, 1985.

Whitehill, Walter Muir. *Spanish Romanesque Architecture of the Eleventh Century*. London: Oxford University Press, 1941.

Wilkinson, John. *Jerusalem Pilgrims before the Crusades*. Warminster: Aris & Phillips, 1977.

Wilkinson, John, et al. *Jerusalem Pilgrimage, 1099–1185*. London: Hakluyt Society, 1988.

Will, E. "La tour funeraire en la Syrie." *Syria* 26 (1949): 258–312.

Williams, Ann, ed. *Prophecy and Millenarianism: Essays in Honor of Marjorie Reeves*. Essex: Longman, 1980.

Williams, George. *Wilderness and Paradise in Christian Thought*. New York: Harper, 1962.

Williams, John. "Purpose and Imagery in the Apocalypse Commentary of Beatus of Liébana." In *The Apocalypse in the Middle Ages*, edited by Richard Emmerson and Bernard McGinn, 217–33. Ithaca: Cornell University Press, 1992.

Wilson, Brian. "The New World's Jerusalems: Franciscans, Puritans, and Sacred Space in the Colonial Americas, 1519–1820." Ph.D. diss., University of California, Santa Barbara, 1996.

Wind, Edgar. "Typology in the Sistine Ceiling: A Critical Statement." *AB* 33 (1951): 41–47.

Wischnitzer, Rachel. "Maimonides' Drawings of the Temple." *Journal of Jewish Art* 1 (1974): 16–27.

———. "The Messianic Fox." *Review of Religion* 5 (1941): 257–63.

———. "Die messianishe Hütte in der jüdischen Kunst." *Monatsschrift für Geschichte und Wissenschaft des Judentums* 80 (1936): 377–90.

Wolin, Judith. "Mnemotopias: Revisiting Renaissance Sacri Monti." *Modulus* 18 (1987): 45–61.

Woodruff, Helen. "The Illustrated Manuscripts of Prudentius." *Art Studies* 7 (1929): 33–79.

Wright, Craig. *The Maze and the Warrior: Symbols in Architecture, Theology and Music*. Cambridge, MA: Harvard University Press, 2001.

Wright, John. *The Play of Antichrist*. Toronto: Pontifical Institute of Mediaeval Studies, 1968.

Wright, Stephen K. *The Vengeance of Our Lord: Medieval Dramatizations of the Destruction of Jerusalem*. Toronto: Pontifical Institute of Mediaeval Studies, 1989.

Wright Carr, David. "Sangre para el sol: Las pinturas murales del siglo XVI en la parroquia de Ixmilquilpan, Hidalgo." In *Memorias de la Academia Mexicana de la Historia, correspondiente de la Real de Madrid* 41 (1998): 73–103.

Ybot León, Antonio. *La iglesia y los eclesiásticos españoles en la empresa de Indias*. 2 vols. Barcelona: Salvat, 1954–63.

Yhmoff Cabrera, Jesus. *Los impresos mexicanos del siglo XVI en la Biblioteca Nacional de México*. Mexico City: UNAM, 1989/90.

Young, Karl. *Drama of the Medieval Church*. 2 vols. Oxford: Oxford University Press, 1933.

Zahm, J. A. *The Quest for El Dorado*. New York: Appleton, 1977.

Zampa, Paola. "Il Giardino: Construzione e Rappresentazione di un 'Utopia." In *Città e linguaggi: Utopie, rappresentazioni e realità*, edited by Franca Fedeli Bernardini, 59–71. Rome: Fratelli Palombi, 1991.

Zavala, Silvio. *El trabajo indígena en los Libros de Gobierno del Virrey Luis de Velasco, 1550–1552*. Mexico City: Centro de Estudios Históricos del Movimiento Obrero, 1981.

———. *Ideario de Vasco de Quiroga*. Mexico City: El Colegio de Mexico, 1995.

Zawisza, Leszek. "Tradición monástica europea en los conventos mexicanos del siglos XVI." *Boletín del Centro de Investigaciones Históricas y Estéticas* 9 (1968): 90–116.

Zea, Leopoldo, ed. *El descubrimiento de América y su sentido actual*. Mexico City: FCE, 1989.

Zeitlin, Solomon. *Maimonides: A Biography*. New York: Bloch, 1955.

Zimdars-Swartz, Sandra. "Joachite Themes in the Sermons of St. Bernardino of Siena: Assessing the Stigmata of St. Francis." In Potestà, *Il profetismo gioachimita*, 47–60.

———. "John of Dorsten's Response to Apocalyptic Prophecy in the 1466 Erfut Quaestio: A Prelude of an Apocalyptic Theology of Papal Grace." In Potestà, *Il profetismo gioachimita*, 259–70.

Zinn, G. A. "Hugh of St. Victor and the Ark of Noah: A New Look." *Church History* 40 (1971): 261–72.

Index

[Locales in parenthesis indicate Mexican states. Numbers in *italics* refer to figures.]

eschatology, 41
 Aztec, 63–65
 Christian, 12, 43–63
 Jewish, 42–43
Escobar, Matías de, 138, 148, 173, 189
Eusebius of Caesaria, 24, 95
evangelization centers, elements of
 atria, 18–19, 21, 37–38, 78, 92, 115–16, 129, 133, 138, 148,
 153, 167–69, 192–95, 199
 atrial crosses. *See* cross
 convents. *See* convents
 corrals. *See* corral
 gardens, 22, 34
 mansions/*mansión*, 30, 36
 merlons/crenellation, 33, 36–39, 127, 129, 136, 199
 "monasteries," 17, 21, 39
 open chapels. *See* chapels
 patios, 27–30, 177, 181, 189–90, 192, 199, *1.1, 1.3, 1.15,*
 1.18–19, 1.21–22, 1.30, 4.30, 4.44–45. See also
 atria (above); corral
 porciúncula doorway, 32–33, 122, 137, 139, 161, 163, 167,
 239n118
 portico/*portería*. *See* chapels
 posas. *See* chapels
 ramadas, 36, 134, 137, 141, *1.35, 4.29–30*
 temples, 18, 21, 183, 187, 193, 195, 199
Extremadura, 29, 66
Eyck, Jan van, 160, 185, 244n199, *5.16*
Ezekiel
 as city planner, 94–97, 100–103, 106, 109, 130
 porta clausa, 33, 139
 temple imagery, 32–33, 48, 50, 79–80, 114–15, 122,
 126–27, 130, 137–40, 163, 166, 173, 238n93

façades, 82, 83, 71, 126, 135, 137, 142, 148, 161, 163, 175, 181,
 187, 213n65
feathered sun, 174
Fermo, Serafino da, 62
Ferrer, Vincent, 25, 58
fifth age of world, 64
Fifth Lateran Council, 62
flagellants, 25, 140, 182, *4.41*
Florence, Church of Santa Croce, 22, 34, 144
Floreto de Sant Francisco, 223n180, 225n232, *2.13*
flowering gardens, 78–79, 114, 194
fons vitae, 79. *See also* fountains
fortifications, 36–39, 49, 58
fortress monasteries. *See* monasteries, fortress
fountains, 18, 35, 39, 79, 122, 140, 163, 195, 211n13, *1.33, 4.42*

Francis of Assisi, St., *56–58*
 Angel of the Sixth Seal, 57, 167, 199, *7.3*
 stigmata, 57, 159, 163, 164–65, 221n140, *2.13*
Franciscans, 54, 57–58, 66–68 and *passim*
 arrival in New Spain, 67
 Custody of the Holy Land, 108, 124
 mission at Cumaná, Venezuela, 225n232
 Observant Reform, 58, 63, 67, 108
 Twelve Apostles, 67, *1.4, 1.31, 2.19*
friaries. *See* convents
friars
 compared with monks, 39
 "second generation," 12, 68
 See also Augustinians; Dominicans; Franciscans

Gabriel the Archangel, St., 103, 164, 166, 233n111
Gante, Pedro de, 48, 98, 137, 141–42, 160, 178, 184–85,
 243n187–88, 253n8, *4.43*
Garcés, Julián, 104–6
gates, 19, 33, 38–39, 49–50, 85, 94, 106, 122, 124, 133–34, 139, 156,
 159, 166, 192, 194, 211n14, 229n337, *1.2–3, 4.2, 4.18, 4.27–28*
 pearly, 50, 85, 156, 166, 192, 194
gazophylacia, 127, 129, 131, 133, 147–48, 193
Geertz, Clifford, 7
Gentile da Fabriano, 183, *6.5*
genus angelicus, 44, 66, 198
Gerlero, Elena Estrada de, 73
Gibson, Charles, 2
Gilberti, Maturino, 70, 166, 178, 247n27, 249n76
Giles of Viterbo, 61–62
Gillet, Louis, 36
Giovanni da Milano, 183–84, *4.50*
Golgotha, 47, 97, 108–9, 116, 119, 139–40, 142, 168–69, 172,
 182–83, 193
Gómez Martínez, Javier, 38
Good Friday, 51, 65, 139, 182
Grabar, Oleg, 96
Grail legend, 56, 220n127, 234n131, 254n25
Granada, Santa Fe de, 101–2, 179
Gregory the Great, St., 10, 50, 113–114, 174
 Miraculous Mass of, 160–161, 173, *5.17*
grids, urban. *See* city planning
Grijalva, Juan de, 147
Gruzinski, Serge, 2
Guadalupe, Virgin Mary of, 5, 199, *7.4*
guided syncretism, 10, 12, 49, 199, 204

Hacoen, Yoseph ben Yeoshua, 69
Hadrian, Emperor, 168

Krautheimer, Richard, 117, 133, 148, 208n13
Kubler, George, 15, 82, 123, 125, 168, 210n111

La Cañada (Querétero), 161
Lafaye, Jacques, 2, 7
La Isabela, 61
Lalibela, Etiopía, 98
Las Casas, Bartolomé de, 60, 67, 178, 194
Last Days, 51, 60, 61, 106, 162, 167, 203. *See also* end of world;
 End Time; last judgment
last judgment, 22, 41, 47, 52, 67, 70, 73, 78, 84, 89, 119, 151,
 160–61, 166–67, *2.21, 2.23, 2.25, 2.39–40, 5.24, 5.27.*
 See also Last Days; punishment
Last Judgment, The, 75, 178
Last World Emperor prophecy, 47–48, 51–52, 56, 122, 126, 134,
 162–67, 180, *2.5*
latera of the Temple, 239n120, 240n126, *4.19, 4.23*
Latin Kingdom of Jerusalem, 50, 52–53, 121, 123–24
latticework grills, 83, 142–43, 145, 148, 243n195, 245n223
León-Portilla, Miguel, 2
Lienzo de Tlaxcala, 162
Limbo, 246n5, 257n1
liturgical theatrics, 143, 190–95, 201–4
liturgy, 5, 45, 52, 60, 62, 63, 146, 187, 190–95, 199, 201, 204
Lockhart, James, 2, 6, 12, 198
López de Gómara, Francisco, 65
Lost Tribes of Israel, 8, 44, 68–69, 111, 122, 136, 147, *2.20*
Lucifer, 89, 165, 245n229, 246n8

Maimonides, 59, 126, 129
 Middot Tract, 126, *4.16*
Malinalco (Morelos), 78–79, *2.41–44*
mansiones, 96, 113, 122, 145, 148, 178, 185, 189. *See also* chapels, *posa;*
 stages, stage sets
March 25th (Annunciation–Good Friday), 51, 225n222
Mary, Virgin, 33, 86, 88, 108, 147, 157, 164, 166, 175, 179, 192, 199,
 201–2, 253n168, *7.4, 7.7*
Mass as sacrifice. *See* sacrifice
Maya, 1, 153–54, 174
McAndrew, John, 15, 125
Medina Vargas, Cristóbal de, 199
Meditations on the Life of Christ, Pseudo-Bonaventure, 159
Memling, Hans, 184, 190, *6.6*
mendicants. *See* friars
Mendieta, Gerónimo de, 2, 17, 21, 67, 69, 81, 104, 129, 134, 147,
 162, 179, 198
merlon. *See* evangelization centers
Mesoamerica, religion of, 63–65, 92–94, 190
mestizos, 12, 198

metaphors, 7–9, 12, 199, 203–4
 city, 44, 94, 149, 191
 cross, 151–75
 right worship, 4, 44, 48–49, 73, 83–84
 temple, 45, 48
 warfare, 45–48, 193, 215n145, 229n341
metaphors, root, 7–9, 149, 154, 175, 203–4
 animal husbandry, 8
 astral, 8
 floral, 8
 natural, 8
 sanguinal, 8
 solar, 8, 64, 175
metaphors of the human body
 body-temple, 8, 48, 214n89
 heart, 49
 navel of the world, 43, 54, 215n124, *3.3*
Metztitlán (Hidalgo), 74, 97, *1.21*
Mexica, defined, 1. *See also* Aztecs
 deities, 3–5, 12
Michael the Archangel, St., 47, 57, 70, 88–89, 104, 117,
 165–66, 180, 204, *2.22, 4.33, 7.7*
mictlán (hell), 5, 65, 70
Milan, Italy, 95, 97
Milhou, Alain, 2, 7
military architecture in Europe, 36–39
millennialism, 42, 62, 199, 257n11
Miraculous Mass of St. Gregory. *See* Gregory the Great, St.
mirrors, 66, 154, 164, 168–70, 174–75, 192, 202, 204
missionary theater, 177–95, 203
momoxtli, 12, 29, 151, 171, 174, 177, 187, 194, 204, *5.33–35,
 5.38, 6.1*
monasteries
 Benedictine, 24, 39, 53
 compared with convents, friaries, 39
 fortress, 36–39
monastic life, 54–56, 78, 122
monks, compared with friars, 39
monumentum. See Easter sepulcher
morality, 69–89
More, Sir Thomas, 42, 62, 99
Morning Star, 152, 208n20, 246n8
Morosini, Barbon, 144
mosques, 21, 26
Motolinía, Toribio de, 30, 33, 66, 69, 99, 104–6, 115, 134,
 147, 158, 179–80, 194–95
Mount of Olives. *See* Jerusalem
Mozarabic Spain, 24. *See also* reconquest of Spanish peninsula
Muñoz Camargo, Diego, 177, *1.15, 2.19, 6.1*

JAIME LARA

is associate professor of Christian art and architecture
and chair of the Program in Religion and the Arts at Yale University Divinity School
and Yale Institute of Sacred Music.

City, Temple, Stage was designed by Wendy McMillen;
composed in 10.4/14.3 Monotype Bell with Malagua
by Four Star Books; printed by sheet-fed offset lithography on
157 gsm Gloss Art - White stock, Smyth sewn and bound over
binder's boards with Brillanta cloth and Heiwa paper,
and wrapped with dust jackets printed in four colors on
157gsm coated stock by Kings Time Printing Press, Ltd.;
and published by

The University of Notre Dame Press
NOTRE DAME, INDIANA 46556